AFRICAN CINEMA

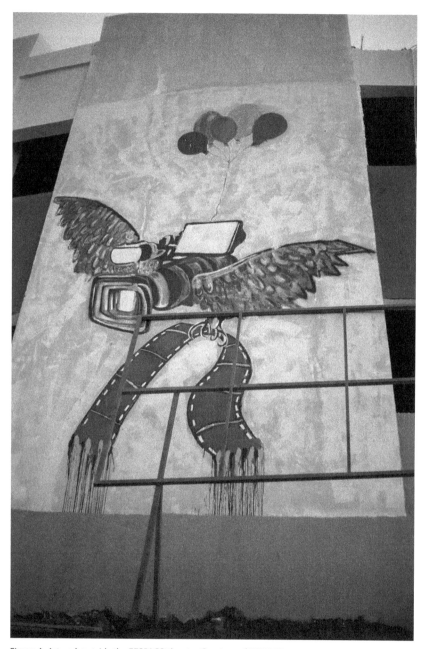

Figure A. Artwork outside the FESPACO theater. Courtesy of FESPACO.

This book is a publication of

Indiana University Press
Office of Scholarly Publishing
Herman B Wells Library 350
1320 East 10th Street
Bloomington, Indiana 47405 USA

iupress.org

Manufactured in the United States of America

First Printing 2023

Cataloging information is available from the Library of Congress.

ISBN 978-0-253-06624-4 (hdbk.)
ISBN 978-0-253-06625-1 (pbk.)
ISBN 978-0-253-06626-8 (web PDF)

This book is a collaboration of *Black Camera: An International Film Journal,* the Pan-African Film and Television Festival of Ouagadougou (FESPACO), and IMAGINE Film Institute, Burkina Faso.

AFRICAN CINEMA

Manifesto and Practice for Cultural Decolonization

Volume 2
FESPACO: Formation, Evolution, Challenges

Edited by
Michael T. Martin and Gaston J. M. Kaboré
with Allison J. Brown, Cole Nelson, and Joseph E. Roskos

INDIANA UNIVERSITY PRESS

**The Editors wish to dedicate this volume to
the Burkinabe**—*the country of the upright people*

What we should expect from intellectuals is that
they at least develop concepts that will help the masses of
Africans to understand what is happening to them.

—Joseph Gaï Ramaka, 2009

African cinema quotes itself. This is a sign
that it now has a history.

—Férid Boughedir, 1992

Contents

Part II: FESPACO: An Evolving Cinematic and Cultural Formation

Part III: Conditionalities and Challenges

Preface

Ardiouma Soma
General Delegate of FESPACO
(2014–2020)

1969–2019: Fifty years of the Pan-African Film and Television Festival of Ouagadougou, fifty years of African cinemas.

From February 23 to March 2, 2019, was celebrated the fiftieth anniversary of FESPACO under the theme:

"Confronting our memory and shaping the future of a Pan-African cinema in its essence, its economy and its diversity."

This theme sums up the entire history of FESPACO, which merges with that of African cinemas.

Since its inception in 1969, the festival has received the vital backing and support of the pioneers of African cinemas, including Ousmane Sembène (the Elder of the Elders, as he was called), Timité Bassori, Oumarou Ganda, Tahar Cheriaa, Med Hondo, and Lionel N'Gakane. For these pioneers, FESPACO represented an opportunity for African audiences, particularly those from sub-Saharan Africa, to access their works, of which they are the first recipients.

FESPACO succeeded in establishing a fusional relationship between cinemagoers and the community of film professionals, thus creating a space for the confrontation of imaginations and talents, for sharing and building both a memory and a present and a future.

FESPACO, as the barometer of African cinemas, has witnessed a succession of different generations of filmmakers and various waves of cinematographic expression. I would like to recall those pioneering films that highlighted the dangers of acculturation and alienation from the world's systems of thought and explanation, from supposedly universal values, and from the ways of life of the colonizing and neocolonial European powers, because these films were precious awareness-raising tools for African peoples struggling for their freedom and for the affirmation of their identities.

Thanks to the vision, determination, and sustained and enlightened activism of the pioneers, as well as the subsequent generations, the festival,

through numerous symposiums, conferences, round tables, and professional workshops, has become the breathtaking laboratory for reflection, analysis, strategy development and definition of national, regional, and continental policies for the development of African cinema.

Fifty years later, many challenges remain; we must capitalize on our achievements, forge our memory and look forward to the future. The African Cinématheque of Ouagadougou, opened in 1995 at the FESPACO head-quarters under the impetus of the Pan-African Federation of Filmmakers, should keep on strengthening its missions of collecting, safeguarding, promoting, exposing, and publicly disseminating the film heritage bequeathed to us and in continuous enrichment.

FESPACO, as a Pan-African festival with its triple professional, popular, and political dimension, should continue to strengthen its position as a guiding beacon, as well as its function as a mirror that reflects Africa's imaginary, historical, artistic, reflective, and cultural heritage.

A professional dimension that should be reinforced by a selection geared towards new talents and new views, an international film market and professional meetings that promote exchanges, the thriving of artistic genius, and the development of structuring projects.

My deep conviction is that all efforts to be deployed should lead to the advent of a new dynamic trend of creation and production of multiple images and narratives in the service of the blossoming of an African and Afro-descendant being rich in its history and geared towards its own reinvention.

Ardiouma Soma is a graduate of the African Institute for Film Education (INAFEC) from the University of Ouagadougou, Burkina Faso. He also studied at the Teaching and Research Unit (UER) for Arts and Archaeology from the University of Paris I Pantheon Sorbonne, France. Soma started his career as a journalist reporter at the national television for a short while, before joining FESPACO. He took an active part in the establishment of the African Film Library of Ouagadougou, opened in 1995. Soma was the General Delegate of FESPACO from December 2014 through 2020.

Acknowledgments

In recognition of this two-year collaboration, we salute the following individuals and institutions upon which was realized this three-volume scholarly endeavor and project of this scope, scale, and utility on African and Black diasporic cinema.

Advising Consultants

- Erna Beumers, Museum Curator, Africa, Utrecht, Netherlands
- June Givanni, Curator & Director, Pan African Cinema Archives (JGPACA), London
- Eileen Julien, Professor Emeritus, Departments of Comparative Literature & French, Indiana University, Bloomington
- Ron Stoneman, Professor Emeritus & former Director, Huston School of Film & Digital Media, National University of Ireland, Galway
- Emma Sandon, Senior Lecturer, Department of Film, Media and Cultural Studies, School of Arts Birbeck, University of London
- Olivier Barlet, Film critic and scholar, former Director of *Africultures*, France
- Justin Ouoro, Professor of Film, University of Ouagadougou, Burkina Faso
- Somet Yoporeka, University of Strasbourg, France, Burkina Faso

Pan-African Film and Television Festival of Ouagadougou (FESPACO), Burkina Faso

- Ardiouma Soma, General Delegate, FESPACO, 2014–2020

Pan-African Federation of Filmmakers (FEPACI), Burkina Faso

- Dramane Deme, Executive Director, Pan-African Federation of Filmmakers (FEPACI)

Institut IMAGINE (Burkina Faso)

- Edith Kaboré
- Edmond Sawodogo, Research Associate
- Toussaint Zongo, Filmmaker and Director of Administration
- Daouda Sanguisso, Interpreter/Translator, Burkina Faso

Media School, Indiana University, Bloomington

- Walter Gantz, Interim Dean
- Radhika Parameswaran, Associate Dean

Black Camera: An International Film Journal

- Megan Connor, Former Managing Editor
- Katherine Tartaglia, Former Managing Editor
- David Coen, Freelance Copyeditor

AFRICAN CINEMA

On Decoloniality: African and Diasporic Cinema

Michael T. Martin and Gaston J. M. Kaboré

The epoch of slavery and concomitant trauma of colonial settlement and rule in Africa, the Caribbean, the Americas, and Pasifika is arguably without precedent in the long history of Western imperialism and ascendancy of capitalism. Africans and the resistance of their descendent peoples in the diaspora are no less a challenge today than they were during the period of conquest, settlement, and enslavement. Indeed, the legacy of this period and those defaced by it, the continuing struggle against its repressive cultural, systemic, and institutional practices in the contemporary world, constitutes an abiding summons to refute the denial, by design and ignorance, of Africa's contribution to world culture and civilization. To this day, along with the hazards of globalization's relentless homogenization of cultures and societies, the corporate project of accumulation sequesters and undermines humankind's capacity and will to "act" in solidarity against the pillaging of the natural world that sustains life and planet Earth. In these relational historical determinations and their inherent collective trauma, what is to be discerned from African cinema and its varied iterations in the Black Atlantic and Pasifika? Like other artistic modes, evinced in and refracted by a kaleidoscope of genres, themes, aesthetics, and representations—emblematic and signifying—African cinema is a work in progress, recuperating the past, as it imagines and gestures a futurity.

In the project of world making, and in the African specificity, cinematic texts labor as mediated solidarity between the filmmaker/cultural producer and marginalized peoples and social movements they identify with and endeavor to represent and advocate for. Such films are "about a subject and about itself," in the former, as political praxis, and the latter, the process and apparatus of filmmaking.[1] Differences in genre, aesthetic registers, and narrative storytelling notwithstanding, films of this kind are in correspondence with historical activity—the evidentiary and the fantastical. Such counterhistorical texts, indeed *all* cinematic texts, are no less contingent on the vagaries and determinations of circumstance, place, and the temporal by which they

are informed and constituted in local, regional, national, continental circuits of production and exchange. Broadly speaking, with these conditionalities in mind, the genealogy—the descent lines—of African cinema are situated and rendered intelligible, historical, and culturally distinct.

What began in the colonial project of denial and cultural devaluation was followed by the formative utterances by African cineastes and their allies to forge and cohere a collective call for a cinema borne from and fashioned by Africanity, as a decolonial assertion and valorization of all manner of African experience. No less determining, this cinema's *nascita* was first made manifest through the interplay of Pan-Africanism and anticolonial struggles from the mid-1950s and 1960s. In considering the postindependence period, with African cinema's "nationalizations" in the early 1980s to late 1990s and under conditions of a "market economy," Olivier Barlet and Claude Forest contend that this marked the decline of "collective awareness" and rise of a cinema of "individuation."[2] Since then to the present moment, the authors assert that the digital revolution has occasioned "a radical thematic and aesthetic revival" of African cinema, which this collection examines, along with earlier formations and stages in the evolution of the African cinematic.[3] Mapping the African cinematographic encounter to the present is rendered in the following, and intentionally, simplified chronology.

In 1895—the year of the Lumière brothers' screening of *La Sortie de l'Usine Lumière à Lyon* (France)—Félix Regnault documented the labors of a Wolof clay potter in *Une Femme Ouolove / A Woman Ouolove*. The following year, screenings took place in Egypt and South Africa, and in the next year, Tunisia and Morocco. During the period of colonial denunciation, René Vautier denounced the colonial project in the documentary *Afrique 50* (1950, France), Paulin Soumanou Vieyra and Mamadou Sarr addressed identity among African students in Paris and the emblematic and locational meaning of Africa as a floating signifier in *Afrique sur Seine* (1955, France), and Chris Marker and Alain Resnais examined racism in readings of African art in *Les Statues meurent aussi / Statues Also Die* (1953, France). For film texts representative of the anticolonial period, see *Borom Sarret* by Ousmane Sembène (1963, Senegal) and *Emitaï* (1971, Senegal); Gillo Pontecorvo's theorized meditation on the Algerian War of Independence in the Algerian-Italian production of *La Bataille d'Alger / The Battle of Algiers* (1966, Italy and Algeria), Sarah Maldoror's *Sambizanga* (1972, Angola and France), Med Hondo's *Soleil Ô* (1967, Mauritania), Djibril Diop Mambéty's *Touki Bouki* (1973, Senegal), and Gaston J. M. Kaboré's allegorical *Wend Kuuni* (1982, Burkina Faso). And during the period of market economy and nationalization, Souleymane Cissé's *Finyè* (1982, Mali) and *Yeelen* (1987, Mali), Hondo's *Sarraounia* (1986, Mauritania), Flora Gomes's *Mortu Nega* (1988, Guinea-Bissau), Sembène's *Guelwaar* (1993, Senegal), Jean-Marie

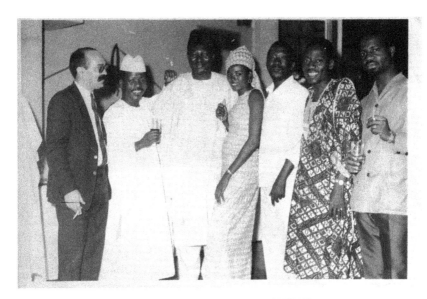

Attendees and participants of FESPACO 1972. Image courtesy of FESPACO.

Téno's *Afrique, je te plumerai* (1992) and *Clando* (1996, Cameroon), Kaboré's *Buud Yam* (1997, Burkina Faso), and Bourlem Guerdjou, *Vivre au paradis / Living in Paradise* (1998, Algeria). Lastly, consigning films to Barlet and Forest's contemporary "moment" ("Aesthetic renewal and digital revolution"), Mahamat-Saleh Haroun's *Bye Bye Africa* (1999, France and Chad) and *Un homme qui crie* (2010, Chad); Sembène's *Faat Kiné* (2001, Senegal) and *Moolaadé* (2003, Senegal); Abderrahmane Sissako's *Heremakono* (2002, Mali), *Bamako* (2006, Mali), and *Timbuktu* (2014, Mali); Téno's *Le Malentendu colonial* (2004, Cameroon); Haile Gerima's *Teza* (2008, Ethiopia); Moussa Touré's *La Pirogue* (2012, Senegal); Amor Hakkar's *La Maison jaune* (2007, France and Algeria); Alain Gomis's *Félicité* (2017, Senegal); and Mati Diop's *Atlantics* (2019, France and Senegal).

Beginning with Vieyra and Sarr's *Afrique sur Seine*, each film entry in the chronology is distinct, and together they foreground the thematics and diversity that is African (and Black diasporic) cinema as a continental and global project, at once particular and universal. And in this chronological continuum, each film is informed by the specificities of historical activity, its temporal and circumstantial registers, as well as by the modalities of story-telling particular to cultural formations.

This collection was first conceived in 2019 during the twenty-sixth edition of the Pan-African Film and Television Festival of Ouagadougou (FESPACO) in Burkina Faso and then assembled and published in 2020–21

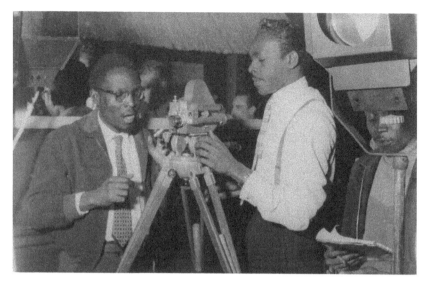

Paulin Soumanou Vieyra (*left*) and Georges Caristan (*right*) during the filming of *Afrique Sur Seine/ Africa on the Seine* (dir. Mamadou Sarr and Vieyra, 1955, France). Image courtesy of Stéphane Vieyra.

in three successive issues of *Black Camera: An International Film Journal* (Indiana University Press) in partnership with FESPACO and IMAGINE Film Institute, both film entities in Burkina Faso. In this new iteration comprising three volumes, volumes 1 and 2 have been reversed in order for greater coherency, and additional materials have been added to the contents of each volume. Relational yet distinct, the following are the contents of each volume delineated.

Volume 1: Colonial Antecedents, Constituents, Theory, and Articulations

Organized into four parts, this volume features foundational essays; thematic, practical, and theoretical conversations; and three dossiers that chronicle and enunciate the development of African cinema to the present.

Part 1: Colonial Formations

Six chapters illumine the ideological project of colonial cinema to legitimize the economic exploitation, political control, and cultural hegemony of the African continent during the period of imperial rule. Roy Armes's chapter, the first, is a case study of colonial policy and practice that is examined in the contexts of Tunisia, Egypt, and Algeria. This is followed by James E.

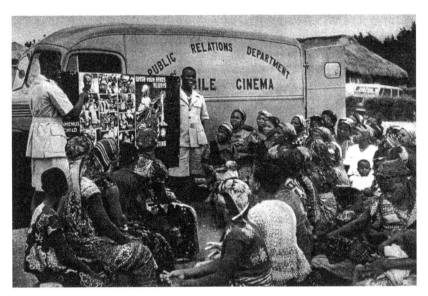

The Gold Coast Film Unit disseminated government policy to local audiences. Here, a Mass Education team outlines scenes from the 1950 GCFU production *Amenu's Child*. Image courtesy of the Public Relations Office, Gold Coast.

Genova's take on the French "Colonialist Regime of Representation," which is detailed in his expansive overview and critical reading of Georges Régnier's *Paysans noirs* (1948, France). The film, Genova contends, "was intended to (re) construct images of Africa that would resonate with African audiences, and also challenge the prevailing tropes of Africa and Africans circulating among external audiences."[4]

Next, Femi Okiremuette Shaka's "Politics of Cultural Conversion in Colonialist African Cinema" examines two variants of colonial cinema: "instructional cinema" and "colonialist cinema," the former deployed for public education in the project of modernization, the latter, commercial, emphasizing "conventionalized stereotypes of Africans in European culture."[5]

James Burns's chapter, "The African Bioscope: Movie-House Culture in British Colonial Africa," assesses the evolution of urban screening sites designated for the nonwhite, largely poor and illiterate population, sites where such audiences "consumed the Hollywood films that their colonial masters found so threatening," while constituting spaces to enable and sustain "urban sociability" among Africans of lower social standing. Tom Rice's chapter, "From the Inside: The Colonial Film Unit and the Beginning of the End," interrogates the shifting politics of British colonial policy engaged with "training Africans" in the postwar period, emphasizing the practice of policy in the Gold Coast (now Ghana). Last, consider in Odile Goerg's

chapter "The Independence Generation: Film Culture and the Anti-Colonial Struggle in the 1950s," on the development of film culture in the postwar years. Here Goerg maps the circulation of Western cinema and the reception of American films by African audiences, the role and variations of censorship practiced by the French and British colonies, and the emergent challenges to colonial discourses on cinema.

Part 2: Constituting African Cinema

Eight chapters engage with (a) the "moment" of what would become African cinema as an anticolonial formation that challenged imperial rule in the continent and the global South; (b) the postindependence period and opposition to, and dependency on, foreign, largely Western, screens, production, and exhibition sites; and (c) the creation of major film festivals in Tunis (Journées cinématographiques de Carthage, also known as JCC) and Ouagadougou (FESPACO),[6] as well as the Pan-African Federation of Filmmakers (FEPACI) that, in counterpoint to foreign domination, institutionalized and promoted African cinema and its role in the educational and cultural development of African societies.

Beginning with two founding texts, Med Hondo's "What Is Cinema for Us?" and Férid Boughedir's "A Cinema Fighting for Its Liberation," the *problematique* and organizing principles of African cinema are declared for its independence and development, decolonizing African minds, and advocacy for the self-determination of African societies. Haile Gerima's contribution follows with "Where Are the African Women Filmmakers?," which revisits patriarchy and sexism on African screens. Gerima asserts, "The depiction and portrayal of women in African cinema is by and large a deformed one,"[7] and he cites three trajectories of this gendered disfigurement: (a) African women are portrayed as sexual objects; (b) symbols of a "pure" Africa; and (c) among "progressive" male filmmakers, portrayals of "liberated men and women with some kind of social, political, and economic vision."[8]

The next two chapters address the Pan-African Federation of Filmmakers (FEPACI), detailed in Monique Mbeka Phoba's interview with Seipati Bulane-Hopa, "New Avenues for FEPACI," and Sada Niang's "The FEPACI and Its Artistic Legacies," in which he assesses the postwar cinematic landscape and context of FEPACI, including the rise of anticolonial movements in the global South and the theorization and deployment of Third Cinema by tricontinental, particularly Caribbean and Latin American, filmmakers, among them Tomás Gutiérrez Alea, Fernando Birri, Julio García Espinosa, Glauber Rocha, Fernando Solanas.[9]

Attendees and participants of FESPACO 1972. Image courtesy of FESPACO.

In "The Six Decades of African Film," Olivier Barlet maps and distinguishes each decade in the evolution of African cinema from the 1960s period of "mandatory commitment" to "mirroring society" (1970s), the "autofiction" of the 1980s, "the individual versus the world" (1990s), "towards humanity" (2000s), and during the 2010s "a tribute to concern," which Barlet describes as "troubled times" marked by "the rise in inequality, populism, and dictatorships."

Part 2's final chapters conclude with overviews of the colonial project and evolution of African cinema in Clyde Taylor's "Africa, The Last Cinema" through to the 1980s and Férid Boughedir's overview and critical summation of the past five decades of African cinema in "The Pan-African Cinema Movement: Achievements, Misfortunes, and Failures (1969–2020)."

Part 3: Theorizing African Cinema

Part 3 interrogates the organizing premises and foregrounds the critical terms, categories, and frameworks upon which African cinema is constituted and debated. Here, such contingent, yet determining, factors, such as nationality, race, location, language, and orality, are examined, along with thorny questions such as "Who is an African filmmaker?"; "What is 'Africanity' in the conception and practice of African cinema?"; and "In defining African

cinema, are we creating a 'theoretical ghetto' and formulaic orthodoxy that will stifle new expressive forms and representational strategies?"

In the first chapter "African Cinema(s): Definition, Identity, and Theoretical Considerations," Alexie Tcheuyap examines the conundrum of fashioning a coherent conceptualization of African cinema. In surveying the theoretical landscape, he foregrounds the disputes and limitations of ensconced notions and arguments that support unsettled claims about African cinema. In doing so, and on behalf of clarity of terms and criteria, this chapter is particularly useful for discussion. Esiaba Irobi's "Theorizing African Cinema: Contemporary African Cinematic Discourse and Its Discontents" proffers the construct of the *Nsibidi* as the framing edifice of a theory of African cinema, which posits "that our filmmakers should, as their own unique contribution into the fabric of world cinema, quilt complex, cultic, iconography that requires an authentic and deep understanding of a given African culture's art history."[10] For comparisons between ideological discourses and frameworks, see Stephen A. Zacks's chapter, "The Theoretical Construction of African Cinema," on "neo-structuralism," "popular modernism," and the neo-Marxist approach of Frantz Fanon and Third Cinema to history and social transformation. Elaboration of this approach can be found in Teshome H. Gabriel's chapter and seminal text "Toward a Critical Theory of Third World Films." On the matter of authenticity, consult David Murphy's "Africans Filming Africa: Questioning Theories of an Authentic African Cinema"; and on the binary of tradition/modernity, Jude Akudinobi's "Tradition/Modernity and the Discourse of African Cinema." To consider the saliency of "oral cultures" in theorizing African cinema, see "Towards a Theory of Orality in African Cinema," by Keyan G. Tomaselli, Arnold Shepperson, and Maureen Eke; and for the importance of African languages on the reception of African cinema by African audiences, see Paulin Soumanou Vieyra's defining chapter, "Film and the Problem of Languages in Africa." Here, Vieyra sets out to address obstacles in indigenous filmmaking when the spoken language is not in the *original*. To invoke Gaston J. M. Kaboré in the construction of an African imaginary, in a people's language, is the capacity to recover and interpret the past, as it is to develop a national and continental identity because language, Kaboré asserts, "brings specificity to our experience."[11] And Frantz Fanon, no less, declares in *Black Skin, White Masks* that "[t]o speak means to be in a position to use a certain syntax, to grasp the morphology of this or that language, but it means above all to assume a culture, to support the weight of a civilization."[12] Against the limitations of dubbing and, ironically, its capacity to reaffirm Western values, Vieyra advocates for dubbing as a trade-off, "the lesser of two evils," rather than support a [foreign] language that is understood by 10 percent of the audience, declaring that "grafting African language would bring local

Panel discussion at the 2017 FESPACO. Gaston Kaboré, Burkinabe filmmaker, pictured on the right.
Image courtesy of FESPACO.

meaning and affective dimension" for African audiences. In this regard, for
Vieyra, "African cinema must start by being totally African," if it is to con-
tribute to the world, which means "that Africa must originate with African
languages."[13] On the refashioning of African screens and their application
to the training of media professionals and reorientation of African visual
media, see Boukary Sawadogo's chapter "In Defense of African Film Studies."

Part 4: Articulations of African Cinema

Part 4 is comprised of three commissioned dossiers, beginning with a
comprehensive chronology, "Key Dates in the History of African Cinema,"
by Olivier Barlet and Claude Forest, who distinguish the four "moments" in
the evolution of African cinema and include entries for films, filmmakers,
countries, defining events, and institutional formations.

The second dossier, "African Women in Cinema," curated by Beti
Ellerson, maps the location, mobilizations, and contributions of African
women filmmakers from African cinema's nascency to the present. This
much-needed intervention serves as a corrective to an understudied and
under-valorized area of study in the literatures, as well as university curricula
on film, visual, and cultural studies.

And the third dossier, curated and introduced by Sada Niang and Samba
Gadjigo, is devoted to the "father of African Cinema," Ousmane Sembène,
and features a poem and statement by Sembène; a tribute by Gadjigo; a
lengthy conversation with filmmakers Gadjigo and Jason Silverman on their

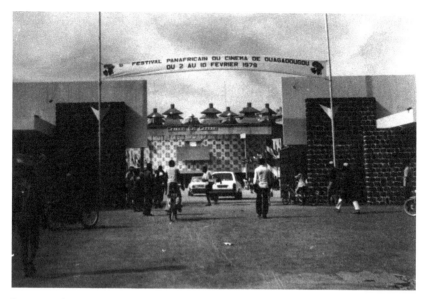

Entrance to the 1979 FESPACO in Ouagadougou, Burkina Faso. Image courtesy of FESPACO.

feature documentary *Sembene!* (2015), by Michael T. Martin; and an anno-
tated gallery of Sembène's personal documents, curated by Cole Nelson.

Volume 2: Pan-African Film and Television Festival of Ouagadougou (FESPACO)—Formation, Evolution, Challenges

The second volume of the collection, which begins with a preface by
Ardiouma Soma, the former General Delegate of FESPACO (2014–2020)
is organized into six parts, the latter part composed of three dossiers. This
volume engages with the decolonizing intervention of FESPACO, the most
celebrated, inclusive, and consequential cinematic convocation of its kind in
the Black world. Since its formation in 1969, FESPACO's mission is, in prin-
ciple, remarkably unchanged, though organizationally distressed, undercap-
italized, and dependent. In the long and fraught history of representation,
FESPACO's defining mission is to unapologetically recover, chronicle, affirm,
and reconstitute the representation of the African continent and its global
diaspora of peoples, thereby enunciating in the cinematic, all manner of
Pan-African identity, experience, and, in the project of world making, the
futurity of the Black world.

With this *raison d'être* of FESPACO in mind, the festival is to neither be
mistaken for merely a site of exhibition, nor a venue for the display of African

and Black artistic achievement, nor a modality for cultural performance and representation. FESPACO is itself a historical activity and intervention on behalf, and in the play of art, politics, modernity, and most important, the cultural identity of African descended peoples and valorization of all manner of Black life on the African continent and diaspora worldwide.

As noted earlier, first published in *Black Camera* in 2020 to coincide with and commemorate the fiftieth anniversary of FESPACO,[14] this second volume includes landmark and commissioned essays, commentaries, conversations, dossiers, and programmatic statements and manifestos that mark and elaborate the key moments in the evolution of FESPACO over the span of the past five decades. Together, they document twenty-six editions of this biennial festival—time enough to assess its development, practice, reception, efficacy, and challenges. By examining FESPACO's role as host to important and defining deliberations about cultural policy and artistic practice in forums, workshops, and colloquia among media professionals, scholars, critics, and cineastes in public conversation, we are able to discern how African cinema, as a local, national, continental, and increasingly in its diasporic iterations, constitutes a global cultural formation influencing other artistic traditions and movements internationally.

Part 1: Sites and Contexts of Exhibition

Part 1 begins with an overview of the "Sites and Contexts of Exhibition" featuring five chapters by Lindiwe Dovey, Manthia Diawara, Beti Ellerson, Sambolgo Bangré, and Dorothee Wenner that together track the international festival circuit for screening African films, the presence of African women filmmakers in the "festival landscape," how and in what exhibition sites African audiences are shaped and cultivated, and the politics that inform transcultural networking and exhibition of African films.

Part 2: FESPACO: An Ever-Evolving Cinematic and Cultural Formation

Part 2 engages with the fifty-year history of the festival itself and comprises nineteen chapters in the form of essays, statements, and interviews by Diawara, M. Africanus Aveh, Mahir Şaul, Sembène, Wole Soyinka, Aboubakar Sanogo, Teresa Hoefert de Turégano, Claire Andrade-Watkins, and Colin Dupré; commissioned essays[15] by Beti Ellerson, Rod Stoneman, Mbye Cham, Claire Diao, Férid Boughedir, Michel Amarger, and Sheila Petty; and interviews with Gaston J. M. Kaboré by Michael T. Martin and Alimata Salambéré by Olivier Barlet.

Part 3: Conditionalities and Challenges

The contents of part 3, "Conditionalities and Challenges," consists of five chapters. Three are formerly commissioned by Imruh Bakari, June Givanni, and Rémi Abéga. The other two are by Mahir Şaul and Olivier Barlet. From the vantage of observation and participation in recent editions of the festival, several contributors project forward into the future of FESPACO and discuss the challenges ahead.[16]

Part 4: Commentaries: Filmmakers, Film Scholars, and Media Professionals

Next in the lineup, part 4, "Commentaries," consists of fifty-four commissioned short statements by filmmakers and other media professionals, film scholars, and critics reflecting on their experience—favorable and otherwise—at past editions, which illume the flaws and grandeur that is FESPACO. Among such statements, include by Françoise Pfaff, Jean-Marie Téno, Danny Glover, Mansour Sora Wade, Bridgett Davis, Jane Bryce, Jean-Pierre Bekolo, Dani Kouyaté, Joseph Gaï Ramaka, Zézé Gamboa, Cheryl Fabio, Cornelius Moore, Makéna Diop, Catherine Ruelle, Melissa Thackway, Mahmoud Ben Mahmoud, to name a few.

Part 5: Documents and Part 6: Dossiers

While part 5 is devoted to the resolutions, regulations, manifestos, record of juried awards, and events obtained during past editions of FESPACO, part 6 constitutes three distinct dossiers. The first dossier addresses the Paul Robeson Award Initiative (PRAI), which was created to broaden the scope of FESPACO by celebrating filmmaking in the Black Diaspora, and the second and third dossiers address the two major film training institutes in Ouagadougou, the Institut Supérieur de l'Image et du Son / Ecole de Studio (Higher Institute of Image and Sound/Studio School, ISIS-SE) and IMAGINE Film Training Institute. Each dossier details the history, purpose, and essential labor of these cinematographic entities in Burkina Faso.

Volume 3: The Documentary Record: Declarations, Resolutions, Manifestos, Speeches

Volume 3 spans the past century and documents decoloniality in cultural policy, emphasizing the cinematic. Closing the collection, it serves as a compendium of proclamations in the form of resolutions, declarations, manifestos, and programmatic statements that chronologically map the

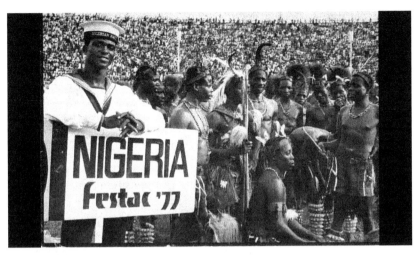

Representatives of Nigeria at the 1977 Second World Black and African Festival of Arts and Culture (FESTAC '77). Public domain.

long history and trajectories of cultural policy in Africa and its diasporas in the Black Atlantic and Pasifika. Part 2 of the volume begins with the 1920 "Declaration of the Rights of the Negro Peoples of the World," which refers to movies as "picture films" and an insidious mode of misrepresentation rather than an affirmation and valuation of African-descended peoples.

> We hereby protest against the publication of scandalous and inflammatory articles by an alien press tending to create racial strife and the exhibition of *picture films* [emphasis ours] showing the Negro as a cannibal.[17]

In counterpoint to such representation of African Americans as "cannibals," the "Declaration" refutes as it anticipates [Black] filmmaking as a self-conscious and reflexive art form and practice that, foregrounding cinema's role in decoloniality, labors to reconstitute African peoples as historical subjects in the project of world making. Later documents in the compendium prescribe and articulate the necessity of media—in its various forms and technologies—as no less important to the development of African societies against neo-imperial forms of globalization under such determinations of capitalism.

However discrete and distinguished by time, institutional affiliation, country/region/continent of origin, venue of address, and historical circumstance and setting, each entry in the compendium is a "speech act" that

- constitutes a public declaration of a decolonial purpose and intention
- prescribes the role of artist, as intellectual in the service of people dispossessed of their culture and humanity
- is ascendant and made manifest during moments of crisis—not stasis
- is instructive, describing means by which social progress and a different world might be realized
- conjures a futurity.

Consider this third volume an aggregate of oppositional assertions and claims in a living archive that as directives on cultural policy and cultural production—aspirational and practical—are in conversation with cinema. As the documentary record and appendix to volumes 1 and 2, this volume is intended to situate African and Black diasporic cinema in the ambit of modernity and the historical project of recovery and renewal.

The compendium is organized into two parts: part 1 references formal statements that pertain directly to cultural policy and cinematic formations in Africa, while part 2 addresses the Black diaspora. Entries in each part are chronologically ordered to account for when such proclamations were created, followed by where and in which setting or context they were enunciated. In doing so, historical time serves to periodize cultural policy and particular cinematic iterations in both Africa and the diaspora alike—in the latter, North/South America, the Caribbean, Europe, and Pasifika. While this organizing approach privileges the temporal and geographical, it draws attention to the cultural politics and determinations of circumstance for each entry in the compendium.

Part 1, on Africa, consists of forty-seven entries. Among the formative and defining proclamations, consider the "Declaration and Resolutions of the Conference of Independent African States" (1958), the "Pan-African Cultural Manifesto, Algiers, Algeria" (1969), and the "Proposed Establishment of an All-African Cinema Union" (1970); and, too, such later statements: "The Algiers Charter on African Cinema" (1975), the "Cultural Charter of Africa" (1976), and "Niamey Manifesto of African Filmmakers" (1982); and on matters of gender and sexuality, the "Statement by the African Women Professionals of Cinema, Television, and Video" (1991), "Queer African Manifesto/Declaration" (2010), "Manifesto: Conference of African Women Filmmakers" (2010), and "Sisters Working in Film and Television (SWIFT)" (2016).

Part 2, on the Black diaspora, comprises fifty-three entries. Note that the earlier entries in this part predate those in part 1 by several decades and start with (as noted earlier) the 1920 "Declaration of the Rights of the Negro

Peoples of the World." This and other defining proclamations are particularly consequential for their emblematic value as denunciations of imperial rule and raced doctrines of domination. Correspondingly, they mobilize and propose programmatic initiatives to decolonize African peoples in solidarity with allied social and political formations. Here, the "Selections from the Declarations and Resolutions of the Fifth Pan-African Congress" (1945), the resolutions of the "Congress of Negro Writers and Artists" (1956 and 1959), and "Towards a Third Cinema" (1970), among others, are foundational followed by the "Resolutions of the Third World Filmmakers Meeting" (1973) and the "Federation of Caribbean Audiovisual Professionals" (FeCAVIP Manifesto, 1990).

While the entries in the compendium document the history, evolution, and trajectories of cultural policy in Africa and the diaspora during the second half of the twentieth century, each proclamation has a backstory—a particular setting, circumstance, motivation, and impetus. In addition to these factors, we should contemplate the human protagonists, who were driven by personal concerns and class and gendered interests, along with competing ideological and philosophical orientations, as well as alliances that privileged one art form over others, and territorial claims and loyalties in national, regional, and continental contexts, which render specificity to each proclamation, and in relationship to larger economic and political affairs and considerations. Together, with these subjectivities and conditionalities, and the relative and shifting notions and practice of Negritude and Pan-Africanism as organizing conceptions, we refer you to volumes 2 and 3 of this collection and to the ever-growing corpus of literature that, in revisiting African decoloniality during the long and tumultuous twentieth century is cause to recalibrate our assessment of the Black world and the artistic and cultural renaissance it spawned.[18]

Notes

1. Ella Shohat and Robert Stam, *Unthinking Eurocentrism: Multiculturalism and the Media* (Routledge, 1994), 279.

2. See in volume 1, Olivier Barlet and Claude Forest's periodization of African cinema, "Key Dates in the History of African Cinema."

3. Ibid.

4. Based on the novel of the same title by colonial administrator and ethnographer Robert Delavignette (1931).

5. Ibid.

6. For a comprehensive account of FESPACO, see volume 2; for FEPACI see also volume 2's "The Long Take: Gaston Kaboré on FEPACI & FESPACO."

7. Ibid.

8. Ibid.

9. For a consideration of the defining texts of Third Cinema, see Michael T. Martin, *New Latin American Cinema: Theory, Practices, and Transcontinental Articulations* (Vol. 1) (Detroit, MI: Wayne State University, 1997).

10. Ibid., 6.

11. Michael T. Martin, "I Am a Storyteller, Drawing Water from the Well of My Culture: Gaston Kaboré, Griot of African Cinema," *Research in African Literatures* 33, no. 4 (Winter 2002): 163–64.

12. Ibid., 164.

13. See volume 2, part 3.

14. *Black Camera* 12, no. 1 (Fall 2020).

15. Formerly published in *Black Camera* 12, no. 1 (2020).

16. Ibid.

17. Drafted and adopted at the UNIA International Convention of the Negroes of the World, New York City, August 31, 1920, see Bob Blaisdell, ed., *Selected Writings and Speeches of Marcus Garvey* (Garden City, NY: Dover Publications, 2004), 20.

18. For example, see *Presence Africaine*, nos. 8–10 (1956): 3–412; *Presence Africaine*, nos. 24–25 (1959): 3–472; Nathan Hare, "A Report on the Pan-African Cultural Festival," *The Black Scholar* 1, no. 1 (1969): 2–10; Olivier Hadouchi, "'African Culture Will Be Revolutionary or Will Not Be': William Klein's Film of the First-Pan-African Festival of Algiers," *Third Text* 25, no. 1 (2011): 117–28; Christopher Bonner, "Alioune Diop and the Cultural Politics of Negritude: Reading the First Congress of Black Writers and Artists, 1956," *Research in African Literatures* 50, no. 2 (2019): 1–18; Guirdex Masse, "A Diasporic Encounter: The Politics of Race and Culture at the First International Congress of Black Writers and Artists Open," https://etd.library.emory.edu/concern/etds/p8418p06z?locaele=en; Babacar M'Baye, "Richard Wright and African Francophone Intellectuals: A Reassessment of the 1956 Congress of Black Writers in Paris," *African and Black Diaspora: An International Journal* 2, no. (2009): 29–42; Merve Fejzula, "Women and the 1956 Congress of Black Writers and Artists in Paris," https://www.aaihs.org/women-and-the-1956-congress-of-black-writers-and-artists-in-paris/; Robert W. July, *An African Voice: The Role of the Humanities in African Independence* (Durham, NC: Duke University Press, 1987), 24–44; David Murphy, *The First World Festival of Negro Arts, Dakar 1966: Contexts and Legacies* (Liverpool: Liverpool University Press, 2016); Paul Cooke, "The Art of Africa for the Whole World: An Account of the First World Festival of Negro Arts in Dakar, Senegal—April 1–24, 1966," *Negro History Bulletin* 29, no. 8 (1966): 172–89; John Povey, "Dakar: An African Rendez-vous," *Africa Today* 13, no. 5 (1966): 4–6; Alioune Diop, "From the Festival of Negro Arts at Dakar to the Lagos Festival," *Presence Africaine*, no. 92 (1974): 9–14; Andrew Apter, "Beyond Négritude: Black Cultural Citizenship and the Arab Question in FESTAC 77," *Journal of African Cultural Studies* 28, no. 3 (2016): 313–26; Etienne Lock, "The Intellectual Dimension of the Second World Black and African Festival of Arts and Culture (FESTAC 1977) and Its Relevance Today," *Canadian Journal of African Studies*, https://doi.org/10.1080/00083968.2020.18 35682; and E. Mveng, "General Report: 1st Pre-Colloquium of the 3rd World Festival of Negro Arts," *Presence Africaine*, nos. 117–18 (1981): 365–74.

I. SITES AND CONTEXTS OF EXHIBITION

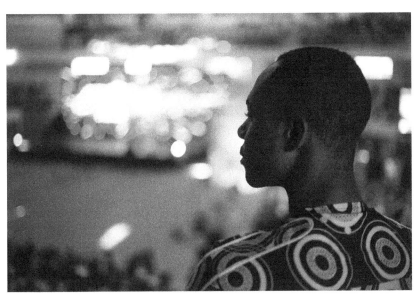

Figure B. An audience member overlooks the FESPACO ceremony. Courtesy of FESPACO.

African Film Festivals in Africa: Curating "African Audiences" for "African Films"

Lindiwe Dovey

The First Film Festivals in Africa: "Educating" the "African Audience"

No celebration, no festival, could take place without a public, an audience, writes Odile Goerg.[1] If this is the case, then it is quite remarkable that so little scholarly attention has been granted to considering audiences at film festivals.[2] Although certain prestigious film festivals (Cannes, in particular) operate mostly as closed, industry events focused on the glamor and business of filmmaking, most of the thousands of film festivals around the world see their main beneficiaries as both filmmakers and audiences.[3] In fact, "the curator Neil Young has questioned whether Cannes, which excludes the public from most of its screenings, qualifies as a festival at all" on this basis.[4] As a field of study, film festivals offer an ideal opportunity to observe films playing out in public contexts, with live audiences and discussions. The contested meanings of films in these settings challenge the dominant hermeneutic practice of close film analysis as it takes place in professional settings, such as universities and newspapers, where the contexts of a film's screening are rarely taken into account in the critic's judgement of the film. There is particular potential for research on the *(dis)sensus communis* surrounding African-made films in this respect, given that festivals are among the few public arenas in which such films are screened. Along with the exhibition of Nollywood movies at thousands of video halls across the continent, festivals are among the public spaces awaiting more in-depth research.[5]

Although there are exceptions, the organizers of many film festivals in Africa put great emphasis on the central value of audiences to their festivals' worth and meaning. As I will show, many Africans have been motivated to found and run their festivals by the structural and institutional barriers to a certain kind of film being accessible to Africa-based audiences, and many curators of these festivals find ways of actually incorporating audience perspectives into their curatorial principles. The kinds of spectators

cultivated by many African curators are a world away from what Shweta Kishore, for example, describes of audience experiences at the first Ladakh International Film Festival in India in 2012:

> Audiences were restricted to the established position of "viewer," which allowed the consumption of film but excluded contributions to structural aspects of the festival. Opportunities for intervention, such as post-film discussions, inter-actions with filmmakers, and festival structures that included audience feedback were missing—especially significant given that LIFF was the first film festival in the entire region.[6]

As Witz explains, if no audience spontaneity is fostered by a festival, there will be little chance of festive excitement. Rather, the festival will assume a uni-directional pedagogical tone. As will become evident in the next few chapters of this book, where film festival directors and curators within Africa have not incorporated audience tastes and desires into their conceptualization of their festivals, audiences have frequently stepped up to claim this power and sense of authorship and ownership over the festivals. It is thus not only the festival organizers who determine whether a festival's culture is participatory or not. As Karin Barber's foundational work on popular culture and audi-ences in Africa has shown, there are especially porous boundaries between production and reception in many African contexts.[7]

Ways of thinking about audiences in Africa have come a long way since colonial times. A significant body of scholarship on the practices of colonial film units and missionaries who used film in Africa has revealed the extent to which "the African audience" was constructed by such groups as a homogenous and non-individuated mass to be feared and policed.[8] While they did not call themselves film festivals, the mobile film screenings held in different parts of the continent by film units and missionaries from the early 1900s onwards satisfy my definition of a film festival, in that they brought together huge, live audiences at specific moments to watch and, sometimes, discuss films. The kinds of films shown were usually instructional, and valo-rized "Western" technology. For example, Africans were shown films about why they should cultivate and drink tea and coffee, and save their money in banks.[9] As research reveals, however, *(dis)sensus communis* prevailed in the interpretation of the value of these films.

Writing about one of the largest of the colonial film projects—the British Educational Kinema Experiment (BEKE) of the 1930s, which operated across five countries in East Africa—Aboubakar Sanogo notes:

> According to the BEKE, these mostly outdoors screenings were well attended, sometimes with crowds of about 3,000 to 5,000 people. Given that the audiences

were reportedly seeing films for the very first time, the BEKE can hardly claim that the huge crowds validated its brand of cinema. Instead, one may propose such motivations as the *desire for communal gathering around the cinema as a recreational object*, the need to compensate for the recreational repressions enforced by the administration and the church (forcing the converts to renounce supposed heathen practices), but also the techniques used by BEKE to attract audiences, which included Swahili songs, missionary choirs, folk stories and the music of Paul Robeson.[10] (my emphasis)

As I have discussed elsewhere,[11] there has been a turn recently in film scholarship to acknowledge the diverse and sometimes surprising reasons people engage in the experience of cinema-going.[12] Cinema-going is about far more than the exercise of personal judgement in choosing a *particular* film to view.[13] In the context of northern Nigeria, Brian Larkin argues that "Cinema draws people because of the narratives and spectacles of the films it shows, but the *experience* of going there is greater than the films themselves."[14] People have historically gone to the cinema for a variety of reasons: to socialize, to escape the mundaneness of the domestic sphere, to engage in otherwise socially unacceptable romantic encounters, or even to sleep.[15] Janice Radway's research on a group of American women's enjoyment of reading romance novels similarly reveals that this practice constituted an *event* for them. What they were gravitating towards was not simply a genre, but an activity—a form of escape from family life.[16]

In my research of audience tastes and desires at film festivals, I too have found that people attend festivals for a variety of reasons.[17] However, in contrast to the sites of "popular" film and literature consumption on which the research mentioned above is based, film festivals do seem to be valued by audiences for their provision of what is seen as alternative or rarely screened content, and many respondents to my surveys and interviews suggest that they attend festivals on the basis of wanting to see a particular film. In audience research I conducted at the 2013 Durban International Film Festival,[18] for example, the majority of respondents said they had attended a screening because of the particular film being shown (thirty-three percent).[19] However, a significant proportion said that they came for other reasons: because they were generally interested in the film medium (twenty-four percent); to spend time with friends or family (eight percent); for enjoyment and relaxation (seven percent); and to support the festival's work (four percent). In terms of what participants hoped to get out of the festival as a whole, knowledge and education were most mentioned (by eighteen percent of respondents).[20] However, other stated reasons for attending the festival were: to see alternative, new, diverse, and "non-commercial" films (thirteen percent); entertainment, enjoyment, and an escape from daily life (eleven percent); a mixture of entertainment and education (eleven percent);

to see great films and good stories (ten percent); to be inspired and have a great experience (eight percent); and to network (six percent). What respondents most associated with the idea of a festival, furthermore, was fun, excitement, and enjoyment (twenty-two percent), and celebration, festivities, and partying (eighteen percent). A significant proportion of my respondents in the township of KwaMashu (twenty-two percent), outside of central Durban, said they associated a festival with community and the gathering of people.

While hardly rigorous enough to sustain a complete argument, a brief preliminary survey I have conducted into the vocabulary used to identify festivals in several African languages suggests that in different African contexts, certain words do not typically point to what we think of today as an "arts festival." For example, the Amharic word for festival—"bä'al"—denotes a feast day, a day of celebration, or a holiday. Similarly, the Yoruba words for festival—"orò" and "àjòdún"—refer to a celebration or feast. In Zulu, the word most frequently used for a festival is "umkhosi," meaning "a gathering of people." "Tamasha" is the Swahili word often used for "festival," as in the local title of the Zanzibar International Film Festival. Notably, it is a word originating from Persian, in which it referred to a performance or show, and was then adopted in other languages, such as Hindi and Urdu, to mean something exciting. Languages such as Kalenjin (spoken in parts of Kenya, Uganda, and Tanzania) and Shona (spoken mostly in Zimbabwe, but also in Zambia, Mozambique, and Botswana) have no original word that equates to "festival." At the same time, a comment by Senegalese filmmaker Ousmane Sembène, that there is no word for "art" in the Wolof language, inspired me to begin exploring whether that is the case in any other African languages. In several I investigated—for example, the Ethiopian languages of Amharic and Oromo—the words used for art (in this case, "t'ibäb" and "ogummaa," respectively) are most commonly also used to identify a skill or craft, but can refer to knowledge or wisdom more generally as well. The arrival of European forms of education in this context saw the adoption of the word "art"—for example, the title of a university liberal arts degree in Amharic is "bä*art* timhirt mät'änä timhirt." (my emphasis)

I refer to the meanings of these words not to seek out a homogenous, indigenous "African" meaning for festivals and art—which would be impossible given Africa's diversity—but to keep in mind the range of ways festivals have manifested themselves on the continent over time. There are signs in these languages, for example, that in the precolonial era festivals had a more celebratory rather than pedagogical flavor, a view confirmed by the few published works that exist on African festivals before the colonial era.[21] If I pay more attention here to the colonial moment, I do not mean to suggest that this moment was more central to African experience than any other historical era, but that it is undeniable that *film* festivals, when they arrived in Africa,

were imbricated with colonialism and the new forms of "Western" modernity and technology that colonial authorities brought with them to the continent.

If we return to the early film festivals organized by colonial film units, then it is clear these gatherings of people were not intended as celebratory experiences in the entertainment sense. Rather, they were a form of educational instruction that would develop "modern," European sensibilities in spectators. The name of the BEKE speaks for itself and, according to Vincent Bouchard, "At the beginning of the 1930s the main colonial empires in Africa (British, Belgian, French) all established filmmaking and distribution services for the purpose of *educating* the local subject populations." (my emphasis)[22] Where mobile screenings were occasionally organized under the rubric of entertainment, there was usually an ulterior motive. For example, although the Rev. Ray Phillips of the American Mission Board screened popular films—such as Charlie Chaplin films—to mineworkers in South Africa from 1919 to 1940, he often turned to such works as a way of quelling political dissent.[23] Ultimately, his interest was in teaching the mineworkers how "to distinguish between good and bad characters" in the films.[24] Entertainment films were to be used then, only insofar as they could assist with Phillips's mission to endow Africans with a moral education.

Reading between the lines of the documentation that we have of these early film festivals in Africa, it is possible to conjure a clash of interpretations—(*dis)sensus communis*—around the meanings and value inherent in the festivals and the films they screened. For many Africans, as Sanogo suggests above, the screenings afforded an opportunity for leisure through the act of gathering with other people amid storytelling and song. For many of the organizers, however, the intention was moral and scientific instruction, and the incorporation of Africans into a European logic, economy, and way of behaving. The colonizers' anxiety about an "interpretive community"[25] that might use the screenings in ways contradictory to their own intentions, is evident in the response of the Mombasa African Affairs Officer in Kenya when a multiracial "Committee on African Advance" suggested holding screenings in the Mombasa Sports Stadium in 1953:

> *Mombasa Africans* do not need entertaining en masse after dark. Most of them like to be at home by then. Should they be encouraged to go out? Once out, will they not want to "go on" somewhere after the show? Where will they go if not to bars?[26] (my emphasis)

The anxiety here has nothing to do with the kinds of films being shown; it purely concerns the *event* of public cinema-going and all that it entails— people coming together "en masse," and the activities that tend to accompany cinema-going, such as drinking and dancing. The anxiety leads the

officer to homogenize the audience, referring to the people derogatorily as "Mombasa Africans," as though they are not individuals with distinct personalities, desires, and behaviors.

If the first colonial anxiety concerned the event of public cinema-going in Africa, the second anxiety concerned the nature of the films available to Africans. Certain films were "harmful," the organizers of the BEKE tell us in their report, because of their explicit sex and violence, and their negative depiction of white people.[27] As Sanogo points out, "a faster-paced cinema . . . was positioned as the bad object that the 'essential' African spectator should be protected from."[28] The BEKE relied on rules devised by William Sellers, a colonial film unit administrator in Nigeria, who argued that films made for Africans should be slow in pace, avoid trick photography, leave nothing to the imagination, and emphasize continuity.[29] "The BEKE even imagined a taste-formation filmic diet," Sanogo notes, "introducing the proverbial illiterate peasants to BEKE educational film to a point of saturation to such an extent that they would be 'weaned off,' 'unsuitable' commercial films before even being exposed to them."[30]

What is perhaps at risk of being overlooked in this focus on the moral order, however, are the economic motivations behind the desire to instill a certain kind of cinematic taste in the colonized. In his study of French colonial censorship of screenings in West Africa in the 1940s and 1950s, Mahir Şaul suggests that much of the French anxiety stemmed from the fact that their own film industry had not recovered since WWII, and that they were concerned about economic competition from other film-producing regions, such as the US, India, Egypt, and Italy.[31] Audience research commissioned by their Overseas Ministry in the late 1940s suggested that "in a few years Indian films would become 'dangerous competition'" for French films; by the late 1950s the French were consistently banning all Egyptian films from their cinemas in West Africa out of fear of their popularity with audiences.[32,33] Notably, one of the members on the Ouagadougou censorship committee was a "representative of French private enterprise."[34] Similarly, Sanogo notes that there was "a representative from a private film company, Gaumont-British Instructional" on the BEKE board of advisors.[35] The difficulty in prizing apart cultural and economic interests offers a rejoinder to any argument that the form French colonialism took in Africa—its *mission civilisatrice*—was predominantly cultural and only secondarily economic.

Contradicting the colonizers' construction of Africans as "a visually impaired audience that had never been exposed to cinema," Sanogo argues that the BEKE was forced to come face to face with "a critical culture of spectatorship"[36] and, we might add, a popular culture of spectatorship through which viewers took and have taken, great pleasure in watching American, Indian, Egyptian, and Chinese films. Audiences questioned not only the narrative relevance of the BEKE films to their own lives, critiquing some of

the films for being "boring,"[37] but also the "quality" of the films,[38] which they felt were "crude."[39] The "African audience," deemed half-witted by the British, had a sense of professional standards when it came to the technical aspects of film and, quite simply, rejected the "ideological inscription of amateurishness" in the BEKE films.[40]

Liberating and Politicizing African Audiences

Just as the colonial authorities were obsessed with African audiences, so too were the first African filmmakers and film critics—although for very different reasons. One might even say that the first African filmmakers and critics were haunted by the audience—or, rather, by the lack of African audiences for African films. As I will argue later in this chapter, FESPACO was envisaged as a kind of phoenix rising from the ashes of colonial exploitation, to connect African films with African audiences, to conquer the problem that African films are "foreigners in their own countries."[41] Nowhere is the issue more emphatically stated, perhaps, than in the opening line of Tunisian film critic and founder of the JCC Tahar Cheriaa's book *Écrans d'abondance: Ou cinémas de libération en Afrique?*: "The problem of distribution is incontrovertibly the *key problem*—the one that largely determines all the rest—*materially affecting the cinema of the African and Arab countries.*"[42,43] When the first filmmakers in Africa devised manifestos at conferences in Algiers, Niamey, and Harare, it was African audiences they had in mind and, inspired as they were by the Third Cinema movement of Latin America and the broader drive of Tricontinentalism,[44] it was the politicization of African audiences they sought.[45]

Ethiopian film scholar Teshome Gabriel was probably the most vociferous African proponent of revolutionary Third Cinema, but what is most theoretically interesting about his early work is how he insists that politically subversive aesthetics are not intrinsic to a film but are able to develop only in the relationships between audiences and films. Gabriel writes:

> Style is only meaningful *in the context* of its use—in how it acts on culture and helps illuminate the ideology within it. It is, therefore, utterly misleading to argue, for example, that only the type of distancing device that Brecht used, makes a film "socialist," or, that only Godard's non-illusionary device is "non-bourgeois camera style," or that the use of a film star or a central figure submits a film to the prototypes of Hollywood individualisms.[46]

Gabriel's interest was in the contextual and contingent nature of film aesthetics and style. In the 1970s, a time in which the independent and autonomous

genius of film auteurs was being celebrated in Europe and North America through the "age of programmers" at film festivals,[47] Gabriel was asking uncomfortable questions about the relationship of aesthetics to cultural location, difference, and reception from his location within a place in which "art" film was not an integral part of culture and society.

While Gabriel's ideas on film audiences have been subsequently eclipsed by more contemporary and sophisticated theories of spectatorship,[48] his work was instructive and enduring within the development of African screen media theory for the way it insisted on the situated nature of audiences and the contingency of film aesthetics. Gabriel made a strong case, for example, that apparent ugliness is not the sign of an aesthetically weak film. In his comparative analysis of two films made in South Africa during apartheid—the pro-apartheid film *Journey to the Sun* (dir. South African Tourist Bureau, 1975) and the anti-apartheid *Last Grave at Dimbaza* (dir. Chris Curling, Pascoe Macfarlane, 1973)—Gabriel writes, quoting from Terry Eagleton's *Criticism and Ideology* (1976):

> The question [. . .] is not which film is aesthetically superior to the other. A work can no longer be considered aesthetically correct because it is sublime or beautiful. A work is aesthetically apt if it is "able to grasp and portray popular life in a more profound, authentic, human and concretely historical fashion."[49]

The look and sound of a film, Gabriel argues in the final analysis, is "not a result of mere quirk on the part of the filmmakers. It is historically and ideologically determined by the 'aesthetics' in a people's lives."[50] In such a way, Gabriel precociously provides us with one of the most compelling ways of moving beyond a position in African screen media scholarship that dares not take Nollywood and its aesthetics seriously, or that sees Nollywood aesthetics only as a form of meaningless rubbish.[51] The kind of spectatorial consensus that has enabled Nollywood's success suggests that this kind of filmmaking is considered aesthetically superior within certain contexts, however lacking in conventional image and sound quality it may appear to other eyes and ears.

A similar critique is at the basis of an important lecture delivered in 1975 at Indiana University by the man often referred to as the "Father of African Cinema," the Senegalese filmmaker and writer Ousmane Sembène. In his lecture, titled "Man is Culture," Sembène argued that, in light of global history and the assaults of slavery and colonialism on Black Africans, it makes more sense to use the term "culture" than "art" to speak about human expression, since culture grounds expression in human production, whereas art is too readily associated with an abstracted aesthetics. As Marcia Landy notes, "by situating culture in all human activity, [Sembène] unite[d] cultural considerations with the *struggle for survival*."[52] (my emphasis) Sembène correctly suggests that it would be "vulgar" and "unscholarly" to discuss art and culture

without referencing the brutal history in which "Africa has paid with her flesh the primary accumulation of capital for the benefit of the bourgeoisie."[53]

The centrality of human activity to cultural production and the centrality of audiences to the meanings of this cultural production is the thread running through the history of African screen media theory and practice. It can be seen surfacing not only in colonial anxieties around "the African audience," and through claims about the potentially revolutionary uses of cinema,[54] but also in a long tradition of criticism discussing the education and conscientization of spectators through African films,[55] and—most recently—in the emphasis given to the popularity of African-made video movies with contemporary audiences, in Africa and elsewhere.[56] In all cases, the yardstick by which the importance of a film has been tacitly measured is its (assumed) relationship and/or popularity with African spectators. The first film festivals founded in the decolonization era in Africa reveal a similar obsession with African audiences, and can thus be used as a way of looking more deeply into this consensus.

Arts Festivals in the Era of Decolonization

In one of the few postcolonial analyses of film festivals we have in an otherwise quite Eurocentric field, Wong argues that "Non-European festivals emerged slowly, as a sense of a festival world of networks and competitors took shape."[57] Wong's focus is mainly on film festivals in Asia and, in particular, the Hong Kong International Film Festival, which began in 1978 as "one of the first Asian festivals."[58] If one takes the first film festivals in postcolonial Africa as one's examples, it is not possible to say that they "emerged slowly"; rather, several burst onto the scene in the 1960s as significant acts of cultural and political resistance, liberation and self-empowerment, inspiring discussions and debates about Africa, African film, African filmmakers, and African aesthetics on African soil.

Certain film critics give the impression that conversations about what constitutes "African cinema" began not within Africa itself, but at the "A-list" film festivals outside the continent.[59] The first festivals to take films made by Africans and Diasporan Africans seriously, however, were held within Africa: the 1966 World Festival of Negro Arts in Dakar, Senegal; the Journées Cinématographiques de Carthage (JCC) in Tunisia (the first regularly held film festival established on the continent, founded in 1966);[60] the 1969 Pan-African Cultural Festival of Algiers in Algeria; and FESPACO, the Festival Pan-Africain du Cinéma et de la Télévision de Ouagadougou (founded 1969), which takes place biannually in Burkina Faso.[61] In the heady years of political independence for some nations, and the continued

decolonization struggles for others, filmmakers from different African countries met at these and other festivals and conferences on the continent, drew up manifestos about what "African Cinema" should and might be, and shared their work with one another and with audiences. As the current director of FESPACO, Michel Ouédraogo, says, FESPACO "was created in a context in which the African states had recently acquired their independence and they wanted to express their sovereignty and their identity" (quoted in the film *Afrique Cannes*).

While JCC and FESPACO were the first major festivals on the continent to focus entirely on celebrating African films, the 1966 and 1969 arts festivals in Dakar and Algiers also featured African film prominently. Jules-Rosette notes, for example, that: "Among the most important resolutions made in 1966 [in Dakar] were those of the cinema group, which planned to build a visual archive of African cultural traditions and develop an inter-African office of cinematography."[62] One could even argue that, along with JCC, which took place later that year in Tunisia, this moment marked the birth of "African Cinema" as a self-consciously defined concept *on* the continent. For, although papers about African film had been presented at the Society for African Culture's 1956 Paris and 1959 Rome conferences, "little attention had been devoted to this domain until the Dakar festival."[63] Film had a similarly important role at the 1969 Algiers festival, to which filmmakers such as Sembène and Djibril Diop Mambéty were invited; Sembène was a particular focus of attention, through the screenings of his films *Borom Sarret* (1963), *Black Girl* (1966), and *Mandabi* (1968) at the Algiers Cinémathèque.[64, 65]

Festivals Dedicated to Films by Africans

In the late 1960s, two festivals dedicated to films by Africans were established in Africa. Of these, FESPACO, in Burkina Faso, soon established its preeminence over its "sister" festival, JCC, in Tunisia. As Bikales points out:

> What the world has come to know, in varied form, as African cinema—categories of film titles, subject matters, and themes; novel aesthetic approaches, uses of "tradition," time, and space; particular *auteurs*—has been consistently and consciously shaped and defined by FESPACO, the major point of introduction of African film makers and their works to national and international audiences.[66]

Similarly, Dupré points out that "[FESPACO] allows for the 'taking of temperature' of cinema on the continent and of opening it to the world."[67, 68] While JCC and FESPACO have worked collaboratively rather than in competition, establishing themselves in alternating years since 1973,[69] the

question arises: why did FESPACO and not JCC become the festive capital of African film on the continent?[70] One potential answer is provided by Gideon Bachmann, in an early report on JCC that reveals the festival took place in an authoritarian context in a way that FESPACO did not: "The police are everywhere, watching against leftist turmoil, and after the 1970 film festival here, it appears that its head [the film critic Tahar Cheriaa] spent six months in jail. This year, all films shown were censored first."[71] By 2008, when Jeffrey Ruoff began documenting the festival, things had changed somewhat, with government censors promising director Nouri Bouzid that they would grant a distribution visa to his film *Man of Ashes* (which deals with rape, and features such characters as a prostitute and a Tunisian Jew treated sympathetically) if it were successful at JCC. Four thousand people queued up to see the film at the festival, guaranteeing the visa.[72]

There are, however, many similarities and correspondences between FESPACO and JCC. They both began at a time of decolonization and framed themselves as highly politicized events, engaged in the process of the liberation of African countries from colonialism. They were both the result of African filmmakers deciding they needed to find a way to exhibit African films for African audiences. And both festivals have received a significant portion of their funding from their respective governments, however much the politics of these states may have contradicted those of the main organizers of the festivals. Furthermore, the grand prizes awarded by each festival are symbolic of their commitment, at least in principle, to the value of the precolonial past and, notably, of women. JCC's Tanit d'Or celebrates precolonial, pre-Islamic Tunisia through the Phoenician mother goddess, and FESPACO's Étalon de Yennenga may be a "stallion" (étalon) of gold, but it references the horse of a female heroine—Princess Yennenga, the mother of the Mossi nation (Burkina's largest ethnic group).[73]

One of the few points on which the two festivals can be distinguished is their geopolitical focus: whereas FESPACO, perhaps taking notes from the 1969 Pan-African Cultural Festival of Algiers, has always positioned itself as a Pan-African event and considers North Africa as much a part of Africa as sub-Saharan Africa, JCC makes a distinction between what it calls Tunisia's "African" *and* "Arab" heritages, promoting films that "critically examine the social realities of Arab and African peoples." (my emphasis).[74, 75] The part-Arab focus of JCC may also be one of the reasons behind its contemporary decline in importance, in a context in which there has been a significant proliferation of festivals focusing on Arab cinema in the Middle East from the late 1970s on.[76] Today, the center of African film exhibition at festivals in the Middle East has shifted also to the Dubai International Film Festival. The point of this brief comparison between JCC and FESPACO is not to dismiss the importance of the former, whose

historical and contemporary contribution to African filmmaking is undisputed, and which is famous for the passionate commitment of its audiences (see the documentary *From Carthage to Carthage*). It is simply an attempt to understand why the majority of filmmakers from Africa make attending FESPACO more of a priority than attending JCC, and why FESPACO has been seen—until recently, when new players such as the AMAA (African Movie Academy Awards)[19] arrived—as the major institutional shaper of a certain kind of African film.

FESPACO: Creating African Audiences for African Films

While discussions of curation in contemporary African art scholarship are far more developed than those specifically around the programming of African film, there are some significant differences between African art exhibitions and film festivals that suggest divergent trajectories. As described by Chika Okeke-Agulu, the origins of the interest in the exhibition of contemporary African art is usually traced to Jean-Hubert Martin's show *Magiciens de la Terre* (1989) and Susan Vogel's *Africa Explores* (1991). These exhibitions were then followed by "a succession of mega-shows in the 1990s," and then by the rise of shows curated by Africans, such as Okwui Enwezor's *Short Century* and Simon Njami's *Africa Remix*.[77] The main problem with these mega-shows, however, was that none of them—except *Africa Remix*—were created or exhibited in Africa, meaning that they knowingly "address a Western audience."[78] This is no doubt one of the reasons contemporary African art scholarship remains relatively impoverished when it comes to the question of African audiences, and why some critics have argued that such curatorial practices "can be faulted for legitimizing a notion of Africa that dispenses with the continent itself."[79] Another might be related to the different experiences offered by galleries on the one hand, and film festivals on the other. Visitors to festivals tend to watch films communally and to discuss them after screenings, developing a sense of aesthetic judgment within a *(dis)sensus communis*. Visitors to galleries tend to move through these spaces haphazardly, in far more individualistic and less social ways. As I hope to show in the following discussion of FESPACO, this Africa-based film festival was founded, unlike the first African art exhibitions, with African audiences fully in mind.

Until the video movie industries in Ghana and Nigeria transformed the distribution and exhibition infrastructures for African films in the 1980s through their adoption of the cheap formats of video and VCD, the means for distribution and exhibition within Africa was restricted to television and cinemas. And since neither television stations nor cinemas initially

prioritized the screening of films by Africans, to begin any history of African films as viewed by Africans one needs to start with film festivals. Providing an alternative to the foreign fare shown on television and in cinemas was perhaps the most basic agenda of these festivals. As Manthia Diawara notes: "[FESPACO] had as its objective 'to make people discover and to promote African film which for the most part was *ignored*.'" (my emphasis)[80]

FESPACO began in 1969 as a film festival run by a group of individuals, including filmmakers such as Sembène, loosely connected through the Franco-Voltaic Cultural Center in Ouagadougou. One of its founders, the Burkinabe François Bassolet, describes the origins of the festival thus:

> In January 1969, during a time of economic upswing, a group of friends got together, and we raised the question of what we could do to make Ouagadougou a point of attraction. We were looking for something such as a festival of music or other arts that would allow the world to get to know Ouagadougou.[81, 82]

By the third festival, in 1972, the government of Burkina Faso had appropriated the festival as its own.[83] This appropriation was organizational, financial, and ideological, with the government continuously providing the majority of the festival's funding from 1972 on.[84] Government support for FESPACO has also survived successive coups d'état and regimes;[85] the Burkinabe state has consistently recognized that promoting cinema is a way of putting this resource-poor, landlocked country on the map, of securing its existence. With cotton its only export, Burkina Faso needed something to raise its profile. Nevertheless, despite appropriation by the state, the independent spirit of the festival's founders is still evident in many ways, as I will describe. In this sense, FESPACO to some extent fits into De Valck's second phase of "independently organized" film festivals (founded from the late 1960s to the early 1990s). Still, it cannot necessarily be said to align itself with the values of the European "age of the programmer" because its focus has been much more on showcasing films from diverse African countries, as a way of valuing the political independence of these states, as well as elevating certain filmmakers to the status of "auteurs."

Despite FESPACO's significant current organizational problems, despite the conflicts that have flared up across its forty years, the existence of such an event in one of the poorest countries in the world has to be celebrated, and one is hard-pressed to find an African filmmaker who denies FESPACO's historical importance, however disillusioned many may be with some contemporary aspects of it.[86] American journalist Kenneth Turan can barely hide his glowing admiration for the festival in his book, which spans film festivals from Sundance to Sarajevo. He points out that "in a scenario that even Hollywood would reject as outlandish, [FESPACO] has managed by a

combination of passion and determination to turn itself into the undisputed capital of the African film world" and that the festival "shreds preconceived notions of festivals as merely places where tickets are taken and movies are shown."[87]

What makes FESPACO distinct from many film festivals is its openness and accessibility. As a timid doctoral student during my first visit in 2003, I was overwhelmed by the generosity of the filmmakers who, instead of cordoning themselves off from the general public, could be easily approached as they drank beer beside the pool of the famous de facto festival headquarters, the aptly named Hôtel Indépendance, or ate a meal of *brochettes* (kebabs) at one of the small, makeshift restaurants outside the main cinema venues, the Ciné Burkina and the Ciné Neerwaya. Due to their generosity, I was able to conduct interviews that year with some of the leading filmmakers, including Sembène and Moussa Sene Absa. FESPACO encourages relaxed relationships among industry participants and the general public through its lack of concern for red carpets and exclusive parties. Warm nights, free midnight music concerts in public squares, a huge marketplace where local traders sell their goods, clowns on stilts who welcome spectators as they approach the entrance of the Ciné Burkina, the sounds of the *muezzin's* call to prayer and the *vroom* of the ubiquitous *mobylettes* on Ouagadougou's dusty streets—these are the defining features of FESPACO, along with the wealth of films.

Unlike many festivals, which formally open and close with gala premieres accessible only to an inner circle of guests, FESPACO kicks off and concludes with ceremonies at the vast *Stade de 4 Août* (Stadium of 4 August), which seats 35,000 people. These ceremonies (particularly the opening) are very popular with the Burkinabe because of the steady stream of entertainment, from music (Malian star Salif Keïta has performed several times, for example) to equestrian shows to fireworks. The stadium is named for August 4, 1984, the day former President Thomas Sankara changed the country's name from its colonial appellation "Upper Volta" to "Burkina Faso," which combines Mossi and Mande words to form the meaning "country of honest people." The festival's openness is also evident in the local public's involvement in and engagement with it. Tickets to films cost a mere 500 CFA (roughly 62 British cents), which makes screenings affordable even to the least well-off. Free screenings are also offered in the less central quartiers by organizations such as the CNA (Cinéma Numérique Ambulant), a mobile cinema, followed by discussions facilitated by local film critics. While a little didactic in tone, these "outreach" screenings are well attended and enthusiastically received by participants eager to see films by their country-people and to learn more about film from local experts. [88] Former director of the New York Film Festival Richard Peña, who is a regular FESPACO attendee, says: "Here

you can see how open and dialogic the relationship to film is. Godard said that cinema is what goes on between the screen and the audience, and it really goes on here. You are seeing a truly communal experience."[89] This dialogism astounded me the first time I attended, where I found myself surrounded by fellow spectators who expressed their enjoyment by applauding, loudly laughing, addressing screen characters, or turning to their neighbors to make comments. Foreigners sometimes do not understand this form of film appreciation, as I witnessed when a young Russian woman at a screening at the Amakula Kampala International Film Festival in Uganda in 2010 bellowed out her disapproval at the noise audiences were making, yelling: "Be quiet and show some respect for the filmmaker!"

As Alimata Salembéré, one of the founders of FESPACO and the first president of the organizing committee, told me in an interview:

> The motivation [to found FESPACO] was, in the light of the emergence of African filmmakers with African films made on African territory, to show their films to African audiences because they didn't have the opportunity to show their own films in cinemas. So, we showed their films, the people came to see them, and the directors discussed them with the audience. In this way, the directors could understand *what the audience expected from the directors*. It allowed them to improve their work. And then, also, amongst themselves, the directors had few opportunities to get together and speak with one another, to discuss their work, and exchange ideas. So [FESPACO] was an occasion during which the directors could talk and exchange their experience with one another. And, at the same time, *they would talk to the audience to understand what they thought about their films*. (pers. comm., my emphasis)[90]

The narrative provided by Salembéré focuses first on the relationship between African filmmakers and African audiences, and second on the relationship amongst African filmmakers themselves. The two inspirations behind the festival, in her account, were, first, to allow Africans to see themselves and their stories on the screen (something that had not been possible up until that point, except in Egypt), and, second, for African filmmakers to exchange ideas and experiences with one another, thereby consolidating an Africanized perspective on filmmaking.[91] At the same time, as I have emphasized, the Burkinabé state clearly saw FESPACO as a way of internationalizing the country and putting it on the world map.

For all stakeholder groups, the idea of creating African audiences for African films was central from the festival's earliest days. The state made its point through statistics. Along with a huge increase in the number of films and participating countries, FESPACO saw a massive growth in audiences, most of whom were local: from 10,000 (in 1969) to 100,000 (in 1979)[92]

and from 400,000 (in 1987) to 500,000–600,000 (in 2009).[93] It was not love (or identification) at first sight, however, when it came to African spectators watching African films at FESPACO. Patrick Ilboudo, a professor at the former film school INAFEC (Institut Africain d'Éducation cinématographique de Ouagadougou)[94] and author of a book about FESPACO (1988), points out that at the early editions of the festival, the Burkinabe audience was quite critical of the African films they saw, comparing them to "the more polished, commercially-oriented films predominantly from Hollywood, but also from Europe, India, and China/Hong Kong to which they had grown accustomed."[95] This critical response was not unlike the earliest documented audience responses to the amateurish films made specifically for African audiences by colonial film units, as I described earlier. In this case, too, instead of immediately gravitating towards films made by Africans, audiences at FESPACO—accustomed to international cinema—questioned their quality, contradicting Burkinabe filmmaker Gaston Kaboré's well-known adage that, after years of being subjected to foreign films, Africans were "thirsting" for African images.

Filmmakers such as Sembène and Mamadou Djim Kola attributed the audience's initial distaste of their movies to a kind of mental "colonization" by Hollywood, and suggested that spectators needed time to become familiar with African films.[96] Sembène also hinted, however, that the problem had to do with small production budgets and that African filmmakers needed more support from African governments.[97] This idea of an impoverished, unfamiliar yet "authentic" African art with which audiences could not initially identify is perhaps not dissimilar to that of Senghor's attempts to build the "African art" of tapestry in Dakar in the 1960s. As Elizabeth Harney points out, Senghor did not provide the Senegalese public with the "guidance or incentive to acquire the kind of 'cultural capital' needed to serve as an active consumer or patron class for these new arts,"[98] which resulted in one of the teachers at the tapestry school telling his students: "You have a very great responsibility: to make our profession legitimate in the eyes of our fellow countrymen."[99] Similarly, FESPACO was involved in a process of attempting to legitimize African filmmaking in the eyes of African spectators. It sought "to teach the population to like African movies."[100, 101]

The FESPACO organizing committee succeeded in building an audience for its new, celebrated art form where Senghor did not, however. The embracing of FESPACO by Burkinabe audiences over time would seem to be related to something greater than a simple change in film tastes, however. The increased popularity of films at the festival is undeniably linked to the national pride that the Burkinabe government, and the festival organizing committee, have engendered through FESPACO. Over the ten years I have been attending the festival (every edition from 2003 to 2013), the films most

popular with the locals have been the Burkinabe ones. Whenever I have been caught in a near-stampede at one of the cinemas and ended up squashed between other spectators sitting on the floor, a Burkinabe film has been at its heart: for example, Pierre Yaméogo's *Moi et Mon Blanc* in 2003, or Apolline Traoré's *Moi Zaphira* in 2013. Burkinabe filmmakers such as Yaméogo and Traoré, as well as Gaston Kaboré, Idrissa Ouédraogo, Fanta Régina Nacro, and Boubakar Diallo, are local legends in Burkina Faso. This is a country where cab drivers aspire to be filmmakers, like Drissa Touré, who succeeded in having a film accepted at Cannes.[102]

What has led to this celebration of Burkinabe film within Burkina? FESPACO cannot be seen as solely responsible, although the festival was critical to the process.[103] From 1970 on, the Burkinabe government engaged on many fronts to ensure the country's existence through cinema. In 1970, just one month after the second edition of the *Festival de cinéma Africain de Ouagadougou* (it only came to be called FESPACO from 1972), the Burkinabe government—under the leadership of General Sangoulé Lamizana—took the courageous move of nationalizing the country's cinemas. This helped to raise significant funds for the production of Burkinabe films, because instead of the majority of box office revenue reverting to foreign distributors, it was now redirected to the government.[104] While the 1970s saw the nationalization of Burkina's cinemas and the growth of FESPACO, the 1980s became the heyday for Burkinabe film. In that decade, filmmakers such as Gaston Kaboré and Idrissa Ouédraogo began to be recognized at home and abroad.[105] Support for local film also grew when thirty-four-year-old Thomas Sankara became the new president of Burkina Faso through a coup d'état in 1983. In power until 1987, when he was assassinated, Sankara threw his weight behind FESPACO and African filmmaking in general, and is credited with bringing back to life an organization—FEPACI (the Pan-African Federation of Filmmakers)—that had remained dormant for almost a decade, despite its ambitious, idealistic manifesto created in Algiers in 1975.[106] At FESPACO 1985, Sankara provided a great deal of funding and support to FEPACI, and the headquarters of the organization was established in Ouagadougou with Kaboré as its Secretary General.[107] Film critic Frank Ukadike accordingly calls Sankara the "only African leader who was wholeheartedly committed to the development of African cinema."[108] Unlike many African governments, who sidelined culture in their national plans, Sankara believed that "the cultural conquest is a central part of the global strategy of the Revolution."[109]

Indeed, Sankara is also one of very few state presidents who have seen the value inherent in a *film festival*, his enthusiasm for FESPACO perhaps rivaled only by Mussolini's fervent support for the Venice Film Festival. Sankara's attempts to pay attention to the economic dimensions of African film is evidenced by the inauguration of the MICA (Marché International

du Cinéma Africain) at FESPACO's 1983 edition,[110] although that entity has never truly established itself as a viable marketplace for African film, as the Marché du Film at Cannes is for global film, for example.[111] In 1989, FESPACO commissioned the University of Ouagadougou to research the festival's economic impact, which was found to be about 700 million CFA, more than twice as much as the festival's budget that year.[112] Many people in Ouagadougou with whom I have spoken, from cabdrivers to sim-card sellers, are most excited about FESPACO because of the extraordinary trade opportunities it offers them, not because of the films shown. These people might not attend any of the screenings (indeed, many struggle to find the time, however affordable the ticket prices), but they are still intricately woven into the fabric of the festival as a different kind of (economic) participant and beneficiary.

Sankara was not only concerned with the local dimensions of FESPACO, however, but had international ambitions of a very particular kind for the festival. Through FESPACO, he courted countries and individuals who shared his "Black Power" and Marxist ideologies, attempting to build transnational linkages on these platforms. His support for FESPACO and for the medium of cinema was greatly inspired by his admiration for the Cuban revolution, and in a public speech on the twentieth anniversary of Che Guevara's death, he said: "Che is Burkinabe."[113] FESPACO's connection with communist countries, however, remained largely ideological rather than practical, although during Sankara's era the Havana Film Festival (founded 1979) showcased the "Largest Retrospective on African Films in the World" in 1986, while FESPACO featured Latin American film programs in 1985 and 1987.[114] In 1987, FESPACO also included, for the first time, a Diaspora category with the Paul Robeson prize, thereby welcoming films from the global Black community.[115] In 1985 and 1987, liberation organizations such as the ANC (African National Congress) and SWAPO (South West Africa People's Organization) were also present.[116] Financial contributions to FESPACO, however, came far more from European organizations—such as the ACCT (Agence de Coopération Culturelle et Technique), the CEE (European economic community), and UNESCO—than from communist countries such as Cuba and the USSR. It was only in 1987 that the USSR embassy in Burkina Faso became a funder of FESPACO, though it provided a minuscule amount compared to other organizations.[117]

We can only conjecture the heights to which FESPACO may have grown had Sankara lived. On October 15, 1987 he was assassinated; many believe his death was ordered by Blaise Compaoré, who was in power from then until 2014.[118] However, while many African filmmakers boycotted the 1989 edition of FESPACO in protest,[119] and while certain African filmmakers (such as Haile Gerima) have altogether refused to return to FESPACO since the Marxist leader's assassination,[120] Gaston Kaboré argues that "cinema in

Burkina does not belong to one government or one president. It is part of the patrimony of our country."[121] While it is true that FESPACO belongs to many people—and especially, perhaps, to those Burkinabe audiences who cherish it for various reasons—it *is* nevertheless possible to pinpoint a dramatic change in the festival after Sankara's death. Many have attributed it to the role of Filippe Sawadogo, FESPACO's general secretary from the mid-1980s to the mid-1990s, at which time he resigned from FESPACO to become Burkina Faso's ambassador to France.[122] Sawadogo was controversial with many African filmmakers for the particular international and professional vision he brought to FESPACO after Sankara's death, something characteristic of what De Valck calls the "age of directors," the third phase of international film festivals.[123] Indeed, it was key to Sawadogo that FESPACO integrate itself more into the international film festival circuit and he began to compare FESPACO's workings to those of Cannes.[124] Unlike the Marxist and "Black Power" approach of Sankara, Sawadogo actively courted the European Union for funds. Perhaps it should not be seen as unrelated to Sankara's death, then, that the festival's budget grew from 160 million CFA (roughly £200,000) in 1987 to 326 million CFA (roughly £400,000) in 1989, largely due to the significant growth in support from the EU, which stepped up its funding from 18.4 million CFA (roughly £23,000) in 1987 to 105 million CFA (roughly £132,000) in 1989.[125] This funding, as well as attempts to broaden the languages of participation to include English and Arabic, and not only French,[126] led to a gradual "dismantling" of specific French hegemony at FESPACO, according to Diawara[127] and Bikales,[128] and to what some see as the introduction of a more generalized European hegemony at the festival. Nevertheless, French influence is still keenly felt, with many of the anglophone filmmakers complaining that they are treated as second-class citizens. Many films in African languages are subtitled only in French, and many of the press conferences are conducted in French.[129]

Setting aside the differences between Sankara and Sawadogo's ideological and international visions for FESPACO, however, what is most important in my analysis is the way the festival has consistently been envisioned by the Burkinabe government and by its organizers not simply as a rare, biannual event, but as part of the lifeblood of this impoverished country. This means it is possible, to some extent, to exempt FESPACO from the critique that has issued from many of the authors in the volume *African Theatre Festivals* (2012), edited by James Gibbs, who argue that festivals, as short-lived events, do not leave lasting legacies. Several African-centered ways of conceptualizing festivals draw on metaphors of harvesting the food that sustains human life. Mshengu Kavanagh refers, for example, to the long-standing importance of harvest festivals across southern Africa—the *incwala* in Eswatini, the Zulu *umkhosi* in South Africa, the *ngoni* of Zambia, and the

ngoma in Tanzania—as well as yam festivals across West Africa.[130] It follows, he says, that an arts festival in the African context "might be regarded as the celebration and showcasing of an artistic harvest."[131] Similarly, Ayi Kwei Armah has called for festivals in Africa to operate not like "destructive tropical storms" but as "gentle, life-giving, daily rain."[132] Biting critique is aimed at one-off festivals such as FESMAN 2010 (World Festival of Black Arts), which Amy Niang argues exploited the "aesthetics of extravagance" to stage a self-aggrandizing "[Abdoulaye] Wade Show."[133] The focus of much of this critique is the disproportion between the sometimes vast amounts of public money spent staging festivals, and the paucity of local artistic production, which the critics feel should be the main beneficiary of such funding. While FESPACO's future remains in the balance, it is difficult not to see the festival historically, at least, as a "celebration and showcasing of an artistic harvest."

The Future of FESPACO

Şaul and Austen suggest that it was the arrival of Nollywood in the early 1990s that started to disrupt the version of "African Cinema" that FESPACO was primarily responsible for curating into existence:

> The great change in the twenty-first century . . . is the coexistence of two distinct African cinemas: a (relatively) long established tradition of celluloid art films centered in French-speaking West Africa and identified with its biennial FESPACO [festival] . . . and a newer, more commercial video film industry based in English-speaking Africa and labeled, after its major Nigerian source, Nollywood.[134]

Indeed, while Sankara's revolutionary regime depended to a large extent on television as a medium of communication, and thus opened the door to an inclusion of the medium at FESPACO from 1987 on,[135] the festival continued to ignore video filmmakers on the continent for more than twenty years thereafter.[136] At FESPACO 2007, Nigerian filmmaker Tunde Kelani was deeply offended when he discovered that filmmakers like himself—simply because they work in digital formats—had been overlooked at FESPACO's biannual conference on African film, held jointly with CODESRIA.[137] FESPACO made a small yet condescending concession to such filmmakers when it introduced a parallel, competitive program called "TV/Video Films" in 2009. The irony of separating out these films due to their format was apparent to many at FESPACO 2011, when some of the most exciting works of the year—such as Kunle Afolayan's *The Figurine*, Hawa Essuman's *Soul Boy*, and Boubacar Diallo's *Julie et Romeo*—were on the "lesser" list.[138]

The arrival of new, cheaper technologies has seen filmmakers who previously worked exclusively with 35mm film try their hand with digital experimentation, as in the case of the Cannes-award-winning Chadian director Mahamat-Saleh Haroun. Haroun is frequently held up as an example of an African art-house "auteur," because of his success at Cannes, but this reductive categorization ignores the heterogeneity of his oeuvre, which includes, for example, the hilarious family drama he made for French television, *Sex, Okra and Salted Butter* (2008). With its grainy, television aesthetic, the general tone of this film is neither meditative nor searing, as in films such as *Daratt / Dry Season* (2008) and *A Screaming Man* (2010) but rather fast-paced and comic in its focus on a Malian man, Malik, whose young wife leaves him for a white French oyster farmer in Bordeaux. Other experiments have gone in the opposite direction, however. For example, those Nigerian filmmakers who have been dubbed part of the "New Nollywood" movement in recent years, such as Kunle Afolayan, have shifted from using cheaper digital formats to working with 35mm in some cases.

The audiovisual mediums used by filmmakers today are remarkably diverse, thanks to technological developments, and have a great deal to do with the political economy of funding and access rather than purely "aesthetic" choices. While there is widespread belief that many African filmmakers whose work is shown at festivals are sustained by European grant funding, a 2013 survey I conducted reveals that the majority are not, and continue to piece together budgets from a range of sources. This contradicts the common association people assume between film festivals and so-called "elitist art films." For example, one critic claims that FESPACO is "[d]eemed elitist by many local practitioners" and that it is "synonymous with art films financed largely through foreign subsidies made essentially to please the tastes of festival-goers all over the world, not necessarily those of local African audiences."[139] While that may have been the case in the past, when the Bureau of African Cinema was still financing many of the francophone African films, it is a markedly different scene today, and the relish with which local Burkinabe spectators watch the films contradicts the simplistic insider/outsider dichotomy drawn here.

The conflicts around the transformation of analog to digital formats came to a head at FESPACO 2013, when several films selected for the official competition were suddenly disqualified because the organizing committee discovered they were not on 35mm celluloid film. That the FESPACO rules around format are a hangover from a much earlier era, and now anachronistic and quite frankly illogical and disrespectful to audiences, was cogently summed up by one of the disqualified filmmakers—Mozambican producer Pedro Pimenta (of the film *Virgin Margarida* (dir. Licinio Azevedo, 2013, Brazil))—who said:

[FESPACO's] projection is so bad that there's no point in [films] being in 35mm. If you're serious about 35mm, start with your projector. Your projection facilities and quality. . . . Alain Gomis [who went on to win the Étalon de Yennenga for *Tey*], he has got a 35mm print. He tested it, and he tested the DVD. And he asked them please screen the DVD . . . it's better quality than the 35mm. . . . What we're seeing here is the DVDs, not the 35mm prints. (pers. comm.)

Pimenta says that he attempted to start a protest about the FESPACO rules before the 2013 edition, by trying "to get all the selected films to take a common position: either our film is screened in its own format, or we are not coming." But this attempt at solidarity and boycott failed, he says, because some filmmakers refused to participate, saying "we spent 30, 40, 50,000 euros to get a 35mm print to come to FESPACO." If FESPACO does not change its rules on format in future years, Pimenta says, it will not only be the fault of the festival, then, but also of the filmmakers (pers. comm.).

The argument does not come down to medium alone, however. It is clearly also related to the perceived threat felt by FESPACO of the popularity of Nollywood films with audiences across the African continent and what that means for the festival's future. The basis on which Nollywood scholars argue for the undeniable importance of the video movie making trend is its huge audience, in contradistinction to the relatively modest audiences other kinds of African films have garnered. As Garritano says: "video has allowed videomakers in Ghana and Nigeria, individuals who in most cases are detached from official cultural institutions and working outside the purview of the state, to create a tremendously popular, commercial cinema *for audiences in Africa and abroad*" (my emphasis). In relation to Jean-Marie Téno's documentary *Sacred Places* (2009), which focuses on the poor Ouagadougou neighborhood of Saint Léon during FESPACO 2009, Garritano asks: "in a documentary about African cinema and African audiences, why was there no mention made of African popular movies?"[140] Similarly, Ken Harrow argues that "Nollywood . . . is the answer to African culture's quest for a viable economic basis that *rests upon an African audience and its taste*" (my emphasis).[141]

While these claims about the popularity of video movies with Africans and Diasporan Africans are undeniable, we must keep in mind a sense of the inequalities in power arrangements that also determine what is available (or not) to audiences at any particular moment. As audience scholar Elizabeth Bird asks,

Are U.S. soap operas successful around the world because they are instantly appealing in all cultures, as local audiences busily reinterpret them within their own contexts? Maybe, up to a point. But we all know that the central reason they

are shown worldwide is that they can be bought much more cheaply than local programming can be made. Viewers "choose" them, but often it is a Hobson's Choice.[142]

A variety of institutional obstacles may have prevented the kinds of films selected at FESPACO from achieving popularity across the continent, their content aside. These obstacles concern who controls film distribution, exhibition, and marketing on the continent. For example, two foreign film distribution and exhibition companies, SECMA and COMACICO, controlled much of the film content that entered the West African market from the 1920s until 1984, when an inter-African distribution consortium, CIDC (Consortium Interafricain de Distribution Cinématographique), was created. CIDC collapsed due to lack of resources and bad organization, however, and a viable alternative was not found. Until the 1990s, when the media began to liberalize and digitize across the continent, African television stations were mostly state-run and under-resourced, and many requested that African filmmakers pay them if they wanted their films screened. In South Africa, prior to 1994, film and television were almost completely controlled by the racist white minority government, and the distribution of Black African films had to operate mostly as a noncommercial, activist, underground movement. The way in which the African audiovisual industries were externally controlled meant that it was very difficult to build diverse film-appreciation cultures. In the 1990s, furthermore, the Structural Adjustment Programs (SAPs), introduced into many African countries, made cinema attendance prohibitively expensive, resulting in the closing of cinemas across West and East Africa, or conversion into supermarkets, churches, or mosques. It was into this context that the video moviemakers stepped, availing themselves of new, cheaper technologies, and with their clever distribution and marketing strategies, making audiovisual products that were actually accessible to Africans.

Setting aside a political economic interpretation of media access, however, it is possible to say—as the scholars of African video movies have so convincingly shown—that video movies afford real pleasures to the people who watch them, speaking to their daily anxieties and aspirations.[143] These audiences do not have to be "curated" in the way that FESPACO has actively curated its audiences, despite the fact that many Africans feel that the "quality" of video movies does need to improve.[144] African popular culture scholars and media anthropologists initially formulated their critique of postcolonial African film studies (focused on so-called "FESPACO" films) within the neo-Marxist rubric of the ordinary (or the "everyday"). The revolution they have inaugurated in African screen media scholarship, through paying attention to Nollywood and other video movie industries, relates primarily to class differences, and they have rightly accused film scholars (and film festival programmers) who refuse to

consider video movies in their work of elitism and dissociation from African sites of cultural consumption, of turning a blind eye to the huge numbers of Africans who consume video movies on a daily basis with great pleasure and enjoyment. Indeed, the video movies made by Ghanaians, Nigerians, and other Africans in the past thirty years have undoubtedly provided an exciting alternative to the kinds of African films typically curated through FESPACO and other festivals, most obviously because they have been available to African audiences in a way that the African films shown at festivals have frequently not. This availability and access explains why Garritano is able to assert that "the emergence of popular video industries in Ghana and Nigeria represents the most important and exciting development in African cultural production in recent history."

To appreciate the value of these popular video industries, however, does not mean that one cannot insist that they should be able to coexist with film festivals and the kinds of films usually shown at such events; to do so would be to adopt a crass utilitarian position, to reductively privilege "mass media" over "small media." Along with providing an alternative to the mainstream Western media images of Africa, festivals such as FESPACO present an alternative to the dominance and ready availability of Nigerian video films. Nollywood scholars were correct to critique the absence of Nigerian and Ghanaian video films from programs or discussions at FESPACO and other festivals in the 1980s and 1990s, when video filmmakers were revolutionizing the models of distribution and exhibition of African films. Today, however, in a context in which video movies are ubiquitous and easy to access within Africa and abroad, we can perhaps reconfigure the ways in which we see the kinds of African films shown at festivals not as elitist but as alternatives to a dominant vision. Nevertheless, we must not forget to credit the popularity of Nigerian video movies for enabling the possibility of different forms of African filmmaking to be seen as offering alternatives in the first place. Neither must we overlook the fact that within African videomaking itself, there are both dominant and marginalized players. As Garritano notes:

> Faced with the relentless onslaught of Nigerian videos in Ghana, some Ghanaian videomakers have come to regard Nollywood as a far more pressing threat to their survival than Hollywood. Seen from this point of view, Nollywood looks a lot like an invader, a regional cultural power whose success has endangered local production.[145]

In this light, Ghanaian videomaking might be seen as the alternative and, as Garritano notes, "margins, like centers, are multiple, relational, and shifting."[146] If FESPACO does not take these shifting margins into account, and does not pay attention to the varied, alternative forms of filmmaking

on the continent, it will risk rendering its programming obsolete and outdated.

At the same time, while providing alternatives to mainstream fare, FESPACO should not lose sight of its original emphasis on the importance of African spectators and participants, because that is where the main strength of this festival lies. Within the fields of (African) popular culture studies, festivals have often been treated with a great deal of skepticism because they are perceived to be inherently "official" and "formal" events.[147] If we broaden our understanding of spectators' and participants' roles in festivals then we are better placed to recognize FESPACO's continued appeal in spite of its significant problems. According to business scholars Moeran and Pederson:

> the symbolic function of fairs is to be seen in activities that are carried on out-
> side the normal course of trade exchange. Food and drink are shared, parties
> held, relationships between ... participants formed and occasionally cemented,
> and all the time information is exchanged. (original emphasis)[148]

It would be impossible for anyone who has regularly attended fairs or festivals to contest this point. Over the fifteen years that I have been directing and attending festivals, I have been constantly amazed at how little is achieved through the formal dimensions of these festivals (the speeches, the organized meetings and conferences) and how much work is accomplished informally, while chatting over cold beer after screenings, dancing, and developing close friendships. At FESPACO 2013, the most successful exchanges happened not in the hallowed halls of the Hôtel Indépendance, traditional home of the festival, but in the maquis (bars) of one of Ouagadougou's busiest streets, Kwame Nkrumah Avenue. At places such as the open-air bar Taxi Brousse, with vivid portraits of independence heroes painted on its walls, filmmakers considered important within the international film festival circuit—such as Jean-Marie Téno, Daouda Coulibaly, and Alain Gomis—relaxed with producers, curators, audience members, and even the prostitutes who frequent the bar, discussing everything under the stars, over whiskies that tasted more like pastis. If one takes away the informality of festivals, they would be empty shells, completely useless, and no one would even bother to attend them. To repeat Goerg's words, "No celebration can take effect without its public, necessary ingredient for warning of the reality of power."[149] I take this statement to mean that the powerful authorities who preside over some festivals—whether governments, or other organizations seeking to promote themselves—*need* the audience to ensure their legitimacy and power, but—whenever an audience is present—the survival and extent of that legitimacy and power is also threatened. The central position historically accorded to African audiences by FESPACO, as well as many

other film festivals in Africa, ensures that this productive tension is unlikely to disappear any time soon.

Lindiwe Dovey is Professor of Film and Screen Studies at SOAS University of London and the Principal Investigator of the ERC-funded project "African Screen Worlds: Decolonising Film and Screen Studies" (June 2019-June 2024).

Notes

Originally published as Lindiwe Dovey, "Curating 'African Audiences' for 'African Films,'" in *Curating Africa in the Age of Film Festivals* (New York: Palgrave Macmillan, 2015): 87–109.

1. Odile Goerg, "Introduction," in *Fêtes urbaines en Afrique: espaces, identités, et pouvoirs,* ed... *en Afrique: espaces, identités, et pouvoirs* ed. Odile Goerg (Paris: Karthala, 1999), 8–9.

2. See the relatively short list of publications on film festival audiences at http://www.filmfestivalresearch.org/index.php/ffrn-bibliography/8-reception-audiences-communities-and-cinephiles/.

3. Mark Peranson, "First You Get the Power, Then You Get the Money: Two Models of Film Festivals" in *The Film Festival Reader,* ed. Dina Iordanova (St Andrews: St Andrews Film Studies, 2013), 193–196.

4. David Archibald and Mitchell Miller, "The Film Festivals dossier: Introduction." *Screen* 52, no. 2 (2011): 250. Summer (2011): 250.

5. See, however, the groundbreaking work of Matthias Krings on veejay performances and audience reception at video halls in East Africa: Matthias Krings, "A Prequel to Nollywood: South African Photo Novels and Their Pan-African Consumption in the Late 1960s," *Journal of African Cultural Studies* 22, no. 1 (June 1, 2010): 75–89; Matthias Krings, "Karishika with Kiswahili Flavor: A Nollywood FIlm Retold by a Tanzanian Video Narrator," in *Global Nollywood: The Transnational Dimensions of an African Video Film Industry,* ed. Matthias Krings and Onookome Okome (Bloomington: Indiana University Press, 2013), 306–26. See also the documentary film *Veejays in Daressalaam* (2010). See also the documentary film *Veejays in Daressalaam* (2010).

6. Shweta Kishore, "Beyond Cinephilia: Situating the Encounter between Documentary Film and Film Festival Audiences: The Case of the Ladakh International Film Festival, India." *Third Text* 27, no. 6 (2013): 738.

7. Karin Barber, "Preliminary Notes on Audiences in Africa." *Africa* 67, no. 3 (1997): 347–62; Karin Barber, "Popular Arts in Africa," *African Studies Review* 30, no. 3 (1987): 1–78.

8. Bodil Frederiksen, *Making Popular Culture from Above: Leisure in Nairobi 1940–1960* (Calcutta: Centre for Studies in Social Sciences, 1994); Charles Ambler, "Popular films and colonial audiences: the movies in Northern Rhodesia," *The American Historical Review* 106, no. 1 (2001): 81–105; James Burns, *Flickering Shadows: cinema and identity in colonial Zimbabwe,* (Athens: Ohio University Press. 2002); Bhekizizwe Peterson, "The Politics of Leisure during the Early Days of South African Cinema," eds, Isabel Balseiro and Ntongela Masilela, *To Change Reels: Film and Film Culture in South Africa* (Detroit:

Wayne State University Press, 2013): 31–46; Brian Larkin, *Signal and Noise: Media, Infrastructure, and Urban Culture in Nigeria* (Durham: Duke University Press, 2008).

9. L. A. Nottcutt and G. C. Latham, *The African and the cinema: an account of the work of the Bantu educational cinema experiment during the period March 1935 to May 1937* (London: Edinburgh House Press, 1937).

10. Aboubakar Sanogo, "Colonialism, Visuality and the Cinema: Revisiting the Bantu Educational Kinema Experiment." eds, Lee Grieveson and Colin McCabe, *Empire and Film* (New York: Palgrave Macmillan, 2011): 239.

11. Lindiwe Dovey and Angela Impey, "African Jim: sound, politics, and pleasure in early 'black' South African cinema," *Journal of African Cultural Studies* 22, no. 1 (2010): 57–73.

12. Mark Jancovich and Lucy Faire and Sarah Stubbings, *The Place of the Audience: Cultural Geographies of Film Consumption* (London: British Film Institute, 2003); Brian Larkin, *Signal and Noise: Media, Infrastructure, and Urban Culture in Nigeria* (Durham: Duke University Press, 2008).

13. Mark Jancovich, Lucy Faire and Sarah Stubbings, *The Place of the Audience: Cultural Geographies of Film Consumption* (London: British Film Institute, 2003): 3.

14. Larkin, *Signal and Noise*, 1–2.

15. Jancovich, et al., *The Place of the Audience,* 8–9.

16. Janice Radway, *Reading the Romance: Women, Patriarchy and Popular Literature,* (Chapel Hill: University of North Carolina Press, 1991).

17. This research has included surveys of audiences at four festivals in Africa: Amakula Kampala in Uganda (2010); the Kenya International Film Festival (2010); the Durban International Film Festival (2013); and the Rwanda Film Festival (2013). It has also involved conducting many one-on-one interviews with individual spectators at festivals across the continent.

18. A total of 352 audience surveys were completed, across four of the festival's five main venues: the Suncoast cinemas (the main festival screening venue), the Elizabeth Sneddon theater at the University of KwaZulu-Natal (the original home of the festival), the Blue Waters Hotel (the festival headquarters), and the Ekhaya Multi-Arts Centre in the township of KwaMashu (the festival's main "outreach" venue). The fifth main venue of the festival (not covered by my survey) is the Musgrave shopping center's cinemas. At each screening at the four venues, across seven of the festival's eleven days, ten spectators were randomly selected to complete surveys.

19. The question asked was "Why did you come to the screening today?," followed by a blank space rather than a list of possible answers for respondents to choose from.

20. The question asked was "What do you hope to get out of the festival?," followed by a blank space rather than a list of possible answers for respondents to choose from.

21. Odile Goerg, "Introduction," *Fêtes urbaines en Afrique: espaces, identités, et pouvoirs* ed. Odile Goerg (Paris: Karthala, 1999); Tejumola Olaniyan, "Festivals, Ritual, and Drama in Africa," in *The Cambridge History of African and Caribbean Literature Volume 1*, eds., F. Abiola Irele and Simon Gikandi, (Cambridge: Cambridge University Press (2012): 35–48. Pelu Awofeso, *Nigerian Festivals: The Famous and Not So Famous* (Lagos: Homestead Enterprises, 2013).

22. Vincent Bouchard, "Commentary and Orality in African Film Reception," in *Viewing African Cinema in the Twenty-First Century: Art Films and the Nollywood Video Revolution*, eds. Mahir Şaul and Ralph A. Austen (Athens: Ohio University Press, 2010): 95–107.

23. Bhekizizwe Peterson, "The Politics of Leisure during the Early Days of South African Cinema," in *To Change Reels: Film and Film Culture in South Africa,* eds. Isabel Balseiro and Ntongela Masilela (Detroit: Wayne State University Press, 2013): 39.

24. Ibid, 43.

25. Stanley Fish, *Is There a Text in This Class? The Authority of Interpretive Communities* (Cambridge, MA: Harvard University Press, 1980).

26. Quoted in Bodil Frederiksen, *Making Popular Culture from Above: Leisure in Nairobi 1940–1960* (Calcutta: Centre for Studies in Social Sciences, 1994): 25.

27. L. A. Nottcutt and G. C. Latham, *The African and the cinema: an account of the work of the Bantu educational cinema experiment during the period March 1935 to May 1937* (London: Edinburgh House Press, 1937): 22.

28. Aboubakar Sanogo, "Colonialism, Visuality and the Cinema: Revisiting the Bantu Educational Kinema Experiment," in *Empire and Film,* eds. Lee Grieveson and Colin McCabe (New York: Palgrave Macmillan, 2011): 240.

29. James Burns, *Flickering Shadows: cinema and identity in colonial Zimbabwe* (Athens: Ohio University Press. 2002): 52.

30. Sanogo, "Colonialism, Visuality and the Cinema," 240.

31. Mahir Şaul "Art, Politics, and Commerce in Francophone African Cinema," in *Viewing African Cinema in the Twenty-First Century:Art Films and the Nollywood Video Revolution,* eds. Şaul and Austen (Athens: Ohio University Press, 2010): 135.

32. Ibid, 135.

33. Two French distribution and exhibition companies, COMACICO (created in the early 1920s) and SECMA (created in 1939) largely controlled distribution and exhibition in the West African territory well into the postcolonial period.

34. Şaul, "Art, Politics, and Commerce in Francophone African Cinema," 135.

35. Sanogo, "Colonialism, Visuality and the Cinema," 235.

36. Ibid, 241.

37. Ibid, 240.

38. Ibid, 239.

39. Ibid, 240.

40. Ibid, 239–240.

41. Emmanuel Sama, "African Films are Foreigners in Their Own Countries" in *African Experiences of Cinema,* eds. Bakari and Cham (London: British Film Institute. 1996): 148.

42. Tahar Cheriaa, *Écrans d'Abondance . . . Ou Cinémas de Libération en Afrique?* (Tunis: Societe d'impression et d'edition Laplume, 1978): 9.

43. My translation from the French.

44. "Tricontinentalism" is the term generally used to describe the rise of a connected anti-imperialist movement among the continents of Asia, Africa, and Latin America. While many attribute its formal origins to the 1966 First Tricontinental Conference in Havana, Cuba, some suggest that the idea of Tricontinentalism began in the 1920s (Pitman and Stafford 2009). For the importance of understanding cultural production in Africa through the lens of Tricontinentalism, see: Akinwumi Adesokan, Postcolonial Artists and Global Aesthetics (Bloomington: Indiana University Press, 2011).

45. Bakari and Cham, *African Experiences of Cinema,* 17–36.

46. Teshome Gabriel, "Third Cinema in Third World: The Dynamics of Style and Ideology," (PhD diss., University of California, Los Angeles, 1979): 89.

47. Marijke De Valck, *Film Festivals: From European Geopolitics to Global Cinephilia* (Amsterdam: Amsterdam University Press, 2007). 167.

48. See, for example, Will Brooker and Deborah Jermyn, eds., *The Audience Studies Reader* (London and New York: Routledge, 2003); Jancovich et al., *The Place of the Audience.* Elizabeth Bird, *The Audience in Everyday Life: Living in a Media World* (New York and London: Routledge, 2003); Nico Carpentier, Kim Christian Schrøder and Lawrie Hallett, *Audience transformations: shifting audience positions in late modernity* (New York: Routledge 2014).

49. Gabriel, *Third Cinema in Third World,* 103.

50. Ibid, 102.

51. Ethnographic French filmmaker Jean Rouch even said that "video is the AIDS of the film industry" quoted in Pierre Barrot, *Nollywood: The Video Phenomenon in Nigeria* (Oxford: James Currey; Ibadan: HEBN; Bloomington and Indianapolis: Indiana University Press, 2008): 3.

52. Marcia Landy, "Review of Ousmane Sembène, 'Man is Culture,' Sixth Annual Hans Wolff Lecture, 5 March 1975, Bloomington: African Studies Program, Indiana University." *Research in African Literatures* 13, no. 1 Spring (1982): 133.

53. Ibid, 133.

54. Gabriel, *Third Cinema;* Teshome Gabriel, *Third Cinema in the Third World: Aesthetic of Liberation* (Ann Arbor: UMI Research Press, 1982).

55. Manthia Diawara, *African Cinema: politics and culture* (Bloomington: Indiana University Press, 1992); Nwachukwu Frank Ukadike, *Black African Cinema.* (Berkeley: University of California Press, 1994); Josef Gugler, *African Cinema: Re-imagining a Continent* (Oxford: James Currey, 2003); Melissa Thackway, *Africa Shoots Back: Alternative Perspectives in Sub-Saharan Francophone African Film* (Oxford: James Currey, 2003); Lindiwe Dovey, *African Film and Literature: Adapting Violence to the Screen* (New York: Columbia University Press, 2009).

56. Carmela Garritano, *African Video Movies and Global Desires: A Ghanaian History* (Athens: Ohio University Press, 2013); Matthias Krings and Onokoome Okome, *Global Nollywood: The Transnational Dimensions of an African Video Film Industry* (Bloomington: Indiana University Press. 2013).

57. Cindy Wong, *Film Festivals: Culture, People and Power on the Global Screen* (New Jersey: Rutgers University Press, 2011): 11.

58. Ibid, 146.

59. For an example see: Sambolgo Bangré, "Le Cinéma Africain Dans la Tempête des Petits Festivals," *Ecrans d'Afrique* 7: 50–8. (1994). http://www.africine.org /?menu=ecransafr&no=7/.

60. As Patricia Caillé (2014) notes, the Festival International du Film Amateur de Kelibia (FIFAK) is, in fact, the "oldest film festival in Tunisia" and thus the oldest film festival in Africa that has paid attention to African films. Created by the Fédération Tunisienne des Cinéastes Amateurs (FTCA), it has held twenty-eight editions between 1964 and 2013, so is not as regularly held or as well known as JCC.

61. I have found a reference to a film festival that existed for several years during this early independence period in Mogadishu, Somalia, but no further information about it (Keyan Tomaselli, "Cultural Interventions: Beyond the Boycott." An interview with Peter Chappell and Jean-Pierre Garcia of the Amiens Film Festival, *The South African Film and Television Technicians Association (SAFTTA) Journal* 4, nos. 1–2 (1984): 6–12.

62. Bennetta Jules-Rosette, *Black Paris: The African Writers' Landscape* (Champaign: University of Illinois Press, 2000): 69.

63. Ibid, 69.

64. Olivier Hadouchi, "'African culture will be revolutionary or will not be': William Klein's Film of the First Pan-African Festival of Algiers (1969)." *Third Text* 25, no. 1 January (2011): 118.

65. I do not have the space in this book, focused as it is on *film* festivals, to analyze the 1966 Dakar and the 1969 Algiers festivals. Further analysis of these festivals—and, in particular, their respective relationships to their audiences—is forthcoming in future work.

66. Thomas Bikales, "From 'Culture' to 'Commercialization': The Production and Packaging of an African Cinema in Ouagadougou, Burkina Faso" (PhD diss., New York University, 1997): 209.

67. Dupré, Le Fespaco, une affaire d'État(s), 15.

68. Translation from French to English from Dupré is my own throughout this chapter.

69. Diawara, *African Cinema*, 131–2.

70. As many have noted, the festivals should be further spaced apart. FESPACO takes place in February/March, just a few months after JCC in October/November, making it difficult for filmmakers to attend both.

71. Gideon Bachmann, "In Search of Self-Definition: Arab and African Film at the Carthage Film Festival (Tunis)," *Film Quarterly* 26, no. 3 (1973): 49.

72. Jeffrey Ruoff, "Ten Nights in Tunisia: Les Journées Cinématographiques de Carthage," *Film International* 6, no. 4 (2008): 46.

73. Bikales, "From 'Culture' to 'Commercialization,'" 300.

74. Rouff, "Ten Nights in Tunisia," 46.

75. It is worth noting here that more recently founded African film festivals on the continent, such as the Luxor African Film Festival (founded 2012), make a similar distinction between North and sub-Saharan Africa. For example, in a press release during its 2014 edition, the Luxor African Film Festival refers to a film workshop in which "20 Egyptians and 20 Africans" will participate. Several scholars have done important work on the relationship between "African" and "Arab" identities in relation to festivals (see Bana Barka and Harouna Barka "Les festivals au Cameroun et leurs enjeux identitaires et politiques: Festik (2000) et Festat (2003)." In Fléchet et al (2013): 187–201: Andrew Apter, "Beyond Négritude: Blackness and the Arab Question in FESTAC 77." Paper presented for the African Studies Association of the UK (ASAUK) conference, Brighton, United Kingdom, September 9–11 (2014).

76. Rouff, "Ten Nights in Tunisia," 49–50; Patricia Caillé, "The stakes in a 'common culture' at the national, regional and transnational levels: the FIFAK," Paper presented at the African Studies Association of the UK (ASAUK) conference, Brighton, United Kingdom, September 9–11. (2014).

77. Chika Okeke-Agulu, Contribution to "The Twenty-First Century and the Mega Shows: A Curators' Roundtable." Moderated by Chika Okeke-Agulu. Nka: Journal of Contemporary African Art (Spring 2008): 156.

78. Ibid, 160.

79. Sylvie Ogbechie, "The Curator as Culture Broker: A Critique of the Curatorial Regime of Okwui Enwezor in the Discourse of Contemporary African Art," June 16, 2010. http://aachronym.blogspot.co.uk/2010/06/curator-as-culture-broker-critique-of .html/.

80. Diawara, *African Cinema*, 129.

81. Quoted in Bikales, "From 'Culture' to 'Commercialization,'" 216.

82. Loist notes that "[e]very city that wants to compete in the global creative/cultural market and in the tourist arena . . . now runs an IFF or city festival" (Skadi Loist, "Precarious cultural work: about the organization of (queer) film festivals." *Screen* 52, no. 2 (Summer 2011): 269.) There is, accordingly, a large body of scholarship about the relationships between festivals and cities (see, for example, Julian Stringer, "Global Cities and the International Film Festival Economy," in *Cinema and the City: Film and Urban Societies in a Global Context,* eds. Mark Shiel and Tony Fitzmaurice (Oxford: Blackwell, 2001), 134–44). The decision to make Ouagadougou the unlikely capital of "African Cinema" was a strategic one on the part of those who founded FESPACO. In the late 1960s, the sub-Saharan African countries most engaged in film production were Senegal, Niger, and Ivory Coast. This was largely due to aid provided by the French Bureau of African Cinema, created in 1963 (see Chapter 2). Ouagadougou seems to have been chosen for its neutrality, as a way of sidestepping French control, and also avoiding rivalry amongst powerful African nations, such as Nigeria and Senegal. The Burkinabe government was delighted to be elected the host of FESPACO by vote and, in this way, to find what would become the main source of existence for this resource-poor nation in the eyes of the world. After the first festival, Sembène wrote to FESPACO treasurer Hamidou Ouédraogo with the resonant commitment: "mon Coeur est voltaïque" ("my heart is Voltaïque") (a copy of the full letter can be found in Hamidou Ouédraogo, Naissance et évolution du FESPACO de 1969 à 1973. Ouagadougou: Imprimerie nationale du Burkina. (1995): 111).

83. Bikales, "From 'Culture' to 'Commercialization,'" 216.

84. See funding tables in Dupré *Le Fespaco, une affaire d'État(s):* 177–8.

85. Burkina Faso gained its full independence from France (still under the name "Upper Volta") on August 5, 1960, with its first president being Maurice Yaméogo, who established a one-party state under his Voltaic Democratic Union (UDV) party. A military-led coup d'état in 1966 brought Lt. Col. Sangoulé Lamizana to the presidency, and he remained in power until 1980, when Col. Saye Zerbo seized control in another coup d'état. The Council of Popular Salvation (CSP) overthrew Zerbo's government in 1982, under the leadership of Jean-Baptiste Ouédraogo, but was hampered by internal conflicts between moderates (such as Ouédraogo) and leftist radicals (such as Captain Thomas Sankara). This conflict led to another coup d'état in 1982, after which Sankara became president. Blaise Compaoré orchestrated a coup d'état in 1987 that involved the murder of Sankara; Compaoré was in power from this time until October 2014, when he was forced to resign after a popular uprising (see Roger Bila Kaboré, *Histoire politique du Burkina Faso: 1919–2000* (Paris: L'Harmattan, 2002)).

86. Many filmmakers boycotted several editions of FESPACO after the assassination of Sankara (Dupré *Le Fespaco, une affaire d'État(s):* 166); certain filmmakers, such as Haile Gerima (from Ethiopia), have refused to attend the festival ever since. The Senegalese filmmaker Amadou Saal-um Seck also notes that he encountered problems screening his film Saaraba, which was among several dedicated to Sankara, at FESPACO 1989; he was refused the typical press conference for the film the day following the screening, and he says that "no commentary was made about [the] film by journalists" (survey response). More recently, some African filmmakers have begun boycotting the festival on account of what they see as a drastic fall in the quality of its organization since the arrival of Michel Ouédraogo as Secretary General in 2008, succeeding Baba Hama. For example, Cannes-award-winning Chadian filmmaker Mahamat-Saleh Haroun made an

explicit decision not to return to the festival after the 2011 edition (see film *Afrique Cannes*). My 2013 survey of African filmmakers reveals divergent opinions on the historical and contemporary value of FESPACO. Cameroonian filmmaker Victor Viyuoh responded: "FESPACO 2013. A disaster! Two screenings [of my film] and a total audience of less than 15 people!!!" Another filmmaker, who wished to remain anonymous, described FESPACO 2013 as follows: "Incredible level of amateurism from the very beginning. . . . Everything is wrong: incoherent and poor programming, technical issues, exceptionally incompetent staff." Other filmmakers have had very positive experiences at FESPACO, however. For example, the Burkinabé filmmaker Elénore Yaméogo says that FESPACO has been most useful to her career of all film festivals and attributes the international success of her film *Paris mon paradis* to its selection in the official documentary section at FESPACO 2011. Despite all its challenges, strong loyalty to FESPACO remains. As festival organizer and curator Katarina Hedrén puts it, "There are still problems to be solved [at FESPACO], like the need to bridge existing language gaps and the appallingly bad organization. However, as is the case in families held together by love or just shared interest, none of these problems seems serious enough to discourage the members to attend the next reunion" (Katarina Hedrén, "A family affair—efrika at FESPACO," 2013, http://www.efrika.tv/index.php/a-family-affair-efrika-at-fespaco/.

87. Kenneth Turan, *Sundance to Sarajevo: Film Festivals and the World They Made.* (Berkeley: University of California Press. 2002): 66.

88. One recalls here Sembène's much-quoted reference to cinema as a "night school" for his people.

89. Turan, *Sundance to Sarajevo,* 66.

90. Translation from French to English is my own.

91. It is important to note here, however, that this Africanized perspective had, and continues to have, its own blind spots, particularly in terms of gender. African filmmaking has been dominated by men, and very few African women have had the opportunity to direct films, especially feature fiction films. Women have mostly taken on roles in the industry as actresses, the makers of low-budget documentary films, and film festival organizers and curators (of which Salembéré is an example). The paradoxical combination of the "feminization" of, and the sexism displayed within, the sphere of film festivals (one of the few industry realms to which women have had access, but within which they are often treated as sex objects by men) requires a great deal of further research and exploration. Unfortunately, a complete gender analysis is beyond the scope of this project. However, in Chapter 6, my analysis of the curatorial approaches of festival directors in South Africa, Tanzania, Zimbabwe, and Algeria includes a gendered angle. See also Lindiwe Dovey, "New Looks: The Rise of African Women Filmmakers," *Feminist Africa* 16 (2012): 18–36, in which I discuss some of the relationships between film festivals and women filmmakers from Africa, and Patricia, Caillé "A gender perspective on the 23rd edition of the JCC." *Journal of African Cinemas* 4, no. 2 (2012): 229–33.

92. Bikales, "From 'Culture' to 'Commercialization,'" 240.

93. Şaul, "Art, Politics, and Commerce in Francophone African Cinema," 146.

94. This film school operated from 1977 to 1987 and was largely funded by the government of Burkina Faso, with assistance from the Mitterand administration in France (Claire Andrade-Watkins, "Film Production in Francophone Africa 1961 to 1977: Ousmane Sembène—An Exception." In Gadjigo et al (1993): 35); Burkinabe director Fanta Régina Nacro received her primary training there.

95. Bikales, "From 'Culture' to 'Commercialization,'" 236.

96. Patrick Ilboudo, *Le FESPACO, 1969–1989: Les cinéastes africains et leurs oeuvres* (Ouagadougou: Éditions La Mante 1988): 116; Bikales, "From 'Culture' to 'Commercialization,'" 236; Şaul, "Art, Politics, and Commerce in Francophone African Cinema," 146.

97. Şaul, "Art, Politics, and Commerce in Francophone African Cinema," 146.

98. Elizabeth Harney, *In Senghor's Shadow: Art, Politics, and the Avant-Garde in Senegal, 1960–1995.* (Durham and London: Duke University Press, 2004): 79.

99. Harney, *In Senghor's Shadow,* 79.

100. Şaul, "Art, Politics, and Commerce in Francophone African Cinema," 146.

101. One of the most fascinating examples of this is how FESPACO used quotes from children saying how much they liked African films in their marketing and publicity materials (Dupré, *Le Fespaco, une affaire d'État(s)*: 189).

102. Bikales, "From 'Culture' to 'Commercialization,'" 331.

103. Bikales, "From 'Culture' to 'Commercialization,'" 244.

104. Diawara, *African Cinema,* 130, Olivier Barlet, *African Cinemas: Decolonizing the Gaze.* (London: Zed Books, 2000)..: 232–237, Şaul, "Art, Politics, and Commerce in Francophone African Cinema: 144.

105. Bikales, "From 'Culture' to 'Commercialization,'" 257–58.

106. Imruh Bakari and Mbye Cham, eds *African Experiences of Cinema.* (London: British Film Institute, 1996): 25–26.

107. Şaul, "Art, Politics, and Commerce in Francophone African Cinema," 142.

108. Ukadike, *Black African Cinema,* 199.

109. Quoted in Dupré, *Le Fespaco, une affaire d'État(s)*: 167.

110. Bikales, "From 'Culture' to 'Commercialization,'" 275.

111. As De Valck points out, "Festivals have organized official markets since the 1950s, of which *Le Marché International du Cinéma,* founded in Cannes in 1959, is undoubtedly the most famous and influential" (Marijke De Valck, "Supporting art cinema at a time of commercialization: Principles and practices, the case of the International Film Festival Rotterdam." *Poetics* 42: 40–59 (2014): 45). There have been several attempts within Africa to establish serious film markets. The creation of SITHENGI (the Southern African International Film and Television Market) in Cape Town in 1996, which initiated a parallel festival called the Cape Town World Cinema Festival in 2002, was perhaps the most promising of these, but it collapsed after CEO Michael Auret was forced to step down after the 2005 edition. Today, the Durban FilmMart, founded in 2010 at the Durban International Film Festival, and a new film market inaugurated at the 2014 Luxor African Film Festival in Egypt, carry the hopes of those who seek to professionalize the sector more.

112. Bikales, "From 'Culture' to 'Commercialization,'" 281.

113. Dupré, *Le Fespaco, une affaire d'État(s)*: 192.

114. Cindy Wong, *Film Festivals: Culture, People and Power on the Global Screen.* (New Jersey: Rutgers University Press (2011): 12; Dupré, *Le Fespaco, une affaire d'État(s),* 173.

115. Dupré, *Le Fespaco, une affaire d'État(s),* 172.

116. Ibid, 196.

117. See funding tables in Dupré, *Le Fespaco, une affaire d'État(s),*177–8.

118. Bikales, "From 'Culture' to 'Commercialization,'" 277.

119. Dupré, *Le Fespaco, une affaire d'État(s),* 166.

120. Turan, *Sundance to Sarajevo,* 77.

121. Quoted in Ibid, 77.

122. Bikales, "From 'Culture' to 'Commercialization,'" 321.

123. De Valck, *Film Festival,* 191.

124. Bikales, "From 'Culture' to 'Commercialization,'" 290.

125. Ibid, 278.

126. Diawara, *African Cinema,* 137–8

127. Ibid, 137–8.

128. Bikales, "From 'Culture' to 'Commercialization,'" 278.

129. The festival brochures started to be translated into English from 1985, and in 1987 French and English were made the official languages of business for FESPACO (Dupré, *Le Fespaco, une affaire d'État(s),* 175).

130. Robert Mshengu Kavanagh, "Festivals as a Strategy for the Development of Theatre in Zimbabwe." in *African Theatre Festivals,* ed. James Gibbs (Woodbridge/Rochester: James Currey, 2012), 3.

131. Ibid, 3.

132. Quoted in James Gibbs, "Theatre Programme for FESMAN and Commentary," in *African Theatre Festivals,* ed. James Gibbs (Woodbridge/Rochester: James Currey, 2012), 41.

133. Amy Niang, "African Renaissance between Rhetoric and the Aesthetics of Extravagance: FESMAN 2010—Entrapped in Textuality," in *African Theatre Festivals,* ed. James Gibbs (Woodbridge/Rochester: James Currey, 2012), 31.

134. Mahir Şaul and Austen, *Viewing African Cinema,* 1.

135. Dupré, *Le Fespaco, une affaire d'État(s),* 182–3

136. Carmen McCain, "Fespaco in a time of Nollywood: The politics of the 'video' film at Africa's oldest festival." *Journal of African Media Studies* 3, no. 2 (2011): 241–61.

137. CODESRIA is the Council for the Development of Social Science Research in Africa and is based in Dakar, Senegal. See http://www.codesria.org/.

138. Ibid, for a critique of this separation.

139. Audrey Evrard, "Report on African Film Conference," University of Illinois at Urbana-Champaign, Scope, June (2008): 1.

140. Carmela Garritano, *African Video Movies and Global Desires: A Ghanaian History,* (Athens: Ohio University Press, 2013), 196.

141. Kenneth Harrow, *Trash: African Cinema from Below.* (Bloomington and Indianapolis: Indiana University Press, 2013), 6.

142. Bird, *The Audience in Everyday Life,* 172.

143. Jonathan Haynes, ed. *Nigerian Video Films.* (Athens: Ohio University Press, 2000).; Jonathan Haynes, "'New Nollywood': Kunle Afolayan." *Black Camera* 5, no. 2 (Spring 2014): 53–73. Birgit Meyer, "Ghanaian Popular Cinema and the Magic in and Film," in *Magic and Modernity: Interfaces of Revelation and Concealment,* eds. Birgit Meyer and Peter Pels (Redwood City: Stanford University Press, 2014), 200–22. Martin Mhando, "ZIFF: A Festival Director's View." (2013); Şaul and Austen, *Viewing African Cinema;* Abdalla Uba Adamu, "Transnational Flows and Local Identities in Muslim Northern Nigerian Films," in *Popular Media, Democracy and Development in Africa,* ed. Herman Wasserman, (Abingdon: Routledge, 2011), 223–35. David Kerr, "The Reception of Nigerian Video Drama in a Multicultural Female Community in Botswana," *Journal of African Cinemas* 3, no. 1 (2012): 65–79. Lindsey Green-Simms, "Occult Melodramas: Spectral Affect and West African Video-Film," *Camera Obscura* 27, no. 2 (80) (2012): 25–59. Matthias Krings and Onokoome Okome, eds. *Global Nollywood: The Transnational Dimensions of an African Video Film Industry* (Bloomington: Indiana University Press, 2013); Carmela

Garritano, *African Video Movies and Global Desires: A Ghanaian History* (Athens: Ohio University Press, 2013); Stephanie Newell and Onokoome Okome, eds. *Popular Culture in Africa: The Episteme of the Everyday* (New York and Abingdon: Routledge, 2014).

144. During a panel discussion at the 2013 Cordoba African Film Festival in Spain, Russell Southwood pointed to a recent market research survey conducted in Nigeria that recorded that: seventeen percent of people surveyed would like improvement to the quality of the acting in Nollywood films, nineteen percent would like production quality improvement

145. Garritano, *African Video Movies and Global Desires, 3.*

146. Ibid, 4.

147. Heidi Lobato, "Art Council of Amsterdam Concludes that African and Diaspora Cinema Has no Actual Relevance," *Shadow and Act: On Cinema of the African Diaspora*, June 21, 2012.. http://blogs.indiewire.com/shadowandact/art-council-of-amsterdam-concludesthat-african-diaspora-cinema-has-no-actual-relevance/.

148. Brian Moeran and Jesper Strandgaard Pederson, eds *Negotiating Values in the Creative Industries: Fairs, Festivals and Competitive Events* (Cambridge: Cambridge University Press 2011), 6.

149. Odile Goerg, "Introduction," in *Fêtes urbaines en Afrique: espaces, identités, et pouvoirs*, ed. Odile Goerg, (Paris: Karthala, 1999), 8–9.

On Tracking World Cinema: African Cinema at Film Festivals

Manthia Diawara

The Pan-African Federation of Filmmakers (FEPACI) convened during the thirteenth edition of the Pan-African Film Festival of Ouagadougou (FESPACO) to reassess, among other things, the leadership of the filmmakers' association, the role of FESPACO and other festivals in promoting African cinema, and the production and distribution of films. The lack of a public for African cinema in Africa is a complex issue. It is true that the colonization of African screens by American and Kung Fu films is the main reason why African films are not seen in Africa. In fact, this situation is not unique to Africa, as it prevails in European countries, as well as Latin America and Asia, where American films take the larger share of the market, and often relegate national films to art movie theaters.

The FEPACI congress recommended quotas and "special tax incentives" to encourage the distribution of African films in Africa. Furthermore, they divided the continent into six sub-regions (East, North, North-West, South-West, Central, and Southern), with regional secretaries to oversee distribution activities. The problem with this compartmentalization of the continent in terms of film distribution is that it is utopian in many regards. The nation-state has failed in Africa, and it is increasingly becoming difficult to use it as the basis for organizing an economic unit such as film distribution. Individual countries do not collaborate with a decision that is not favorable to the national interest (i.e., the interest of the ruling party) or to bilateral relations with such Western countries as France and the United States which are opposed to quotas.

African cinema exists in exile. Gaston Kaboré, the General Secretary of FEPACI, was criticized for traveling too often to Europe and America on behalf of African cinema, and doing little networking in Africa. More African films are seen in Europe and America than in Africa. In fact, an African filmmaker told me that the recent African Film Festival organized in New York was more important to him than FESPACO, because African films have a better market in America than Africa. Yet other filmmakers criticize the

proliferation of African film festivals everywhere in Europe and America, for they do not always have the interest of African cinema as their main goal.

FESPACO used to look favorably upon Le festival des trois continents à Nantes, Le Festival d'Amiens (France), the Milan Festival of African Cinema (Italy), and Vues d'Afrique in Montreal (Canada) as sister festivals. Today, FESPACO considers some of these festivals as threats to its own growth into an annual and international festival. Since the best African films are screened at these European and American festivals, not to mention the ones that get into the Cannes, Venice, Berlin, and London film festivals, filmmakers no longer look to FESPACO for the premiere of their films. These European and American film festivals also contribute to the "ghettoization" of African films, because they only use them for the purposes of multiculturalism as required by their own citizens.

The cultural industry around African cinema is growing larger and larger, generating new festivals in every corner of the world, but, from the point of view of the film industry, African cinema is no more important than it was ten or fifteen years ago: there are no production nor distribution structures in place. The realities are those of an auteur cinema with diversified funding sources coming mainly out of Europe.

African Cinema in Ouagadougou

Ironically, the most ambivalent festival for African film today is FESPACO. Ask any African filmmaker what is the meaning of FESPACO, and he or she will tell you that "FESPACO is our own, Ouagadougou is the home of African cinema, I don't feel marginalized here." It is the only film festival devoted to Pan-African cinema, a festival that takes seriously the task of nurturing, publicizing, and celebrating African films. Ouagadougou is the place to meet filmmakers from other countries, compare notes on films, and exchange information on funding sources. FESPACO is also a homecoming and a family reunion for filmmakers, a chance to meet old friends in the same bars or restaurants and talk about the good old days. Finally, filmmakers come to Ouagadougou to discuss strategies for the decolonization of African screens, and the creation of the ever-elusive African film industry.

Ask any African filmmaker what is his or her impression of this year's festival, however, and you are liable to hear the following complaints: the festival is no longer attentive to the concerns of filmmakers; it is not just a film festival anymore, it is a *Grande Fête* highlighting drummers from Burundi, fashion shows, and business entrepreneurship in the streets of Ouagadougou. It is a festival of the sponsors: the festival cares more about pleasing the French tourists than about African filmmakers. For 5,000 Francs CFA (about

twenty dollars), anybody can buy a badge stating that he or she is an invited guest, just like filmmakers. The programming is too political, not to say chaotic, favoring some filmmakers, and excluding others.

The city of Ouagadougou has reached the limits of its capacity during the festival. While there are only 1,200 hotel rooms in Ouagadougou, the festival had more than two thousand guests, and there was an additional rush of tourists in search of hotels. FESPACO cannot get any bigger lest it overflow; some filmmakers have to sleep in hotel lobbies. And some hotel managers are corrupt: FESPACO paid full price for rooms, but some of its guests were told that the hotel had no rooms available, so that the same accommodations could be rented to tourists. There are never enough seats in the movie theaters for certain films.

The government's involvement in the festival has become cumbersome, as seeing movies with the president or his ministers always involves strict security checks and the relegation of many seats to their entourage. With the president in particular, one has to be seated one hour before he arrives, and no movement in or out of the theater is allowed once he has arrived. Perhaps there should be private screenings for the president, if he must see the films. The festival would also be less political if it were run by the private sector instead of by the government. Some filmmakers complain that the government influences the distribution of awards at the festival, and some threaten not to come back if things remain the same.

From the Burkinabes' perspective, the festival is a success. In spite of the fact that Burkina Faso is alone in organizing a festival of this magnitude, second in size only to the annual championship soccer match in Africa, it has done so with professionalism: computerized programming, badges with identification photos for thousands of invited guests, buses from hotels to movie theaters, films that start on time, meal tickets acceptable in all the major restaurants in Ouagadougou, and a film market for television and film distributors.

Close to a million people participate in the festival, which mobilizes everybody in Ouagadougou, as well as other cities and villages in Burkina Faso. The *Grande Fête* also attracts middle-class tourists from Mali, Senegal, Guinea, and Côte d'Ivoire who prefer to get away from the long drawn-out fasting days of Ramadan, in order to shorten the days in a lively and carnavalesque atmosphere like Ouagadougou during FESPACO. Burkina Faso has done more for African cinema than any other country in Africa. Now that FESPACO has become the most important cultural event in Africa, the Burkinabes suspect other African countries of trying to steal it from them.

It cost about 1.5 million dollars (320 million Francs CFA) to organize the thirteenth FESPACO (February 20-27, 1993). The French government and the Francophone organization, Agence de Cooperation culturelle et

technique (ACCT), paid the bill with some assistance from UNESCO, the European Economic Community, and donors from other European countries. Burkina Faso, one of the poorest countries in the world, supplies resources in mankind, venues, and infrastructure. Other African countries do not pay their membership dues, which leads some critics to say that FESPACO is a European festival organized in Africa.

The French delegation, by far the largest group of foreign guests, is led by the minister of Francophony, Madame Tasca, and the director of the French Centre National de Cinema (CNC), Dominique Wallon. Ninety percent of African films are produced by the French government and Francophone organizations; it is important for them, therefore, to make a strong showing in Ouagadougou, and defend their films. FESPACO is a coup in French foreign policy toward Africa: France pays the bill for a festival showing African films, ninety percent of which are produced by the French government and French organizations. The festival was a big international media event, rivaling in coverage the Somalia crisis on such radio stations as the BBC, RFI (Radio France International), and Africa No. 1. What better place than FESPACO for France to show its friendship with the Francophone countries, to demonstrate the old adage that the action of funding films and paying the bill for the organization of FESPACO speaks louder than the words of politicians?

It is said that Mitterand sees Francophone Africa as crucial to French foreign policy, if France is to remain a world power in the twenty-first century. Rumor also had it in Ouagadougou that the Right was coming to power in France, and that the Left functionaries were mounting new schemes for African film production companies to fall back on after the elections. Thus, this year's FESPACO witnessed the inauguration of yet another new production company, Écrans du Sud, which will be based in Paris and funded by French philanthropic societies.

Finally, FESPACO's credibility is threatened by two important factors. First, it is no longer a secret that the films from North Africa receive only secondary prizes, reserving the big ones such as Étalon de Yennenga, and the Oumarou Granda Award to French coproduced sub-Saharan African films. Tunisian cinema is experiencing its golden age, with directors such as Nouri Bouzid and Férid Boughedir, but they have been silenced at the last two FESPACO along with brilliant directors from Morocco and Egypt. Is it possible that Tunisian cinema's explorations of a new film language that dares to include homosexuality and eroticism have dissuaded FESPACO from celebrating it?

The festival has also turned down diaspora films like *Tongues Untied* (dir. Marlon Girggs, 1989, United States), and *Looking For Langston* (dir. Isaac Julian, 1989, Britian), in the belief that they are inappropriate because of their homosexual content. The other serious threat to the credibility of FESPACO concerns

the decision of Africa's most famous filmmakers not to put their films in the competition, as a noble gesture to African cinema and an encouragement to younger and less popular filmmakers. Sembène's *Gelwar* (1992, Senegal), and Djibril Diop Mambéty's *Hyena* (1992, Senegal) did not compete this year.

As if the entanglement of African cinema with African politics were not enough, FESPACO has also become the *Grande Fête*, which creates a breeding place for a free market economy in Ouagadougou, and the conditions of possibility for the renewal of connections between Africa and the diaspora. For most people attending the festival, everyday life consists of hard choices between films, shopping in the famous Rue Marchande, receptions and cocktail parties at foreign embassies, and fashion shows.

La Rue Marchande is a discovery for many festivalgoers. Shaped in much the same way as the New York Book Fair, La Rue Marchande consists of several blocks closed off to traffic for one week, allowing vendors to set up their shops and pedestrians to fill the streets from sunup to sundown. La Rue Marchande is principally two streets intersecting each other, each approximately five blocks long, and crowded with more than five hundred vending stands, thousands of shoppers, and performance artists. There are millet beer vendors, tourist art merchants, vendors of original textiles from Burkina Faso (called *Faso Dan Fani*), condom stands, T-shirt stands, fruit stands, fashions from neighboring countries and from France, musical instruments, lottery ticket booths, advertisement agencies, and booths for radio stations and political parties.

La Rue Marchande constitutes an important part of the economic tour de force that FESPACO creates for the city of Ouagadougou. Conservative estimates put the revenue of the vendors at about five thousand dollars each during the week of the festival, which is a considerable amount given that Burkina Faso has one of the world's lowest GNPs. It is also estimated that the festival will gross about 3.5 million dollars (700 million Francs CFA) this year, and La Rue Marchande comes right after the hotels and the airlines as generators of revenue. Restaurants, gas stations, bars and discotheques, and the shoe shining businesses are the other important sources of revenue.

At a creative level, Africa's two most talented designers, Chris Seydou (Mali), and Alphadi (Niger), also took part in the FESPACO festivities. Alphadi emphasizes bright colors and works mostly with Kinte cloth. Chris Seydou is a revelation for many people who are interested in African fashion. His rethematization of the *Boxolan* (the traditional mud cloth from West Africa with motifs from Bambara scripts), and other exquisite designs reflecting the classic colors of black, white, and the light blue of the Sahel nomads, are always soothing. Seydou's designs surprise many people because of the original and hybrid ways in which he prints traditional Bambara motifs on modern textiles, and the stylized yet classical manner in which he sews

his hats, jackets, vests, skirts, dresses, and shirts (1960s style miniskirts, for example). Seydou's designs, symbols of one kind of marriage between France and Africa, superimpose the traditional as image onto the surface of the modern, so that some of his jackets and dresses rival the films in competition at the festival.

La Rue Marchande is a metaphor for the market that has so far eluded African cinema and many industrial prospects on the continent. For one week, La Rue Marchande bustles with buyers and all varieties of merchandise. At the end of the week, the buyers disappear and the market with them. Similarly, African cinema realizes its dream of African audiences during the week of FESPACO. During that time, the crowd gathers in front of movie theaters, the international press talks about the films, and the streets are animated with discussions of individual films. At the end of the festival, the tourists go back home, Western and Kung Fu films resume their monopoly of the movie houses, and African cinema waits for two more years to be celebrated again.

The lack of a market within national boundaries is the single most important obstacle to the development of African cinema. It is impossible to have a Senegalese or a Burkinian film industry, just as it is impossible for individual countries to sustain a sugar or a shoe industry, because the cost of producing a chain of films exceeds the ticket revenues of each individual country. African films have to compete with foreign films, just as the sugar produced nationally has to compete with the imported brands.

For African filmmakers, only an extended market beyond national boundaries can provide them the opportunity to conquer an audience for their films. The filmmakers' federation gathers at every FESPACO to put pressure on governments to open up markets beyond national boundaries, and to lower taxes for the exhibition of African films. Is it possible that African cinema, like many other modern industries, will fall victim to African nationalism which, ironically, celebrates the films of Sembène, Cisse, and Ouédraogo as national treasures?

While the nation-state in Africa is busy mimicking Europe in power-sharing and in the celebration of the Western democratic model, African cinema realizes that, without a market, art and democracy are not possible. Markets are Africa's road to democracy and the good life society, and only Pan-Africanism can gather such markets. Democracy without a market is like putting the cart before the horse; African cinema without African audiences is like a cinema in exile.

FESPACO 1993 was also a *Grande Fête* for African-Americans, otherwise known in Ouagadougou as *les Americains Noirs*. Not since Dakar 1966 (*Festival africains des arts nègres*), and Lagos 1977 (FESTAC), has there been a similar convergence of Africans and blacks from the Diaspora on

the African continent. Just as it was possible to see side by side in Dakar and Lagos Duke Ellington, Alvin Ailey, Ousmane Sembène, Wole Soyinka, and many more black intellectual leaders, FESPACO 1993, too, has its black who's who: Alice Walker, Clyde Taylor, John Singleton, Tracy Chapman, Ahmadou Kourouma, Ibrahima Baba Kake, Ngũgĩ wa Thiong'o, and of course, Ousmane Sembène.

Spike Lee and Danny Glover were expected, but only Spike Lee's 1993 film *Malcolm X* (United States) arrived, dubbed in French, and to the delight of spectators in the festival. Singleton said that he had asked his distributors to send *Boyz 'N the Hood* (1991, United States), and that the copy was lost on the way. The African-American interest in FESPACO is also evident through the presence of cultural workers and cultural policy makers such as Andrea Taylor (of the Ford Foundation), Michelle Materre (formerly of Women Make Movies), Cornelius Moore (California Newsreel), Ayuko Babu (Los Angeles African Film Festival), and Mahen Bonetti (Africa Film Festival/Lincoln Center).

The diaspora's adoption of FESPACO started in 1983 and 1985, spearheaded by Haile Gerima and such independent filmmakers and Pan-Africanists as Larry Clark, Menelik Shabazz, Abiyi Ford, Mbye Cham, and Clyde Taylor, who wanted to include films from the diaspora in the official competition reserved to African films only. Thomas Sankara, then the president of Burkina Faso, was also a Pan-Africanist who was supportive of the idea of bringing black Americans to Ouagadougou to subvert the Francophone hegemony. At FESPACO 1993, the diaspora award, also known as the Paul Robeson Prize, went to *Lumumba, la mort du prophète / Lumumba: Killing of a Prophet* (1991, Democratic Republic of the Congo) by Raoul Peck (Haiti). It is interesting that Haile Gerima, (whose new film, *Sankofa*, was shown in Ouagadougou) and Larry Clark have not attended FESPACO since the death of Thomas Sankara, killed by the present regime.

Ironically, the names of Spike Lee and John Singleton are the new symbols of Pan-Africanism at FESPACO today. The audiences in Ouagadougou loved *Malcolm X*, identifying with the protagonist's every transformation, the film often drawing tears. Spectators in Ouagadougou enjoy interacting with actors on the screen; they call bad guys names, applaud good guys, and warn them of imminent dangers. The screening of *Malcolm X* was very animated with many rounds of applause. The fact that Denzel Washington, Nelson Mandela, Spike Lee and the Malcolm speeches were dubbed in French did not bother Ouagalais (name for people who live in Ouagadougou) at FESPACO. The strongest scenes for them were Malcolm's visit to Mecca, his speeches, and Mandela stating that he is Malcolm X. Most of the complaints about the film came from Europeans and some Americans, for whom Spike Lee has sold out to Hollywood through recourse to a less radical film language, and a commodification of Malcolm X's life.

African Cinema at the Lincoln Center

The African Film Festival (AFF), which ran at the Lincoln Center through the month of April 1993, and at the Brooklyn Museum April 17 through May 23, has catapulted African cinema to a new level of appreciation for New York audiences. For international cinema, the Lincoln Center has been a sure passageway to commercial theaters; a testing ground for cinephiles and distributors with their eyes open for foreign films that would go over well with American spectators. For African cinema, which so far has depended on French film festivals to be discovered, the Lincoln Center film festival provides the first opportunity to cut through the politics of intermediaries, and to address Americans directly with the best African films.

Among the directors whose films were screened, Fanta Regina Nacro, the first female filmmaker from Burkina Faso, assumes her voice by putting African cinema into question with her unforgettable *Un Certain Matin / A Certain Morning* (1991), a thirteen-minute film. One of Nacro's characters puts to African cinema the same reflexive question that André Bazin put to French cinema in the 1950s: "Father, what is cinema?"

The story is a simple one. A man stumbles on a small chip of wood on his way to work. He cannot put it out of his mind because it is a sign of bad luck in his tradition. However, he goes to his workplace in the forest, and begins fixing chairs with dried leaves. Suddenly, he hears a woman screaming: "Help me! Help me, he's killing me!"

The man stands up and grabs his rifle. At that moment, the camera cuts to a woman walking peacefully toward her destination. The man puts down his rifle, swearing to himself that he must have been seeing things. But he hears the woman screaming again, and this time he picks up the rifle and shoots a man running after her with a saber. The following scene reveals a perturbed film crew with the director shouting "Cut! cut!" Our man has interfered with the world of a film in progress; he has blurred his reality, layered with superstition, with a mise-en-scène for a film.

They take the actor to the clinic: luckily, he is only wounded. (Killing him would have broken the spectator's heart, since he/she identifies with the superstitious man as an innocent guy who only wanted to save a woman from harm's way.) Meanwhile, the camera cuts to our man and his son who is now curious about cinema. He asks, "Father, what is cinema?" We hear Nacro's answer on the soundtrack in a Dioula song (a Mandinka language widely spoken in Burkina Faso, Mali, Côte d'Ivoire, Guinea, and Gambia) composed for the film: "Cinema is make believe, cinema is sad, cinema is play, cinema is reality, cinema is love."

A Certain Morning won the gold medal for short films at the Carthage International Film Festival in Tunisia, but it was overlooked at the Pan-African

Film Festival of Ouagadougou in Burkina Faso, the other major film festival in Africa. Fanta Nacro's reflexive cinema, which calls attention to its own style of storytelling, may have eluded the jury in Ouagadougou, which was composed mostly of cultural policy elites with little appreciation for the work of art. In spite of its playfulness and simple narrative, *A Certain Morning* makes an important intervention in the present situation of African cinema.

The lasting effect of Ousmane Sembène's cinema and the emergence of worldclass directors such as Souleymane Cisse and Idrissa Ouedraogo compel us to go beyond a monolithic image of Africa. First of all, Fanta Nacro's question addresses this largely male cinema. One reason for the dearth of female filmmakers in Africa is women's exclusion from the apprenticeship tradition. There are several African men who were trained on the production spots as assistants, gofers, camera persons, sound persons, and even directors. It is only after this involvement in production that they went to film schools. Women, on the other hand, earn the university degree before encountering cinema. Safi Faye, the first female director from Senegal, earned a PhD in anthropology before becoming a filmmaker. She often brags about being overqualified, or about being more educated than the male filmmakers. Mariama Hima, another female first from Niger, earned a superior degree in anthropology before directing her first film.

There is an Idrissa Ouédraogo school of African cinema that calls itself new, and that is characterized by beautiful images, perfect frames, and flawless editing. For this school, Sembène's political cinema is now passé; we can no longer afford to make films in opposition to Europe, because Europe is in us and we are in Europe. This is Africa's postmodern cinema.

The Ouédraogo school wants to make films that will appeal to European audiences because there are no markets for African films in Africa. The filmmakers in the Ouédraogo school, such as Moussa Touré's (*Toubab Bi* (1991, France)), Pierre Yameogo (*Laafi–Tout Va Bien* (1991, France)), and Leonce Ngabo (*Gito, L'Ingrat / Gito, The Ungrateful* (1992, Burundi)), emphasize what they see as universal in Africa; they stress the need to go beyond didactic cinema and to posit diversity of desires and the desire for diversity. There is a negritude element in both *Toubab Bi* and *Gito* which posits the city and modernization as dehumanizing, and nature, particularly African nature, as authentic, warm, and good for the soul.

Sembène responds by saying "Ne me parlez pas de negritude, ce sont les negres qui ont tue Lumumba, et Malcolm X" ("Don't talk to me about negritude, it is the blacks that killed Lumumba and Malcolm X.") Sembène states that Europe is not his center of reference; Africa is. Furthermore, Sembène's supporters qualify the Ouédraogo school as "*cinema de calebasse*" (a calabash cinema), or a *cinema à la National Geographic*, where the beautiful images serve to fix Africans as exotic primitives. Some see Sembène's radicalism as

the stance that saves African cinema from being co-opted by the hegemonizing language of European film, and a courageous cinema against colonialism; they dismiss the Ouédraogo school as village cinema.

Between Ouédraogo and Sembène, there are veterans like Souleymane Cissé (*Yeelen*), Djibril Diop Mambéty (*Badou Boy*), Med Hondo (*Sarraounia*), Safi Faye (*Letter From My Village*), and Gaston J. M. Kaboré (*Rabi*), and a proliferating talent emerging from the works of Godwin Mawuru (*Neria*), Adama Drabo (*Ta Dona*), Clarence Delgado (*Niiwan*), Jean-Marie Téno (*Africa, l will Pluck You*), Flora Gomes (*The Blue Eyes of Yonta*), and Jean-Pierre Bekelo (*Quartier Mozart*).

Unlike most of Sembène's films, which are allegories of colonialism and modernization in Africa, and the films of the Ouédraogo school which avoid crowded and complex spaces in their mise-en-scène, most of the filmmakers in the last category confront social problems such as sex education, poverty, polygamy, and corruption in post-independence Africa. They draw on elements of popular culture like song and dance, oratory, traditional theater, and popular stars. Their films are about the African public sphere, where entertainment is linked to hidden messages about how to be smart in the city, honesty as a virtue, and the failure of African systems to improve the lives of the citizens.

Niiwan is a gem among the films in this category. Most of the film takes place in a crowded bus moving from one end of Dakar to another. Delgado succeeds in telling a very sad story (which is typical in many African cities today) in a lively manner and with a sense of humor; and, most importantly, defines a character in a well-rounded manner at every bus stop before he or she steps out.

Niiwan provides one answer to Fanta Nacro's metafilmic comment about the nature of cinema in Africa. Fiction and reality get blurred together as Delgado's bus stops to take in some people and discharge others. It is also easy to appreciate, in light of small budgets in African film production, the difficulty of making a film like *Niiwan* with non-professional actors, and the travail that goes into convincing the crowd not to interfere with the fiction in the manner of our man in *A Certain Morning*.

The metafilmic tendency in Fanta Nacro's film also invites us to think about the difficulties of filming among people that, even though they may be acquainted with television and movie theaters, have not seen live film production. African directors work mostly with nonprofessional actors who bring the flavor of the everyday life to the films, and serve as a bridge between fiction and reality. "What is cinema?" in African cinema is a way of asking African filmmakers to consider African populations as their primary audiences; a question that begs the need for African cinema to anchor itself in the aesthetics of everyday life, to fashion stories of pleasure, not just sad stories.

The choice of the Lincoln Center as a venue for this gathering of African films is a tribute to the new international stature of African cinema, an allure shaped by thirty years of filmmaking and styles spearheaded by Sembène, Ouédraogo, and Cissé. As festival organizer Mahen Bonetti puts it, "We felt that African cinema compares with the best of world cinema today, winning top awards at the festivals of Cannes, Berlin, and Venice; and we chose the Lincoln Center, a Mecca for the arts, to introduce Americans to the best African films." Richard Pena, Director of Programming of the Film Society at the Lincoln Center, agreed with Ms. Bonetti. He told me that since the festival opened, African films have broken all attendance records at the Walter Reed theater. It seems also that African films attract the most mixed audiences, affording the festival another record at the Lincoln Center: that of multiculturalism.

However, the filmmakers, who have overdosed on film festivals, come here, too, on their guard. They do not want their films or themselves to be used for causes they do not understand or support. They are used to that, in France, Italy and Canada, where people create well-paid jobs for themselves in the name of African film festivals. They have also seen their films disappear, or promises made to them withdrawn after the screening of their films. In other words, these festivals have served more to ghettoize their films than to open markets for them.

Manthia Diawara has taught at the University of California at Santa Barbara and the University of Pennsylvania. He is the author of *We Won't Budge: An African Exile in the World* (Basic Civitas Books, 2003), *Black-American Cinema: Aesthetics and Spectatorship* (ed. Routledge, 1993), *African Cinema: Politics and Culture* (Indiana University Press, 1992), and *In Search of Africa* (Harvard University Press, 1998). He also collaborated with Ngũgĩ wa Thiong'o in making the documentary *Sembène Ousmane: The Making of the African Cinema*, and directed the German-produced documentary *Rouch in Reverse*.

Notes

Originally published as Manthia Diawara, "On Tracking World Cinema: African Cinema at Film Festivals," *Public Culture*, v. 6 (1994): 385–396.

Figure C. Women gather at FESPACO festival. Courtesy of FESPACO.

African Women on the Film Festival Landscape

Beti Ellerson

A vital function of the film festival is in its capacity to showcase on a local, continental and international level, the works of African women, and to serve as a networking space to professionalize their experiences as stakeholders on the global film festival landscape. As these entities proliferate on the continent and internationally, African women are leading the way, often at the helm of or in top-level positions at these institutions.

The objective of many local film festivals is to facilitate an interconnected triadic relationship between the film, filmmaker and audience—especially with the organization of press conferences and panel discussions. Hence cultivating a critical audience via ciné-clubs and after-screening debates has been a long-standing practice of these local film initiatives.

Drawing from this background and historical context, this article and the associated timeline, outline: women's film festival practices in Africa as a vehicle for promoting leadership and featuring women as role models; the cultural leadership functions that African women have taken on at the helm of film festivals on the continent and the diaspora; the diverse film festivals in Africa and their initiatives toward the empowerment and advancement of women in cinema; the showcasing of African women at African film festivals around the world; the flagship international film festivals and their interest in including African women in the global cinematic conversation.

As there is an abundance of African and women-related film events, because of their obvious relevance they are described in the timeline that follows the discussion, while a few select festivals receive more detailed focus because of their historical importance, longevity and significance to this analysis of African women and film festival practices.

Furthermore, this piece examines film festival practices and discourses to demonstrate the strategic function they have played in strengthening African women's participation in the myriad spheres of the moving image and beyond. Notably, Burkinabe Alimata Salembéré's trailblazing role in the creation of FESPACO carved a space for women who journey in her

path, as founders, organizers, curators, and stakeholders of film festivals (film events, screening venues, cinema conferences-symposia-colloquia). Likewise, it reveals the importance of film festival practices in the promotion, advancement, and visibilization of African women in cinema, visual media and screen culture over the past Fifty years.

One of the particularities of the article is that it is informed by my primary-source based research derived from interviews with organizers, programmers, curators, festival planners, and other key players; the collection of posters, festival programs and catalogues; as well as my own participation at festivals as jury president and as member, as consultant, panelist, facilitator, and as festival participant. What inspired me to frame the film festival as a site of inquiry developed as I recognized the undeniable role that FESPACO—from its inception in 1969—and the cinema-related structures that it supports, have played in the capacity building of women in cinema as leaders. The interplay between FESPACO and the initiatives that derive from its prominence for a generation are now part of the cinematic landscape across the continent. The MICA marketplace, the Cinémathèque, Journées Cinématographiques de la Femme Africaine de l'Image (African Women Image Makers Cinema Days). This is the first mention of the JCFA, Institut Imagine, the historic film school INAFEC that existed between 1977 and 1987, all based in Burkina Faso, are important stakeholders in the country's cinema culture.

While film festival scholarship highlights the significance of women's film festivals towards the global visibility of women in cinema since their rise in the 1970s, the emergence of continental-based film festivals/days in the 1960s marks the beginnings of an African-women presence in the milieu of the film festival event, notably the Journées Cinématographiques de Carthage (JCC), the Carthage Film Festival, created in 1966 in Tunisia and as noted, FESPACO in Burkina Faso.

The JCC's recognition of women dates to its early history, particularly at the fourth edition, and it continues to acknowledge their work by discerning its top awards as well as incorporating women in the key echelons of its organizational structure, notably Dora Bouchoucha who served as director of JCC, general delegate Lamia Belkaied Guiga, among others. Moreover, Sayida Bourguiba's 2013 doctoral dissertation on the history of the JCC attests to the increasingly visible presence of women in African and Arab film studies.

Sarah Maldoror's *Sambizanga* under the banner of Angola was awarded first prize, the Tanit d'or in 1972. In 1980 *Fad'jal* by Senegalese Safi Faye received the Tanit de bronze; Tunisian Moufida Tlatli hailed as laureate of the Tanit d'or for her film *Les Silences du palais* in 1994; and Kaouther Ben Hania also of Tunisia was bestowed the Tanit d'or in 2016 for *Zaineb n'aime pas la neige*. Moreover, the 2015 edition gave tribute to pioneer Safi Faye of Senegal, establishing a prize in her name: "symbolically, the award bears the name of

Safi Faye, the first African woman filmmaker, an artist who has shown the way to a potentially woman-inspired and African cinematographic creation."

Sayida Bourgidia notes that "festivals are the showcase for the exhibition and visibilization of all filmmakers and especially women, it is a way to show their creation and convey their point of view ... everything depends on the artistic directors, how they will perceive and choose their themes and the festival's editorial policy is very personal so sometimes many women find themselves at a disadvantage or are even ignored." Nonetheless, she asserts that: "women have always been visible in Tunisian cinema and the JCC, as a filmmakers, editors, actresses, costume designers, script supervisors, etc. Film documentarian Fatma Skandrani was the first woman television director, there was Sophie el Goulli as the Cinémathèque administrator, Annie Chadly as marketing director at the SATPEC [Tunisian Company for Cinematic Production and Expansion], and there are [pioneers] Moufida Tlatli, Selma Baccar.... On the other hand, the turning point for the JCC is with the appointment of the producer Dora Bouchoucha as festival director in 2008, with reappointments in 2010 and 2014, which gave an energy to the JCC structure.[1]

Similarly, from the very beginning of the history of cinema in Burkina Faso, women have played a prominent role. Two women were among the organizers of the first festival: Alimata Salembéré, a director of the RTV (Radiodiffusion Télévision Voltaïque) at the time, presided over the organizing committee; while Odette Sangho, a representative of the CCFV (Comité d'Animation du Centre Culturel Franco Voltaïque), served as a member of the program committee. In the subsequent organizing committees, Simone Aïssé Mensah took over the presidency of the organization of the second FESPACO and continued in this position through the fourth. The Festival is directed under the General Secretary, a post that Alimata Salembéré held from 1982 to 1984, thus overseeing the eighth FESPACO in 1983.

The first African Film Week of Ouagadougou (the name preceding the current FESPACO), which ran from February 1 to 15, included in the film program Senegalese Ousmane Sembène's iconic *La noire de ...* thus introducing the public to the pioneering actress Thèrèse Mbissine Diop, and *Le Retour de l'Aventurier* by Mustapha Alassane of Niger, featuring the groundbreaking actress Zalika Souley. Most significantly, the festivalgoers were witness to the first film directed by an African woman. Cameroonian Thérèse Sita-Bella's 1963 documentary film was among the official selection for the first festival.[2] FESPACO hosts a compendium of parallel events providing visibility, networking opportunities and critical discussion. In 1989, the Association of African Actresses was created. The twelfth edition in 1991 marked a defining moment for African women in the visual media. The genesis of an organized movement of African women in the image industry, as it was later named, may be traced to this edition, during which a part of

the platform was organized under the title "Women, Cinema, Television and Video in Africa." At the workshop, women filmmakers, producers, actors, technicians, and others in visual media production laid out the tenets of a viable edifice to represent their interests. The events of this meeting set in motion the foundation for what would become the visual media network called L'Association des femmes africaines professionnelles du cinéma, de la télévision et de la vidéo/The Association of Professional African Women in Cinema, Television and Video (AFAPTV). It was reorganized in 1995 under the name, the Pan-African Union of Women in the Image Industry/L'Union panafricaine des femmes de l'image (UPAFI). In 2013, women took the leadership role as president on the five official juries. Alimata Salembéré had this to say about the women-helmed jury presidencies: "For us, women of the image, this twenty-third edition truly marks our successful integration into the world of cinema. FESPACO dared to believe in us, entrusting with us the presidency of all the official juries. It is a well-deserved tribute." Several women-focused events marked the twenty-fifth edition in 2019, in celebration of the fiftieth anniversary of the festival. The one-day conference entitled "The place of women in the film industry in Africa and the diaspora" organized by the Non-aligned Women Cinéastes Collective, emerged as an important forum to speak out against sexual harassment and other abuse that women professionals in cinema have endured. The #Metoo movement at FESPACO was introduced under the hashtag MêmePasPeur (loosely translated from French as "nothing to fear" or "not even afraid") as women film professionals of Africa and the Diaspora shared their experiences and gave their support. Alimata Salembéré, was honored once again, with a tribute by UNESCO, for the ensemble of her work in the promotion of culture in Burkina Faso and Africa. In addition, the high-level roundtable, "50 years of FESPACO: 50–50 for women," was organized with the participation of Audrey Azoulay, Director-General of UNESCO and Madame Sika Kaboré, First Lady of Burkina Faso.

Moreover, it was across the Atlantic, in Canada, at the 1989 edition of the Montreal-based Vues d'Afrique Festival, at a special section devoted to African women in the visual media that inspired the continental-based African-women-in-cinema movement. This initiative is indicative of the significant potential of the film festival in the visibilization and professionalization of African women in cinema (see timeline, beginning on page 68).

The emergence of a Women's Film Festival Movement in Africa has played a significant role in empowering women locally, reaching out to regional, continental, and international networks. The Zimbabwe-based IIFF (International Images Film Festival for Women), created by writer-filmmaker-cultural activist Tsitsi Dangarembga, which has been instrumental in the cultivation of a veritable women's film culture, is an example of the crucial part local initiatives perform in the cultural production of their country,

extending to regional and continental alliances. For instance, the Udada Women's Film Festival created in Nairobi, Kenya in 2014, partnered with IIFF for its second edition. Hence, confirming the significance of forging continental networks. In the same way, the Pan-African platform, African Women Filmmakers' Hub, was created as a means to increase African women's presence and production capacity. The inaugural meeting held at the fifteenth edition of IIFF in 2016 assembled women throughout the continent from Côte d'Ivoire, Ghana, Kenya, Malawi, Rwanda, Senegal, Tanzania, and Zimbabwe.

Similarly, several flagship international film festivals, notably the Festival International du Film de Femmes de Créteil FIFF (International Women's Film Festival) and the Festival de Cannes, both in France, organize special platforms and/or feature African women's oeuvres among the festival activities.

In 1998, the FIFF devoted an impressive platform to women of Africa, with a tribute to Safi Faye. During the thirty-second edition in 2010 entitled Trans-Europe-Africa, Safi Faye presented a master class and a gala was held in her honor, again attesting to the important place she holds as pioneer in the history of women in cinema. Invited to film events internationally to share her experiences in cinema, Safi Faye often reflects on the environment during that time, nearly forty years ago, in the early 1970s. She recalls the curiosity of her European colleagues in the midst of the "first African woman to dare make a film."

The presence of Sarah Maldoror representing the country Angola in the Quinzaine de Realisateur/Directors' Fortnight at the Cannes Film Festival with the selection of *Monangambee* parallels with the emergence of a women's visibility on the film festival landscape in the 1970s. In 1976, the film *Peasant Letter* by Safi Faye was screened and in 1979, her film *Fad'jal* was selected in Un certain regard, a part of the Official Selection introduced in 1978 at the Sixty-first Cannes film festival in 2008, as well as providing a space to screen their films, two roundtables were organized to discuss relevant issues regarding women of the South. The first highlighted the cinematic journey of three "emblematic" women: Tunisian Moufida Tlatli of Tunisia, British Ingrid Sinclair in Zimbabwe and Lebanese Nadine Labaki. The second brought together filmmakers, producers and actresses from Africa, Brazil, Iran, and Iraq to discuss the theme: "Cinema and engagement: a feminist, artistic and/or political engagement?" The selection of African women as member of the main jury is further evidence of their continued visibility at Cannes. In 2015, Malian singer and musician Rokia Traoré joined co-presidents Joel and Ethan Coen on the sixty-eighth Cannes festival jury, and at the Seventy-second edition in 2019, actress-documentary filmmaker Maïmouna N'Diaye, already known for her film activism, served as jury member. In addition, the seventy-second edition marked an historic first, as Franco-Senegalese Mati Diop was awarded the Grand Prix for her film *Atlantique / Atlantics* (2019).

The Women's Film Festival has become an integral part of the African cinema network. For instance, the JCFA, which is held in alternate years with FESPACO in Ouagadougou is an example of how the flagship continental film festival extends its platform for the promotion of African women in cinema. The JCFA takes place in the form of a celebration; though no prizes are awarded, the selected films, receive participation trophies called "the Sarraounia." The newsletter JCFA, whose editor-in-chief, Laurentine Bayala wears multiple hats as filmmaker, organizer and journalist, provides in depth reports of the activities and films during the five-day event.

The role that Africa-born expatriate and first generation Diasporan-born women have taken on as cultural producers in the realm of film and art festival organizing, curation and programming in their diasporic communities reflects their deep connection with African culture and their interest in producing realistic images, especially in the western locations where stereotypical representations of Africa are commonplace. The most internationally known is the New York African Film Festival launched in 1993 by Sierra Leonean Mahen Bonetti who is also the executive director. Similarly, Ethiopian filmmaker and film professor Lucy Gebre-Egziabher, based in United States, created the NOVA Student Film Festival, where she teaches in Virginia. Films Without Walls—a parallel initiative, presents films made by students through international collaborations. As a Fulbright Fellow in Ethiopia, she developed the screenwriting workshop "Telling Herstory" an initiative that she hopes will be an ongoing collaboration between her home institution and Ethiopia. Guyanese Britain-based June Givanni has made an important contribution to the Pan-African cinema network through her indefatigable work as film curator. French-Burkinabe Claire Diao, Belgium-Congolese Djia Mambu, Norwegian-Ghanaian Lamisi Gurah, South Africa-based Swedish-Ethiopian Katarina Hedrén, German-Ghanaians Jacqueline Nsiah and Esther Donkor, UK-based Cape Verdean-Portuguese Isabel Moura Mendes are among the many first-generation Diasporan film activists engaged in the promotion of African culture through film curation.

Likewise, Mary Holmström, co-founder of the Cascade Festival of African Films (Portland, Oregon), Lindiwe Dovey, co-founder of Film Africa and the Cambridge African Film Festival and Lizelle Bisschoff, founder of Africa in Motion (Scotland), white South African-born academics who teach in the United States, England, and Scotland respectively, marry their academic focus on Africa and African cinema with their interest in sensitizing their western audience to realistic images of Africa through film festival organizing.

It is a prevalent practice at academic venues such as African Studies and Women's Studies conferences to include a film screening section or even a full-fledged parallel film program. For instance, in the United States,

at the African Literature Association Conference and the African Studies Association Annual Meeting, film screenings are often incorporated in the program. In addition, at the African Studies Association Meeting, the Film Prize for an outstanding film is awarded. The 1997 African Literature Association Conference organized a "FESPACO Nights" which featured a women-filmmakers component. In 2012, a mixture of academic presentations, filmmakers' voices and a cinema lesson by Sarah Maldoror converged in Paris under the colloquium: "Francophone African Women Filmmakers: 40 years of cinema (1972–2012)," presented at the Bibliothèque Nationale de France - François Mitterand and the Musée du quai Branly - Jacques Chirac. Similarly, the main component of the International Colloquium "Women's Struggles in the Cinema of Africa and the Middle East," held in May 2016, at the Centro de Estudos Africanos da Universidade do Porto in Portugal involved a film screening event.

While international festivals on and outside the continent offer the spaces for networking among global stakeholders in cinema, local festivals play the vital role of audience-building and cultivating the skills of local talent, particularly in countries with little or no infrastructure, due to the lack of movie theatres for film viewing as well as learning institutions for film training. The article "African Women of the Screen as Cultural Producers"[3] highlighted the significance of local cinema-related initiatives—often grass root organizations initiated by people already connected regionally or internationally to cinema and cultural networks. In fact, many of the women who are founders of film festivals or cinema-related events wear multiple hats: having already established themselves as filmmakers/professionals and cultural activists. Undeniably, the realistic presentation, interconnected spirit and popular character of continental African film festivals assume an alternative "glocal" space to the international events where African presence is minimal if not absent. Hence performing a vital function in interpreting and restoring the perception of community into cultural, social, and political engagement.

Moreover, local film festivals incorporate women and women-related initiatives into the film event and programing. For instance, the Festival International du Cinéma et de l'Audiovisuel du Burundi (FESTICAB) has visibilized women's engagement on the cinematic landscape by incorporating them as "marraines," patrons of the current edition: 2019, Djia Mambu, Belgium-Congolese journalist and film critic; 2015, Gihan Fadel, Egyptian actress; 2013, Fatoumata Coulibaly, Malian actress, director, activist; 2012, Aminata Diallo-Glez, actress and director from Burkina Faso; 2011, Monique Mujawamariya, Rwandan human rights activist; 2010, Fatou Ndiaye, Franco-Senegalese actress; 2009, Consolata Ndayishimiye, Burundian businesswoman.

Some festivals—both on the continent and in the diaspora—operate intermittently or sporadically with a local body of supporters, while others may currently exist in name only. Nonetheless their existence highlights the role that they have played in their respective country as well as underscoring the enormous resources that are necessary to organize, promote, and maintain a festival. Hence, it is fitting to note the importance of local initiatives such as the CNA, where women have an impressively visible presence in leadership roles. CNA Afrique, Cinéma Numérique Ambulant (Mobile Digital Cinema) is currently located in Benin, Niger, Mali, Burkina Faso, Senegal, Cameroon, and Togo. Beninese Rosalie N'dah served as president and Malian Kadidia Sidibé, currently holds that post. Aïssata Maïga Ibrahim from Niger, Togolese Juliette Founou Akouvi, and Cameroonian Stéphanie Dongmo, are all positioned at the top echelon of the association in their respective countries.

Former president Rosalie N'Dah had this to say about the CNA:

> The CNA is an important cultural tool for communication and entertainment, bringing African films to African populations marginalized by their geographic or socio-economic isolation. It also provides immediate accessibility to the public, giving it both a popular aspect and an educational value. The CNA opens up possibility and access to a collective imaginary, a source for reflection, and oral testimony and dialogue among the populations regarding different traditional practices and their evolution.

> CNA screenings take place outdoors and are not like other events, during which films are viewed with little reflection before returning home. The CNA encourages the exchange of ideas regarding the world and cultural intermingling among people. In so doing, it cultivates a discerning cinema-going public and participates in the development of African culture.[4]

Social media and web-based platforms have offered game-changing opportunities to film festival practices and organizing. Social media networks and Internet platforms provide a form of "glocal" sharing as film festival networks are able to simultaneously reach out to the local and global communities. For instance, in addition to announcing a virtual "call for films," at the start of the event to its closing, festivals increasingly offer live coverage of the activities on social media, in the form of direct feeds, photographs and videos of the event. In tune with the ubiquitous mobile phone in Africa, the Kenya-based Udada International Women's Film Festival launched the Udada Cell Phone Short Film Competition for its 2016 edition. Based on the sub-theme "how women and girls bring humor and happy moments in our society," the

competition called for a three-minute short comedy film produced from a mobile phone. Similarly, the Out of Africa International Film Festival, initially a multiple-site event with three Kenyan women at the helm, moved the third edition in 2017 exclusively online, all films selected were screened on the festival's video-sharing channel as well as the website.

Film festival practices emphasize the important role that the film festival event plays in promotion, exhibition, marketing, and training and its potential as local and regional conduits around which women may interconnect continentally and globally. As it is at the same time a meeting place for pitching, networking, workshopping and sharing ideas, it is often a pivotal space where African women continent-wide may gather and meet.

Moreover, film festivals and meeting places, both women-focused spaces and general venues created by women, have mechanisms set in place for the kinds of activities necessary for the organization, analysis, and archiving of information, as the events, meetings, and activities are often recorded and filmed, biographies, artists' statements, and filmographies amassed and newsletters and catalogues and directories published, all of which are fundamental for the acquisition of resources and data collections.[5] These initiatives demonstrate the genuine effort to globalize the experiences of African women in cinema and their potential as information-gathering strategies, for opening avenues for access to informational networks and for creating archival sources for research and consultation.

These initiatives spanning fifty years demonstrate African women's social, cultural and political engagement in film festival practice and the advocacy role that African women in cinema take on to create the requisite infrastructures for promoting African cultural production.[6]

Timeline of African Women on the Film Festival Landscape

This timeline of key events, although not exhaustive, provides a chronology of many of the important moments during the span of Fifty years of African women's engagement on the film festival landscape.[7] This chronicle has been an enduring feature of the Centre for the Study and Research of African Women in Cinema. It attests to the significance of following, documenting and especially archiving these occasions—as pamphlets are tucked in cabinets, websites and pages come and go, and yet, these moments remain relevant, and historical.

1969

- Alimata Salembéré of Burkina Faso is one of the founding members of **FESPACO** (Pan African Film Festival of Ouagadougou), and president of the organizing committee of the first festival.

- *Tam Tam à Paris* by Thérèse Sita-Bella featured at the first Week of African Cinema—later to become **FESPACO**.

1970

- Sarah Maldoror's *Monangambee* included in the 2nd edition of **FESPACO** under the country Angola.

1971

- Sarah Maldoror's *Monangambee* selected under the country Angola at the Quinzaine des Réalisateurs at the **Cannes Film Festival**.

1972

- Sarah Maldoror's *Sambizanga* receives first prize, the Tanit d'Or at the **Carthage Film Festival, JCC.**

1976

- *Lettre paysanne* by Safi Faye of Senegal is presented in the Semaine de la Critique at **Cannes**.

1979

- *Fad'jal* by Safi Faye is presented in the Un certain regard at **Cannes.**

1980

- *Fad'jal* by Safi Faye is awarded the Tanit de bronze at the **Carthage Film Festival.**

1982

- Alimata Salembéré serves as General Secretary of **FESPACO** from 1982 to 1984, overseeing the eighth FESPACO in 1983.

1987

- At the Fortieth edition of **Cannes** the Panorama of Independent African Cinema, a first-time programming of South African independent films, featured anti-apartheid themes by progressive South Africans. Films by white South African women included in this category were: *Last Supper at Hortsley Street* by Lindy Wilson and *Re tla bona,* (We will see) and *Sharpevelle Spirit* by Elaine Proctor.

1989

- The Montreal-based film festival **Vues d'Afrique** organized a special section devoted to African women in the visual media. The program consisted of: 1) a screening of short and feature length

films, television shows, and video programs produced and directed by African women; 2) a discussion of the on-screen image of women and the influence of the media; 3) a colloquium on the role of African women in the audiovisual media which included a survey of the participants' assessment of the current situation and their recommendations. *Femmes d'images de l'Afrique francophone* (1994), compiled by Tunisian Najwa Tlili, was one of the direct results of the meeting. The index brings together the biography and filmography of women in the cinema from francophone Africa, as well as a listing of other relevant contacts. Another initiative that came from the meeting was the creation of the "Images de femmes" (Images of Women) project, from which emerged the prize "Images de femmes" offered by ACCT and presented during the annual Vues d'Afrique.[8]

- L'Association des Actrices Africaines/The Association of African Actresses created at **FESPACO** with the election of actress Zalika Souley of Niger as president in recognition of the role she played in asserting the value of women in the world of African cinema.

1990

- **RECIDAK,** Rencontres Cinématographiques de Dakar [film gatherings of Dakar], created under the auspices of the Consortium of Audiovisual Communication in Africa by Senegalese pioneer journalist and cultural activist Annette Mbaye d'Erneville.
- Sierra Leonean Mahen Bonetti, founder and president of the **New York African Film Festival** forges an important Diaspora network, conceived in 1990 and launched in 1993.

1991

- At the twelfth edition of **FESPACO** a part of the platform includes the meeting group "Women, Cinema, Television and Video in Africa." During the workshop, women filmmakers, producers, actors, technicians, and others in visual media production put forth the fundamentals of a structure to represent their interests.
- During the **Cascade Festival of African Films** (USA)— the Women Filmmakers Week is a major component of the month-long event. Mary Holmström, co-founder of the festival located in Portland, Oregon and its first film programmer, is a white South African-born academic, who realizing that her students had western stereotypes of Africa wanted to offer realistic images.

1992

- South African-Namibian Bridget Pickering launches the **Pan African Film Festival of Namibia**.

1993

- **London African Film Festival (Africa at the Pictures)**, a film festival organized by the Africa Centre and hosted by the National Film Theatre, featured a one-day conference focusing on women in African cinema.

1994

- **Kommunalkino Bremen Film Festival** (Germany) is devoted entirely to African women filmmakers.
- Tunisian Moufida Tlatli, laureate of the Tanit d'or for *Les Silences du palais* at the **Carthage Film Festival**.

1996

- The creation of Women Filmmakers of Zimbabwe (WFOZ) ushered in a network of prolific Zimbabwean women in cinema. The goals laid out by the association: to train more women for the film industry, collect funding for the continuation of the work, plan distribution and exhibition of films made by women, and organize production workshops. The web of structures that followed has provided the bedrock for the local Zimbabwean cinema culture. Notably, the **International Images Film Festival for Women (IIFF)** founded by writer-filmmaker Tsitsi Dangarembga and launched in 2002. The Distinguished Woman of African Cinema Award, presented at the IIFF, was inaugurated by WFOZ in 2007.
- *Mossane* by Safi Faye presented in the Un certain regard at **Cannes**.
- *Flame* by Britain Ingrid Sinclair, naturalized Zimbabwean citizen presented in the Quinzaine des Réalisateurs at **Cannes**.
- Rencontres Cinématographiques de Dakar, **RECIDAK** focuses on "Women and Cinema." During the colloquy, several themes were addressed: the place and role of women in Senegalese cinema by Oumarou Diagne; towards a sociological approach to the cinema of Black women by Osange Silou; problematizing women's cinematic writing as it relates to "women and cinema" by Martine Condé Ilboudo, among others. From this meeting comes the slogan "When women of the cinema take action, African cinema moves forward."[9]

1997

- Led and created by Moikgantsi Kgama of South African descent, the New York-based **ImageNation** Cinema Foundation, is a vehicle for exhibiting and distributing progressive images of Black people worldwide through special events and a chain of boutique cinemas dedicated to progressive cinema from the African Diaspora.
- The fifteenth edition of **FESPACO** presents an unprecedented number of films by women in all categories: feature, short fiction, animation, TV/video, documentary.

1998

- The **Festival international de film de femmes de Créteil, FIFF** (International Women's Film Festival) has an impressive platform devoted to women of Africa, with a tribute to Safi Faye.
- **Images d'ailleurs**, the Paris-based cinema house organizes a film forum entitled "Cri du coeur des femmes" featuring African women. This event sets a precedent for the afrodescendant women-focused events that are becoming increasingly prevalent with the coming-of-age of the French-born and -raised women in cinema—a noticeable trend in other African Diasporas in Europe.
- The audiovisual production company "African Queen Productions" inaugurates the **Festival International du Court Metrage d'Abidjan, FICA** (International Festival of Short Films of Abidjan). Ivoirian actress Hanny Tchelley Ivoirian is the General Secretary.
- Among the activities of the **Southern African Film Festival** held in Harare include the African Women Filmmakers' Forum—a platform for African women filmmakers to meet.

2000

- **London African Film Festival (Africa at the Pictures)** organizes the Weekend Seminar on African Women and Cinema 'Taking Care of Business."

2002

- *Rachida* by Algerian Yamina Bachir-Chouikh selected in Un certain regard at **Cannes**.

2003

- The **African Women Filmmakers Awards**, launched at Sithengi, the Southern African International Film and Television Market under the auspices of the South African-based Women of the Sun organization.

- The first cinema meetings, **Films Femmes Afrique**, is launched in Dakar, Senegal.
- The **New York African Film Festival** release of the publication: *Through African Eyes: Dialogues with the Directors,* edited by Mahen Bonetti and Prerana Reddy. Women featured: Françoise Pfaff: "The Early Years, 1960–1985"; Safi Faye with Zeiba Monod; Wanjiru Kinyanjui with Dommie Yambo-Odotte.

2004

- The **African Women's Film Festival** is established in Johannesburg under the theme "film from a woman's perspective." The festival showcases films of all genres by women, about women, and from women's perspectives, with a special focus on the continent.
- The **FIFFS, International Women's Film Festival** of Salé in Morocco is created in order to feature women's artistic cinematographic contributions and to give women, and women of the moving image in front of, on and behind the camera, the recognition that they deserve.[10]

2005

- Musola Cathrine Kasketi, founder of Vilole Images Productions, launches the **International Film Festival of Zambia**. In 2010, under the name **View Images Film Festival**, Kaseketi, who is differently-abled, also creates a space to celebrate through the art of film, the abilities of all women, and particularly to integrate women with disabilities.
- *Sisters in Law,* co-directed by British filmmaker Kim Longinotto and Cameroonian Florence Ayisi, is awarded the Prix Art & Essai (CICAE) in the Quinzaine des réalisateurs at **Cannes**. During the same edition, Rahmatou Keïta of Niger presents her film *Al'leessi… an African Actress,* selected in the Cannes Classics.
- Nigerian Amaka Igwe launches **BOB TV, the Best of the Best African Film and TV** Programmes Market and Expo, which has as objective to offer a continental platform for African practitioners of the moving image.
- The Nigerian-based **African Movie Academy Awards (AMAA),** established by Peace Anyiam-Osigwe, highlights the significance of African cinema by providing a platform for recognition and celebration.

2006

- Aminatou Issaka launches the **Festival Paroles de femmes** (women's voices) in Côte d'Ivoire.

- Nigerian Mojisola Sonoiki describes the creation of the **Women of Color Arts & Film Festival** as her destiny. The WOCAF's mission is to be at the forefront in promoting the leadership capabilities of women of colour media makers/artists; the Festival serves to expand the global dialogue on women's issues through the presentation of positive empowering images in film, music and art.[11]
- Founded by white South African Lizelle Bischoff, a portion of the **Africa in Motion (AiM) Film Festival** of Edinburgh was dedicated to African women in 2007 and has continued to locate their work prominently in its programming.

2007

- A portion of the **Africa in Motion (AiM) Film Festival** of Edinburgh festival was dedicated to African women. Founded in 2006 by Lizelle Bischoff, a white South African-born academic, the festival has emerged as an important festival of African films in the UK.
- Filmmaker Amal Ramsis is founder and director of **The Cairo International Women Film Festival**, which has become an important event in the Arab world. The festival features the caravan between women filmmakers, the creative documentary workshop and the rough-cut workshop.

2008

- Nadège Batou creates the traveling film event, **Festival des 7 Quartiers of Brazzaville**. The festival honored the women filmmakers of the Congo and elsewhere during the third edition in 2010.
- **Ladyfest London,** an arts festival celebrating female creativity in all its forms, showcases several African women filmmakers.
- **Cannes Film Festival**: Comorian Hachimiya Ahamada presents *La résidence Ylang Ylang* in La Semaine de la Critique. Djamila Sahraoui was also present, invited by ACID (Association du Cinema Independant pour sa Diffusion) to present her film, *Barakat*. Also during the festival, the Pavillon Les Cinémas du Sud/Cinemas of the South (renamed Cinemas du Monde/ Cinemas of the World) organized two roundtables. The first featured: Moufida Tlatli (Tunisia), Ingrid Sinclair (UK/Zimbabwe and Nadine Labaki (Lebanon). The second roundtable included women in cinema from Africa, Brazil, Iran and Iraq: Rakhsan Bani Etemad - filmmaker (Iran), Tan Chui Mui - filmmaker (Malaysia), Fatoumata Coulibaly - actress (Mali), Angèle Diabang Brener - filmmaker (Senegal), Fatoumata Diawara - actress (Mali)

Mati Diop - filmmaker (Senegal), Taghreed Elsanhouri - filmmaker (Sudan), Dyana Gaye - filmmaker (Senegal), Marianne Khoury - producer (Egypt), Nadine Labaki - filmmaker (Lebanon), Osvalde Lewat - filmmaker (Cameroon), Angie Mills - producer (South Africa), Teona S. Mitevska - filmmaker (Macedonia) Lucia Murat - filmmaker (Brazil), Awatif Na'eem - actress (Iraq), Joséphine Ndagnou - filmmaker (Cameroon), Bridget Pickering - producer (Namibia), Hend Sabry - actress (Tunisia), Naky Sy Savané - actress (Côte d'Ivoire), Ingrid Sinclair - filmmaker (Zimbabwe), Rahel Tewelde - filmmaker (Eritrea,) Moufida Tlatli - filmmaker (Tunisia), Ishtar Yasin - filmmaker (Costa Rica)

- The twelfth edition of **écrans noirs du Cinéma africain**, held in Yaoundé, Cameroon, has as its theme, Women, Cinema and the Audio-visual.
- The **Festival International du Documentaire of Agadir** (Agadir International Documentary Festival) in Morocco, founded by Nouzha Drissi who died tragically in 2011, is devoted exclusively to documentaries.

2009

- Villant Ndasowa, Malawian filmmaker and media consultant, creates the **Malawi International Film Festival**. A key objective of the festival is to pioneer the film industry in Malawi by sourcing and providing training to talented Malawians.
- Mariem mint Beyrouk forms the **Association of Mauritanian Women of the Image** as a means to raise women's consciousness about women in general, issues around health, female genital cutting, marriage of adolescent girls, among others. In addition, their hope is to organize festivals and meetings with other women throughout the continent.
- At the 62nd **Cannes Film Festival**, three women from Africa are invited at the Pavillon des Cinemas du Monde: Nadia el Fani (Tunisia), Marie Ka (Senegal) and Djamila Sahraoui (Algeria), to discuss their films. Nadia el Fani is invited to present *Ouled Lenine* at the Marché du Film; *Didi and Gigi* by Marie Ka is screened in the Short Films Corner; and Djamila Sahraoui discusses *Ouardia Once Had Sons*, a project under development.

2010

- Women of the Sun, created in 2000, in conjunction with the Goethe Institut, the Gauteng Film Commission (GFC) and the Department of Arts and Culture (DAC) launches a seven-day film festival in

Johannesburg to celebrate African women filmmakers. **The Women Of the Sun Film Festival** (WoS Film Festival) takes place in South Africa, featuring 25 films by 23 women filmmakers from 15 African countries with 15 of the filmmakers present at the screenings. Eve Rantseli, Director of Women of the Sun, had this to say about the festival: "The time is ripe to change the widely held belief that filmmaking is a male domain. Women in film have much to say and are saying it with unique vision and flair. The launch of this annual women's film festival will be the start of getting women filmmakers and their works part of the mainstream."[12] The creation of the South African-based Women of the Sun organization, a resource-exchange network of African women filmmakers, inspired several other projects in the region, notably, the African Women Filmmakers Awards in 2003.

- The **New York African Film Festival** release of the publication: *Through African Eyes Volume 2: Conversations with the Director*s, edited by Mahen Bonetti and Morgan Seag, (New York: African Film Festival Inc, 2010). Women featured: Mahen Bonetti with Françoise Bouffault; Ngozi Onwurah with Simon Onwurah; Fanta Régina Nacro with Guetty Felin; Zina Saro-Wiwa with Oladipo Agboluaje; Jihan El-Tahri with Alonzo Richo Speight; Osvalde Lewat and Katy Lena Ndiaye with Aurélien Bodinaux; Tsitsi Dangarembga with June Givanni; Dyana Gaye with James Schamus; Wanuri Kahiu, Judy Kibinge, and Lupita Nyong'o with Ekwa Msani-Omari.

- Maji-da Abdi, Paris-based Ethiopian producer-filmmaker launches **Images That Matter International Short Film Festival (ITMSFF)** in Addis Abeba, Ethiopia, which has as main objective to expose the Ethiopian public to local and international films, especially by utilizing subtitles in Amharic, the national language.

- **Des journées cinématographiques de la femme africaine de l'image (JCFA)** [tr. African Women Image Makers Cinema Days], is launched in Ouagadougou, Burkina Faso, March 3–8.

- First Edition of **Mois du cinéma féminin à Dakar**, [tr. Month of women's cinema in Dakar] launched by l'Association sénégalaise des critiques de cinéma (ASCC) [tr. Senegalese Association of film criticism], every Saturday during the month of March.

- **Mis Me Binga International Women's Film Festival** is an important initiative for the promotion and empowerment of women in cinema, locally, continentally and internationally. The goal of the festival is to promote the creativity of women from Cameroon, Africa and the whole world, to establish a network among women filmmakers from different parts of the world and to bring about a better understanding of different cultures and of each other. Cameroonian Evodie Ngueyeli,

chief representative of Mis Me Binga, International Women's Film Festival of Yaoundé describes the name in this way: "Mis Me Binga is from the local Cameroonian language Éwondo. Mis refers to "the eyes" and Me Binga means "women." So Mis Me Binga translates to "The Eyes of Women." And to put it into the context of the festival, it means "A Woman's Perspective," since we would like women to speak up and express their vision of society." The QIDEF Residency - Quand l'idée devient un film (When the idea becomes a film) is a successful initiative of Mis Me Binga. The residency "QIDEF" aims: to encourage engaging scripts that through their theme and form bring new perspectives to cinema; to support the emergence of talented filmmakers from countries of the southern hemisphere; to make the "QIDEF" a "label" of quality and rigor; to be a valuable exchange of ideas between scriptwriters from different backgrounds and cultures. By selecting and supporting already developed scripts, and supervising their development within a rigorous schedule, "QIDEF" hopes to provide every opportunity for these projects to find artistic and financial partners.[13]

- The 32eme **Festival international de film de femmes de Créteil** (International Women's Film Festival) presents the program Trans-Europe-Afrique, April 2–11.
- Kenyan Wanjiku wa Ngugi founder of **Helsinki African Film Festival** wants to show the diversity of the African continent to the Finnish public in order to have a conversation informed by Africans themselves thus giving a more realistic view of their realities. The theme of the second edition "Women's Voices and Visions" had as objective "to celebrate women in film but also raise awareness about African women's experience, highlight the global economic and political issues that affect them…, to showcase the diversity of African women, as well as hopefully move away from the tendency to depict African women as weak, voiceless and always as victims."[14]

2011

- **People to People** held in Johannesburg, South Africa from September 12–14, includes an striking line-up of African women in cinema among the participants.
- Two women are awarded the top prizes for the Best Documentary Film at **FESPACO**: Kenyan Jane Murago-Munene receives the first prize for *Monica Wangu Wamwere: The Unbroken Spirit* and Ghanaian Yaba Badoe the second prize for *The Witches of Gambaga*.
- Franco-Beninese Farah Clémentine Dramani Issifou launches **Africadoc Benin**.

- The first edition took place in Porto Novo, Cotonou and Paris: "The spectators, who attended the festival, whether in Paris, Porto Novo or Cotonou, were all seduced by the realistic images, images that were also created by Africans about their realities, of a continent that is evolving at full speed." The 2015 edition was held under the theme "Women Confronting Inequality … other Perspectives" while revisiting the worldwide women's rights struggles and promoting the contemporary perspectives of young filmmakers.[15]
- The Women's Panorama at the **Zanzibar International Film Festival**, a program of cinema designed especially for the women of Zanzibar.
- Gele Day (Women Day), special segment at the **Festival of Indigenous African Language Films** (FIAF) held in Akure, Ondo State, Nigeria, on the topic: Women Empowerment in the Film Industry, October 2–5. Biodun Ibitola, the festival director, had this to say: "While making of films in African languages will refocus, reengineer and reposition them and save them from extinction, it also will expand the coding, documentation, and communicative capacities of the languages. Making of films in indigenous languages will facilitate the linkage of Africans in Diasporas to their roots and project the rich tourism potentials in Africa."[16]
- **Cannes Film Festival**: Cannes Classics 2011, *Sugar Cane Alley* (1983) is screened as a special tribute to Martinican filmmaker Euzhan Palcy. In addition, Chika Anadu from Nigeria is among the twelve young directors selected to participate in this year's Festival Residency. She attended the twenty-first session from October 2010 to February 2011.
- **FilmAfrikana**, founded by Norwegian-Ghanaian Lamisi Gurah, is an independent Oslo-based film festival whose purpose is to expose the Norwegian public to films by people of Africa and the African Diaspora. Providing a different perspective is an important goal for Lamisi Gurah. Films that deal with cultural, political and social issues, showing realistic, positive images of black people, counter the dominant media portrayals of a helpless, war-ravaged, disease-ridden continent. Her hope is that initiatives such as FilmAfrikana will provide new knowledge and introduce debates about the issues covered. A goal as well is to collaborate with other film festivals and to reach out to schools and cultural institutions, and eventually to be able to provide Norway-based distribution outlets to promote African and African Diasporan films. The 2011 festival focused on women in front of and behind the camera.[17]

2012

- Women prominently featured at the inaugural **Luxor African Film Festival**, February. Visible at the Festival were women in every aspect. Executive director Azza El Hosseiny's hope is that the festival will play an important role in making the change that the revolution evoked. Thirty countries were represented, and of the forty-one films in competition, eleven were by women. Spanning the continent, the films represented every region with a broad spectrum of themes; women were the laureates of the two top awards. The Greater Nile Award for Best Film: the Golden Mask of Tutankhamen was awarded to Ghanaian-Kenyan Hawa Essuman for her film *Soul Boy* and The Special Jury Award: the Silver Mask of Tutankhamen to British-Sudanese Taghreed Elsanhouri for her film *Our Beloved Sudan*.
- Nigerian Adaobi Obiegbosi's desire to create a continental platform for African film students to share their work and ideas inspired the creation of the **African Student Film Festival (ASFF)**.
- Visual activist Zanele Muholi is the guest of honor of the sixth edition of **Some Prefer Cake - Bologna Lesbian Film Festival** with an exhibition and audiovisual project focusing on the life of lesbians in South Africa.
- Naky Sy Savané, president of **FESTILAG (the International Film Festival of the Lagunes)** created in 2012, has this to say about the festival in Côte d'Ivoire: "We want to revive movie theatres and outdoor screening venues. Cinema is a vehicle for unity and social cohesion."
- Women on and Behind the Screen is theme of the **Afrikamera Film Festival** (Berlin).
- Colloquium-Meeting **"Francophone African Women Filmmakers: 40 years of cinema (1972-2012),"** Paris, November 23–24.
- Tsitsi Dangarembga, Branwen Okpako, and Auma Obama (film school classmates in Germany), reunite at the screening of Branwen Okpako's film *The Education of Ouma Obama* featured at the eleventh edition of the **International Images Film Festival for Women, IIFF** in Harare.

2013

- Algerian Djamila Sahraoui receives the second prize, the Silver Yennenga for her film *Yema* at **FESPACO**.
- Two women are awarded the top prizes for the Best Documentary Film at **FESPACO**: Tunisia Nadia El Fani receives the first prize for *Même pas mal / No Harm Done* and Cameroonian Pascale Obolo receives the second prize for *Calypso Rose the lioness of the jungle*.

- **Quartiers Lointains** (distant neighborhoods), an initiative of Franco-Burkinabe journalist-film critic Claire Diao, is a touring short film program, whose objective is to bridge distances by showing commonalities, rather than differences.
- Sayda Bourguiba defends her dissertation research on the **JCC, Carthage Film Festival**: Finalités culturelles et esthétiques d'un cinéma arabo-africain en devenir. Les Journées Cinématographiques de Carthage (JCC). Thèse de Doctorat en Arts et Sciences de l'Art - Université Paris 1 - Panthéon - Sorbonne.
- The **New York African Film Festival** release of the publication: *Looking Back, Looking Forward, 20 Years of the New York African Film Festival*, edited by Mahen Bonetti and Beatriz Leal Riesco. Women featured: Osvalde Lewat, Isabelle Boni-Claverie, Yara Costa, Angèle Diabang, Jihan El-Tahri, Taghreed Elsanhouri, Hawa Essuman, Wanjiru Kairu, Judy Kibinge, Ekwa Msangi-Omari, Akosua Adoma Owusu, Xoliswa Sithole.
- **FESPACO**: Women take leadership role as president of the official juries: Euzhan Palcy (Martinique) Feature Film Jury; Osvalde Lewat-Hallade (Cameroon) Documentary Jury; Beti Ellerson (USA) Diaspora Jury; Jackie Motsepe (South Africa) TV and Digital Jury; Wanjiru Kinyanjui (Kenya) Short fiction and Film School Jury.
- Nadine Otosobogo creates the **Film Festival of Masuku–Nature and Environment** (Gabon)
- The **Cultural Healing Festival**, conceived to carry on the legacy of the Cultural Healing project, was originated by filmmaker British-Sudanese Taghreed Elsanhouri. The first edition of the festival launched in Khartoum in January 2013, was later produced as an annual diaspora event to connect with Sudanese and South Sudanese in the west.
- **Her Stories - Filmmakers with African Roots**, a film event that ran from February 21 through June 13, was organized by Frauenkreise Berlin and the Educational Institute of Berlin Heinrich Böll Foundation in partnership with AfricAvenir International e.V and AFROTAK TV cyberNomads. Frauenkreise Berlin's objective is to provide a platform for creative work by women, who continue to be underrepresented in the world of business as well as in the arts; black women in particular.
- The second **African Women in Film Forum** held in Accra, Ghana, includes a film-screening component.
- The Madrid-initiated Mujeres por África has as objective to promote the accomplishments of African women in all spheres of society. **Mujeres por África : Ellas Son Cine**, presented film events for five consecutive years from 2013 to 2017 in order to showcase the myriad experiences of African women.

2014

- The **African Women Film Festival TAZAMA** is launched in Brazzaville, Congo. It purpose is to bring together women film-makers from the African continent and provide a new platform for exchanges, meetings and sharing.
- Ethiopian filmmaker and film professor Lucy Gebre-Egziabher, based in United States, is founder/director of the **NOVA Student Film Festival** located in Virginia.
- The **Mzansi Women's Film Festival (MWFF)** founded in Johannesburg, South Africa, is a platform for women filmmakers showcasing films by women and about women.
- In commemoration of its twentieth anniversary, the **Africa Alive Festival** organized by FilmForum Höchst and Filmmuseum Frankfurt is dedicated to women of Africa, in the presence of: Sita Traoré, Claude Haffner, and Safi Faye.
- AfricAvenir Namibia and the FNCC presents **Namibian Women in Film** featuring: *100 Bucks* by Oshosheni Hiveluah, *Uno's World* by Bridget Pickering and *Tjiraa* by Krishka Stoffels.
- The Association of Congolese Women Filmmakers presents the first edition of **Cinema au féminin (CINEF)** under the theme "Empowerment of Congolese women through its initiatives for development."
- **Udada,** which means sisterhood in Kiswahili, is the first women's film festival in Kenya, held in Nairobi.
- Kenyans Mumbi Hinga (Australia), Wairimu Mwangi (Kenya), Rose Wachuka (France), launch the **Out of Africa Film Festival (OOAIFF)**, whose objective is to hold simultaneous screenings in three countries.
- Several films by women are included in the Short Film Corner at the **Cannes Film Festival**: Gabonese Samantha Biffot's nine-minute fantasy drama *Return to the Source*, *Jin'naariyâ!* by Rahmatou Keïta of Niger and *Peau de Colle* by Tunisian Kaouther Ben Hénia, who is also in the prestigious ACID selection, with her first feature film *Le Challat de Tunis*. In addition, four women are among the five young Ethiopian filmmakers selected to attend the "From Addis To Cannes" initiative: Adanech Admasu, Hiwot Admasu, Hermon Hailay, Yamrot Nigussie. Also, Senegalese Angèle Diabang is in attendance at the Fabrique des cinémas du monde with her film project "So long a letter."

2015

- The **New York African Film Festival** gives particular focus to women of African descent.

- Burundian filmmaker Floriane Kaneza, director of the Rwanda-based **Mashariki African Film Festival** views cinema as "a data-base for the future generation."
- Malian singer and musician Rokia Traoré is member of the jury at **Cannes**.
- A tribute to pioneer Safi Faye at the twenty-sixth edition of the **JCC, Carthage Film Festival** with an award in her name, "Prix Safi Faye pour la meilleure réalisatrice" [Safi Faye Award for the best woman filmmaker].

2016

- *Maman(s)* by Maïmouna Doucouré receives the **Sundance Film Festival** Short Film Jury Award - International Fiction.
- *The Revolution won't be televised* (2016) by Senegalese Rama Thiaw selected in the **Berlinale Forum**.
- **The Black Star International Film Festival**, launched in Accra, Ghana by founding president Juliet Asante.
- Sisters Working in Film and Television (SWIFT), formed at the **Durban International Film Festival** in South Africa.
- **Festival des films d'Afrique en pays d'Apt** (France): Roundtable of African women filmmakers: Chloé Aïcha Boro, Hinde Boujemaa, Nina Khada, Aïcha Macky, Amina Weira.
- Fokus: Sisters in African Cinema – **Afrika Film Festival Cologne**.[18] The Afrika Film Festival, organized by FilmInitiativ had as its focus for the fourteenth edition, "Sisters in African Cinema. Women were visible in all spheres of the festival—on its organization team and its advisory board for the Fokus film selection. Stories by and about women, a dominant theme throughout the festival was evident in the overall festival selection of films. A key feature of the four-teenth edition of the Festival was the Sisters in African Cinema Roundtable moderated by Beti Ellerson (USA), featuring Leyla Bouzid (Tunisia), Françoise Ellong (Cameroon), Judy Kibinge (Kenya) and Monique Mbeka Phoba (Democratic Republic of Congo).
- Houda Benyamina's directorial debut is awarded the Caméra d'or, an award of the **Cannes Film Festival** for the best first feature film pre-sented in one of the event's selections. Also in 2016, Tapiwa Chipfupa of Zimbabwe and Angolan Pocas Pascoal are in attendance as part of *La Fabrique des Cinémas du Monde*. Tapiwa Chipfupa presented her film project "The Other Half of the African Sky," while Pocas Pascoal discussed her film project "Girlie," (second feature film). *La Fabrique des Cinémas du Monde*, a professional program helping

talented young directors from emerging countries increase their international exposure.

- **International Colloquium and Film Screenings: Women's Struggles in the Cinema of Africa and Middle East**, CEAUP, Porto, Portugal
- **International du Film de Fribourg** – Roundtable: être réalisatrice en Afrique (To be a woman filmmaker in Africa): Claire Diao with Angèle Diabang, Nadia el Fani, Pocas Pascoal, Rama Thiaw.
- **Her Africa Film Festival** (South Africa). The inaugural edition celebrates the African woman filmmaker.
- **Udada Cell Phone Short Film Competition** at the Udada International Women's Film Festival in Nairobi.

2017

- The purpose of the **Aswan International Woman Film Festival** is to connect women in Aswan with AIWFF and also, to encourage women to participate in the festival activities and with the audience. The films presented in the festival are by or about women. AIWFF includes: seminars on the issues and concerns of women in Aswan, a roundtable about women and cinema, a program for women with disabilities in Egyptian cinema.[19]
- The **Ndiva Women's Film Festival** holds its first edition in Accra, Ghana.
- The **Mama Afrika Film Festival** is created in Nairobi, Kenya.
- Women are prominently featured at the Fourteenth edition of FCAT **Festival de Cine Africano Tarifa–Tánger**.
- The Adiaha Award for Best African Female Documentary Filmmaker established at the twentieth edition of ZIFF, **Zanzibar International Film Festival**.
- CaribbeanTales and the Durban FilmMart present CineFAM - Africa, an accelerator program for African women filmmakers. The two-day program took place during the **Durban FilmMart:** The program provides an exciting new platform to support the development of women-led audio-visual content in Africa, and promote more representational narratives.
- **Texas Tech University: The Spring 2017 Spotlight on African Women Filmmakers**. The purpose of the series was to share stories of Africa and women through the eyes of African women filmmakers and in so doing the showcase will help to highlight African cinema. The series opened on January 24 with the screening of *Sisters of the Screen* (2002) with filmmaker and scholar Beti Ellerson in attendance followed by a public talk on January 25 entitled: African Women in Screen Industries: Evolutions, Trends and Tendencies."

- **Cannes Film Festival**: Tunisian Kaouther Ben Hania's *Beauty and the Dogs* is selected in Un certain regard as well as Zambian Rungano Nyoni's *I am not a Witch,* which she developed at the Cinéfondation du Festival de Cannes in 2013. Moreover, South African Twiggy Matiwana's *The Bicycle Man* is included in the Festival Corner.
- **Toronto International Film Festival** 2018 Laureates: Aäläm-Wärqe Davidian for *Fig Tree* and Meryam Joobeur for *Brotherhood.*
- The fifth edition of the Cameroon-based **FESTICO, Festival International des Images Comiques** (International Festival of the Comedy Films) had as theme: Women's Impact on the Comedy Genre. The panel discussion featured filmmaker and lecturer Hélène Ebah and Marie Nadège Tsogo Momo, doctoral student and lecturer in cinema history.

2018

- The first edition of the **Festival Africain des Films de Femmes Cinéastes** (African Film Festival of Women Cineastes) was held in Lome and Agbodrafo, Togo, during which a variety of activities were organized: Conferences, panels, awareness building sessions, a competition of documentary and fiction films made by all-women film crews, and a master class entitled: "Mentoring women film-makers for the advancement of the industry." A key objective is to promote female leadership in cinema. Sonia Larissa Allaglo, head of the organizing committee had this to say about the goals of the festival: "We want to involve women in the festivities of La Francophonie Day, to create and organize tutorials and support systems among established women filmmakers and newcomers in the field."
- *Maki'la* by Machérie Ekwa Bahango of the Democratic Republic of Congo selected at the **Berlinale Forum**.
- **Cannes Film Festival**: *Rafiki* by Wanuri Kahiu and *Sofia* by Franco-Moroccan Meryem Benm'Barek are part of the official selection of Un certain regard. In addition, Safi Faye's *Fad, Jal* returns to Cannes, restored by the CNC, presented at Cannes Classics.
- **Out of Africa International Film Festival**, originally helmed by three transnational Kenyan women, focused the 2018 theme on Economic Empowerment of Youth and Women Through Film.
- Ache Coelo, sociologist and filmmaker, creates the **Festival Tchadien des Courts Métrages, FETCOUM** (festival of short films), which takes place in N'Djamena, Chad.

2019

- Burkinabe Aïcha Boro receives the first prize for the Best Documentary Film for *Le loup d'or de balolé* (The golden wolf of Balolé) at **FESPACO.**
- South African Shameela Seedat receives the third prize for the Best Documentary Film for *Whispering truth to power* (Chuchoter la verité au pouvoir) at **FESPACO.**
- **Sabbar Artistiques: Women's Reflexive Workshops of Dakar.**[20] Filmmaker and producer Rama Thiaw is at the forefront of the initiative, she had this to say about the workshops: "… I think that an artist must help the political, cultural, social and collective evolution of her/his society. I firmly believe in this famous quote by Angela Davis: 'the success or failure of a revolution can almost always be gauged by the degree to which the status of women is altered in a radical, progressive direction.'" Traditionally, Sabbars are women's meetings accompanied by traditional Senegalese drumming. Here, based on the same principle, Sabbar Artistiques are women's workshops built around reflection, emotion and transmission. The aim is to invite African women from the continent to talk with Afro-descendants and black women from around the world, to problematize the theme of African, Afro-descendant and black women's place after the revolution. A film-screening component is an integral part of the program.
- Nigerian-American Chinonye Chukwu's *Clemency* receives the **Sundance Film Festival** grand jury award.
- *Oufsaiyed Elkhortoum | Khartoum Offside* by Sudanese Marwa Zein selected in the **Berlinale Forum.**
- Panel discussion at the **Berlinale Africa Hub** on "Interconnectivity, Self-Empowerment and Inclusive Network Building of African Women Film Professionals:" Tsitsi Dangarembga (AWFH, Zimbabwe); Bongiwe Selane (Producer, South Africa); Mmabatho Kau (Producer, South Africa); Edima Otuokon (The Ladima Foundation, Nigeria). Moderated by Katarina Hedrén (Goethe Institute, South Africa).
- The twenty-fifth edition of **FESPACO** marked the fiftieth anniversary of the festival created in 1969. A visible presence of women-focused events included the recognition of pioneer Alimata Salembéré a cofounder and the president of first organizing committee.
- **African Women at Cannes 2019:** Jury: Main Jury, French-Guinean actress and filmmaker Maïmouna N'Diaye; Caméra d'Or, Franco-Senegalese filmmaker Alice Diop; Semaine de la critique, Belgian-Congolese journalist and film critic Djia Mambu. Films: Feature in

Competition - Franco-Senegalese Mati Diop: *Atlantique* laureate of the Grand Prix. Un certain regard –Algerian Mounia Meddour, *Papicha*; Canadaian-Tunisian Monia Chokri, *La Femme de mon frère*; Moroccan Maryam Touzani, *Adam*; Short film—Egyptian Nada Riyadh *Fakh*; Special screening – Franco-Algerian-Tunisian Hafsia, *Tu mérites un amour*. Selection Committee : French-Beninese researcher and independent film curator Clémentine Dramani-Issifou, is part of the Semaine de la critique selection committee; French-Burkinabe journalist and film critic Claire Diao serves on the Director's Fortnight.

- **African Women Arts & Film Festival, AWAFFEST** has as objective to create a platform for the appreciation of the art and stories of African women, to celebrate women practitioners in the arts and to empower aspiring artists and filmmakers. The Tanzanian based event takes place in March in Dar es Salaam in celebration of International Women's Month.

- **Women Filmmakers of Zimbabwe (WFOZ) Stakeholders Report 2019**. The report summarizes the findings of the project by Women Film Makers of Zimbabwe (WFOZ) on Eradicating Violence against Women and Girls through mainstreaming women's audiovisual narratives in marginalized urban and rural communities.

2020

- The COVID-19 pandemic of 2020 revealed the vulnerability of the whole cinematic enterprise, brought to a standstill when the entire world was forced into lockdown mode and social distancing practices. Film festival events were postponed or cancelled, film shoots put on hold, film screenings and releases waiting in the wings for a future date. And sadly, one of the pioneering women of African cinema, Sarah Maldoror, passed away, due to complications of the novel coronavirus. And yet, the pandemic underscored the ubiquity of digital technologies, which restructured the platforms and resources needed to support the ever-expanding transmedial practices of the moving image. The virtual audiovisual landscape, with a plethora of tele-conferences, interviews, self-promotional presentations and other transmedial events, has become the norm. Video streaming environments in full-force. Traditional film festivals transformed to online versions, potentially an important feature of future programming. In many ways cinema in the time of the COVID-19 pandemic has offered a self-reflective space for change and a place for forward-looking

possibilities. Following is a selection of virtual events and on-location pre-pandemic activities.

- **7 jours pour 1 film (7 days for a film).** In association with the Films Femmes Afrique Festival, the Association *7 jours pour 1 film* organized a cinema-training workshop in Dakar. (February 14–29).
- **Storytelling and West African Cinema, a panel of established women filmmakers from the Sahel**. Organized by the African Film Festival and the Metropolitian Museum of Art). Participants included Mahen Bonetti, Founder and Executive Director, African Film Festival, Inc.; Yaëlle Biro, Associate Curator, Arts of Africa, Oceania, and the Americas, The Met; Rahmatou Keïta, filmmaker; Fanta Régina Nacro, filmmaker; and Fanta Kouyaté, griot, oral historian, and storyteller. (February 20).
- **The Legacies of Sarah Maldoror.** The feminist film journal *Another Gaze* hosted the Zoom virtual event in tribute to Sarah Maldoror, who passed away on April 13. (May 12).
- **iFilm Conference: The Future of Women in African Cinema 2020** organized by the PanAfrican Film Consortium. (May 29).
- **African Women in the Time of COVID-19**. A Short Film Competition organized by Ladima Foundation and DW Akademie. (Deadline for entries, June 21).
- **Women's voices heard loud and clear in the cinemas of Africa**. The first Zoom e-conference of the Pavillon des Cinémas d'Afrique in a program of roundtables organized by the ACA-Agence Culturelle Africaine: Porter haut et fort la voix des femmes dans les cinémas d'Afrique (translation from French: Women's voices heard loud and clear in the cinemas of Africa). Producer, director, actress, film critic, came together to discuss their experiences and concerns in the world of cinema. (June 22).
- **The Gauteng Film Commission on Women's Month 2020**. The Gauteng Film Commission (GFC) launched the month-long Women's month 2020 program, showcasing the work and efforts of women in the film and television sector in Gauteng, South Africa using virtual platforms across popular social media channels. (August 10–13).
- **Durban FilmMart Virtual Edition 2020 organized a series of women-focused themes**. (September).
- **2nd Annual Black Women's Film Conference (virtual).** A month-long screening and conversation series with extended conversations, films, and music featuring: Sophia Nahli Allison, Haley Elizabeth Anderson, Shirley Bruno, Nuotama Bodomo, Dessane Lopez Cassell, Dyani,

Zeinabu Irene Davis, Ja'Tovia Gary, Gessica Geneus, Faren Humes, Iyabo Kwayana, Chanelle Aponte Pearson, Diana Peralta, Numa Perrier, Stefani Saintonge, Yvonne Michelle Shirley, Angelique Webste, Keisha Rae Witherspoon, Rikki Wright. (September).

Beti Ellerson, PhD, is the founder and director of the Centre for the Study and Research of African Women in Cinema and publishes extensively and lectures widely on African women of the moving image. She is the author of *Sisters of the Screen: Women of Africa on Film, Video and Television* (Africa World Press, 2000) and maker of the documentary *Sisters of the Screen: African Women in the Cinema* (2002). She has juried at international film festivals, notably FESPACO in 2013 and the JCC, Carthage Film Festival in 2018.

Notes

A version of this article was published as Beti Ellerson, "African Women on the Film Festival Landscape: Organizing, Showcasing, Promoting, Networking," *Black Camera*, vol. 11, no. 1 (Fall 2019): 424–456.

1. Interview with Sayida Bourgidia by author.

2. Hamidou Ouedraogo. *Naissance et Evolution du Fespaco de 1969 à 1973, Les Palmares: de 1976 à 1993*. Ouagadougou: Imprimerie Nationale du Burkina, 1995.

3. Beti Ellerson. "African Women in Cinema Dossier: African Women of the Screen as Cultural Producers: An Overview by Country" *Black Camera: An International Film Journal* 10, no 1 (Fall 2018): 245–287.

4. "Rosalie Ndah, president of CNA Afrique talks about the CNA tribute to women at Fespaco 2013." Interview with Rosalie Ndah by Beti Ellerson, *African Women in Cinema Blog* http://africanwomenincinema.blogspot.com/2013/02/rosalie-ndah-president-of-cna-afrique.html.

5. Beti Ellerson. Building a Historiography of African Women in Cinema. *Africa Update Newsletter*. CCSU, Vol. XIX, Issue 4 (Fall 2012).

6. African Women and Film Festivals. *African Women in Cinema Blog*. https://africanwomenincinema.blogspot.com/2009/03/african-women-at-film-festivals.html

7. Many of the entries outlined here are discussed in the article "African Women of the Screen as Cultural Producers: An overview by country."

8. Beti Ellerson. *Sisters of the Screen: Women of Africa on Film, Video and Television*. Trenton, NJ & Asmara: Africa World Press, 2000:4.

9. Cheriff Amadou Diop "Recidak 96 : Quand les femmes du cinéma se mobilisent / When women of the cinema take action". *Ecrans d'Afrique*, no. 16, 1996:39.

10. Text source from festival catalogue.

11. Mojisola Sonoiki: The Women of Color Arts & Film Festival is "my destiny." Interview by Beti Ellerson. *African Women in Cinema Blog*. https://africanwomenincinema.blogspot.com/2012/02/mojisola-sonoiki-women-of-color-arts.html.

12. Women of the Sun website no longer available.

13. Texts from the *African Women in Cinema Blog*.

14. "Wanjiku wa Ngugi talks about the Helsinki African Film Festival." Interview with Wanjiku wa Ngugi by Beti Ellerson. *African Women in Cinema Blog*. https:// africanwomenincinema.blogspot.com/2011/05/wanjiku-wa-ngugi-talks-about-helsinki .html.

15. Farah Clémentine Dramani Issifou: the 2013 Africadoc Benin and Festival des Nouveaux Cinémas Documentaires (New Documentary Cinemas Festival). Interview by Beti Ellerson. The *African Women in Cinema Blog*. https://africanwomenincinema .blogspot.com/2013/11/farah-clementine-dramani-issifou-2013.html.

16. Link to the Festival of Indigenous African Language Films (FIAF) website no longer accessible.

17. Focus on Women: Perspectives from Oslo, FilmAfrikana 2011. The *African Women in Cinema Blog*. https://africanwomenincinema.blogspot.com/2011/04/focus -on-women-perspectives-from-oslo.html.

18. Report on Fokus: Sisters in African Cinema – Afrika Film Festival Cologne 2016. https://africanwomenincinema.blogspot.com/2016/09/report-on-fokus-sisters-in -african.html.

19. Source of text: Aswan International Woman Film Festival website: http://aiwff .org/home/media/attachments/2018/09/19/2017-en.pdf.

20. Sabbar Artistiques: Première édition des Ateliers Reflexives Féminins de Dakar | Women's Reflexive Workshops of Dakar - 19–24 03 2019. The *African Women in Cinema Blog*. https://africanwomenincinema.blogspot.com/2019/03/sabbar-artistiques-premiere -edition-des.html.

African Cinema in the Tempest of Minor Festivals

Sambolgo Bangré

"To become known, African cinema has gone towards international festivals," said the father of African critics, Paulin Soumanou Vieyra, at the beginning of the 1970s. Kept at a distance from the continent's screens monopolized by the former distribution structures of Compagnie Africaine Cinématographique Industrielle et Commerciale (COMACICO) and Société d'Exploitation Cinématographique Africaine (SECMA), the first films by African filmmakers produced from the early 1960s onwards were revealed to the public only after having negotiated their recognition at festivals organized outside the continent.

The 1961 Berlin Festival was the first to select African films, which were by Senegalese filmmakers: Blaise Senghor's *Grand Magal de Touba* (1960), which received a Silver Bear for the best short film, and Paulin Soumanou Vieyra's *Une Nation est née* (1961), which received a special mention. Between 1961 and 1975, numerous festivals in Europe and America followed Berlin's example, thus contributing very early on to the recognition of African cinema. Films shown to the public at Moscow, Leipzig, San Francisco, New York, Venice, and Locarno included *Borom Sarret* (1961, Senegal), Ousmane Sembène's first short film, and *The Mummy* (1970) by the Egyptian Chadi Abdel-Salam. But there can be no doubt whatsoever that it was the prestigious Cannes Festival, by awarding prizes to Sembène's *La Noire de* (Senegal) and *Le Vent des Aures* by the Algerian Lakhdar Hamina, in 1966 and 1969 respectively, that definitely marked the recognition of African cinema. Since then, it has continued to arouse increasing popular and critical interest at Western festivals.

In Africa itself, the idea of creating film festivals on the continent came about with the birth of African cinema as a solution that would enable the cinema to go forth and meet its public. The first Festival des Arts Nègres at Dakar, organised in 1966, responded in part to this spirit. It was to open up the way for the Journées Cinématographiques de Carthage, created in 1966 in Tunis, and the Pan-African Festival of Cinema and Television in Ougadougou in 1969.

For twenty years, with a production having its fair share of ups and downs, African cinema thus went out towards the festivals to find credibility that neither the monopolized African market nor the local cinema authorities could guarantee. For about ten years, it has now been the festivals that have been going towards African cinema. The number of international festivals and events has been growing and, with them, the number of seminars and professional meetings. The window that was opened in the past to African films in the festivals has now been opened much wider and festivals devoted exclusively to African cinema have been established almost everywhere in the course of the years. European countries now have a total of more than 500 film events. The record belongs to France, where more than 160 film events are held each year. Here, three major festivals are exclusively or partially devoted to African cinema, namely the Amiens Festival, created in 1980, the Cinemas of Africa Festival of Angers, first held in 1987, and the Festival of Three Continents, held in Nantes since 1982.

Whatever the "obsessions" behind them, the other events in Europe or in America (women's film festivals, festivals of films for children, and the like) all or nearly all grant a place to African cinema. The flourishing of festivals was noticeable especially in the years between 1983 and 1990, a period during which very different types of festivals were established in the majority of European cities. In France again, more than 150 towns are concerned. In the film industry, the disappearance of film clubs in the 1960s and of art theaters in the 1970s left a void that the festivals have filled, thus continuing to satisfy the desire of cinema lovers for images. In 1992, the French public interested in festivals was estimated to be about a million, that is, one percent of cinemagoers.

When they are being created, all the festivals declare the same objectives: to distribute and promote films; to enable filmmakers, critics, the public and producers to meet; to offer an opportunity to get to know the realities of the different filmmakers and of their countries—noble objectives, which may at times hide other ambitions behind certain festivals.

An Attempt at Classification

Three categories of festivals can be distinguished. The first concerns festivals which are devoted to discovering films that have never been shown before, to the satisfaction of lovers of the seventh art. The second category uses the cinema as a support for a market. Cinema becomes business. Finally, the third category of festivals is that of "public relations festivals." The cinema becomes an instrument to promote a city or a product. The proliferation of festivals gives the unpleasant sensation that this category of festivals is the only one that applies. And African cinema is the ideal excuse to fill this role

of promotion that the majority of cities need against a background of drums celebrating cultural dialogue and the promotion of marginalized films.

In France, thanks to a law passed in 1901 authorizing subsidies for events of a cultural nature organized by non-profit making associations, any city or any mayor can take advantage of the subsidies to create a film festival to promote the image of the city. Most years, the municipalities, the departments, the regions and also state institutions and private partners contribute to the budget of cultural events, of which film festivals are the main beneficiaries. Festivals that are financed essentially by their own takings are few and far between. The budget for an average festival held in Europe is estimated at between five and twelve million French francs. Cannes or Berlin go way beyond this figure with budgets of more than twenty-seven and forty-one million francs respectively. As well as the promotion of the cities holding the festivals, it is not impossible that, in the current situation of economic crisis, a festival represents a solution for a temporary reduction of unemployment.

All African filmmakers are unanimous in recognising that festivals are useful. The best-known filmmakers in fact owe their careers to the opportunities to meet people, and the presentation of their films at festivals have often led to their winning awards. The "cultural expectations" of African filmmakers vis-à-vis the festivals have always been fulfilled. The large audiences created by international festivals have always extended a warm welcome to the filmmakers' work. These cultural expectations are met to an even greater extent when the African filmmaker has the opportunity to meet the public at festivals in Africa itself. The economic expectations—distribution in cinemas or sale to televisions—are less obvious. The addition of a film market to a festival has not always led to improved distribution or to the creation of viable conditions for coproduction.

Few festivals, even amongst the most serious organized both in Africa and outside the continent, have had this driving force. However, original ideas are being increasingly developed regarding the funding of filmmakers' projects or training in the sectors of distribution, production, and so on. It is therefore not surprising that many filmmakers increasingly have the ambition of knocking at the doors of the major festivals, such as Cannes or Venice. *Chronique des années de braise* (1975), by Lakhdar Hamina (the only Golden Palm—awarded in 1975—granted to an African film), *Yeelen* (1987), by the Malian film-maker Souleymane Cissé, awarded a prize at the 1987 Cannes Festival, and Idrissa Ouédraogo's *Tilai* (1990), which was also awarded a prize at the same festival three years later, only began their commercial careers after this festival. Mohamed Camara (*Denko* (1993)), prize for the best short film at FESPACO 93) and Burkina Faso's Regina Fama Nacro (*Un Certain matin* (1992)), who were able to sell their films to several televisions after having won awards at Ouagadougou and Carthage, are examples which do

not yet allow a definite degree of optimism for the career of the majority of young filmmakers.

Their dream of ascending the steps of the theater on the Croisette comes to a halt more often than not at the markets of the minor festivals, more inclined to awarding accommodating prizes to the young filmmakers invited. Between accepting an invitation from some city or another in Europe and the refusal to play at puppets, many do not hesitate and choose the first solution. Henri Duparc, the filmmaker from Côte d'Ivoire (*Bal poussière*, 1988; *Le Sixième doigt*, 1991; *Rue princesse*, 1993), who took a clear stance several years ago, choosing only to go to festivals which guarantee the sale of his films, has few, if any, followers.

A real discomfort has existed for some time with African filmmakers regarding the proliferation of festivals and their consequences. The frequency of the festivals (festivals are often only a week or even less apart) has as one consequence the overexploitation of the films. Between May 1993, the date his short film *Octobre* was released, and April 1994, Abderrahmane Sissako, the Mauritian filmmaker, received at least thirty invitations to attend festivals all over the world. The same applies to Mohamed Tazi, the Moroccan filmmaker whose recent film *A la recherche du mari de ma femme* (1993) has aroused a similar frenzy. On the other hand, many festivals graciously exploit the films entered in the competition without any particular beneficial consequence for those concerned. Taking as their argument the insufficiency of their budgets and their prime concern in promoting the films, many festivals are unaware of or pretend to be unaware of the principle of the payment of a fee (between 1,000 French francs for short films and 3,000 French francs for features, according to the rates currently in force) for the rental of the films shown. Worse, and that's where the shoe pinches, it is not infrequent for festivals to send invitations to filmmakers who live in Africa with the condition that their travel expenses are paid from Paris.

The filmmakers' ill-ease is also the feeling of *déjà entendu* with regard to what is being said at the various seminars organized by the festivals on the problems of African cinema. On this topic, one filmmaker says:

> When I go to festivals, I know that the same things are going to be repeated again and again. I have the impression of being a record that's played at each festival. Why don't they stop asking us to speak about our problems? We've had enough of speeches; we want more money to make films.

FEPACI's Initiatives

Well aware that the only solution lies in the organization of a market based on South/South cooperation and conquering the market of the North, for many

years filmmakers have contributed to working out different strategies for the development of their cinema. The festivals of Ouagadougou and Carthage and the meetings at Maputo in 1974, Mogadishu in 1981, and Niamey in 1982 have provided a framework for reflection on the question of the film market. The first realization of these reflections had been the creation in 1974 of CIDC (Inter-African Consortium of Film Distribution). Its aim was to regulate the market of fourteen countries in Western and Central Africa. The failure of CIDC in 1984 again left African cinema like "a head without a body," according to the phrase coined by Tahar Chériaa.

The absence of an internal market and the increasing desire by the continent's population to see their own images led to voices being raised to demand the creation of other festivals in Africa apart from FESPACO and Carthage. The recent birth of the Southern African Film Festival, which materialized in October 1993, is a response to this request. Several initiatives encouraged by FEPACI tend towards the organization of weeks of cinema in the majority of countries. The urgency of the question of festivals open to African cinema led FEPACI, in conjunction with FESPACO, to organize a seminar on the subject on the occasion of the twenty-fifth anniversary of FESPACO held in Ouagadougou from February 20–25, 1994. The conclusions of this meeting noted the historic role played by the festivals of Ouagadougou and Carthage in the promotion of African cinema, the diffusion of images of the continent's filmmakers, the strengthening of the bonds of solidarity between the peoples of Africa and the assertion of African cinemas in the face of that of the North.

The intensification of dialogue between these festivals was seen as a pressing need. The real risk for the film festivals held on the continent can be stated in terms of the interest of the filmmakers in their own festivals because the economic expectations of the filmmakers who are satisfied by the large international festivals remain stronger in appeal than the cultural expectations. The laudable initiatives taken by the Ouagadougou, Carthage, and Harare festivals to organize the film market respectively through MICA, the project market, and Input Africa are to be encouraged. African cinema still has a lot to do if it wants to continue to exist first and foremost for its audiences.

Sambolgo Bangré is a journalist, critic, and filmmaker. He has regularly contributed to *Ecrans d'Afrique*.

Notes

Originally published as Sambolgo Bangré, "African Cinema in the Tempest of Minor Festivals," in *African Experiences of Cinema*, Imruh Bakari and Mbye B. Cham, eds. (London: BFI Publishing, 1996): 157–161.

Postcolonial Film Collaboration and Festival Politics

Dorothee Wenner

As a filmmaker Dorothee Wenner has a particular interest in the relationship of the West to non-European cultures. Since 1990 she has also worked as programmer for the Berlin Film Festival/Forum and has acted as the delegate for the regions of sub-Saharan Africa and India. Wenner is also a program consultant for the Dubai Film Festival, and she has been a member of the board and of the jury of the Africa Movie Academy Awards (AMAA) since its inception.[1] In her capacity as film festival programmer Wenner travels extensively across Africa and India to network, source new films, and spot trends. She is an expert on the development of cinematic cultures and in this piece she reflects on her observations of the existing and emerging cinematic practices of women on the African continent. In a candid and refreshing multi-faceted approach to the variables that inform the curatorial choices, exhibition platforms, and reception contexts that shape how content is determined, her insights reveal the push-pull factors that position African films in an international environment. She elaborates on these insights by describing the complex layers informing the production, circulation, and eventual exhibition challenges that face African filmmakers. These challenges are about straddling the divides between the reception of their films by local audiences in their home territories and by audiences farther afield: on the African continent itself and within the international context of the festival circuit. Coupled with this is the persistent issue of the politics of representation of African cinema in Europe.

This contribution evolved as a result of conversations Dorothee Wenner and Antje Schuhmann had over three years, beginning when she shared some of her thoughts upon returning home to Berlin on the occasion of AMAA in 2011 after one of her trips.

On a flight from Port Harcourt to Lagos I had the chance to chat with Hawa Essuman, the young codirector of *Soul Boy* (2010), a Kenyan film that had recently created quite a stir internationally and had been nominated in many categories at the AMAA in Nigeria. Hawa was "the chosen one" who was invited to climb on the director's seat in "one-of-those"

Euro-African projects currently so much in vogue in various African countries. Internationally acclaimed German director Tom Tykwer was her mentor. He, with support of major funding sources from Germany, had provided the infrastructure and finances that had made this film possible.

Soul Boy is as much a realistic ghost story as a romantic fairytale, with two teenagers falling in love against the background of Kibera, Nairobi's largest slum, where the entire film was shot.

Since its premiere, the film has been screened at virtually every other festival worldwide, and it was wonderful to watch this Kenyan success story unfolding. But the joy was not shared by all—some people in Nairobi were highly critical of the project and asked, on the occasion of the nominations, whether *Soul Boy* was really an African film, given the strong German involvement. Hawa said she could not understand the debate—she insisted that it was, indeed, her film, which she alone had directed, even though Tom Tykwer was on the set all the time, except for when they split into two units. Hawa said, "On set, Tom and I discussed the shots and I took all his advice and suggestions." She frankly admits that she benefited greatly from the project's framing—not only because of what she learnt back then, but also because she was able to seek advice later on from the German crew she had worked with. She was currently busy writing the script for her next film, she said, and was making the best possible use of the advantages and networks she has thanks to *Soul Boy*. Who would not? Hawa told me that she much prefers not to work alone, even during the writing process. Yet this time she has different company—a group of highly energetic women in Nairobi. Her remarks on the importance of a local support system brought us to an interesting new phenomenon: the "Kenyan girls thing." These days in Kenya there are so many young female directors and producers suddenly surfacing in the film industry that everyone is wondering: where are the men? Hawa replied, laughingly, when I asked her about it: "Yes… it is true. But honestly, I don't know, we don't know how it came to that, how we became an almost exclusive women-only circle… Well, we are all anxiously awaiting the next film one of us makes. And we hang out together a lot and help and support each other, when we can."

I also asked energetic young Kenyan filmmaker Zipporah 'Zippy' Nyaruri to give me her explanation for the 'new phenomenon'—and her first reaction was: "Women are fighters!" But she reflected on it overnight and came back with more reasons: "Most women in Kenya generally are independent by default, which I think reflects the situation of women in film, too. But we also want to be independent of men in our filmmaking so we are able to tell the stories in our own ways. What I feel is, we need men in the team to help with the technical aspect of things, as most of them have more experience than us in this field."

Zippy explained to me that Kenyan men in the industry simply have the advantage of having years more experience than women and most men also did—and still do—receive a better education. But why have female film-makers in Kenya suddenly become so much more visible? I think it is because of a particular momentum within which a certain kind of personalities came together: these are women who are not in competition with each other, and who seemed to have understood that the success of one is not a disadvantage to the others, but rather the opposite. For me, it is also interesting that this way of being with each other—of relating to each other—is highly political, in the sense that I would say this is feminist practice at its best. However, I realize that many African women would not situate their mutual support within this framework, as it is often perceived as exclusively Western. Of course, this solidarity amongst women—which can also include men—still does not resolve the very difficult conditions of filmmaking in a context where there are hardly any funding opportunities.

More than once, crucial movements have started in the film world as a result of some filmmakers or other film professionals becoming friends (instead of envious competitors). Of course, it takes many more ingredients than just friendship to make this happen, but, time and again, personal support between people who create a scene has proven to be absolutely essential to get such a movement going.[2] This fact is crucial, as there are neither governments nor other institutions that support filmmakers in any way in many African countries today. Needless to say, this is not only true for the African continent, but also in other countries around the world. It is also necessary to add that in Africa major differences exist between the various countries. In some places, like Burkina Faso or Angola, for example, film-makers have enjoyed tremendous support from their governments, especially in the past when cinema was considered important in the process of decolonization by some visionary politicians like Thomas Sankara, the famous president of Burkina Faso. The FESPACO[3] festival of Ouagadougou is but one example of that proud heritage. These are also places with historically strong traditions of filmmaking practices, but with the demise of celluloid cinema and the rise of newly-structured funding realities in Europe, that period came to an end—with sad results, like the closing of most cinema halls in sub-Saharan Africa, or the recent death of some established film festivals on the continent, such as in Mozambique.

Next to the financial precariousness, there is yet another challenge that is often overlooked. At the African Film Summit in 2006 there was a discussion about developing a blueprint media law for countries without applicable media jurisdiction: filmmakers and producers from such places know how crucial it is to get this going and they backed the idea wholeheartedly. At first glance media law might be considered a low priority when looking

at the situation for filmmakers in sub-Saharan Africa—but only until one discovers that in many cases it is a precondition, for instance, for embarking on coproductions or for receiving support and funding. Media law is actually crucial for stimulating local productions in Africa.

When trying to outline the essentials of today's challenges for filmmakers from Africa, another encounter comes to my mind: my meeting with a young filmmaker from Zambia at the Durban Film Festival's coproduction market. I very much liked the project she presented there, and she even had a French producer attached to the project. However, she could not apply for many of the existing funds because, in her country, there is currently not even a single production house in operation; thus, her film technically did not even qualify as Zambian.

Given these financial and infrastructural challenges, it becomes obvious that filmmakers have little choice but to help themselves, be they men or women. Whereas the new female-dominated set-up in Kenya is quite specific, the debate on the African identity of films made with international support is "hot" throughout the continent. Increasingly, factors of globalization and migration make it extremely difficult to adjust criteria and make distinctions regarding what constitutes an "African" film or to decide on the "authenticity" of an African film in the context of a coproduction. Is a film shot in Africa by an African director based in the Diaspora, who sourced money from abroad, more or less African than a production financed and made totally independent from Europe? What about productions based on scripts supervised by Western screenwriting labs? Are films by African directors, which win critical acclaim on the international festival circuit but fail to find a release in Africa, more African than box office hits from Nigeria or Ghana? What about films which are released on a wide scale, but only on DVD or on the Internet? It is an endless debate, but it is none the less highly relevant. Who decides what is right or wrong, good or bad, and based on what criteria?

When it comes to reflecting on forms of collaboration between African filmmakers and their funders, whether they be individuals or organizations it might be more productive to shift the focus of the debate towards the ambitions and intentions of foreign interests in African filmmaking. Indeed, most initiatives seem welcomed in Africa, if only because of the simple lack of other support mechanisms available. In principle, at the moment, there is a huge difference between films produced in Africa solely or mainly for domestic markets and those made with the ambition of releasing them internationally, especially for the festival circuit. And this is not to forget the many films commissioned by Western funding agencies and NGOs for educational purposes, on topics such as HIV/AIDS-awareness, which make up the bread-and-butter work for many African filmmakers. This area of commissioned films for educational purposes released only in African countries is largely

ignored in the Western debate on this matter, whereas from an African perspective these films belong to the same game of dependency—just with a different set of rules. I remember a South African filmmaker complaining that she was really tired of making films on HIV/AIDS in order to survive. Yet, as she continued, her main concern was her observation that, increasingly, many Western-educated filmmakers in search of work opportunities push into this one area, which used to be exclusively reserved for filmmakers from the regions for which these films are made.

In my view, one area that is overdue for study is that of the different types of films produced in Africa, which would require an in-depth analysis of the differences regarding audience expectations and distribution realities, taking into account the very few 'classical' cinemas that still operate across the African continent. It is also a fact that audiences all over Africa crave films that relate to subjects, issues, and realities familiar to them. The Nollywood success story has made this clear, not least by creating ways to reach out to, and cater for, the expectations of contemporary local audiences. This analysis would also need to address issues like stereotypes and pre-conceptions of African cinema in the Western world. For example, the film *U-Carmen eKhayelitsha* (2005, South Africa)[4] by Mark Dornford-May,[5] which won the Golden Bear at the Berlinale in 2006, was argued by some critics not to be a 'proper African' film because it appropriated what was seen as genuine European culture—opera. One journalist explained why he so disliked the film: he could not understand "the necessity" of adapting George Bizet's *Carmen* given that African filmmakers have such an abundance of "authentic" music to choose from. Such reactions can be very disturbing, even misleading, particularly in light of art produced in the West and its long-standing citing, copying, and appropriating of African artistic expressions of all kinds. In light of global accesses, these essentialist notions are caught up in a colonial perception of the "other," which must remain the "Other." This notion is not only outdated, but causes manifold further misunderstandings and often harms potential for (future) collaborations.

I have often observed that African artists are afraid to (or are tired of doing so) speak out against such colonial discursive formations, either from frustration or out of fear of losing a chance with potential funders or commissioning editors for current or future projects. Worse still, some African filmmakers believe that they have to accept such realities; for example, working on scripts that cater to outdated assumptions or stereotypes. This easily causes a short-circuit effect: the more progressive jurors or lecturers in the Western film funds time and again reject such projects precisely because they dislike the outdated African reality described in the script, but at the same time these are the projects that are being developed or financed. Such matters, however, are rarely openly discussed by Westerners, especially those engaged with

African art or artists because they are equally shy, or too reserved to speak up because of the fear of being labeled racist, or concerns of being considered as imposing on a debate which is not theirs. So there is a discourse happening, but it is very complicated and multi-layered, and the conditions make it difficult to stimulate an open and honest debate in a postcolonial context. This more often than not prevents constructive/creative communication between active African and European partners. It also further complicates cultural exchange and collaboration between African filmmakers and Western decision makers.

Yet so far many of the new and existing initiatives have failed to work towards greater transparency of intentions on both sides. I do not want to be misunderstood: by no means am I implying a conspiracy of bad intentions from those active in this field. On the contrary, I think partners from the West would work more successfully with African filmmakers if they were more aware of their own historic legacies and contemporary privileges, and of how this positions them in the eyes of African artists and collaborators. For example, concerning festival politics, I know that many festivals worldwide would love to have more content from Africa, especially representations of an urban Africa with modern cinematographic aesthetics, which work well with the rest of their programs. The problem, however, is that, due to the multiple challenges most filmmakers in Africa face, such as a lack of access to international productions, festivals and cultural discourses, their aesthetics often do not speak to contemporary cinematographic trends elsewhere. Harun Farocki's[6] films are in vogue in Europe, but no one on the African continent wants to see them. On the other hand, there are films which are very popular on the African continent but do not fare at all well in the West. I recall screening Djo Wa Munga's[7] film *Viva Riva!* (2010, Democratic Republic of Congo) in Burundi, forty kilometers away from the DRC, where he lives. In the DRC the film was a great success, but in Burundi the exclusive audience, filled with people from the local film community, were shocked and left the screening. This is also a reflection on the diversity of the audiences and their expectations and reception of content in different contexts.

In light of these experiences and observations I can only say that it would be of great advantage if those in decision-making positions in Europe and the West would synergize their efforts in closer cooperation with African partners. Even more important might be to understand the need to support the development of existing partner organizations of a non-private nature in African countries. Most of these organizations are deprived of any aid—financially and politically—but are requested to "be there and function" in order to be the much sought-after partners for the next round of training to take place. When, in September 2010, some thirty of the leading women in the African film industries met in Johannesburg by invitation of the Goethe-Institut, South

African filmmaker Jyoti Mistry had a wonderful idea: she suggested creating informal producer-hives between African filmmakers across different countries. Her idea was a response to the fact that most of the participants pointed to their loneliness and isolation in the film world as their most difficult and burdensome struggle, apart from the chronic lack of funding, of course. The producer-hives, as they were discussed, could function as little units of three or four film professionals, who—independent of their locale—support each other by, for example, reading each other's scripts, checking budgets sent via email, sharing contacts with whom proposals could be submitted, and taking time for Skype sessions now and then, among other initiatives.

The idea clicked instantly, and less than six months later the first offspring of these producer-hives were taking off. During FESPACO 2011, Egyptian producer/director Jihan El-Tahri told me how excited she was about working with Sudanese Taghreed Elsanhouri on a documentary in Khartoum. From Taghreed I heard more than once that Khartoum is a truly lonely city when it comes to filmmaking. It was during the conference in Johannesburg that the two had decided to work together as support for one another. The film *Our Beloved Sudan* (2011, Sudan), written and produced by Taghreed and coproduced by Jihan, was released a year later.

As to how far these few inspiring and encouraging stories from Kenya and Sudan can be seen as indicators for a brighter future for women in the African film industry, it is hard to tell or predict. No doubt it would be an easy game to collect stories and biographies to prove things are getting worse and worse by the day, especially for women. To survive as a woman director or producer is hard anywhere in the world, but in Africa there are quite a few additional burdens placed on the individual's shoulders. By this I mean, for instance, traditions or framings stemming from within the various cultural backgrounds; take the small number of active female filmmakers in Africa: this is evidence that the challenges faced are different from those found in the European context. Another challenge is the global financial crisis, which has given a good excuse to prioritize the issues surrounding filmmaking as part of cultural production even less, when they were second or third on the list anyway in comparison with health issues or education. Therefore, looking at women's issues in male-dominated African filmmaking certainly falls under the category of challenges facing women filmmakers. But the women who met in Johannesburg during the conference have addressed this issue as only one burning topic amongst many others. It was both interesting and encouraging to watch the debate highlighting their opportunities, namely the access to female audiences in Africa, which are easier target groups than male audiences. Besides, who would have foreseen the events in the Middle East and North Africa (MENA), which are reshaping the established world order on a big scale? No matter what is yet to happen, no matter what the

political consequences are, a single reality is that from now on both Europe and North America are being forced to look much more closely at events in this region (MENA), which has historically suffered from a lack of good media coverage—or complete media oblivion—but has now got to be recognized.

During the Berlinale in February 2011, Berlin-based distributor Irit Neidhardt from MEC-film curated a program, "Traces of Change in Egypt," to run parallel to the festival as an impromptu reaction to the revolution which had just begun. At this event it became very clear that, contrary to the general point of view, we in Europe had simply overlooked the signs of foreboding, namely films from filmmakers of the region which offered clues as to the state of things. Before there was simply no interest: no audience and no screening slot in Europe for these films which, suddenly, everyone was rushing to come and see. To paraphrase Irit Neidhardt, since 2010 an independent film scene has emerged in Egypt. With the help of digital technology, more and more filmmakers are trying to express themselves outside of the highly commercial state-run film industry and against the ever-increasing repression of the regime. In this ad hoc program, made possible with the support of Berlinale's Forum section, we showed some short films as well as trailers of full-length independent Egyptian films which introduced the range of political and aesthetic approaches to filmmaking in this context.

The current political situation seems a crucial moment to review the European and Western media and film collaborations, not only in the MENA region, but also in sub-Saharan Africa. Such a review is overdue, and yet not an easy task. For decades commissioning editors, festival programmers, sales agents and other decision makers agreed that there were hardly any audiences in Europe for films from Africa. Thus the *circulus vitiosus* gained speed: with less and less funding available for African filmmakers, who were largely dependent on funds from Europe, fewer productions were made, resulting in many older professionals in Africa losing their skills due to a lack of practice, whereas only a few younger people were lucky enough to receive an education abroad and they joined the Diaspora life in order to retain their opportunity for a filmmaking career.

Indeed, it is very hard to market African films commercially in Europe, even those of outstanding quality like, for example, *Un Homme qui crie* (dir. Mahamat-Saleh Haroun, 2010, Chad),[8] which was released in 2011 in Germany. This was the first African film with a regular cinematographic release in months, and while the German critics raved in their reviews, this did not lead to full houses in Berlin. And this was far from unexpected, since in Germany films from or on Africa have long been associated with topics of hunger, deprivation, and misery in all its facets, which goes against audience expectations of good entertainment. More or less automatically, films from or on Africa seem to be deemed of interest only to those very few cinemagoers

with a preexisting political or cultural interest in Africa, which is certainly not enough in numbers (economically) to fill multiplexes in Hamburg or Cologne for more than a week. This comes as no surprise to people with a close eye on the market: after ignoring films from Africa for so long, it will take some time, clever strategies and different films to build up audiences in Germany or any other Western country, and to prove that African films have much more to offer than—and are able to challenge—outdated preconceptions of African experiences. Of course, festivals can and must play a crucial role by discovering new talents and sparking interest in fresh imagery of hitherto untold stories from countries like Kenya or Chad or South Africa. This is what people love and cherish during the festival days of Berlin, Cannes, Venice or Sundance. But once the festivals end, the very same people who willingly form long queues and wait for hours to see a film from Egypt or Senegal disappear into thin air and very few of them seem to attend such films outside of the festival context. Buyers, sales agents, and cinema owners know about this and anticipate a flop even if everyone agrees that the film is a masterpiece.

Still, the most promising approach might be to keep looking for individual projects and initiatives that have the potential to bring change, whether it be with the success of a single film, one functioning network or particular training that has concrete results for participants. Building on those pilot projects would mean having intelligently to create both local and international alliances in order to further protect and nurture new and experienced talents. This might be regarded as the old-fashioned grassroots approach, but the female film practitioners who gathered at the Johannesburg conference at the Goethe-Institut were absolutely keen to explore just this route without losing time on detours.

It is just as important to accept that there is no master plan or blueprint for this process available, not in Africa, not in Europe, and not anywhere else. This seemingly simple insight might bring a breeze of fresh air into this huge debate, since it is as frustrating to wait for such a revelation as it is to look for the scapegoats in charge.

In my opinion it is crucial to introduce a new approach to analyzing the complexity of the situation: the interdependencies of problems, challenges and potential in media production and dissemination in the many different realities of today's Africa. Europe must accept its active role in this matter, and must deal with its own postcolonial and sometimes neocolonial realities and confront itself with its contemporary legacies. This very debate is currently at the top of the agenda in the academic world of postcolonial studies, which could also be of practical benefit for the film industries on both sides of the pond, as it could potentially open up spaces for mutual learning and exchange. It should be reiterated that Africa has a huge market for audiovisual products which is far from saturated and explored, and which could

be of vital interest in the near future for film industries worldwide, explicitly including African players. It is also refreshing to see that Europe and the West do seem to be coming to understand that the lack of images and media from the African continent is too important an issue to further ignore, since it has not only cultural but also economic and political implications.

In the end, it *does* matter whether or not Europe takes an interest in these developments and reacts with an appropriate sense of its responsibilities. To come to terms with and define concrete actions and consequences would require urgently focused and enhanced communication between artists and politicians, decision makers and economists stemming from both African and European backgrounds.

Dorothee Wenner is based in Berlin, where she works as a freelance filmmaker and writer/curator. Her documentaries often transgress borders of traditional genres, as she uses elements of feature filmmaking when working with protagonists. In 2008, her theatrically released documentary *Peace Mission,* won critical acclaim as it gave international audiences an insider perspective into the world of home movie production in Nollywood. *Peace Mission* premiered at IFF Toronto and toured the international film festival circuit on all continents.

Notes

Originally published as Dorothee Wenner, "Post-Colonial Film Collaboration and Festival Politics," in *Gaze Regimes: Film and Feminisms in Africa*, Jyoti Mistry and Antje Schuhmann, eds. (Johannesburg: Wits University Press, 2015): 188–200.

1. Founded in Nigeria in 2005.
2. The French New Wave (Godard and Truffaut), Italian Neo-Realism, Dogma '95 with Lars von Tier and Thomas Vinterberg or the initial stages of Third Cinema with Solanas and Getino are only a few examples for the creation of such productive scenes.
3. FESPACO, Festival Panafricain du Cinéma et de la Télévison de Ouagadougou, Burkina Faso (Pan African Film and Television Festival of Ouagadougou) is the largest existing African film festival, and was founded in 1969.
4. A South African remake of Bizet's opera *Carmen* (1875), the operatic film is shot in isiXhosa, set in the Cape Town township of Khayelitsha, and combines music from the original opera with African musical traditions.
5. Mark Dornford-May is a British-born South African theater and film director.
6. German filmmaker who made over ninety films, many of them short documentaries with an experimental character.
7. Film director and producer from the Democratic Republic of Congo who won the African Movie Award for *Viva Riva!* in 2011 and also an MTV Movie Award (2011).
8. Well-known director, producer, and writer from Chad.

II. FESPACO: AN EVER-EVOLVING CINEMATIC AND CULTURAL FORMATION

Figure D. Ouagadougou fountain. Courtesy of FESPACO.

African Cinema and Festivals: FESPACO

Manthia Diawara

When it first took place in 1969, only five African and two European countries participated in the Festival Panafricain du Cinéma de Ouagadougou (FESPACO). By 1985 it had become the biggest cultural event in Africa, with thirty-three countries competing for the now prestigious Étalon de Yennenga award and several other prizes such as the ones conferred by the Organization of African Unity, UNESCO, the Institut Culturel Africain (ICA), the Agence de Coopération Culturelle et Technique (ACCT), the Organisation Catholique Internationale du Cinéma et de l'Audio-visuel (OCI), and the European Economic Community. The ninth FESPACO (February 23–March 2, 1985) brought to Ouagadougou, Burkina Faso, more than five hundred guests: filmmakers, journalists, and critics from Africa, Europe, and America. An unprecedented half-million people participated in the events.

While such newspapers and specialized magazines as *El-Joudjahid* (Algeria), *Le Monde* (France), and *Cahiers du Cinéma* have regularly covered the festival since 1969, FESPACO 1985, which was attended for the first time by newcomers such as the *Los Angeles Times* and the independent British TV network, Channel 4, marked a clear improvement over the preceding ones. It was also at FESPACO 1985 that the Organization of African Unity (OAU) award was inaugurated. The purpose of this chapter is to explain the success of the FESPACO in becoming the most important and culturally unifying event in Africa, despite the ideological contradictions and linguistic differences between some African countries.

FESPACO had to overcome several obstacles and undergo several transformations before becoming the international event that it now is. Begun in 1969 as La Semaine du Cinéma Africain, it was only at its third meeting in 1972 that the Ouagadougou film events took the name FESPACO and introduced competition between films for awards. The 1969 Semaine du Cinéma Africain was organized by Burkina Faso (then Upper Volta) and the French Ministry of Coopération, which was the biggest producer of African films. Five African countries (Senegal, Mali, Burkina Faso, Cameroon, and Niger)

and two European countries (France and Netherlands) were represented by filmmakers and their films. On the African side, *Borom Sarret* (1964) and *La noire de ...* (1966) by Ousmane Sembène, *Et la neige n'était plus* (1964), *Le retour de l'aventurier* (1964), and *Aoure* (1966) by Moustapha Alassane, and *Cabascado* (1964) by Oumarou Ganda were shown. On the European side, Jean Rouch showed *Jaguar* (1966), *Moro Naba* (1957), and *Bataille sur le grand fleuve* (1950), and Joris Ivens showed *Demain à nanguila* (1963). In total, twenty-five films were exhibited on a noncompetitive basis.

This first Semaine du Cinéma Africain (February 1–15, 1969) had many structural elements and rules that are still maintained by the FESPACO. It had a local committee of Voltaics in charge of the organization. The committee was assisted by subcommittees for the reception, housing, information, programming, and entertainment. The French cultural attaché in Ouagadougou participated in the organization and the Ministry of Coopération in Paris supplied most of the films and contributed funds for the festival. The Semaine du Cinéma Africain had as its objective "to make people discover and to promote African film which for the most part was ignored. The purpose of this encounter was therefore to show that there exists an African cinema, which was made in Africa, by Africans, on African subjects."[1] Some ten thousand people saw the films, and this encouraged the organizers to have a Semaine du Cinéma every year.

The second Semaine du Cinéma (February 1–15, 1970) was more successful on all levels. Nine African countries (Algeria, Tunisia, Ivory Coast, Mali, Guinea, Ghana, Niger, Senegal, Burkina Faso) and the French government participated in the events. Thirty-seven films were exhibited, including *Mandabi* (*The Money Order*, 1968) and *La noire de . . . (Black Girl)* by Ousmane Sembene, *Dianka-bi* (1969) by Mahama Johnson Traoré, *La femme au couteau* (1968) by Timité Bassori, *L'aube des damnes* (1965) by Ahmed Rachedi, and *La voix* (1968) by Slim Riad. The number of spectators also jumped to twenty thousand, making the Semaine du Cinéma a major international event both in the eyes of filmmakers and the governments. The second Semaine du Cinéma was special and innovative for at least two reasons. It took place just after the government in Upper Volta had defied the foreign monopolists and nationalized its film industry.[2] The second Semaine du Cinéma also included Maghreb countries (Algeria and Tunisia) and an Anglophone country (Ghana), showing that the festival had pan-African visions and that it was not limited by a parochial Francophone outlook.

The nationalization of film distribution and production in Upper Volta and the success of the two Semaines du Cinéma convinced other governments of the existence of an African cinema and of its economic, political, and cultural importance. During the Semaines du Cinéma, filmmakers and journalists not only exchanged notes and criticism, they also explained to

government officials the importance of decolonizing their movie theaters. The nationalization in Burkina Faso marked the beginning of similar actions by Mali the same year and later by other countries. Burkina Faso's symbolic action against the foreign distributors and the exposure the two Semaines du Cinéma provided for African films also encouraged the filmmakers of the continent (La Fédération Panafricaine des Cinéastes-FEPACI) to unite with the Burkinabe government and change the Semaines du Cinéma into a continental festival that could engage African films in competition and make awards. The second phase of the Ouagadougou film events began with qualitative and quantitative innovations and with a new name: the Festival panafricain du cinéma de Ouagadougou (FESPACO).

There was no festival in 1971 because of the Burkinabe government and because the African filmmakers were still at work laying down the conditions of eligibility for the films that were to compete for awards. They had to contact African governments and international organizations for their sponsorship of the events, improve the structure of organization left behind by the Semaine du Cinéma, and make provisions that were necessary for an international event such as FESPACO. It was only after these conditions were met that FESPACO took place in March 1972.

The preamble of FESPACO was similar to that of Semaine du Cinéma. The main objective was "to facilitate the dissemination of African films so as to allow contacts and confrontations of ideas between the filmmakers. The aim was also to contribute to the development of cinema as a means of expression, education, and a means to raise consciousness."[3] According to the rules, the competition is open only to African films. Each African country is allowed to enter two films by two different directors. The films must be proposed "by the competent authorities of the said country, and in the absence of such authorities they are selected by the delegates attending the Festival." At the last instance, a film accepted in the official contest has met the following criteria: it is directed by an African, it is less than three years old, it is entering FESPACO for the first time, and it is in a 16mm or 35mm format. Finally, Article 13 of the rules said that "the official jury of the FESPACO is an international one which is made up of a chairman and ten members at the most, including two Burkinabe (formerly Voltaics).

The first prize, Étalon de Yennenga, of the 1972 FESPACO went to Oumarou Ganda (Niger) for his feature film, *Le wazzou polygame* (1971). The second prize went to Moussa Kémoko Diakité (Guinea) for *Hydre dyama* (1970), a documentary co-directed with a non-African, Gerhard Jeutz. Other winners included Ahmed Rachedi (Algeria) for *L'opium et le baton* (1970) and Kwami Mambu Zinga (Zaire) for the best short film, *Moseka* (1972).

The 1972 FESPACO (known as the third FESPACO even though it is technically the first one) set the tone for the ones that followed. More and

more African countries took part in the events. The audience grew from one hundred thousand in 1972 to five hundred thousand in 1985. More awards were offered (from six in 1972 to twenty in 1985), and FESPACO began to enjoy the same reputation as other international film festivals. According to Filippe Sawadogo, General Secretary of FESPACO, the objective of each FESPACO is to be better than the preceeding one and the "ultimate aim is to be perfect."

Since 1972, only two decisions affected the progress and regularity of FESPACO. The first was made during the fourth FESPACO (1973), to alternate FESPACO with the Journées Cinématographiques de Carthage (JCC), which was the major festival site for African and Arab films. Because the FESPACO had become so important, and because the filmmakers at FESPACO in Burkina Faso were for the most part the same as those at the JCC in Tunisia, there was concern that the same film would dominate both festivals. In order to reduce the number of films shown at both festivals, the filmmakers proposed a plan to the governments to alternate FESPACO and JCC. It was in this sense that the two festivals became biannual, with FESPACO taking place in odd years and JCC in even ones.

The other major irregularity in the FESPACO followed a frontier dispute in 1975 between Mali and Burkina Faso. In that year the festival, which was now biannual, did not take place. It was in 1976, three years after the fourth FESPACO (1973), that the fifth FESPACO took place. Fortunately, the only effect the irregularities had on FESPACO was the delay in time. Although this alternation with the JCC forces fans who cannot afford to go to Carthage to wait two years for the Ouagadougou events, it also has contributed constructively to FESPACO.

The quality of the films selected has improved over the years; the organizing committee has more time to promote the festival and invite film historians and scholars from the different corners of the world. The two years it takes to put a FESPACO together has also contributed to an increase in the number of international organizations that fund the festival. Because of the alternation of FESPACO and JCC, they do not have to compete for funds at the same time from such organizations that fund the festival as the Agence de Coopération Culturelle et Technique or UNESCO. Finally, there are economic advantages for the spectators. They have more time with the biannual festival to save for the ticket to Ouagadougou, unlike the annual one, which seems always to come too soon. As for the irregularity caused by the conflict between Mali and Burkina Faso, it was soon forgotten after the fifth FESPACO (1976). The best proof of this is the fact that a Malian director Souleymane Cissé, has since broken all records by twice winning the Étalon de Yennenga, at the sixth FESPACO with *Baara* (1979) and at the eighth FESPACO with *Finye* (1983).

After this historical overview, it is important to pause for a moment to evaluate FESPACO and its impact on African culture. I have already indicated the success with which FESPACO has developed since 1969 and the innovation of each FESPACO over the preceding one. I would like now to focus on the ninth FESPACO (1985) in order to illustrate some of these innovations. The most obvious difference between FESPACO 1985 and the preceding ones was in theme: "Cinéme et Libération des Peuples." For the first time FESPACO had a theme and the festival reflected it in several ways. The theme of freedom was denoted by signs like "Libérez les écrans africains," "FESPACO '85, Arme de la Libération des Peuples," "FESPACO '85, Hommage aux Peuples en Lutte," which were everywhere, on posters in front of movies theaters and hotels, on banners, flyers, newspaper headlines, radio, and television. The theme of freedom was also seen in the selection of films that were shown on a noncompetitive basis. There was a special retrospective on Algerian war epics and on Latin and Central American Third Cinema films.[4] There were also anti-apartheid films.

Another feature of FESPACO 1985 was a colloquium on African literature and film. African writers such as Mongo Beti and Kitia Touré, filmmakers Ousmane Sembène and Haile Gerima, critics, historians, and many others were brought together to discuss the possibilities of adapting African literature into film. There were also films adapted from oral literature: *Toula* (1972) by Moustapha Alassane, *Wend Kuuni* (1982) by Gaston Kaboré, and those adapted from written literature such as *L'aventure ambigue* (1984) by Jacques Champreux and "Petanqui" (1984) by Yea Kazoloa from the novel *Quinze ans, ça suffit* by Ousmane Amadou.

The purpose of the colloquium was to make accessible to the public at large the rich body of African literature which is so far only available to a small elite who know how to read and write. As Algerian critic Azzedine Mabrouki put it, "Because film is the only cultural product which is capable of reaching the largest number of audiences (television has not yet made its impact on Africans), it can be used to mediate between the written works and the African audiences."[5] In other words, the filmmakers must familiarize themselves with African literature and learn narrative techniques and rhetorical devices from it. This will not only make the film more coherent historically and ideologically, it will also contribute to the poetics of African cinema.

Most of the discussion centered around the notions of representations, verisimilitudes, and faithfulness to the original text. Champreux's adaptation of the *Ambiguous Adventure* by Cheick Hamidou Kane was criticized, for example, for not being true to the characters and the decor of the book. It was argued that the dignified air with which the Djalobés group is portrayed in the book, and for which it is known in West Africa, is missing in the film. Champreux is also said to have overemphasized the Senghorism or the

symbiosis between cultures. For Champreux, this marriage between cultures is necessary, and those who cannot adapt to it become insane and dangerous like the fool in the film. Critics said that in the book, Kane had deliberately left the issue ambiguous. Others argued that the strong point of the film was to have clearly explained to people the Senghorism that is in an elliptical Cartesian dialectic in the book.

The different criticism leveled at the film *Ambiguous Adventure* led Haile Gerima, an Ethiopian residing in the United States and director of *Harvest, 3000 Years* (1975), to say that it was not always a good idea to adapt into film African literature that is written in the former colonial languages. Arguing from personal experience, Gerima said that in order for him to film a script written in English, he must translate it first into Amharic, his mother tongue. During the translation process, several cultural subtleties may be lost. Another objection to the adaptation of African literature in English, French, or Portuguese is that the choice of the colonial language has already removed and deterritorialized the literature from its cultural setting. For all these reasons, Gerima believes that the oral literature is a richer and more authentic source of inspiration for African film.

Another important addition to FESPACO 1985 was the strong representation of Afro-American filmmakers, distributors, promoters, critics, and historians. There were special screenings of films from the Diaspora such as *Burning an Illusion* by Menelik Shabazz (Barbados), *Rue case nègres* by Euzhan Palcy (Martinique), *Passing Through* by Larry Clark (United States), *Losing Ground* by Kathleen Collins (United States), etc. The Afro-American filmmakers and historians gave a seminar at the Institut Africain d'Education Cinématographique de Ouagadougou (INAFEC), Africa's only international film school, on the issues of distribution, coproduction and student/scholar exchange. They discussed several ways they could work together and help one another. Drawing on his own experience in producing *Passing Through*, Larry Clark showed how African directors can cut the cost of producing their films, help each other with camera work, editing, and even acting, and not have to depend on expensive Hollywood studios or unionized cameramen and actors.

Gerima, who was at FESPACO 1985 both as a filmmaker and as the North American distributor of the Comité Africain des Cinéastes (CAC), signed distribution contracts with several filmmakers. There was the question of letting filmmakers from the Diaspora participate in the official competition of FESPACO in the future. Short of agreeing to this, the African filmmakers decided to study the issue and promised, at any rate, to open the future festivals more to their brothers and sisters from the Diaspora. Prix du Public (a new prize at FESPACO), which was open to all the films shown at FESPACO 1985, was awarded to *Rue case nègres* by Euzhan Palcy.

To turn now to the cultural significance of the festival, I would again like to focus on FESPACO 1985. In Third World countries, film is particularly important because, as a cultural vehicle, it can also communicate social and political issues. Film instructs and entertains by means that are not available in other representative arts. In Ouagadougou, the unique quality of film is understood by everyone. Every FESPACO is an opportunity for filmmakers to cover new issues and problems that are turned into cultural events for the festivalgoers to see. At FESPACO 1985, for example, Angolan director Ruy Duarte de Carvalho dramatized famine in a film called *Nelisita* (1984). The film tells the story of two families caught in the mythical "great famine." The narrative, which is drawn from two folktales of eastern Angola, beautifully depicts the hero, Nelisita, as he fights different evil spirits and survives the famine. Although the story has a once-upon-a-time aura to it, this is not an escapist film. De Carvalho intertwines the myth of folktales and the reality of famine in Africa today in an effective manner. Thus, what would have been a purely cathartic and escapist film in a consumer-oriented Western cinema, has here been given a historical and cultural dimension. By mixing the myth with current events, the film teaches the viewer how to survive famine. The film won second prize at FESPACO 1985, giving de Carvalho (a Portuguese by birth, an Angolan by citizenship), who has been making documentaries in Angola since 1975, his first international recognition as a director.

Paul Zoumbara from Burkina Faso is another director at FESPACO 1985 who succeeded with *Jours de tourments* (1983) in broadening the concept of culture beyond entertainment. The film is about a young peasant, Pierre, who wants to change an arid patch of land into a garden. He forms a farmers' union with his peers in the village in order to dig wells and fight the drought. His ambitions of self-reliance threaten the merchant of the village who sells millet and rice. The film can also be "read" as a love story between Pierre and his fiancée, Sali. Pierre does not want to marry Sali until he is able to support a family. In *Jours de tourments*, Zoumbara broadens the concept of culture to lay claim on such social and political issues as agriculture for self-reliance, workers' unions, and migration to urban areas. For a revolutionary country like Burkina Faso where Sankara's regime is teaching people about freedom and self-reliance, films such as *Jours de tourments* are the best tools of instruction.

At FESPACO 1985, seeing Zoumbara's film with a Burkinabe audience was an unforgettable event. The film is in Dioula (also known as Bambara and Madinka), a language widely understood in West Africa. The Burkinabe spectator identifies with Pierre, the hero of the film, laughs with him or at the misfortune of his enemies, and sometimes even shouts at the screen in order to warn him against imminent danger. Seeing *Jours de tourments* with the Burkinabe is an experience comparable to seeing Superman with

Americans, with the difference that one is revolutionary and the other is escapist. FESPACO awarded Zoumbara the Oumarou Ganda Prize, which goes to the first feature film of a director whose creative efforts are particularly noteworthy. Other highlights of FESPACO 1985 were *Histoire d'une rencontre* (1984) by Brahim Tsaki (Algeria), a love story between two young people who are deaf and dumb and from different social backgrounds. Tsaki displays a remarkable talent by narrating the story through gestures. *Histoire d'une rencontre* won the Étalon de Yennenga. The best short film was awarded to *Arusi ya Mariamu* (*The Wedding of Mariamu*), codirected by Ron Mulvihill (United States) and Nanga Yoma Ngoge (Tanzania). The film is about the traditional science of healing, and it effectively depicts the conflict between tradition and modernity in a developing country.

The importance of film as a cultural and political act is also understood by African governments and international organizations. FESPACO is not only a platform for the dissemination of a pan-African spirit, but also a place to assert national identities. The international media is watching, and for each film that wins an award, it is a victory for the country of origin of the director. Furthermore, FESPACO is used as a platform to make political statements of international values. In front of television cameras and microphones, filmmakers and government representatives denounce the apartheid regime in South Africa. At FESPACO 1985, for example, Thomas Sankara, the head of state of Burkina Faso, gave a press conference not only to address film issues, but also to explain the domestic and foreign policy of the country. The delegate from the OAU said in his address to the press that FESPACO was the reflection of the most complete dialogue between African cultures. He believed that "every event of the FESPACO is a victorious moment for the OAU."[6] It was in this sense, he continued, that the OAU had decided to create a prize, the "Unity Awards," to promote African cinema.

It remains to assess the contradictions of FESPACO. The question of languages is at the heart of these contradictions. Some filmmakers and critics have accused FESPACO of having a francophone bias because the festival has so far been dominated by French-speaking countries and their films. The fact that most of the filmmakers, from the beginning of FESPACO to the present, have been aided by the French Ministry of Coopération has led some observers to point to a French neocolonialism in African cinema.

It is necessary, however, to look at the question of languages alongside the spirit of pan-Africanism that exists at every FESPACO. It is true that France participated in the founding of the Semaine du Cinéma Africain in order to promote films that were produced by the Ministry of Coopération. Furthermore, it is clear that francophone countries lead other African countries in production (excepting Egypt and the Maghreb) because of the production and postproduction facilities France has made available to

them since their independence. Dependence on French facilities has until recently prevented the francophone countries from building their own facilities of production and postproduction. But it seems to me that the strength of FESPACO has been gradually to dismantle French hegemony in Ouagadougou and to replace it with a pan-African hegemony. Because of the persistent criticism of the francophone bias by such African directors as Lione Ngakane and Gerima, FESPACO now provides earphones for non-French speakers, selects jury members from anglophone, lusophone, and Arabophone countries, and writes most of its programs in French and English. While it is true that the prestigious Étalon de Yennenga has so far only gone to Arab and francophone countries, at FESPACO 1985 anglophone and lusophone countries such as Ghana, Nigeria, Tanzania, and Angola won awards ranging from the Best Cinematography and the Critics Award (Ghana), Best Actress (Nigeria), Best Short Film, and the OAU Award (Tanzania) to the Award of the Seventh Art (Angola).

Another contradiction in FESPACO that, in my opinion, will also be solved with time concerns the Africanity of a film. In other words, is any film presented by an African government eligible for the official competition? At FESPACO 1981, Souleymane Cissé tried to stop *A banna / It's Finished* (1980) sent by Mali, arguing that the film was directed by a woman from Czechoslovakia instead of by the proposed author, Kalifa Dienta. The FESPACO overruled Cissé's objection without further investigation because it did not want to antagonize Mali. In the past, films co-directed by Africans and non-Africans had won awards at FESPACO. Some obvious examples are *Hydre dyama* (third FESPACO) by Moussa Kémoko Diakité (Guinea) and Gerhard Jeutz and *The Wedding of Mariamu* (1985) (ninth FESPACO) by Nanga Yoma Ngoge (Tanzania) and Ron Mulvihill. Some Afro-Americans present at FESPACO 1985 tried to stop *The Wedding of Mariamu* from participating in the competition, arguing that the film was presented in the United States as only being directed by Mulvihill. The objection came particularly from Pearl Bowser, who was a member of the jury and a film distributor in North America. It was overruled without further investigation. On the other hand, FESPACO also has to decide on the Africanity of films that are produced by African countries and directed by non-Africans, and vice versa. Such was the problem with *Le courage des autres* (1982) produced by CINAFRIC (a private production company in Burkina Faso) and directed by Christian Richard (France). The film was prevented from participating in FESPACO 1983. Filmmakers from the Diaspora want also to have their films included in the official competition. FESPACO has yet to accept them, but there is no doubt in Ouagadougou that their argument is a good one in view of the fact that their films promote African culture and they are suppressed in the West.

Only time and the prospect of a developed industry will solve these complex issues. Meanwhile, since the purpose of FESPACO is to encourage African production, the collaboration of governments and non-African directors is necessary in order to allow FESPACO to measure the efforts of those who have not had access to the camera until recently.

FESPACO has succeeded in interesting all the African countries in film production. Ouagadougou is now the place to score pan-African as well as national victories. Even though critics and historians of African cinema agree that the quality of the films at FESPACO 1985 was slightly below that of FESPACO 1983, no one was disappointed. There were so many cultural and intellectual activities going on in Ouagadougou that it will take more than the films in competition to evaluate FESPACO 1985—and for that matter any FESPACO.

Manthia Diawara has taught at the University of California at Santa Barbara and the University of Pennsylvania. He is the author of *We Won't Budge: An African Exile in the World* (Basic Civitas Books, 2003), *Black-American Cinema: Aesthetics and Spectatorship* (ed. Routledge, 1993), *African Cinema: Politics and Culture* (Indiana University Press, 1992), and *In Search of Africa* (Harvard University Press, 1998). He also collaborated with Ngũgĩ wa Thiong'o in making the documentary *Sembène Ousmane: The Making of the African Cinema*, and directed the German-produced documentary *Rouch in Reverse*.

Notes

Originally published as Manthia Diawara, "African Cinema and Festivals: FESPACO," in *African Cinema: Politics & Culture* (Bloomington: Indiana University Press, 1992): 128–139.

1. *Sidwaya: Quotidien Burkinabé d'Information et de Mobilisation du Peuple (Ouagadougou)*, no. 217 (1985): 6–8. For more information on FESPACO, see a series of articles by Omer Ousmane Ouédraogo, "Si le FESPACO, m'était conté," in *Sidwaya*, no. 217–22 (1985).

2. One of the most important events in the development of African cinema took place in 1970 when Upper Volta nationalized its movie theaters. It signaled a historic break between African cinema and the two monopolist companies, COMACICO and SECMA, and the beginning of national production subsidized by revenues from distribution and exhibition.

3. *9ème FESPACO: Cinema et Libération des Peuples* (Ouagadougou: Secrétariat Général des Festivals Cinématographique, 1985), 24.

4. On the theories and practice of Third Cinema, see Teshome Gabriel, *Third Cinema and the Third World: The Aesthetics of Liberation* (Ann Arbor: UMI Research Press, 1982)

5. El Moudjahid (Algiers), March 16, 1985.

6. Quoted in *Sidwaya*, no. 217.

FESPACO—Promoting African Film Development and Scholarship

M. Africanus Aveh

If there is any single event that has significantly developed and promoted African film over the past half century, then it is the Festival Panafricain du Cinéma et de la Télévision de Ouagadougou (Pan-African Film and Television Festival of Ouagadougou), or FESPACO, based in Ouagadougou, Burkina Faso, West Africa. The festival also has been a source of great scholarship in film studies.

Historical Development

At a meeting in Algiers in 1969, a group of African filmmakers decided to organize a "Film Week" to showcase African films produced on the continent and share creative ideas. The event was hosted in Ouagadougou, and its initial success led to the repeat of the event in the subsequent two years, with increased participation not only of filmmakers but also of attendees. This led to the formation of the Fédération Panafricaine des Cinéastes (Federation of Pan-African Filmmakers) with the acronym FEPACI. In 1972, the festival was instituted. It received official state support in Burkina Faso and was placed under a ministry. This marked the birth of the Pan-African Film and Television Festival of Ouagadougou with the acronym FESPACO. For fifty years, FESPACO has grown to become the most significant event in the promotion and development of African film through its biennial festival in Ouagadougou, Burkina Faso. It has become the converging point for showcasing African film as well as a congregation of the continent's filmmakers in one place. But for this festival, little would have been known of Burkina Faso even by its neighbors in the region.

The Organizational Structure

FESPACO is organized as a body corporate headed by a chief executive and staff operating a secretariat located in Ouagadougou. It is currently headed by Ardiouma Soma.[1] The secretariat is funded with budgetary allocations from the Burkina government and donor support from international agencies. The secretariat also houses the African Film Library, established in 1989 to preserve African film heritage. The library boasts a collection of original prints of African films and a restoration center for processing films for storage. It is a major resource for African film research in the world.[2]

The Festival Structure

FESPACO is a biennial film and television festival on specific themes. For the 2019 edition, the theme was "Memory and Future of African Cinema." Calls are made for full-length films to be submitted in competition for the grand prize, which takes the form of a stallion named after a royal princess warrior, Yennenga.[3] Other categories in competition are short films, documentaries, animation, television series, and student films from African film schools. Each competitive category has its own jury that adjudicates separately. Films in competition must be made by African nationals. There is, however, a Paul Robeson Prize for films made by Africans in the Diaspora. There are non-competitive special prizes awarded by juries according to certain laid-down objectives. The festival also screens a selection of non-competitive films from around the world.

The dates of the festival are fixed, beginning on the last Saturday in February and ending on the first Saturday in March in odd years. There is an opening ceremony, normally held at the sports stadium on the opening Saturday evening, with musical fanfare, dances, and gymnastic displays. The festival is symbolically opened with a giant clapperboard operated by the prime minister. The closing ceremony on the evening of the last day also normally has taken place at the sports stadium, with the juries' reports accompanied by the announcement of the winners of the awards in the various categories. Each winner is called to a podium to collect a statuette and a dummy check of the accompanying cash prize, culminating in the ultimate grand prize, which is presented by the president amid fanfare. After the awards ceremony comes a massive display of celebratory fireworks. In the past there was then a screening of the grand prize–winning film on a giant inflatable screen mounted in the middle of the soccer pitch. This has not been done for the past four or five festivals, so the closing ceremony ends with the fireworks display.

During the eight-day festival period, film screenings are held at several venues from morning until about midnight. The actual screening days are from Sunday morning to late Friday evening. There are no screenings on the Saturdays as preparations are made for the opening and closing ceremonies. Visitors arriving for the festival first visit the secretariat to get their accreditation tags and program brochures in order to plan their itinerary. At the end of the festival, the last Saturday can be used for shopping at the markets or sightseeing before attending the evening's ceremonies. The screening venues include proper cinema theaters, conference halls equipped with projection facilities, and some premises converted for screening just for the festival duration. These venues are spread throughout the city and into the suburbs, but a cluster of venues are within walking distance of each other. Open-air venues screen only at night for obvious reasons.

A comprehensive program brochure in English and French provides technical production details of the films, synopses, and detailed screening schedules to help participants choose which movies to watch at what time. There are early-morning press screenings of the full-length films competing for the grand prize. These are sometimes followed with press conferences by the production company, with the director and some lead actors in attendance. However, each screening session is preceded by a short introduction from the filmmaker or representative if present. Clusters of short films are programmed together in slots for a screening duration of up to two hours.

Accreditation is the key to participation in the festival. Interested participants must submit a completed accreditation form with picture by a set deadline in order to be accredited. Accreditation tags allowed free entry to screening centers in the past, whereas those without tags were made to buy entry tickets if space was available. The accreditation tags serve as identification and also as security for participants because the police provide protection for festival participants from abroad. The accreditation process additionally is used to generate the festival attendance statistics and data that are compiled into a directory of various film professionals as indicated on the form.

Another noteworthy feature of the festival is Marché International du Cinéma et de l'Audiovisuel Africains (International Film and Television Market), or MICA, established in 1983 to promote the sale and distribution of African films by linking producers to television network managers. A big exhibition space is provided, and partitioned cubicles are allocated to registered film producers to showcase their products and their companies for possible distribution deals with television networks. Equipment manufacturers and dealers also can be found there, demonstrating the latest digital technology in cameras and other production gadgets. A comprehensive brochure listing contact details for registered participants is available each year.

The festival is awash with musical concerts at multiple locations in the evenings, providing opportunities for dancing and socializing; drink vendors and food courts operate day and night, especially on the secretariat grounds; and a market square with a variety of items for sale, especially artifacts from the region, is also created at the revolutionary ground. These aspects of the festival create an atmosphere for socialization in a culturally diverse ground. It is an all-night event, making the festival period a long one, covering several days and nights without break.

Aside from the social and entertainment events, there are also creative, scholarly, and academic activities organized at multiple locations. The Federation of Pan-African Filmmakers (FEPACI) normally organizes its meeting and conference debate on the festival theme. Some issues of global appeal are also discussed, and declarations are sometimes made and a communiqué issued to propagate the stand of the federation. Since 2007, the Council for the Development of Social Science Research in Africa (CODESRIA) has organized creative and scholarly workshops and conferences on various themes during the FESPACO period. The council brings together film scholars and practitioners for several days of discussions on selected topics, usually with a keynote and plenary presentations. For 2019, CODESRIA organized a five-day institute on the theme "The Essence(s), Diversity and Economies of the (Pan)-African Arts: (Re)making and Confronting Memories and Futures."

Challenges and Changes over the Years

There have been changes in the way FESPACO is organized within the last decade or so. These changes have affected general participation and also filmmakers' submission of entries. The free entry to film screenings for accredited participants has been no more the case since 2011. It was a huge embarrassment personally as well as a financial burden when my students (numbering about forty) and I were asked to pay for entry tags for screenings in 2011, though we had accreditation as usual. Since 1999, under my leadership, a group of performing arts students from the University of Ghana in Accra has been traveling by bus to Ouagadougou to participate in FESPACO as an academic field trip. FESPACO gave some of the students a rare opportunity to experience cinema. This is because cinema houses ceased to operate in Ghana as such in the early 1980s, before the students were born, and thus they have grown up watching films either on television or as discs played on home electronic devices. The Silverbird cineplexes established in the two big shopping malls in Accra in the last ten years have some elitist status, and the entry fees are out of reach for the average Ghanaian. Some of these students have

not had the opportunity to be in a proper cinema theater. This accounts for the high enthusiasm for embarking on the sixteen-hour (or more, depending on delays at the border crossing) bus trip from Accra to Ouagadougou. So every festival year, application for accreditation was made by the deadline, and we arrived for the festival and picked up our tags that gained us entry to all screening events. The year 2011 was not to be. We had to pay for individual entry passes. That year we learned that some film-makers protested vehemently when meted the same treatment.

Additionally, festival brochures were in short supply, and some advertised screenings were swapped with different films. There were some logistical challenges that hitherto had not been so. Some people attributed the challenges to changes in management at the secretariat, while others blamed cuts in funding from the Burkinabe government as a result of economic problems. It was also heard that there was reduced support from France and the European Union as a result of the Ivory Coast political crisis in which French soldiers and nationals had been attacked by Ivorian rebels, with rippling effects on the francophone zone in West Africa.

FESPACO has not been able to overcome these challenges since 2011 as it has gradually lost some of its shine. The situation has been compounded by recent political turmoil on the national front, with the civil rebellion against President Blaise Campaoré's attempt to extend further his twenty-seven-year rule. The ensuing chaos of mass protests led to the destruction of the National Assembly building, with several official vehicles parked in the yard set ablaze. The rioting also extended to the nearby Hôtel Indépendance (also known as Azalai Hotel), where it was learned the members of the National Assembly were housed while attempting to review the constitution to back the president's plan for extending his stay. This hotel used to be the festival hotel where key African filmmakers and festival participants stayed during FESPACO. Thus, to meet, say, Ousmane Sembène, Djibril Diop Mambéty, or other big names in African cinema, one needed to pitch camp in this hotel's lobby.[4] This is no longer the case. The place has lain in ruins since 2014, a pale shadow of its former glory. Since then it has been difficult to locate where notable film-makers lodge during FESPACO because they are now scattered across the hotels in the city.

In addition to the national political upheaval that created tension and led to changes in political leadership, since 2014 terrorist attacks on the city have resulted in high numbers of casualties. Fortunately, the attacks have not happened during the festival period, but the effects on subsequent festivals have been very devastating. Attendance has dropped as a result of travel warnings issued by some countries to their citizens. There has been increased security during festivals, with people passing through metal detectors and security checks at cinema theaters and other events, resulting in long

queues and delays. Armed police and military presence all over the city can be intimidating to participants not used to such situations. Ouagadougou looks more like a war zone, with heavy gun trucks either stationed at vantage points or patrolling the streets. There are concrete crash barriers erected around selected buildings, along with stacked sandbags. There are several roadblocks, and certain places are even designated as "no walking zones." The insecurity has resulted in the opening and closing ceremonies of FESPACO no longer taking place in the sports stadium but rather transpiring at an indoor sports arena with reduced attendance. This has meant no fireworks display as characterized by previous festivals.

There was a security scare in 2015 when the Burkina government and FESPACO management debated whether to screen the controversial Mauritanian movie *Timbuktu* (2014) by Abderrahmane Sissako because of terrorists' threats against the film. The film is based on events of the infamous invasion of Timbuktu by armed extremists, and the extremists thus tagged the film "anti-Islam." In the end, the film was scheduled for a single screening amid tight security, resulting in two-hour-long security checks on people who waited in long queues to see the film. The Cine Burkina theater was jam-packed. The filmmaker was shepherded by about a dozen armed guards even inside the cinema theater during screening. This was unprecedented in the history of FESPACO.

Some of the cinema houses in Ouagadougou are no longer in operation. For example, the premises of Cine Oubri and Cine Riale are now used by market traders. These were two open-air cinema houses that screened films during FESPACO. The cinematic experience at these two theaters was very different from the experience at Cine Burkina, an indoor theater a stone's throw away. The kinds of viewers you will encounter at such venues are very different, and as such, reactions to events unfolding onscreen do not compare at all. Thus, as a film scholar, I used to watch selected films at the air-conditioned elite Cine Burkina and do the same at the open-air bench-seating Cine Oubri and undertake film audience research. The results were very interesting. Cine Nerwaya, also in Ouagadougou, was in a state of disrepair in 2017, which made viewing films there not too comfortable. However, new cinema houses continue to be opened in Ouagadougou. Cine Guimbi opened in 2017, and Canal Olympia also has opened two new cinema theaters in Ouagadougou since 2017.

There were some significant changes to FESPACO that are worthy of note. The organizers in 2011 broke the top award into three categories: gold, silver, and bronze. It used to be only one Yennenga stallion prize for the winning full-length film. The accompanying cash prizes were also increased. These were attempts to revamp the festival to attract more film entries. Over the years, FESPACO had also accepted only 35mm celluloid film prints for films in competition, which placed a burden on filmmakers shooting in the

digital mode to make film transfers at a huge cost in order to compete in the festival. This allowed francophone films to dominate the festival because digital filmmaking has been the dominant format in anglophone Africa. The francophone African filmmakers were able to produce in 35mm with the support of grants from France.[5] Though many anglophone filmmakers made very good films in the digital format, the high cost of transferring to 35mm print prevented them from making any prominent appearances at FESPACO. Such digital-format productions were labeled by FESPACO management as "video," were consigned to some obscure low-key screening centers, and were not accepted in competition. This explains why anglophone African films have not featured too prominently in the top awards at FESPACO. To date only three have taken the top award: Kwaw Ansah from Ghana won with *Heritage Africa* in 1989; Zola Maseko from South Africa won with *Drum* in 2005; and Newton Aduaka of Nigeria (but based in France) won with *Ezra* in 2007. FESPACO management decided from 2015 to accept digital copies in DCP format for full-length films and to accept DVDs for short films. This has resulted in a significant increase in film submissions to the festival from across the continent. In addition, Africans in the Diaspora are now allowed to compete for the awards in all categories.

Significance and Contribution to Development of African Film

FESPACO has been dubbed the "African Oscars" in comparison with the Academy of Motion Picture Arts and Sciences based in North America. Though the two are not the same, they compare in the way filmmakers serve as the backbone of each event. Without the Federation of Pan-African Filmmakers, FESPACO would not have come into existence or even survived over the years. It has been the productions of the filmmakers that have supported the festival and allowed it to thrive. On the other hand, without FESPACO, there would have been no platform for African filmmakers to generally showcase their craft. Thus, FESPACO contributed immensely to the development of African film by offering it visibility. Due to the distribution bottlenecks of films, especially in Africa, films produced by African filmmakers do not get shown to Africans on the continent. The problem is compounded by the absence of cinema theaters across the continent. Ghana, for example, could boast of many cinema theaters in the capital Accra and other towns across the country up to the early 1980s. Then operations ceased due to several factors discussed elsewhere.[6] FESPACO, therefore, has been the avenue by which some of us have been fortunate to watch films produced by African filmmakers. It also created the opportunity for me and my students over the years to meet in person some of the big names in African

cinema at FEPACI conferences. Despite the challenges already discussed and the reduced shine of FESPACO, it still maintains some significance, especially in the operation of the African Film Library, already discussed, as preservation of cultural heritage.

The Durban International Film Festival (DIFF) in South Africa is another major film festival on the continent, and some have argued that it has overtaken (or will overtake) FESPACO in terms of scale of organization. That assertion to me is difficult to support, given that the two are not easily comparable due to differences in their features. DIFF (unlike FESPACO) is an annual event established and run by the Centre for Creative Arts at the University of KwaZulu-Natal, Durban, South Africa. It is also a weeklong festival with screenings at several venues across the city and spreading into the suburbs. A special unique feature is the "Wavescape," films on surfing screened at the Durban beachfront to sporting enthusiasts especially. Unlike FESPACO, DIFF accepts entries in competition from all over the world but has special prizes for South African productions. DIFF operates the Durban FilmMart, which is very different from FESPACO's market, MICA. The Durban FilmMart is a platform where selected film producers pitch their productions before potential financiers at a forum for serious film business. DIFF also has a Talent Campus affiliated with the Berlinale film festival where selected young filmmakers and critics across the continent are taken through master classes and workshops by established filmmakers in a kind of mentoring program. Unfortunately, there are no scholarly conferences organized as part of DIFF where academic presentations can be made, despite the fact that it is located at a university. The ability to sustain the yearly event to its fortieth anniversary in 2019 is very commendable. DIFF also has contributed greatly to the development of South African film (and for that matter, African film) through its special competitive category for local films separate from all others. It has therefore been a platform for premiering South African productions before they are distributed worldwide. I noticed the nationalistic flavor of the festival when I attended in 2012. However, similar to circumstances in Ouagadougou, there is concern about creeping insecurity in Durban, with recent reported xenophobic attacks on African nationals by South Africans. In a discussion with my students about our possible participation in the future, some of the students raised this issue as a mitigating factor against their interests in attending DIFF.

The Ideal Film Festival

Film festivals contribute immensely to the development of film in many ways. Therefore, the inclusion of attendance at film festivals in the film studies

curriculum in academic institutions should be supported. Film festivals should have features that cover the various aspects of film as a creative endeavor, a business enterprise, a cultural artifact, a social developmental tool, and an academic and scholarly event. My ideal film festival would therefore embrace all these in its organization. There are emerging industry events on the continent where filmmakers are just awarded for films entered into a competition, without any associated screening schedules. In some cases, a film that has not yet been released for public screening has been awarded. In such circumstances, people do suspect that some producers buy the awards in order to hype their films before they are released. These awards ceremonies are copying the Oscars but forget that the Academy Awards is anchored in an industry with distribution and exhibition outlets. Thus, films are released into theaters and are seen by many before the Academy votes to nominate them for the various categories and finally votes for the ultimate winners. African Movie Academy Awards, based in Nigeria, has no serious "academy" of filmmakers in Africa. It just calls for film entries, and a jury then decides the awards, and a public event is organized to present the winners with all the pomp and glamour that sponsorship can promote. In the absence of cinema theaters across the continent, Africans watch films mainly on television (either free over the air or through subscription), through Internet downloads where available, or through shared pirated copies. Thus, many of these films being awarded at these events are not seen by the majority of the people until later, when they become available on television. These awards therefore are detached from film audiences in Africa. They are just "show-off" events for people in the entertainment industry.

Film awards also should carry some prestige to boost the morale of filmmakers. An award is recognition for hard work, perseverance, and creativity. It should be respected by people both within the industry and outside of it. It should be very competitive to be targeted by industry players. Some African filmmakers now carry their films through festival circles across the globe for a period before releasing them to theaters and other distribution and exhibition outlets. They stamp their films with all festivals they have participated in. Film awards should also carry with them some financial rewards in the form of accompanying cash prizes. This is because film production is capital-intensive, and in our parts of the world, where the industry is still struggling for support and production funds are very limited, cash prizes become a form of welcome revenue for defraying part of production expenditures. The top prize at FESPACO has a cash award of twenty million CFA (equivalent of 34,000 US dollars). The cash prize for the Best Feature at DIFF is fifty thousand Rand (equivalent of 3,500 US dollars). These amounts will cushion a filmmaker against production costs yet to be recouped.

It is very interesting hearing filmmakers discuss their concepts and production processes, including challenges that they had to overcome to get to the screen. Film discourse with or without filmmakers promotes scholarship as well as creativity. There is nothing like a "perfect art," and it is through reviews and criticisms that art gets improved. Thus, a film event that includes a gathering of scholars, critics, and practitioners debating issues on a given theme, broadly and relating to specific films, is of high academic interest. Therefore, it is a little disappointing that the Durban International Film Festival has no scholarly session despite being anchored in an academic institution. What DIFF organizes is a film business forum where producers and financiers discuss funding opportunities and processes. Perhaps adding a two- or three-day conference on film as part of DIFF would be a plus for the University of KwaZulu-Natal.

Contribution to Scholarship

I first attended FESPACO in 1997 on a fellowship under the CODESRIA African Humanities Institute Program, at the University of Ghana, Legon. I was among a group of selected African fellows who were sponsored to participate in the festival. Apart from attending numerous film screenings and press conferences by film production companies on their films in competition, fellows also observed heated debates at FEPACI meetings on various issues. We also held our own sessions where we discussed not only the films but the organization of the festival as well. As a young lecturer then, I was struck by the rich resource that the festival provided for film studies and decided that my performing arts students who were taking courses in film, video, and television would gain some practical experience from this festival. So in 1999, I took about a dozen students, mostly in their final years, to FESPACO. The road trip was tiring but worth it. This initial success pushed me to officially apply to university authorities for approval to make FESPACO a field trip for students. In effect, I have attended the festival with students from the University of Ghana for the past twenty years, and the benefits have been great despite some challenges.

As earlier discussed, these students are not familiar with the era of cinema in Ghana in which the Ghana Film Industry Corporation operated cinema theaters across the country where both local and foreign films were screened daily. For them, cinema is watching films on television, slotting in a DVD and watching on monitors, or in recent times, watching on smartphones and tablets. The closest thing to a cinematic experience is when video projectors are used to screen DVDs in large halls. The trip to FESPACO, with special arrangements to visit the projection rooms of the cinema theaters and

see films on reels being loaded onto celluloid film projectors, has been an experience of a lifetime for students. They could now relate to what they study in film history about the development of film with experiments in projecting still photographs in a way to create the illusion of motion on a screen.

Opportunities to meet up-close some big names in world cinema also have arisen. The students have met and heard some of these filmmakers speak about their productions and experiences. Photo opportunities have not been missed. It was hysterical for some students to meet and talk to the Nobel Literature Laureate Wole Sonyinka at one of the FESPACO events in 2013. Hearing these personalities speak directly is not the same as reading what they reportedly have said in textbooks and journal articles.

The students also have been made to predict which competing films are likely to win awards. Exciting debates have ensued up till the announcement of the winners on the final day and even after on the return trip, with students trying to figure out what went on in the minds of the jury in selecting winners. They have studied various strategies that filmmakers adopted to popularize their productions, including poster and banner design and parading the streets of Ouagadougou with busloads of cheering squads displaying large banners of the film in competition. The festival also has offered ample avenues for audience research, where students notice which films are sold out and which are poorly attended and also appreciated. There additionally has been the issue of the francophone and anglophone divide clearly displayed in films in the festival as well as among participants and the hosts. FESPACO has offered studies in curation, event programming, and management. Students' essays and theses on FESPACO over the years have been varied in topics but have demonstrated acquisition of rich knowledge.

Conclusion

There are now avenues for African filmmakers to showcase their productions outside the continent, with the emergence of several film festivals featuring categories for African films. Thus, when the challenges for FESPACO began impacting negatively on the organization of the festival, African filmmakers began to look elsewhere. Cannes, London, Berlin, Tokyo, Sydney, Toronto, Los Angeles, New York, and many other cities have film festivals that now attract African films. Though the filmmakers are getting exposure on supposed global stages, they are alienating themselves from their home audiences, who still do not get to see these films despite being the source of their stories.

Participation in these film festivals happening around the globe is beyond the average African in terms of cost and cumbersome processes. I

can imagine the hurdles to surmount if I were to attempt to take even two of my students to any of the film festivals listed previously, especially in securing visas to travel, not to mention cost of flights. The alternative, then, is depending on media reports for studies on these festivals. But these media reports can be very subjective and misleading, especially with the rise of fake news. Firsthand experience at such events is required for scholarly discourse. There is the need, therefore, to develop more film festivals on the continent. There are some fledgling film festivals in Ghana hoping to grow over the years to the stature of FESPACO—the Black Star International Film Festival curated by Juliet Asante, the Ndiva Women's Film Festival curated by Aseye Tamakloe, and my own Legon International Film Event. With adequate support, these festivals will grow to become resources for film scholarship just as FESPACO has been for over half a century.

M. Africanus Aveh is the Head, Department of Theatre Arts, School of Performing Arts at the University of Ghana. He is a specialist in Radio, Film, Television and Video Studies and has supervised numerous student academic essays, projects and creative videos. He speaks English, Norwegian, Swedish, French, and many local Ghanaian languages.

Notes

Originally published as M. Africanus Aveh, "FESPACO—Promoting African Film Development and Scholarship," *Journal of Film and Video*, vol. 72, no. 1–2 (Spring/ Summer 2020): 58–66.

1. For profiles of the current and past chief executives of FESPACO, see "Délégues Généraux Fespaco," *FESPACO*, https:// fespaco.bf/ delegues-generaux-fespaco.

2. "Presentation of the Cinematheque," *FESPACO*, https://fespaco.bf/en/presentation -cinematheque.

3. Nduta Waweru, "Yennenga the Dagomba Warrior Princess Whose Son Founded the Mossi Kingdom of West Africa," *Face2Face Africa*, 7 July 2018, https:// face2faceafrica .com/article/yennenga-the-dagomba-warrior-princess-whose-son-founde-the-mossi -kingdom-of-west-africa. Accessed 23 May 2019.

4. Manthia Diawara has an interesting account of his experience at Hotel Independance in chapter 1 of his book *African Film: New Forms of Aesthetics and Politics* (Prestel: 2010).

5. This issue is discussed in detail in Manthia Diawara's *African Cinema: Politics and Culture* (Bloomington, Indiana: Indiana University Press, 1992) by Bakari, Cham, and Diawara.

6. Africanus Aveh, "The Rise of the Video Film Industry and Its Projected Social Impact on Ghanaians" *African Literature Today*, vol. 28 (2010): 122–132; Manthia Diawara, *African Film: New Forms of Aesthetics and Politics*. (Prestel, 2010. Durban International Film Festival), https://www.durban filmfest.co.za/, Accessed 13 Feb. 2019.

FESPACO and Cultural Valorization

Mahir Şaul

What eventually became FESPACO started as a whiff of *cinéphilie*, occurring in advance of the struggles between the Burkinabe government and the French distribution firms or the production of local films. In 1968, a group from the French cultural center in Ouagadougou and the president of the local ciné-club met with the executives of the national TV station, officials from the information and education ministries, researchers from the local branch of the Institut Fondamental d'Afrique Noire, and other public personalities to think about how to provide the city's population with access to the new African films. The resulting 1969 Semaine du Cinéma Africain (African Cinema Week) was modestly titled but brought together the necessary elements for a recurring festival: a supply of films from the Paris Ministry of Cooperation, the enthusiastic participation of African filmmakers, including especially Ousmane Sembène, and the promise of continuing support from the national government.[1]

In the following three years, the setting up of a national film import and theater management company and the consolidation of a periodic international African film festival went hand in hand. In 1972, the festival acquired permanent structures, included competition and a grand prize, and assumed its present name, FESPACO (Festival Panafricain du Cinéma et de la Télévision de Ouagadougou). The same year as the first full-length feature film of the country, *Le sang des parias* (*The Blood of the pariahs*) by Mamadou Djim Kola, FEPACI, which had been recently created, gave its support and its contacts fully in the service of the festival. To avoid competition with the established film centers of North Africa, FEPACI arranged for the FESPACO festival to take place once every other year, in odd-numbered years, so as to alternate with the festival in Carthage in Tunisia.

Over the years FESPACO became more than a showcase for African filmmakers, or a place where foreign distributors meet filmmakers and critics view recent movies. Filmmakers themselves see each others' films during the festival, become acquainted with one another personally, discover reactions to their collective work, and get fired with inspiration. The festival created a

cinema community in sub-Saharan Africa, and a site from which cinematic influences and fashions radiated.

The enthusiasm of cinephiles, filmmakers, and government officials was not initially shared by the intended beneficiaries of the festival, the Ouagadougou population. Sembène drew a conclusion with humility: "The public saw our movies, with all their insufficiencies, and was perhaps disillusioned, because perhaps they do not conform to its wishes. But if government authorities all over Africa gave us some consideration, we may reach the point of fulfilling its expectations." Mamadou Djim Kola communicated greater frustration: "Over the course of the years our public underwent the influence of images and developed ... a passion for cinema [but] their minds absorbed some of the most negative aspects of a certain kind of cinema ... The public often remains indifferent to the African film, even apathetic, if it doesn't reject it outright."[2]

In anticipation of this reaction, outreach activities were organized as early as the 1969 African Cinema Week to teach the population to like African movies. Eventually audiences embraced the festival; viewers went from ten and twenty thousand in 1969 and 1970 to a hundred thousand in the late 1970s, when they were still mostly locals, and to about four hundred thousand in 1987.[3] The twenty-first edition of the festival, in 2009, had an estimated attendance of five to six hundred thousand. This reminds us that the anticommercial reputation of francophone films needs some modification. Sembène's films *Mandabi* and *Xala* (1974) were extremely popular in Senegal; Kramo Lanciné Fadiga's *Djeli* (1981) beat all box office records when it opened in Abidjan; Gaston Kaboré's *Wend Kuuni* (1982) remains an all-time hit in Burkina Faso.[4]

Despite showing a concern for increasing the size of the movies' audience, it remains true that from its beginnings FESPACO was guided by an art conception of cinema and by cultural nationalism rather than by entertainment or market value. In the words of the festival's official 1969 communiqué, "We intend to affirm the existence of an African cinema, made in Africa, by Africans, on African topics. These recent works ... allow one to understand that cultural values are part of the African heritage just as much as traditional values."[5] These words accord with the opinions of Paulin Vieyra, namely that African cinema would contribute a critical new Sembène voice to universal art, provided European audiences could be open-minded enough to welcome diversity. Nourished by African values, African film would at the same time stimulate the growth of a new African civilization.[6]

Filmmakers and critics aspired to works of lasting value, which meant that even the release of a picture did not relieve the burden of improving it. Vieyra reports, for example, that Moustapha Alassane's *Women, Cars, Villas, Monay / F.V.V.A.: Femme, Voiture, Villa, Argent* (1972, Nigeria) won the OCORA Prize at the 1972 FESPACO, but his friends and film buffs were

dismayed by the poor soundtrack of the movie. Alassane promised them that he would use the prize money to redo the soundtrack.[7] When we consider how scarce film funding was in those years, the direction in which peer pressure was exercised in this case is very revealing. An important sum of money was given to director Alassane for his accomplishment, but his friends in the film establishment encouraged him to spend this prize money not to start a new filming project but to correct a flaw in the already finished and prized film. And this was done not because anyone thought that the extra expenditure would increase the finished film's box office prospects, but only to add value to what people thought had the potential of becoming a future African film classic. Besides the commitment to creating works for the posterity, the director was expected to represent African culture. French art influence was not the only reason for this commitment; it also grew out of the decolonization ethos, as can be appreciated in accounts given by Onookome Okome and by Birgit Meyer of Nigerian and Ghanaian intellectuals who accuse the video film industries of their nations for presenting Africa to the world in the degrading terms of superstition, crime, violence, and magic.

In the beginning, the search for a proper African aesthetic encompassed both the desire to "contribute to universal art" and an effort to reach the local audience. Vieyra opted for medium-length static shots of long duration, which research (of colonial origin) suggested would help the viewers comprehend the story.[53] Sembène held a contrasting opinion: "We looked at our films, and discussed them . . . often in our films there is too much talk and the rhythm is slow. We have to change that. Films with less talk, more rapidity, and much more explicitness are needed."[8]

Today these words will reveal a certain irony, because established critical opinion associates Sembène's films with slow pace, the reverse of what he wanted to achieve. There was some ambiguity in the value assigned to cinema itself in the larger struggle for an African high culture. Sembène, on the heels of his first great triumph with *La noire de... / Black Girl* (1966, Senegal) said in a French radio interview, "I would have preferred for us, for Africa, that there were more readers than film buffs. I consider literature a more complete art where you can really plumb a person. With cinema, in our country, things stay at a very elementary level."[9]

Mahir Şaul is a Professor of Anthropology at University of Illinois Urbana-Champaign. His research spans two world areas, Africa and the Middle East, and considers household organization, economic and political history, the transnational movement of people and ideas, and language and visual arts in their social context. On the heels of an African film festival in Urbana, Illinois, he curated in 2012 a high profile African film series for the Istanbul Museum of Modern Art in Turkey.

Notes

This selection was originally published in Mahir Saul, "Art, Politics, and Commerce in Francophone African Cinema," in *Viewing African Cinema in the Twenty-First Century: Art Films and the Nollywood Video Revolution*, ed. Mahir Saul and Ralph A. Austen (Athens: Ohio University Press, 2010): 133.

 1. Patrick G. Ilboudo, *Le FESPACO, 1969–1989: Les cinéastes africains et leur oeuvres* (Ouagadougou: Editions La Mante, 1988), 114–19; Teresa Hoefert de Turégano, *African Cinema and Europe: Close-up on Burkina Faso* (Florence: European Academic Publishing, 2004), 62–65. The then military ruler of Upper Volta, Maj. Gen. Aboubakar Sangoulé Lamizana, was won over in part by the choice for the opening screening, Oumarou Ganda's Cabascabo, a film about a soldier who returns to his native Niger after fighting (as Lamizana himself had done) for France in Indochina.

 2. Both quotes in Ilboudo, *FESPACO*, 116.

 3. Ibid., 139.

 4. Philippe Maarek, ed., *Afrique noire: Quel cinéma?* Actes du colloque Université X Nanterre, December 1981 (Paris: Association du Ciné-Club de l'Université Paris X, 1983), 69; Hoefert de Turégano, *African Cinema*, 255; Mahir Saul, "History as Cultural Redemption in Gaston Kaboré's Precolonial-Era Films," in *Black and White in Colour*, ed. V. Bickford-Smith and R. Mendelsohn (Athens: Ohio University Press, 2007), 26–27. For other popular FESPACO films see Melissa Thackway, *Africa Shoots Back: Alternative Perspectives in Sub-Saharan Francophone African Film* (Bloomington: Indiana University Press, 2003), 11.

 5. Quoted in Ilboudo, *FESPACO*, 115. 51. Paulin S. Vieyra, *Le cinéma africain des origines à 1973* (Paris: Présence africaine, 1975), 245–46.

 6. Ibid., 143. OCORA (Office de Coopération Radiophonique) was created in 1955 by the French state radio and TV company (RTF) to promote radio programming in the colonies.

 7. J. M. Burns describes colonial research conducted in British Africa to discover native viewing habits and help develop a simplified film language that could lead to effective educational and propaganda films, including the work of L. A. Notcutt and G. C. Latham. Burns, *Flickering Shadows: Cinema and Identity in Colonial Zimbabwe* (Athens: Ohio University Press, 2002), 37–59.

 8. Ousmane Sembène, "Interview with Ousmane Sembene," by Teshome H. Gabriel, *Third Cinema in the Third World: The Aesthetics of Liberation* (Ann Arbor: UMI Research Press, 1982), 115. Compare this opinion of Sembene's with the remarks of a freelance editor whom the Bureau of Cinema often hired to work on African films: "I often reproached those young people, for their cinema was a cinema of dialogue; for me cinema is … images … But for them it was dialogue. Even Sembène. I believe that dialogue is part of the African mentalité." Andrade-Watkins, "France's Bureau," 124.

 9. Reproduced in Paulin S. Vieyra, *Sembène Ousmane, cinéaste* (Paris: Présence Africaine, 1972), 188.

African Cinema: Between the "Old" and the "New"

Mbye Cham

As we mark and celebrate the fiftieth anniversary of FESPACO this year, I want to dig up and share a short essay I wrote back in 1998, reflecting on trends and tendencies then in African cinema, focusing basically on continuities, ruptures and transformations in African filmic practices over time. Although the specific time frame I was dealing with in that essay is now more than two decades past, I want to believe that the general concepts and dynamics highlighted in the essay are useful today as we take stock of and engage the very exciting shifts or lack thereof (positive or not so positive) in just about all areas of African film practices since the dawn of the new millennium. Here is what I wrote back in 1998.

Not unlike many film and narrative cultures in other parts of the world, African cinema is marked by a relatively substantial degree of intertextuality, a description I use here to refer to the many ways in which the ensemble of films that constitute the current corpus of African cinema relate to one another, and particularly the ways in which certain recent African films relate to earlier ones, be it by way of repetition, revision, sampling, parody or transgression, or a combination of these and a few others. Many of the recent films entertain specific types of relations to ones that preceded them. They may exhibit characteristics and features (in terms of subject matter, theme, style and language) that may elicit the label of 'new,' but they also resonate in various ways with elements that characterize many earlier films. Convention as well as 'common sense' have it that few things under the sun are really new, and that few things occur in a vacuum, without reference or relationships to antecedents, whether conscious, willful, purposeful or not, and certainly, the realm of African cinema yields its own modes, patterns, and rationales of referencing, resonances and relationships.

These are varied and complex, embracing not just the relations on a variety of levels between 'old'/pioneer/first generation films and younger/'new generation' films, but also the ways in which these two categories of

films engage the resources of African indigenous artistic and popular traditions, in particular, as well as other, mainly western, traditions and practices. They also involve relations between films made by the same director over a period of time. How do recent films such as *Tableau Feraille* (1999, Senegal) by Moussa Sène Absa, *Clando* (1996) by Jean-Marie Téno, *Asientos* (1995, Cameroon) by François Woukoache and *Pièces d'Identité* (1998, Cameroon) by Ngangura Mweze, for example, stand in relation to earlier films such as *Xala* (1973, Senegal) by Ousmane Sembène, *Soleil-O* (1971, Mauritania) by Med Hondo, *Reau Takh* (1972, Senegal) by Mahama Johnson Traoré and *Black Goddess* (1975, Nigeria) by Ola Balogun, respectively? How do all of these films implicate their respective indigenous and other traditions of creative practice? And what lines of filiation can we trace in the work of, say, Senegal's Safi Faye, from *Lettre Paysanne* (1976) to *Mossane* (1997), or between *Wend Kuuni* (1982) and *Buud Yam* (1997) by Gaston Kaboré of Burkina Faso and can we label *Borom Sarret* (1963, Senegal) the template on which the rest of Sembène's subsequent film work is erected? I believe that pondering such questions can shed much light on issues of continuity, change, rupture and novelty in African cinema practices.

Such issues have always preoccupied African filmmakers from the very start in the late 1960s and early 1970s. They persist to the present moment, and filmmakers and others continue to debate the myriad challenges that have perennially faced them, as they explore paths and strategies that could possibly enable them to break out of the confined spaces within which they have been operating thus far. For some of the younger ones, especially, the answer is a clean break with the past, the imperative of new directions, the urgency to install new modes of signification for African films to become more 'commercially viable', more appealing to audiences, both in and out of the continent, in short, to become more 'Cinema', period, more 'universal.' Such pronouncements of the imperative of change and renewal, of a different and viable and truly African cinema have always been a prominent feature of the creative and activist agenda of African filmmakers, evident in the numerous manifestos (Algiers 1975, Niamey 1982, and others thereafter), as well as groupings such as the Comité Africain des Cinéastes (Med Hondo, Ousmane Sembène, Tahar Cheriaa, Lionel Ngakane, Haile Gerima etc., the so-called "Les Anciens") whose purpose was/is the advancement on all fronts of African cinema. Such pronouncements also animated the short-lived moves in the early and mid-1980s of the group of then young filmmakers (Cheick Naigdo Ba of Senegal, Gaston Kaboré of Burkina Faso, then still Upper Volta, Kramo Lanciné Fadika of Côte d'Ivoire, and many others) who mobilized under the banner of *L'Oeil Vert* to militate for new directions and practices for African cinema. Whether the results (textually speaking) matched the vigor of the rhetoric is a matter of debate. Cheick Ngaido Ba, one of the leading and most

vocal advocates of *L'Oeil Vert* went on to make *Xew Xew* (1984) before dropping out to become a political operator in Senegal; Gaston Kaboré came out with *Zan Boko* (1988), followed by a series of shorts and his latest feature, *Buud Yam* (1997), which can be seen as perhaps the first 'sequel' in African cinema; and Kramo Lanciné Fadika, after winning the Étalon de Yennenga for his film *Djeli* at FESPACO 1983 from Ivory Coast, followed with his most recent feature, *Wariko* (1994). How new and different are these in relation to earlier ones by the same directors as well as by other directors? When we consider the ensemble of issues animating current debates referred to above, are there elements that constitute a throwback to the recent period of the early and mideighties and before? What is new in 'new' recent African films?

Commentaries by some filmmakers and critics on recent African films posit novelty and difference [thematic as well as formal] as hallmarks of the recent productions of the nineties, which, in turn, signal shifts and departures in relation to their predecessors of the early days of African cinema of the 1960s and 1970s. Among many other elements, they draw attention to acceleration in the pace of some recent films (as opposed to the slow rhythm and pace of earlier ones), higher production values (as opposed to lower quality visuals, sounds, scenario), their urban, cosmopolitan, and metropolitan locales (as opposed to the predominantly rural, 'bush' locations of earlier films), their unabashed referencing and appropriation of western, particularly African American and MTV-type, hip-hop styles and languages (as opposed to narrow ethnic references), their more open engagement with and display of gender and sexuality (as opposed to a certain prudishness of earlier films), their embrace of hybridity, racial and cultural, as the direction of the future (as opposed to a narcissist and essentialist racial, ethnic, and cultural nationalism), their stress on the individual and desire (as opposed to the communal focus and concerns of preceding films), their deemphasis of or flight from politics and ideology (as opposed to an obsession with nationalist politics and ideology and grand narratives of oppression and liberation characteristic of earlier films). In short, the absence of marks of the older films in the new ones is figured as a significant difference, which brings the latter closer to what is considered 'normal' or more 'universal' cinema, thus increasing their fortunes in the normal circuits, both domestic and beyond. And in this lies, to a degree, the future development of African cinema. As with the case of *L'Oeil Vert*, I believe time will be the arbiter of such prognosis.

In the meantime, I want to subject some of these observations to some scrutiny to see what patterns emerge from juxtaposing old and new films. I am not interested in invidious comparisons, for such undertakings yield little of value in attempts to situate and understand the nature of the ties or lack thereof between recent and earlier African films, nor am I suggesting a stasis, a lack of movement in African cinema as a whole from earlier times to the

present in my argument that traces of the old mark the new in many ways. I am not speaking of influence of the old on the new, either, even though such influences have been acknowledged and can be traced and identified in some cases. Not to speak about the relations between the old and the new in terms of influence helps avoid the trap of erecting the old as norm, as the yardstick with which to measure recent films which should be taken on their own terms. The relations are dialogic and dynamic, I believe, and the many ways in which the old is manifest in the new are, to my mind, complex, productive and transformative. In this view, the old is regenerated with a difference within the framework of different or even new orientations and styles.

Remakes and sequels are rare, even non-existent, in African cinema at the moment. With the exception of *Buud Yam* which, in spite of Kaboré's initial resistance, many spectators and critics consider *Wend Kuuni Part 2*, I cannot at the moment recall any other two or more African films by the same or different directors that can be placed together in this manner. Although Djibril Diop-Mambéty characterizes his work in terms of two sets of trilogies, one set of his feature films dealing with power and insanity, *Touki Bouki* (1973), *Hyènes* (1992) and the projected *Malaika* (interrupted due to his untimely death in August 1998), and the other set of his recent short films labeled "Tales of Ordinary People," *LeFranc* (1994), *La Petite Vendeuse du Soleil* (1999), and the projected *L'Apprenti Voleur* (also interrupted), one cannot speak of remake or sequel in this case, either. What obtains, instead, in African cinema generally, especially between old and recent productions, is a complex web of relationships whereby recent films purposefully or unconsciously continue, revise, recontextualize, allegorize, parody, contest, and subvert aspects and elements of earlier films at the same time they project new concerns and new styles and expand into hitherto uncharted domains.

It is unproductive to speak of a total absolute divorce and disconnect between the old and the new, for such is never the case in any narrative tradition. In African cinema, the odor of the founding fathers is still present. Take an earlier film like *Xala* and a recent one like *Tableau Ferraille*. The rise of fall of Daam Diagne narrated in Moussa Sène Absa's 1997 film *Tableau Ferraille* invites parallels with the fortunes and fate of El-Hadji Abdou Kader Bèye in Ousmane Sembène's 1973 feature, *Xala*. Both films locate their narratives within discourses of post-independence betrayals, politico-financial mismanagement, double-dealings and corruption, cultural dislocations, and distortions, and urgency of real individual as well as social transformation. Daam Diagne revises, repeats and re-contextualizes El-Hadji Abdou Kader Bèye in a post-devaluation, World Bank structurally-adjusted Senegal, as does Gagnesiri, Daam's first wife, Adja Awa Astou, El-Hadji's first wife. Female agency and subjectivity hinted at in *Xala* in the revolt of El-Hadji's second wife, Oumie Ndoye, and signified in the words and acts of El-Hadji's

daughter, Rama, are given a post-devaluation, mildly womanist, more worldly boost in *Tableau Ferraille* in the person of Daam's second wife, Kiné, whose desire for financial freedom (she wishes to open an art gallery and do lots of international travel) lures her to work with her husband's erstwhile colleagues to eventually bring about his downfall. The narrative strategies of *Tableau Ferraille* evince instances of repetition with a difference in relation to those of *Xala*. Both operate within the presentational modes of realism, and a certain linearity mark each narrative movement. However, *Tableau Ferraille* employs flashback to tell its story through the eyes of Gagnesiri. The cautionary thrust of *Xala* is very much present in *Tableau Ferraille*. These elements, as well as numerous others which space does not permit me to detail, enable us to place a new film such as *Tableau Ferraille* in a frame of continuity, complementarity and revision in relation to an antecedent one such as *Xala*, as well as another earlier Senegalese film, *Sey Seyeti* (1980) by Ben Diogaye Bèye.

 Reou Takh (1972) by Mahama Johnson Traoré, *Black Goddess* (1978) by Ola Balogun and *Asientos* (1995) by François Woukoache are related by their overarching concern with slavery and its legacies for Africans as well as people of African descent in the Diaspora. However, the representational codes deployed by Woukoache stand in radical contrast to those used by his predecessors, notwithstanding the imaginary flashback to slavery times in *Reou Takh* and in *Black Goddess*. All three films privilege a search motif. *Reou Takh* anticipates partially the much-heralded *Roots* TV series of the late 1970s in the US to the extent to which it has an African American return to a now independent Senegal in search of his roots. *Black Goddess* is a kind of *Roots* in Reverse. A Nigerian goes back to contemporary Bahia in Brazil in search of descendants of his family captured and taken away during the slave trade. To help his search, he carries with him the piece of a pair of twin carvings that are his family heirloom that remained in Nigeria. The other piece was taken away at the time of capture. Armed with this carving, he succeeds in reconnecting with family on the other side when the other piece is produced and identified. *Asientos* is also an exercise in reconnection, an imaginary one this time. In *Reou Takh*, the visit to Gorée Island by the African American protagonist of the film triggers a series of imaginary flashbacks to the times when the island was active as a slave fort, the last point of contact with Africa for the millions of captured Africans on their way across the Middle Passage to the New World of plantation slavery in the Americas. His encounters with contemporary Senegal also reveals the cruel legacies of colonialism, a proximate cousin of slavery, in the social inequities, conflicts and injustices rampant in the society. *Reou Takh* reconstructs the African past and speaks to her present in the same breath. *Asientos* repeats this feat, but with signal differences. It retraces the institutions and practices of slavery and inserts them within prevailing discourses of race

and capitalism, all from the point of view of a young African attempting to come to grips with this repressed chapter of history. The film visually revises the image of Gorée Island and, thereby, extends its significance for the present. Like *Reou Takh*, its most apparent concern is slavery, and to the extent to which the latter is emblematic of human suffering the film posits possible parallels with contemporary abuses of human beings in Africa, in general, with visual references to Ethiopia and Rwanda. It ruminates on the past while linking it to the present, and it poses questions about the future. Unlike the linear realist narrative mode of *Reou Takh*, *Asientos* undertakes the task of re-memory, reconstruction and reconnection by means of a skillful and highly imaginative blend of collage (of disparate images, sounds and silence), of documentary and invention, juxtapositions, contrapuntal montage, direct address and rhetorical questions. Its visual style and rhythm endow the film with formal elements that mark it as different, if not 'new', relatively speaking. However, in spite of its novelty *Asientos* bears certain formal and stylistic marks of Djibril Diop-Mambéty's 1972 classic *Touki Bouki* as well as Med Hondo's *Soleil-O*.

Perhaps as to be expected within the oeuvre of any one filmmaker, there is a fair amount of continuity, revision, self-quotation, recontextualization, and transformation evident in the old and recent work of Med Hondo, with his overarching engagement of questions of immigration and resistance. So also in the work of Safi Faye, Haile Gerima, Ousmane Sembène, Idrissa Ouédraogo, Djibril Diop-Mambéty and countless others. The work of Djibril Diop-Mambéty is particularly instructive in this sense, for if one takes a global glance at his films from the earliest to the latest, from *Contrast City*, *Badou Boy*, *Touki Bouki*, *Hyenas* to *Le Franc*, the varying modes of relations (formal and thematic continuity, revision, subversion etc.) between them simply impose themselves. Of greater interest for me in the context of this present discussion are the ways younger Senegalese and other filmmakers consciously or otherwise position themselves vis-a-vis the thematics, styles, demeanor and orientations of Diop-Mambéty's work. A clear case in point involves the work of people like Ahmet Diallo, who unfortunately passed away at a young age, Joe Gai Ramaka and, as pointed out earlier, even François Woukoache. Ahmet Diallo's *Boxulmaleen* (*L'An Fer*, 199?), in particular, stands in a relation of parody and revision to films like *Contrast City*, *Badou Boy* and *Touki Bouki*, both from the points of view of subject matter and style. *Boxulmaleen* constructs a counter society ruled by preadolescent and young people, a counter culture which mimics, yet simultaneously parodies and transgresses the institutions, actors, norms, conventions and practices of established society, a staple in the oeuvre of Diop-Mambéty. The radically unconventional tone and temperament of the film echoes Diop-Mambéty's films.

Some critical circles have hailed Mohamed Camera's *Dakan* (1997, Mali) as the first African film to engage frontally and extensively the issue of gay sexuality in African cinema, and other recent films like Jean-Pierre Bekolo's *Quartier Mozart* (1992, Cameroon), Fanta Nacro's *Puk Nini* (1994, Burkina Faso), Adama Drabo's *Tafe Fanga* (1997, Mali) and Safi Faye's *Mossane* (1996, Senegal) have been held up as instances of African cinema's jettisoning of prudish attitudes in regard to sex, sexuality and nudity. While accurate to a certain degree, the novelty and difference usually attributed to these films should be given some perspective. In such discussions, it is vital to bring into the picture the many antecedent films that in one way or another prepared the ground for these later films. *Dakan's* exposition of homosexuality revises and subverts the somewhat satirical or even stereotypical portrait of African gay sexuality offered in Djibril Diop-Mambéty's 1972 classic *Touki Bouki*, as well as the fleeting hint in the character of one of the servants at the wedding celebration in Ousmane Sembène's 1973 *Xala*. The bolder and less nuanced displays of heterosexual love scenes and female as well as male nudity in Henri Duparc's *Bal Poussiere* (1989, Ivorian), *Tafe Fanga*, *Mossane* and *Fools* (1997, Ivorian) by South African filmmaker Ramadan Suleiman, among many others, stand in a relationship of repetition and revision to similar scenes in forerunner films like *Touki Bouki* and Desiré Ecaré's 1985 contro-versial and sexually explicit *Visages de Femmes*, a film started in the early 1970s but completed more than ten years later in 1985.

The corpus of African films made from the 1960s to the present provides ample instances of repetition, revision, and transformation, and we can multiply the examples in the above paragraphs along these and many other lines and levels. What makes this possible is the staying power, appeal, and openings of a great deal of the thinking, practices and examples of the pioneers of African cinema, for within their practices are inscribed elements that invite and compel repetition, revision, subversion, parody, contesta-tion, and change. I believe that we can get a more productive understanding and appreciation of African cinema, particularly the compelling achieve-ments and innovations of the present moment, with such patterns of rela-tions in mind.

Mbye Cham is a Professor and former chair of the Center for African Studies at Howard University and co-editor, with Imruh Bakari, of the anthology *African Experiences of Cinema*. His research interests include oral traditions, modern African literature of West Africa and South Africa, and African and Third World cinema.

Figure E. Ousmane Sembène statue. Courtesy of FESPACO.

Statement at Ouagadougou (1979)

Ousmane Sembène

The Role of the African Filmmaker in the Struggle for National Liberation in Africa

At the Sixth FESPACO (Pan-African Film Festival), LIPAD[1] hosted a public debate on February 7, 1979 at the Maison des Jeunes et de la Culture de Ouagadougou (Ouagadougou Youth Cultural Center). LIPAD had invited renowned filmmaker Sembène Ousmane to give a talk, followed by a Q&A session with the audience. In attendance at the event were many LIPAD militants and sympathizers, all brimming with fervor and enthusiasm.

Below is a transcript of the talk. We apologize to Sembène and the readers for any error or flaw in this rendering.

Opening Remarks and Presentation of the Speaker

Ladies and gentlemen,

Fellow LIPAD comrades and sympathizers,

It is quite an honor to have among us this evening Ousmane Sembène, the great writer, filmmaker, and African patriot. I guess everyone in Ouagadougou knows Sembène in one way or another, through direct engagement and enjoyment of his brilliant literary works and films, which include:

Literature

Black Docker (1955)
O Beloved Country, My Beautiful People (1957)
God's Bits of Wood (1960)
Tribal Scars (1962)
The Harmattan (1964)
White Genesis (1966)
The Money Order (1966)
Xala (1973)

Cinema

Borom Sarret (1963)
Niaye (1964)
Black Girl (1966)
The Money Order (1968)
Tauw (1970)
Emitai (1971)
Xala (1975)
Ceddo (1977)

Indeed, filmmaker Ousmane Sembène is a household name in the city of Ouagadougou. He has been involved in all the editions of FESPACO, going back to its inception in 1969. Sembène has thrown all his weight in the fight to tilt the balance toward billing FESPACO as a grassroots, popular cultural event, rather than enclosing it within the narrow confines of movie theaters. More importantly, he has championed open air popular film screenings, followed by a discussion with viewers.

The quintessential man of the people, easy-going, as plain as his speech, and with a bright mind: these are, as can be gathered from his interviews and interventions, the dominant features of the man Sembène, without a doubt the most popular contemporary African filmmaker.

So today we are welcoming an exceptional individual. On behalf of LIPAD's National Executive Committee, we warmly thank Sembène for accepting to be here among us, this evening, and give a talk on a topic dear to us all, that of the role the African filmmaker is supposed to play in the struggle for national liberation in Africa. We appreciate the gesture all the more since his stay in Haute Volta[2] is short, and seeing that he is quite on demand during the festival.

We picked this topic after pondering the exemplary conduct of Sembène as writer and filmmaker, as a man who, both in his daily activities and his works, spurs us into raising the question at issue here, while also challenging us to probe deeper into all possible answers.

For to regard oneself as a popular artist means, above all, to partake, with all one's gifts and talents, in the struggles of the people. At present, the fundamental issue African peoples are facing is that of their complete liberation from imperialist domination, whether such a domination exhibits all the outward features of naked colonialist exploitation, as in the southern part of the continent, or dons the cool mask of neocolonialist exploitation, as here in Haute Volta.

How, then, can one become a popular artist? How can one get to know the people and get involved in its struggle for liberation? How can one, as

an artist, writer, painter, sculptor, musician, actor, filmmaker, and so on, contribute to development and the victorious outcome of the struggle?

As creative artists or public, should we adopt the same attitudes with regard to various literary and artistic works, whether they are put out by deeply bourgeois or feudal elements of society to vent their reactionary class feelings, or are authored by artists seeking to identify with the people and its cause? Should we seek in artworks only beauty, the purely artistic and technical side of the equation, and consider as subsidiary their content and the ideology they convey? What role should fiction, the imaginary, play in this context, far removed from the real concerns of existence, the concrete issues of life in society? What should be the relationships between the artwork and the political and ideological factors making up the fabric of our society? Are the views of the bourgeoisie and of professional art critics the only ones worthy of consideration? Or should we attempt to know how popular masses understand, feel and appreciate the work that stands in front of them? In other words, who should be the intended public of literary and artistic works, and what elements should be deemed essential to bringing these works to completion and out in public view?

These are the fundamental questions we ask ourselves, as revolutionaries from Haute Volta, living in a neocolonial society but determined to fight on, no matter how hard and tough things can get, and in solidarity with the popular masses, to bring to an end the imperialist domination that has caught our country in its grip, to achieve popular revolution and national liberation, and to usher in the era of direct popular democracy.

By accepting our invitation, in spite of his tight schedule, Ousmane Sembène, the African patriot, is doing us an immense favor. Yet once again this illustrates, concretely, the solidarity that, of necessity, must bind the patriots of all countries.

Without further ado, I will now give the floor to comrade Ousmane Sembène.

Transcript of the Talk Given by Ousmane Sembène

Good evening, comrades,

I do not have a text to read out to you on the topic under discussion. You see, I'm no university lecturer, and I freely admit that I do not have a thorough knowledge of everything.

Mine is a class struggle, it is a fact of life for me, there is no point in denying it. Even when I'm dead, I want everybody to get this fact straight. (*Applause*) We are going to talk about a very important issue: the role of the artist living among his people. The speaker introducing me has touched on

some key points and ideas. Before addressing them, I would like first to share some personal reflections, and ask questions, questions meant for both you and me.

To start with, the artist is nothing without his people. There is no such thing as art without a people. So I cannot claim to be an internationalist if, first off, it is impossible for me to say that I belong to this or that people, if I cannot intensely feel and empathize with its most dramatic and joyous moments. This is a personal view, but I want it to be like a prick of conscience, my daily prayer. As an artist, what did I do for my people? I know what the peasant has done for me, what the baker, the mason, the electrician, the taxi driver, the teacher, etc., have done for my family, my wife, myself. In return for their bounties and services, what do I have to offer them?

We artists are often sought after, spoiled, flattered: this is the sideshow. They say, "See this one here? He is an artist." They think the artist is above the fray, that nothing can affect him, but let me tell you, it is so easy to bribe and coopt an artist, so easy. We can be easily swallowed up, treated like puppets dangling on strings. In a nutshell, this is the tragedy of African cinema, but we shall come to that later on.

Another side of the issue, the hardest to confront, is the role of the artist among his people. Who is this man who, overnight, claims to advocate for the masses and speak on their behalf? On what basis and why? Why do we recognize in him our spokesperson, "our mouth, our ears, our feet," as Césaire put it? On what grounds do we see ourselves in this man and, so to speak, give him power of attorney? Here is the break between the creative artist and his public. This public reveres and trusts him unreservedly, so in the end nobody keeps an eye on him anymore, instead people are invading his privacy, they spoil and flatter him, and at times take advantage of his nice, gentle demeanor. This could damn well happen to me, and that is why sometimes I have to come down hard on some of my so-called admirers, because they think I have no commitments, that my day does not consist of a 24-hour cycle, but of a 72-hour cycle.

For the militant who struggles every day and faces daunting odds, come rain or hail, day or night, there is no Sunday, no rest, no retirement, every day he sacrifices a little bit of his family welfare, and the quiet intimacy with his wife, on the altar of the struggle. At times, for those who are heads of families, this means you will never find the time to help the children with their homework. It is like the doctor who must send his children to do their checkup with another colleague. So the militant person working among the people has more responsibilities than the writer. I know quite a handful of them, and can mention their names, men and women who gave the cause everything they got, exemplary figures of what I call the heroism of the everyday.

In order to live intensely among one's people, there is no need to show off and parrot revolutionary catchphrases. That is, if we truly harbor the ambition of changing our dear continent. For it is not the Chinese, Russians, Frenchmen, Americans, etc., who are going to change Africa, but us, and only us, Africans. At what price? Let us, together you and I, try to look deeper into the matter.

We need art just like we need millet or *chapalo*.[3] We need art just like we need love and affection. The problem is: what purpose does art actually serve? That is the question I keep asking myself all the time. Can we live without art? I think it would be very difficult, quite a challenge, but I cannot answer the question on my own. We need to hear singers, read writers, go to the movies. It brings us solace, some sort of inner peace. If art is only meant to lull us into sleep, to tear us away from thinking, or to prevent us from thinking altogether, then I believe we have no need of such art.

Art can bring us joy, enhance our senses, cool down our tempers and, at times, ignite powerful ideas. The fact is, art can only come from the people. It is the sum total of the daily experiences the people go through. When I watch folks on the streets of Ouagadougou, I feel like I could write a short story every day, if I were to live here. Sure, it has a different vibe than the pulse of urban life in Dakar, but the difference is almost negligible, of a material kind, perhaps. In Abidjan, same thing. So there are no barriers for artists, no airtight partition wall between the Senegalese artist and his counterpart from Haute Volta.

Let us get back to the issue at hand: African cinema. First let me give you a brief overview of its history. African cinema came into existence during the colonial period. We tend to forget that the colonizers, as part of the skillset their native cadres were supposed to gain through training, had actually trained some filmmakers on how to extol colonial occupation and daily life, its achievements, in order to perpetuate said colonial occupation and get us to a point where we would accept it as just a "natural" fact, like the air we breathe. Until 1960, there were the *actualités* ("newsreels") of regional governors and district commissioners, and there were schools, cultural centers, and so on, where the screenings of these *actualités* took place. Cinematographic art went no further than that.

Nobody said what should be done. A few tried to break out of this debilitating deadlock, but they were mostly abroad, especially in Paris, London, and Italy. African filmmakers tried to shoot films, but only if these were historical "reconstitutions" tinged with nostalgia for the past. For us, this is nothing new. When you pay attention to all things literary in Africa, you realize there was a period when African literature consisted of nothing but evening storytelling sessions around the communal fire, folktales and, as always, choice morsels of our so-called African wisdom. Arguably, this was not a regression into some primitive state, but rather a form of resistance

against the permanent assault African society was under, on a daily basis, during the colonial era. These tales and novels, like the first films of the same ilk, served a purpose, we cannot dismiss them out of hand. These literary and cinematic trends played no small part in the emergence of *Présence Africaine*, the *Société des Auteurs Africains*, and the *Société Africaine de Culture*. This revivalist movement was born prior to the nominal independences of 1960. But from then on, things started to change. Until then, it was nothing but the nostalgic evocation or contemplation of some idyllic past. But is it fair to say that the few books on these topics did not deserve to be published? Do we have a right to be so harsh in our judgment?

Most of the artists from that generation did not take an active part in the struggles for national liberation. Living outside their homelands, in high demand at milquetoast private gatherings and chic salons, they were not equal to the task, could hardly feel the burden of historical responsibility weighing on their shoulders. They spoke grandiloquently of one thing, and one thing only: Africa's glorious past. What was lacking in most of them, I think, was active involvement in the struggle alongside the masses. Those from my generation here today no doubt remember that Ouagadougou was a major hub, a hotbed of protest and unrest in the days of RDA's anticolonial resistance. But what writer bore witness to all the meetings that took place here with the late Ouezzin Coulibaly, Mamadou Konate from Mali, etc.? None that I know of. If you draw a parallel with other contexts, you realize that elsewhere writers have done just that: bear testimony to similar situations of vibrant grassroots militancy. This is the crucial difference I think, a real knowledge of their people was sorely lacking in those writers. They were just not in the thick of it, not deeply involved in the resistance movements and the people's struggles. This is a matter of paramount importance for an artist: to be among his people and take part in the daily quest for freedom, a freedom both inside his mind and outside in the world.

From 1946 to 1948, the struggle of trade unions was primarily anticolonial. I take my generation as a case study to illustrate this point. At the time, we came to this struggle like flies in a soup or, if you prefer, like cockroaches in a bowl of *chapalo*. (*Laughs*) I cannot cite any source, but all those who were in Dakar like Sekou Touré, Nazi Boni, spoke of the dialectic of national culture and liberation. We were the first to address these issues because the people who hosted those meetings paid more attention to the number of degrees earned than to effective organizational work. For us, the point was not so much to catch up with them and earn as many degrees as possible, as to delve deeper into the life of our peoples, that is, to learn more from the peoples, not in order to get on our high horses and then say, "Look here, this is what needs to be done," but simply to learn how to better attune our ears to what the peoples have to say.

Some chose to ply this route. At the time, their enemies wrote to raise issues that they were supposed to address as individuals. For someone like Ahmed Sekou Touré, literature was, you know, not devoid of interest, but for him direct struggle took precedence over culture, literature, the fine arts. For me, everything took a backseat to literature. There was this duality between those who, twenty years later, would lead our countries and me as an individual. Today, the debate still rages on, and it is what we are gathered here to discuss, on this evening.

Is art essential? We have seen what Sekou Touré was able to achieve in terms of cultural politics. In Guinea, the failures in matters of economic policy are hard to miss, but there is no way we can say that Sekou Touré's cultural politics did not help Guineans, and by implication all Africans, to regain some sense of dignity. When state power takes hold of art, grabs it by the roots, as it were, and sets out to mold it into some shape, such a state has the wherewithal to succeed. But the individual artist, especially the young artist, who tries through his works to reach as many people as he can while remaining faithful to his idea or ideal of art, that individual artist will necessarily encounter some mishaps and difficulties.

To come back to cinema, let us say that until 1971 there were many forms of cinema epitomizing the cultural movement, on the one hand, and the political movement, on the other. In 1960, at the time of our sham independences, I did not know how to make films, not yet. It so happened that through my frequent journeys inside Africa, and my hiking on foot from Dakar to Kinshasa, in the Belgian Congo, I found myself involved in Lumumba's political movement. For months I waged the struggle on the frontline of culture, while trying to remain an artist at heart. It was a contradiction, because for the Congolese real independence was the priority, it dwarfed everything else. For me the main thing was to document this period in writing. So during the day I was absorbed in my tasks, and at night I debated. It was around that period, after the death of Lumumba, that I decided to learn how to make films. I had just turned forty.

At the time, I had twenty years of trade union militancy under my belt, whether in Senegal or in France with the Communist Party. So I found myself in Moscow for a year, to learn filmmaking. During that year, I reflected in private on cinema, but always in relation to what I consider to be the just cause, that is, the communist ideal. Two years later, I returned to Senegal and started making films. I shot *Borom Sarret*, I made a documentary on the Songhay Empire, explaining, through the lens of my camera, the chain of events that led to the collapse of that great West African empire. For this film, I ran afoul of Modibo Keita, who harbored motives that I deem legitimate, but that I do not condone. To the extent that the fall of our states, the unraveling of our political structures, can be traced back to imperialism,

whatever its form, we must stand up and denounce it. If you refuse to tell your friend that he is lying, it can only mean that the two of you are no longer friends. Anybody who hesitates to tell his friend the hard truth must regard himself as his worst enemy.

So in Dakar, I shot *Borom Sarret*. For a long time, the government banned its distribution. Maybe it was entitled to act like that. For my part, I was entitled to make the film, it was my civil right. Why? Because I had chosen my side. I was not necessarily standing on the side of the cart drivers and other underprivileged. I shot the film because I saw that, at the time, my comrades from PAI, that is, the Communist Party branch in Senegal, were tossed into jails, and still they were struggling for an invisible cause, a cause that still had their wholehearted support. Making films was my assignment, nobody else could perform the task. Just like I cannot fill the shoes of our leaders and do in their stead what they are supposed to. So there is always this duality between the artist and power structures, whatever their form.

Eventually, we managed to shape our own cinema, making films, roving across Africa to screen them, staging impromptu meetings off of them, not just through the regular gatherings of radical militants, but also by casting our films as discussion topics, the post-screening debate as a forum. In so doing, our films could last longer in their public life, without any need for us to peddle them like commodities only meant for instant gratification. Thus, we distanced ourselves from a certain cinema that drowns truth in the acid bath of rank falsehoods, a cinema that does not enrich us a bit and, instead, turns us away from ourselves, planting the seeds of alienation deep in us. On this score, and if one follows the evolution of cinema as a medium and a technique of representation, one comes to the bitter realization that in Africa commercial cinema has always invaded, occupied, monopolized our screens, and this is consistent with its collusion with our rulers, for they are complicit in this. We speak of government complicity to the extent that, to give you a concrete example, since 1978 we are in a position to supply Haute Volta in African films for six months. Yes, we can. So there is no reason, none that we can see in any case, why SONAVOCI[4] could not distribute these films. So we must come to the conclusion that African states are in cahoots with French or American cultural imperialism. (*Long applause*)

Okay, okay, let us settle down, let us not get easily carried away, this is not an electoral campaign meeting. Like I said, I do not hold the key to absolute truths and, of course, it may well be the case that I'm dead wrong on some of these issues. I'm only doling out these reflections, especially my own musings, as food for thought. Actually, you can enrich me more than I can enrich you, for only through your critiques, your own reflections, observations, and experiences can I improve my work and go beyond the simple, naturalistic representation of how we act and behave in society.

To come back once more to the issue of cinema: it is worth noting that African filmmakers of the first and second wave—now we are in the third wave—are increasingly treading on a dangerous path, and I would like to draw your attention to this alarming trend. Cinema, our art, is also an industry. You cannot make a film without funding. In Haute Volta, a film would cost around thirty to forty million CFA.[5] In the high-volume spheres of state industry and multinational corporations operating on the continent, this is not a costly investment, it is a bargain price. Actually, thirty million CFA is a pittance, in this context. There are films that cost nearly a billion CFA,[6] and in the case of some films, the advertising campaign alone is budgeted north of a billion CFA. Why? Because to instill in you, the public, a burning desire to go and watch these films, they churn out ads like lube out of a Vaseline tube, so that once seated in the movie theater you are sure to get your kicks out of the images on the screen. More seriously, we see today that African cinema, next to what is called militant third cinema, is branching out toward commercial cinema. This is hardly an insight, and I'm not making this stuff up. Omar Bongo, yes Omar Albert-Bernard Bongo, the president of Gabon, is the first to venture into this niche. Recently, he had his filmmakers, with the help of European technicians, shoot a cute little movie,[7] technically flawless but amounting to no more than a stale sentimental slush. The public, in Senegal and Haute Volta, is going to love it. They are going to love it because it is shallow, devoid of any substance, albeit impeccably shot. This is precisely the tragic flaw of cinema: the aesthetic, form primes over content. We can expect to see more movies like Bongo's, as other states are bound to jump on the bandwagon of entertainment cinema. We'd rather that African filmmakers translate into images the concerns of the masses, instead of selling themselves out to their governments. But what is there to say, really, about these filmmakers? Aren't we even being self-righteous in our complaint? The truth is, we avail of neither incentives nor disincentives to steer them in this or that direction, so we have no right to cast the first stone. They feel the need to express themselves, and that is exactly what they are doing. What would you do, if you were in their shoes?

But at least there is a silver lining amidst the dark clouds of contemporary African cinema, and it is the fact that, as the previous speaker pointed out in his opening remarks, signs and symbols of class belonging and social status cannot be concealed any longer. Cinema is the first medium to shed light on this, to bring them out of the shadows. This is normal, given that the state has commandeered radio and television, just like it seeks to confiscate cinema itself in order to spin its own narratives on celluloid, all well-rounded, formulaic and sanitized, with mind-numbing themes, junk food that will leave us still craving for something more substantial. Yet we will

go watch them. We will, indeed, because Africa is going through its biggest crisis, a cultural crisis in which classical African culture, the one we have tried, until now, to salvage and preserve, is showing worrying signs of decay. In most cases, going to the movies tends to be our preferred cultural activity. It is so much easier and less expensive than buying and reading a book. We prefer going to the movies over listening to a kora player. Why? Because in a movie theater you are seated, you come with a party, and depending on your ticket category you are more or less feeling the cool breeze from the AC. This should be a matter of alarming concern, given that cinema is now so much a part of the fabric of social life. The youth of today, even their elders, start out their Saturday night date with a trip to the movies, don't they? In practical terms, yes, it saves you much trouble with a girl if you can just tell her, "I'll see you at the movie theater, then, right?" or "Let's meet after the movie, okay?" In itself, this is none of our concern, but since it exemplifies the deep reach of cinema's ideological tentacles inside our collective consciousness, more than juvenile romance and dating strategies is at stake here. When we watch a movie, we do not analyze the images because we are seeking an escape from reality.

The cinema controlled by our governments is pernicious to the extent that such a cinema provides a frame of reference for new forms of behavior, attitudes, ways of doing things. We all know of many young men, even older men, who often try to identify with this or that actor. We all want this or that three-piece suit, this or that pair of shoes. Women want this or that hairstyle, this or that gown, seen in this or that movie. Well, if this is not alienation, I do not know what is. Let us face it, these fashion trifles are indeed the symptoms of our acute alienation. (*Applause*) They have been infused in our blood vessels, but I'm not blaming the common people, rather I say and I repeat that the state is the culprit, that our leaders should be held to account. In the light of our chronic lack of any frame of reference, what is called the identificatory complex reigns supreme. If one takes a closer look, one even notes that some want to look like Marlon Brando and Jean-Paul Belmondo, down to the haircut. Look at your hair salons and barbershops, study them like sociological phenomena. (*Laughs*) We also have the Django style. (*Laughs*) You are laughing, but I'm telling you this is no laughing matter, because this belies a lack in us. It is severely affecting you, me, your son, your daughter. We are all painfully aware of the great emptiness inside us, and what we are asking our governments is to change their course of action and find in African culture the role models we need and crave. We can forge our own myths, too, you know. At the end of the day, however, you and I know that this is going to be an uphill battle, insofar as our governments have their hands tied by various brands of cultural imperialism imposing their foreign cultures on them, meaning on us.

I was not here in January 1970, when the government of Haute Volta decided to shut down all the movie theaters. We arrived in Ouagadougou two days later, after the closures. For three days, I do not know if you also noticed it back then, people did not know where to go at night, since they were deprived of the regular outlets where they could let off some steam. So for three days the movie theaters were shut down, but the government was forced to reopen them, not for your sake, mind you, one never closes and opens a movie theater just to please the public. But pressure was mounting, and it reached such proportions that it would have been foolish not to let people go back to the movie theaters. So cinema plays a huge role in contemporary civilization, in what is also called the civilization of the image. Far from contesting the value of cinema as a technique and medium of representation, what we object to, what we deplore is our overexposure to content not aligned with our desires and needs. This content continues to alienate and colonize us. In the days of our fathers, and even in my own time, colonization meant the occupation of lands. Now neo-colonization is a more advanced species, it means the occupation of both lands and minds. (*Applause*) When you go back home, everything around you is tainted with Western culture, down to the bed you lie in. (*Laughs*) In the times of our fathers, they worked the land, afterwards they went back home to their huts, to be among their agemates, to retreat back into the bosom of their culture. Right now, African governments, unwittingly or not, are allowing cultural imperialism into our very homes, the last strongholds of our intimacy and integrity. Of course, you can always point out to me that we only have ourselves to blame for this sorry state of affairs, that this is our own doing, nobody else's.

To come back to the filmmaker, I will only say this: I think the tragedy of African cinema, and of its filmmakers in particular, is that they embraced the medium as individuals. They did not embrace cinema out of a deep sense of commitment to political beliefs, no, they embraced it for the glitz and blitz of celebrity, for the thrill it held out. Some enjoy being pampered and adulated, they love to hear critics say, "He's an artist after this or that manner." It is quite flattering, but I think it also shows that we are only humans, especially in the case of young filmmakers. However, what is more alarming to me is that in the next decade or so, we are going to see Africans putting out European contents for other Africans, that is, they are going to peddle Western cultural products to you and me, whilst making you believe it is still African. In such a context, I anticipate a bitter struggle between power holders, who want to control cinema as their propaganda tool, and those who want it to serve the people. The power structures that control cinema, the movie theaters, can ban any film that does not fit into their cultural policy schemes. As a result, there are many countries in Africa where films are banned outright, where film cannot be screened because, allegedly, they are not in compliance with

government policy. As filmmakers, we want to bear witness to the historical situation and convey the aspirations of the people.

Cinema is the medium best suited, today, to throw a stark light on the historical situation of the ordinary African: corruption, nepotism, grand thefts, wasteful spending, private accumulation of capital. (*Applause*) I think one has to be singularly dishonest to deny that these things exist in our societies. In Senegal or Haute Volta, we know of many people who pounce on public assets to claim them as their own, and without skipping a legal beat, because they made laws tailored to suit their predatory designs. We know of many more who own four or five properties and rent it out to the state, who pimp huge amounts of money out of state coffers, in order to put up buildings they will then lease out to the same state or to use it themselves and have the state foot the bill. This is nothing but highway robbery in high places. (*Applause*) What else does it look like? But when we, filmmakers, denounce it, we are scolded for "meddling" in politics. Well, yes, the hell we are, actually we have never denied it. But our politics is primarily cultural, it is meant to help the people to shape their own consciousness. We know for a fact that one hundred MPs cannot replace a single filmmaker. On the other hand, a peasant is worth ten filmmakers. This is how we set our value system, if you will. But when we decry the thefts, we are flagged as subversives, when we decry influence peddling, interloping, and abuses of power, they say we are meddling in politics, exactly what they do every single day. Well, it is just that they do not have the balls to admit it, (*Laughs*) while we, by contrast, do have the courage to watch, listen, and engross ourselves in such matters so as to expose the dirty laundry in public.

Perhaps we won't be able to do it anymore, in the near future. It will be due to the simple fact that the thieves and crooks of today are going to be the film producers of tomorrow. With all their accumulated ill-gained wealth, they are going to fund films, on condition that they exert absolute control over the whole process, from script to screen. Once again, we are issuing a stern warning. We have no ready-made solution to the issue. However, we believe the same scheme of dominance is repeating itself over and over, just like in the context of trade unionism you have the trade union of honest men and the trade union of crooks set up by the state. In the context of trade union organizations, we know that often, in a single country, a situation arises where you have these two groups battling for dominance: state representatives and members of the working class. The same split obtains among African filmmakers.

The other deplorable trait in the character of the African filmmaker is his lack of knowledge about the society he lives in. We can speak of a generation cut loose from the living roots of African culture, more attuned to Western cinema and little concerned with shaping new film forms from within the

hub of African culture. Instead of working on scripts with writers, they prefer to sketch out some treatment in collaboration with a European. Here, I deliberately refrain from citing the name of any country. We know of certain African countries that pay Europeans up to twenty-five million CFA,[8] just to cloak their long history in a tight cinematic garb, and of films where the entire crew is "shadowed" by a second team, all Europeans. The only thing the African filmmaker has to do is sign his name, for he is nothing but a dummy. This is our misfortune, us filmmakers. We say it here out loud, in front of you: we have no clue how to fix this. In any case, personally I do not know how to set this crooked matter straight. This dangerous trend threatens to morph into a huge trap. The severe lack of knowledge with regard to African culture is not only hobbling the evolution of cinema in Africa, it is not only hanging over the film screens like a cloud of doom: sooner or later it will prove our undoing as a relevant, meaningful cinema.

Cinema involves a lot of money, but making a film also implies that you have a story to tell. Not everybody can pen down a storyline. If you look at countries outside Africa, say France and the United States, a single film mobilizes four or five persons, just to hash out a script. There are those handling dialogues, those handling the plot, and so on. That is why we have helped to kickstart a network of schools where people can get training or some preparatory training prior to entering other film schools. In some film schools, you are only trained to acquire the ropes of film technique, it is like when you attend a driving school, you learn how to drive a car without knowing the ins and outs of automotive mechanics. As far as celluloid cinema, you won't be told that a given speed corresponds to a set volume of words or spool velocity, why at some point a given speed is always required. Why is such film spool velocity required? It is like you are being told: when you reach 20 mph, shift into a higher gear, when you get to 25 mph, shift gears again, and when you reach 30–35 mph, settle into cruise mode. (*Laughs*) It is true, that is how it is supposed to work. If you know your road safety code, like I do, then you can get on the road and drive smoothly through traffic. But when the car breaks down, and you have to fix it, that is an altogether different matter. It is like the end of the world! I will give you a concrete example: the screening of my film *Ceddo* at the opening ceremony.[9] The operator was provided with a worksheet detailing all sorts of technicalities: speed, images, sound, etc. A man of goodwill, he confined himself to applying what he knew, that is, changing the speed regimes of the spool. It did not pan out, during the projection something was off. So we went up to his booth to tell him that he was doing a poor job. His answer was, "Boss, this is how I work, this is how I have always worked." After some inquiries, it turned out that for the last two years the man had reported the flaws in his projection apparatus, but since the supervisors in charge were as clueless as he was, the issue was left pending.

In training filmmakers, one can run into similar problems. The goal is to introduce you to topics without necessarily taking you deep inside the sociological contexts, without opening your eyes to the complex mutations underway, the new emerging trends and movements, the new layers in the pyramidal stratification of society. Nowadays, one can pinpoint the signs of an emerging bourgeoisie in our societies, even though its members are a far cry from the bourgeois of Western Europe, now or during the eighteenth or nineteenth centuries. They form a small clique enjoying a number of privileges. As a creative artist, it is always a good thing to know the laws, the causal chains, how all of this takes shape over time and winds up into a specific form, at some point, like our current comprador bourgeoisie. So you see that artists have a huge responsibility. In any case, we are always reminded of it, but we must equally remind ourselves of all the things that we do not know and perhaps will never know.

African cinema is grappling with a host of issues that are far more complex than the issues literature is facing or has ever faced. In the current struggles for national liberation in Africa, filmmakers, whatever their weaknesses and contradictions, are way ahead of their counterparts in the other arts. It is not so much that we are more cognizant, smarter or whatever, as that the tool of our trade is the most widespread, and its products the most consumed. Actually, the crowd inside a movie theater is bigger than the congregations inside a church or a mosque. We can safely claim to mobilize, every day, a sizable chunk of the population. I wish churches and mosques were able to pull it off the way we do on a daily basis. It is a tough assignment for them, for the motives inclining us toward this or that direction are always shifting. Moreover, the African Church, for good or ill, displays a keen interest in cinema. Well, we know that the Lord works in mysterious ways, but how to account for the fact that all of a sudden these people show such an intense and passionate interest in cinema?

Governments try to control distribution. For a long time, over the course of its first decade, they showed no interest in cinema at all. Those were the good old days when we had carte blanche to attack, rail against politicians, launch into whatever critique we fancied. But when they came to grasp the impact cinema could have, they quickly set up new ministries, staged events to draw crowds, built movie theaters. Bypassing us, they issued decrees and crafted regulations, even laws, to rein in our freedom of speech. It shows you that cinema, albeit not the most significant, must be counted among today's most potent cultural weapons. We could spend all evening talking about man and cinema, the public and cinema. On all these points, I have my own private thoughts. But I would like to end on a different note and sketch out for you the relationship between cinema and the awakening of consciousness.

Let me tell you a real story about an experience I went through in Yaoundé, Cameroon, where I was invited to take part in a conference. I was

well accommodated, in a hotel room with a properly functioning AC. Strange as it may seem, we often find more hospitable living quarters outside our own home, that is true in my case anyway. (*Laughs*) So I was staying at my hotel room when the phone rang. I picked it up, and at the other end of the line someone says, "A police commissioner is asking for you, sir." Well, out of habit I took my passport and sent brief notes to some comrades nearby in the adjacent rooms. A police commissioner? Oh boy! Am I in some deep trouble? So I took the necessary precautions, since the comrades who were supposed to welcome me were not there yet. I went down to the lobby. The commissioner turned out to be a nice, good-natured fellow. He asked me, "Do you drink beer?" This caught me off guard, but I just said, "No, but a glass of water would be fine." (*Laughs*) He was having none of that and insisted I order a proper drink, so in the end I found myself fondling a glass of beer. He started looking at me intently. Honestly, it made me feel uneasy, fidgety. (*Laughs*) Don't laugh, this was serious stuff, I was standing before a police commissioner who was eyeing me as if I were some girl he wanted to score. (*Laughs*) After a while he said, "You know, your film *The Money Order*, do you know that you did it for me?" I said, "Really? How so?"

So here is his story. A Cameroonian peasant had received a money order from his son living abroad. He went to the post office to cash the check. He made the trip multiple times, and every time he was told that the money order wasn't in yet. Out of frustration, one day he took aside the post office employee and, punching him in the face, said, "Look here, mister, don't play me for a sucker, *The Money Order* trick doesn't work on me! I have seen the film, I know what's going on!" (*Laughs*) So they went to the police commissioner, the same who called on me at the hotel. They rummaged through the logs, and they found out that indeed the money order had reached the post office, but the employee had simply diverted the funds, he "ate" the money order. The commissioner was surprised I never heard of this story! (*Laughs*)

Whatever the limits set to the distribution of a film, we have always managed to reach many people. So we can discuss politics with them without assuming a patronizing tone. A film must raise issues, but going forward, I think in the future African cinema must transcend this too, it is crucial that we filmmakers be sensitive to the aspirational heartthrobs and desires of African masses.

This leads me to assert that without a revolutionary power structure no revolutionary cinema will ever come into existence. Progressive cinema is tied to the action of progressives and the dynamic of revolution. However, there is no such thing as revolution by proxy, from the comfort of your living room armchair. By the same token, we are not out to make propaganda leaflets, but films that stand in osmotic relationship with the struggles of oppressed peoples. The birth of revolutionary cinema is coterminous with

the ultimate victory of the revolution. In francophone African countries, words like "culture" and "truth" are scarecrows for government officials. Well, we did not learn from foreigners how to seek and speak the truth. Africans gained that skill through their deliberations under the palaver tree. But as long as power is not genuinely popular, the going will be rough for artists, and we will keep ingurgitating decadent works, artistic junk food. This does not mean that in capitalist countries there is no militant cinema, a cinema sympathetic to the struggles of ordinary peoples, but we do not know of it, or we know only half the picture, given that once a film is banned in France the ban is automatically carried over to our countries.

So to conclude this talk, I will sum up by saying that truth resides with the people. The struggle must be waged alongside the fighting, downtrodden masses, we must put ourselves wholly at their service and be part of the journey, not mere bystanders or fleeting fellow travelers. Otherwise, any given day, any artist can end up the way of turncoats and sellouts: by accepting bribes. There is always a struggle to wage, always, and we should never recoil from fighting if we want to achieve the ultimate victory of the people and of the revolution. (*Applause*)

After his presentation, comrade Ousmane Sembène took questions from the forum participants, who were entreated to make it short, given the numerous commitments that did not allow him to stay for too long after the presentation. The filmmaker then asked the audience to tell him about their critiques and complaints with regard to African cinema, the role of women in cinema and in the films, the performance of actors, the technical quality of the films, the social themes and issues addressed, etc. Various LIPAD militants and sympathizers provided thoughtful and candid answers.

Notes

1. Ligue Patriotique pour le Développement (Patriotic League for Development).
2. Former name of present-day Burkina Faso.
3. Also called *dolo*. A popular beer in Burkina Faso, made from millet
4. Société Nationale Voltaïque du Cinéma (National Cinema Society of Haute Volta).
5. 54,500 to 72,700 USD, in today's currency exchange rate.
6. Around 1.8 million dollars, in today's value.
7. The film is *Demain, un jour nouveau* (Tomorrow Will Be A New Day), by Omar Bongo, with Pierre-Marie Dong (Gabon/1978).
8. 45,500 USD, in today's currency exchange rate.
9. *Ceddo* kicked off the 6th edition of FESPACO in 1979.

A Name Is More Than the Tyranny of Taste

Wole Soyinka

First, permit me to unburden myself. A little bit of carping is essential to mental balance, and, the Arts are no exception to this principle of psychological release. Indeed, that is an understatement. I should have said: the Arts especially are the supreme example of that truism. You and I know that there is no other human preoccupation that so readily provokes either suppressed or exploding feelings than this singular expression of the human imagination and inventiveness that we call the Arts. Within the prolific field on which we are gathered here today—the cinema—there is a word that has become current, one that I still find difficult to utter. It sets my teeth on edge, this hideous child of lackluster imagination. And yet it appears to be a source of pride to the practitioners it implicates. What one would have regarded as a singular aberration, a regrettable moment of a verbal infelicity, has developed into a child of competitive adoption, sustained by a number of would-be surrogate parents. One shudders to imagine how many other variations can be squeezed out of the original banality, as each nation evolves a cinema industry and strains to force the original horror into the tube of its own nominal identity—again, with pride!

Do I speak objectively? Of course not. I readily confess my subjectivity in these matters. Acknowledging this in advance makes it easier to for me to wear the badge of verbal fundamentalism without the slightest embarrassment. Having conceded that much, I also have to state, on my own behalf, that it has not been for want of trying that I have failed to reconcile my tongue to each new offspring of a nomenclatural misalliance. My main trading commodity, as you all know, is largely in words, so it is not surprising there are some sounds that I find difficult to mouth—not simply in their own being, but on account of their histories, their association and their limitless capacity to proliferate and people the world of words with new infant monstrosities. This is said matter-of-factly. In addition, however, I do propose that words are allied to images.

Now, I wouldn't go as far as Richard Ford, the American writer who, in declaring himself a dyslexic, adds that he actually sees words as images. No, I wouldn't make such a far-out claim. However, I do subscribe to the view that words have shapes, which are in turn evocative of more than the mere sound of them or their literal meaning. Indeed, one can claim that some images become eventually attached to words with such intimacy that they can no longer be prised apart—hm, I appear to be getting closer and closer to Richard Ford. All right, let us simply try and sum it up thus: the power of suggestion goes beyond mere suggestion. A word can distort the palpable reality that your own senses have already determined. Where such a word is deployed as values and summation, as a category of phenomena, even as a loose umbrella for a family of products, it can distort other entities under that umbrella completely, influencing their apprehension in our minds. Where we are concerned with creative activity, the word can contract the scope, or reduce the quality within the overall undertaking. In short, a word can inhibit or expand imagination. It can prove a curse or a blessing.

Regarding the creative process, let it be understood that I am not necessarily speaking of originality. I have read critiques of artistic works that appear to make originality the benchmark of creativity, blithely dismissing such a work on the grounds that it is not "original." Some masterful works—in all genres—have been produced that are based on deliberate imitativeness. Or plagiarism. There are different kinds of plagiarism, some can actually emerge as a new product of its kind, a kind of creative provocation, or a commentary on the original, sometimes a sleight of expectations or attribution—what is sometimes called signification—especially in American literary discourse. So, we are not speaking here of originality.

We all share—with variations—a basic culture, and that culture places a heavy premium on—for instance—child naming. "The child is father of the man," as the poet William Wordsworth reminds us. We can add, however that, for African societies, "the name is father to the child"—such careful thought, sense of history, hopes, and expectations ride on the name we decide to give a new human entity we have brought into the world. Child naming, on this continent, is itself a creative act. Only this last Friday, February 22, the following observation appeared in the Nigerian journal *The Nation*, on the back page weekly column, "Comment and Debate," an impeccably timed contribution to this address:

> Naming in Africa, especially in Yorubaland, is special gift that the ancestors as progenitors of the nation bestowed on the elders. Names have meaning, and—as they would have us believe, names push their bearers to actualize their encoded meanings. *(Oruko a maa ro omo)*—literally—The name may mould the child. So you don't find any Yoruba parent giving to their babies names that embed evil meanings.

Let it be admitted however that all we do is play variations on existing naming templates; not that we strain to be fully original. The same process applies, as stated earlier, applies to the creative process: styles, themes, and even—very often—content. Actually, this merely provides me an excuse to veer off and comment on a recent cinema controversy—the subject and directorial approach—but one that does concern us here most intimately.

I am sure you have all heard of this film; it seems destined to become what is sometimes known as a "cult film," and largely because it so successfully plays variations on established genres. I am speaking of *Django Unchained* (dir. Quentin Tarantino, 2012, United States), starring the actor Jamie Foxx, with a superlative, though underrated performance in the role of the revolting, Uncle Toming race traitor by Samuel Jackson. Its theme is Slavery, a subject that touches the historic sensibilities of virtually all of us assembled here. Now, just as an aside—one cannot ignore certain other aspects of the controversy it has stirred up. Slavery is a very serious, even solemn subject. Such a weight of history, of race recollection, rests upon it that one cannot think of any aspect of that traumatic passage that lends itself to humour. *Amistad* (dir. Steven Spielberg, 1997, United States), even *The Birth of a Nation* (dir. D.W. Griffith, 1915, United States), with its open derogation of black slaves etc., etc.—these films conform to the expected treatment of that subject—heroic, tragic, indicting, inciting, racist etc.—certainly not mock-heroic. One's instinctive response to the subject is that it would be indecent and insensitive to extract any shred of humor from Slavery, except perhaps what is known as gallows humor. Long before *Django*, there was the stage play *Purlie Victorious* (1963), later made into a film, starring Ossie Davis and Ruby Dee. The same complaints made about *Purlie Victorious* are what I have read during the past few months—that is, at least four decades later—by some black critics, among them, Spike Lee, a leading black American cineaste. This is a trivialization of my history, complained Spike Lee.

That commentary leads us conveniently back to the thread of our main theme—that criticism was based on a misconception—the director of that film was in fact doing what we have identified as "signifying." He was signifying on a number of cinematic genres, familiar clichés, not least of which was the Western, the Cowboy film. Beneath the spoof, there was serious thematic business. Even the sinister Ku Klux Klan was spoofed, and everyone knows that there was never anything remotely amusing about those Knight Templars of the trilogy of Lynch, Castrate, and Dehumanize.

By my reckoning, the film is most intelligently crafted, very much in the manner of Mel Brooks' *Blazing Saddles* (1974, United States), only, this time, our film is set in a slave plantation with opulent trimmings, generous close-up helpings of blood and gore, and flying flesh. The "n" word, that contempt ridden version of the neutral word "negro," was also in overabundant usage,

a feature that also offended some sensibilities. I found this complaint rather strange, since it indicated a refusal to take into account, not only the fact that the word was historically accurate, but that its proliferation in the film was deliberate, tripping glibly off the tongues of the blacks themselves than off the white masters'. If excessive application has ever been claimed to take the sting out of the offensive, *Django* was definite proof of this.

So, we are speaking of an original work of art that is anything but original, filled with borrowings from so many genres. My complaint therefore is not against borrowings and adaptations as a principle, but against the lack of originality that translates as plain, unmediated imitation, or a tawdry, unenhanced borrowing that is conceived and delivered on the very edge of the pit of banality, and out of which it has no wish to clamber, once it has fallen in. It indicates a preset mind, a basically unadventurous mind dressed up in castoff clothing, of which nothing can be expected except as a breeding ground, a reproductive automatism of its own kind—especially in taste. We move closer to the substance of my complaint—that of another unspeakable "n" word that has taken such a hold on our homebred imagination. This "'n" word constitutes a mutative explosion that I consider most unfair to others in the same creative field—the cinematic—more especially as there have been predecessors who impacted on our cinema world without burdening themselves with such a verbal albatross. Again, I must hold you in suspense for just a little longer while I skirt around the subject, although I know that a number of you have guessed by now where I am headed.

I still recall the first Negro Arts Festival in Dakar, which marked the formal outing of contemporary African cinema even as a rudimentary exploration of the genre. Yes, some of the products were amateurish, but they already bore the stamp of genuine exploratory minds at work, interrogating the new medium. Even the clumsiest was refreshing, and of course the more skilled were inspiring. If my memory were not so clotted, I would reel off five new names. I recall the young Djibril Diop, however, and—I think—Oumar Sissoko from Mali. What remain fresh in my mind are snippets of scenes—such as the satiric use of the tro-tro, the passenger lorry, to ridicule the pretensions of a figure of the Europeanized black sophisticate—that species that is known in Nigeria as Johnny Just Come, or *Ajebota* (weaned on butter). This figure of fun considered himself unfortunate to be compelled to ride in the same conveyance as peasants, workers and other "uneducated" beings. It was a simple but hilarious film, I recall, that introduced the viewer to the makeshift existence of semi-urbanized life, a picaresque work filled with incidents along a journey that covered the gamut of daily survival and challenges, inducing the passengers of the tro-tro transportation into a transient community. Our principal, played by the young Diop himself, was reduced,

coattails and all in that suffocating Sahelian heat, to push the tro-tro when it broke down.

Don't ask me why I recall that scene so vividly after so many decades, but I wish that the young aspirants to the cinema trade would have the opportunity to watch such films, if only as a basic lesson of extracting a film nearly out of nothing, on what must have been a shoe-string budget, bringing reality to life without the ponderous injection of excess craftiness. Beginnings can be very instructive, especially beginnings that are deceptively artless. They strike at recognizable truths without the cluttering of over-labored techniques. Perhaps, at the back of my mind was recollection of one of my all-time favourites—Fellini's *La Strada* (1954, Italy), with the unforgettable performance of Giulietta Massina in the archetypal role of the tragic clown. I am not making the same claims of accomplishment for both—by no means. They are both variations on the same theme—the many faces of *The Road*, my own favorite foraging ground, admittedly—and there the comparison ends. That touch of creative innocence however—perhaps that is what sticks so charmingly to the mind.

And then of course, there was the already socially dedicated hand of Ousmane Sembène, who grew in self-assurance as he tackled increasingly demanding historical and contemporary social themes—one and all were gathered in Dakar, brimming with confidence in multiple disciplines, a churning magma of artistic forces of a post-independence generation. It is evidently too late now to appeal to those who have embraced—yes, we come close to the "n" word, I am gearing myself to utter it—yes, those nationals who have fallen for the hackneyed short cut to their own naming ceremonies. Even more thankless than preaching to the converted is preaching *against* the converted. When so much time has passed and a habit become deeply engrained, what forces of persuasion can one muster to undo that mind? As we say in Yoruba—*t'ewe ba pe l'ara ose, oun na a d'ose.* If the leaf wrapping of soap sticks too long stays too long to the soap, that leaf also turns to soap. So, peace unto all upon whose sensibilities I have certainly intruded. This drawn out exposition is not really addressed to them; rather it is a simple entreaty to those who have not yet succumbed to the lure of the soap and leaf. To you, I plead: Imagine if the then putative film venture that made its organized debut in Dakar 1966 had been lumbered with the name—Dollywood? Every ensuing product is already doomed in the mind with its associated baggage of infantilism, even before its exposure. Just imagine the annunciation of—a Dollywood film festival. Or perhaps "Sellywood" for Senegal? Nothing could be sillier.

If only it stopped at subjective revulsion? However, there are more provocative questions, such as: Does the branding influence the product? If you give a product a deleterious name, does it affect, in advance, the consciousness of future producers? If, on the other hand, a propulsive, challenging name, one that even intimates more than it presently is, would that provoke in

the artiste a tendency towards adventurousness, experimentation and originality? Or are we merely indulging in self-flagellation? If the pioneers of 1966 had grouped itself around the formulation—Dollywood—would we have produced today's Souleymane Cissé, Ola Balogun, Kola Olaniyan, Bello, and the rising generation of cineastes? Consider this, following the mentality at the base of this, FESPACO, because based in Burkina, would be Bullywood. Or perhaps, since that is so close to Bollywood—Bellywood. Try and think—just one more!—of anything more ghastly, more ghoulish than the contribution from Ghana—Ghollywood! Well, you know where it all started. However, do the emerging Nigerian new breed still deserve to be associated with that commencing second-hand clothes market tag, or with an evolving designer cut production, catering, not for the lowest common denominator in taste but for more discerning audiences, and/or raising—and surprising—expectations in their limited scope. Even a casual study of current film making indicates that the Nigerian film occupation is rapidly bypassing the stage of such infantilism. So why should the films of such artistes continue to be classified under that unprepossessing monstrosity of a verbal shroud known as—here it comes at last!—Nollywood?

How do we extricate—both for internal and external references, including potential markets and consumers—the grain from the chaff, the silkworm from the congealment of the pupae? See what the Indian film industry has churned out so prodigiously since it succumbed to the perverse name of Bollywood. Thousands of films emerged, mired in that same Bollywood mush. It took a Satyajit Ray to plot a truly original path through the morass with his masterful *Pather Panchali* (1955), the first of a trilogy of ordinary lives that opened the eyes of viewers to the vast world of mundane rhythms, East and West Africa. See what toll this has taken in the conditioning of audience tastes, expanding to southern, and West Africa. We must point out however that there may be a correlation between the product and the environment that brought it to life in the first place. Each phenomenon of naming is not unrelated to the social space of that naming ceremony. The social, political, business, religious. . . . [I]ndeed the entire interactive environment of Nigeria, birthland of Nollywood—unpredictable, raucous, egotistical, callous, sentimental, irrational, and pugnacious all at the same time—the manifestations that make up Nigerian reality are so grossly improbable that it sometimes appears to me that all you have to do is set up a camera in an office, in a market, in the motor garage or indeed any street corner, go away for lunch, and return several hours later and—voila!—a film has already been shot, ready for only a little editing here and there, but virtually ready for release as a truthful reflection of Nigerian life. This, by the way, is not entirely speculative. Some Nollywood products have been made that way.

Indeed the very material raunchiness of Nigerian life does create a tendency to reach out towards improbabilities. Nigerian social actualities are of such a nature that the filmmaker's creative mind feels a compulsion to top it with excess in order satisfy the demands of novelty. In other words, life around the contemporary filmmaker, where the grossest excesses take place every day but are treated as the norm, forces imagination to reach outside and beyond reality to convince itself that it is at work, that it is not merely imitating reality. Everything is oversize in the birthplace of Nollywood—oversize consumption, oversize class distinctions, oversize exhibitionism, oversize egos, oversize superstition, oversize dehumanization, oversize corruption, oversize inflation—both human and economic—oversize national real estate, oversize pugnacity, oversize garbage heaps, oversize decay, oversize media, oversize foreign investments, oversize churches and oversize mosques, oversize consumerism by an oversize elite, even oversize First Ladies with oversize vulgarity, oversize rapacity, avariciousness, and over-reachiousness. You will not find that last word in the dictionary, but I happen to come from the land of Nollywood, where, if an expression is outside your non-existent vocabulary, you have the license to make up your own.

As a dramatist, I think I can sympathize with the artistic representation that goes after the grossest aspects of the environment with a sheer oversize productivity at the expense of quality. After all, when I wanted to capture the sheer brutishness of existence under one of our most notorious dictators, did I not reach for the Theatre of the Absurd—in Alfred Jarry's *UBU ROI*? I proceeded, quite deliberately, to try and top the already grotesque excesses of Jarry's adaptation in my creation of King Baabu. Reality could no longer suffice. The same creative process probably affected those early video lords. The Nigerian creative mind opens his newspaper day after day and what lurid headlines confront him? with the headlines: RITUALIST CAUGHT WITH FRESH HUMAN HEADS, BODY OF ONE MONTH OLD BABY WITH MISSING VITAL ORGANS—MOTHER IN CUSTODY, KIDNAPPERS INVADE CHURCH, ABDUCT OFFICIATING PRIEST; BOKO HARAM KILLS SEVEN HEALTH AIDF WORKERS; BOKO HARAM ABDUCTS SEVEN CONSTRUCTION WORKERS; TWENTY-SEVEN BODIES WASHED ASHORE ON THE BANKS OF RIVER BENUE; PROPHET ARRESTED WITH FIVE HUMAN SKULLS AND A BABY FEOTUS . . . and so on and on. These are not made up headlines. Is it any wonder that the filmmaker goes for the horror genre, where the staple news is that the local chief is cooking up his subjects piecemeal, order to make millions or win a local government election.

An inclination towards accommodating foreign models of the sensational then follows, faced with such gargantuan proportions of societal reality

begging for expression—and where is this to be found but in the ready-made formulae of cheap Hollywood? Cheapness calls to cheapness. Where what are generally valued as social assets—and that includes human life itself—are held so cheaply, the artiste may consider it beneath him or her to expend more than the cheapest representational responses. The precedence is not lacking. The early contemporary African-American black directors rode to cinematic prominence on the shoulders—in case we have all forgotten—of what came to be known and early described as Blaxploitation Movies, films that exploited Blackness, albeit in a stereotypical and imitative genre, substituting black actors for Grade B white actors, black environment for white, but catering equally to what was considered low taste—Richard Roundtree in the *Shaft* [1971–73] movies, and even, *Blacula* (dir. William Crain, 1972, United States) instead of that classic horror genre of limitless exploitative potential—*Dracula*, all blood and gore, only black blood this time, albeit red. What is the difference between Blacula's fangs fastened on the jugular of a prostrate black victim and the fangs of the insensate ruler fastened on the life-blood of a prostrate generation?

All that conceded, the objective of art does not exclude transformation, and by that I do not mean simply—societal transformation. Indeed, you may have observed that I do not say—the objective of art is to transform society. No, I deplore that familiar, ideological but dictatorial demand of art. The objective of art is also—among other purposes—Revelation. Whether Revelation leads to transformation or not is a different issue. The primary objective of Art is to constantly transform itself, its own modes of expression and representation. The objective of Art is also to be chameleonic and protean—that is, to change shape and color at will, to supersede both reality and expectations. Yes indeed, the goal of transformation is not only desirable, it is an integrated element of what art does. We do not want us to get bogged down with that ancient, ragged discourse based on a one-track, reductionist relationship of art to society, what the artiste's obligation is etc. etc. Writers have put themselves through this wringer, especially during the phase of ideological self-bashings that all societies undergo, and in particular societies that have been victims of imperialism and colonization—including cultural degradation from external forces. Filmmakers should please understand that that discourse is daily overtaken by events, and we should now primarily interest ourselves in how the cineaste, as artist, transforms the material at his or her disposal. What applies to the writer, painter, musician, sculptor, even architect is just as pertinent to the filmmaker.

Nonetheless we must acknowledge that there is a kind of imagic immediacy that is more applicable to the cinema than to other forms of expression, including even theatre. Cinema is a powerful tool for transformation, no question about that. However, just as in literature, the cinema can easily become a medium of crude propaganda that is totally devoid of artistic solace, blaring

out an ideological line as a substitute for creative rigor. Art is its own rigorous master; it makes demands, and the primary responsibility of the artist is to fulfill those demands. This, for instance is what makes Ousman Sembène a cineaste of great versatility, one of the most consistent that the continent has produced—his ability to embed a social message in a work without sacrificing its artistic vision. I have singled out Ousmane Sembène because the same kind of artistic integrity is apparent in his writings—*God's Bits of Wood*— for instance, as in his films—*Ceddo* (1977, Senegal) or *Xala* (1975, Senegal).

Must films carry a message? My answer to that is: does *Harry Potter* (dir. Chris Columbus, 2001, United States) carry a message? All we know is that those films—like the book itself—carry a wallop and generates envy in the minds of most filmmakers. Nothing wrong with envy, by the way. Indeed envy can actually be a good motivator. Even the Vatican is not free from it. About four or five years ago, the Vatican issued a condemnation of the film series as a dangerous endorsement of Satanism. Well, my reaction was— oh-oh, here comes the green-eyed monster eyeing the greenbacks flowing into the box office. After all, has the Church, ever since its mammoth success with the bible, ever come up with another literary success story? To rub pepper in the wound, each time some lavish, money-spinning production from the scriptures takes place—like *The Ten Commandments* (dir. Cecile B. DeMille, 1956, United States), with the over-muscled Charlton Heston in command—the Church gets no royalties whatsoever. I think we should simply dismiss the Church's demonizing encyclicals. Fantasy is a different matter. Each time I see news coverage of mile-long queues winding round a cinema theater where a new Harry Potter book is being launched, and the same endless queues when the next Potter film is due to open—grand-parents, parents, children of all ages—I fantasize about meeting Madame Multi-billionaire Rowlings in a dark alley where there are no witnesses. As that opportunity became less and less likely, I began to think seriously of matching skills against hers, but based on our own African mythological resources. Needless to say, the very first step of the creative idea is always the easiest part—which is to think to oneself—hn-hn, that seems to be an interesting idea. Then the second step forward is—hn-hn-hn, that is a very good idea. Then the third, which is of course—wait a minute, that really is a brilliant, creative idea. After that, other distractions intervene, and a dead-end looms in view. I know I shall never even succeed in setting down even the mere film treatment of a *Harry Potter* success. Others can, however, and should. Why should a Bambara equivalent of the Potter series not also take the world by storm? If anyone here has a new idea on the subject—but without the Nollywood stamp—let me announce right here that I am open to propositions. But don't even bother to get any ideas on the subject unless you have the preliminary, capital idea—which is how to raise the capital.

Motivation is a question that any serious artiste must face—and do note that I use that expression deliberately—"serious artiste." Artistic seriousness is not a contradiction of material success—all it requires is honesty, the courage to come to terms with the question—why am I in this occupation? Why did I choose to go into it? If it is to make money, then you must study the consumerist trends, and apply yourself to them. But then, if you are also a serious artist, you decide whether you wish to indulge that taste by remaining on that same level or—take it to a higher state, however slight, even though your starting blocks are set firmly on that track known as popular appeal. Creativity lies in advancing the level of one's artistic choices. Yes, the practical question of even "breaking even" is not to be pushed aside—whether we like it or not, no serious film artist can blithely ignore the economics of taste—and there lies the tyranny. Taste in itself is a very ambiguous, indeed vexatious issue. Taste, one has to acknowledge, can be a snob affectation, or elitist consciousness. How does one define good and bad taste? Is minority taste necessarily the most refined, while the majority is despised as the fodder of the masses? Taste? The pulp video producer would probably sneer. Taste? The only taste I know is the taste of food and anything that puts food in my mouth—that's good taste!

Yes, taste. The often intolerable weightiness, yet lightness of taste! Even censorship, ever opportunistic, cashes in on Taste—this or that is in bad taste because it goes against African—or increasingly, religious—culture, as if culture is static, not dynamic and evolving. This is what many advocates of culture fail to understand. The extreme policy choice of outright and extreme censorship in the name of cultural purity—most notable in societies that are infected by the virus of religious fundamentalism—banning or controlling the means of reception—such as video cassettes, satellite dishes and even—books. are of course, futile and retrogressive. The incursion of the negative or dubious alien cultures, values and tendencies, is best countered by the strengthening and exposure of indigenous cultures, ideally in innovative ways, not by creating a hermetic society, closed to all external development. Even *Big Brother Africa* (2003-present), a series I thoroughly detest—suitably overhauled—is not, as format, without cultural and transformative possibilities. To be able to watch, for instance, a group of young people—Christian, Muslim, Buddhist, traditional believers such as the *aborisa*—interacting as normal beings, worshipping in their own way day in day out, indifferent to the frenzy of religious extremists, within an intimate environment—now that may speak meaningfully to viewers regarding one of the most devastating crises of cohabitation that currently confronts us—the crisis of the aggression of faith, now ravaging swathes of our continent.

Images are the most powerful ambassadors of the cultural exchange, and thus, the cinema and video can affect modes of thinking, perception and—most pertinently—human regard. The temptation for the African filmmaker

is to attempt to be a Stephen Spielberg when it is possible to make a small classic of memorable dimensions. Such gems exist, manifestations of the claim: Small is beautiful. Having served on quite a handful of film juries since the sixties—African, Asian, Latin American, Eastern European, and others, I do confidently assert this. It should not suffice to display only new films on occasions such as this. There are some modest but inspired works that require to be made more accessible, films that were made when Africa had greater leisure, when internecine wars had not worn out the creative resources of the younger generation, driven into exile, lodged in dungeons for expressing dissident views through their art, turned into child soldiers or driven underground by the rampaging virus of bigotry, and vulgar, murderous religious fundamentalism. Courage is constantly on call.

Try and recall the number of filmmakers—in company of writers, painters, and other creative individuals—whose lives have been snuffed out for attempting to actualize their vision of humanity, and I am not simply speaking of cases that made international headlines, such as the Dutch filmmaker, Theo van Gogh, who was gunned down in the streets of Holland for a film that denounced the oppression of women under narrow, twisted, chauvinistic interpretations of scriptural texts. Before van Gogh, filmmakers had been routinely cut down in their prime during the fundamentalist upsurge of Algeria—in some cases, sent into exile. I recall the case of one filmmaker who resisted all efforts to by concerned friends and colleagues to make him relocate to Europe for his own safety. He however made a habit of spending at least two months a year away from the Algeria of that time, as a therapeutic regimen, simply to decompress, to ease off the tension of daily survival in his homeland. These are themes that you will confront sooner or later. You will be confronted with life-impacting choices. The video cassettes—DVD, CD-rom etc.—are our allies. They are handy weapons in the battle for creative freedom—let us not hesitate to use them. It is only a matter of time—if it is not happening already—when we shall be able to download entire films via satellite onto hand-held phones, escape into a transformed vista of humanistic possibilities, uncensored, snatching hours of refuge from the agents of mind-closure, from criminal minds masquerading under religious fervour.

Let us not mealy-mouth about, or underestimate the enemies of creative life—they are in reality no more than brutal, unconscionable replacements for the old order of political repression by alien imperators, from which our nationalist pioneers have labored and sacrificed to extricate our humanity. If you made a film today about pedophilia in Nigeria, and the plight of girl children who, victims of so-called religious permissiveness, end up as pathological wrecks of vestico-vaginal fistula, be sure that you will incur the ire of those perverts who, exposed as confirmed, serial pedophiliacs, actually sit at the apex of your law-making structures—as in my own Nigeria. They will

team up with the homicidal deviants of the religious mandate and attempt to snuff out your existence, be they called Boko Haram or whatever else.

We are all living on the edge or daily survival—if you are still in the exemption zone, if you think you are immune, take it from me, you soon will discover different. It is a virulent contagion. And so you must make up your mind but—make your choice. In the early days of this now notorious insurgency, a television newscaster was deliberately shot and killed by one such group. Deliberately, I said, with murder aforethought, since the killers sent a message afterward that this was a collective punishment for journalists who—in their view—had distorted accounts of their activities—as if it was possible to distort a pattern of activities already more bestial than anything the Nigerian people had encountered in postcolonial times. So just think what the risks are when you confront such retrograde interests with stark, realistic moving images of their anti-humanist mission. The creative founts are being shut off every day, and the mere business of survival is driving potential talent off the abundant terrain for the flowering of their genius. Reminders of what was produced in African film immediately before, and during the continent's early energized burst of creativity, that inspirational surge from the flush of independence, should always be made available as yardsticks of the possible, and the relevant. This is what guarantees continuity, and continuity in the Arts is as essential as the DNA spiral is to human evolution.

Themes change, as does fashion, but art is constant. If you asked me what is the pressing theme of this moment for us on the African continent— for those who feel compelled to be socially relevant, who do not feel artistically comfortable or fulfilled unless their lenses are directed inwards into the anomalies of society—permit me to isolate that perennial theme that weighs us down on this continent. It is an answer you should have discerned from the foregoing, but let me spell it out even more succinctly by calling your attention to events that are undoubtedly very fresh in your minds.

The literary treasures of Timbuktu are invaluable. As a writer, I experienced days, weeks of anguish when the neo-barbarians of our times invaded Mali, with the avowed mission, already brutally executed in other places— such as Somalia and Northern Nigeria—of resuming an age of censorship that one thought the world had repudiated at least a full millennium before. Valuable as these manuscripts are however, perhaps filled with hitherto unheard-of narratives for the jaded filmmaker seeking to break new grounds—but never mind even if they are devoid of such—they mainly serve as a solid, prideful foundation, as heritage. They are monuments to the past, the measure of a people's creative and potentially transformative signposts of the future. That tangible future however, is what we read in the products of the contemporary artistes, and most especially those artists who employ the most contemporary medium of expression—the cinema.

Then, ask this question: what is the social condition of such artistes? What would have been their fate if the zealots had been permitted to retain and consolidate their asphyxiation of culture in Mali. There is no need to speculate. Simply demand of the Souleymane Cissés, the Oumar Sissokos of that nation, ask them from which direction they encountered the greatest obstacles in the practice of their trade—directly or indirectly—over the past decades of cinematic engagement? I am speaking of those entrenched censors constantly spreading their shadows over creativity. Enquire what themes, so pertinent to the present and the cause of full artistic expression, have raised the hackles of the religious irredentists of society, to the extent that governments have often been obliged to ban the screening of such films, in order to appease such atavists.

Yes, indeed, if you seek the iconic images of our time, you will find them in the plight of women who are being lashed publicly for showing off an inch or two of bare flesh above their ankles. They are to be found in the disfigurement of individuals whose hands have been amputated, equally on account of stealing a loaf of bread as for shaking hands with a human being of the opposite sex. You will find them in those blood-drenched pits where women have been buried to the neck and stoned to death by a public for the crime of giving their bodies to whomsoever they please. They proliferate in images of men awaiting execution for yielding to the impulses of that biological make-up that responds only to others of the same sex and result in homosexual relationships. You will find them in the ruins of the heritage of the past as well as the rubble of the centres of leisure and enlightenment— the theatres, the artiste clubs, and the cinema houses. We cannot all, and for much longer, evade the call of re-constructed images of nine female health workers, shot in cold blood for the incredible "crime" of inoculating our youth against the polio scourge that fills our streets with human millipedes crawling in between vehicle wheels in traffic, eternal beggars from the leftovers of our indifferent elite. Yes, you, our front-line filmmakers from West to Southern Africa, who have used these very images of the cripple, the blind, the amputees, the stunted, the twisted and mangled from birth to press your message of responsibility on society, or even simply—as in Ghollywood, Nollywood, Bellywood etc.—to pander to the thrill of the grotesque in voyeuristic audiences, maybe it is time to delineate a cause-and-effect between the prevalence of those unfortunates on our streets, and the brain infection that leads to the deaths of nine health workers, women who are dedicated to preventing the very ailments that produce such malformed humanity. Or the three foreign doctors from North Korea whose throats were slit for no other crime than that of ministering to the ailments that must beset a people with a grossly deficient proportion of medical practitioners per populace.

Yes, these are impositions from the hands of the latest in the line of internal neocolonialists, and their backers, the external imperators. And such pressing issues of our postcolonial times, alas, are obscuring the battle against corruption, camouflaged dictatorship, social marginalization, hunger, lack of shelter, and the brutal alienation of political practice—that urgent issue is easily summed up as bigotry, intolerance, the degradation our own very humanity in the name of antique interpretations of sectional scriptures. The prime issue of our time however remains painfully the same, the ultimate battleground, as ancient as it is eternal: that battle is one between Power and Freedom. Power as exerted, not this time by the state but by quasi-states, without boundaries, and without the responsibilities of governance. History demonstrates however that Power is transient, while Freedom is eternal. Let our film practitioners engage in this battle—but only if battle is in their blood. If not, do not despair or burden yourself with guilt: simply, make—films.

But films need capital. They require subsidy. For the younger generation, a fraction of what governments waste, what politicians steal, what civil servants divert, the total value of the holdings of two or three indicted or fugitive governors from Nigeria or elsewhere on the continent, stored in offshore businesses with their mattresses stuffed with cash in place of cotton or kapok, the sum of off-shore properties, of which more and more are being confiscated—thanks to a slowly evolving conscience of some European nations—and occasionally restored to national ownership . . . a fraction of all this is more than enough to turn the African continent into—do excuse yet another neologism—the Fespascene—or perhaps the Fespacity of the world. Or whatever. A veritable film Valhalla, if you prefer, only anything but, absolutely not yet another exocentric, dumbing down, brain-dead cliché such as—Africa's—Allywood!

Wole Soyinka is a distinguished poet, playwright, and author from Nigeria. From 1975 to 1999, Soyinka taught Comparative Literature at the Obafemi Awolowo University in Nigeria. He has since taught courses in creative writing, African Studies, and theater arts at a number of universities in the United States, becoming Distinguished Scholar in Residence at Duke University in 2008.

Notes

Text of a keynote address at *CODESRIA at FESPACO*. Delivered at the CODESRIA-Guild of African Filmmakers-FESPACO workshop, "Pan-Africanism: Adapting African Stories/Histories from Text to Screen," February 25, 2013, in Ougadougou, Burkina Faso. Previously published as Wole Soyinka, "A Name is More Than the Tyranny of Taste," *Black Camera* vol. 5, no. 1 (Fall 2013): 237–250.

Cine-Agora Africana: Meditating on The Fiftieth Anniversary Of *FESPACO*

Aboubakar Sanogo

> It is good [for African films] to go to Cannes, but Africa must create her own.
> We have FESPACO. We begot FESPACO, now it is FESPACO that carries us
> forward.… Let us be the ones to first recognize the quality and the value of
> our artists and their works.… It is up to us to create our own values, to cele-
> brate them, to carry them throughout the world. We are not alone in the
> world, but we are our own sun. In the deepest of all darkness, if the Other
> does not see me, I see myself. And I shine.
>
> —OUSMANE SEMBÈNE[1]

The week of February 23–March 2, 2019 witnessed one of the most important events on the cultural calendar: the fiftieth anniversary of the Pan-African Film Festival of Ouagadougou (FESPACO), launched in 1969 and a biennial event since 1979. It is rare in world cinema that a festival becomes the embodiment of both the aspirations and frustrations of a conti-nental and indeed global film community around the idea of the image of Africa, the world's oldest and youngest continent. Indeed, the festival is an institution around which all kinds of projections, imaginaries, demands, ambitions, and expectations are articulated regarding the place of Africa in cinema—and through it, in the world.

How FESPACO Came Into Being and What It Sought to Achieve

Although African-led experiments with the moving image date back to the medium's beginnings in the late 1890s, it was really in the late 1950s and early 1960s that a movement toward a continent-wide cinematic project began to take shape through the emergence of African filmmakers recently trained in European film schools. Influenced by the general decolonization movement and inspired by the politico-theoretic-artistic work of a genera-tion of artists and intellectuals, they began to create small collectives and to

attend gatherings and meetings at international congresses (such as those organized by the Présence Africaine movement in Paris in 1956 and Rome in 1959), art and cultural events (the World Festival of Black Arts in Dakar in 1966 and the Pan-African Cultural Festival in Algiers in 1969), and film festivals (Cannes and others). And they mulled over the need, in the context of a historic external dominance over the continent's screens, to create film festivals in Africa.

After the creation of the Journées Cinématographiques de Carthage (JCC) in Tunisia in 1966, due in no small part to the collaboration of Tahar Cheriaa and Ousmane Sembène, there was an even stronger desire to create another festival that would be located, for lack of a better term, "south of the Sahara." According to Sembène, he was assigned by his pioneering colleagues to travel across Africa in search of a country that would agree to host such a film festival.[2] After several rejections, he found very receptive ears in Burkina Faso (what was then Upper Volta), where President Aboubakar Sangoulé Lamizana welcomed the idea in spite of the country's very limited resources. This origin narrative is complemented by another domestic one, according to which Upper Volta's Ciné Club Federation, which used to meet at the French Cultural Center, was also involved in advocating for a festival that would screen African films in Africa.[3]

It is thus through the combination of the desires and efforts of African filmmakers and of the Burkinabe ciné-club movement, together with the benevolent support of enlightened military leaders, and of the French Cultural Center, that the Premier Festival de Cinéma Africain de Ouagadougou (First African Film Festival of Ouagadougou) was held in Burkina Faso from February 1 to February 15, 1969. The first edition screened thirty-four films and was attended by directors Timité Bassori, Paulin Soumanou Vieyra, Moustapha Alassane, Oumarou Ganda, and Ousmane Sembène, along with Jean Rouch and Joris Ivens, among other original participants, and even included a questionnaire to the public about their favorite festival films.[4]

FESPACO 2019

With its consolidation in the 1970s—from its institutionalization and start of an official competition in 1972 to its move to biennial status in 1979—the festival arguably reached its golden years between 1981 and 1987, corresponding to the rise of the legendary figure of Thomas Sankara, who would mark FESPACO and African cinema history in the most indelible fashion. A dynamic, charismatic, and cinephile head of state, he channelled Jean-Luc Godard in arguing that African cinema ought to pursue the truth twenty-four

frames per second. Sankara was a rare statesman who uniquely supported the cinema politically, financially, theoretically, and ideologically.

Sankara helped consecrate the role of cinema in the transformation of the destiny of the African continent, and, in the process, secured the place of FESPACO in Burkina Faso. He sought to decolonize FESPACO by reducing European influence and promoting the African diaspora as an important counterpoint. Through his efforts, the Paul Robeson Award was added to festival to celebrate the contribution of filmmakers from the African diaspora.[5] His actions also led to the rebirth of the Pan-African Federation of Filmmakers (FEPACI), whose heyday also dates back to this period and its immediate aftermath under the leadership of director Gaston Kaboré. He also financially supported filmmakers in difficulty, as in the case of Med Hondo during his tribulations while making *Sarraounia* in 1986.

The assassination of Sankara on October 15, 1987, was a significant blow not only to Burkina Faso but also to the FESPACO festival, leading to its desertion by many important figures including the late Med Hondo, Haile Gerima, and others. The event also marked the temporary defeat of a certain idea of Africa that the festival had tried to embody. Finally, it meant that the festival would now take place within a reconfigured geopolitics that would profoundly affect it and the cinema it set out to promote.

In the five decades since then, the festival has sought to respond to a multiplicity of imperatives, including the need to provide a space where African cinema's cultural workers can encounter African audiences and have a conversation through the cinema about the place of Africa in the world. FESPACO may also be said to have contributed significantly to the permanence of the idea and production of African cinema. It has become a home for African filmmakers, one where they are instantly recognized and celebrated (within the means and abilities of the festival's own organizational infrastructure, which is constantly financially and organizationally challenged).

Over the years, the festival has also contributed immensely to the emergence and consolidation of national cinematic traditions across the continent. Indeed, there would be no Burkinabe cinema without FESPACO. Likewise, the festival serves as a barometer of the health or lack thereof of the various national film industries on the continent. A film's success at FESPACO can prompt policies and measures favorable to the cinema in a filmmaker's home country. Such is the case in nations like Senegal, where Alain Gomis's triumph with *Tey* (*Aujourd'hui*, 2012), which was awarded the Gold Yennenga Stallion (the festival's top prize), in 2013, prompted several initiatives to encourage domestic film production.[6]

FESPACO is also, significantly, a library and archive of debates on African cinema. It has always been the place where filmmakers, film professionals,

academics, public intellectuals, and financiers gather to articulate ways to improve the state of African cinema and its role in African and global polities, as well as to propose new theoretical and critical grids through which it might be read.

The Fiftieth Anniversary of FESPACO

FESPACO set out to celebrate its golden jubilee in a grand style, articulated around the twin aspects of retrospection and prospection, as evidenced by the festival's official theme, "Memory and Futures of African Cinema."

Turning Fifty, Part One: Retrospection

The retrospective dimension of the festival took several forms in 2019—some innovative, others building on past practices. Among the most significant were the Sunday-morning remembrance ceremony, the inauguration of a statue of a past Yennenga Stallion winner on the festival's Walk of Fame Alley, a new heritage section, and a fiftieth anniversary colloquium.

The festival's traditional Sunday-morning event at the Monument des Cinéastes was, and indeed has long been, one of the most important cinematic rituals anywhere in the world. The monument becomes a very literal place of memory where departed filmmakers are remembered through a ring of memory, constituted by festival participants who hold hands and make several revolutions around the monument in a counterclockwise direction in order to represent resistance to the implacable logic of the passing of time.

Ouagadougou's Monument des Cinéastes

One of the highlights of the fiftieth anniversary was the unveiling of the sixth monument on the new Avenue des Cinéastes on the left flank of Ouagadougou City Hall. Initiated in 2009 to mark the passing of Ousmane Sembène, the avenue is now home to bronze statues of past winners of the festival's Yennenga Stallion award such as Souleymane Cissé, Gaston Kaboré Idrissa Ouédraogo, and Fadika Kramo-Lancine. For 2019, a new bronze statue of Dikongué Pipa, who won the top prize in 1975 for his now classic *Muna Moto*, was unveiled.[7] The passageway is set to stretch over hundreds of meters, from the Monument des Cineastes to the National Cathedral of Burkina Faso, making it a unique walk of fame where the famous are not looked down and walked upon (as on Hollywood Boulevard) but rather looked up to as sources of inspiration.

The retrospection occasioned by the fiftieth anniversary was also reflected in the programming. Indeed, this year's celebrations were marked by a special curation of the opening screenings and of a new heritage section of restored African classics. These initiatives were an outgrowth of recent efforts by FEPACI to durably intervene in the field of film archiving in order to create an archival *dispositif* in Africa.[8] One of the most publicized dimensions of this work is the African Film Heritage Project (AFHP)—a partnership between FEPACI, Martin Scorsese's Film Foundation, UNESCO, and the Cineteca di Bologna—to conduct the preservation and restoration of fifty African films of historic, cultural, and artistic significance.

The fiftieth anniversary of the festival offered the opportunity to "return" to African audiences four major works restored to date: Timite Bassori's *La femme au couteau* / *The Woman with the Knife* (1969, Ivory Coast), Med Hondo's *Soleil Ô* / *Oh Sun* (1970, Mauritania), Mohamed Lakhdar-Hamina's *Ahdat sanawovach el-djamr* (*Chronique des années de braise* / *Chronicle of the Years of Fire* (1975, Algeria)*, and Dikongué Pipa's *Muna Moto* (1975, Cameroon). These films anchored a series of twenty-three classics (many restored) of African cinema, with homages to directors including Ousmane Sembène, Shadi Abdel Salam, Djibril Diop Mambéty, Idrissa Ouédraogo, and Gaston Kaboré, among others, often in the presence of figures involved in their creation. One of the results of this exhibition of restored and classic films was the festival's expressed desire to institutionalize it for future iterations, creating a new "Classics" section.

An anniversary colloquium set out to consecrate FESPACO as a site of knowledge production about the history, politics, aesthetics, economics—in fact, as a site of the renewed vision(s) and project(s) of African cinema as a whole. It sought to do so through a very productive examination of the festival's narratives of genesis and emergence, as well as by discursively articulating the stakes as well as prospects for contemporary and future African cinema. Of particular importance were the reminiscences of pioneering filmmakers and festival organizers, as well as major keynote addresses by two prominent continental and diasporic public intellectuals: Aminata Dramane Traoré and Christiane Taubira.

Turning Fifty, Part Two: Prospection

The festival's prospective dimensions were marked by innovative curatorial practices intended to potentially transform African film and film-festival practice. One of the most significant yet quasi invisible was the entrance, for the first time in the entire history of the festival, of a Nollywood film in the official feature competition: Oluseyi Asurf Amuwa's debut feature, *Hakkunde* / *In Between* (2017, Nigeria).[9] This was a landmark event for African cinema

that symbolized the formalized beginning of a fruitful conversation between its so-called popular and auteurist traditions. Clearly the festival that bills itself as home of "all of African cinema" could hardly continue keeping at bay the films that are most watched by Africans both on the continent and in the diaspora. Other significant innovations included granting the documentary category the same status as the fiction-film category, with the same number of Yennenga Stallion awards for both. Additionally, the festival initiated a full-fledged animation section.

The fiftieth anniversary also saw the beginning of an important movement toward gender parity and an end to gender discrimination within the African film industry, which has often been celebrated for offering very powerful female characters and roles in the moving image, including such figures as Sembène's Colle Ardo, Mambéty's Linguere Ramatou, and Hondo's Sarraounia. Inspired by the #MeToo movement and taking its name from the famous anti-imperialist and anticolonialist Non-Aligned Movement, a new collective of women filmmakers emerged: the Cinéastes Non-Alignées, which articulates a program and project aimed at advancing the place and role of women in African cinema.[10] The Paris-based collective—initiated in 2016 by Algerian filmmaker Rahma Benhamou el Madani and comprising primarily African and Afro-diasporic filmmakers and film professionals—has an advocacy strategy that includes organizing roundtables and meetings at major film festivals. Significantly, after attending Cannes in 2016, they came to FESPACO.

With the hashtag #MêmePasPeur (#NotEvenAfraid), they organized a roundtable, titled "The Place and Role of Women in African Cinema," that opened a floodgate of testimonies by women—directors and actresses, victims of sexual harassment both in the African and French film industries. One of the most dramatic testimonies was that of Burkinabe actress Azata Soro. She was the victim of violent physical aggression by director Tahirou Tasséré Ouédraogo: he slashed her face with a broken beer bottle, yet his TV5 Monde–funded film *Le trône / The Throne* (2019, Burkina Faso) was initially accepted into FESPACO's TV series competition. Only after a petition was filed by the Cinéastes Non-Alignées was the film withdrawn—before the end of the festival—and the francophone channel's airing, set for March 2019, cancelled. The collective also noted that, in the entire fifty years of FESPACO, not a single woman had ever won the Golden Yennenga Stallion, even though it was named for a warrior princess.

FESPACO 2019: The Films

Festivals are first and foremost about the films themselves. For this particular edition, FESPACO—unlike festivals such as Cannes and Venice—did not

commission an omnibus project with important cinematic voices from across the continent to celebrate itself. It lacked the resources for such a project. However, it did select and screen a broad range of short and feature films in the fiction, documentary, and animation categories as well as its panorama, television series, and film school sections. There, with the benefit of a diverse representation of decades and countries, key interests and challenges in contemporary African cinema could be discerned. The films' concerns over memory, the geopolitical, and the effects of powerful external forces were ever present, along with one of the grand narratives of twenty-first-century Africa: the advent of jihadism and its effects on the continent.[11]

Ntarabana (2017) marked the return of Cameroonian director François Woukoache, a major voice in the documentary form, to the continental scene. *Ntarabana* is the third part of a triptych on the genocide against the Tutsi in Rwanda, which started with *Nous ne sommes plus morts* (2000). Its focus in on "the Just"—those in the "hegemonic" camp of Hutus who saved Tutsis—but the film also introduces the notion that victims of the genocide themselves must also be counted among the Just, for performing a great act of human affirmation by forgiving—indeed, even "loving"—the former perpetrators. *Ntarabana* becomes a lasting testimony to human transcendence while refusing, à la Claude Lanzmann, to utilize archival footage of the catastrophe, opting instead for poetic and overexposed cutaways that turn the lush beautiful Rwandan landscape suddenly into spaces of death and destruction. In so doing, Woukoache interrogates the very represent-ability of horror.

Rwandan filmmaker Joël Karekezi chose to examine the geopolitical implications of the Rwandan genocide in the Central African region in *The Mercy of the Jungle* (2018), which won him a Gold Yennenga Stallion, seen by many as a gift to Rwandan President Paul Kagame, this year's FESPACO guest of honor. The film actually functions as a critique of the position of the Rwandan state—indeed, of its presence in the Congo in the first place. Through the narrative trajectories of its characters, *The Mercy of the Jungle* demonstrates the moral bankruptcy of war and offers an indictment of all the armies and factions involved. It is an anthem to peace, to the return of peace, and to the possibility of cohabitation and conviviality within a complex context overdetermined by national, regional, and international geopolitical manoeuvring. It is by no means a masterpiece, though it is competently directed and filmed, but *The Mercy of the Jungle* carries on an antiwar humanist tradition that is agnostic about geopolitical rationales for war, instead placing the value of human life above such violence.

FESPACO also saw the screening of the latest film by one of the enfants terribles of African cinema, Jean-Pierre Bekolo. His *Miraculous Weapons* (2017, Cameroon) was initially supposed to be set in the United States but

was transposed to the context of apartheid South Africa in the period of the late 1950s and early 1960s. It is beautifully shot, emphasizing primary colors in its story of three women ostensibly in love with the same man on death row. Multilayered and complex, the film explores the tools necessary for the emancipation of the African subject, from cultural and political nationalism to the poetic sensibility of knowledge, language, and logophilia. Finally interrogating the instrumentalization of the liberal-savior complex as a dimension of the struggle, the film is expressive of the philosophical-theoretical-poetic turn that Bekolo's work has taken since the mid-2000s.

In recent years, the grand narrative of jihadism and Islamism has become a topic of importance to African filmmakers, who see some of the foundations of their societies shaken by it. Two such films screening at FESPACO seemed to resonate with each other: Mahmood Ben Mahmood's Bronze Yennenga Stallion winner, *Fatwa* (2018, Tunisia); and the much smaller documentary *Dawa, l'appel à Dieu / The Call to [Praise] God* (2018, Cameroon), by a Malian follower-turned-filmmaker, Malick Konaté.

Set in Tunisia in 2013, *Fatwa* follows the trajectory of Brahim (Ahmed Hafiene), a Tunisian migrant to Europe, who has returned home upon hearing news of the supposedly accidental death of his son Marouane. Through his gaze, the audience discovers an unrecognizable Tunisia, under the sway of an ascetic version of Islam, seeking hegemony over a nation with a long Islamic tradition. It is in effect a battle between Islam and Islamists for the soul of a country. One of the most powerful figures in the film, representing the resistance of Tunisian society from within, is Marouane's mother, Loubna (Ghalia Benali), who, through her principled writings and public stances, remains uncompromising in the face of the rising Salafism (whose leaders declare a fatwa against her) and calls for the return of a secular Tunisia.

Exploring a similar theme is Konaté's *Dawa*, a film that articulates its autobiographical theme through grand narratives of the twenty-first century: jihadism, national sovereignty, globalization, identitarian crisis, geopolitical games, and the validity of spiritual quest. The film presents the redemptive journey of a former adherent of the sect/movement Dawa, which originated in Pakistan and India in the late nineteenth century and apparently entered Mali in the 1990s. Beginning slowly by advocating for a more ascetic version of Islam, Dawa was by the dawn of this decade collaborating with the jihadist forces that took over northern Mali, stopped only by French troops. Using unique archival footage from the fall of Mali and presenting some of the country's key figures of jihadism—and indeed revisiting the places of the brief territorial victory of jihadism in northern Mali and its traumatic consequences for the people there—the film may also be put into dialogue with Abderrahmane Sissako's *Timbuktu* (2014), since it takes up two of the same events.

Questions, however, remain about Konaté's use of jihadist propaganda video in *Dawa* as well as the inclusion of footage of Dawa preachers who still advocate for stringent Islamist laws. To what extent is Konaté reinforcing the views of this strain of Islam, which seems to be seeping into the minds of Malians at a grassroots level? To what extent is *Dawa* the genteel ideological face of a much more sinister and gangster-like jihadist movement? To what extent do the two need each other to succeed?

Indeed, it might be argued that the historical Dawa prepared the work for the soldiers of jihadism—a level of analysis missing in the film. The film's lack of sophistication at the level of ideological analysis produces an emphasis on personal (re)conversion and redemption as a way out of both the ideological and the military dimensions of jihadism, conveying an impression of double naivete, both spiritual and cinematic, on the part of the director.

Finally, the festival saw the potential birth of a new school of documentary. Although Burkina Faso, the land of African cinema, is known for contributing many major names in the continent's fiction-film tradition, few have adopted the documentary form as their primary creative home. This makes Michel K. Zongo—whose *No Gold for Kalsaka* (2019) continues his concerns with the plight of the country's downtrodden populations—a genuine exception in Burkinabe cinema and an increasingly masterful voice for the documentary tradition on the continent, followed closely by Aïcha Boro, winner of the Gold Yennenga Stallion for best documentary for her film *Le loup d'Or de Balolé* / *The Golden Wolk of Balolé* (2018, Burkina Faso).

Their films celebrate the dignity of marginalized workers who toil in conditions of indignity. There is a sense in which both directors appear confident in the possibility of change through collective action. If one (Boro) records change while the other (Zongo) elicits it, they both make it an indispensable part of their documentary projects and may well be partaking in a cinematic actualization of the Sankarist belief in the emancipatory and dignifying character of labor—and the imperative to take one's destiny into one's own hands.

In *Le loup*, her observational participatory documentary, Boro mediates (not unlike Sembène with *Borom sarret* in 1963 regarding the recent African independence movement) the semiotic gap between "revolution" and "spring" in recent African history, interrogating the meaning of the genuinely popular uprising in late October 2014 against the much-reviled twenty-seven-year regime of Blaise Compaoré. The film explores an abandoned granite quarry, a phantom site hidden in plain sight at the heart of Ouagadougou, that was reclaimed by over two thousand workers including orphans, widows, and divorced women, with children—all "phantom" citizen-subjects unacknowledged by the state. Placing high hopes on the demise of the dictator, the manual stone breakers soon find themselves the

victims of predatory and cutthroat negotiating and remuneration practices by middlemen. Unlike John Grierson's subjects in his classic *Drifters* (1929, US), however, they soon stop expecting much from the state and take their destinies into their own hands in their very workplace, overturning the relations of production and starting a process to transform their fate.

Boro's camera is superb in its ability to register both violent visual class conflict and its more subtle manifestations. She shows a pair of school-age quarry workers who walk through the city's poshest neighborhoods, built with the very stones that they break; in transformational sequences, the same children then return to school and, later, see their class status improve through the acquisition of a bike—a shift that resonates like giant steps on the moon. In a revelatory vérité moment that turns the camera into a confessional couch, one of the film's protagonists confides that breaking stones has made him impotent. Finally, Boro has an uncanny ability to pay close attention to the quotidian details of her subjects' lives, such as children playing, cooking, and studying, making home into a space of rehumanization outside the quarry, refusing to reduce the workers to their social condition.

With *No Gold for Kalsaka* (2019, Burkina Faso), Michel K. Zongo continues his exploration of the consequences for local populations of actions, by powerful forces from outside, that create desolation and destruction. In *La sirène de Faso Fani / The Siren of Faso Fani* (2015, Burkina Faso), he had brilliantly analyzed the decimation by

World Bank/IMF structural adjustment programs of Burkina Faso's relatively self-sufficient (at the time) textile industry, which had been a source of national pride, particularly in the era of Thomas Sankara.

In *No Gold for Kalsaka*, Zongo offers a diagnosis of the deleterious effects of the activities of a British company, Kalsaka Mining SA, on the peasant and mining populations of the eponymous village of Kalsaka. The film depicts victims of abusive and destructive extractive practices on the part of the mining company, which reneged on all the pledges it made upon signing the original contract with the Burkina Faso government. The British company reportedly left behind a long trail of broken promises of infrastructural development—destroyed water sources, lands, agriculture—along with traumatized children and abandoned villagers.

One of the most striking dimensions of Zongo's film is his aesthetic. In addition to exposing the news media as an ideological state apparatus that serves as diversion rather than a genuine platform of productive relationships between the governors and the governed, the film uses the metaphor of the Western as one of the ways to read what was very much a "gold rush" by high-tech gold diggers who wiped out all available gold within an incredibly short amount of time (more than eighteen tons, excavated over a period of six years), leaving behind an impoverished and voiceless population—who are

finally endowed with speech through the documentary. To anchor its metaphor, the film adopts the Western's visual and aural tropes through the creation of three latter-day cowboys, who function as transitional figures. They appear in different parts of the film and ride off into the sunset with bags of gold at the end. Aurally, the film's soundtrack evokes Ennio Morricone's scoring of Sergio Leone's spaghetti Westerns.

More importantly, *No Gold for Kalsaka* reflects a new interventionist strategy on the part of the filmmaker, who has been developing over his past few films what might be considered an "action documentary." In his hands, this entails first identifying populations that have suffered at the hands of overwhelming outside forces, then cinematically exposing such suffering and creating within the text of the film itself the conditions aimed at the reversal of the situation.

Zongo profilmically encourages his subjects toward collective action. In *The Siren of Faso Fani*, he helped them create a cooperative by bringing together the varied talents he encountered during the film's production. In the case *of No Gold for Kalsaka*, he invited a team of expert analysts to come test the potability of the village's water. Once the results were available, they became part of the evidence for a potential class-action suit against the company. Thus, the film itself contributes visible evidence, not only through its recording ability but also through the cinematic device created by the filmmaker whereby the victims (peasants and miners) directly address their perpetrators (the mining company) through the camera and state their claim for their collective dues.

This "action documentary" mode delivers something like a wish fulfilment, not in a fantasy Hollywood way but rather by allowing the long-repressed voices of the oppressed to explosively emerge, like a volcano, to express the need for reparation and the restitution of heretofore silenced dues. Zongo is making an important contribution to the documentary form itself with this model and its ability to help effect change within its own praxis.

FESPACO at Fifty: What's Next

Heading into the future, FESPACO faces formidable challenges to its self-renewal: the deployment of new technologies, a radical revision of its organizational and promotional practices, its inadequate economic model, and the need to restore—in keeping with Sembène's wish—its mandate to define the values of African cinema and propose them to the world. Instead, the sometimes secondary rank conferred by its biennial status too often leads it to miss the premieres of important African films and thus the ability to shape their trajectories. In that, it is increasingly challenged by many of the

A-list festivals intent on premiering African films. This blatant disregard on the part of more high-profile festivals was evident in the decision this year by the new Berlinale leadership to move its dates later to accommodate the Oscars and thereby commandeer FESPACO's long-held calendar slot.[12]

FESPACO also has a role to play in helping extricate African cinema from the twin dictates of the commercial imperative and the quasi-inescapable and omnivorous workshop/lab culture that currently hold world cinema hostage. Finally, it needs to participate in providing film and cultural workers on the continent with the weapons to combat the increased risk of recolonization within a new geopolitical context, whereby the armies and corporations of the West, the East, the Far East, Russia, and beyond might very well turn Africa into a neo–Cold War playground—a possibility signaled by the staging of war games involving African and NATO troops during FESPACO.[13]

Aboubakar Sanogo received his MA and PhD from the School of Cinematic Arts of the University of Southern California (USC) in Los Angeles. His work is located both inside and outside academia and seeks to intervene in both spaces in a mutually transformative manner. His research interests include African and Afro-Diasporic cinemas, documentary film theory, history and form, transnational and world cinemas, film preservation and restoration, colonial cinema, early and silent cinema, and film festival studies. He is currently working on completing two manuscripts, *The History of Documentary in Africa* and *The Indocile Image: The Cinema of Med Hondo*, and an edited collection on the cinema of Med Hondo.

Notes

Originally published as Sanogo, Aboubakar. "Cine-Agora Africana: Meditating on the Fiftieth Anniversary of FESPACO". *Film Quarterly*, volume 73, no. 2, 31–40.

1. The late pioneering figure of African cinema made this statement in September 2002 on the set of his final film, *Moolaade* (2004), in Djerisso, Burkina Faso, close to the Malian and Ivorian borders, in Yacouba Traoré's *Référence Sembène* (2002), which told the story of the making of Sembène's film.

2. Ousmane Sembène, interview with the author, Dakar, 1996.

3. Among them was Mrs. Alimata Salembéré, who would become the president of the organizing committee of the first festival and then in 1982–84 the secretary general of FES-PACO. See Hamidou Ouédraogo, *Naissance et évolution du FESPACO des origines à 1974* (Ouagadougou: Imprimerie Nationale du Burkina, 1995), 30–37.

4. Ouédraogo, *Naissance et évolution du FESPACO*, 60.

5. Figures like Haile Gerima played an important role in this—to such an extent that he refused to return to the festival following the assassination of Sankara in 1987.

Although his film *Teza* (2008, Burkina Faso) won the Gold Yennenga Stallion in 2009, he returned only thirty-one years after his 1987 departure, and then only briefly, to FESPACO, after the end of the government of Sankara's assassin. He was then, in 2018, officially awarded a Yennenga Stallion in person.

6. These initiatives included the revival of Le Fonds de la Promotion de l'Industrie Cinématographique et Audiovisuelle (FOPICA). See www.sencinema.org /presentation-fopica/.

7. Dikongué-Pipa has since renounced his Christian first name, Jean-Pierre. Interview with the author, Il Cinema Ritrovato festival, Bologna, Italy, June 2019.

8. This author was centrally involved in the initiative. For an account, see Aboubakar Sanogo, "Africa in the World of Moving Image Archiving: Challenges and Opportunities," *Journal of Film Preservation,* no. 99 (October 2018): 8–15.

9. Nollywood is the term given to today's commercial Nigerian film industry.

10. See their website: http://cineastesnonalignees.com/.

11. Many other films also deserve close examination both as embodiments of both new or returning talents and as unique perspectives on the predicaments and aspirations of the continent and its citizens—among them, Yasmine Chouikh's *Ila akher ezaman / Until the End of Time* (2017, Algeria), Amil Shivji's *T-Junction* (2017, Tunisia), Selma Bargach's *Indigo* (2019, Morocco), Sol de Carvalho's *Mabata Bata* (2017, Mozambique), and Issiaka Konaté's *Hakilitan* (2019, Burkina Faso).

12. See Selina Robertson, "Berlinale 2019: Changing of the Guard," *Film Quarterly* 72, no. 4 (Summer 2019): 79–86. She notes that the Berlinale is shifting its dates to February 20-March 1, 2020. FESPACO takes place during the last week of February and first week of March.

13. The war games, which perhaps not so coincidentally took place during the festival, were held under the banner of "Operation Flintlock" (itself a former NATO Cold War set of military exercises now repurposed for the fight against terrorism) and were allegedly intended to help strengthen African armies' ability to respond to jihadi attacks. These military exercises have been subject to critiques and accusations as being instruments for the methodical recolonization of Africa in the context of the rise of China on the continent, thereby opening up the risk of a twenty-first-century-style Cold War on the continent. For a full list of participating countries in Operation Flintlock 2019, see https://bf.usembassy.gov/flintlock-2019-in-burkina-faso/.

Cultural Politics of Production and Francophone West African Cinema: FESPACO 1999

Teresa Hoefert de Turégano

The world's leading festival of African cinema, the Pan-African Festival of Cinema and Television in Ouagadougou (FESPACO), celebrated its thirtieth anniversary last year. Held every two years in the capital of Burkina Faso, the festival is a venue where all the latest films by African directors are screened, and anyone involved in African cinema is certain to be there. But many people who watch this cinema are not aware of the complex foundations of francophone West African (FWA)[1] cinema. Beyond the immediate pleasure of watching the films, the way that FWA cinema is produced can tell us a lot about the continuing struggle by African directors to appropriate their own cinematographic image. In a broader sense, this cinema reveals much about FWA's ability to engage in a dialogue with France, Europe, and beyond.

Many people only see Burkina Faso as an impoverished country because it is in sub-Saharan Africa and the World Bank classifies it as one of the world's least developed countries (LDC). As a result, there is a tendency to give FESPACO special treatment, which means that people don't like to criticize it under the assumption that it is so fragile that criticism would cause its collapse. In this logic, the mere fact that the festival exists is already a major accomplishment, more than can be reasonably expected. However, no one gains from this attitude. FESPACO has already proven its legitimacy, but as with all festivals some years are better than others. So what can we expect from FESPACO, and what do we really get? Why is there so much talk about change in FWA cinema and so little action?

FESPACO 1999 was not as successful as other editions for reasons linked to the same complications that have shadowed francophone West African film since its beginnings. Those familiar with FWA cinema already know about the difficulties of production, so tied to Europe; they are aware of the consistently unresolved problems of distribution, and the battle to have African governments coherently legislate and act on the behalf of cinema,

nationally and regionally. In 1999, the consequences of those problems were magnified. Not until the filmmakers themselves begin to look honestly and critically at their own position within the world of FWA cinema and of cinema on an international scale, will their cinema move forward. In the first part of the article, I look at some of the weaknesses of FESPACO 1999, and in the second part, I show their links to the major problems that continue to impede the development of FWA cinema.

FESPACO 1999

What makes a successful film festival? Let's say it is a combination of the quality of films programmed, the deals made, the people encountered, and the discovery of new films and talent, all of which come together to create the excitement of a good festival. The first problem with FESPACO 1999 was in the overall lack of African, and in particular francophone West African, feature film production. Many FWA films are made with public funding from European countries, from within a sector that has suffered considerable cuts. The European Union (EU), the largest financial supporter of FWA film since the early 1990s (a role that had always been held by France), had a roughly two-year freeze on its funding for African cinema, until recently, when the Eighth European Development Fund was finally approved. Some filmmakers who had applied for financing and even received approval from the EU were not given funds. Production of FWA cinema has been down, largely because of the EU standstill. This situation exemplifies the close affiliation between Europe and FWA in matters of production. Many established filmmakers did not have films to enter the competition, again attesting to a malaise of FWA production. In addition, the official competition of feature length films seemed uneven in quality.

Few new films premiered at the festival, one exception being opening night's *La Genèse / Genesis* (1999, Mali)[2] by Cheick Oumar Sissoko, a beautifully filmed adaptation of the Biblical book of Genesis. Although the film was underappreciated at the festival because it is not easily accessible, *Genesis* is important for FWA cinema because it attempts to challenge the existing status quo in the milieu. The film is interesting because its subject is highly relevant, given the rampant ethnic strife and fratricide found across the globe, but also because of its epic interest, its use of the Bible, the way it addresses a universal audience by means of the local, its use of high-profile actors, and because of way it calls for a new dialogue to be initiated.

Two other highlights included *La petite vendeuse de Soleil / The Little Girl Who Sold the Sun* (2000, Senegal), a marvelous, fabulist, posthumous work by Djibril Diop Mambéty, and the memorable *La vie sur terre / Life on Earth* (1998, Mali) by Abderrahmane Sissako, whose filmic poetry questions both personal

identity and the identity of an African village space, examining how each is positioned and positions itself in relation to modernity and the new millennium. Both these films were made by well-known directors with established reputations in African film circles. However, the discovery of new films and talent was not one of FESPACO's strengths; there were neither surprises nor great revelations. The reason for this is surely not that there are no new, exciting and talented African directors, but rather relates to the combination of all the various problems and a sustained inability to change the prevailing situation.

The affiliation with Europe also affects the type of film production coming from FWA. As in any aid-based relationship, the financial, technical, practical and moral support that France has given to FWA cinema has created certain ties. Thus, the French film industry has also served as a practical and conceptual model. In practice, this really only applies to film production, not distribution—France had little to gain from an efficient system of distribution in Africa. As French film structures responded to the realities of the global film industry its tutelage of FWA film making evolved. However, one problem has always been the confusion about precisely which markets and audiences are being addressed. Are the French and Europeans really funding films made for a mass African market? It seems likely that they are most interested in funding films that might also appeal to European audiences. Of course, an African filmmaker might decide to make films for an African audience, but then he/she would be faced with the absence of an outlet in African markets. At some point, though, African directors need to make choices about what audiences they want to reach and where they need to go to find the funding for the films they choose to make. Many FWA filmmakers recognise the implicit interests which France and the Europeans have in funding their films but they have done little to move beyond that context.

The awarding of the grand prize to Mweze Ngangura for his accessible, mainstream film *Pièces d'identités / Identity Card* (1998, Democratic Republic of the Congo) reinforces a fairly recent trend among European funders to encourage production which is more likely to have commercial success. In addition, Ngangura did obtain a considerable amount of funding for the film from television. The selection of feature films in general reflects the different directions which FWA film production has been tentatively moving. Some are in the European art cinema style; others are mainstream-oriented production destined either for African and/or European audiences. And this goes to the heart of one of the struggles of FWA filmmakers, namely, an attempt to move away from the reliance on European subsidies while at the same time failing to have a viable domestic market. And while all African film directors say they would like their films to be shown in Africa, the question of markets doesn't seem to get confronted head on. This discussion needs to take place among the directors themselves and among the relevant infrastructural bodies. The lack

of progress in this area was again confirmed in the conference on the distribution of African film held during the festival.

In comparison to the feature films, there was more excitement about the short films, because they at least attempted to broaden the scope of FWA film, as well as much enthusiasm for work coming from the anglophone directors, best reflected by the winning short film *On the Edge* (1998, Nigeria) by Newton Aduaka. The film maintains a level of dramatic tension in a no exit situation dealing with drug addiction, love, cultural, and personal heritage. Among the francophone films, Issiaka Konaté, best known for his documentary work, made his mark with *Souko, le cinématographe en carton* (1998, Burkina Faso), which delves into the melange of cinematic fiction and reality in the minds of young children.

The video entries for fiction and documentary were unfortunately not indicated in the regular film schedule, making it very difficult to catch the screenings. Some might say that this is not so surprising because FESPACO has traditionally been a film festival (in a classical 35mm format). But the neglect of video is noticeable in view of its importance in the African markets and especially in some of the anglophone countries. The French legacy which attributes the highest value to *cinéma d'auteur* is inherent to FESPACO and to film making in general in FWA. Film was germinating there during the era of the *nouvelle vague*, a French film movement that asserted the importance of the director as an author who places his/her stamp on whatever genre is undertaken. France hoped that out of their support for FWA film production, African *auteurs* would emerge, bringing a new African film language to the screens, ideally in French-language productions. Best of all, this new African cinema would be a way of validating the French system, standing alongside it, and respecting similar cinematographic values. Given this view, the festival's attitude toward video comes as no surprise, because in France video is not seriously considered art on the same level as film.

FESPACO 1999 was also missing its usual highlife ambiance. Some of the deflated festival fervour was due to the lack of excitement about the productions, but other factors also contributed, among them the recent deaths of Djibril Diop Mambéty and David Achkar[3] and most importantly perhaps, the unexplained death of Norbert Zongo in December 1998. Zongo was an openly critical Burkinabe journalist whose death was announced amid suspicions of government involvement. The Burkinabe people did not remain silent on this occasion, demonstrating in the streets and organizing strikes that were quickly stamped out by the government. Even though President Blaise Compaoré agreed to make concessions by opening an investigation, there was little faith that truth would be learned, and as a result there was an unspoken state of siege looming over Burkina. The Zonga killing is a reminder of the political climate in parts of West Africa, notwithstanding apparent waves of democratization. Elsewhere on the

continent, there are far worse situations, all of which cannot help but have a negative impact on the establishment of filmmaking in Africa.

A Context of Continuity

Production

The past sixteen FESPACO festivals revealed more similarities than differences in the African film making scene and in the types of films presented. Indeed, there is generally a low rate of film production, and this year was particularly sparse. About five to ten films are produced each year in all FWA. So there is a lack of production, a lack of new and innovative films, and the lack of a place in both local and global markets. But if the problems are so well known why has so little changed? In the first place, because of the context of production, and secondly, the problem of distribution. Both of these processes need to be in a healthy state if a film industry is to be created and sustained. Thirdly, there is an attachment to the status quo in the African film milieu in general that was particularly evidenced in the festivalgoers.

As I mentioned earlier, FWA production is largely financed through public funds often within the categories of aid from Europe and France. In FWA, there is no film industry per se in the sense of local film production with local distribution networks that generate profits that can be reinvested in new productions. Traditionally, francophone African films receive funding from entities such as the Cinema Bureau of the French Ministry of Cooperation and Development (under the auspices of the Ministry of External Affairs since January 1999), the Ministry of Culture, the *Centre National de Cinématographie* (CNC), or the *Agence de Cooperation Culturelle et Technique* (ACCT), the cultural branch of the *Agence de la Francophonie*, or from the European Union's Directorate General for Development, and various other foundations, institutions and organisations across Europe, as well as with some input from televisions such as *arte* and more recently Canal +.

What should be clear is that much of the financing for FWA cinema comes in the form of "development aid" and not through the mechanisms of a standard industry process, which in simplified form is something like: production, distribution, profit, reinvestment, production… Of course, for filmmakers in the independent circuits this process may vary, because it is often based more in subsidies. African filmmakers do exist who adroitly circulate among different circuits available to French and other European filmmakers, but these examples are relatively few. A big problem is that aid for films (like all aid) is part of the donor's cultural context and is often accompanied by conditions. Although many African directors argue that they are not influenced by aid conditionalities, the situation is in fact complex and not straightforwardly causal.

France and Europe's expectation has always been that films made by African directors should reveal aspects of African culture and society. Over the years policy emphasis has changed. For example, while recent French policy has encouraged more television production, prior to that the emphasis was on more commercial work, and prior to this the focus was on the professionalisation of scenarios, etc. Each of these periods is reflected in the film making. The "Africanness" of all these films, however, always had to be consistent with the expectations of the European funders. This history is as important as the immediate conditions imposed by various film funding organizations, e.g. a "strong cultural identity," the use of French technicians, laboratories, or other requirements. I am not suggesting that this type of FWA film not be made, but only that it is worth reflecting on the fact that after more than thirty years this type of production has not enabled or helped FWA cinema move out of a marginal space.

Within this particular system of guidance and support that France and Europe provide for francophone West Africa, the initiatives and the importance of the work by African filmmakers should not be diminished. A long-term perspective on FWA cinema shows how and where structural constraints have been negotiated through the images and in the production process. What exists today is almost forty years of FWA film making that have resulted in cinematic representations of and by Africans, work that may not have existed without the help of the Europeans and is intricately linked to Franco-African relations. However, these films reveal a wealth of images that stand on their own, but also speak of both Africa and Europe, separately and simultaneously. So even if some radical contextual changes in the African film scene are necessary, there is no denying the significance of what African filmmakers have done thus far.

Many scholars have tried to categorise FWA cinema. Férid Boughedir in particular defined five groups[4] of African cinema during the 1980s. Some of these categories still hold today; others have merged or evolved into something new. In contrast, I suggest that there are two tendencies, both linked to French production politics, which can help understand FWA cinema. The first is based in *cinéma d'auteur* or art cinema and can be understood as a universalist/world cinema tendency, and the second is a based in a socio-educative form of cinema that was meant to contribute to development in the African countries.[5] Within these tendencies, different categories have evolved. For example, the demand for more commercial work affects each one in different ways. Whatever categories African films might be divided into, they are nevertheless usually linked to African cultural identity in a way that is also connected to French production politics. In different respects, the following three films from FESPACO 1999 fit into different categories but still adhere to the main tendencies.

First, within the art cinema tendency is the intellectually directed work of Sissako, who addresses a more European-style cinephile. He has a distinctive film style, subtly abstract and implicit, with recurring motifs, such as a symbolic play with light which are consistent throughout his work. *Life on Earth* is about a man (Sissako himself) who returns to the Malian village where his father lives. The result is an encounter, with a place so removed from urban life that making and receiving a telephone call can take days. Simultaneously, there is an appreciation for a local space and time, achieved through an easy reception of the impromptu, an atmosphere of levity, and through a camera that films the village as an open, unlimited expanse, where people visibly come and go through the frame. Sissako contemplates the role of this village in relation to the rest of the world and he contemplates his own identity in relation to both worlds. For example, he films some village men sitting in the shade and repeatedly returns to them each time they stand up to move their chairs another meter out of the advancing sun. Here, Sissako is amused at the Africa that sits immobile, moving only when the sun gets too hot for comfort. The spectator is left to contemplate the kinds of connections this Malian village, and others like it, can have to the increasingly globalized world that surrounds them.

Linked to the socio-educative tendency but emphasising socio-political criticism is Pierre Yameogo's film *Silmandé* (1998, Burkina Faso). While this film also deals with questions of African culture and identity, it reaches out in a very direct and dynamic way to wider African audiences. It is a critical film meant simultaneously to entertain and address real issues facing the audience, showing class conflict and prejudice among wealthy Lebanese merchants, the local Burkinabe population, and the elites in power. This same configuration can be found across West Africa. The story unfolds around an established Lebanese family in Ouagadougou who have been in the city for many years; the matriarch, however, insists that they are only there in temporarily exile until they return home, which enables them to assert their distance from the society in which they live. The youngest son accidentally kills a man, and because of the family's connections to local power, he is released without repercussions. The son is also in love with a Burkinabe woman who has his child, only to have it taken away from her by the father's family. *Silmandé* denounces the prejudice of the Lebanese and the ignominious excesses and corruption of the African power elites. It is linked to the socio-educative tradition of FWA film making by the way it informs and attempts to foster greater awareness in the audience. However, *Silmandé* is not didactic and was made with an African audience and market in mind.

Also linked also to the socio-educative tendency is the winning film of FESPACO 1999, *Pieces d'Identité* by Mweze Ngangura, which exemplifies how African film has evolved in a more commercial direction oriented toward European audiences. An amusing, accessible film that engages the spectator's interest, *Pieces d'Identité* deals with African immigration in Europe and

questions of postcolonial identity, its loss and remodelling. Mani Kongo, an aging Zairean king, goes to Belgium in search of his lost daughter wearing his symbols of traditional power: a head-dress, a finely carved stick, and an elaborate cowrie and pearl necklace. By representing cultural and personal identity in such a concrete manner, the film becomes more entertaining yet also essentializes notions of identity.

In sum, each of these three films takes a different direction but all remain based in the same francophone or French production politics. The ideas about FWA cinema promoted by France and linked to African cultural identity have also become the ideas that francophone West Africans have of their cinema. This is a two-way street. At the same time, these three examples show how French politics have been fully appropriated by the Africans. Ultimately, however, there needs to be more reflection on what FWA cinema could be outside of its historical link to France and Europe.

Another aspect of FESPACO hints at the peculiar state of production in FWA. Apart from the regular awards, forty special prizes were attributed by parallel juries. While this also occurs in other film festivals, the number does seem high for a total of sixty-eight films and videos in competition. The often very informal nature of the way these prizes are designated has been cause for concern. Some of the prizes are industry-related (television broadcasters, laboratories, etc.); others are given by regional and local organisations. Quite a few, however, are given by various UN organisations (UNICEF, WHO, UNDP, UNFPA, etc.) or agencies promoting some type of development (EU, ACCT, French cooperation etc.). The large number of these "development-related" prizes from European and UN organizations is again reflective of the problematic nature of francophone African film production, specifically its dependence on European aid and support instead of a more standard cinematographic infrastructure.

Another debate that arose about the films in feature length competition pertains to Sissako's *Life on Earth*, which was commissioned for a French-produced project about the year 2000.[6] There was some question as to whether or not a commissioned film should be part of the official competition. But it should be asked whether a thematic restriction is really different from any other restriction (i.e. budgetary, time constraints) encountered in film production. It could be argued that the other films were conceived with the freedom of thematic choice, which is part of an entire creative process, whereas Sissako's film was developed around a designated theme that in effect created a different work standard. However, whether the theme is provided in advance or not, what is judged in competition is the creative signature of a director, and Sissako's originality is clearly evident. And in any case, how is the thematic restriction in Sissako's case different from the 'cultural identity' requirement that FWA filmmakers work around?

FWA filmmakers know that for the moment their main market is still in Europe, be it in film festivals or through regular distribution. They know that the majority of funding for FWA film is obtained in Europe and that the projects supported are likely those that match European ideas of what African film making should look like. They know that to get funding from most of the usual sources to which they apply, their films have to be linked to a European idea of African cultural identity.

A comparable argument can be made in other filmmaking scenes. For example, how many Black British filmmakers receive funding in Britain to make science fiction, detective, or comedy films and how many receive funding to make films about the social and cultural issues in the Black British community? The balance is heavily weighted toward the latter, even though no one says that a Black British filmmaker cannot make a sci-fi film. When it comes to European support for this marginalised type of film production, it is usually those projects which relate to the preconceived notions of FWA or, say, Black British culture that are most likely to receive funding and support.

Distribution

Another persistent dilemma of African film making is distribution. The major theme of FESPACO 1999 was precisely about how to deal with eternally short-circuited film distribution in Africa, and it was effectively translated into a three-day conference. This was not the first time that distribution has been the theme of FESPACO, but after thirty years of discussing the same problems of film distribution, little has changed. It is worth noting that while France assertively supported FWA film production it did not really promote the distribution of African films in Africa. Most African markets are dominated by American, India, and Hong Kong films while West African films are rarely shown on local screens. Under normal circumstances in Western Europe or North America, a distributor will buy the rights to a film for a particular territory (for cinema theatres and often video and television), and then coordinate the film screenings and organise the marketing and promotion of the film with various theatres in the region. This does not really happen in FWA, although it does in South Africa and Zimbabwe.

In contrast, a type of pseudo-distribution occurs in FWA. The distributors are generally intermediaries of other intermediaries. Distributors in FWA usually rent films for a very low price from European companies (often selling American films) which have bought the rights for the francophone African regions from an original French distributor. Because the films are usually sold or rented in block bookings as a group of perhaps thirty films, they are advantageously priced as a "package deal." The price depends on

how many blockbusters are included and how many of the films have long disappeared from the European market or never even made it to the screen there. Most importantly, because the films have already been amortized many times over in other markets, West Africa is a type of dumping ground. This situation quite effectively blocks the market for smaller competitors, with the result is that it is very difficult for an African filmmaker to come with one film in the hope of being paid a fair market price, because a company or "sub-distributor" can get a number of films for a very low price. Economic incentives are clearly in the package deal. This problem has been generally constant in West Africa since independence.

Filmmakers from francophone organization West African countries can usually obtain distribution of their films in their home country where they often experience huge success. However, the process breaks down again when an attempt is made to have the film distributed in other West African countries, because there is still no regional homogenization in terms of the legislation and organization of cinema. A filmmaker is practically obliged to take the film in person, to a theater in a neighboring capital and negotiate the rental themself. If the film is negotiated on a percentage basis and not for a flat fee, it is in the interest of the filmmaker to hire someone they trusts to oversee the ticketing in order to get accurate accounts. This situation applies to about eighty percent of the cases where African filmmakers seek distribution in the region.

Burkina Faso is usually considered an exception, in that ticketing is systematized on a national level and a percentage of each ticket sold goes into a special fund[7] to support film production, making accountability possible. Burkina Faso nationalized its theaters in 1970, and while it still distributes films in the same manner described above, it is one country where more African films are screened. Admittedly, this is linked to FESPACO being held in Ouagadougou and the ready accessibility of the filmmakers to SONACIB, the national distribution company. In most countries, there is no national, systematized ticket collecting, nor is there a tax taken from those tickets for deposit into a fund that can be used for film production. Most governments do tax the cinema tickets sold but the proceeds are not put back into developing cinema. Usually, taxes are so high as arguably to stimulate fraud.[8] Theater owners have more incentive not to declare all the tickets they sell in order to pay less taxes and make some profit. But the filmmakers lose more than anyone else.

One reason for optimism about FESPACO 1999's conference on distribution was the unexpected attendance of a number of theater owners and distributors who came from various countries in West Africa, many on their own initiative. Niger, Ivory Coast, Senegal, Mali, Cameroon, and Burkina Faso were represented. The discussion centered on an interchange between the invited panelists and the theater owners and distributors, who contributed practical input. At the same time, some of the resolutions, such as the homogenization

of ticketing and taxation on a regional scale in West Africa, have probably been reached at every conference ever held on distribution of African film.

One of the most interesting resolutions was to create an *African Cinema* label in order to recognise theaters interested in showing African films. Assistance could be given for renovating cinema theaters on the condition that they screen African films and carry the *African Cinema* label, which should also facilitate their access to public funding and investment. To do this, an accurate census would have to be made of all the theaters in the region.[9] Resolutions were also made to have, in the immediate future, a regional tour screening the films given prizes at FESPACO and to establish long-term regional connections for distributing African films. Funders of African cinema were requested to assist the publicity and marketing of African films. Finally, it was suggested that the video industry should be subject to regulation and be brought from its informal status into a regularized market situation.

The current tendency toward privatizing distribution was discussed, particularly with respect to Senegal, where privatization has had little effect on the showing of African films. The consensus was that the State should maintain some involvement, creating a movie theater destined exclusively for African cinema and maintaining or supporting a cinemathèque. Concrete strategies on how the State and the private sector should work together remained vague. The expectation of State involvement in improving distribution problems remains high. But in a general climate of IMF stabilization and World Bank structural adjustment programs, where privatization is the priority, it is reasonable to wonder how realistic this is.

Some private initiatives were discussed, while others were overlooked. *écrans noir,* an initiative by Cameroonian filmmaker Bassek Ba Kobhio, was noted as a dynamic association promoting the exhibition of African film throughout Central Africa.[10] For the time being, it functions as a cultural non-profit organization receiving financial support and assistance from the standard support entities, some of which were mentioned in the section on production. It is a successful and promising project, and *écrans noir* hopes in time to become a self-sufficient profit-making organization. One initiative not mentioned during the conference is an organization headed by Souleymane Cissé[11] called the Union of Creators and Entrepreneurs of Cinema and Audio-Visual Production of West Africa (UCECAO). Created in 1996 to develop cinema as a cultural industry in West Africa, and possessing associate member status in the Economic Organisation of West African States (ECOWAS), UCECAO is still in an organizational stage, but recently acquired a space for its headquarters in Bamako. It has a coherent mandate in terms of distribution and is trying to develop a viable private alternative to the defunct CIDC[12] although again, it is an association and not a real enterprise. It will face many of the same problems that caused the downfall of CIDC, most notably the lack

of coherent business practices and the need to ensure the committed cooperation of the member countries to make the organization work.

Two things can be extrapolated from the events of the conference. There seem to be two active forums trying to develop an infrastructure for distribution, each aiming at different geographical regions. However, they are both seeking funds from the same public sources in Europe. The one in Central Africa is politically entrenched through Ouagadougou within the reigning structures of FWA filmmaking, with established links to the major funders, and is moving more in a line of continuity with the history of FWA. However, if it does become a self-sufficient organization, it will be the sign of something new. The other one is trying to edge its way into this territory, where Burkina Faso has traditionally exerted control. The development of different projects working to establish better distribution of African films has created a more competitive atmosphere (even though the two projects focus on different areas) which could motivate some needed efficiency. Then again, regional cooperation might be a better strategy if they continue to seek funds from the same sources. In this sense, a new scenario is potentially being written on the distribution of African film in FWA, but this was not discussed at the conference.

The crux of the current dysfunctional production-distribution cycle on the African continent is that the films by African filmmakers are regularly seen in festivals, in Europe and in fewer numbers in North America, but in Africa they cannot count on distribution. In Europe, the audience for African filmmaking is fairly limited, often although not exclusively to an art cinema audience. In Africa, these films are still exceptions. It is unlikely that a film industry will evolve, built only on this type of cinema. In most countries where art cinema is produced—i.e. the US, India, Japan, and even France—it exists parallel to a more popular film industry. Independent, art-oriented film production often only survives with the help of various types of public and art-supporting sources, which are often fed by the commercial side. FWA filmmakers basically have only that possibility for support in Europe.

African filmmakers should certainly be able to make art cinema in all its varieties, but more than that is needed in order to have an African cinema in the sense of a real industry. What is missing in the case of FWA, as well as in other areas, is a functioning level of a cinematographic organization and, optimally, a film industry. In FWA the popular film market is dominated by foreigners, as is the case in many other countries. Even though FWA has to deal with a type of "film dumping" they still have not organized themselves in terms of basic infrastructural regulations, such as ticket controls or taxation. Cinematographic organization in FWA seems most viable at a regional level, but can occur only where national and regional interests cooperate and recognize that they all need each other.

If FWA filmmakers wish to move out of an aid system, or at least place themselves on an equal footing within the art cinema circuit, at least two types of film movements must exist. The roots of the first, art-oriented type are already there. But the second has to reach some larger audiences, and the form it takes can only be determined between the filmmaker and the spectators. One obvious answer is that African cinema needs to reach African audiences, in a similar manner as the African music industry. While producing a film is far more costly than producing a CD, the strength of the African music scene, which is so popular abroad, lies in many ways in the confidence of its domestic market. When African films can draw crowds like African musicians, the problems of distribution are sure to change.

In the meantime, another alternative for distribution is the African-American market in the US and its thirty-five million potential spectators. With some targeted and intelligent marketing strategies, there is little reason that African films could not find a place in North America. Even though the focus of the conference was film distribution in Africa, it could have been useful to discuss the screen time that African films obtain in general markets. Considering the current degree of globalization and the necessity of conceiving distribution beyond national terms, it seems worthwhile to think as broadly as possible.

The Status Quo

One of the merits of FESPACO is the easy solidarity among those who direct, produce, organize, analyze, criticize, support, or revolve in some way around African cinema. There is a positive, unpretentious openness among all the festivalgoers. That ease of interaction in the African film circuits contributes to an unusual sense of unity. Paradoxically, that very unity prevents constructive criticism and objective self-assessment. As filmmakers and funders sit around the same table, what filmmaker would risk addressing the real problems and thereby alienate their funders? And even among themselves, few filmmakers engage in more than superficial criticism or move beyond their immediate situation to look at what is happening to FWA cinema as a whole.

In some ways, that same solidarity also side tracks the responsibility of the festivalgoer. Festivals are opportunities to see the latest productions in a way not normally possible. There is potential for discovery which can then be revealed to others beyond the festival situation, a possibility to shape and change tastes. Festivalgoers also have a unique opportunity to reflect on African film making as a conjunctural whole. If they only leave FESPACO praising the work of directors who are already recognized and applauded, they do as much to perpetuate a status quo as anyone else working in the area. This year's FESPACO was symptomatic of that phenomenon.

Because of the predominance of a type of production, so linked to aid, the circle of those who receive funding is very small. Most African film-makers would not agree that, as far as production is concerned, they are in some ways privileged compared to other film directors. But this is not to say they don't also face disadvantages. The politics of FWA film production tends to discourage change and favour the status quo. Thus, similar types of films are made and similar structures perpetuated, even if they need to be reno-vated. But in the long term, how will FWA cinema develop and prosper if it remains entrenched in the complex structures of aid?

There is much protection of privilege by all those involved, even by some of the *patrons* (the pioneers and those with established reputations) of the FWA film circuit. In many ways, the current politics of FWA film reflects French colonial politics. France encourages a privileged elite, who is held as an example of Franco-African solidarity, but which can actually be under-stood in terms of Bourdieu's notion of perpetuating cultural capital. The ultimate consequence is that this privilege also subverts the impetus for any significant change in the structures of FWA film.

FESPACO itself continues to obtain a considerable amount of funding from aid agencies. In spite of its splendor, the festival is not really crucial to African filmmaking as a place where new talent is brought to the fore, projects are conceived, production and distribution deals are made, and films and ideas discussed and debated. The winners of FESPACO leave with cash prizes but not necessarily with distribution contracts or deals for future films. For example, this year's grand prize winner, already had distribution deals in Europe and the US prior to FESPACO. Furthermore, the filmmakers at FESPACO aspire to be selected for competition in the Cannes International Film Festival.

Finally, FWA cinema has always been tied to French and European poli-tics of film production, and it has engendered a particular type of cinema. Certainly, some FWA directors have found ways to move through a Europe-defined infrastructure in order to speak and film as they wish, at least to some extent. Valuable images and ideas reflecting on the knowledge that FWA and Europe have of each other, emerge as a result of this cinematographic rela-tionship. But the current dialogue is still heavily weighted in a one direction; FWA still has not organized itself to establish the basis of a cinematographic industry. And while there is little reason that FWA should not benefit from the subsidies it has now, as long as it remains limited to that support and fails to create new spaces of production and representation, FESPACO will remain as it is now.

The reality is that FWA filmmaking has always been part of an interna-tional festival circuit, and this is integral to its existence. It has never been isolated or removed from other cinemas of the world, even as it remains on the sidelines. Yet it has never really claimed a place in international markets.

Nowhere has it ensured for itself an economically viable and sustained audience, despite isolated success. When FWA filmmakers and those in other parts of Africa, claim an audience and a market of their own, the results will be seen in a new and more meaningful FESPACO that will reflect a cinema with a sense of where it is going. FWA cinema needs to be considered alongside other similar cinemas with which it must compete for screen time. Filmmakers and spectators need to ask how the heroes of African cinema—those crowned and confirmed at FESPACO—measure up outside the African film circuit? Ultimately, the filmmakers themselves, along with the funders, need to acknowledge the marginalization and honestly grapple with it, asking themselves by whom is it really perpetuated?

Author's comment (2020):Twenty years later and having worked fifteen years now in the European film industry, one point in particular is worth adding. Having been embedded in the French and European politics of film production, there was, and to a significant extent still is, a crucial factor missing in the African film industry—a strong, solid base of experienced African film producers who know how to negotiate the markets. It is impossible to overstate the vital role of a producer in the sustainability of a film industry, both creatively and economically.

Teresa Hoefert de Turégano is a film funding executive at the Medienboard Berlin-Brandenburg (Germany) for international co-productions, documentary and experimental projects. Prior to that she taught cinema at the University of Lausanne, Switzerland and worked for Eurimages (European cinematographic co-production fund) and the European Audiovisual Observatory at the Council of Europe in Strasbourg. She also works as a consultant and evaluator for various institutions, including the EU-Creative Europe MEDIA Programme. She has published a book and numerous articles related to film, politics, and culture.

Notes

Originally published as Teresa Hoefert de Turégano, "FESPACO 1999: The Cultural Politics of Production and Francophone West African Cinema," Black Renaissance, Vol. 3, Issue 1 (Fall 2000): 145–180.

I would like to thank the Swiss National Science Foundation for its funding under grant # 8210–53424 and the Africana Studies Program at New York University for its generous support.

1. FWA includes former French colonies in West and Central Africa. It is a linguistic based distinction. The following countries are among those tied to France through the FCFA: Benin, Burkina Faso, [Cameroon], [Central African Republic], [Congo], Ivory

Coast, [Gabon], [Equatorial Guinea], Guinea, Mali, Niger, Senegal, [Chad] and Togo. The countries in brackets are not part of West Africa, whereas Mauritania and Guinea-Conakry are not part of the FCFA zone, but are part of francophone West Africa.

2. Since FESPACO, *Genesis* has been reedited and was selected to appear in the section *Un certain regard* at the Cannes International Film Festival 1999, where it received critical acclaim.

3. Djibril Diop Mambéty, a Senegalese film maker died in July 1998. He was one of the most creative spirits of African cinema and best known his avant-garde work in *Touki Bouki* (1973). His later films include *Hyènes* (1992) and *Le Franc* (1994). David Achkar, a Guinean filmmaker, was perhaps best known for his film *Allah Tantou* (1990).

4. "...a) a political (or socio-political) trend; b) a moralist trend; c) an 'umbilical' trend; d) a cultural trend; e) a (rare) commercial trend." Ferid Boughedir, "African Cinema and Ideology: Tendencies and Evolution," (paper presented at *Africa and the History of Cinematic Ideas Conference* London, British Film Institute, September 1995). This is an updated version in English of his earlier *Economie et thémathique des cinémas Africains 1960–1985*, (Ph.D. diss., University of Paris VII, 1986).

5. Closely linked to art cinema, the universalist/world cinema tendency includes films which readily negotiate—reject and/or reinforce—a received body of knowledge of Africa. They tend to emphasize universal aspects of African culture and focus on African self-sufficiency in itself instead of as part of a given modernizing project and they are often tuned to international audiences. Films in the socio-educative tendency are often concerned with the modernity/tradition dichotomy; they either maintain a strong nation-building, modernising discourse and are critical of tradition; or they criticize the nation-building, modernising process and make overtures toward traditional values without totally calling for a return to these. In addition, some films which stem from the latter tendency have moved in different ways toward more mainstream, commercially-oriented production.

6. *2000 seen by ...* is an anthology of seven films by seven international filmmakers, each of whom imagine the last day of the millennium. It was produced by Paris-based *Haut et Court* and distributed in the US by Fox Lorber.

7. The fund was empty for most of the 1990s because of fraud in the administration.

8. Dominique Wallon, Rapport d'évaluation de l'appui financier de l'Union Européene à la promotion du cinéma des pays ACP - Tome II - Annexes, November 1996, p.149.

9. Rapport Final (Extrait), Ouagadougou, March 1999.

10. Between 1995 and February 1999, *Ecrans Noir* distributed 32 African films in the cities of Cameroon. They have acquired two portable 35mm projectors in order to show films in rural areas. They now show about two films per month in cities which are part of the circuit. These screenings are usually in the *Alliance Française* or French Cultural Centres. Once a month they show an African film on television. Their circuit is increasing and now includes Cameroon, Gabon, Congo - Brazzaville and the Central African Republic with Chad as the next likely member.

11. Souleymane Cissé (Mali) is a well-known director whose films include *Finye* (1982), *Yeelen* (1987) and *Waati* (1995). The latter two films were shown at Cannes.

12. The Interregional Consortium of the Distribution of Cinema was established by ten members of the *Organisation Commune Africaine et Mauricienne* (OCAM) in the 1974 and dissolved in 1984 largely as a result of a lack of cooperation on the part of the various countries.

A Mirage in the Desert? African Women Directors at FESPACO

Claire Andrade-Watkins

Every other year, thousands take to the air from points in Africa, Europe, and the US to head to the Festival Panafricain du Cinéma du Ouagadougou (FESPACO). Braving searing heat and dust rising from the Sahara Desert, the hordes descend on Ouagadougou, or "Ouaga," as it is affectionately called, the capital city of the tiny West African country Burkina Faso (formerly Upper Volta) for the continent's biggest cultural event.

Held in alternate years from the Carthage Film Festival in Tunisia, the eight-day FESPACO showcases productions from sub-Saharan Africa and the Diaspora, particularly the Caribbean, US, and Brazil. Burkina Faso was one of the first West African countries to nationalize film production and distribution and maintains a firm commitment to African cinema. The brief term of charismatic President Thomas Sankara, who came to power in 1983, witnessed an unprecedented increase in popular support for African film within Burkina. Sankara threw open the doors to African Americans and others from the Diaspora with a formal invitation to the ninth festival in 1985, followed again by a warm reception in 1987. His successor, Blaise Compaoré, has continued this commitment, which, along with strong international support, particularly from France, has sustained Burkina as the home of FESPACO.

Now in its twelfth year, FESPACO remains the best place to see new African talent and gauge the level of activity and interests of African filmmakers. It is a festival created by African filmmakers for two main purposes. The first and more visible side of FESPACO is the international showcase of African cinema. But FESPACO is also the preeminent meeting place for African filmmakers. Day and night, clusters of directors, producers, critics, journalists, scholars, actors, and distributors from all over the world can be seen milling around the pool of Hôtel Indépendance, the festivals unofficial hub. There and elsewhere they, debate issues surrounding African cinema, from its financing to its audience and distribution within the continent and abroad.

Films are screened from morning to night in the city and outlying areas, in theaters ranging from the posh, air-conditioned Burkina to the wonderful open-air Riale and Neerwaya theaters where one sits comfortably on bench chairs under the stars and enjoys the lively calls, laughter, and warnings shouted by the African audience to their favorite characters.

The wise and experienced FESPACO visitor comes armed with festival French. Other essential skills are quickly acquired, such as resisting the lure of the open markets where fabulous wares from all over West Africa are sold and sidestepping myriad street vendors. If your foray into the city is successfully negotiated, with enough bottled water for the day (dehydration is a reality when temperatures hover around 100 degrees Fahrenheit), a veritable film feast of new and classic African films awaits you. This year's festival featured sixty-eight films, with thirty-three African countries participating and close to half-a-million visitors—a quantum leap from the first festival in 1969, when five countries took part and the audience totaled twenty thousand.

This year's festival opened with *Karim and Sala* (1991), the fourth feature by internationally acclaimed Burkina Faso filmmaker Idrissa Ouédraogo. Ouédraogo's previous feature, *Tilai / The Law* (1990), won FESPACO's grand prize and was later a hit at Cannes, marking the first time a native son of Burkina earned this prestigious award. Other festival highlights attest to the wide range of new faces and work on the scene, with premieres from Cameroon, Mali, Burkina Faso, and Guinea Conakry.

A festival favorite, *Ta Dona / Fire!* (1991), by Adama Drabo from Mali, received the Oumarou Ganda award for outstanding first work. In it, Drabo weaves Bambara mysticism and ritual—an increasingly recognizable trait of Malian films—into the quest of a young engineer for the lost seventh Canari, the last link in a mystical chain of knowledge. Drabo is part of an impressive line of filmmakers from Mali, whose ranks include Souleymane Cissé and Cheick Sissoko.

Burkina Faso launched several new features. *Laada* (1991) (meaning traditional law), Idrissa Touré's first feature, examines a group of young men as they choose between following the path of traditional life or leaving for the city. Abdoulaye Sow's *Yelbeedo* (1990), a Burkina Faso/Togo coproduction, examines the issue of abandoned children and incest through the eyes of a young couple who take in a baby left on the street. Pierre Yameogo's *Laafi - Tout Va Bien* (1990) reveals the dilemma and anxiety of a recent graduate who wishes to attend medical school abroad despite administrators' fears that, like many others, he may not return home with his new skills.

Cameroonian novelist Bassek Ba Kobhio garnered special mention in the Critic's Prize with his second film and first feature, *Sango Malo* (1990). Based on Kobhio's novel, this tight narrative tells the story of a young, progressive teacher who introduces his students to ideas on politics and sex, much to the chagrin of

the headmaster. He eventually collides with the village chief and nobility when he tries to start a peasant cooperative.

Allah Tantou / God's Will (1991), an outstanding documentary by David Achkar of Paris/Guinea-Conakry is a brilliantly crafted purview of the heady early days of Sékou Touré one of Africa's first nationalist leaders. *Allah Tantou*, which won the Telcipro award, is a beautiful mixture of archival footage, home movies of the director's father, who was an official under Touré and stunning dramatic segments of the father's imprisonment. The work is an absorbing glimpse of a fascinating moment in history.

Tunisian filmmaker Férid Boughedir, a longtime journalist on African cinema, presented his first feature, *Halfaouine* (1990), a charming and sensual portrait of a young boy crossing the bridge to manhood. Among other award-winning films was Felix de Rooy's (Curaco) *Almacita di Desolato* (1986). This netted a Paul Robeson Award, and a special mention went to British director Auguste Reece's *Twilight City* (1989).

Of the thirty-two films in competition, none were by sub-Saharan women, and those films in the festival by women from the diaspora—Zeinabu Irene Davis and Carmen Coustaut from the US—were scheduled late in the week and hard to find. The invisibility of African women behind the camera is not unusual. Addressing and correcting this inequity has been a priority of the Federation Panafricaine des Cinéastes (FEPACI) since its conception in 1969. An organization of African filmmakers from thirty-three countries, FEPACI has served as a powerful lobbying voice for African cinema within the continent and abroad.

The role of women as central characters in films, however, is an honorable and long-standing tradition in sub-Saharan Africa. Powerful female characters have anchored such classic films as Senegalese director Ousmane Sembène's *Ceddo* (1977) and *Emitai* (1971), Ivory Coast director Desire Ecare's *Faces of Women* (1986), and Med Hondo's masterful portrayal of the legendary warrior queen *Sarrounia* (1986, Mauritania). More recently themes concerning African women's struggle against female circumcision have been manfully tackled by Cheick Sissoko in *Finzan* (1989, Mali).

In part, the scarcity of women directors has to do with the scarcity of resources for film south of the Sahara. Only a very small group of filmmakers, male or female, are actively engaged in African film production. Feature filmmakers number no more than forty or fifty, with twenty or thirty having financing at any given time. Still, scarce resources alone do not explain why, in African film's thirty-year history, only two women south of the Sahara have achieved the prominence of their male counterparts. In 1972, Sarah Maldoror (Guadeloupe/Angola) became established as the first African woman director with her feature *Sambizanga*. She subsequently went on to make close to twenty films. Maldoror was followed by Senegalese Safi Faye, who has made about

ten films, including two features, *Peasant Letter* (1975) and *Fad'jal* (1979), since 1975, and is currently completing her third. This stands in contrast to countries north of the Sahara, particularly Tunisia, Algeria, and Egypt. They have long-standing film traditions and industries from which a respectable cadre of women directors has emerged.

Tucked in the corner of FESPACO was a workshop on Women, Cinema, TV, and Video in Africa, organized in collaboration with the Montreal organization Vues d'Afrique, which hosts a large annual festival of African film. This workshop was the very first gathering of women from Africa and the Diaspora. It brought together close to one hundred invited guests from the continent, the US, Europe, and the Caribbean. According to the official communique, the workshop was intended to identify the problems women face in their fields and come up with strategies ensuring their participation in media and its development.

At least eight women filmmakers were in attendance. Two, Flora Shelling M'mbugu from Tanzania and Anne Mungai from Kenya, came seeking financing for feature projects they had in hand. Veterans Sarah Maldoror and Miriama Rima from Niger, plus Attia Kehena (Tunisia), Kadiatou Konate (Mali), Grace Keiiyua (Kenya), Sepati Bulane (South Africa), and Lola Fani Kayode (Nigeria) also took part. For most participants, it was the first time they had met women engaged in similar work from other countries.

The energy found at the workshop generated the kind of excitement that marked earlier start-up initiatives at FESPACO, such as the International Market for African Film and Television (MICA) in 1983 and the International Partnership Day in 1989. If a typical conference had taken place, the following sequence would have unfolded: the group would be well met, engage in fruitful dialogue, have a substantive closing plenary, establish an agenda for the next gathering, and top off the whole event with gracious multilingual social events, finally departing with warm feelings of sisterhood and a common sense of mission and purpose for women in cinema, TV, and video in Africa and the Diaspora.

It didn't happen. Instead, the workshop unleashed a riptide of emotion, confusion, and animosity which tore across the festival. It triggered often heated debates on a broad range of areas, including the relationship of the Diaspora to Africa, relations between the French- and English-speaking regions of Africa and their positions within African cinema, and the appropriateness of FESPACO as the forum for this workshop.

Following a week of informal and cordial meetings between African women and a handful from the Diaspora prior to the festival's official start, the workshop opened with an unexpected request. As invitees gathered around the table, the panel chair asked all non-Africans to leave the meeting. Most of the participants were caught by surprise, particularly given the legendary

warmth and camaraderie of the festival. Over the hubbub, the request was repeated. Things quickly deteriorated.

Emotional addresses from women of the Diaspora had the poor translators at a loss for words, clearly distressed by the messages they were forced to convey back and forth between workshop spokeswomen and participants. Further confusion ensued as a debate arose on what exactly constitutes an African. Women born in Africa but raised elsewhere angrily defended their right to be there, as did women born abroad of African parents. Before the debate was over, most of the "others" had left.

The emotional momentum caught festival organizers off guard. Some Africans saw the incident as a misunderstanding; others, particularly from the Diaspora, saw it as a rejection of non-Africans. A call for action came from many fronts to make amends to the Diaspora and put the workshop back on course. A formal letter of protest was sent to festival organizers by several women of the Diaspora. Subsequently there were many abashed and embarrassed apologies by all parties.

At a glance, the workshop could be perceived as an unmitigated disaster. But over the long run, it could be a catalyst for understanding and growth. During the pre-workshop discussions and workshop itself, patterns emerged that showed many more African women working in television and audiovisual services than in film. Those in cinema were generally actresses, with no ready access to technical training for production. In the television and audiovisual sectors, participants noted that women were often steered toward distribution and editing. Even those with extensive production backgrounds, such as Deborah Ogazuma, a senior producer at the government-owned Nigerian Television Authority, the country's largest television network, feel restricted. Ogazuma is one of the few women in Nigerian television to direct drama. Her projects have included forty-one live weekly episodes based on a literary adaptation of the novel *Magana Jari Ce* (*Wisdom Is an Asset*). Ogazuma notes, however, that women are steered away from directing drama and toward women's magazine and children's programming.

These bits and pieces of different women's experiences are part of a larger pattern of problems that, prior to the workshop, women struggled with in isolation. These were summarized in the workshop's opening statement by chair Annette Mbaye d'Erneville, who laid out the program's broad objectives: 1) provide a forum for women to exchange and share their experiences; 2) adopt propositions that will help ensure women their rightful place, particularly in the areas of training and production; 3) devise a follow-up structure for dialogue and common action; 4) identify the frustrations of women professionals and produce images that consciously reflect women's realities, social contexts, cultures, and histories; and 5) disseminate that perspective.

The workshop made clear that while African women filmmakers share many of the same obstacles, there are also vast differences. It seemed that participants were looking at the role of women—in cinema, Africa, and the Diaspora—through lenses of different focal lengths. Their widely divergent expectations reflected the tremendous range of the participants' complex cultural, historical, political, and societal realities.

Most advancements in African cinema have been the result of arduous and painstaking effort over many years. Viewed from this perspective, the women's workshop was a painful birth for what may become a new network of professional peers. Perhaps holding it under the aegis of FEPACI and FESPACO was inappropriate. Anything that occurs within such a context is subjected to a tremendous amount of international attention. For such a fledgling initiative, some privacy for dialogue, growth, mistakes, and the formation of a sense of identity might have been better for meeting the workshop's objections and mission.

The workshop did produce some concrete results. An eight-member panel of women from Burkina Faso, Kenya, Nigeria, Ghana, South Africa, Rwanda, Gabon, and Tunisia was established and workshop participants identified four initial projects for the panel to pursue: 1) develop a repository for film and audiovisual works by African women; 2) establish subregional itinerant training workshops; 3) train staff to conduct these workshops; and 4) support the participation of women at film festivals in Africa, the Caribbean, and elsewhere. In addition to these plausible and pragmatic goals, an appeal was made by the panel in its closing communique to FEPACI to support the initiative under its aegis, in addition to generally increasing its activism for women in the film profession.

The pattern of the women's workshop is consistent with the vision and weaknesses associated with the development and dissemination of African cinema as a whole. The dominance of Africa's French-speaking areas in the development of cinema is the direct result of a very aggressive program by France on the eve of its colonies' independence in 1960. France distributed financial and technical assistance and expertise through the Ministry of Cooperation in areas ranging from agronomy to cultural expression. Support to cinema was considered important because it coincided with France's intent to maintain the cultural and linguistic bonds that had characterized the colonial relationship. In contrast, France's colonial counterpart, Britain, had no great interest in supporting cinema by Africans, either before or after Independence.

The catch-22, however, was that the financial and technical facilities and personnel provided by France were based in Europe. Distribution and exhibition circuits within Africa were also controlled by non-Africans. So, paradoxically, the most prolific region of African film production teetered on a

very precarious base—one without an indigenous infrastructure for production, distribution, and exhibition.

In 1980, France began to shift funding from individual African film projects toward experiments in regional infrastructure. When this happened, the filmmaking community was jolted into seeking alternative means of support. The emphasis on strong ideological, Marxist, and postcolonial critiques in film during the subsidized 1960s through late 1970s gave way to a focus on building infrastructures, both through South-to-South cooperation and North-to-South collaborations that could help develop Africa's film resources, technical expertise, and trained personnel.

FESPACO is the forum through which filmmakers address such concerns and chart the future course of African cinema. It is regular practice for FESPACO to focus on specific themes through its workshops, colloquia, and panels. In the past, programs on the oral tradition and narrative film structure and international coproduction have anchored significant activities during the week, often launching major continent-wide initiatives. One such venture was the International Market for African Film and Television, which celebrated its fifth anniversary at FESPACO this year. Set up at the George Méliès Center, a beautifully appointed air-conditioned space, the market served as a convenient meeting place for filmmakers and distributors. Both festival films and other works from Africa, the Caribbean, US, and Brazil were available for buyers, distributors, and exhibitors to screen at their convenience.

FESPACO's major business agenda centers on the Second International Partnership Day, an initiative of FEPACI, which built on the foundation laid during the 1989 festival. The idea at this year's International Partnership Day was to look toward aggressively maximizing North-to-South and South-to-South cooperation and coproduction in order to obtain the resources necessary to finance and disseminate African cinema. Over one hundred participants came together, including numerous representatives from Europe and the US—including Britain's BBC and Channel Four, ZDF in Germany, Centro Orientamo Educativo in Italy, Agence de Coopération, Culturelle et Technique in France, and the Rockefeller Foundation in the US.

Although African cinema's basic problem of undercapitalization has not been resolved, both dialogue and action on this matter are now moving beyond the rudiments of production to other, more internationally attuned concerns, such as competitiveness in the foreign market and the accessibility of African films to non-African audiences.

Even with the current interest in African cinema at international festivals and the promising prospects of partnership, there still are no guarantees for the individual filmmakers. They must still log thousands of miles on the gypsy trail, hopping between three continents to pursue partnership

and coproduction opportunities. Despite daunting obstacles, African film-makers persevere. It is this vitality and courage that makes FESPACO more than just a film festival. FESPACO showcases a cinema on the move and a movement with potentially unlimited range and impact within the continent and throughout the global community.

> **Claire Andrade-Watkins** is a filmmaker and historian specializing in African cinema and an invited participant to FESPACO since 1985. She is assistant professor of mass communication at Emerson College and is currently a visiting professor in Wellesley College's Black Studies Department.

Notes

Originally published as Claire Andrade-Watkins, "A Mirage in the Desert? African Women Directors at FESPACO," in *Cinemas of the Black Diaspora: Diversity, Dependence, and Oppositionality*, Michael T. Martin, ed. (Detroit: Wayne State University Press, 1995): 145–152.

Cabascabo, the Film That Lastingly Established FESPACO: Interview with Alimata Salambéré, President of the First Edition (1969)

Olivier Barlet

Much is read about the birth of FESPACO. It was therefore necessary to return to its source, to its first president. It was an opportunity to discover the essential role played by the opening film. In 1969, Alimata Salambéré, head of programs at the national television association, was twenty-seven years old. Nevertheless, she was chosen to be the president of the organizing committee of the first "Festival of African Cinema of Ouagadougou," which lasted a fortnight (February 1–15) and became the "Pan-African Film Festival of Ouagadougou" (FESPACO) at its third edition in 1972.

The biography written by Yacouba Traeré, *Alimata Salambéré Ouédraogo: Itinéraire et leçons de vie d'une femme debout,*[1] provides a better understanding of why. Odette Sanogoh, who was short of time in her post at the national television association, had delegated Alimata Salambéré to participate in the organizing committee meetings. François Mifsud also participated as head of the cultural service of the French embassy in Ouagadougou. While he was principal of the Bouaké high school in Ivory Coast, he had as a student Alimata's husband, Emmanuel Salambéré, whom he had appreciated, and who is by now a jurist. He therefore proposed the only woman in the group to be president, and she was elected with great applause.[2]

But Alimata Salambéré would not have been in charge if she were not already known as a star presenter for the television news and for her work as a journalist, showing a strong character that had allowed her to ward off a woman's fate as a housewife. Her programs *Magazine de la femme*, which she already hosted in 1969, then *Nul n'est censé ignorer la loi / Ignorance of the law is no excuse*, stimulated Burkina Faso's national radio, to the point that Thomas Sankara later appointed her as Minister of Culture after a tense interview that the book delightfully relates.

During her inaugural speech, she insisted on the festival's objective: "an African cinema that speaks of Africans, an African cinema made by Africans."[3] General Sangoulé Lamizana, Head of State, had agreed to sponsor the festival and embraced its terms, as the following demonstrates.

Alimata Salambéré insisted that the opening film be *Cabascabo* (1968, Niger), by Nigerien Oumarou Ganda, in which a young African enlisted in the French Expeditionary Corps in Indochina sees his comrades die for a cause that is not theirs and returns home quite distraught. The following interview shows why this stroke of genius allowed the perpetuation of the festival.

Olivier Barlet: *Working on the history of African Cinema, I would like to verify some information with you because we can read contradictory things about the beginnings of FESPACO, especially concerning the role of filmmakers. In one article,[4] Inoussa Ousseini indicates that Claude Prieux was stationed in Saint-Louis, Senegal, before being named director of the Franco-Voltaic Cultural Center in Ouagadougou:*

Alimata Salambéré: It is possible.

OB: *And that he already had the project to create an African film festival in the same spirit as the Black Arts Festival, in collaboration with Ousmane Sembène and Paulin Soumanou Vieyra.*

AS: That's true.

OB: *So, they already had an active advisory role?*

AS: I even dare to say collaboration because they contributed to enriching his idea. When you want to see the founding members of FESPACO, I include them, Sembène and Vieyra, even if on the national level it is Upper Volta that had the initiative "with" Prieux to establish this event. Sembène and Vieyra were the first filmmakers who arrived, and Prieux based the festival on their films, along with Ganda, Mustapha Alassane, and Timité Bassori, who also made their films available for free. If he was in Saint-Louis, he probably rubbed shoulders with them, and when he was relocated, he found people here who were able to adhere to this idea and he launched out.

OB: *From when were they active?*

AS: FESPACO was born thanks to Prieux, director of the Franco-Voltaic Cultural Center. I did not know him when he arrived, but I imagine that he had the necessary contacts to pursue his idea. He had contacted François Bassolet, the director of information who ran the state press, *Carrefour*

africain, the forerunner to today's *Sidwaya*. There was also Mamadou Simporé, the director of the PTT [Office of Post and Telecommunications]; Eugène Lampo, from the Ministry of Education (at that time there was no Ministry of Culture); Sanogoh, who was in charge of the television association (I was then the program manager); and Hamidou Ouedraogo for the mayor's office in Ouagadougou. They had many meetings, and one day Sanogoh asked me if I would be interested in replacing her because she was very busy. I had listened to what she had to say with a slightly distracted ear, but I accepted. The idea was that the films shown at the Franco-Voltaic Cultural Center were only seen by expatriates. There was a film club, but it was seldom attended by Africans.

OB: *Like Ousseini in his article, Colin Dupré insists in his book on the history of FESPACO on the role played by the "Ouagadougou film club" of the Franco-Voltaic Cultural Center.*[5]

AS: It was [Rene] Bernard Yonli who hosted it, and he made a film afterwards: *Sur le chemin de la reconciliation / On the Road to Reconciliation* (1976, Burkina Faso). I don't know if they lobbied for a festival, but I don't think that was their concern. It was more that of Prieux, who realized that Africans could not see films made by Africans, and he did not find that normal.

OB: *So you set up a committee.*

AS: Yes, when it started to take form, Prieux invited his boss, the cultural advisor of the French embassy, Mifsud, to participate. During the introductions, he asked me if I knew Emmanuel Salambéré. Everyone knew that he was my husband. But he had been [Mifsud's] student in Ivory Coast. I was the only woman. So when it came to electing a board for the different tasks to be accomplished, he proposed my name and everyone applauded. I was afraid, but I accepted! We had meetings, and we established who could help us. All the services concerned were there: the press, television, Air Afrique had been asked to help with transport, the national education authorities, etc.

OB: *Did Sembène participate in these meetings?*

AS: No, he was abroad and there were many meetings. He came to the festival as a filmmaker with the films he used to offer for free, which showed his commitment and conviction. He understood that the festival could truly help African cinema.

OB: *What was your relationship with President Lamizana?*

AS: Lamizana had welcomed us very well, and the State financed the expenses that we could not afford, even before the festival, to bring in about thirty

films. I proposed to show Ganda's *Cabascabo* as the opening film. Lamizana was a military man, and I was sure that he would be receptive. After some hesitation, everyone finally agreed. He enjoyed the film immensely. He came with his wife, which was not common at the time. I teased them a bit thanks to the joking relationship we had, and we laughed. His aide-de-camp was my husband's uncle, Kouaka Salambéré: the day after the first edition, Lamizana had his aide-de-camp give 200,000 CFA francs to our committee, a large sum at the time, probably taken from the slush fund, and he made sure that the festival continued.

OB: *And who was the secretary-general of the festival?*

AS: It was Prieux who assumed this role, but then there was a desire to make it more African and Bassolet succeeded him, followed by Louis Thiombano. In 1970, it took the form of a festival. I was pregnant, and I asked to be replaced. So we asked Mr. Mensah, a renowned film enthusiast, who was also the mayor of Ouagadougou. Was it the fact that he was to replace a woman? In any case, he suggested his wife, who was secretary to the Minister of Foreign Affairs. This was accepted and she replaced me. It was then with her that the name FESPACO was given. There is a controversy about who was the first president, but that's because of the name of the festival. She was not present at the first meetings. I never intervened in this controversy because she was an elder, older than me. As far as I am concerned, I simply did my job when I was in charge.

OB: *At the first edition in 1969, you were twenty-seven years old, and you gave a militant speech that was noticed, placing the festival at the service of a cinema made by Africans and that speaks to Africans.*

AS: At the time, I was presenting the eight o'clock news. On the opening day of FESPACO in 1969, I was on duty for the eight o'clock news, and I had my speech next to my papers for the news. I was going over it during the preparation. I was very anxious!

OB: *At the fiftieth-anniversary symposium in 2019, you insisted on the pan-African dimension of the festival. This was 1969 at a time when African countries were divided between the non-aligned, who had an internationalist definition of pan-Africanism, a conception shared by Sembène and others, and those who preferred a transnational pan-Africanism. How did that affect you?*

AS: To be honest, I especially noticed that films made by Africans were not being seen by Africans.

OB: *The COMACICO [Compagnie Africaine Cinématographique Industrielle et Commerciale] and SECMA [Société d'Exploitation Cinématographique Africaine] movie theaters weren't projecting any African films?*

AS: No, that was not their concern. I was only driven by this conviction, without any underlying political activism. It had become a passion to be able to watch African films.

OB: *At the time, there was a great deal of mistrust towards these films. Prieux was transferred to Lomé shortly after the first festival for having screened them. They were reproached for being critical. This was the case for* Cabascabo, *for example. How was that articulated, politically speaking?*

AS: I didn't see it that way. It was on a cultural level, with a passion for what we are, what we can offer and share. That's what motivated me.

OB: *Did President Lamizana have strong positions in this regard?*

AS: I don't think so. In any case, he didn't express them at the festival.

OB: *The nationalization of cinemas in 1970 came about as a result of the demand that cinemas add to the ticket price the new 25 percent tax imposed by the Minister of the Budget, [Tiemoko Marc] Garango, who was seeking to replenish the state's coffers, and known as the "garangose." The cinemas refused and threatened to close on January 1, which they did, and were thus nationalized on January 4! Bassolet was sent to France to buy films, but without any knowledge of the business and the field, he only brought back one: Z (1969), by Costa Gavras.*

AS: Eventually, inexpensive films were accepted, most notably Hindi films, and the boycott didn't last very long. This encouraged African filmmakers to produce, in order to replace these images coming from elsewhere that were not part of our culture. These cinemas were run by businesspeople who only thought about their profitability, and we were determined to do it ourselves. SONACIB [Société Nationale du Cinéma Burkinabe] functioned well for a certain period of time and made it possible to finance the production of Burkinabe films through a tax on tickets, which fed the famous 30-115 account, allowing for the allocation of subsidies at a time when the Ministry of Culture did not have large resources. People continued to go to the cinema, and the State also intervened by financing production, which was exceptional in Africa. The State also took on the cost of bringing invited filmmakers from other countries to the festival.

OB: *This is still the case, for that matter!*

AS: Yes, but partnerships are established that divide the cost. The support of the IOF and the European Union was decisive. The festival bureau went to

meet what has become the IOF. I was myself, long after, director general of culture at the IOF, after having been minister of culture under Sankara and then Blaise Campaoré.

OB: *How did you experience this change in power?*

AS: Sankara had thought that I was capable of defending culture as he understood it, and I told myself that I had to continue with the same conviction in order to consolidate what he had seen in appointing me. As I am not a politician, I do not take sides, but I owed it to him to continue the mission he had entrusted me with. I did not want to leave the place to people who would not have gone in the direction of what he wanted.

OB: *If Sankara forced you into this position that you did not want, it is because he knew about your program* Nul n'est censé ignorer la loi / Ignorance of the law is no excuse, *which apparently disturbed many people.*

AS: Yes, it did bother. He had been observing me for a long time. The fact that I was at the head of FESPACO in 1983 as a woman and a journalist had impressed him. My children also insist on how novel this was, so much so that I have become aware of my rebellious side!

OB: *You are part of the Council of Experts of FESPACO. What is your role?*

AS: We intervene if there are questions or differences. There was one between the Minister of Culture and the general delegate, who were both working on their first FESPACO. I took the liberty of reminding them so, and of the need for complicity between the two of them to succeed and serve cinema. Alex Moussa Sawadogo is very competent and knows the field very well, and his minister recognizes that. I do not believe that you have to be a politician to be at the head of FESPACO. Felipe Sawadogo was also present, and he agreed with my position. He had been appointed secretary-general under Sankara in 1984. I had proposed him, and Sankara had told me that he was a bit young. I told him that I had no one else and also reminded him of his own age (thirty-five)! He laughed and Felipe Sawadogo was appointed until 1996!

OB: *The link between the State and the festival has always been problematic: the management of a festival requires the ability to act quickly, without administrative complications. All the general delegates have insisted on strengthening the festival's autonomy, to no avail.*

AS: Absolutely. I don't believe that this is the particular objective of the current general delegate, but his work is heading in that direction.

OB: *This is the first time that the composition of the selection committee was unveiled, which brought together competent people, and all are pleased with the quality of the 2021 selection. In the future, won't the challenge be to have world premieres that would strengthen the attraction and international visibility of FESPACO?*

AS: Certainly, but for this edition, the postponement from February to October meant that many films were presented in other festivals. In February, we would have been the first to screen some films. If we can overcome terrorism and the pandemic, we will be able to make it!

OB: *How did FESPACO find its mark in the beginning? Was it from the beginning the huge popular success it later became?*

AS: The attraction was that the public recognized itself in the films. This reminds me of an anecdote: when Gaston Kaboré was director of cinema, the director of Air Afrique was asked to show African films during flights. He agreed, but this was not really followed up! And one day, I was taking a flight, and seeing that I was onboard, a manager changed the list of films in order to include an ethnographic film to please me! This was absolutely not our expectation and showed the gap in the understanding of films!

OB: *Did you have enough screening venues?*

AS: There were six movie theaters in the country and only two in Ouaga, the Ciné Simon and the Ciné Nader. Souleymane Ouedraogo, the projectionist of the Franco-Voltaic Center, managed to install a projector at the Maison du peuple. We must pay tribute to him because it was not easy. He is currently visually impaired. During Sankara's first FESPACO, I insisted that the opening be done at the Maison du peuple despite some reticence. I reminded him that this is where Lamizana had seen *Cabascabo* and this is where it happened!

Interviewed in Ouagadougou on October 17, 2021
Text reviewed and corrected by Alimata Salambéré
Translated by Christian Santa Ana

Notes

1. Yacouba Traeré, *Alimata Salambéré Ouédraogo: The Journey and Life Lessons of a Woman of Principle* (Ouagadougou: Editions, 2019).
2. Ibid, 97.
3. Ibid, 16.

4. Inoussa Ousseini, "Hasard et nécessité dans l'invention du FESPACO," in *Cinéma africain—manifeste et pratique pour une décolonisation culturelle—1ère partie: le FESPACO: création, évolution, défis* (FESPACO/Black Camera/Institut Imagine, 2020), 117–21. An English version is available in *Black Camera.*

5. Colin Dupré, *Le Fespaco, une affaire d'Etat(s)* (L'Harmattan, 2012), 89. For a review of the book, see http://africultures.com/le-fespaco-une-affaire-detats-de-colin-dupre-11325.

Figure F. Gaston Kaboré. Courtesy of FESPACO.

The Long Take: Gaston Kaboré on the Formation, Evolution & Challenges to FEPACI & FESPACO

Michael T. Martin

This extended conversation with Gaston Kaboré, renowned Burkinabe filmmaker, founding director of the Film Training Institute, IMAGINE, past President of the Pan-African Federation of Filmmakers (FEPACI), and recipient of the Étalon de Yennenga prize for *Buud Yam* (1997), was occasioned in commemoration of the fiftieth anniversary of the Pan-African Film and Television Festival of Ouagadougou (FESPACO). It occurred on November 2–5, 2019 at IMAGINE, Ouagadougou, Burkina Faso.[1]

Michael T. Martin: *Given your long-standing engagement with both FEPACI and FESPACO, I would like to begin with the creation of FEPACI in 1969, although others contend, 1970. Who were the principle protagonists and the circumstance in FEPACI's formation? Why FEPACI?*

Gaston Kaboré: Why FEPACI? You must know that I am not among the first pioneers [wave] of African filmmakers. The second and third editions of FESPACO were the occasion in which I met most of them: Ousmane Sembène[2], Paulin Soumanou Vieyra[3], Med Hondo[4], Oumarou Ganda[5], Moustapha Alassane[6], Timité Bassori[7], Désiré Ecaré[8], Mahama Johnson Traoré[9], Safi Faye,[10] and Sarah Maldoror.[11]

I am very grateful to them, my elders; among their accomplishments was the creation of the Pan-African Federation of Filmmakers. While I agree with you about which of the two dates FEPACI was formed, we have, more or less, officially adopted 1970, although discussions among filmmakers began in 1969 at a symposium organized by the Algerian cinémathèque during the first Pan-African cultural festival held in Algiers. This was where a provisional FEPACI committee was formed. A year later in 1970, FEPACI was officially established in Tunis.

Moreover, the Carthage Film Festival [JCC, Les Journées Cinématographiques de Carthage], was itself established in 1966[12] by

Figure 1. Timité Bassori, Filmmaker, Ivory Coast, image courtesy FESPACO.

Figure 2. Safi Faye, Filmmaker, Senegal, image in the public domain.

Figure 3. Sarah Maldoror, Filmmaker, Guadeloupe, image in the public domain.

Figure 4. Paulin Soumanou Vieyra, Filmmaker, Senegal, image courtesy FESPACO.

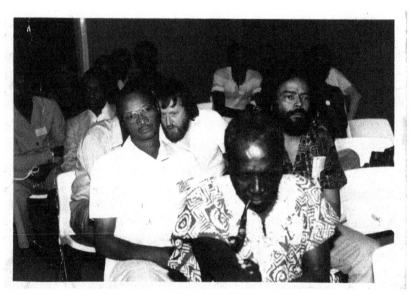

Figure 5. Ousmane Sembène, Senegal, and Med Hondo, Mauritania, image courtesy FESPACO.

Tahar Cheriaa, who was among the most prominent theorists of Arab-African film. He illumined how cinematic narratives and their consumption by African audiences created dependency from outside of the continent because of the way films had been exhibited compelled African countries to import from abroad. In a country like Burkina Faso, which had between twelve to fifteen cinema houses in the 1970s and early 1980s, we imported hundreds of films rather than make them. Sembène described this circumstance as "a fact of dependency," where people consumed stories in which they were not themselves reflected.

For the most part, we were screening European and American stories that dominated the minds of African audiences who couldn't see themselves in these films and whom therefore assumed that cinema could only tell other peoples' stories. FEPACI declared "cinema is not insignificant!" While you may associate it with a form of entertainment, it constitutes a representation of people and the stories their lives tell.

African filmmakers felt the urgency to get together and speak to all stakeholders, the first of whom were African states and governments. FEPACI was very quickly accepted as an observer member by the Organization of African Unity [OAU], which undoubtedly strengthened its representation and legitimacy. This led to the establishment of all manner of dialogue regarding the political, budgetary, and technical support needed for the achievement of FESPACO's missions.

In order to achieve its objectives, FEPACI prioritized vocational training, film production, distribution, and exhibition as well as the development of technical and cultural infrastructures of cinema (i.e. laboratories, auditoriums, cinema halls, cinémathèques, film schools, festivals, and cinema clubs, etc.).

FEPACI wanted African filmmakers held in the same high regard as doctors, agronomists, and engineers. They wanted filmmakers to be recognized for contributing to the development of their countries. They made two fundamental claims: firstly, that cinema is a tool to deepen the consciousness of African people to understand that their lives matter and that their stories warrant cinematic attention; and secondly, that cinema can portray reality and expose the injustices, class inequality, and dysfunction of neocolonial society.

MTM: *As Frantz Fanon did in an unsparing critique "The Pitfalls of National Consciousness" in* Wretched of the Earth *[1961].*

GK: Yes! And of course Sembène addressed class privileges and political corruption in *Borom Sarret* [1963][13] and *Xala* [1975].[14] Such films by African filmmakers were not for economic gain, but rather for moral, cultural, social, and political motives and needs. As African filmmakers, we made these films to

affirm we exist and that we have deep cultural roots. We must not forget that the Pan-Africanism of Patrice Lumumba, Kwame Nkrumah, Sékou Touré and the others was a movement and cinema contributed to this transnational affirmation of, and effort to, recover our own memories, values, and identity.

FEPACI was created to unify the filmmakers of Africa and to support them to confront their respective governments and decision-makers. That was FEPACI's organizing creed in the beginning.

Along the lines of this mandate, FEPACI addressed the need for a training and production apparatus on the continent and to build an infrastructure to normalize the distribution and exhibition of African films. We were always dependent and struggling to make our films in a foreign system of production. As difficult as it was, our films were shown at festivals in Africa and abroad that promoted respect and admiration for their artistic value. However, the problem was integrating our films in the market and FEPACI labored to make national governments aware of the cultural, economic, and political aspects of cinema. These critical aspects of African cinema discussed in Paulin Soumanou Vieyra's *Le cinéma africain des origines à 1973.*[15]

MTM: *Vieyra's book has yet to be translated from the French to English.*

GK: Yes, you are right and it is certainly a pity. Vieyra engages with these issues and, at the conclusion of the book, raises a key question: What more does African cinema signify? He responds by stating African filmmakers, rooted in their respective cultures, are conscious that cinema can enable people to obtain economic, social, cultural, and political liberation.

So, an organizing principle for creating FEPACI was the recognition that cinema is not only entertainment, but more important and fundamental, is that it is a tool to develop consciousness and foster a renaissance among Africans from their own perspectives and lived experiences.

MTM: *Was the project of recovery your motivation to become a filmmaker?*

GK: Yes. And, then by chance in 1985—fifteen years later—I was elected to head FEPACI in Mogadishu, Somalia.

MTM: *The motivation and rationale.*

GK: Yes, from the beginning you can see how revolutionary FEPACI was; it was funded despite the governing body being from all over Africa. The organization's president Brahim Babaï[16] was Tunisian while the general secretary, Ababacar Samb-Makharam,[17] Senegalese. In the early 70s, a delegation from FEPACI, with very strong convictions, visited the US and met with members of the Hollywood film guild. They said "You are exploiting our market and we want you to understand that as Africans, we must make films. We are here

to discuss our needs with you." The Americans were pretty surprised by this display of determination and anti-imperialist activism. In France, FEPACI officials raised their voices, making clear demands to the head of the powerful film distribution company in Africa .

MTM: *Was the consortium the CNC?*

GK: No, the CNC came later. What I'm speaking of was a private consortium. The head of this powerful film distribution company responded rather scandalously saying: "You know, African audiences don't need your films, they don't like your stories." What this gentleman was condescendingly and arrogantly saying, was that films made by African filmmakers did not interest African audiences, as they were instead fond of Hollywood and European films.

Of course, that was a lie made evident at the Carthage Film Festival and by the reception of audiences at Ouagadougou, the same audiences that used to see American, European, and Indian movies stormed the cinema halls in Tunis and Ouagadougou, Niamey, Abidjan, Bamako, Accra, Casablanca, Algiers, Constantine, Douala, Yaoundé, Libreville, etc. to watch locally-made films. When given the opportunity to see African stories, African audiences did and favored them. Their reception of African stories renewed African filmmakers' commitment to continue making films. As I noted earlier, broadly speaking, producing films in Africa by Africans was not a lucrative endeavor because our films were not produced in a normal process nor were they distributed and exhibited. Our films were like strangers in their own home and, unfortunately, securing resources to make them was difficult, particularly for filmmakers who criticized the policies of African governments. African politicians viewed such filmmakers as untrustworthy and troublemakers. Consequently, for francophone filmmakers, like Paulin Soumanou Vieyra and Henri Duparc, they sought funding from France,[18] where they studied at the L'Institut des hautes études cinématographiques, [IDHEC/Advanced Cinematographic Studies],[19] which is today referred to as FEMIS [Fondation Européenne pour les Métiers de L'Image et du Son]. This paradox and obstacle did not escape us: for the francophones, we relied on the funding and cinematic infrastructure in France to make our films, but we did so without compromising ourselves; for the lusophones, Portugal, and so on. Some local state governments were very nervous about the films we made, but in Ouagadougou, filmmakers believed in the nation and audiences strongly supported them.

MTM: *What countries abroad exported films to Africa?*

GK: France, Italy, Germany, and to a much lesser extent, Belgium; later followed Bollywood. In West Africa, Nigerian filmmakers, like Ola Balogun

who made *Ajni Ogun* [1976], were already successfully producing unique films based on plays in Aruba Theater. Nigeria has always been a special place for filmmaking because of the size of the country, its history, and the diversity of its cultures. While this is true for some countries, the question is how to create the proper conditions to make films? I say this because unfortunately for us, cinema is comprised of art, techniques, industry, and trades. These elements need to exist and be in balance and coordinate if you want to create the conditions for viable and sustainable production. And, as I noted earlier, FEPACI was fighting to articulate and create these conditions, but state governments were not mature enough to understand that.

MTM: *They were also threatened by it.*

GK: Of course! They were frightened that cinema could provoke dissent against them.

MTM: *Not to get off track, but where does Férid Boughedir[20] stand in the evolution of African cinema? Is he among the first or second wave of filmmakers?*

GK: He is a bridge between the first and second generations. I say this because he was a critic and journalist, and before he made his first film, or the first long feature film, *Halfaouine: Boy of the Terraces* [1990], he was well acquainted with African cinema having seen most of these films writing for *Jeune Afrique.*[21]

MTM: *And then followed by the book,* African Cinema from A to Z *[1992].*[22]

GK: Yes, of course, and he made the film on Arab cinema, *Caméra arabe* [1987]. Férid has contributed to the discussion on the role and need for cinema in Africa and he has been a good mediator among filmmakers. He is my elder, literally speaking, and my personal view is that, while he did not begin as a filmmaker, he had one foot as a creator and the other as a journalist. I made his acquaintance at the Ouagadougou or Carthage festivals.

MTM: *Okay! You've clarified the circumstance, raison d'être, and mission of FEPACI, which underscores the continuing dependency of Africa with the complicity of African governments in the postcolonial period, as well as their reluctance, indeed, fear to support local and indigenous production because it could challenge their legitimacy and rule.*

GK: Yet, cinema contributed to the revolutionary movements in the anti-colonial struggles of Algeria, Angola, Cape Verde, Guinea-Bissau, Mozambique, Namibia, South Africa, and Zimbabwe. It is a fact that cinema contributed to the triumph of liberation movements.

FEPACI had the intelligence to grant direct membership to all liberation movements located in countries that were warring and without national associations of filmmakers.

MTM: *As in Cuba, particularly in the immediate aftermath of the revolution with the formation of* [Instituto Cubano del Arte e Industria Cinematográficos].

GK: Of course. Unlike however the post-revolutionary government of Cuba, African states that attained independence were very cautious and resistant.

MTM: *Let's transition to the factors that enabled FEPACI to cohere as an institution. What enabled in the formative stage of the postcolonial period, filmmakers from Algeria, Tunisia, Egypt to convene with filmmakers from sub-Saharan Africa? What commonalities and urgency explain how FEPACI was constituted as a Pan-African project of continental and transnational scope and purpose?*

GK: I think, a factor was, as filmmakers, we were in the same craft and artistic discipline. Another, was that we knew the importance of the image. Together, they brought us together in common cause. We *all* wanted to tell our own stories, despite the particular circumstance in each country. Our formal training, cinematic experiences from the ground up and involvement and activities with film federations, we were acutely aware of the power of cinema as a mass communication tool. These factors and our common convictions, commitments, and awareness compelled us to sit together and articulate shared concerns and aspirations in French, English, Arabic, Portuguese. For this reason, no one questioned the legitimacy of FEPACI.

MTM: *Okay! At the table sit filmmakers from distinct countries, cultures, and language groups whose shared commitment was to use cinema...*

GK: To liberate!

MTM: *"To liberate." How was FEPACI constituted to do that?*

GK: Yes, first, by recognizing that the Pan-African Federation of Filmmakers is representative of all national groups of filmmakers. In France, we say *Les Unions Nationales des Cinéastes*. "Union" means different things in French and English.

MTM: *Federation.*

GK: We also call it *le syndicalisme*, trade unions of guilds in each member country. Each has to create a national association of filmmakers…

MTM: *As a condition of membership in FEPACI?*

GK: Yes, exactly, but at the same time, we knew that the national associations were not…

MTM: *Equal?*

GK: Yes, and that they were not necessarily functioning well; each country had its own particular issues to confront. As the head of FEPACI for twelve years, I know how difficult it was. Whenever I arrived at local branches of the film associations, I had the opportunity to meet with most of the filmmakers in the area. They would meet with me because they knew that they were part of something larger than the local association. In spite of this, the local associations often experienced a lot of tension between members. Sometimes I served as a peacemaker.

MTM: *You mediated between them.*

GK: Yes, and I would say that while difficulties and challenges are expected, one has to overcome them and not lose sight of the common objectives, our differences and tensions are less important than the work we are doing. We have to together find a way, otherwise we weaken ourselves when we go to negotiate with the government for support and resources. It was amazing that many of the filmmakers disagreed on minor things. Sometimes, they said "No, Gaston, we understand, we are going to meet among ourselves and come into dialogue." Years later, it would be the same, even worse sometimes.

Fortunately, FEPACI endures. It is important because it has survived, despite its weaknesses, continuing to promote a vision of what can be done, and not dictating any particular type or genre of film. Most of the pioneers, along with the second and third generations of filmmakers, understand the importance of cinema as a tool of liberation, to expose and condemn social injustices. For that reason, such cinema referred to as *cinéma militant* ["militant cinema"]; and slowly that vision has expanded to include other types of films.

For example, although I should not be the one to point this out, when I made *Wend Kuuni* in 1982,[23] it was unexpected and film critics said the film signaled another mode of storytelling that opened the door to new possibilities for representation and narration. My second feature film, *Zan Boko* was released in 1988 and some, particularly European film critics, said "Oh Gaston, we believe that you are going down another path making poetic cinema and things like that. While I endorse both *Wend Kuuni* and *Zan Boko*, to this day, people ask, "Which of your films do you prefer?" I tell them that I have equal regard for all my films, because I made them with the same level of conviction and commitment, and I didn't lie to myself.

MTM: *Before we transition to FESPACO, I would like to revisit something you alluded to earlier. When FEPACI was formed, each national association had a place-set on the table, but were some associations more dominant that others. And by that I mean was the francophone presence more influential and determining than say the Arabic and anglophone ones?*

GK: Before I respond, among the filmmakers I cited earlier, Ghanaian film-maker, Kwaw Ansah[24] and Nigerian filmmaker Ola Balogun,[25] were both there in the beginning of FEPACI. I will say that the filmmakers from fran-cophone countries were more dominant at the time because they were making more narrative fiction films than their anglophone counterparts. But, I want to be tentative about what I'm saying here because I don't have the facts readily available to substantiate this claim. For historical reasons, more fiction films were produced in the francophone countries and that the constitution of FEPACI was defined along the lines of the Latin view of art.

MTM: *Latin language, linguist groups.*

GK: Yes, but I am also speaking of their vision of art and I think another reason was that the anglophone [African] countries did not subsidize the arts.

MTM: *While France subsidized local production?*

GK: Yes. Later, dependent on the filmmaker, many, if not most, of the films made directly or indirectly denounced colonialism. So, it's true that the anglo-phone filmmakers were a minority in FEPACI because they had different concerns and working more in the documentary genre.

MTM: *Was language a factor in the cultural dynamics of FEPACI?*

GK: To use myself as an example: A francophone, when the necessity arose, I spoke [speak] English to communicate with and provoke English-speaking filmmakers. I would say "You don't make any effort to speak French, yet you complain of the dominance of the French language at the festival [FESPACO]." However, elsewhere most of the francophone filmmakers speak English. Haile Gerima once told me "You might be right, but there is no more room in my head to learn another colonial language." I replied, "I like your opposition—I respect it." In Montreal, attending the fiftieth anniversary of the National Film Board of Canada (ONF), Gerima started speaking in Amharic during a speech and people said "Oh, wait there is no translation!" By that, Gerima was intentionally making a statement. He replied "But why should I translate? Amharic is my language! There is poetry and there are novels in Amharic, so I'll speak my language." When he switched back to English, said "Okay, I have to compromise. I am going to speak one colonial language that I know, and that's English."

MTM: *I recall some years ago, you appeared exhausted and, looking directly at me, you said, "Michael, why don't you learn French?" And you were right because this was a labor you burdened, not me. The subtext of your response was then, as it would be now, "Why must I speak another language to accommodate those who can't speak French!"*

GK: For many people, English is the language of God. We know that.

MTM: *Language and empire! Were there other conditions that privileged one national association over others in FEPACI during the period of its formation?*

GK: I don't think so, but after ten years, a crisis occurred in FEPACI.

MTM: *When did the crisis start?*

GK: After 1975 because people believed that FEPACI was engaging in what we call "bi-cephalism," operating with two heads. It was a challenge for FEPACI to make decisions as the President was in Tunisia and the Secretary General in Senegal. Then, after many attempts failed to organize the congress, as consequence of Thomas Sankara's intervention, it relocated to Burkina Faso in 1985.

MTM: *In 1984 or '85?*

GK: It started in 1984. Our association in Burkina Faso hosted the Third Congress of FEPACI. I worked very hard on it, even though I was not a member.

MTM: *Why not?*

GK: Because, for many years, I was the head of the program and communication and press of FESPACO. That year, I helped with writing the literature for the festival because I had certain historical knowledge and a particular perspective. When the Congress started, Mamadou Djim Kola[26], president of our national guild, L'Union des Cinéastes de Burkina [UNCB], presided over the congress. During the deliberations, the issue of a new constitution arose and I was invited by representatives of our association [guild], and at the suggestion of many of the pioneer filmmakers present, to address the crisis. During the course of that memorable experience, I was honored to be nominated and then elected, among the finalists were Jean-Pierre Dikongué Pipa [Cameroon], Ousmane Sembène [Senegal], and Jacques Behanzin [Benin], Secretary General of FEPACI.

MTM: *What caused the crisis?*

GK: Imagine, in each country, having to self-organize without adequate resources—not easy! And cinema was something new. While we were an independent nation since 1960, the film industry didn't exist. There were also no cinema halls and, in most of the country, the ciné-clubs were dysfunctional. There weren't programs on TV or on radio, except in several countries, like Burkina Faso. Cinema had yet to become a well-known artistic form. It didn't work because there was no film sector.

MTM: *Undeveloped.*

GK: It was certainly underdeveloped, however, situations differed between countries. Some filmmakers in francophone Africa managed to find funding from France and from the Agence de Coopération Culturelle et Technique [Agency for Cultural and Technical Cooperation/ACCT], now called Organisation Internationale de la Francophonie [International Organization of the Francophonie/OIF]. They made films that had commercial success, which in turn roused pride of their countries of origin, the same countries that had not originally contributed to the production of these films. When a filmmaker from an African country had a film that was acclaimed by European critics and African audiences, then the country's government was forced to pay attention, at times countries capitalized on film success, making a point turning it into a source of national pride. Some of these countries' governments even began to feel compelled to offer some sort of support for cinema, particularly if the film had won the prestigious Étalon de Yennenga Award at FESPACO, which put the spotlight on a film, a filmmaker, and a country.

The weakness of national filmmakers' associations stemmed from the non-existence of national cinema organizations in many African countries. Nevertheless, there were a few countries that had film production, albeit in a limited capacity [Algeria, Burkina Faso, Ghana, Ivory Coast, Morocco, Niger, Nigeria, Senegal, and Tunisia.]. Many of these countries either had: sufficiently functional national associations of filmmakers [Algeria, Burkina Faso, Morocco, Senegal, and Tunisia]; very active ciné-clubs [Algeria, Burkina Faso, Morocco, and Tunisia]; demonstrated political support for cinema [Algeria, Burkina Faso, Ghana, Morocco, and Tunisia]; held internationally renowned film events [Algeria, Burkina Faso, Morocco, and Tunisia]; were host countries for major international productions [Algeria, Morocco, and Tunisia]; contributed to the training of local competencies [Algeria, Morocco, and Tunisia], or had a combination of many of the aforementioned and favorable qualities [Algeria, Morocco, and Tunisia]. Egypt was a special case since it had established a real film industry very early on and its film production was larger than the total number of films produced in other independent African countries. Egyptian cinema exported films throughout the

Maghreb, the Middle East, and the Gulf countries and its stars were famous worldwide. As for us in Burkina Faso, as a result of FESPACO's presence, the National Association of Burkinabe Cinema, was a bit stronger.

MTM: *More advanced.*

GK: And that is the reason why, we were able to convince the government to accept and organize the congress in Burkina. The Ivory Coast was on the rise then, but knew they didn't have the resources or capacity to organize themselves a congress.

MTM: *Burkina had infrastructure?*

GK: Yes, but it was very modest.

MTM: *Was President Sankara a major figure in support of cinema in Burkina Faso?*

GK: Yes, but it is worth expounding on Sankara's path. It's important to know who he was before arriving on the scene in 1983, before he launched the revolt. This will help you understand Sankara's impact on what would become the future of cinema in our country.

Captain Thomas Sankara's introduction to the film sector occurred in 1981, the year he was appointed as the Secretary of State, which put him in charge of Information and Culture. I met him then, as I was the Director of the National Film Center, which was under his supervision. I was also directing my first feature film, *Wend Kuuni*, which was shot between October 1981 and February 1982.

While Captain Thomas Sankara remained in the Secretary of State position for less than eight months, it was enough time for us to build a warm rapport. I think he held my filmmaking practice in esteem. I found his perspectives on information media, cinema, and culture in general, to be very interesting. Giving the ups and downs of our country's political climate, he returned to his post as an army officer, then in 1982 and 1983 he was part of several regime changes, which eventually led to the August 1983 revolution which made him president until his assassination on October 15, 1987.

During his four years as president [August 1983–October 1987] he brought extraordinary dynamism to the development of information media, cinema, and culture. For example, he succeeded in more than tripling the country's total number of cinema halls [from fifteen to fifty] and he instituted the National Cultural Week [La Semaine Nationale de la Culture/SNC], and allowed the creation of the first private radio station [Horizon FM].

Sankara's charisma, commitment to anti-imperialism and revolution, Pan-Africanist vision, and international fame, made the world pay attention

Figure 6. Thomas Sankara giving out an Étalon de Yennenga to Algerian filmmaker Brahim Tsaki, image courtesy FESPACO.

to Burkina Faso. By making FESPACO accessible to the African diaspora and to all people fighting for their independence and cultural affirmation worldwide, he brought a new dimension to the organization. President Thomas Sankara leveraged FESPACO's importance, while managing to maintain the Pan-African sentiment it claimed to promote.

Sankara was aware of the history of cinema in the Soviet Union and Cuba, he understood that cinema, strategically deployed, could promote the goals of the revolution. With this in mind, he infused a new energy in FESPACO. In fact, every August 4, cinema was used to commemorate the start of Sankara's presidency. Screenings happen throughout the country and *ciné-bus* transport people to screenings in villages. It was during such a celebration that I organized Ouagadougou's first Cuban film festival.

Sankara had vision, as well an understanding about the importance of cinema. He even addressed this subject, and that of the cultural arts more generally, in a speech before the General Assembly of the United Nations in 1984 and then in Ireland where he popularized in public statements FESPACO. Indeed, Sankara's efforts made cinema more popular than ever, which partially explains why African people of the Diaspora came to realize that Burkina Faso was a country and host to FESPACO. However, it would be historically inaccurate to say that FESPACO began with Sankara. And that for the fourteen years that preceded him, regardless of the regime in power,

no one dared question its existence in Burkina. But in promoting cinema and FESPACO, Sankara shed light on Burkina Faso.

MTM: *To speculate: absent Sankara, would FESPACO have the same presence that it does today? And what was Sankara's relationship to FEPACI, if any?*

GK: He strongly supported the national association [UNCB] and helped to obtain financial support from the European Union to organize the 1985 congress of FEPACI. And because we wanted the headquarters of FEPACI to relocate from Dakar to Ouagadougou, he did everything to ensure the success of the relocation. Regarding FESPACO, he was involved in its programming, particularly musical performances. What helped too was his stature as a young president; and his elocution, the way he truthfully addressed the struggles for Pan-Africanism and against neocolonialism and imperialism. This stance and its articulation attracted people to visit Burkina Faso and attend FESPACO editions. People wanted to be in Sankara's presence.

Together, it is fair to say that Sankara did a lot to promote FESPACO into prominence, so much so that the festival became synonymous with African moving images. It's amazing how much Sankara accomplished domestically and internationally, in the period of his presidency [and life]: August 1983, occasioned the revolution and Sankara assumed power in 1984 until his assassination on October 15, 1987.

MTM: *Talk about national interests!*

GK: Yes, of course. We should not be naive. And giving support to particularly FESPACO nurtured and empowered FEPACI because we were so closely related.

MTM: *Did FESPACO legitimate Sankara's government?*

GK: I don't think we had the power to legitimize it. He understood why FEPACI and FESPACO were important, and he did his best to celebrate FESPACO on a grander scale. And being as clever as Sankara was, he knew that FESPACO would attract attention to the country and people of Burkina Faso.

MTM: *I hear that, but by extolling Sankara, FESPACO must have appeared to endorse his government, and unlike other African heads of state, projecting a positive relationship between government and progressive artistic sectors in Burkina Faso.*

GK: Yes, of course. When the revolution occurred, what it created exists today. For example, given Sankara's knowledge and intelligence, he understood that culture was very important for development of society; and he

created the La Semaine Nationale de la Culture, the National Cultural Week [SNC]. During the first edition of SNC, I was a member of the music jury. It took place in Ouagadougou, at the People's House[27] [Maison de Peuple].

MTM: *At the epicenter of the discourse on the role of culture in revolutionary formations is, arguably, best articulated in the writings of Amilcar Cabral.*[28]

GK: Certainly, and Sankara was a dynamic leader and understood that culture is a tool to cultivate and sustain a revolution.

MTM: *And unify a nation.*

GK: Yes, and since cinema was already present, it enabled this cultural and artistic form to develop in the country. The goals and aims stated in FEPACI's constitution correspond with this principle and role for cinema in the development of society. So, while Sankara didn't create FESPACO or FEPACI, he understood their essential importance to culture, particularly visual culture, and was able to contribute to FESPACO in a way that strengthened it. Thanks to him, FESPACO became an even larger and more prominent festival, which enabled him to invite progressive leaders and filmmakers from the diaspora to Burkina Faso.

MTM: *Did FESPACO have a liaison government representative on its governing board during Sankara's time?*

GK: No, but FESPACO could not have existed without the government's support because, at that time, the volunteers were workers and civil servants. No one received a salary because we didn't have funds to compensate people for the work they were doing on behalf of FESPACO. Sankara, who came to observe the progress, witnessed the spirit and commitment for FESPACO. Its very existence was progressive and *all* the filmmakers associated with it spoke in unity and in solidarity with Sankara.

MTM: *No doubt you took great pride at this critical moment in FESPACO and, as a Burkinabe, the nation. As FEPACI's mission and cultural project formed and developed, did it correspond to and was in conversation with other parallel or similar cinematic formations in the Third World?*

GK: Indeed. Yesterday, we spoke about the mission of FEPACI and I would like to add some other elements to that. FEPACI strived to explain and convince African governments that cinema was essential for the development of their countries, and not just on the culture level. What I mean is that films could educate people about agriculture and healthcare in the fight against diseases like malaria and chronic diarrhea in children. We have made these kinds of films to inform and educate new ways of improving the lives of people.

Another example, is using film to chronicle cultural events that celebrate dance, music, and the diversity of the people and their particular traditions. In this regard, FEPACI emphasized to governmental agencies how film disseminate and exchange knowledge amongst different ethnic groups, affirming the importance and value of diversity.

FEPACI, also endeavors to this day to encourage governments and countries in Africa to cooperate in filmmaking and to deal with the shared problems of production, distribution, and exhibition. Among the most important documents produced by FEPACI was drafted in Niamey, during a colloquium held Niger in 1982. Referred to as the Niamey Manifesto of African Filmmakers, among recommendations, it enunciates a series of initiatives ["measures"] to support national movie markets, financing local production, development of technical infrastructure, and training media professionals.

And, FEPACI was instrumental in the creation of two distribution entities: the Inter-African Consortium of Cinematographic Distribution [Consortium Interafricain de Distribution Cinématographique/*CIDC*] and CIPROFILM [Inter-African Consortium of Film Production], both established in 1979, although early discussions and efforts to create them began in 1968 in Kigali, Rwanda.[29]

MTM: *Were there other [cinematic] movements in correspondence with FEPACI?*

GK: FEPACI was the only organization of its kind on the African continent, as it was exclusively dedicated to cinema. FEPACI was accepted as an observer member by the Organization of African Unity [OAU], an organization that had political prowess. As an observer member, it could take part in most of the meetings organized by the OAU. It's also worth mentioning that the African Cultural Institute [ICA] was in existence and had interactions with FEPACI and FESPACO.

FEPACI endorsed all liberation movements in Africa. Such movements were accepted as members of FEPACI: ANC,[30] SWAPO[31] and we extended membership to the liberation movements in Mozambique, Cape Verde, and Guinea Bissau.

MTM: *Latin America?*

GK: To my knowledge, FEPACI was the only group in Africa associated with, for example, l'Union des Cinémathèques d'Amérique Latine [UCAL] whose position, status, discourse, and strategy were very similar to that of FEPACI. When I was the secretary general of FEPACI in 1986, we co-organized a retrospective on African cinema with the Cuban Institute of Cinematographic Art and Industry [ICAIC], which was held in Havana, Cuba and was part of

that year's Festival of New Cinema. The entire federal office of FEPACI, of which I was in charge, was present. It was during this occasion that we began strengthening our links with UCAL.

December 15, 1986 marked the official opening of the International School of Cinema and Television of San Antonio de Los Banos [Escuela Internacional de Cine y TV/EICTV], located in Cuba's Artemisa Province. As Secretary General of FEPACI, I delivered the opening speech in the presence of President Fidel Castro; following my address white doves were released as a sign of peace, cooperation, and friendship among peoples. It was also to signify a bright future for Third World cinemas.

We also formed relationships with the European Union and the different filmmaker organizations in Europe and contacted several international festivals to promote the distribution of African films during FESPACO editions. Our contacts included Cannes, Venice, Berlin, Locarno, Vues d'Afrique in Montreal, and film festivals in Amiens, Angers, London, Namur, Mannheim, Moscow, Oberhausen, Tashkent, and beyond. It was quite expensive, but important.

Recall that FEPACI is not a governmental institution and that its resources are limited. In spite of this, FEPACI's legitimacy allowed us to go anywhere. Unfortunately, a respectable reputation wasn't enough; it couldn't sustain the on-the-ground change. It was impossible to bring about concrete policy changes that would support the development of national filmmaking infrastructure in African countries. Many countries were not receptive to our requests, advice, strategies, even with the endorsement and support of the Organization of African Unity on our side. And change was limited also because of weaknesses of these national associations, which were in a continual state of struggle.

MTM: *For resources?*

GK: Yes, but not only that. They were lacking in the areas of organizational efficiency and collective determination as well.

MTM: *What is FEPACI's legacy and is it relevant today?*

GK: FEPACI is here, but the environment has significantly changed. When created, image production was not what it is today. We were fighting then to obtain control of our screens. Today, this is no longer the imperative because people are watching films on TV sets. There is no longer, how to say it, a frontier to explore because with satellites and other technological innovations, the situation has changed since period when films were physically imported and shown in theaters. The situation has completely changed.

MTM: *For worse or for the better?*

GK: In my opinion, for the worst because Africans, Africans in the Diaspora, and peoples of the Global South are underrepresented on screen. This under-representation is a threat to the imaginations of many peoples in the world; furthermore, this negatively impacts our countries' youths. On many television stations, American and European films vastly outnumber African productions because we haven't resolved the issue of resources. Despite advocacy and efforts to sensitize governments, absent the political will, few countries have taken steps to fund film production, support new and sustain existing film training centers, or restrict the importation of films from abroad. Consider, too that today we have less cinema halls than in 1970. Low ticket sales, and the inability to make a profit, cinema hall owners now rent to churches or convert them into storage units. It's as if FEPACI's labors have been thwarted or arrested over the span of two decades. While the regression is uneven across countries, in Central Africa cinema halls have largely vanished. In the Ivory Coast that once had eighty cinemas, poof! After the 1984 revolution in Burkina Faso, we increased cinema halls from fifteen to fifty, but since then, have declined to less than fifteen able to function properly.

MTM: *But were there other factors in play competing with cinema halls for audiences?*

GK: In the beginning, television was not a competitor. The problem was economic. When we created the CIDC, it circulated films among fourteen francophone countries in West and Central Africa. Unfortunately, the consortium, poorly managed, after a few years began to collapse because the cinema halls failed to compensate the distributor, CIDC. Simply put, the relationship between production, distribution, and exhibition was destabilized and rendered unsustainable. That was the problem. In this context and setting, FEPACI played the role it could play.

MTM: *Under those conditions.*

GK: Yes, under such conditions, the challenges were insurmountable. Even today, FEPACI has tried to bring more countries into its organization, including anglophone countries. We tried the South African solution, unfortunately it didn't work. Kenya also tried and pledged to annually contribute funds to FEPACI. For this reason, many filmmakers declared "Why return to Burkina?" where FEPACI once had credibility in the 1980s and 1990s. And this accounts for why the last Congress was held here [Burkina Faso]. Hopefully, in the near future, a new vision will inspire and reenergize FEPACI.

MTM: *When was the last Congress?*

GK: In 2019. It convened two days before FESPACO. I was a go-between FEPACI and the government, which sponsored the Congress and preparatory meeting in advance of it.

MTM: *The creation of FESPACO precedes that of FEPACI by a year. If there was no FESPACO, would there have been a FEPACI?*

GK: Yes, because the organizing concept of FEPACI was under discussion and in play among filmmakers before FESPACO. However, FESPACO arose from the experience of the Carthage Film Festival, which began in 1966. African filmmakers who attended Carthage promoted the idea of having a festival in the sub-Sahara. So, no doubt FESPACO enabled and strengthened FEPACI.

MTM: *Were the motivations and determinations that gave rise to FEPACI the same for FESPACO?*

GK: No, because they are entirely different entities. FESPACO was created from several sources: among them cineastes and, under the umbrella of the French Embassy in Ouagadougou, the French Cultural Center that held African films in its library, but had no site to show them to large audiences. Another source were the members of the ciné-club in Ouagadougou who wanted to create a festival based on the model of the Carthage Film Festival. But the major source was a group comprising of Alimata Salambéré,[32] who was associated with the National Television of Burkina Faso. Sent by the director, Odette Sanogo,[33] to meet with this group, as the only woman present, she was chosen president of the festival that would organize to become FESPACO. Lastly, at that time, the government of Burkina Faso was not interested in cinema, but they, nevertheless, agreed to help. So it was a conjunction of people and institutional entities that cohered to constitute FESPACO.

MTM: *Given Salambéré's and Sanogo's importance in forming FESPACO, let's address the matter of the location and role of African women filmmakers. From the very beginning of African cinema, women have largely been marginalized. Is that the case today in FESPACO?*

GK: When FESPACO began, it didn't declare "Where are the women?" or "We should include women in film!" There were few female directors then, including Safi Faye and Sarah Maldoror. Others contributed, as I noted earlier, Alimata Salembéré who was instrumental in formally organizing FESPACO. Along the years, women filmmakers have raised important questions about their image and representation on screen, as well as their underrepresentation before and behind the camera. And consider that some male filmmakers cast women in their films. Let's not forget that the first feature

Figure 7. Alimata Salambéré, former general secretary of FESPACO, and Gaston Kaboré, image courtesy FESPACO.

film of Timité Bassori [Ivory Coast] was *The Woman with the Knife* [*La femme au couteau*, 1969] and earlier in Sembène's *Black Girl* [*La noire de...*, 1966].

After FEPACI was established, women's issues began to be addressed more formally and officially. In French, we use the expression *le front de la main* meaning "head on."

MTM: *To promote, to foreground.*

GK: To foreground. For example, when FESPACO paid tribute to a deceased filmmaker, we invited his wife or companion because they often played a major role in their lives and creative work.

MTM: *What about the politics of gender in FESPACO itself?*

GK: Yes, the constraints, obstacles, and challenges. While Safi Faye and Sarah Maldoror were already key figures, by inviting actresses to FESPACO, helped to raise the profile of women.

There were, of course, very animated discussions occurring on women's issues, particularly their portrayal as submissive, or disruptive, wreaking havoc in family life. A commonly deployed trope was the woman who seduced another woman's husband, thus taking her place as the second wife. Even then there were films about polygamy and prostitution by male

filmmakers, revealing patriarchal views, prejudices, and stereotypes about women in general and African women in particular. Once, however, women directors started to portray themselves and society through their own eyes, things changed, though slightly.

MTM: *Was the group that constituted FESPACO the same that contributed to the creation of FEPACI?*

GK: They were not the same people. There were very few filmmakers involved in the creation of FESPACO in 1969, perhaps only Mamadou Djim Kola, who was close to completing his debut film.

MTM: *I appreciate the distinction between the two entities and the expectation of FESPACO's creators. What was FESPACO's reception during the formative years?*

GK: FESPACO immediately was embraced and supported by filmmakers, particularly Ousmane Sembène, who, while attending the Carthage Film Festival, had expressed interest in creating a film festival in the sub-Sahara. From that moment forward until his death [2007], Sembène was a major proponent of FESPACO. He said "We are the children of FESPACO." What he helped to create is now our national patrimony. We understood even then that FESPACO was more than a festival, connected to the people of Ouagadougou and nation of Burkina Faso. Both people and nation embraced FESPACO. Residents of the city, without reservation, publicly recognized filmmakers, shouting their names "Sembène! Timité!" The city has erected sculptural monuments in honor of particular filmmakers' artistic achievements.[34]

MTM: *I can tell how celebratory and animated the population was just by observing the expression on your face.*

GK: They identified with and embraced FESPACO, which is uncommon for many festivals in the world, because local inhabitants seldom exhibit such strong commitment to film festivals hosted by their towns or cities. Filmmakers were happy to be in Burkina Faso for FESPACO and that sentiment nurtured the residents of Ouagadougou who often would declare "Yes! FESPACO is ours and we welcome it!" Consider, too, that the mix of cultures during editions of the festival enabled people to perceive cinema in a different way. And when screenings were held in the stadiums and outdoors, it was something incredible. People lined up in long queues to see the films, and after, engage in discussions with the directors. There was also a radio program at Hôtel Indépendance that hosted an open forum, and no matter your background and status, you could attend and participate in the discussions. Later such discussions were broadcast on public radio, which further promoted discussion among the populace, nationally.

ETALON DE YENNENGA 1976
DIKONGUE PIPA

Figure 8. Statues of FESPACO award-winning filmmakers line a street in Ouagadougou, including (a) Jean-Pierre Dikongué Pipa (previous page); (b) Souleymane Cissé, and (c) Gaston Kaboré.

MTM: *All over the country.*

GK: Yes, all over the country. It was unique and when conditions changed, we lost that. We want to reconnect with the first ten years of FESPACO, where the fervor was powerful.

For the eight-day duration of each festival edition, the whole country moved to the rhythm of this huge celebration of images and stories. These are makings of the soul of FESPACO, and that we should never forget.

MTM: *The first decade…*

GK: I said ten, but it was more than ten years, including the period of the revolution when money was not an issue. No one could have predicted the scale of FESPACO, nor that it would evolve to become the premier Pan-African film festival in the world. What initially envisioned was an event where African films could exhibit at theaters in Ouagadougou.

MTM: *What was the relationship between FESPACO and FEPACI during the formative years, say the first decade?*

GK: Even the Carthage Film Festival recognized FESPACO as a vital resource and venue to promote and develop African cinema. It constituted a site for

Figure 9. Moroccan director Nabil Ayouch wins the Étalon de Yennenga for his film *Ali Zaoua* at the 17th edition of FESPACO (2001). Image courtesy FESPACO.

Pan-African filmmakers to exhibit films, convene to exchange ideas about cinema as something more than entertainment, and to debate and elaborate strategies for film development in Africa. Ouagadougou played a significant role in these developments. Carthage in Tunis emphasized the Arab world, and to a lesser extent, the African region, while FESPACO, the sub-Sahara where filmmakers identified with Ouagadougou.

MTM: *Understandably.*

GK: As for myself, I resisted this distinction because the appearance and practice of unity across this divide was more important to me. Of course, Algeria, Tunisia, Morocco, and Egypt are important as evidenced by the films from the Maghreb [North Africa] that won the Stallion of Yennenga Award. While the number of countries in North Africa are less than in the sub-Sahara, films from Algeria won at least twice at FESPACO; Morocco perhaps four times. And through our films, we tried to demonstrate that filmmakers are more of visionaries than government officials are. As I noted earlier, FEPACI recognized and included African liberation movements in their organization, but FESPACO foots the bill for invited festival guests because FEPACI didn't have the resources, although its strong links to FESPACO, along with the political sentiments and aspirations of filmmakers, in solidarity, an umbilical cord was forged between the two entities.

MTM: *Was there a formal agreement to collaborate between Carthage Film Festival and FESPACO?*

GK: Yes. For example, to avoid competing against each other, by agreement Carthage occurs during the even years, FESPACO, the odd ones. By design, the two festivals connect filmmakers rather than divide them. And it works, enabling screenings, forums, colloquia to occur unfettered by competing timeframes and locations.

More than just a film festival, FESPACO has gradually become a huge cultural meeting place where many other forms of artistic creation are expressed [handicrafts, textile and fashion design, music and dance, masks, culinary arts, etc.]. Every utopia, dream, and desire we wished for our future, every idea and claim for freedom, every subject that interested us, every bit of inspiration, every form of interrogation: at FESPACO, they were welcomed and given space to pollinate.

We should constantly strive to preserve and revisit the constituent DNA of this festival, which was born out of a fruitful partnership between African and Diasporic filmmakers, a country, a people, a city, and a steadfast commitment to bringing cinema to life in its most diverse form, thereby fulfilling its most extraordinary promise.

Notes

1. Much thanks due to Yalie Kamara for critical edits of this interview.

2. Often referred to as the "Father of African film," Senegalese filmmaker, writer, and actor Ousmane Sembène (1923–2007), directed such films as *Black Girl* (*La noire de...*, 1966), *Camp de Thiaroye* (1988), and *Mooladé* (2004), to name a few. He garnered several critical film prizes, including awards from FESPACO and Cannes Film Festival.

3. Considered a mentor to some of Africa's most lauded filmmakers, the Senegalese-Beninense filmmaker and film scholar Paulin Soumanou Vieyra (1925–1987) is noted as being the first black African to receive a directing credit for *Afrique-sur-Seine* (1955).

4. Med Hondo (1936–2019), a Mauritanian filmmaker and voice actor whose film work garnered international critical acclaim, including a prize from FESPACO and a selection from Cannes Film Festival. His film work includes *Fatima, the Algerian Woman of Dakar* (*Fatima, l'Algérienne de Dakar* (2004)**,** *Sarraounia* (1986) and *Oh, Sun* (*Soleil, Ô*, 1971).

5. Oumarou Ganda, (1935–2001) a Nigerien filmmaker of Djerma ethnicity whose film *The Polygamist's Morale* (*Le Wazzou Polygame,* 1971) won the Stallion of Yennenga Prize at the FESPACO in 1972 International Critics Award at the International Critics Award at the 1972 Dinard Film Festival.

6. Often lauded as the father of African animation, Nigerien filmmaker Moustapha Alassane (1942–2015) was a filmmaker whose oeuvre included fiction films, animations, and documentary films among them, *Return of the Adventurer* (*Le Retour d'un aventurier*, 1966) *Bon Voyage Sim* (1966), and *Kokoa* (2001).

7. Timité Bassori (1933–) is an Ivoirian filmmaker, writer and actor who received critical acclaim for *La femme au couteau* (*The Woman with the Knife*, 1969), which has been the focal point of several international restoration projects.

8. Désiré Ecaré (1939–2008), was an Ivoirian film director whose film *Concerto for an Exile* (*Concerto pour un exil*, 1967), Femme noire, femme nue À nous deux France (1970) *France*, 1969 *Faces of Women* (1985), which earned a FIPRESCI Prize.

9. A founding member of FESPACO, Mahama Johnson Traoré (1942–2010) was a Senegalese filmmaker whose well-known works include the Dinard Film Festival Grand Prize winner, *The Young Girl* (*Diankha-bi*, 1968) and its sequel *The Young Woman* (*Diègue-Bi*, 1970).

10. Senegalese filmmaker and ethnologist Safi Faye (1943–) is cited as the first female director of a commercially distributed film *Letter from My Village* (*Kaddu Beykat* and *Lettre paysanne*, 1975), which garnered prizes from FESPACO, Berlin International Film Festival, and prize from the International Catholic Organization for Cinema and Audiovisual (Organisation catholique internationale du cinéma et de l'audiovisuel/OCIC).

11. Sarah Maldoror (1929–2020), was a Guadeloupean filmmaker who produced more than two dozen films and received international notoriety for *Sambizanga* (1972), which received the grand prize (Tanit d'or) at the Carthage Film Festival.

12. Founded in 1966 by Tunisian filmmaker and scholar Tahar Cheriaa, the Carthage Film Festival was Africa's first Pan-African and Pan-Arab film festival.

13. Also known as *The Wagoner* or *La Charretier*, *Borom Sarret* (1963) was the first of Senegalese filmmaker Ousmane Sembène's films in which he had full artistic control. It is widely held that this is the first film created in Africa by a black African.

14. Sembène's 1973 film is based on his novel bearing the same title.

15. See *Le cinéma africain: Des origins à 1973* [*African Cinema, Volume 1: From Its Origins to 1973*]. Paris, Présence Africaine, 1975.

16. Responsible for such films as *And Tomorrow? (Et Demain ?/Wa ghadan*, 1972) and *A People's Victory (Victoire d'un peuple/Intissar chaab*, 1975) Tunisian filmmaker and producer, *Brahim Babaï (1936–2003) served as vice-president and president of FEPACI, with terms beginning in 1970 and 1975*, respectively.

17. Senegalese filmmaker Ababacar Samb-Makharam (1934–1987), served as secretary general of FEPACI (1972–1976) and received international acclaim for his film *Jom (l'histoire d'un people*, 1982)

18. Henri Duparc (1941–2006) was an Ivoirian film director, actor, and writer whose films included *Mouna, le rêve d'un artiste*, 1969 (Mouna, an artist's dream), *Rue Princesse* (*Princess Street*, 1997) and *Caramel* (2004).

19. Founded in 1943, IDHEC was a film school founded by Marcel L'Herbier in 1943 and was eventually absorbed by La Femis (École nationale supérieure des métiers de l'image et du son) in 1988.

20. Férid Boughedir (1944–) is a Tunisian filmmaker and film scholar whose *Twenty Years of African Cinema* (*Caméra d'Afrique*) was screened at Cannes Film Festival in 1983.

21. Founded in Tunisia in 1960 under the name *Afrique Action*, *Jeune Afrique* is a weekly magazine dedicated to Pan-African political and economic affairs and based in Paris since 1962.

22. *African Cinema from A to Z*. Brussels, Belgium: OCIC, 1992.

23. Also known as *God's Gift*, Gaston Kaboré's first feature received a César Award for Best French language film in 1985.

24. *Kwaw Ansah* (1941–) is a Ghanaian filmmaker who won the Yennenga Stallion for *Heritage Africa* (1989) and served as a chairman of FEPACI.

25. Considered a member of Nigeria's first generation of filmmakers, his nearly two dozen short and full-length films of Ola Balogun (1945–) have achieved international success.

26. Burkinabe filmmaker *Mamadou Djim Kola* (1940–2004) received a 1973 FESPACO jury prize for his film *Le sang des parias* (*The Blood of Pariahs*, 1973) and also contributed to other sectors of African production such as the Inter-African Film Production Center (CIPROFILM) and CIDC-CIPROFILM.

27. A culture and arts venue and theater in Ougadougou, Burkina Faso.

28. Of Cape Verdean and Bissau-Guinean descent, Amilcar Cabral (1924–1973) was a theoretician, politician, intellectual, and poet, and founder and secretary-general of the African Party for the Independence of Guinea and Cape Verde (PAIGC) whose political action led to the independence of Guinea-Bissau, see *Unity and Struggle: Speeches and Writings of Amilcar Cabral*. NY: Monthly Review Press, 1979.

29. Sources vary the dates these two organizations were created: 1974, 1979, 1981.

30. Founded in 1912 by John Langalibalele Dube and under the name of the South African Native National Congress, the African National Congress (ANC) is the ruling political party of the Republic of South Africa.

31. Founded in 1960 by Andimba Toivo ya Toivo, Sam Nujoma, Jacob Kuhangua, Louis Nelengani, Lucas Nepela, The South West Africa People's Organisation (SWAPO) was historically a political movement and is currently a political party in Namibia.

32. *Alimata Salambéré (1942–) is a Burkinabe film administrator and one of FESPACO's founding members.*

33. Odette Sanogo was the first female general director of National Television of Burkina Faso and was a founding member of FESPACO.

34. Later, among the memorials, is one in honor of Gaston Kaboré.

Pressing Revelations[1]: Notes on Time at FESPACO or The Memory of the Future

Rod Stoneman

> "Cinema was born in Africa, because the image itself was born in Africa."
> -DJIBRIL DIOP MAMBÉTY[2]

I am writing this note about FESPACO in the first person as part of that person has emanated from the experience of FESPACO itself—I have been coming to the festival in one role or another for most of its editions since 1985.

The first encounter inevitably had a huge and unexpected impact—it was an immense culture shock as I had little preparation for it. The critical mass and confidence of African filmmaking was immediately apparent. The place, the festival and the moment indicated the convergence of potent and diverse cinema cultures.

I was working for a new television station in Britain, Channel 4. It was one of the earliest publisher broadcasters in Europe (as it did not make its own programs, but commissioned and bought them from independent producers); we had a remit to innovate and challenge British audiences introducing them to forms of programs and films they had not encountered before. Working in commissioning within the Independent Film and Video Department I was used to going to far-flung festivals and meeting various filmmakers from distant places. But in FESPACO I understood things were different here—it was clear that the African films had emerged from the more serious and demanding endeavor to tell urgent stories and histories, to connect with their cultures.

Sankara

Subjectively my sense in those first two years—1985 and 1987—combined the full impact of discovering the films, the city, the people and the dynamic

debates but this was in the context of a dramatic political moment of transformation for the country itself. It was clear that, through Thomas Sankara's support for FESPACO and his 'aura' the festival was accelerated in those years. I am sure I was only glimpsing fragmentary and superficial aspects, I could see the political tourism taking place around me.[3] The revolution was a big revelation, I was coming from England where the glacial lack of political movement had brought a sustained pessimism to socialist politics. Even though I was just a teenager at the time 1968 had been a formative political moment for a whole generation, but arguably the New Left's agenda had not found its way into the wider public domain. Many of the issues and movements continued to be marginalized.

Whilst one could not ignore the problems and contradictions and mistakes involved in the Sankara revolution, I felt it was a foretaste of radical political possibility being realised in front of my eyes. The prospects and patterns of thoroughgoing social transformation will always be different in each time and place, but I felt privileged to experience an exhilarating moment of optimism and witness the energy released when people shifted into a new mode, when it seemed possible that they could collectively seize control of their own destiny. At the time I wrote "Last night a group of small children sang L'Internationale, uncertain about the words, out of tune, but with an authenticity and optimism that is no longer possible in Europe."[4]

I was in the same room as Sankara enough times to get a closer sense of his combination of intelligence and charisma: there was a vivid sense of humor at play, enjoying the ironies of an astonishing social and imaginative instant, barely suppressing a half-formed smile on his lips. This, in my experience of political discourse, was entirely rare and welcome, as Thomas Sankara put it himself: "You cannot carry out fundamental change without a certain amount of madness."[5]

Languages, Cultures, and the Origins of FESPACO

The late 1960s had seen small active groups who with courage and vision began to organize a film festival in Ouagadougou. Importantly a combination of cinéphiles and cinéastes were involved, and *Journeés du Cinéma Africain* was born. The festival in Ouagadougou took place alongside the birth of the *Journeés Cinématographiques de Carthage* in Tunis. The involvement and participation of film makers was crucial from the start as was the foundation of the filmmakers' organization FEPACI. Created in Carthage in 1970, it provided a clear nexus for those involved and enabled them to develop policies to influence the available structures including negotiating with governments and funders, exploring South-South coproduction. The African

Diaspora had a close and reciprocal relationship with filmmakers on the African continent. The discussions and disputations that went on were necessary, sometimes they took place with the harmonious sound of conscience and principle, sometimes the fury of frustration. Self-organization and autonomy were crucial in creating a space which was productive and leading to change—it did not involve advisors flying in from distant continents.

Films and debates in FESPACO helped me to begin to understand the dynamic of languages in a different way. As Ousmane Sembène suggested in *Camera d'Afrique*: "The role of cinema is vital in African countries; people belong to different cultures, to different ethnic and linguistic groups. Until now, we did not have a Senegalese culture or a Malian culture or a culture specific to Guinea or the Ivory Coast. Culture was linked to languages; the Mandingues had their culture, the Fulfulde speaking Fulani and the Wolofs had their culture."[6]

Arbitrary colonial frontiers and the ineptitude of post-colonial regimes have led to the spread of separatist movements. The current conflict around the borders of Cameroon and Nigeria springs from the colonization of those places by England and France and the imposition of European languages.[7] The multiple, contradictory and hybrid identities of verbal languages sit within the broad Pan-African concept of a diverse continent with a range of cinemas. There can be a relative integration based on difference, respect and solidarity.

Sankara's reinvention of the nomenclature of this country in 1984, discarding Haute Volta for Burkina Faso, was integral to a process of remaking the country's identity.[8] And, as Sembène suggested, cinema has a central role to play: "Now under modern states we are trying to fuse these cultures into one. We are in search of a new African culture that will comprise the ensemble of ethnic group cultures and to this we will add external influences to form a national culture. So cinema has an important role to play in creating homogeneous state[s] in which people will find a national identity."

Television from Abroad

Acting for Channel 4 my role gradually became more helpful to African filmmakers as we moved to pre-sales as well as purchases (pre-sales committed support in advance of production and put higher levels of money into the films). Of course the attrition rate was always painful—we could only support a very small proportion of possible projects. BBC 2, another non-commercial British television station, entered the arena to compete with us, screening their own season of African films and sometimes getting to view and purchase an important finished film before I had a chance to see it—but

this was, I felt, a welcome development. Although we were notionally rivals it strengthened and built the project of taking versions of African cinema to Europe. On the continent the German stations ZDF and WRD were also involved, and there was the long term commitment of French funding focused on the francophonie. During my ten years with Channel 4, we were involved in commissioning, buying or funding more than fifty African feature films. Sadly for both Channel 4 and BBC 2 these activities faded away as part of the gradual debilitation and demolition of European public service television in the 1990s as a result of the more aggressive market-led commercial policies that have prevailed since.

I wrote an article, "African Cinema: Addressee Unknown,"[9] which was originally drafted as a tentative taxonomy for a symposium at the 1992 Carthage Film Festival in Tunis. It outlined some of the determinations on films made with elements of Western funding providing transmission and distribution to audiences in Europe. I argued that one had to be guarded about the potential of external funding to disrupt or distort the relationship of African filmmaking and its primary audience on this continent.

Direct Speech

Involvement here was part of a dynamic moment and a commitment to support 'direct speech' from African communities and cultures at home and abroad to minimize the processes of mediation by 'television professionals' from outside those communities. We felt an obligation to shift the balance towards direct speech in all its forms—allowing access and interactivity. For a decade this endeavor was sustained through the various genres of documentary filmmaking and also fiction and included an attempt to create a space for direct speech from Africa and other parts of the global South for the specific British audience. We moved from initial seasons of purchased films accompanied with an introductory program like *Africa on Africa*, *New Cinema of Latin America*, *Camera Arab* and *Vietnam Cinema* to a weekly "slot" called *Cinema of Three Continents* (after the festival in Nantes, Northern France) with a mixture of films, by then we had begun to coproduce by committing pre-purchases for new films in advance of their production. Although the proportions of Channel 4 funding were modest they helped build confidence in and, crucially, attracted other finance to new projects.

There were some short films and a new television magazine series called *South* was added in 1991. *South* was billed as "A new peak time television magazine program that takes a radical approach to global affairs and features the work of filmmakers from Latin America, Africa, the Caribbean, Asia, South East Asia and the Arab world." This approach was in stark

contrast to the 'parachute journalism' of most existing television coverage from the West.[10]

The role of new digital production technology and, in the last decades, the birth of Nollywood in Nigeria, with the eventual political return of South Africa to the continent and the development of its filmmaking were all important in creating new versions of autonomous African cinemas— with less dependency on outside funding. A high proportion of contemporary Nigerian and South African fiction production has developed a model of commercial entertainment for popular audiences. Crucially, the self-sufficiency of this cycle of production and reception avoids the potential distortions of foreign funding referred to above. It also strengthens a Pan-African basis for cooperation in cinema here.

Much of this production encountered its audience and enjoyed popular success via television and video distribution, the problem of a weakened exhibition infrastructure limits the reach of African films for national audiences in cinemas; in many countries a factor in the decline of film theaters as a traditional exhibition space has been an inevitable increase in viewing material on smaller electronic screens. The new infrastructures of the electronic age continue to transform the means of distribution and access as new digital production offers a partial and complex shift in cultural forms. Television itself is in a gradual transition from scheduled broadcasting (with the exception of live news and sport) to non-linear access—the viewers' choice of programs looked at in their choice of time.

Over a fifth of this continent has access to broadband, and Pan-African connections are fostered through the digital networks, exemplified by a website like *Africasacountry.com* which reviews films from Africa as a whole. National interchange can become global as new cultural forms allow African voices direct speech, the possibility of retort and dialogue with perspectives from elsewhere.

From England to Ireland: Newsreels

After I left Channel 4 Television in London in 1993 I went to Bord Scannán na hÉireann / the Irish Film Board in Galway, Ireland. When I was invited on the FESPACO Television Jury in 1997 I had already had the experience of a film festival jury in Carthage in 1992 which was when I gave the "Addressee Unknown" paper (mentioned above) at the festival symposium.

I was away from FESPACO until 2005, when having been involved in setting up the Huston School of Film & Digital Media at the University in Galway, Ireland, I came to the conference on training and gave a presentation that year.

I had a role in the production and editing of the *IMAGINE Newsreels* in 2009, 2011 and 2013; it was a collective enterprise and it was clear a new generation of filmmaking was emerging. Personally I was able to see the festival anew through younger eyes. In each year there were four to six teams of students from all over Africa and new Burkinabe filmmakers working in IMAGINE, proposing ideas for items in the newsreels. There was some technical support and also meticulous sub-titling, but the teams discovered and delivered their pieces for themselves. Three 15-minute newsreels were produced during the week of the festival for three years running as a means of highlighting the capacity building efforts of IMAGINE and the talents of its young filmmakers; the films were uploaded to the internet, shown on RTB immediately, as well as in the cinemas ahead of some of the main features in the festival. They touched on the full range of activities in FESPACO: combining interviews with filmmakers showing extracts from their films, as well as short reports on conferences and art exhibitions. In addition to the festival opening and prizes at the end there were also lively items on acting in African films and 'Ouaga by Night' revealing the full range of delights in the nocturnal life of the city vicariously for those who, like me, were too old or decrepit to stay up through the small hours.

In 2011, we organized a one-day colloquium at IMAGINE, entitled "Film Training and Education in Africa: Challenges and Opportunities;" in 2013 this was followed with an event that offered an opportunity to discuss human rights filmmaking within the safe space of IMAGINE, announcements for the occasion having been carefully worded, in order to avoid undue attention from the authorities.

Routes to the Memory of the Future

These experiences over the years raise many questions: what role can cinema play in developing a dynamic, responsive framework for talking about the world and our conditions in it? It is not an exaggeration to see all the films and debates in Ouagadougou as one of the places, one of the ways that a continent talks to itself and the world. Cultural and political memory should never be static or complacent—this is the indulgence of nostalgia.

And in describing all these years of FESPACO since 1985 I've not mentioned a single film title, which is strange as it was the screenings that have always been at the center of things. But it would seem too arbitrary to point to a few individual movies, amongst such a rich tapestry. Those relationships of affection and respect forged in Ouagadougou endure and, through memory, so do those that have passed: Ahmed Attia, Djbril Diop Mambéty, Andrée Davanture, Ousmane Sembène.

But taken together, all these experiences and knowledges through the festival contribute to some degree of overcoming cultural insularities and unawareness, although I would say there are always limits to exchange and osmosis, even within cultures. The layers of identity and performance are complex and contradictory, changing our perspectives is like 'rebuilding a ship at sea' for all of us.[11]

Congratulations to the over fifty years of FESPACO, which is fifty years of African cinema, which is fifty years of Africa, which is fifty years of the world! Ouagadouguou is a place where one can find traces of the possibilities passed and the anticipation of those yet to come. Memory is the other side of the future.

Recollections of the Sankara epoch persist—it surely time for a resolute reaffirmation of the utopian; for the right to change the world completely and to reassert the need for that which gives meaning to our lives: the poetic, the imaginative, and the reflective and insist on the aspiration to self-fulfilment nourished by cinema, music, art, reading, philosophy, spirituality, and love.

Rod Stoneman is an Emeritus Professor at the National University of Ireland, Galway and a Visiting Professor at the Universities of Exeter and the West of England. He was the Director of the Huston School of Film & Digital Media, Chief Executive of Bord Scannán na hÉireann / the Irish Film Board, and previously a Deputy Commissioning Editor in the Independent Film and Video Department at Channel 4 Television in the United Kingdom. In this role he commissioned and bought and provided production finance for over 50 African feature films. His 1993 article "African Cinema: Addressee Unknown," has been published in 6 journals and 3 books. He has made a number of documentaries, including *Ireland: The Silent Voices*, *Italy: the Image Business*, *12,000 Years of Blindness* and *The Spindle*. He is the author of *Chávez: The Revolution Will Not Be Televised*, *A Case Study of Politics and the Media*; *Seeing is Believing: The Politics of the Visual* and *Educating Film-Makers: Past, Present and Future* with Duncan Petrie.

Notes

1. The name of a Ouagadougou laundry and dry cleaning shop.
2. N. Frank Ukadike, 'The Hyena's Last Laugh, A Conversation with Djibril Diop Mambéty', *Transition 78*, (vol.8, no. 2 1999), pp. 136–53. W.E.B. Dubois Institute and Indiana University Press. http://newsreel.org/articles/mambety.htm (accessed 29 November 2018).

3. Hans Magnus Enzensberger, 'A Theory of Tourism', [1958] *New German Critique*, No. 68, Special Issue on Literature (Spring - Summer, 1996), pp. 117–135.

4. *Seeing in The Dark*, ed. Ian Breakwell & Paul Hammond, (London: Serpent's Tail, 1990), pp. 84–85.

5. "I would like to leave behind me the conviction that if we maintain a certain amount of caution and organization we deserve victory... You cannot carry out fundamental change without a certain amount of madness. In this case, it comes from nonconformity, the courage to turn your back on the old formulas, the courage to invent the future. It took the madmen of yesterday for us to be able to act with extreme clarity today. I want to be one of those madmen. ... We must dare to invent the future." *Thomas Sankara Speaks: The Burkina Faso Revolution 1983–87*, (New York: Pathfinder, 1988. p185).

6. Férid Boughedir, Tunisia, 1983.

7. Adewale Maja-Pearce, 'Prospects for Ambazonia', *London Review of Books*, v40 n20 / 25 October 2018.

8. Originally named Haute Volta / Upper Volta by French colonizers, the new title combined the groups and cultures of the place: 'Burkina' means 'dignity' in Mooré (spoken by the Mossi ethnic group) 'Faso' means 'house of' in Diula (spoken by traders and originating from the second city, Bobo Dioulasso). The suffix and name for an inhabitant, 'Burkinabe' is in Fulfulde, spoken by the Fulani, meaning 'Land of the upright men / People of Integrity'.

9. Published by *Vertigo, Ecrans d'Afrique, Kinema*, http://www.kinema.uwaterloo.ca /article.php?id=367&feature (accessed 20th November 2018), translated into four different languages and published in several books and journals.

10. Channel 4 Press Office invitation to launch at Venezuelan Embassy, London, September 19, 1991. As CEO Michael Grade quipped in his speech at the launch, "Most British television research into the Third World takes place in Terminal 3 [for intercontinental flights] of Heathrow airport."

11. An expression used by Ludwig Wittgenstein, originating from Otto Nuerath.

Figure G. Women gather at FESPACO. Courtesy of FESPACO.

Fifty Years of Women's Engagement at FESPACO

Beti Ellerson

> *Our role as an elder is to transmit our knowledge to the younger ones…I am very happy to see that I am a model for the youth and especially for young girls.*
>
> **Alimata Salambéré at the UNESCO reception at FESPACO in her honor on March 4, 2019 and on February 26 during the launching of the book by Yacouba Traoré about her journey as cinematic and cultural advocate: *Alimata Salembéré / Ouedraogo: itinéraire et leçons de vie d'une femme debout* [translation from French: Alimata Salembéré- Ouedraogo: the journey and life lessons of a woman of principle].**

The words of Burkinabe Alimata Salembéré, as the title of the book dedicated to her work indicate, reflect her seminal role in FESPACO's development, setting the stage for women who follow in her footsteps as cultural workers in the myriad missions of the world of cinema. Her trajectory is indicative of the essential function African women perform as founders, organizers, curators, and stakeholders of film festivals and film-focused events. In addition, her work puts a spotlight on film festival practices and their importance in empowering women in cinema as well as encouraging and developing future women film specialists. Hence, since its inception, FESPACO, as well as the cinema-related structures that it has initiated and supported, play a paramount role in women's empowerment in all sectors of the moving image.

> *The grand prize of FESPACO is in the image of Princess Yennenga, which is very significant. It demonstrates the importance of women in society. To have this prize, the Étalon de Yennenga, is a crowning achievement … Princess Yennenga was the proof of courage and bravery, the proof of endurance … To fight for a woman to obtain the Yennenga is truly a step forward, and it will be for the greater welfare and development of women in general.*[1]
>
> FRANCELINE OUBDA

So, "when will a woman receive this honor?" one asks, fifty years since the creation of FESPACO. Every two years, during the weeks before the start of the festival, with journalists abuzz, eager for information on the status of African women in cinema, and in particular their representation at the festival, this question is often posed, along with a catalog of queries regarding African women's accomplishments. My response has always been by way of suggested readings, presenting a list of sources offering a more comprehensive perspective on African women's place in African cinema history. Nonetheless, there appears to be a bit of impatience to peruse this ever-growing research on the timeline of African women in cinema. At the start of the celebration of the fiftieth anniversary of the creation of FESPACO in 2019, a provocative announcement in large letters circulated on social media (in French, hence the translation): *Did you know? In the fifty years of FESPACO, the number of Gold Yennengas conferred to: Male filmmakers: twenty-five. Female filmmakers: zero.*[2] Though the balance sheet was not quite accurate, as the Yennenga was bestowed for the first time in 1972 and not at the first event in 1969. Hence at the start of the twenty-fifth edition in 2019, twenty-three Gold Yennengas had been awarded. To note, the Étalon de Yennenga was the sole grand prize until 2005; during which second and third prizes were established. Hence, the names of the three prizes for feature films: Gold Yennenga, Silver Yennenga and Bronze Yennenga.

And while the core of the debate is accurate, that no woman to date has yet to win the Gold Yennenga, I suggest that rather than focusing on how many and why not more, it may be useful to trace the development of African women in cinema and the role that they have played within it, highlighting what they have achieved—as well as to analyze how they have evolved during these past fifty years. A strength-based approach, which I find both empowering and encouraging, also reposes questions that take into account the potentials rather than the drawbacks. For instance, in 2013 Djamila Sahraoui of Algeria was the laureate of the Silver Yennenga for her film *Yema*, bravo!

In the 1995 FEPACI-sponsored publication commemorating one hundred years of cinema, *L'Afrique et le Centenaire du Cinéma | Africa and the Centenary of Cinema*, the focus was not on how many African filmmakers were or were not among the Oscar, Palme d'Or winners throughout cinema history, but rather, it served as a moment of contemplation regarding African filmmakers' entrance into the world of cinema some sixty years after its birth in the 1950s. Similarly, when the feminist film movement emerged in the West in the 1970s, and women became increasingly visible agents of their own images, it was at the same time a moment of reckoning with their male counterparts—indeed they asked, where are the women laureates

of the Oscar, Palme d'Or and so on—but only after having established a balance sheet filled with facts, names, dates, and analyses of their own role in the world of cinema and the contributions they have made, rewriting cinema history to reflect their realities omitted in the historiography. This is not to diminish the "where are the Yennengas?" declaration, which in fact, was meant to provoke, but rather to suggest that the dialogue should begin based on deliberations that may serve as a more substantive response. Indeed, numbers are important; statistics are paramount in supporting facts and discerning cause and effect. Hence, the importance of research, data collection, storage, and analysis, in order to quantify information and determine trends, to then discuss solutions and suggestions for future possibilities.

My research on women's engagement and representation at FESPACO reveals that before the 1990s films by women in the official selection have been for the most part documentaries, short films, and TV series. Hence, the oeuvres of women would not have been included in the feature film category in competition for the Yennenga in previous editions. For instance, at the fourth edition in 1972, the acclaimed docu-fiction *Kaddu Beykat* (*Peasant Letter*) by Safi Faye of Senegal, received a Special Mention. However, in 1993, *Saikati* (1992) by Kenyan Anne Mungai—which, based on the FESPACO research by Patrick G. Ilboudo and Hamidou Ouedraogo, may have been one of the first feature films by a woman to be part of the official selection[3]—won the UNICEF award for best representation of an African woman's image and the APAC Award—l'Association des Professionnelles Africaines de la Communication—(Association of African Women Professionals in Communication) for best African Woman Director. Moreover, Kahena Attia won the prize for the best editing for the film *Bezness* (1992) by Nouri Bouzid of Tunisia. In 1995, several women received awards in the Official Television-Video Competition, which was established during the previous edition: *Femmes de brousse : survivre à tout prix* by Franceline Oubda and Benjamin Nama (Burkina Faso), *Dilemme au féminin* by Zara Mahamat Yacoub (Chad), *Un Cri dans le Sahel* de Martine Condé Ilboudo (Burkina Faso), and Franceline Oubda's *Sadjo, the Sahelien*. Also in this edition, the grand jury awarded a prize, again, to the editor Kahéna Attia (Tunisia) for the excellence of her work on three films in competition *A la recherche du mari de ma femee / Looking for the husband of my wife)* (Morocco), *Guimba* (Mali) and *Haramuya* (Burkina Faso). A Special Mention was attributed to Yamina Benguigui (Algeria) for her film *Femmes d'Islam: le voile et le silence / Women of Islam: The veil and silence.*

In 1997, the fifteenth edition of FESPACO included an unprecedented number of films by women—feature, short, documentary, animation, TV/Video—recognized with awards in all categories: the Official Selection for feature films included, *Everyone's Child* (1996, Zimbabwe)

by Tsitsi Dangarembga (Zimbabwe), *Mossane* (1996, Senegal) by Safi Faye (Senegal), *Miel et Cendres / Honey and Ashes* (1996, Tunisia) by Nadia Fares Anliker (Tunisia), *Flame* (1996, Zimbabwe) by British-born Ingrid Sinclair (Zimbabwe). Perhaps this may have been the year that the prospects of a woman laureate of the Yennenga were the strongest, with four entries by women.

Nonetheless, it is significant to note the ascendancy of women documentarians, and while the feature film is hailed as the pinnacle of the film hierarchy, the documentary is an important mode of cinematic expression among African women filmmakers; and there are those such as Safi Faye who have insisted on the non-distinction between documentary and fiction in their work. Moreover, Jihan El Tahri asserts:

> I want to interest more people in doing documentary because there is this glamor bit that wants to treat documentary films as less significant or less artistic or less glamorous than fiction. There is this idea that it is not a proper film. This is something that I reject totally. The younger people must realize that you can do fiction and documentary if you want. It is not an inferior form of expression. It's just a different form of expression.[4]

Indeed, to promote the institutionalization of the documentary, offering it more prestige and recognizing its significance, an official documentary competition was established in 2009 with an official jury and the introduction of second and third prizes. And in some ways as proof of women's significance as documentarians, during this same edition, all of the awards were bestowed to women: First Prize for Best Documentary: *Nos lieux interdit / Our Forbidden Places* (2008, Morocco) by Leila Kilani (Morocco), Second Prize for Best Documentary: *Behind the Rainbow* (2008, Egypt) by Jihan El-Tahri (Egypt) Third Prize for Best Documentary: *Une Affaire de nègres / Black Business* (2007, Cameroon) by Osvalde Lewat (Cameroon) and for the Diaspora: Special Mention: *A Winter's Tale* (2007, Trinidad and Tobago) by Frances Anne Solomon (Trinidad and Tobago), bravo! In the subsequent years, women laureates dominated the official documentary selection, winning the top prizes in 3 of the 5 editions: In 2011, First Prize for Best Documentary: *Monica Wangu Wamwere, The Unbroken Spirit* (2011, Kenya) by Jane Murago-Munene (Kenya); Second Prize for Best Documentary: *The Witches of Gambaga* (2010, Ghana) by Yaba Badoe (Ghana). In 2013, First Prize for Best Documentary: *No Harm Done* (2012, Tunisia) by Nadia El Fani (Tunisia); Second Prize for Best Documentary: *Calypso Rose the Lioness of the Jungle* (2011, Cameroon) by Pascale Obolo (Cameroon). In 2019, First Prize for Best Documentary: *Le Loup d'or de balolé / The Golden Wolf of Balolé* (2019, Burkna Faso) by Aïcha Boro (Burkina Faso); Second Prize for Best

Documentary: *Whispering Truth to Power* (2018, South Africa) by Shameela Seedat (South Africa).

> *The moving image, a culture that involves into thoughts-in-movement,*
> *also preserves memory...*[5]
>
> SARAH MALDOROR

In addition to the film screenings, press conferences, and awards sections, FESPACO extends its reach by hosting myriad cultural activities offering visibility, networking opportunities and critical discussion, including an array of parallel events and measures promoting the professionalization of women. Some notable actions include: the eleventh edition in 1989, which witnessed the creation of the Association of African Actresses. In 1991, as part of the program of the twelfth edition, the historic conference of African women in the visual media was structured under the title "Women, Cinema, Television and Video in Africa." This defining moment turned into a movement, the genesis of an organized network of African women in the image industry. At the meeting, women filmmakers, producers, actors, technicians, and stakeholders in visual media production laid out the tenets of an organizational structure to represent their interests; establishing the groundwork for the visual media network called l'Association des femmes africaines professionnelles du cinéma, de la télévision et de la vidéo/the Association of Professional African Women in Cinema, Television and Video (AFAPTV). In 1995 it was restructured under the name, l'Union panafricaine des femmes de l'image/the Pan-African Union of Women in the Image Industry (UPAFI). Throughout the next decade, the network widened as regional affiliations were established throughout the continent and diaspora.

In the alternate year of 2010, FESPACO launched the JCFA, Journées cinématographiques de la femme africaine de l'image (African Women Image Makers Cinema Days) in Ouagadougou, which runs the first week of March, coinciding with the United Nations International Day of the Woman. In 2013, women took the leadership role as president on the five official juries: Euzhan Palcy (Martinique) Feature Film Jury; Osvalde Lewat-Hallade (Cameroon) Documentary Jury; Jackie Motsepe (South Africa) TV and Digital Jury; Wanjiru Kinyanjui (Kenya) Short Fiction and Film School Jury; Beti Ellerson (USA) Diaspora Jury. Alimata Salembéré, who was recognized at this edition, had this to say about the women-helmed jury presidencies: "For us, women of the image, this 23rd edition truly marks our successful integration into the world of cinema. FESPACO dared to believe in us, entrusting with us the presidency of all the official juries. It is a well-deserved tribute."[6]

Several women-focused events marked the twenty-fifth edition in 2019, in celebration of the fiftieth anniversary of the festival. Alimata Salembéré, was honored once again, with a tribute by UNESCO, for the ensemble of her work in the promotion of culture in Burkina Faso and Africa. In addition, the high-level roundtable, "50 years of FESPACO: 50–50 for women," included the participation of Audrey Azoulay, Director-General of UNESCO and Madame Sika Kaboré, First Lady of Burkina Faso. Moreover, the one-day conference entitled "The place of women in the film industry in Africa and the diaspora" organized by the Cinéastes Non-Alignées (tr. Non-aligned Women Cineastes Collective), emerged as an important forum to speak out again sexual harassment and other abuse that women professionals in cinema have endured. Hence, the #Metoo movement emerged at FESPACO under the hashtag MêmePasPeur (loosely translated from French as "nothing to fear" or "not even afraid") as women film professionals of Africa and the Diaspora shared their experiences and gave their support.

FESPACO looking forward

The year 2021 will mark the thirty-year anniversary of the historic conference of African women film professionals in Ouagadougou. The fruits of these efforts are particularly visible in the institutions that form the future generations of film professionals. Building on the intentions of this gathering: to establish an environment to exchange views, to create a framework for free expression, to elaborate an action program, to fast-track women's integration at all levels of the cinematic process, to present a woman's perspective of the world, to have power over their own images, to mobilize funds and human resources—many of these objectives have been concretized throughout these past decades at local, regional, continental, and international meetings related to African women in cinema. While there have been varying levels of success at reaching these goals, the resources offered in this digital age may heighten the chances and the capacity for all African women to participate in the global dialogue. At the same time they continue to make invaluable contributions on the local level, devising mechanisms to extend networks regionally and beyond. FESPACO's status as the Pan-African cinema network, and with its level of prominence, may facilitate outreach into local initiatives to support the development of alliances and relationships.

How do we safeguard our images with the ubiquity of the Internet?[7]

SARAH MALDOROR

The interchanging dynamics of the centrality of women in FESPACO's evolution and the importance of FESPACO to women's empowerment have been evident through the festival's history. Drawing from the discussion above regarding African women in the film festival landscape and my own research and experiences in African and women's film festival environments, following are proposed initiatives for continued engagement.

- FESPACO is in a key position to facilitate a bilingual dialogue exchange, through the auspices of JCFA, a structure already in place to promote women. The print newsletter distributed during the alternate-year event may extend throughout the year developing into an ongoing electronic publication in the form of a participatory blog inviting women in all areas of the moving image to introduce themselves and announce relevant information. This format could include a participatory user-generated continuous timeline of women's cinematic histories, managed by interested users and volunteer facilitators.
- Also under the umbrella of JCFA, the FESPACO website could be used to host individual webpages for women to include content about their film-related activities. Moreover, to promote the training and development of women film critics, initiatives could include internships and workshops for journalists to cover events at the JCFA and FESPACO to be published in the festivals' newsletters.
- Parallel to the main JCFA event could include a traveling section in partnership with other Africa-based women's film festivals and women-focused initiatives, such as the Ndiva Women's Film Festival of Ghana, the International Images Film Festival for Women (IIFF) of Zimbabwe, the South African-based Mzansi Women's Film Festival, the Udada Film Festival in Kenya or the Mis Me Binga Festival of Cameroon, to name several events in different regions of the continent.
- In addition, the CNA-Afrique—Cinéma Numérique Ambulant, the traveling digital cinema association, which has an important presence at FESPACO, is a model example of the leadership and achievement of women in the organization. A year-round partnership related to women, cinema, and leadership may be considered.
- In order to encourage the early appreciation for professions in cinema among young girls, a visual storytelling project "African girls make movies," for grammar or high school students could be created as an outreach initiative throughout the continent. This project could encompass an intensive workshop during which the students learn to write a script, direct, shoot, and edit a mini one-minute film.

- During each edition, there is a great deal of buzz around women's chances of winning the grand prize: the Gold Yennenga. However, discussion must also focus on what is needed for a film to have a real chance of winning, what efforts have been made to boost these possibilities. Was there a strong pool of women-directed films with real award-winning potential? The selection committee is also important in the process—what constitutes an award-winning film? An ad hoc structure could be formed to address these points.

- To facilitate African film research the FESPACO website may serve as a database for selected films of each edition. Retaining information about the filmmakers and the films, serving as a primary source for research.

- The women-helmed jury initiative at the 2013 edition put a spotlight on women in leadership positions. This feat should not be an idea that is left tucked away in the files of FESPACO history. It would be useful to know, in addition to the obvious goal of promoting women as leaders and encouraging better representation of women, did the initiative garner discernible outcomes. Moreover, it would be worthwhile to have a follow-up discussion of the presidents' experiences—what worked or did not, did being a woman make any discernible impact, do the women presidents have ideas regarding future concrete actionables to produce/ensure award-winning films in the selection pool, especially by women. Do they think that gender parity on the jury ensures more gender-sensitivity regarding women-directed films?

- While continent-wide projects that include women do exist, activities continue to be linguistically-based, with the languages of communication in English or French, often at the exclusion of one or the other, which has been a concern of the Pan-African women of the moving image organization from its beginning. As an established preeminent bilingual festival, FESPACO is in a distinctive position to use its prominence to address this enduring concern.

FESPACO has the structures already in place for knowledge management, retention, and dissemination. Thus, it may take on the vital role as gatekeeper of a continental database for African cinema. The need for a cohort of journalists, scholars, and researchers is vital, in order to probe, examine, and study the rich history of African cinema and women's engagement in particular—a task that FESPACO may facilitate, for instance, in partnership with FEPACI which initiated *Ecrans d'Afrique, the International Revue of Cinema, Video and Television* (1992–1998). Its preeminence as the pantheon of Pan-African film organizing offers the opportunity to draw the

energy and forces of the continent and Diaspora to coalesce and network with the diverse institutions that have emerged in the last several decades—thus functioning as a center for the production and retention of cinematic knowledge. And in so doing, it will continue forging a path for the empowerment and development of women.

Beti Ellerson has a PhD in African Studies (Howard University, USA) with interdisciplinary specializations in Visual Culture, African Cinema Studies, and Women Studies. Her research on African women in cinema, include the book *Sisters of the Screen: Women of Africa on Film, Video and Television* (2000), the film documentary, *Sisters of the Screen: African Women in the Cinema* (2002) and the Center for the Study and Research of African Women in Cinema founded in 2008.

Notes

This article draws from another version by the author, originally published as Beti Ellerson, "African Women in Cinema Dossier: African Women on the Film Festival Landscape: Organizing, Showcasing, Promoting, Networking." *Black Camera: An International Film Journal* 11, no.1 (Fall 2018), 245–287.

1. Interview with Beti Ellerson. *Sisters of the Screen: Women of African on Film, Video and Television*. (Trenton, New Jersey: Africa World Press, 2000)

2. Translated from French: Le Saviez-vous? En 50 ans de FESPACO, nombre d'étalons d'Or de Yennenga remportés par: Réalisateurs: 25—Réalisatrices: 0 (#WeAreYennenga)

3. Patrick G. Ilboudo. *Le FESPACO. 1969–1989, Les Cineastes Africains et Leurs Oeuvres*. Ouagadougou: Editions La Mante, 1988 and Hamidou Ouedraogo. *Naissance et Evolution du FESPACO de 1969 à 1973, Les Palmares: de 1976 à 1993*. Ouagadougou: Imprimerie Nationale du Burkina, 1995.

4. "A Tête-à-tête with Jihan el Tahri," *African Women in Cinema Blog*, November 2010. https://africanwomenincinema.blogspot.com/2010/11/tete-tete-with-jihan-el-tahri.html.

5. Sarah Maldoror, "Une culture du devenir," in *L'Afrique et le Centenaire du Cinéma | Africa and the Centenary of Cinema*, ed. FEPACI, (Paris: Présence Africaine, 1995): 393.

6. Excerpted from an article by Aimé Nabaloum in Fasopresse.net, 18 January, 2013: http://www.fasopresse.net/fespaco-2013/1890--fespaco-2013-la-conference-de-paris-a-tenu-ses-promesses - No longer available.

Figure H. Sarah Maldoror and Férid Boughedir, 1993. Courtesy of FESPACO.

Thiaroye or *Yeelen*? The Two Ways of African Cinemas

Férid Boughedir

At the end of the eighties, two different ways for the future of African cinema, including its mode of production, were open the same year by two films directed by its two most famous filmmakers: on one hand, *Camp de Thiaroye* (1988, Senegal), by Ousmane Sembène, a virulent politically committed film, and a South-South coproduction with no financial or technical help from Europe; on the other hand, *Yeelen* (1987, Mali) by Souleymane Cissé, an intemporal "cultural roots" aesthetical film, mainly produced by French governmental grants. In the early nineties, the new generation of African filmmakers confirmed the reality of these two opposite tendencies, whose challenge could imply the end of the South-South self-production dream and the return to the French & European sponsoring for "Art Films" production in Africa.

During their first 90s sessions, the two most important Pan-African film Festivals—FESPACO (Burkina Faso) and the JCC (Journées Cinématographiques de Carthage - Tunisia) gave proof that a new generation of African filmmakers had arrived on the scene. In March 1991 at FESPACO alone more than half the thirty full-length films in competition were first works; four of them *Laafi* (1991, Burkina Faso) by Pierre Yameogo, *Ta Dona / Fire!* (1991, Mali) by Adama Drabo, *Laada* (1990, Burkina Faso) by Idrissa Touré, and *Sango Malo / The Village Teacher* (1990, Cameroon) by Bassek Ba Kobhio were to be found two months later on the selection list of the Festival of Cannes which had never before welcomed such a profusion of films from Black Africa.

The previous sessions of FESPACO and the JCC were dominated by a friendly confrontation between two great names of South Saharan cinema representing its two most important trends. The pioneer and doyen, the Senegalese filmmaker Ousmane Sembène, presented his *Camps de Thiaroye*, an uncompromising testimony of the bloody repression exercised by the French colonial army against a rebel batallion of Senegalese infantry. As an established challenger, the Malian filmmaker Souleymane Cissé, showed his celebrated *Yeelen*—a brilliant illustration of the mythical and magical dimensions of African culture.

Although both these films have received awards from the highest international authorities (*Yeelen*, the Jury's Prize at the 1987 Festival of Cannes and *Camps de Thiaroye*, the Special Jury Prize at the 1988 Festival of Venice), these two films were nevertheless complete opposites. *Camps de Thiaroye* was the outcome of a certain vein of African cinema which sprang up at the end of the 1960s, being heavily committed socially and politically and militating in favour of true independence for the continent. *Yeelen* was the first outstanding work of a new universalist current devoted to celebrating the African Cultural Identity.

The contrast between these two films was not only in the theme: economically, *Camps de Thiaroye* represented a rare example of a South-South coproduction, which had not called on European support. Coproduced by three African countries—Senegal, Algeria, and Tunisia—technical and sound finish were carried out in the highly reputable laboratories of SATPEC in Tunisia where several international films had been dealt with. This film perfectly illustrated Ousmane Sembène's theories about the need to produce African cinema (even though deprived of a true home distribution market as is the case at the moment), with only the African means available. On the other hand, *Yeelen* had been conceived mainly thanks to direct aid from the French Ministry of Culture and completed with support from European television channels; it was shot by a mainly French technical crew and all its laboratory and finishing operations were carried out in France.

On examining the works of the new generation of African filmmakers, it seems that although the current is with *Yeelen* for the moment and is from now on opening up a whole predominant movement in African cinema, the political, ideological, and nationalist trend seems to be marking time for the moment, to the advantage of the cultural trend with an international vocation. Just like *Yeelen*, the two films by Idrissa Ouédraogo—*Yaaba* (1989, Burkina Faso) and *Tilai* (1990, Burkina Faso)—are films of great plastic beauty, unfolding in a timeless Africa where they undertake to determine the cultural traditions. The new element, confirmed by *Yeelen*, is represented by an important evolution in the general themes of African cinema in the South Sahara compared with the works of the 60s and 70s. The principal theme on which almost all African cinema is based still remains the clash of the Old and the New. The true change has, as we have seen, in the position of the filmmakers faced with irrational beliefs and the veridicality of ritual magic practices, which are part of the African cultural heritage.

Out of four films of the new African generation unveiled in 1991 at FESPACO and Cannes, only *Sango Malo* by Bassek Ba Kobhio, which shows the struggle between a teacher with modern ideas and a conservative head school teacher, keeps the traces of the didacticism proper to the preceding ideological tendency. On the other hand, two films of the four (*Laada* by

Drissa Toure and *Ta Dona* by Adama Drabo) show us just as *Yeelen* does how the initiates master supernatural phenomena, which are entirely integral within the framework of the story. Since *Yeelen,* and above all thanks to *Yaaba* and *Tilai,* the cinema of Black Africa is at present a reality recognized at a world level. This is thanks to the film festivals and that international club of cinephiles which they have created all over the world. For a cinema deprived of its home distribution market, as is the case with African cinema, depending to this point on festivals in order to be distributed profitably outside the continent comprises both advantages and a risk. One of the major advantages is to condemn the African filmmakers (sweet condemnation) to produce author's cinema of good artistic workmanship rather than commercial products which are legion in the other cinemas of the Third World, which possess a large enough home market to make their films profitable. Very fortunately, all European cooperation with African cinema tends to support quality films.

One of the risks with this situation is that certain filmmakers end up modeling their works on the tastes of Western filmgoers and do not address themselves in the first place to their first natural public, which should be the African public. A caricatured translation of this risk would end in making African films conform to titles, which have been successful in the West and cultivate either the primitivism, the hieraticism, and the timelessness or exoticism of a commercial type. The two greatest successes of Black African cinema in France having been the very fine *Yaaba* (Burkina Faso) and the extremely funny *Bal Poussiere / Dancing in the Dust (1988, Côte d'Ivoire)* by Henri Duparc the colleagues would no longer have the right to only two alternatives, i.e. to filming either changing Africa or amusing Africa. Very fortunately, the fourth musketeer present at Cannes in 1991 has contradicted this apprehension: *Laafi* by the Burkinabe Pierre Yameogo is situated in the very heart of social nowadays Africa. He has filmed the wanderings around the town of a young African, who brushes up against the daily problems and contradictions of his society with a camera set at a man's height. And this is done without an ideological discourse or the wish to educate, but with freshness and poetry issuing directly from the real, with justice and truth which themselves compel recognition.

The same goes for *Udju Azul di Yonta / The Blue Eyes of Yonta* (1991, Guinea-Bissau) of Yontaby Flora Gomes presented at Cannes in 1992. The same temptations towards timeless aesthetics are also coming to light in Algeria (*Louss, La rose des sables / The Rose of the Desert* (1989)) by Rachid Benhadj.

The new phenomenon in the Maghreb is the vertiginous popular adhesion, which took place in Tunisia with regard to Author's films such as *L'homme de cendres / Man of Ashes* (1986) and *Les sabots en or* (1989) by

Nouri Bouzid, then *Halfaouine* (1990) by the author of these lines, which have in turn smashed all the box-office records ever achieved in the country.

An observation which has now become classic: African cinema remains above all within the circumscription of the French-speaking countries of the continent. In more than twenty years of FESPACO and more than twenty-five of the JCC, English full-length films have been very rare. The only exception which won the Grand Prix at Ouagadougou in 1989 was the film from Ghana—*Heritage Africa* (1989) by Kwaw Ansah.[1] At Cannes in 1992, it was a Francophone, Djibril Diop Mambéty, who was in competition with *Hyénes / Hyenas* (1992, Senegal). The other new phenomenon, which appeared in 1992, is that certain African films are from now on being openly inspired by earlier films. So *Ta Dona* by the Malian Adama Drabo makes a direct reference to *Yeelen* and also to *Baara* (1978) by the same Souleymane Cissé (for the denunciation of political corruption) as well as to *Nyamanton / The Garbage Boys* (1986) by his other compatriot, Cheick Oumar Sissoko (for the vigour of the dialogues).

African cinema quotes itself. This is a sign that it now has a history.

Férid Boughedir is a director, critic, and film historian, who began by making documentaries about the new cinema coming out of Caméra d'Afrique and Caméra arabe, both of which were presented in the Official Selection at Cannes. His first fictional work, *Halfaouine: Boy of the Terraces,* was shown at Cannes in 1990 to acclaim from critics and audiences alike and remains to this day the biggest success in Tunisian film. *A Summer in La Goulette* (1996), in competition in Berlin (1996), also won many prizes. A passionate lover of film, he became Delegate, then Director, of the oldest Pan-African festival, the Carthage Film Festival. He finished *Villa Jasmin* in 2008, co-produced by France 3 and Arte. His 2016 comedy, *Zizou or The Sweet Smell of Spring*, won Best Arabic Film at the 2016 Cairo International Film Festival.

Notes

Originally published as Férid Boughedir, "African Cinemas in 1992," in *African Cinema from A to Z* (OCIC, 1992): 181–185.

1. This imbalance was a little bit corrected later, in the years 2000, by the "Anglophone" African film directors whose films won the Grand Prix of three successive sessions of FESPACO in 2005 (*Drum* by Zola Maseko, South Africa), in 2007 (*Ezra* by Newton Aduaka, Nigeria), and in 2009 (*Teza* by Haile Gerima, Ethiopia), these three films belonging to the *Camps de Thiaroye* politically commited tendancy.

Long Live Cinema! Long Live FESPACO.
A luta continua

Claire Diao

February 2005. In the open air auditorium of the Georges Méliès Cultural Center in Ouagadougou (renamed the French Institute of Ouagadougou), is being screened Ismaël Ferroukhi's *Le grand voyage* (2004, Morocco), opening on a star-studded night with a voice over by ARTE.

"This film was born under a lucky star." In the stands, hundreds of spectators are religiously following this competing fiction feature film that traces the story of a boy, born in France, and his father, born abroad, going together to Mecca despite strong cultural misunderstandings.

What about the first time I attended FESPACO! I was certain I would meet the film family (composed of directors, actors, technicians, faculty, and programmers from all over the world)! The screening of Diaspora films was sometimes done in French and anglophones had trouble finding their way around. Discussions on movies were held at Hôtel Indépendance, by the pool, although Ousmane Sembène can no longer attend, as he passed away the year before. Some dared to approach filmmakers they did not know, others stayed in their corners. And always, at the entrance of cinema rooms, those interminable queues, those crowded stairs, and those screenings where the magic of cinema transpires. A feeling of union and collectivity…

For me who was born in Africa and raised abroad, there was a feeling of homecoming, added to my passion for cinema which, unintentionally created a perfect link between my father's country—my dear and beautiful Faso, cradle of FESPACO, INAFEC, CIPROFILMS, and CIDC—and that of my mother—cradle of the Lumières brothers, the cinematograph, the Cannes Film Festival, and the CNC.

What to say about this feeling that I had then, watching dozens of films, rubbing shoulders with hundreds of moviegoers, meeting late Samba Félix N'Diaye, then president of the FESPACO Documentary jury backed by Écrans Association, of which I had the honor of being a member? This is where I met Teboho Edkins who was vilified in the Petit Méliès room for shooting a documentary about men spreading the AIDS virus in South

Africa. There, I met many journalists who later became my colleagues. There, I confirmed my love for cinemas from Africa which later guided my university and professional choices.

During my internship at the Centre Culturel Georges Méliès, I had the pleasure of organizing two screenings for four hundred students from Ouagadougou around the Second World War. These high school students came in large numbers and above all, actively participated in the ensuing debate with their History teachers. It was a personal revelation—that of transmitting cinema–but also a cultural revelation. There was (and still is) in Burkina, an unprecedented thirst for learning, far from the overconsumption and overcrowded cultural offer available to French high school students, overwhelmed by TV screens, cultural outings, discounted rates and video recorders in class to illustrate courses delivered by their teachers.

In my discussions with Ouaga high school teachers, two remarks held my attention: the first one was related to language. Savvy moviegoers like to see movies in VO. One teacher hailed me "Why screen a film in English when even French is not the mother tongue of our students?" Then the remark from this other lady: "This movie screening idea is very good. But why bring high school students to you while cinema could come to the students? You could reach a lot more people."

Here are two remarks I have never forgotten and which helped forge my career. While studying cinema in France and then in England, I discovered many filmmakers and scholars, many of whom wrote great papers for the magazine *Écrans d'Afrique* edited by the Italian association COE. I realized that the cinema of a whole continent was often shrinking due to lack of knowledge, of interest and especially of means. We talk about "African cinema" as if there were only ten productions per year on the continent, whereas in reality, each country has built its cinematography since (or well before) the independences!

The fight is on all fronts and I was delighted to discover the Pan-African Federation of Filmmakers, the African Federation of Film Critics, and the myriad of festivals that have emerged with the advent of the digital era. I realized that anglophones and francophones would benefit from connecting, exchanging, and working together, simply because they have neither the same approaches, nor the same feelings, nor the same relationship to business.

When I wanted to write about African cinemas at the end of my studies, I discovered that the media were not much interested in that cinematography: African media did not care about the seventh art and cinema media were not interested in Africa. Where could one find a framework to discuss, to discover, to advertise films and authors who were not even known in Europe? The answer had its undeniable economic impact: on the Internet, through volunteer publications that had value only through their own existence, and

the visibility they gave to these ostracized works. Freedom meant precariousness and cultural wealth had no impact on the payment of rent. *Africultures, Afrik.com, Clap Noir, AFRICINE* ... I do not count the number of publications for which I wrote, but I remember my wish in 2011 to leave my status as an employee to act as an independent worker. Participating in international festivals was one of the best gifts I received, and I was lucky to meet those prolific creators from all over the world. That's how I initiated *L'Afrique en films*, a blog on the website of the Courrier International where I wrote about the careers, desires, and disappointments of various filmmakers.

In parallel with this work, another journalistic project was launched, that of French filmmakers who had grown up in popular neighborhoods and who did not have access to the same sources of funding as the others and found themselves in a no-man's land of precarious broadcasting, with no return on investment, whose only pleasure was to see their films finished and sometimes awarded. That series of articles published on *Bondy Blog* gave birth to an essay, "Double Wave, the new breath of French cinema," published in 2017, a questioning of our generation living between two cultures, two continents. One of them, a Franco-Moroccan, won FESPACO's Étalon d'Or de Yennega in 2015, Hicham Ayouch, the brother of Nabil, with his feature film *Fevers* produced through hard work. An overseas recognition that made sense, and had its importance, when we know that French-Senegalese Alain Gomis twice won the Étalon d'Or with *Tey* (in 2013) and *Felicité* (in 2017), and that his first victory caused the Senegalese government to set up a fund for film and audiovisual industry promotion, FOPICA.

However, what type of economic model should be applied to that knowledge? What distribution solutions can be developed without being devoured by American blockbusters and companies who have understood that cinema was an art but above all an industry? Too many filmmakers and producers were satisfied with what they were offered: festival broadcasts, non-commercial circuits, and no TV broadcast. Too much money has been diverted, too many artists live in precariousness, and too many TVs ask beneficiaries to pay to be broadcast...

It is in this spirit that I launched in 2013 the itinerant short films program *Quartiers Lointains* to "make distance closer and reveal commonalities rather than differences." An independent program sponsored in turn by Alain Gomis, Melvin Van Peebles, Jihan EI-Tahri, Lucien Jean-Baptiste, which promotes new filmmakers and travels between France, the United States and several African countries (Algeria, Benin, Burkina Faso, Cameroon, Ivory Coast, Mauritius, Nigeria, Rwanda, Senegal). One must see the impact of these films on audiences, whatever the continent, and the resulting testimonies. Understand the intercontinental and cultural commonalities that connect us to our brothers and sisters from Chicago to Yaoundé, from

Porto-Novo to Pantin, from Kigali to Los Angeles. It's a fact, Cinema is there to help us discover different horizons, different stories, but it's also there to gather us, bring us together and reduce distrust and misconceptions.

In 2015, it was the turn of a magazine, *Awotélé*, to be launched, cofounded with Michel Amarger, who has written for decades on African cinemas. Once more, people were amazed: a paper cinema magazine at a time when the press is going downhill? Bilingual? Without any shareholder? Yet we did it! By registering annually in the continent's broadcasting circuits (Carthage, Ouaga, Durban), by multiplying subscribers, broadcast booths and advertisers, by besieging social networks and TV channels, we are still around. Because critics must also educate the audience about what is happening, what exists. Because we are fed up of being a minority at Cannes, Venice, and Berlin while being the majority on our continent. We are not enough aware of the number of people who are interested in African cinemas without really knowing where to get information about them. Only long-term work can bear fruit. This is, in any case, our philosophy.

As a result of these projects, I created a Pan-African film distribution company, Sudu Connexion, to carry *Quartiers Lointains*, *Awotélé* but also other films (short, feature, fiction, documentary, animated, or experimental films). Because my point of view as a journalist is that demand exists but channels of communication are inexistent. Buyers and programmers do not know where to go. Producers do not know who to contact. So our films remain in drawers, years go by and the cinema community remains convinced that Africa is perpetually late. One must see the astonishment of the filmmakers we accompany when they glean selections and awards at festivals and when TV channels want to broadcast their movies. One must see the distrust when the time comes for signing contracts. There has been such silence, such scams between coproducers, producers and distributors, festivals and awardees, that there is a real need to professionalize the distribution sector in order to defend authors and promote films, but also to try to rebalance a precarious system where money has always sown discord.

And yet the wheel is turning and Africa is returning to the heart of the geopolitical, ecological, and monetary concerns of the whole world. Writing residencies have been set up in Tunisia (Sud Écriture), Morocco (Fidadoc), South Africa (Realness) and West Africa (Africadoc). Cinematographic creation and production workshops have sprung up everywhere (Maisha FilmLab, Africadoc, Ouaga Film Lab). Film schools have been created. Financing funds as well (in Egypt, in Madagascar, in Burkina Faso). At the turn of the twenty-first century, African cinemas definitely have their cards to play on a global scale because everyone is looking for something new.

So this is it! FESPACO is celebrating its fiftieth anniversary and Africa is proud for holding its cinema week every two years in the four corners of

Ouaga. Of course, everyone would like more decentralization of this event in Burkina and across Africa. Of course, everyone would like to see bilingual French/English Artistic Directors, whose job it is to travel the world in search of new films, connected to those who are in the process of production or editing and those who have just received funding. Of course everyone would like all the Gold, Silver, and Bronze Étalons to circulate as a year-round caravan across the continent, providing producers with a source of income and audiences with news from around the continent. Of course, everyone would like programs to be printed on time, guests to receive their tickets in advance, screenings to take place in a limited number of places, presenters to know the films they are showing, projectionists not to get lost and selections to contain fewer films, with better quality. Despite these shortcomings, FESPACO remains an unmissable event for moviegoers, a not-to-be missed event in one's agenda.

In order to "Confront our memory and shape the future of a Pan-African cinema in its essence, economy and diversity," let us rely our strengths, on the importance of our actions and look forward. Africa and its Diaspora need to be connected in their diversities, the seventh art must build the wealth of this continent plundered from all sides and the economy will depend on those who defend these productions, not in order to "make a name" or because Africa is coming back into fashion, but in order to bring forth resources so that they are fairly distributed among all the creators of the production chain. Because it is by fostering the establishment of a virtuous circle that we shall be able to produce more films, without having to beg money from those who will not fail—and have never failed—to impose their conditions.

Claire Diao is a Franco-Burkinabe journalist and member of the Association of Burkinabe Cinema Critics (ASCRIC-B) and the African Federation of Film Critics (FACC). Specializing in African cinemas, she is a correspondent for the South African magazine *Screen Africa* and collaborates with *SoFilm*, *Bondy Blog*, *Le Monde Afrique*, *Canal Afrique* and in 2015 co-founded the digital review *Awotélé* with several film critics.

Rethinking FESPACO as an Echo

Michel Amarger

The following comments about FESPACO are based on my work as a journalist, specialized in African cinematography, coming to Ouagadougou since the 1980s to produce radio reports on behalf of RFI, organize round tables, participate in professional meetings, and select films for foreign festivals. Having been a member of the jury for fictional feature films, I was also able to take a close look at how FESPACO functioned, following the actions of its successive managers, while helping promote it within the media I collaborate with.

The reflection I'm suggesting for the fiftieth anniversary book has been developed in all modesty, with the goal of contributing to the collective reflection on the existence and impact of FESPACO while paying tribute to all those who have been making it to live and evolve in favor of African contemporary audiovisual culture.

The importance of FESPACO is widely recognized. Yet its essence, organization, and even its legitimacy need to be discussed. It is as if this fifty-year old festival had been able to emerge and thrive without questioning its first momentum, driven by the founding principles of another cinema era. Undebatable but changing, evolving in line with Burkina Faso's political environment, the changes in FESPACO are sometimes distorted echoes to the transformation taking place in Africa.

FESPACO is first and foremost a meeting place to break down barriers between Africa's filmmakers and film professionals. It provides a framework—for artists, technicians, and film managers, scattered, isolated, and sometimes at odds in their countries—to get together to develop projects. In this sense, it is a major gathering framework aimed to boost the audiovisual sector in Africa.

The showcase of films it provides makes it possible to measure the current trends underway on the continent by comparing works and points of view. But this selection sometimes looks like a distorting prism, due to somewhat opaque choices and organization contingencies that depend on the political views of the administration of FESPACO itself.

One cannot ignore that the event, co-opted by the State of Burkina, is both propelled by the impetus once sparked by Thomas Sankara and his exceptional commitment to the seventh art, and subject to diplomatic requirements, both domestic and foreign. This means that FESPACO—after striving to become autonomous under its general delegate, Philippe Sawadogo, who campaigned for the creation of a foundation—is still dependent on the state organization that controls it.

Such dependence on the power and its contingencies and influences has often compromised the organization of certain aspects of FESPACO. Sometimes, the organization of guests' trips—entrusted to a person imposed by the authorities but barely skilled to do the job—is not managed properly. Sometimes, the printing of catalogs is delayed until the last days of the event. During one edition, badges were not properly produced and therefore could not be distributed to guests. Sometimes again, some filmmakers could not have access to rooms reserved for them. The list could be further developed, but the most compromising fact is when cinema becomes the stake of a more serious malfunction. Screenings are poorly managed, sometimes relocated, delayed, interrupted, or canceled.

Cinema, the main purpose of FESPACO, is often a secondary concern behind official, diplomatic, and political events. The festival has become a representation space for Burkina Faso. It embodies its openness, its democracy, its positioning in relation to other countries of the continent; it has become a platform for attracting foreign and Western investors. FESPACO is then displayed as the emblem of Burkina Faso's respectability. By securing spaces reserved for guests, by regulating local trade, FESPACO opens its arms to consumption, to capitalism, but also to partying, to the joy of getting together, to the pleasure of belonging to the great cinema family.

This ability is also an echo to current trends, in an era marked by the multiplication, blurring, and perhaps redefinition of images that look faster than the reflections of professionals of the field. FESPACO audiences are not claiming that much. The craze for movies, directors, actors, direct exchanges during and after screenings, is still tangible. Because FESPACO aims to be a festive event, a meeting place, a nodal point to unravel current audiovisual issues, fueled with debates, symposiums, discussion sessions involving a great deal of guests, FESPACO seems to be growing under the impulse of an ever stronger ambition in a globalized world where competition is the rule.

That's why its spectacular appearance is able to hide its organizational and positioning imperfections in relation to technical problems. And we know that organizers have for a long time preferred screening on celluloid while digital technology has existed in Africa for some time, regenerating movie production and distribution. Then FESPACO decided to join the

movement, ready to redefine some of its ideological criteria without abandoning its original utopia: to be a Pan-African festival.

Now that this idea is being undermined by the economic, political, and cultural realities of the continent, how can FESPACO react? By responding to the rapid transformations of cinema in order to be able to adapt to these realities. By proposing new orientations driven by a new impetus. This means new springs, an unprecedented impulse available to FESPACO if it could get rid of what it seems to be and think differently. A hanging challenge, submitted to these echoes of FESPACO.

Michel Amarger studied literature, cinema, and theater and works as a critic in many periodicals about cinema and art. Since 1981, he has made more than forty experimental films and uses techniques such as scratching and writing on film, drawing inspiration from letterist theories. Amarger wrote a book about cinema called *Cinerama, Another Way to Make Film* in which he argues the case for other, unusual ways of filmmaking.

Figure I. Workers at the FESPACO festival. Courtesy of FESPACO.

Figure J. Outside the FESPACO theater. Courtesy of FESPACO.

Going to the Cinema in Burkina Faso

Mustapha Ouedgraogo

This is a personal account by Mustapha Ouedgraogo, who was born and raised in Burkina Faso. For teaching purposes, it is an interesting glimpse into the cinemagoing experience of a young African boy and may lead to discussions around students recalling their own early experiences of cinemagoing, and considering how and why they differ.

The first time I went to the cinema was in 1968. I was a school boy aged ten, in a small village of Burkina Faso. Although I was from Muslim origin I was attending one of the numerous Catholic schools that missionaries have set up all over the country. We used to pray to start and finish school days. The missionaries had a church where people from surrounding villages used to come to pray every Sunday. One day, after the mass, the news went around by word of mouth that the missionaries were showing a film at the Cultural Center. For the village people, the Cultural Center was a place where white people used to meet to eat, drink a lot, talk, and spend time playing like children. The Cultural Center proudly stood at the heart of the village, looking down on the huts spread around it and could be seen from a distance because of its huge white-painted walls.

My step-brother and I were staying with our elder brother who was teaching mixed aged groups of pupils at the village three-classroom school run by the state. No time was given for the screening but everybody knew that all-night activities start after the evening meal. So, after we finished eating, my step-brother and I set off for the Cultural Center. We came across many other groups of people making their way to this meeting. The screening was to be in the open-air. It was the hot season and, therefore, there was no risk of rain. The big square around the Center was getting crowded and people were still coming out from the darkness, and from all sides; some were on bikes, but the great majority were on foot. All the snaking paths were leading the village people to the "Cercle," the name given by the white man to the ensemble of the local administration buildings including the Cultural Center

and the local elite houses. Our brother was part of this elite since he was the government school teacher.

There were many entrances to this square, where no ticket was required and therefore no seats were available for the village people. About twenty chairs were displayed in two rows facing the white wall of the Cultural Center; I presumed these were for the missionaries and their friends. Every day at sunset the generator was switched on from about 8–11 p.m., supplying just the "Cercle" area with electricity. Two lamp bulbs hanging from the trees lit the square. I could see there was not a single female face here. Apart from the local elite, the audience was made up of middle-age peasants and a few children of my age. According to the social values, this was no place for women. A few yards behind the two rows of seats, in the middle of the crowd, a white man with a lamp torch was fixing two small wheels on a machine standing up on three feet. His strange activity attracted curious people around him. When I managed to get closer to him I recognized Père Jean. I had seen him before in his long white dress during Sunday masses. I enjoyed going to the church to listen to white and black people, singing together and playing drums.

Around us some people were making comments and acting out films they had seen before. I wondered where they had seen them. The audience was laughing at them and the excitement was growing as people were now impatient to see the film. Suddenly, a middle-aged man came into the middle of the crowd on his bike. He shouted while pointing at a boy of my age: "I want to see you at home, right now." Then he disappeared. A minute later the boy disappeared too. The lights went off. The message did not go around that the film was about to start. "Sit down, sit down," a voice shouted. People were sitting anywhere they could find—on the ground, on stones, pieces of wood and stools that some were clever enough to bring with them.

A light came out of the machine, followed by a sharp noise. The two wheels went on turning around and a small square of light came out on the huge white wall. For a while the square was full of things like squiggly patterns. The audience was quiet. Then a fuzzy black-and-white picture filled in the square, followed by people talking. Père Jean activated something and the picture became clear enough to see peoples' faces. The sound, too, seemed to have improved but I could not recognize the words. Now the film had started but some people went on commenting on it to others. A short man came on the screen with a hat and a stick. They called him Charlot. He was walking fast and performing tricks for his friends and the audience was bursting out laughing. People said, because he was dumb, he was very intelligent. Sometimes, someone would stand up in the middle of the crowd and try to imitate him, provoking more laughs. Later on I found out that the short man called Charlot was the famous Charlie Chaplin.

But I was getting tired of sitting in the same place for so long. My neck was hurting and the film was going on and on. I was not used to staying up so late at night, so I fell asleep. When I woke up in the middle of the night the big square was completely empty and dark. For a while, I wondered where I was. I panicked when faced with this giant white wall in the darkness. I shouted my step-brother's name but nobody responded. I started running and trembling. I crashed into a tree. I don't know how, but I managed to stand up, wide awake now. Limping, I ran on to the main road, running across the village. I was now sure that I was going in the right direction for home so I started walking fast. Suddenly, I saw something white in the middle of the road, rising from the ground and disappearing in the sky just a few meters away from me. I thought it was a ghost. I turned back immediately and started running as fast as I could. I was about to run past the first hut when I heard voices. I ran around the hut and could not find the access to its yard. I jumped over the wall and dived into the yard. I heard a man's voice asking, "who is it?" I stood up and walked to the group of people still chatting through the night. I told them my misadventure and they laughed. I spent a sleepless night there, in the open-air, and returned home in the early hours of the morning. I lied to my brothers, telling them that I stayed with a friend's family, so they did not laugh at me. From then I knew I was not prepared to go to the cinema again, until further notice.

Going to the cinema again happened five years later. I was attending secondary boarding school in a bigger town which had one cinema. The school was in the town centre only a half mile away from the cinema theater. It could not be better! People here were used to going to the cinema. There were screenings at least three days per week and twice a day.

The school was organized like a convent. At the end of the lessons at 5 p.m. we had a free period and we would spend time doing sport or chatting with friends within the school premises. Dinner was at 6:30 p.m., followed by registration and compulsory study period from 8–10 p.m. The lights were off at 11 p.m., then throughout the night our two "Surveillants" (Supervisors) would go around the dormitories to see whose bed was empty. A non-author-ized absentee would stay at the school the following weekend, cleaning the tables and the schoolyard! Each dormitory had a "Chef" (another Supervisor) who would justify an absence, among others, to the "Surveillant." We were all trying to maintain good relationships with the "Chef." Sometimes we would make an arrangement with him to enable one or two people who had enough money to go and watch a film and then tell us the story afterwards. They would disguise themselves with funny clothes to avoid being recog-nized by any member of staff who might be attending the film. Although I could often pay for a ticket, I was never brave enough to attempt the adven-ture. I would rather lend my money to someone else!

On windy nights, from our beds we could hear the sound coming from the cinema, recognize the shootings of cowboy or gangster films and hear people being delirious. We would argue over actors' names until we fell asleep. I heard such strange names like Michel Strogoff, Sam Wallace, Gringo, Capitaine Fracass, Sabata, and Charlot, again! Sunday night was film comments night. We could leave the school on Friday after lessons and stay with our parents for the weekend. Students at the school came from all over the country. Some would return home and manage to go and see a film. Back at school on Sunday they would gather many students around them who would listen enviously to film stories. For us, there were only three types of films: war films, Hindu films, and cowboy films, which were our favorite movies. We liked cowboy films because of the way people were dressed, the way they played, and the actions. Although we could hardly understand the language, we were able to follow the story.

Because of the school discipline, I had to wait until the summer holidays to go to the cinema for the second time since my misadventure. I was now seventeen. This time I went with a cousin who was running a music shop and spending his earnings going to the cinema with friends, every screening day and all sessions, for many years. But what else could they do with the little money they were earning? They had no bills to pay, no transport fares, no worries about new CDs or trainers, and their ambitions were modest. There were three pubs in the town but young people here were not very interested in drinking. Cinema was the only regular night activity which could keep them busy for hours. They had seats they allocated themselves in the second class zone and nobody would dare occupy them. The cinema was charging fifty CFA francs (6p) for a second class ticket and one hundred CFA francs (twelve pence) for first class. The Cinema Nader, as it was called (Nader was the name of the Lebanese owner of the cinema), was a semi-open cinema which was covered just for the first class. Both classes were separated with a wall about eighty centimetres high. The seats in the second class were made of rows of concrete about fifty centimeters high, all at the same level. People in this zone were workmen, such as dishwashers at restaurants, itinerant water and bread sellers, firewood breakers, retailers of a wide range of western-made products, and also schoolboys. All those who had or believed they had an important social status (school teachers, mechanics, policemen, tailors, etc.) attended the first class zone. There were about one hundred chairs in this area. The second class zone could accommodate the same number of people, but the seats were not marked on the concrete and some people would take up as much room as they could.

Just before the screening started a man went around and checked the tickets. After fifteen minutes I could feel my bottom burning me. Later on I understood why some people were completely lying down or were restless

during the film. Having been exposed to the sun all day (an average of thir-
ty-three degrees centigrade) the concrete was steaming!

In times of rainy weather, people in the second class zone would jump
over the wall to shelter in the first class area. This worked as a deal between
both classes and nobody would complain. Sometimes the rain was followed
by thunder, cutting off the power and interrupting the film for a long time.
A rainy evening would then result in the postponement or the cancelation of
a session. But, apart from the weather, a screening was expected to be inter-
rupted a few times by the changing of reels. A feature film had at least two
reels which would cut off at any time whenever they were tired. In spite of
the audience's murmur of disapproval, everyone seemed to be used to these
annoying interruptions and took it easy. Some people would walk outside the
cinema to buy cigarettes or drink. The doorman knew everybody and every-
body knew him. Some people would go to chat with friends and others would
go and relieve themselves at the corners of the screen just a few meters away
from the first row of seats. They would ignore the crowd yelling behind them.
There were no public toilets anywhere in the town except at the market, and
the cinema did not have one. Another person would turn his radio on, loud
enough to be heard from anywhere in the theater. He would tune it either
on *Ici Washington, La Voix de L'Amerique* (*This is Washington, The Voice of
America*) or *La Voix de la Revolution* (*The Voice of Revolution*) broadcasting
from Guinea. People enjoyed listening to Sékou Touré, Guinea's first leader
who said no to De Gaulle's referendum in 1958. They called him the brave
man. Every week since Guinea's independence, for hours Sékou Touré would
violently attack imperialism and neocolonialism by means of his powerful
radio station which covered at least all of West Africa.

It was not approved of for women to go to the cinema, so the audience
was ninety-nine percent male—excited, swearing, but above all friendly.
According to Islamic customs, night life outside the home was for men only.
Even then, a good, decent, and responsible man would not be going out late
at night for the futile reason of going to the cinema. Whether she was married
or not, a woman at such places at night would be considered a loose woman.
Educated men and students, with their western way of life, and lower class
people, were regular cinemagoers.

The way we used to find out about the cinema program was to go and
check it out at the cinema theater and, in 1976, I came across my first African
film *Le Retour d'un l'aventurier.* I could not believe my eyes. Together with
many bystanders, we stayed for a long time to read and reread the film poster.
It was not even a Burkinabe film (originating from Burkina Faso) but a film
made in 1966 by Moustapha Alassane from Niger. It did not matter; since
it was an African film, with African people in the picture, it was an event
and we were all excited and impatient to watch it. I ran to inform my cousin

at his shop. He asked me to look after the shop and rushed to the cinema theater. That day he decided to close his shop early to get himself ready for the screening.

One hour before the film started we were queuing for the tickets. The place was crowded and noisy with men, many of them accompanied by their women! There were children, too, running all about. After pushing and shouting at the doormen we managed to get in. But there were no more seats available; those who were coming were standing against the side walls. The men were kind enough to leave their seats to the ladies.

The tickets were completely sold out, including standing. The doors were wide open but nobody could move forward. From outside, some people, including children, managed to climb on top of the walls which were about four meters high. They looked comfortable in their positions and were now shouting and whistling at the projectionist to start the film. But the film started forty-five minutes late. I was already suffocating and tired of standing up, and because of my height, I had to struggle to see the screen. I realized that the film was going to be memorable in a different way. In spite of the rainy season and the fact that the cinema was half open-air, the heat was unbearable. The four ventilators hanging from the roof in the first class zone were running at top speed, but what was the point? They could only shuffle the hot air around.

All that I remember about this film is the noise coming both from the speakers and the audience; black people were dressed up and playing with guns like real cowboys and talking in a foreign language. I found it distant from my reality and was going to give up if I had not had to wait for my cousin who paid for my ticket. I also remember that many people left before the end of the film but I don't know why. Was the color of the people and the African settings enough for them to say "This is our cinema"? I believed that they were much more confused than able to identify with the characters in the film.

Years later, in 1983, I was studying at the University of Ouagadougou—the only university in the country—and receiving a bursary from my government. I could afford to go to the cinema regularly, at the best cinema in the country. Cine Volta (now called Cine Burkina) was an outstanding quality theater compared to the three others in the capital. It was entirely covered, airconditioned, and had comfortable armchairs and facilities such as a cafe-bar, toilets, and car park. The tickets cost about sixty pence and there was no second class. All middle-class people attended films there. Furthermore, plenty of women (married or unmarried and civil servants or students) were also part of the audiences. Love films and Hindu films were their favorites and they would come out in droves with friends or husbands.

Going to the cinema today in Burkina Faso is part of the daily life of people between eighteen and forty-five, especially those living in towns. The expanding western way of life, the willingness of the successive governments in Burkina Faso to promote cinema, and the FESPACO festivals could explain it. From only six cinemas in 1970 there are forty today, with improved screenings, conditions, and facilities. It seems a long time since my first encounter with cinema in the late 1960s.

Mustapha Ouedgraogo was, at the time of writing this piece, a youth and local resident of Ouagadougou, the capital city of Burkina Faso.

Notes

Originally published as Mustapha Ouedraogo, "Going to the Cinema in Burkina Faso," in *Teaching African Cinema*, ed. Roy Ashbury, Wendy Helsby, and Maureen O'Brien (London: British Film Institute, 1998).

FESPACO and Its Many Afterlives

Sheila Petty

When thinking of practices for cultural decolonization—current and future challenges to FESPACO and its mission to address and exhibit the cinematographic representation of African peoples on the continent and diaspora—I am reminded of something that Chinua Achebe once wrote: "Art must interpret all human experience, for anything against which the door is barred can cause trouble."[1] From this perspective, the power of African filmmakers' contributions to the treasure trove of world cinema lies in the depth and breadth of creativity and innovation since the beginning of film production by Africans on the continent. This work has the capacity to alter the course of history as fundamentally as any advance in science, engineering, or industry. Indeed, in 1989, Filippe Sawadogo, then Secretary General of FESPACO, proclaimed that "the cinema of the world needs an African cinema which can bring new life thanks to its cultural richness. . . . It stands when other works lose their breath from lack of originality."[2]

What Sawadogo is referring to is the sustainability of a festival that has endured for more than fifty years through major upheavals on the continent, including local and global political and economic influences and the pop-ups of more recent (albeit smaller in scope) African film festivals on the continent and in the diaspora, especially specialty festivals such as Festival Issni N'Ourgh International du Film Amazighe in Agadir, etc. Much has been written about the systemic difficulties and recurring organizational problems that beleaguer the festival: transportation, lodging, sponsorship, subtitling and language versioning, accreditation, and badges. For example, during the 1991 edition, I sat at a manual typewriter in the FESPACO office and typed out name badges for many of us at the opening of the festival, although we had all sent in our accreditation forms and photos well in advance.

Despite all these issues, FESPACO's gift to the world of cinema and visual culture is that it has always provided the richest form of "afterlife" possible. The network of filmmaker-film-spectator is paramount to building communities and social networks off-screen in local communities and throughout the diaspora. According to Haida artist and master carver Bill Reid, an

artwork/film's "real life" is the process through which it becomes a work, but its "afterlife"[3] is constructed during readings of and engagement with the work through shared participation in local and diasporic cultural manifestations. FESPACO's Traveling Digital Cinema, which provides free open-air screenings to neighborhoods in Ouagadougou and to nine other cities and towns in Burkina Faso, is an afterlife case in point— where the wealth of the festival is shared by the people, with the people, as local film critics lead debates with the audiences following the screenings.

Another FESPACO afterlife gift is the International Market for Cinema and Audiovisuals (MICA). Established in 1983 to answer a call to action during the 1982 Niamey Congress, MICA opened its doors to FESPACO festivalgoers in 1989 to encourage exchanges between producers, directors, distributors, and TV-buyers and the diffusion of the richness and plurality of African cultures around the globe.[4] It seems, however, that thirty years later, MICA "does not yet organize English language screenings for international buyers, as is done in more established festivals."[5] Olivier Barlet makes a salient point here. Indeed, what should the festival's official language be as Indigenous languages increasingly stake out more prominent space in cultural manifestations? And on a continental level, this seems almost overwhelming to surmount. Yet, perhaps it is FESPACO's "openness and accessibility" compared to other festivals, and the "generosity of the filmmakers" who take the time to meet industry professionals and scholars alike, that softens the edges of this frustrating situation.[6]

MICA, and the generosity of industry professionals exhibiting their films, videos, and television programs, made it possible for me as a scholar to research the circulation of ideas and aesthetics in global television in the 1990s. To be sure, feature films and their prize categories have dominated FESPACO since its inception. Yet, many lauded filmmakers who began their careers making feature-length films transitioned to television and have moved back and forth working in multiple platforms. For example, at the 1991 Journées du Cinéma Africain et Créole de Montréal, a symposium was held at the request of the FEPACI, on the feasibility of creating a Pan-African television mini-series. During the symposium, Gaston Kaboré, then Secretary General of FEPACI, reminded participants that African television screens have been inundated with serials from the United States, Latin America, and France. Kaboré indicated that the FEPACI was encouraging filmmakers to move into television production—especially series production—in order to create local/national productions with which Africans could identify. Kaboré proposed the mini-series project, Africa Scoop, a South-South coproduction involving Algeria, Burkina Faso, Cameroon, Democratic Republic of Congo, Gabon, Guinea, and Tunisia. This interesting project, focusing on a press agency, was to comprise fourteen fifty-two minute episodes with each

country responsible for two episodes each. The idea was to create an African story that allowed for multiple points of view in national and Pan-African contexts.

More recently, in an article about African television, Boukary Sawadogo has asked if sitcoms are the future of francophone West African cinema.[7] Interestingly, he grew up in Burkina Faso watching many of the same sitcoms we watched in Canada, such as *Derrick* (1974), *Columbo* (1968), and *Dallas* (1978). Sawadogo argues that the "popularity and accessibility of sitcoms" has helped transform the landscape of West African cinemas as audiences clamor for more local stories. He further maintains that "sitcoms also represent a more dependable source of income for the filmmaker as opposed to chasing an elusive big-budget film or mortgaging all their resources to produce a feature film with no guarantee of ever recouping the costs."[8]

A similar sentiment was expressed by the late Senegalese director, Mahama Johnson Traoré in an interview that he graciously accorded me twenty years earlier in 1995 at MICA during FESPACO 1995. Considered one of the founders of FESPACO and a major figure of post-independence Senegalese cinema, Johnson Traoré is known for Wolof-language films: *Diankha-bi / The Young Girl* (1968); *Diègue-Bi / The Young Woman* (1970); and *Njangaan / The Disciple* (1975). Although active in government funding organizations for cinema and other cultural activities, Johnson Traoré made it very clear to me that he was an "independent" agent who worked across film and television platforms, and for both African and European productions. Not wanting to wait up to ten years between film productions, he turned to other means such as television to develop his creativity and to make a living. In some ways, Johnson Traoré presaged Sawadogo's claim when he said to me, "*Je pense que la télévision est l'avenir du développement du cinéma en Afrique*/I believe that television is the future of cinema development in Africa."[9]

In many ways, television answered the call to action of the Niamey Manifesto of 1982 by providing industry training for African technicians and creative personnel. At MICA on March 1, 1995, I conducted interviews with Carin Leclercq (Production Manager reporting to RTBF—Radio-télévision belge de la Communauté française) and Mahama Johnson Traoré (*Fann Océan*'s director), about the television training project, *Fann Océan* (1992).

Senegalese television, inaugurated in 1963, is one of the first television systems in sub-Saharan Africa to begin production of indigenous television drama in order to challenge the influence of imported American and European serial drama programming. Organizations such as CIRTEF (Conseil International des Radios-Télévisions d'Expression Française) maintained a presence in Africa by contributing training and infrastructure support to emerging francophone television industries. At the General

Conference in Rabat, Morocco, in 1991, CIRTEF created a program known as "formaction" with the intention of providing an exchange of knowledge between North and South partners, in a training environment focused on the production of audiovisual projects originating in the South. The ultimate goal was to create "high quality" television programming capable of broadcast in both the North and the South.

In 1986, Mamadou Seyni Mbengue, a writer and career diplomat, developed a screenplay for a daily television serial based on life in Dakar. Although the project languished for four years due to lack of financing, a coproduction deal was eventually arrived at between Radio-Télévision Sénégal (RTS) and the Belgian television organization, Radio Télévision Belge de la Communauté Française (RTBF). Recognizing the need to develop African production infrastructure through the training of technicians and creative personnel, Mactar Silla, then director of International Relations at RTS, proposed *Fann Océan* to RTBF as a project suitable for "formaction." The final production deal included the two broadcasters and a private production company, Vidéocam, which provided camera, optics, and some post-production support. Carin Leclercq asserts that, "in no case were we implicated in the artistic choices of the film," and therefore it is clear that RTBF's intention was to respect the creative autonomy of the director, Mahama Johnson Traoré and writer, Momar Seyni Mbengue.[10]

During the interview with Carin Leclercq, she cited circumstances in which the production management plan, created in advance of shooting, as would be done in Europe, was subject to considerable modification in Senegal. Johnson Traoré's divergent perspective of the script's role is clear when he remarks that improvisation of the script is a major component of his production approach. He places high regard on the participation of the actors in script development by declaring that, "they should not be entrapped by a system that rigidly imposes the script, but they should be allowed to make their maximum artistic contribution."[11]

Traoré described his own goals by observing that the creation of *Fann Océan* was intended to "impose a certain vision of African society that reflects us (as Africans)."[12] This position is echoed by Momar Seyni Mbengue in a newspaper interview when he states that the serial was meant to be "anti-Dallas," and was intended to allow the average Senegalese citizen to find a reflection of her/himself in the characters.[13] The importance of representing society as a whole, alluded to by both writer and director, is a concern that has traveled to television from African cinema. Earlier sub-Saharan television serials such as Cameroon's *Miseria* (1991) share with *Fann Océan* a world view that begins with society as its primary subject, and then narrows to focus on individual characters, a process contrary to Western narrative constructions which generally begin with the individual before widening

to society as a whole (although this character and aesthetic construction is increasingly evolving).

During the interviews, both Johnson Traoré and Leclercq alluded to the difficulty of securing broadcast opportunities for *Fann Océan* outside of Senegal. Such limitations do not diminish the importance of the mini-series as a "formation" project, as both parties agreed that the training opportunity afforded by the series outweighed all other concerns. Coproductions offer a potentially interesting opportunity to stimulate Indigenous African production—especially South-South coproductions. Knowledge keepers and filmmakers Janine Windolphe and the late Trudy Stewart once stated that if you take a story and film it, then you must give it back.[14] This is a fundamental philosophical principle of decolonized storytelling. Co-creation of a story as process rather than product or outcome is the ideal practice for cultural decolonization.

Sheila Petty is Professor of Media Studies at the University of Regina, Canada. She is author of *Contact Zones: Memory, Origin and Discourses in Black Diasporic Cinema* and coeditor of the *Directory of World Cinema: Africa*. Her current research focuses on Amazigh and North African cinemas and issues of citizenship and immigration in French cinemas. She is also currently writing a book on Algerian feminist filmmaker Habiba Djahnine.

Notes

1. Chinua Achebe, "The Igbo World and Its Art," *Hopes and Impediments. Selected Essays* (New York, Anchor Books, 1990), 65.

2. Filippe Sawadogo, Secretary General of FESPACO, MICA in Ouagadougou: 4th Market for the Independent Cinema of Africa in Ouagadougou. (Ouagadougou, MICA, 1989), 5.

3. Chadwick Allen, "A Transnational Native American Studies? Why Not Studies That Are Trans-Indigenous?" *Journal of Transnational American Studies* 4, no 1 (2012): 1–22. https://escholarship.org/uc/item/82m5j3f5. Accessed 11 June, 2018.

4. Alimata Salambéré, State Secretary for Culture, MICA in Ouagadougou: 4th Market for the Independent Cinema of Africa in Ouagadougou. (Ouagadougou, MICA, 1989), 4.

5. Olivier Barlet, "Africultures Dossier: FESPACO 2019: Moving Toward Resurrection," *Black Camera: An International Film Journal* 11, no. 1 (2019): 408.

6. Lindiwe Dovey, *Curating Africa in the Age of Film Festivals* (New York, NY: Palgrave Macmillan, 2015): 98.

7. Boukary Sawadogo, "Are Sitcoms the Future of Francophone West African Cinema?" *Cineaction,* 94 (2014): 40.

8. Ibid., 41.

9. Interview with Mahama Johnson Traoré, Ouagadougou, March 1, 1995.

10. Interview with Carin Leclercq, Ouagadougou, March 1, 1995.

11. Interview with Mahama Johnson Traoré, Ouagadougou, March 1, 1995.

12. Ibid.

13. Modou Mamoune Faye, Le Soleil, September 30, 1992.

14. Janine Windolphe and Trudy Stewart, "Indigenous Film Festivals in Canada," presentation given to FILM 804 graduate seminar, University of Regina, April 11, 2017.

FESPACO Film Festival

Colin Dupré

The Pan-African Film and Television Festival of Ouagadougou (Festival Panafricain de Cinema et de Television de Ouagadougou–FESPACO) was set up in Burkina Faso (Upper Volta at the time) in 1969. Born out of a modest private initiative, it received official backing from the Burkinabe authorities in 1972. That year, awards were introduced, the first editions not having had any competition sections. By the sixth edition (1979), the FESPACO adopted a biennial rhythm, the festival starting on the final Saturday in February every odd year. This choice was partly motivated by Tahar Cheriaa, founder of the Carthage Film Festival (JCC), who wanted to avoid competition between the two events. Set up in Tunisia in 1966, the JCC was originally intended to be a festival for films from sub-Saharan Africa, North Africa, and the Arab world. In practice, however, even though Ousmane Sembène won its first prize in 1966 with *La Noire de… / Black Girl* (Senegal), the JCC soon became a festival focused on the Maghreb, Mashriq, and Arab world in general.

Placed under the authority of the Ministry of Culture, Tourism, and Communications, the FESPACO continues today to reflect the determination of the Burkinabe government. Michel Ouedraogo has been its Delegate General since taking over from Baba Hama in 2008.

As it became institutionalized, the event adopted clear objectives, aiming principally to encourage the distribution of all African films, to facilitate contacts and exchanges between film and audiovisual professionals, and to contribute to the emergence, development, and safeguarding of African film as a means of expression, education, and consciousness raising (Statuts du FESPACO, 1999). The best of African film production is thus screened at the festival. At the end of the feature film competition, three major awards are attributed: the Gold, Silver, and Bronze Étalons de Yennenga (Yennenga Stallions). Short films are awarded the Gold, Silver, and Bronze Poulains (Foals). The horse plays a highly important role in the epic founding myth of the Mossi people, Burkina's majority ethnic group. Princess Yennenga met her future husband, Riale, thanks to his mount. Their child was the first in the line of the founders of the Mossi Empire. They named him Ouedraogo,

which means 'the stallion,' in reference to the horse that brought about their meeting.

A Festival of its Kind

The FESPACO brings together a considerable number of film enthusiasts. Today it easily attracts over half a million spectators. It is characterized by its popular dimension, lacking in a lot of other international film festivals. The Ouagadougou festival is one of the rare festivals to offer the general public the possibility of seeing the films selected during the competition, and on no other condition than buying one's ticket. Right since the outset, one of the FESPACO's major stakes has been to show African films to African audiences, and that at a time when the continent's screens were flooded with American, French, and Indian films. Largely inspired by Pan-Africanism, this militancy has remained unfailing since 1969 and has translated into Africans' desire to reappropriate their culture and develop their cinema. A real showcase for African film, the FESPACO helps 'keep a finger on the pulse' of filmmaking on the continent and makes it accessible to the world.

FESPACO: Birth and Evolutions

Born thanks to the initiative of a few enthusiasts, the FESPACO was created by the Franco-Voltaïque Cultural Centre (CCFV) film club in 1969 under the name of the Ouagadougou First African Film Festival. It emerged in a favorable context, several cultural initiatives having been launched across the continent, and notably in the domain of film. From the rudimentary nature of its first editions, it has evolved into a major event on the international cultural agenda. It was renamed FESPACO in 1972. That year, the Burkinabe government decided to institutionalize it, in an effort to thereby benefit from this showcase. Indeed, whatever the period, the FESPACO has always represented a key asset in Burkinabe diplomacy. Each regime has benefited from the platform that the event represents to convey certain positions to the international community. That was the case in 1983, for example, when deportations orchestrated by the Nigerian regime were denounced at the festival. Or again, during the apartheid era, when South Africa was boycotted and the FESPACO mobilized against this system, to give but a few examples. The relationship between the State and the FESPACO is pretty equitable and mutually beneficial to both parties. The State encourages the festival at several levels, notably financially, since, from the outset, it has and continues to contribute significantly to the FESPACO's budget. The State also gives

the FESPACO access to structures and institutions, thereby giving it more ample technical means.

Three major phases that have often been related to the country's political evolutions have marked the development of the FESPACO. A first phase marks its original structuring: from 1969 to 1983, the event grew at a fairly slow rate, consolidating its base. After a timid start, the FESPACO progressively imposed itself in the 1970s as a major rendezvous for African film. From 1983 to 1989, the FESPACO passed under the influence of President Thomas Sankara, who instrumentalized it to political and propagandistic ends. This second phase (the 1980s) marked the festival's expansion during the Sankarist Revolutionary era in which the event was politicized by the regime. Sankara used FESPACO to promote Burkina Faso and the Burkinabe Revolution. This period also corresponds to the FESPACO's enshrinement, as it became a truly international festival, opening up to the Black Diaspora, South America, and the entire world. The people's participation also exploded, with nearly four hundred thousand spectators in 1987. Contrary to what is sometimes written, Sankara did not create the FESPACO; he seized upon the event and enabled it to achieve a much greater dimension. Sankara died in a coup d'etat in October 1987, but the edition of the festival that followed his death remained marked by his influence.

The third evolutionary phase of the FESPACO has lasted from 1991 until the present and corresponds to a new dynamic. In 1983, the festival took on a commercial aspect, with the creation of the MICA (International African Film Market), which enables exchanges with television companies and the acquisition of film rights. Blaise Compaoré's government, which succeeded that of Sankara, has continued efforts to ensure that the event contributes to the positive image of the country. Nonetheless, certain events, such as the assassination of journalist Norbert Zongo in 1998 (the consequences of which were felt during the 1999 edition), or the Ivorian crisis in the 2000s, and their negative repercussions, have marked the festival. Seeking to become more professional, the FESPACO has also undergone a succession of changes and fitful progress. Changes are today inevitable—notably if the event is to evolve towards greater autonomy and independence, and if its commercial dimension is to take hold more firmly—in a new context that is seeing the confirmation of competition from festivals in South Africa, the rising star of African film.

A Decisive Role in African Film

Throughout its history, the FESPACO has contributed to transforming the filmmaking industry on the African continent. In 1970, the first edition of the festival encouraged the government to nationalize Burkina Faso's film

industry. Several neighboring countries followed suit; for example, Mali, with the OCINAM (Malian National Film Office) in 1974, and Senegal and Benin in turn took their industries in hand, respectively creating the SIDEC (Film Import, Distribution and Exploitation Company) and the OBECI (Beninese Film Office). The FESPACO has contributed to the general development of the film and video industry. Today, it remains the main festival of its kind in sub-Saharan Africa, a pole of excellence and springboard for directors and actors. It gives African films visibility and offers an ever greater public of festivalgoers a panorama of recent production on the continent, which is otherwise often sparingly or poorly distributed. In the mid-1980s, FESPACO administrators decided to incorporate video. This evolution horrified certain purists, but reflects the event's desire to remain in touch with spectators of all backgrounds; the most popular films in Africa are often seen on video, whereas so-called 'calabash cinema' has suffered somewhat of a decline in interest. This cinema is dubbed calabash in reference to the traditional recipients used in the rural areas mainly because this kind of filmmaking deals with rural tales. Its detractors mainly criticize its repetition of the same themes and the slowness of its screenplays. Moreover, given the difficulties of finding funding, joint cinema-television coproductions are on the rise.

From an institutional point of view, the FESPACO is one of the driving forces of the FEPACI (Pan-African Federation of Filmmakers). This federation, which more or less fulfills the role of a filmmakers' union, has taken responsibility for defining the main orientations for filmmakers and nations too. It has, for example, ensured the nation's greater implication in film circuits in Africa and encouraged African coproductions. Even after independence, these film circuits were long dominated by the leading European majors (notably Comacico, the African Film, Industrial, and Commercial Company; and SECMA, the African Film Exploitation Company), then American majors (notably the MPEAA, Motion Picture Export Association of America). Since the 1980s, the FESPACO and FEPACI have attempted to create their own distribution and broadcasting networks on the continent, in particular with the CIDC (the Inter-African Film Distribution Consortium) and CIPROFILMS (the Inter-African Film Production Centre), unfortunately in vain. Yet, this distribution and broadcasting issue is truly at the heart of everything, for, as Tahar Cheriaa, founder of the JCC, stated: "Whoever controls distribution controls cinema." In 2011, the situation in this respect is not the most favorable.

The distribution problems facing African films are slightly attenuated by the FESPACO which, with the help of financial backers, pays for the printing of copies or the distribution of its award-winning films on western circuits, thereby opening up the possibilities of a life beyond the festivals. For the moment, this distribution remains extremely limited, and international

festivals (the FESPACO and others) remain the main site of distribution for African films. Some television channels, such as M-Net (South Africa) and Arte (France, Germany) broadcast African films, but on a small scale. The FESPACO also encourages African production and above all, filmmakers' professionalization. The holding of a range of seminars, workshops, and roundtables helps the creation of networks. These networks are highly important in inciting partnerships between different countries and African directors. It is one of the major objectives that the festival has set itself.

Finally, in conjunction with the Ouagadougou African Film Library, the FESPACO plays a role in all that concerns the conservation and safeguarding of African film heritage. This institution—a veritable emanation of the FESPACO—has in theory made the distribution and valorization of this heritage possible, even if the floods in September 2009 had serious consequences on the state of copies and lastingly disrupted the running of the Film Library. Given the fragility of this source of documentation, the festival contributes to this heritage conservation mission. While film is still very fragile in Africa—the closure of its cinemas remains the underlying tendency as, with a few rare exceptions, movie theatres are shutting down one by one all over the continent—the Ouagadougou Pan-African Film Festival remains a reference and a driving force. Encouraging continental production, the distribution of certain works, and a reflection on the difficulties that filmmakers face, the FESPACO is a model in the promotion of African cinema. With an ever-increasing number of spectators, it remains a major cultural event in Burkina Faso and the whole continent.

Colin Dupré is a historian specializing in cinema. He holds a Master 2 research in Contemporary History at the University of Toulouse—le Mirail. Specialized in the history of African cinemas, he is the author of several articles for the journal *Africultures*, *Journal of Film Preservation*, and the *FIAF (International Federation of Film Archives)* periodical.

Notes

Originally published as Colin Dupré, "The FESPACO, a matter of state(s) 1969–2009," in *Directory of World Cinema Africa: Directory of World Cinema Africa*. Vol. 30. Blandine Stefanson and Sheila Petty, eds. (Intellect Books, 2014).
 This entry was translated from French by Melissa Thackway.

III: CONDITIONALITES & CHALLENGES

Figure K. Vendor market outside FESPACO theater. Courtesy of FESPACO.

Towards Reframing FESPACO

Imruh Bakari

Grounding with the Pioneers

As is widely recorded, over fifty years ago, an African cinema presence emerged through the work of a number of individuals, of whom, Paulin Soumanou Vieyra, Ousmane Sembène, Tahar Cheriaa, Lionel Ngakane, and Med Hondo, are among the most widely known.[1] Their work encompassed not only making films, but the establishment of FEPACI, the Pan-African Federation of Filmmakers, an organization of filmmakers; and FESPACO, the international festival of African cinema in Ouagadougou. In view of the global status of Africa and its peoples by the mid-twentieth century, the emergence of African filmmakers in the 1950s, undoubtedly posed a threat that was not taken lightly by the entrenched colonial and imperialist powers. Opposing the established hegemonies was a primary stance of the new African filmmakers. Their ideas and intentions found resonance in the political movements for the establishment of independent African states, and in the foundational ideas of the Organization of African Unity (OAU), later to become the African Union (AU).

Hence, the questions of a cinema economy, its dynamics, and the essential need for a film industry (or film industries) could also not be avoided. As an underlying impulse towards pursuing these goals in the post-independence era, the idea of Pan-Africanism also, cannot be over-emphasized, as it speaks directly to the issues of Africa as a "global" reality. It also speaks directly to the historical processes of African identities, as being both dynamic and diverse, and shaped over the centuries through various human migrations and interactions. Pan-Africanism, therefore, emphatically offers perspectives for engaging with the past and envisioning the future. This future, in my understanding, is predicated on the notion of a modern Africa, "as much a space as an idea" in human history, which essentially brings into focus the question of the "Diaspora."[2] It is here, within a legacy of Pan-African ideas and action, can be located two personally influential "pioneers," Lionel Ngakane (South Africa) and Med Hondo (Mauritania). As an anecdotal note, both Ngakane

and Hondo lived outside of the African continent for significant periods of their lives and have both provided an inspirational counterpoint for my own contemplation on FESPACO, as a forum designed to give form and expression to the lived experience of the continent's people, both past and present.

Ngakane and Hondo were both profoundly shaped by and through the unavoidable and simultaneous negotiation of diaspora realities and global forces impacting on the African continent in the twentieth century.[3] Their situation can be understood as being intrinsic to defining their individual work in African cinema. While these filmmakers would claim as their principal focus, the work of making films, this unavoidably involved a confrontation with established codes, conventions, and ideas about cinema, and importantly, the representation of Africa and Africans in cinema. Like their contemporaries from other parts of Africa, Latin America, and Asia, the questions of a cinema economy, its dynamics, and the essential needs of a film industry could also not be avoided. Across Med Hondo's eight feature length films made between 1967 and 2004, there are the recurring themes of Africa's diversity and the diaspora condition. Importantly, his statement "What Is Cinema for Us?," Hondo articulates the modern experience of the global African diaspora, as one of being subjected "to leave their countries, often despite themselves, to contribute to the development and overdevelopment of countries that don't need them, and that use their excesses to dominate us."[4] Although this statement can be interrogated to reveal a range of specific and nuanced meaning, it essentially defines the core predicament of the African diaspora condition, from "trans-Atlantic slavery" to "Black Lives Matter" and the present postcolonial era.

During my tenure as Festival Director of the Zanzibar International Film Festival (ZIFF), Med Hondo was the first filmmaker invited as guest of honor in 2000. ZIFF was then in its third year, and as part of the effort to reinforce the festival's identity, this was a significant decision. The aim was to refocus the festival's underpinning aims and ideals and to establish the principle that a film festival should give primacy to filmmakers. Med Hondo's presence was also an important reminder of the formative role of both FESPACO and FEPACI in the history of ZIFF. In essence, establishing ZIFF in the context of Tanzania and East Africa was motivated by the well-rehearsed need to "change in the relation between the dominant Euro-American production and distribution networks and African and Arab production and distribution, which we must control."[5] It also was intended to give expression to a commitment to promote the critical importance of this political stance as part of a cultural and economic strategy, which would be preoccupied with creating "our own networks of film production and distribution, liberating ourselves from all foreign monopolies."[6]

As one of the filmmakers who had "been gagged or altogether kept away from movie-thinking and/or movie-making in their country," part of Lionel Ngakane's motivation for choosing to go into exile in 1950 was to make films.[7] As well as his particular Diaspora experience, Ngakane is recognized as a significant figure in expanding the influence of FESPACO and the aspirations of FEPACI across the African continent. As the Southern Africa Regional Secretary for FEPACI, he was pivotal in the founding of the Frontline Film Festival in Zimbabwe in 1990 and ZIFF in Zanzibar in 1998. Ngakane was also involved as an organizer of the 1959 season, "The Negro World" at the National Film Theatre in London. This cinema program presented for the first time in the UK, a selection of films offering a global view of contemporary Africans and their world. During the 1970s and 80s, Ngakane is noted as being "the only voice representing Southern African filmmakers at international festivals."[8] In many ways, Ngakane's role in shaping the inclusive institutional structures for the film industry in post-apartheid South Africa can be regarded as a definitive milestone.

Fulfilling the shared ambition to "make films," however, demanded a much greater effort to construct a conducive and enabling environment. Thus, the pivotal role envisaged for FEPACI, constituted in 1969 at the Pan-African Cultural Festival in Algiers. Its founders included Ngakane and Hondo; Paulin Soumanou Vieyra, Ousmane Sembène, and Momar Thiam of Senegal; Oumarou Ganda, Moustapha Alassane, and Zalika Souley of Niger; Tunisians Tahar Cheriaa, Hassan Daldoul, and Hatem Ben Miled; from Guinea, Moussa Diakité; Ivorian Timité Bassori; Souleymane Cissé of Mali; Gadalla Gubara, Sudan; and Nigerian Ola Balogun.

Two critical factors are implicit across this historical sketch. Firstly, there is the symbiotic relationship between *Journées Cinématographiques de Carthage* (JCC) led by Tahar Cheriaa, the Pan-African Cultural Festival in Algiers (1969), FESPACO, and FEPACI. Secondly, there exists an underlying anti-imperialist stance, expressing the will of African filmmakers in pursuit of professional and ideological ideals. This anti-imperialist agenda was clearly reinforced by the Mogadishu Pan-African Film Symposium (MOGPAFIS), an initiative supported by FEPACI and conceived as a complimentary event to JCC and FESPACO. MOGPAFIS was organized during the years 1981, 1985, and 1987, as a forum for the exchange of critical and theoretical ideas. It was prematurely terminated by the escalating political and economic crisis that led to the disintegration of Somalia between 1988 and 1991. In effect, however, by 1982 at least, a consensus is evident among African filmmakers on: 1) a specific role for "cinema in Africa's struggle for cultural identity, independence, education, and socio-economic development;"[9] 2) a Pan-African principle of "cultural solidarity;"[10] 3) an understanding that cinema was an art as well as an industry in need of "means, technical parameters, and

capital;"[11] 4) a need to institute an "aesthetic and political" program,[12] with film festivals being an essential part of this program; and 5) an understanding that the full integration of the work of African filmmakers into African societies therefore, necessitated the "recovery" and "the control of the African market"[13] in the widest sense of the communications media, and at all levels.

Declarations of Intent

As we moved towards a celebration of fifty years of FESPACO, my focus was unavoidably on the signified history, the institutional structures, and the ideas that had come into being over the decades, articulating, and responding to the African experience of cinema. As I have asserted elsewhere, the contemporary manifestations of African cinema culture are indicative of "the ongoing process of establishing national cinemas and a viable Pan-African film economy."[14] Hence, it is within this light that I am obliged to take on the FESPACO fiftieth anniversary theme, *"Confronting our memory and shaping the future of a Pan-African cinema in its essence, economy, and diversity,"* as a point of departure. The reflection undoubtedly called for a re-visioning of FESPACO. As the deliberations of the colloquium (February 25–26) seemed to indicate, there was an urgent need to reframe FESPACO with a new awareness of its historical foundations. Most definitely, this effort encompassed an awareness that the exercise was part of an ongoing process.[15]

Across the history of FESPACO, there are now twenty-two themed colloquium events. The first of these was "The role of the filmmaker in the awakening of consciousness of Black Civilization" (1973); and immediately prior to the fiftieth anniversary, there was "Training, Cinema and Audiovisual Trades" (2017). As a defining element of FESPACO, the colloquium at every biannual edition established an important centrepiece for deliberations, debates, and responses to the ways in which the film industry is valued across most of Africa, and the status of cinema in African societies. The FESPACO colloquium may indeed also be placed in a wider historical context, which situates the ongoing process of reflection, critique, and propagation, in relation to the foundation upon which the festival was established.

Here, along with the Pan-African Cultural Festival in Algiers (1969), recall can be made to the World Festival of Negro Arts in Dakar (1966), and prior to this, the First International Congress of Negro Writers and Artists held in Paris (1956), and the Second Congress of Negro Writers and Artists held in Rome (1959). As the titles of these events signify, the concept of "African" or "Pan-African" is subliminal. The historical reality suggests that the foregrounding of these terms was part of a process in which consensus

was forged in relation to wider programmatic and ideological tendencies. Instructively, between 1900–1945, as Adi notes, what can now be recognized as "a formal Pan-African movement" was "re-established" in 1919 at the First Pan-African Congress in Paris, following a "conference" held in London in 1900.[16] Congresses that followed, were held between London, Paris, and Brussels (1921), Lisbon (1923), and New York (1937). The fifth congress in Manchester, England in 1945, established a radically new paradigm and momentum. This occasion is noted for the critical involvement of continental Africans, Kwame Nkrumah, and Jomo Kenyatta among them; who along with diaspora Africans such as George Padmore, C.L.R. James, and Ras Makonnen, went on to spearhead the movement for independent African states, leading to the contemporary modes of global Pan-African engagement.

Recalling this history is of importance in contextualizing the emergence of African cinema and its seminal ideas. Hence, the iconic significance given to the production of *Afrique sur Seine / Africa on the Seine* (dir. Paulin Soumanou Vieyra, 1955, France) and the deliberations in 1956 at the First International Congress of Negro Writers and Artists. Under the auspices of *Présence Africaine*, the opening address outlined a statement on "modern culture and our destiny." While asserting that "what is common to the conscience of all mankind is the feeling that certain problems are gravely urgent and dangerously interdependent," what was delineated as the "primordial tasks" of the moment, were proposed as being "to bring before the world audience the expression of our original cultures, so far as they interpret the present life of our peoples and our personality" and "reflect back to our own peoples the image of their aspirations, their experience and their joys, illuminated by the experiences, joys and hopes of the world."[17]

It is my understanding that there were no edicts or reductive orthodoxies being propagated in this opening statement or during the entire congress, which included papers from Leopold Sedar Senghor—"The spirit of civilization or the laws of African negro culture," Frantz Fanon—"racism and culture," Ben Enwonwu—"Problems of the African artist today," Aimé Cesaire—"Culture and colonization," George Lamming—"The Negro Writer and his World," Cheikh Anta Diop—"The Cultural Contributions and Prospects of Africa," and Richard Wright—"Tradition and Industrialization: The plight of the tragic elite in Africa." As well as expressing what is distinctly a non-aligned position, Wright, for example, engaged with the conundrum of Imperialism/Colonialism that faced Africans on one side and Europeans on the other. In his estimation, the "problem is freedom from a dead past. And freedom to build a rational future." The conference, he exhorted, "must proceed to define the tools and the nature of finishing that job."[18] This work undoubtedly continued to the Second Congress, where a direct consideration was given to the issue of "the cinema."

As one of the earliest declarations on "African cinema," as opposed to "films for Africans," the report on "the Arts" from the Second Congress of Negro Writers and Artists (1959), distinctly linked the prospects for an African cinema to "national independence," and recognized the cinema as "an art and an industry."[19] Within the congress resolutions put forward by a "Commission on the Arts," issues of "the domain of cinematography" were given prominence.[20] For critical reflection here, are the references to the role of the state, the issue of "training," and examples of the cultural function of cinema, which were highlighted.

For FESPACO today, the immediate significance of these events that precede its existence, seems to reside in the ways in which the seminal ideas indicative of the 1950s, have continued to resonate in various manifestos and declarations, charters, and communiqués. Across the decades, these include a significant number emanating from FEPACI. In view of concerns evident at the fiftieth anniversary of FESPACO, I can recall five of these declarations of intent for scrutiny: *The Algiers Charter on African Cinema* (1975), the *Niamey Manifesto of African Filmmakers* (1982), Ola Balogun's *Pathways to the Establishment of a Nigerian Film Industry* (1982), the *Final Communiqué of the First Frontline Film Festival and Workshop* (1990), and the *Statement of African Women Professionals of Cinema, Television and Video* (1991). Cognizant of the discussion opened up around these documents (excluding Ola Balogun's "Pathways") by Tcheuyap and Niang, for example,[21] and the need here for brevity, I will offer a summation of each in order to reinforce their essential significance in relation to the current challenges of FESPACO and the African filmmaking fraternity.

The Algiers Charter on African Cinema comes in the wake of the transformative emergence in world cinema of filmmakers and theorists from the "Third World."[22] Here can be found the new national cinema of India, with its constituent popular and auteur tendencies. Here, too, can be found the radical work from Cuba and Latin America, coalescing around the new paradigm of "Third Cinema," as a theory, a practice, and as a critique of the established North American and European approaches. The charter, which was produced at the Second Congress of FEPACI, therefore, is a statement of intent recognizing the shared condition of Africans "undergoing an experience of domination exerted on a number of levels." Hence, cinema is emphasized as being a "vital" part of a desired "process of development."[23]

The *Niamey Manifesto of African Filmmakers* emanates from an International Conference on Cinema Production in Africa.[24] This event brought together an array of filmmakers, critics, "officials from several African counties and international cinema experts."[25] Importantly, the conference focused on cultural, institutional, and economic issues relating to the prospects of film industries in Africa. The most critical points within the "manifesto" can

be identified around the need for "legislation on cinema, nationally or region-ally," and for a wide engagement with representative film industry interests.[26]

Ola Balogun's *Pathways to the Establishment of a Nigerian Film Industry* is a timely reminder of the pre-Nollywood legacy in the cinema culture of Nigeria.[27] Following Niamey, however, this critique and plan of action for a Nigerian film industry, indicates a plethora of intricacies, which have become associated with the postcolonial African state. Balogun bemoans a "deficiency of long-term vision and understanding on the part of the vast majority of African leaders" concerning the role of media and culture within "modern" African society.[28] This is recognized as being one cause for a deficit in legislation, appropriate investment, and use of national resources. In propagating the need for a film industry, a Pan-African cultural rationale is coupled with proposals for infrastructural and institutional requirements. These are outlined along with a critique of the inherited colonial media structures, typical of Anglophone Africa. Many of these, as apparatus of the postcolonial state, can undoubtedly find their comparable continental replications.

The *Final Communiqué of the First Frontline Film Festival and Workshop* is the product of a festival and workshop in Harare, July 15–21, 1990 supported by FEPACI, the OAU, and the Southern African Development Coordination Conference (SADCC) Secretariat. Taking place as it did, about six months after Nelson Mandela was released from his long incarceration, this was a moment of euphoria. In this context, filmmakers from the (soon to be named) Southern African Development Community (SADC) region of "Frontline States" were in the vanguard of a wave of optimism. The communiqué provides a significant assessment of "the film industry in Africa and the Southern African region in particular," which can be seen to reinforce much of what Ola Balogun had articulated in relation to Nigeria. Equally, the recommendations, called for action on a regional level in much the same way, as related to the Nigerian national situation.

The *Statement of African Women Professionals of Cinema, Television and Video* is the product of a FEPACI workshop at the twelfth edition of FESPACO in 1991. In essence, it provides a historical marker, which Sada Niang suggests is "a direct gendered criticism," of both the 1975 Charter and the 1990 Harare communiqué.[29] In the tone of a campaign statement, a call was made here, for a more significant presence and consideration of women within African cinema. In its essence, this statement, along with the others noted, can lead towards a number of critical deductions. These, I would suggest, may be considered in relation to the historical record of FESPACO, and the unresolved issues raised two decades later by Yaba Badoe, Amina Mama, Salem Mekuria, Beti Ellerson, and others, for example.[30]

The future, its essence, economy, and diversity

Surveying the history of FESPACO since 1990, observations can be made on four critical instances that may serve as points of reference in "confronting our memory" and developing a perspective on the current state of the festival:

1. The marginalization of the Paul Robeson Award within the FESPACO program comes immediately to mind. This prize was first awarded in 2005 at the nineteenth edition of the festival. On this occasion the award was given to *Beah: A Black Woman Speaks* (dir. LisaGay Hamilton, USA). As the award was conceived, the prize was intended to pay tribute to the African American actor, vocalist, and activist Paul Robeson. It was to be granted in three categories: full-length feature drama/documentary, short documentary and/or drama, and a "Youth Watch" category; to films in the Diaspora section of the festival, chosen from a "Best of the Best" selection. Haile Gerima was among the principle figures who had lobbied for this award and to secure its inclusion. This involved a considerable effort and engagement from particularly African American filmmakers. From accounts of the institutional dynamic of managing the award, two issues become prominent. One issue can be identified around Gerima's observation of the "dominance France had over the festival."[31] The other issue concerns a persisting inability to make credible "best of the best" official selections for the competitions.

2. *La Guilde Africaine des Réalisateurs et Producteurs* (The Guild), was founded in 1997 in Paris, by a group of filmmakers representing a postcolonial and diverse Diaspora experience. As being symbolic of new wave signifying what Diawara calls the "post-Sembène African cinema," this generation has had a contentious relationship with FESPACO as an institution.[32] As Mahamat-Saleh Haroun declared at the twenty-second edition of FESPACO in 2011, "This is the last FESPACO I'll be coming to."[33] Haroun's subjective views undoubtedly pointed to wider critical issues, including the problems that arose in relation to film selection. The widely recognized failure on the part of "those who curated the festival" to secure a credible and balanced selection for the competitions, as noted in relation to the Paul Robeson Award, remains an unresolved matter.[34] By 2013, this matter was already an issue, along with the inability of the festival to deal adequately with new (at the time) digital formats.[35]

3. Nollywood presented another instance in which it became apparent that FESPACO's institutional ability and capacity was out of step with the changing reality of African film culture. The impact of this

presence was part of the conflict that came to a crescendo in 2013, "when several films selected for the official competition were suddenly disqualified because the organizing committee discovered they were not on 35mm celluloid film."[36] Hence, the question of the festival's inability to change "its rules" in response to filmmakers' needs and a transformed cultural reality, created a climate of exclusion. This can be seen to have inhibited both Pan-African diversity and contemporary deliberations relevant to African cinema.

4. Arriving at the twenty-sixth edition of FESPACO, it is perhaps a tragic irony that news of Med Hondo's passing coincided with the awards and closing ceremony of the festival on Saturday, March 2, 2019. In fact, Hondo's passing seemed to underline a critical and transformative moment. In my view, the official proceedings seemed to confirm a marginalization of filmmakers, giving primacy to a celebration of politicians and bureaucrats. This tendency had been observed by Diawara in 2009 at the twenty-first edition of the festival, prompting his contemplation that "I have long forgiven the festival's organizers for what I interpret as their disdain for African filmmakers and critics in favor of European tourist and small bureaucrats."[37]

In my confrontation of the FESPACO "memory" therefore, a deliberate detour has been necessary in order to clear a path for coherence, toward the possible future. This in essence, situates a perspective around the umbilical link between FESPACO and FEPACI. In effect, the premise for the future seems to be located around the ways in which African filmmakers are positioned in relation to their processes of production, distribution, and exhibition. For FESPACO, this is even more critical in the present moment. Here, can be observed a cauldron of persisting imperialist legacies in a postcolonial world order. Very evident is a particular *la francophonie* "entanglement," which has reconstituted Wright's conundrum noted above.[38]

It is my view that African cinema, "as a body of ideas, and as a diversity of practices operating in the contemporary postcolonial and globalized world," is arguably a cinema that has a transnational existence.[39] As Teshome Gabriel seems to suggest in the preface to *Questioning African Cinema*, this is a cinema that "draws its strength from [a] web of traditions," and can be said to exist "as an adventure in visual thinking, a way of imagining a different reality, a different future."[40] At work here is a certain praxis, and a certain "sense of community or collectivity." This offers both a challenge and an opportunity, as much as it is a reminder of the unavoidable politics that frames the discourses constructed around Africa and its historical processes. It therefore seems essential to keep the foundations of FESPACO in critical focus, while allowing for a historically informed approach to the continuum

of ideas that have accumulated around the core concept of African cinema over the decades.

Imruh Bakari is a filmmaker, writer, and creative industries consultant. From 1999–2004 he was Festival Director of Zanzibar International Film Festival (ZIFF), and is a founder/director of Tanzania Screenwriters Forum. He was a founder/director of Ceddo, the film and video production and training organization in London (1982–93). He is a former member (2012–15) of the Advisory Council of the Pan-African Federation of Filmmakers (FEPACI) and currently a member Tanzania Independent Producers Association (TAIPA), and the Editorial Board of the Journal of African Cinemas. His professional work includes a number of film and television credits, which include *Riots and Rumours of Riots, Street Warriors, The Mark of the Hand, Blue Notes and Exiled Voices* and *African Tales*. In 2013 he received a Lifetime Achievement Award from the Afrika Filmfestival in Leuven, Belgium for his work in African Cinema.

Notes

1. See Sada Niang, *Nationalist African Cinema: Legacy and Transformations* (Lanham and Plymouth: Lexington Books, 2014); *Cinema, Colonialism, Postcolonialism: Perspectives from the French and Francophone Worlds,* ed. Dina Sherzer, (Austin: University of Texas Press, 1996); Olivier Barlet, *African Cinemas: Decolonizing the Gaze* (London: Zed Books, 1996); *African Experiences of Cinema,* ed. Imruh Baraki and Mbye Cham, (London: BFI, 1996); Nwachukwu Frank Ukadike, *Black African Cinema* (Berkeley: University of California Press, 1994); Ferid Boughedir, *African Cinema from A to Z* (Brussels: OCIC, 1992); Manthia Diawara, *African Cinema: Politics & Culture* (Bloomington: Indiana University Press, 1992); Roy Armes, *Third World Film Making and the West* (Berkeley: University of California Press, 1987).

2. *Global Africa: Into the Twenty-First Century,* ed. Dorothy L. Hodgson and Judith A. Byfield, (Oakland: University of California Press, 2017), 1.

3. See Nwachukwu Frank Ukadike, *Questioning African Cinema* (Minnesota: University of Minnesota Press, 2002), 57–83.

4. Med Hondo, "What Is Cinema for Us?" in *African Experiences of Cinema,* ed. Imruh Bakari and Mbye Cham (London: BFI, 1996), 41.

5. Ibid., 40.

6. Ibid., 41.

7. Françoise Pfaff, "Eroticism and Sub-Saharan African Films," in *African Experiences of Cinema,* ed. Emruh Bakari and Mbye Cham (London: BFI, 1996), 252.

8. Keith Shiri, "Lionel Ngakane – South African film pioneer," in *The Guardian,* 1 December 2003, http://www.theguardian.com/news/2003/dec/01/guardianobituaries.artsobituaries, accessed July 15, 2020.

9. Ibrahim M. Awed, Hussein Mohamed Adam and Lionel Ngakane, *First Mogadishu Pan-African Film Symposium—Pan-African Cinema: Which Way Ahead?* (Mogadishu: MOGPAFIS Management Committee, 1983), ix–x.

10. Ibid., 13.

11. Ibid., 32.

12. Ibid., 35.

13. Ibid., 36.

14. Imruh Bakari, "The Role and Function of Film Festivals in Africa," in *African Film Cultures: In the Context of Socio-Political Factors*, ed. Añulika Agina, Barbara Knorpp, and Winston Mano (Newcastle: Cambridge Scholars Publishing, 2017), 201.

15. See Olivier Barlet, "Fespaco 2017: A Discredited Festival," *Africultures*, 4 September 2017, http://africultures.com/fespaco-2017-a-discredited-festival-14235/, accessed November 30, 2019; Barlet, "FESPACO 2011: A Festival Under Threat," *Black Camera* 3, no. 1 (2011); Barlet, "'This Is the Last FESPACO I'll Be Coming To': An Interview with Mahamat-Saleh Haroun," *Black Camera* 3, no. 1 (2011); Barlet, "'The Way to Help Us Is to Give Us Our Funding on Time!': An Interview with Michel Ouedraogo, Delegate General of FESPACO," *Black Camera* 3, no. 1 (2011); Lindiwe Dovey, *Curating Africa in the Age of Film Festivals* (New York: Palgrave Macmillan, 2015); K. Harrow, "Notes on FESPACO 2015," *Africultures*, 7 April 2015, http://africultures.com/notes -on-fespaco-2015-12888/?utm_source=newsletter&utm_medium=email&utm_campaign=456, accessed November 28, 2019; Manthia Diawara, *African Film: New Forms of Asthetics and Politics* (New York: Prestel Verlag, 2010).

16. Hakim Adi, *Pan-Africanism: A History* (London: Bloomsbury Academic, 2018), 48.

17. *Présence Africaine*, no. 8–10, June–November 1956, 5–6. https://www.freedom archives.org/Documents/Finder/Black%20Liberation%20Disk/Black%20Power!/ugah- Data/Journals/Presence.S.pdf, accessed 9 June 2016.

18. Ibid., 369.

19. *Présence Africaine*, no. 24–25, February-May 1959, 456. https://www.freedom archives.org/Documents/Finder/Black%20Liberation%20Disk/Black%20Power!/Sugah Data/Journals/Presence.S.pdf, accessed 9 June 2016.

20. Ibid., 458–459.

21. A. Tcheuyap, "African Cinema(s): Definitions, Identity and Theoretical Considerations," *Critical Interventions* 5, no. 1; Niang, *Nationalist African Cinema*.

22. "The Algiers Charter on African Cinema, 1975," in *African Experiences of Cinema*, ed. Imruh Bakari and Mbye Cham (London: BFI, 1996), 25–26.

23. Ibid., 25.

24. "Niamey Manifesto of African Film-Makers, 1982," in *African Experiences of Cinema*, ed. Imruh Bakari and Mbye Cham (London: BFI, 1996), 27–30.

25. Ibid., 27.

26. Ibid., 30.

27. Scott Mackenzie, *Film Manifestos and Global Cinema Cultures: A Critical Anthology* (Berkeley: University of California Press, 2014): 183–192.

28. Ibid., 183.

29. Niang, *Nationalist African Cinema*, 20.

30. Yaba Badoe, Amina Mama and Salem Mekuria, eds., *Feminist Africa: African Feminist Engagements with Film*, issue 16 (2012).

31. D. Boyd, "In Conversation with Haile Gerima, Baker Center Ohio University Athens, Ohio Thursday, April 14th 2011," *Journal of the African Literature Association* 6, no. 2, 210.

32. Diawara, *African Film*, 45.

33. Barlet, "An Interview with Mahamat-Saleh Haroun".

34. Harrow, "Notes on FESPACO 2015."

35. Dovey, *Curating Africa*, 104–109.

36. Ibid., 105.

37. Diawara, *African Film*, 70.

38. See Achille Mbembe, *On the Postcolony* (Berkeley: University of California Press, 2001); *Présence Africaine*, 1956.

39. Bakari, "The Role and Function of Film Festivals in Africa," 189.

40. Ukadike, *Questioning African Cinema*.

FESPACO Past and Future: Voices from the Archive

June Givanni

Introduction

FESPACO came into being in an era of struggle for independence, when Fanonian principles of self-determination and decolonization of the mind were necessary prerequisites to that process, and any historical review of its existence will find these key purposes as significant drivers for all constituencies of users (visitors/participants) and those who value festivals—audiences, filmmakers, actors, writers, technicians, curators and programmers, critics, policy makers, cultural activists, archivists, and others. All hold not only memories, but opinions based on their own experiences of this major festival that gathers people from across the continent and across the globe to explore, promote, and celebrate African cinema.

To provide an idea of the position from which my comments and observations are made, I am writing as a curator and programmer of Pan-African cinema[1] and an archivist by necessity from the pre-digital era; and as someone who has been a regular attendee at FESPACO since 1985 during the Sankara era—in all of those capacities. I have not only my own observations[2] and experiences of FESPACO, but in the shape of the June Givanni Pan-African Cinema Archive (JGPACA) I have captured, recorded, and gathered materials that witness the festival's history over those years and the views and experiences of many other professionals and local fans of cinema at the festival. Of course mine is not a unique position—other collectors from their position have also done the same; notably the Tunisian archivist and filmmaker Mohamed Challouff who has assiduously recorded the history of both FESPACO and its twin festival JCC (Journées Cinématographiques de Carthage) for many decades in the form of a number of publications and films.

Most recently, in celebration of the 50th Anniversary of FESPACO, the JGPACA organized an installation of films made at the festival over the years (with in-kind support from FESPACO, *Black Camera* at Indiana University, and AiM), where the films were open to all visitors to the JGPACA stand at

the MICA (The International Market for TV and African Cinema) all day to view on five screens with headphones, and we held lunchtime discussions at the stand with the filmmakers concerned present at FESPACO who we invited to discuss their work with spectators and colleagues.[3,4]

The materials I have gathered in the June Givanni Pan-African Cinema Archive are not exhaustive and were not collected to present an objective assessment (some years later) of the film festivals and of Pan-African cinema. So there is not only subjectivity in the collections in the archive and in my views on FESPACO, there are also limitations of formats and of deterioration which have an impact on what is available for such a reflection. However, there are materials in various formats from FESPACO over those years to be found in the archive, including films shot at FESPACO by various filmmakers.

The JGPACA archive materials contain the views of others including many filmmakers and industry professionals and some of those responsible for staging FESPACO, which—in addition to my own memories, experiences, and impressions—I will use to address a few key points that might contribute to this collection of ideas around FESPACO past, present, and future.

One of the underlying sources of cinematic ideas that I think is important to mention here relates to the significance of Third Cinema which was the platform around which I began to engage with and shape ideas around the potential for cinema as a liberating force, in working on *London's Festival of Third World Cinema 'Third Eye'* in London in 1983,[5] and is therefore evident in the archive at various levels. *Third Eye* was a festival where filmmakers and other film professionals from Africa, South America, and the Caribbean, the Indian sub-continent, as well as African American and Black British filmmakers were gathered for a two week film festival in London and a four-day Symposium (which continued the following year with a focus on Black British cinema).

Third Cinema and *Third Eye* signalled a clear context for the revolutionary role of cinema and the role of festivals as key sites beyond regular cinema-going, for exposing audiences to a range of cinemas that can expand and nurture their tastes in film and its potential beyond the domain of entertainment, as a politically significant cultural product. Some of those filmmakers already engaged through FEPACI with the development of FESPACO were present at *Third Eye*, including Gaston Kaboré, Lionel Ngakane (one of the advisors for *Third Eye*), Haile Gerima, and Kwaw Ansah, speaking ardently about the significance of the development of these two partner institutions for the cinema of the continent. This was an important opportunity to link with, discuss, and explore strategies for revolutionary filmmaking that could expand the creativity of cinematic arts and foster intercontinental collaboration—such were the aims of the Third Eye Advisory Board, which included filmmakers Lionel Ngakane, Imruh Bakari, H.O. Nazareth

alongside the Director of *Third Eye*, Parminder Vir, and coordinator June Givanni.[6, 7]

Archives are significant because they provide context for various phenomena and events that permit a deeper and wider understanding. The following section uses elements from the JGPACA to address just a few of the many issues that FESPACO has faced over the years and will no doubt be facing as it moves forward; elements in the form of comments and views on ideas about FESPACO—including from commentators in the five films that were included in the JGPACA installation at FESPACO 2019.[8]

Underlying issues and politics that have informed various editions of FESPACO and what they may mean for the future of the festival

These have related very much over the decades of the existence of the art and industry of African cinema, involving all interest sectors of the festival (including festival organizers and administrators) to its core partner FEPACI. The underlying issues and politics are also related to, and have been informed by, the cultural politics and context of the era, in particular the political agenda of Burkina Faso, which has hosted this festival since its inception. The Organization of African Unity (OAU—now the AU) was the main political forum for uniting the continent in the beginning of the postcolonial era around a Pan-African ideal. Ideas related to revolutionary cinema and links with areas of world cinema provided important alternatives to the dominant cinemas which also dominated African screens. (Third Cinema has already been mentioned above, but it is also useful to note that some African filmmakers trained in filmmaking in Russia from the 1960s into the 1990s.)[9] Major forums between filmmakers in the 1960s, 1970s, and 1980s include the first Festival of Negro Arts held 1966 in Dakar (where the African Film Group, formed in 1950s around the Paulin Vieyra project 'Afrique Sur Seine', was present); the first FEPACI Congress in Algiers in 1969, which founded the first edition of FESPACO that same year;[10] the 1973 Third World Filmmakers Meeting in Algiers. The resolutions of that meeting, written jointly by the filmmakers in attendance, defined the role of cinema as a social act within a historical reality and stated that the role of the filmmaker,

> ...is extended to other fields of action such as: articulating, fostering and making the new films understandable to the masses of people by associating himself [sic] with the promoters of people's cinemas, clubs and itinerant film groups in their dynamic action aimed at disalienation and sensitization in favor of a cinema which satisfies and interests the masses[11]

identifying as one of the chief goals for the distribution of Third Cinema the fostering of festivals, film markets, and film days on a tricontinental level, implying a collaboration between Third World nations and their festivals. (I witnessed some of these discussions in Havana, Cuba, and at FESPACO in the 1980s and 1990s.)[12]

Another Algiers Conference was held in 1975 which was also part of this formative movement. "The Algiers Charter on African Cinema, 1975," and later in Niger, the "Niamey Manifesto of African Film-Makers, 1982."[13] Latin American filmmakers were present and supportive of FESPACO attending the festival in the early 1980s and were linked through their respective federations of filmmakers. African filmmakers were in turn invited to major fora for Third Cinema in Havana in the 1980s and 1990s. These periods were all part of that formative time which also celebrated and required a Pan-African geopolitical and cultural identity.

Cultural politics have changed and are constantly changing. It remains to be seen how festivals formed at such times are able to maintain this deep purpose and these characteristics of their existence. The world of African cinema has grown and the political and cultural influences on the art, culture, and industry of African cinema are many and varied. A big Pan-African step beyond the continent came at the 1987 edition of FESPACO, when the African Diaspora was invited to have representation at FEPACI and to be eligible to enter the FESPACO competition with a special prize. Another step was taken in recent years (2017), when FESPACO opened up the possibility for Diaspora films to compete in the main sections of the festival—while also permitting African filmmakers to compete for the African Diaspora Robeson Prize. However, there was no public announcement of the new ethos behind the changed role of the Diaspora award, merely the statement that it would be eligible to all African and African Diaspora filmmakers. Once issues around insufficient outreach to diaspora filmmakers—and more significantly, issues around the selection of films from the African Diaspora countries for competition—have been resolved, the lack of participation of African Diaspora films is likely to dwindle still further. The selection and curation of films for the festival generally is an issue and in the area of African Diaspora films it would only lead to further alienation from the festival if it is not addressed.

As a strong advocate for filmmakers to submit their films to FESPACO, I have been disappointed in recent years that some excellent African films have not been officially selected or invited for the festival. At the same time, I have seen new films of significant artistic, cultural, and industry quality in small separate screenings and other fora taking place independently during the festival;[14] films which have either been rejected or received no response from the festival. The quality of selection generally is one of the aspects for

which the festival has been criticized in recent years. While it is true that managing the volume of films submitted and the amount that the festival could properly manage is a problem, I suspect also that the festival may not have a sufficiently robust selection process to keep up with its aspirations and the expectations of filmmakers and audiences—especially when it comes to viewing and assessing films in different languages—and this would be something that it needs to address in its selection procedures which are urgently in need of review.

African Women in Cinema

> "When Safi Faye got into film (her first feature: Lettre Paysanne, 1975) There was a recognition that film is a job, a profession not a luxury pastime for women and that there was an emergence of a female voice and a female presence."
>
> JIHAN EL TAHARI (HIBROW FILM)

As the major festival of Pan-African cinema, FESPACO, in collaboration with its partner organization FEPACI, has for years sought to address the question of women's professional participation in African cinema.[15] In 1991 FEPACI organized with FESPACO the Workshop on African Professional Women in Cinema—the main theme of the festival that year— led by the only female Burkinabe filmmaker at the time, FEPACI member Aminata Ouedraogo, and supported significantly by the founding director of FESPACO, Alimata Salembéré. FEPACI was at that time under the leadership of Gaston Kaboré, since the 1985 FEPACI Congress when the Sankara administration offered FEPACI support for their administrative base in Burkina Faso. The workshop is believed to be the first of such international meetings at a major African festival and combined women both in front of and behind the camera from across Africa (although there was already a national Women in Cinema Organization led by actress Alexandra Duah[16] that had been actively promoting African women film professionals in Ghana)—women of the African Diaspora were also invited for the majority of the sessions of that day-long workshop.[17] Since then both FEPACI and FESPACO have continued to pursue this agenda in different ways that all parties involved believe is needed to achieve the full potential of Pan-African cinema.[18] Under the leadership of Suzane Kourouma and Lucie Tiendrabego, FESPACO has since 2010 organized and been running a small women's biennial film festival (Journées Cinématographiques de la Femme Africaine de l'Image–JCFA) on the alternate years to FESPACO. The festival made a major statement on the gender issue at the 2013 edition of FESPACO, where it provided a significant platform that placed female African film professionals at the center of

the festival, with all-women FESPACO jury heads and the main feature film jury, which accords the Étalon de Yennenga, was led by Martiniquan director Euzhan Palcy.

Sankara's determination to decolonize the minds of African people was evident at FESPACO festivals during his time as President of Burkina Faso in the early 1980s, especially when it came to the role of women. At a time when global cultural agendas were still struggling with the idea of women's equality, Sankara's motorbike out-rider Guard of Honor who accompanied him to major public and state events were all women. It was an impressive sight and left a major impression on the local population and international visitors to the festival—a clear demonstration of Sankara's wider political commitment at the time to valuing women in society.

Fast-forward thirty-two years, to 2019. At the fiftieth anniversary of FESPACO (its twenty-sixth edition), one of the independent discussion forums brought to African cinema a different agenda item regarding women in the industry, and one that in the wake of #MeToo was already very high-profile on the world film industry agenda—the exploitation, disrespect, and abuse of professional women in the industry. Organized by Collectif des Cinéastes Non-Alignées (CCNA) and attended by women professionals from across the spectrum of the industry, the discussion was the first opportunity for many of the women in the room to go beyond the more obvious issue of exclusion to share publicly how they had been treated personally and sometimes physically in the industry, and the impact this had had not only on them personally but professionally. A number of attendees spoke out about how exploitation, sexual harassment, and physical attacks were already driving African women away from the industry, and prevented many with ambitions and talents from joining.

The stories were painful, harrowing and it was impossible to treat this as simply a discussion of what policy changes are needed in society. One female cinema professional still bore the dreadful physical scars of her experience. There were definitely demands for all institutions, all professionals and festivals—including FESPACO—to take this on board in their policies, their organizational, and selection practices. It remains to be seen the extent to which such a powerful, high-profile festival as FESPACO will be able make this happen. We should be reminded of the scope of the omission and exploitation and the forms these take. The declaration at the end of the 1991 FEPACI/FESPACO workshop of African Professional Women in Cinema included the words: "In 1991, almost ten years before the year 2000, African women are still victims of pressures at their place of work, and exploited both as women and as professionals." It appears that in the field of cinema, they still are today.

Technology and Audiences

Filmmakers have become so removed from the audience. Cinema is an elit-
ist thing which makes it inaccessible with European money. That is why Nigeria
and Egypt was a good thing—self-sufficient with their films being shown to their
audiences and raising money from their audiences.

JIHAN EL TAHARI

The identity of the festival is one which has a populist/popular dimension—we
do not exclude cinephiles—everyone has the right to come to the festival—as long
as that dimension doesn't cost us any money—for this reason I think that is why
more and more people are coming from all over—we are not doing this festival
just for ourselves—we are doing it so that our cinema and our cultures are better
known—so we are completely open to others.

PHILIPPE SAWADOGO

Cinephiles in Burkina are true cinephiles—they can understand films in differ-
ent languages because they understand cinema—they can watch and understand
Westerns, Hindi films, English, and French films—they can understand more
than the filmmakers (so called 'trained') even when they cannot fully speak the
language.[19] *.... They are searching universal and great themes, feelings, and emo-*
tions that they can understand; you're good, you're bad, you are hungry or thirsty
etc. (This is what Nollywood understands and this—together with their very
large population—is the background to their success on their own terms.)

IDRISSA OUÉDRAOGO

Technology has also influenced changes in the film and audiovisual indus-
tries: in the shape and content of African cinema, in audience tastes and
expectations, and consequently in festivals such as FESPACO. In the early
days of FESPACO and throughout the 1980s, francophone African cinema
dominated the profile of cinema of the continent, although the prolific and
pioneering cinema from Africa North of the Sahara had a long and strong
history—Egypt in particular had demonstrated achievements and skills in
cinema since the birth of this artistic medium. The dominance of 35mm and
16mm production on the continent required post-production in Europe for
many African countries (in France, UK, Portugal, Belgium, Germany), before
South-South coproduction on the continent began to offer a few alternatives.
At that time, to compete at FESPACO films had to be produced and presented
on celluloid. This meant that many of the early films coming to FESPACO
produced on video (VHS, U-matic, etc.) from, for example, Nigeria and
Ghana were not eligible for the main competition and were shown in other

parts of the festival—despite the fact that established Nigerian director Ola Balogun had been making feature films on celluloid since the 1970s (his 1978 feature *Black Goddess* was shown at FESPACO).[20] Ghana was the first of those two anglophone countries to produce a film to be entered into feature competition, and the first anglophone country to win the coveted Étalon de Yennenga, for Kwaw Ansah's second film, *Heritage Africa*, in 1989, followed in 2007 by the Nigerian filmmaker Newton Aduaka's *Ezra*.

In between these two dates, 'Nollywood' arrived to demonstrate another level of domination of screens within the industry for popular consumption, not only on the African continent but on many other continents, too. The Nigerians were able to elaborate a mode of production that did not require reliance on Western funding—only direct access to their very large population already engaged through popular Nigerian theater. Technological change facilitated the birth of this popular Nigerian cinema.

As time and industry practices progressed, it became evident that to insist on celluloid films was anachronistic: FESPACO needed a more flexible approach to its competition criteria if it was to maintain its role on the continent and internationally. So from 2015, FESPACO permitted digitally produced and projected films beyond the video and televisual categories, also in the main FESPACO competition.

In *Lieux saintes / Sacred Places* (2009), shot during FESPACO, Jean-Marie Téno explored the street locations of Ouagadougou where a parallel profile of cinema in the city was taking place in small local ad hoc set-ups and lean-tos where the local youth could go to view films of the popular genres they wanted, easily and repeatedly for next to nothing—a practice that had long been established in anglophone Africa, notably in Nigeria.

However, digital films require digital projection (argued Idrissa Ouédraogo) and FESPACO in 2019 had only two cinemas with that provision. More would be required to be able to keep abreast of the number of films being submitted in that format for competition, and to update policies and investment relative to advances in technology. But what does that mean for still serving the local population who were the ones who really made FESPACO great? The challenges of financing, programming, and technological change mean the festival will need further investment and partners on the continent who share the key purpose and vision. Unhappy and dissatisfied, others are talking about developing new festivals. But they are yet to discover the reality and the true cost—in many ways—of staging and running a major festival in the 2020s.

Futures[21]

"I think that the improvement of the festival is a constant objective that we are trying to achieve (...) and I think we have in the last ten years placed an emphasis on the film and TV market and we have started the TV and video competition: We have improved the general organizational structure of the festival.

The future of the festival has to achieve one of its key purposes for which it was created—to provide a space for contact between filmmakers, a meeting place and to at last help to advance the African film industry—and while African cinema doesn't have regular production and distribution, we have to continue to stress and redouble our efforts for the industry to come into being. So that in the future FESPACO becomes more professional to meet the needs of the participants."

PHILIPPE SAWADOGO, SECRETARY GENERAL **FESPACO**
(1993 Interview with June Givanni FESPACO)

"[I argue] that coming to FESPACO brought the visions and aspirations for the continent to life. But after a few times, as problems with the festival and small organizational issues persisted ... we shouldn't accept it and should voice our criticisms."

JEAN-PIERRE BEKOLO
(Hibrow Film 2015)

"FESPACO is important because it is a moment when you get to take account of the films that have been made in the last two years and it's where progress in African cinema is assessed and measured; you see what has been accomplished that I believe is invaluable and necessary ...

It's more than a cinema festival; it's a big cultural meeting place where people get together, eating together, conversations: It's no longer a Burkina Faso festival, it belongs to the whole continent."

WASIS DIOP
(Hibrow Film 2015)

"Yes, not simply on a practical level, to give people a sense of camaraderie, but also as a space and an umbrella where there is an understanding—but not to create an umbrella term of African cinema defined as such by 'the other' who refuses to give you a space, as that is how they see you, but by African filmmakers —so you have to create something for yourself and as long as those labels don't trap you there as that is what would kill it—sooner or later it will die. The festival is good purely on a pragmatic level—as a support system."

NEWTON ADUAKA,
(On being asked if there is need for an African festival like FESPACO)

The reasons why FESPACO exists have been revisited and commented on many times over the years. Although the cultural policy and political philosophy of a major festival has to be determined not only by the country but by the continent's ambitions for its cinema, one might argue that—in spite of its importance as a cultural industry—this is insufficient at a time when there are other factors at play, including the commercial context of the international structures which dominate cinema now. Major digital platforms such as Netflix or Amazon no longer respect physical borders and are expanding their repertoire to include mass popular and internationally recognised African films; their platforms connect directly with consumers through their phones and other personal telephonic means, but are also entering the major collective screening platforms, cinemas, and multiplexes. How will FESPACO adapt to this changing media landscape?

It is not a novel question to consider whether government administration might be the best structure to deliver a festival of the size and aspirations of FESPACO in this age. However, a major festival on the African continent in the current era can only happen with key provision by governments for security and consular services to ensure the safety of its population and international visitors at this time of mass movement in and out and around its country. No other agency can provide that within any sovereign state—even if the state becomes a strategic partner in the festival alongside other professional agencies. It is crucial for their own economic well-being, that the countries of Africa benefit from the economic potential of cinema and the audio-visual industries on the continent. (We have recently been reminded of who controls Africa's currencies, especially the CFA.) Whatever the shape of these key administrative structures responsible for staging the festival, they have to be made fit for purpose.

One of those crucial requirements, as Imruh Bakari has pointed out in his article on the "Role and Function of Film Festivals in Africa,"[22] is the professionalization and organization of festivals, which is needed now more than ever on the continent for festivals to thrive and realize their full potential—to the benefit of their countries, their populations, and their film industries.

Also needed are strategies encouraging partnership and collaboration between festivals on the continent, developed and actioned by those with the vision to take them forward. Professional training and experience at every stratum of the industry while maintaining existing skills and knowledge is indispensable to ensure that African film professionals are equipped to deal with current challenges.

Professions in cinema are changing, combining new artistic and technological skills, which have to be explored and taken on board in the

organization of a festival. What is a festival now? And how important are festivals in a world where each individual is seeking their own AV product to consume? Why do we keep going? For the spectacle? The showcase? The commercial potential? The social moment? The professional gatherings? All are still part of the main appeal that draws crowds from near and far to be part of a major happening they can buy into. But it has to be meaningful and to serve the industry professionals it gathers from across this vast continent, and who also need to use the occasion to showcase their talent in the best possible conditions. Showcasing should lead to media exposure and opportunities for production, distribution, and exhibition of their work in different ways—ultimately to the provision of resources and opportunities to generate the industry further and ensure its future. This is where a major festival like FESPACO may be best placed to draw together the skills and the ideas that can serve the African film industry on its own terms rather than to compete with the digital platforms. We need to address the question of whether there is scope and need for a marketplace that goes beyond the digital experience—and in the wider cinema industry. Such questions are also at the core of what we imagine that FEPACI will be addressing as African cinema's key industry organization and a key partner of the festival.

FEPACI has a major focus on archiving African classics; FESPACO should also be a major location for drawing together and harnessing African cinema archives and curators of African cinema. Each edition of the festival might seek to advance the continent's position in archiving and curating, which need to be seen as areas of skill development and expertise that can provide unique experiences; as sources of artistic inspiration to enrich cinema in all of its originality; and as sources of generating finance for the continued support of African cinema (though not at the expense of resources for new work harnessing the every growing ambitions of new filmmaking talent on the industry). There are African and Diaspora professionals in this area who could be drawn upon to contribute to the organization of the festival as partners and collaborators. Such collaborators can contribute ideas, lead workshops around curating, contribute new and creative propositions for archival presentations, and partner with FESPACO for its presentation and promotion in other countries—notably the Diaspora (sometimes with the help of FEPACI, when it is operating effectively).

As a showcase and a platform for the recognition of excellence in African cinema, the festival has to be rigorous in its selection standards and to maintain its integrity. It would not be appropriate for it to hand over its selection to other organizations, but it can involve others or have strategic relationships through which professional curators focused on those related areas could propose and nominate films for consideration—and also train its own ambitious young curators. As noted earlier, this might help the festival at

least at the first stage of selection—to look at a wider range of materials from different language regions. It would also make sense for FESPACO to recruit a number of African and African diaspora curators as part of its selection panel—again, to expand the knowledge and contact base of African and diaspora filmmakers, and to really open up possibilities more conscientiously to those from language backgrounds other than French.

Archives offer opportunities for enrichment in cinematic forms, in expanding education, in proposing new levels of appreciation. Draw on previously unrealized potentials and links with the past, they are fountains of inspiration and reinvention for the future development of African cinema. A regular FESPACO section focused on archival films would provide an enriching context for consumers, film fans, and would-be filmmakers of the future.

Despite FESPACO's troubles, there is scope for improvements to be made. Other festivals on the continent have problems, too, and it would be hard to see which is in a position to replace or challenge FESPACO in the near future—although any seeking to do so should also seek to learn some of the lessons that FESPACO has had to learn over the fifty years of its existence—hopefully without repeating any of its errors. *A luta continua...*

June Givanni is a pioneering international film curator who has considerable experience in film and broadcasting for over thirty years and she is regarded as a resource for African and African diaspora cinema. The development of the Pan-African Cinema Archive is based on her collections from years of working in the field of cinema. Her motivation for the archive is to make this valuable heritage collection as widely accessible as possible. In the early 1980s she was involved in bringing Third Eye London's first Festival of Third World Cinema to London and she worked as a film programmer at the Greater London Council's Ethnic Minorities Unit, at a key development stage for Black British Independent cinema, and Black British art and culture generally. June ran the African Caribbean Film Unit and edited the quarterly *Black Film Bulletin*; and the book *Symbolic Narratives: Africa Cinema* for the British Film Institute. She also programmed *Planet Africa* at the Toronto International Film Festival for over four years. She has worked as a film curator with festivals on five continents—including India—and has been involved in key moments in the development of Pan-African cinema on these continents, and the development of the links between them.

Notes

1. Cinemas of the African Continent and the African Diaspora.

2. I have attended not only as a curator seeking to increase and keep up-to-date my knowledge of African cinema and meet filmmakers, but also as a consultant for companies filming at FESPACO—BBC and Hibrow; a member of the FESPACO jury in 1995 alongside Pedro Pimenta, Henri Duparc and chaired by Ousmane Sembène; as one of the founder members of the African Diaspora dimension of the festival and the introduction of the Robeson Prize in 1987 and subsequent editions of the festival; an observer at the FEPACI congresses and meetings held at FESPACO since 1985, assisting as a member of the first FESPACO/FEPACI Women in African Cinema Workshop 1991, and many other aspects in relation to my work with major international cinema bodies such as the BFI, TIFF, and others.

3. Notably Balufu Bakupa Kanyinda; Nii Kwate Owoo; Aboubacar Sanogo; Representing the FESPACO Newsreels produced by the students of IMAGINE Institute; and active supporters and advisors of JGPACA filmmaker Imruh Bakari, Prof. Michael Martin, and Dr. Emma Sandon.

4. Outside of the biennial festival there have been other occasions when I have participated at focused events organized in relation to the development of the festival e.g. in 1994, the year after the inauguration of the African cinémathèque in Ouagadougou, I attended the workshop where FESPACO launched their call for filmmakers to donate their films to that archive; and in 1992 with other colleagues we initiated Philippe Sawadogo's (then Secretary General of FESPACO) invitation during the BFI's London Film Festival to have a brief platform to promote FESPACO.

5. Third Eye: London's Festival of Third World Festival organized by Parminder Vir of the Greater London Council 1983 and co-ordinated by June Givanni.

6. Present at Third Eye, in addition to the African filmmakers mentioned above, were Bill Gunn, Clyde Taylor, Reggie Hudlin, Miguel Littín, José Massip, Prema Karanth, Shyam Benegal, and others from the U.K. film scene including Martina Attille, Maureen Blackwood, Isaac Julien, John Akomfrah, Avril Johnson, Karen Alexander, Carlos Carrasco, etc.

7. The BFI/Commonwealth Institute curator Jim Pines had previously staged at the CI a Nigerian Film Week and a Ghanaian Film Week to showcase African Cinema in London.

8. JGPACA FESPACO @50 Installation Flier.

9. Some key African filmmakers who trained in Russia: Souleymane Cissé, Ousmane Sembène, Sara Maldoror, Flora Gomes, Abderrahmane Sissako.

10. 1969 was also the year that the 2nd Festival of Negro Arts was held—in Algeria (following Senegal in 1966 and before FESTAC Nigeria in 1977).

11. In *African Experiences of Cinema*, ed. Imruh Bakari and Mbye Cham (London: BFI, 1996), 24.

12. This includes Philippe Sawadogo, Sergio Giral, and Haile Gerima together on the Havana location of Giral's shoot of the film *(1986, Cuba)* and at FESPACO; Sergio Giral, Fernando Birri (the Argentinian filmmaker and one of the architects of Third Cinema), at FESPACO in the 1980s.

13. In *African Experiences*, 17–30. The Algiers moment is echoed/featured in the visual motifs of this revolutionary connection in Med Hondo's last film *Fatima The Algerienne of Dakar (2004)*, when the male protagonist goes from Senegal to Algeria to ask permission to apologize for his crime against Fatima.

14. Eg. Jean-Pierre Bekolo's 2013 film *The President (Cameroon)*.

15. And it is perhaps worth remembering at this point—in light of earlier comments about diaspora participation—that the seminal film *Sambizanga* of our dear departed sister and African Cinema revolutionary, Sara Maldoror of Guadeloupe, was not shown/awarded at FESPACO for her masterpiece, rather at JCC in Tunis 1972. However thirteen years later the ground breaking Euzhan Palcy of Martinique participated with her seminal film *La Rue Cases-Nègres* which took the Audience Prize [Prix du Publique] at FESPACO in 1985.

16. Alexandra Duah, who played the major role of Nunu in Haile Gerima's *Sankofa* (1993, Ethiopia).

17. The workshop was reported in *Écran d'Afrique* No.1 May 1992; and *Jeune Afrique* 1991. See also, "Statement of African Women Professionals of Cinema, Television and Video Ouagadougou, Burkina Faso, 1991" in *African Experiences of Cinema,* ed. Imruh Bakari and Mbye Cham (London: BFI, 1996): 35–36.

18. Report to 1993 FEPACI Congress of the Women's Workshop held at FESPACO 1991.

19. Many learn languages from their passion for films—Mansour Sora Wade of Senegal has demonstrated in his documentary *Dakar Bombay (2011)* how the fans of Hindi films in Senegal have learnt to speak Hindi from watching.

20. Balogun's filmmaking career is distinguished by his determination to identify and engage 'south-south' collaborations, his most noted one being *Black Goddess*, a 1978 Brazilian co-production that demonstrated collaborations both in front of and behind the camera.

21. This section on 'Futures' was written pre-COVID pandemic which is now changing the whole spectrum of the consumption of audiovisual media, and the role of films, the technology, the markets, and the directions they might go in… We will need to revisit our futures post-COVID (dare we dream that far ahead), see what lessons we have learnt, and how we might use them.

22. Imruh Bakari, "The Role and Function of Film Festivals in Africa," in *African Film Cultures: In the Context of Socio-Political Factors,* ed. Winston Mano, Barbara Knorpp, and Anuli Agina (Cambridge Scholars Publishing, 2017).

The Opening of South Africa and the Future of African Film

Mahir Şaul

The newest development in African cinema is the eruption of South Africa, previously isolated from the rest of the continent, as a film industry giant. In 2005, South Africa made a strong showing at FESPACO, with a large number of visitors and four feature films in the competition, one of which (*Drum*, dir. Zola Maseko, 2004) took the grand prize. In 2006, South Africa's Department of Arts and Culture hosted an African Film Summit in Pretoria-Tshwane, including a congress held by FEPACI. At this meeting, the members voted for the creation of a full-time secretariat in South Africa, though the headquarters remains in Ouagadougou, and elected Seipati Bulane-Hopa, a South African woman producer, as Secretary General. The decision was hailed as a watershed in the history of FEPACI, and no doubt it serves as an emblem of the shifting center of gravity for the African film world.

On the commercial front, the South African media company M-Net, already broadcasting to the rest of the continent via satellite and a subscription-based online TV service, began compiling its African Film Library by purchasing exclusive electronic rights to the films of the major francophone and anglophone directors. M-Net's pay-per-view entertainment channel, Africa Magic, airs daily Nollywood dramas and is starting to have an impact on both the finances and technical services of Nigerian video production.[1] Another South African company, Nu Metro, operates theaters in several African countries, produces and distributes films and TV programs, and sells videos, DVDs, and video games for home entertainment.

This new configuration is strengthened by two different imperatives stemming from South Africa: the local film industry's desire to reach a new market and the struggle of the formerly disadvantaged groups within the country to find proportional representation in post-apartheid society. The South African film industry, one of the oldest in the world, intermittently produces features that triumph at the international box office—for example, Academy Award winner *Tsotsi* (dir. Gavin Hood, 2005) and *District 9* (dir. Neill Blomkamp, 2009)—but suffers from a narrow domestic market, which

observers attribute in part to the lack of exhibition theaters and filmgoing habits in the Black townships. Adjustment to the realities of majority rule after the 1994 elections created a temporary lull in production, which was softened but not totally offset by the small flurry of anti-apartheid films. At the same time, the Cape Town World Cinema Festival and the simultaneous Sithengi Film and Television Market, promoted by the South African film industry, have now become major showcases for African cinema, on par with FESPACO and Carthage.[2]

The rise of a new generation of young Black South African producers and directors is the second crucial element in the opening of South Africa. The latest crop of filmmakers is different from the small numbers who matured in the underground film scene during apartheid. Young filmmaker Carmen Sangion distinguishes "two generations of filmmakers, the younger generation that is focused on fantasy, entertainment, and commercial work, and the group from the old school with political and social baggage about the country."[3] The younger cineastes may wish for work in a normalized commercial film sector, but they find it hard to break into the existing professional circuits. The studios around Johannesburg, and the major broadcast companies and distributors as well, are dominated by white capital and employ an old coterie of producers, directors, and technical personnel. Government aid administered through the National Film and Video Foundation (NFVF) prods this establishment to integrate the new Black professionals, but progress has been slow.

Policy debates turn around a contrast, the independent filmmakers on one side, who establish start-up companies or operate informally, and industry organization on the other. During the 2008 Gauteng Film Commission conference, which was an "industry" event, Bulane-Hopa said that "ten percent of the population continue to determine the nature of cultural content production . . . only by creating and sustaining more opportunities for Black filmmakers will the industry be able to meet the changing demands of South Africa."[4] The barriers to entry are decried sometimes under polite terms such as "faith in young talent" or "commitment to transformation," at other times in the harsher tones of "means of production" and "transfer."

This ongoing strife has impelled Black film professionals to latch on to francophone African cinema and its FESPACO legacy. South African audiences met this African cinema after the 1994 elections, and now it stands as a major argument for local government assistance against both the commercialism of Hollywood-style entertainment and the past glory of the white Afrikaner art film. The francophone model shapes the restructuring of incentives in the new South Africa. The NFVF focuses on short films as a training ground, and its program for first-time producers and directors

receives funding from taxes on non-domestic film showings, videos, and TV advertising, following the model of Burkina Faso, which itself followed the example of the French National Cinema Center.[5] The translocated FEPACI in Johannesburg is now financially sustained by the Department of Arts and Culture through the NFVF. The prestige of African cinema prompts support from the private sector as well. M-Net set one of its New Directions training programs in Gorée Island, Senegal, under the leadership of Gaston Kaboré.[6]

The developing cinematic ties between these two African regions have also generated new challenges. Huge economic disparities exist between South Africa and the rest of the continent. The hard-fought new incentives scheme put in place for South African cinema may look modest to its proponents, relative to the wealth circulating in their country; the film industry itself struggles and remains dependent on government subsidies. But from the perspective of tropical countries, these same resources appear as inexhaustible bounties. South African Black intellectuals understand that their claims to a rightful place in both their home film industry and the continent as a whole bring correlative obligations vis-à-vis the cinematic institutions of the rest of Africa. The FEPACI "secretariat" in Johannesburg, now that it has secured its own budget, is trying to raise money for the "headquarters" in Ouagadougou, to allay the misgivings of the Burkinabe and other francophone colleagues. But certainly the filmmakers place larger hopes on South African connections. As noted by FEPACI secretary Bulane-Hopa, "Huge expectations put on us by fifty-four countries in Africa . . . call for enormous finances, infrastructure support and human resources."[7]

To the extent that black South African producers, directors, and technical professionals gain a more secure foothold in the cinema and broadcasting industries of their country, the linkages to other sub-Saharan countries may well produce a general amelioration in production conditions. Collaboration has already started on a small scale. Souleymane Cissé, Jean-Pierre Bekolo, and Idrissa Ouédraogo completed feature films in Zimbabwe and South Africa, with South African crews and casts and soundtracks in English.[8] The development of such relations will not necessarily cast a shadow on the existing ties with France and the European Union. French cultural aid, now administered by the Ministry of Foreign Affairs, is no longer tied exclusively to the francophonie and embraces a global strategy of support for all national alternative cinemas; the South African link may be welcomed as a bridge to English-speaking countries. In South African festivals and cultural events, French cultural centers enthusiastically promote the independent cinemas of the global south that have benefited from grants from Fonds Sud Cinéma. *Zulu Love Letter* (dir. Ramadan Suleman, 2005), a South African film lauded as a possible artistic forerunner of a new, Africa-oriented style, received French

and European Union funding, and Suleman himself had worked in the past with Med Hondo and Souleymane Cissé.[9]

Finally, television programming achieves a better mix of imported fare and local productions than theater distribution. Local dramas capture more airtime not only because of the quotas that the government incentive schemes impose but also because they receive higher ratings from audiences. This is true in South Africa and in the other countries of sub-Saharan Africa (as well a broader trend worldwide).[10] This development provides a framework for understanding the growth of Nollywood; it had started with the desire to emulate TV soap operas and flourished when, for a variety of reasons, theaters closed down and TV programming declined in Nigeria. Seeing these video dramas as ersatz TV also points to possible scenarios in the future. Digitalization is leading to the convergence of all communication into a single platform. The internet has created Web TV, film distribution is moving to the phase of broadband delivery, cell phones are turning into mobile TV sets. All these changes are well advanced in sub-Saharan Africa. Industry representatives in South Africa are calling for a niche of extra-low-budget films that rely more decidedly on DVD sales—in effect, the Nollywood model. Will the genre distinctions we know survive when African Film Library and Nollywood dramas become available as choices made at the touch of a button?

African francophone cinema emerged from intricate historical connections, including the colonial heritage, the local and global postcolonial experience, and the economic and technical exigencies of celluloid film production. Now in a transformed world it is moving ahead in uncharted ways: from the new generation of high-end, internationally successful (and supported) filmmakers, to locally funded projects responding to anchored sensibilities of what may become national cinemas, to the new internationalism emerging from collaboration with South Africa and the English-speaking world. One artist presages perhaps the hybrid meeting point that may be one aspect of the foreseeable future. Jean-Pierre Bekolo's spirited camp has an undeniable affinity with the video products coming out of Nigeria and elsewhere, though clearly it also incorporates a different kind of discernment and artistic intelligence. It may nonetheless be the prototype for a kind of film that will be finished on a laptop, receive the imprimatur of a new FEPACI, be delivered by broadband, and viewed on a mobile TV.

Mahir Şaul is a Professor of Anthropology at University of Illinois Urbana-Champaign. His research spans two world areas, Africa and the Middle East and considers household organization, economic and political history, the transnational movement of people and ideas, and language and visual arts in their social context. On the heels of an African

film festival in Urbana, Illinois, he curated in 2012 a high profile African film series for the Istanbul Museum of Modern Art in Turkey.

Notes

This selection was originally published in Mahir Şaul, "Art, Politics, and Commerce in Francophone African Cinema," in *Viewing African Cinema in the Twenty-First Century: Art Films and the Nollywood Video Revolution*, ed. Mahir Şaul and Ralph A. Austen (Athens: Ohio University Press, 2010), 133–159.

1. Pierre Barrot, *Nollywood: Le phénomène vidéo au Nigeria* (Paris: L'Harmattan, 2005), 41, 61.

2. Lucia Saks, "The Race for Representation: New Viewsites for Change in South African Cinema," in *To Change Reels: Film and Film Culture in South Africa*, ed. Isabel Balseiro and Ntongela Masilela (Detroit: Wayne State University Press, 2003), 148–49.

3. Willem Kerkhoven, "Making Cinema in South Africa: Interview with Five Young Film Makers," *Kunst*, November 20, 2007, *Africaserver magazine*, http:// www.africaserver .nl/magazine.htm?taal=nl&art=a20071119171322505.

4. Gauteng Film Commission, 2008 *Gauteng Film Indaba: Summary of Proceedings*, 36, http://www.gautengfilm.org.za/live/content.php?Item_ID=754.

5. Saks, "Race for Representation," 134.

6. Ibid., 144. New Directions is a significant training program organized by M-Net to foster new directors and screenwriters from among the disadvantaged (Coloured and black) groups.

7. Seipati Bulane-Hopa, "The Challenges of Formalising Cinema in Africa," interview by Ogova Ondego, Southern African Curriculum Symposium, July 31–August 1, 2008, http://artmatters.info?p=601. Art, Politics, and Commerce in Francophone African Cinema

8. Mbye Cham, "African Cinema in the Nineties," *African Cinema Quarterly* 2, no. 1 (1998), http://web.africa.ufl.edu/asq/v2/v2i1a4.htm.

9. Jacqueline Maingard, *South African National Cinema* (London: Routledge, 2007), 166.

10. Saks, "Race for Representation," 144–45; Peter Davis, review of *To Change Reels: Film and Film Culture in South Africa*, ed. I. Balseiro and N. Masilela, *HSAfrica H-Net Reviews*, February 2004, http://www.h-net.org/reviews/showrev .php?id=8906.

FESPACO 2019: Moving Toward Resurrection

Olivier Barlet
Translated by Chloe Farrell

The twenty-sixth edition of the Pan-African Film and Television Festival of Ouagadougou (FESPACO) was intended to be both a celebration of the festival's fiftieth anniversary and an attempt at rejuvenation. In the following, we take a critical look at the twenty films of the feature-length film competition. Other articles are to follow concerning the documentary films and the conference.

For this twenty-sixth edition and fiftieth anniversary of the festival, it was essential to celebrate with fanfare that which has endured and continued to embody a Pan-African idea of cinema. And this is what came to pass. Self-congratulation was the norm when it came to the speeches given and the fireworks of the opening ceremony. An awareness of the steady decline since 2009, the year of the "Fespachaos," was nevertheless noticeable. The sponsors lobbied for artistic supervision of the programming and the conference prepared by Gaston Kaboré focused on the festival's sustainability. Of course, the goal was to save this festival, which is so essential to the visibility and quality of African cinema.

There were, however, recurring organizational problems with the festival. Linked with bureaucracy and cash-flow issues, they were a detriment to the management of transportation and of housing for the guests. Faced with an influx of guests, the partnership with Morocco Air did not go as planned. Many festivalgoers did not receive their tickets in time or if they did, they received them very last minute. The distribution of badges was again chaotic, and the catalog (finished and correctly printed this time) was late. But this was not the root of the problem. Indeed, the fear is that FESPACO is no longer capable of taking into account—in terms of cinema—that which is most pressing in Africa today. It is clear that a rupture of this sort with the socially engaged cinema of the older generation, from Ousmane Sembène to Djibril Diop Mambéty, would be just as harmful to FESPACO as to the consistency of African filmmaking itself, considering that the festival plays an essential role in showcasing Pan-African talent.

Notably, the attendance of Western journalists this year was limited and was accompanied by a certain disaffection from the inhabitants of Ouagadougou themselves, considering that the entry price remained set at one thousand Fcfa, the general pass was twenty-five thousand Fcfa (about $43 USD), and that the language question had not been resolved. It was seen in a lack of subtitles in French, but it also begged the question of which version should be shown at a professional festival, given that the IMACA (International Market for African Cinema and Audiovisuals)[1] does not yet organize English language screenings for international buyers, as is done in more established festivals. Yet a growing number of free, open-air screenings in Ouagadougou's neighborhoods and in nine cities in Burkina Faso have been established, thanks to the organization Cinéma numérique ambulant (Traveling Digital Cinema), with the hope of reestablishing the festival's widespread success.

The selection at FESPACO 2019—clearly superior to 2017's disaster—was nonetheless rife with ambiguity reflected in the list of award winners. As a rule, programming is concerned with balance and diversity. Considering that FESPACO is biennial, it pulls from two years of cinematic production and ultimately has a wide range of choices for the selection. This year, advisers from various countries were called upon, yet artistic standards remained unclear. For example, *I Am Not a Witch* (dir. Rungano Nyoni, 2017, Zambia) was demoted to Panorama,[2] and many excellent films—often superior to those in competition—were not selected. Notably, from Algeria: *En attendant les hirondelles / Until the Birds Return* (dir. Karim Moussaoui, 2017), *Les Bienheureux / The Blessed* (dir. Sofia Djama, 2017), *Revolution Zendj / Zendj Revolution* (dir. Tariq Teguia, 2013), *Vent divin / Divine Wind* (dir. Merzak Allouache, 2018); from Egypt: *Yomeddine* (dir. Abu Bakr Shawky, 2018), *Sheikh Jackson* (dir. Amr Salama, 2017), *Les Derniers jours d'une ville / The Last Days of a City* (dir. Tamer El Said, 2016); from Morocco: *Sofia* (dir. Meryem Benm'Barek-Aloïsi, 2018), *Volubilis* (dir. Faouzi Bensaïdi, 2017), *Headbang Lullaby* (dir. Hicham Lasri, 2017), or *Jahilya* (dir. Hicham Lasri, 2018); from Mozambique: *Convoi de sel et de sucre / The Train of Salt and Sugar* (dir. Licínio Azevedo, 2016)); from Chad: *Une saison en France / A Season in France* (dir. Mahamat-Saleh Haroun, 2017); and from Tunisia: *Vent du nord / North Wind* (dir. Walid Mattar, 2017), *The Last of Us* (dir. Ala Eddine Slim, 2016), *Mon cher enfant / Dear Child* (dir. Mohamed Ben Attia, 2018).

Like half of those selected in competition, these films have already been shown in festivals and in theaters. At the international level, innovation is expected from FESPACO, which would imply the presence of world premieres at the festival, thus establishing its renown and importance. The acquisition of film rights before other festivals is a difficult process, which requires constant monitoring of current productions and negotiation; yet

this would also act as an impetus for directors to finish their films in time for FESPACO.

New Aesthetics

In order to respect and maintain the magic of the cinema, a large international festival's selection for competition must include works that are accessible to the general public, without leaving behind aesthetic considerations that stimulate and revitalize cinematography itself. This delicate balance was successfully maintained this year, illustrating that, as Christiane Taubira noted in her talk, "It is possible to reconcile substance with form, the content with beauty, the message with aesthetic." Indeed, there is nothing that puts mainstream cinema in opposition to art-house cinema, if not the occasional film that proves puzzling to audiences increasingly conditioned by mainstream commercial media. But since when must we question the intelligence of the audience? They do not seek mere amusement, but reflection which can lead to emotion.

Three films that offered unexpected and unconventional approaches to filmmaking were absent from the list of award winners—starting with my very favorite: Peter Sedufia's *Keteke* (2017, Ghana). The film follows the story of a man and a woman, completely secluded deep in the bush, following the railway tracks. Atswei (Lydia Forson) is pregnant and Boi (Adjetey Anang) carries a suitcase bearing the word "Musik." Having missed the weekly train, they must walk to the next station to get to Ateke, where Atswei can give birth surrounded by her family. Their travels are accompanied by music. Rhythmic song and drums are heard each time they run to catch a passing train or when they are frightened by an enormous bush rat! This film is both serious and absolutely hysterical. The couple is constantly fighting and reconciling, making jokes that touch upon all the conflicts that can arise in the course of a marriage. From time to time, the shadows of their silhouettes in the sky evoke a marionette theater.

The film's rhythm builds progressively with each unexpected encounter. They barely escape a witch's trap, which leads up to the pivotal scene in which Atswei gives birth. This scene is simultaneously both incredibly funny and incredibly moving. The music once again plays an important role. Edwin Acquah & Sponkeys perform a cappella, while the rest of the music was created for the soundtrack. Sedufia, studied at the NAFTI, the excellent film school based in Accra, where he rallied his fellow students to act in and provide technical support for the film. Yet the two main characters, Atswei and Boi, are professional actors, who command the screen throughout the entire film. Although it had a limited budget, *Keteke's* simple and effective screenplay—coupled with a beautiful mastery of image—proves that creativity is not a matter of funding.

What's more, *Keteke* (which means "train" in the Akan language) is much more than entertainment; it addresses gender relations with subtlety. Boi does not listen to what his wife tells him; instead, his reactions are consistently dictated by his need to have the last word. He gets what he wants by asking her to do things for the baby—the ultimate argument. Written collectively with fellow producer and film editor Laurene Manaa Abdallah and other colleagues from the NAFTI, *Keteke* opens up the debate while remaining both a visual and sonic pleasure.

In this way, creativity is not a question of budget—a concept which is also confirmed in Hajooj Kuka's delightful film *aKasha* (2018, South Africa). It was shown at Film Critics Week at the Venice International Film Festival, at the Toronto International Film Festival, and at the Marrakech International Film Festival. The film takes place in Southern Sudan and highlights the same fear of bombs dropped from Russian planes that the director documented in *Beats of the Antonov* (2014, Sudan), but this time with a healthy dose of humor, satire, and cheekiness. It is the akasha, the moment in which the rebel soldiers round up those who did not return to battle after having gone to help their families in the field during the rainy season. Adnan boasts that he is a hero, claiming that he believes in the revolution. His affections are torn between his beloved Lina and Nancy—his kalashnikov. But it is Lina who delays him as he attempts to flee the akasha. The garrulous captain Kuku Blues pursues them with his unit, in large part because he wants his chess partner back; the men don women's clothing to escape him, but the women are more than happy to point them out; and when Adnan makes Lina jealous, she says that she will make do with a banana! These comical scenes mock the wartime logic in a conflict that seems neverending, even as the young recruits think only of love. Produced by South African Steven Markovitz, all aspects of the film are masterful (image, rhythm, sets, and acting). The film is undeniably quirky, and the scenarios that it depicts are far-fetched, bordering on fantasy, and even include a moment of 2D animation. This being the case, the film nevertheless makes use of cultural resources and local norms, ending with songs and dances that bring together the village community.

On the other hand, Burkinabe director Issiaka Konaté's *Hakilitan / Memory on the Run* (2018) stagnates beneath the weight of its metaphors and its serious tone. After the flooding of the African film archive in Ougadougou, it tells the story of a professor with amnesia who, little by little, returns to life. Mr. Cinema will come face-to-face with rituals carried out by a spiritual guide accompanied by gothic women in the ruins of what was meant to be a movie theater near the FESPACO headquarters, the construction of which was interrupted by a fire (in addition to being poorly located in a sacred woods). The film is all over the place, much like memory itself. As Konaté explained in our interview, he constructed the film in fragments, based off

of happenstance encounters. He was guided by Bambara mythology and Sri Aurobindo's Indian spirituality, which led him to turn the film into an ode to tolerance, without which the film would risk returning to primitivism and sinking into the swamp of ignorance. Its presence indicates a strong belief in progress on the director's part but also a deep concern for the loss of humanity with the advent of new technology. Mr. Cinema teaches because knowledge must be passed down. The world may change, but responsibility and fidelity remain benchmarks. In the film, these values are embodied in Djata's character; his knife suggests a determination to defend them. The richness of its renderings makes this film captivating, yet it struggles to maintain this energy in its more dreamlike moments.

Self-Image

During the conference, Taubira quoted Guadeloupian poet Alvert Béville, alias Paul Niger, saying: "Africa rises up before humanity, without hate, without reproach, no longer asking but asserting." Cinema as a vision, as a way of seeing Africa and the world at large was palpable, that "self-produced image of Africa resisting that which is forced upon us by the world at large" was the essential question set forth by Aminata Dramane Traoré at the conference.

With general agreement thanks to the film's quality of introspection concerning history's tragedies, first prize, the Golden Stallion, was given to Joël Karekezi's *La Miséricorde de la jungle / The Mercy of the Jungle* (2018), and star Marc Zinga won the prize for Best Actor. As Rwanda was the guest of honor this year, President Paul Kagame attended the awards ceremony. He was obliged to participate, even as the film goes against the official Rwandan discourse. Indeed, it is set in neighboring Congo, where in 1998 the Rwandan army was carrying out operations during the second Congo war, fighting for the region's mineral riches. This is common knowledge, and the trauma inflicted by the army commander's abuses is unspeakable. Thus, the film takes on the challenge of reflecting on exerted violence, with the hope of a spiritual healing to facilitate the construction of a more peaceful future.

In 1994, Karekezi was eight years old. When his father was murdered, traumatized by what he had witnessed, Karekezi sought refuge in Kivu with his sister. His first film was self-produced and touched upon the genocide: *Imbabazi, the Pardon* (2013, Rwanda). In his second feature-length film (*The Mercy of the Jungle*), he developed the theme of mercy for the creation of a peaceful future with a story that is simple but full of unexpected twists—two soldiers must help each other to survive in the jungle, fleeing the madness of war and their own demons.

The confrontation with the wildness of nature, as well as the evolution of the relationship between the two men, prove to be initiatory. They grow together in conscience and in depth of spirit. The audience finds themselves immersed alongside these two men in a sensory experience—that of a captivating yet hostile jungle. The absurd cruelty of war is highlighted even more strongly by its contrast with the overwhelming beauty of the environment. The soundtrack and Line Adam's subtle musical style reinforce this apprehension. In this way, Karekezi goes beyond the Congo-Rwandan context to attain the essential: that which allows a human being, lacking any point of reference, to imagine a future.

This extremely masterful film benefits from the help of a successful international coproduction and an excellent artistic and technical team. The narrative contains vibrant moments of humor and profound interactions, without being overshadowed by dialogue. Instead, the story places emphasis on the human condition and on a movement away from the self. Filming was exhausting; at times, the forty-person team had to carry their equipment because there were no nearby roads. But it was also blessed with rare sightings, such as an encounter with a gorilla! It must be noted that the film was shot in Uganda, near the Congolais and Rwandan border, where expeditions permit gorilla observation.

The Mercy of the Jungle—both an inner journey and a manifesto for a new humanity—is convincing because of the distance it establishes between its subject matter and its protagonists. It maintains a tension that captures the audience's interest without falling into the obviousness of genre film. What's more, it reveals the vulnerability of those who would like to believe themselves impervious, and it values introspection when faced with the violence of history and the upheavals of this world.

Sol de Carvalho's *Mabata bata* (2017, Mozambique) won two well-deserved prizes—Best Cinematography and Best Editing. It tells the story of a dead man who observes the living as they attempt to ask forgiveness for the violence they have inflicted. During the ceremonies on November 11, which mark the hundred-year anniversary of World War I, one imagines the pastor going into a trance, brandishing a fly swatter, and calling upon the dead to beg their forgiveness. Considering the bloodshed of that war, he has his job cut out for him. Such is the relevance of this narrative adapted from a short story by the great Mozambican author, Mia Couto, who thus evokes the civil war's dead. The refined style and the aesthetic beauty of the film culminate in this brilliant narrative, serving as an example of a film that is deeply anchored in the Mozambican culture but that tackles issues that affect all of humanity.

Death was a central theme of the winner of Best First Film, *Until the End of Time* (2017), as well. This film came to FESPACO having already won awards and having represented Algeria at the Oscars. It was made by the daughter of

filmmaking couple Yamina Bachir Chouikh and Mohamed Chouikh, Yasmine Chouikh. Paradoxically, the success of this young director's first feature-length film is due to her subtle depiction of the relationship between two senior citizens, thus affirming that love knows no age. Indeed, in the film, affection develops between a suicidal sixty-year-old widow and an elderly gravedigger. The story unfolds in Sidi Boulekbour, in what can be considered an open-air theater of death—a graveyard and its surroundings. Young Nabil's character hopes for a neverending pilgrimage and pulls out all the stops to sell a full package, complete with hired weepers and a contract for funeral preparations. This modern worldview contrasts sharply with the careful modesty of the older generation—a comparison that is touched upon with humor and subtlety, especially considering that the older generation is in the process of coming back to life. The same dynamic is at play when the bricklayer-poet Jeloul falls in love with the beautiful and liberated Nassima. In the film, women are not judged by their appearances, and even the Imam is cool. This touching comedy—constructed as an ode to life between tombstones and within a tolerant community—is an optimistic satire about an Algeria haunted by death but hoping to be reborn, where "there is no shame in living one's dreams."

Wanuri Kahiu's *Rafiki* (2018) was shown at the Cannes Film Festival and is memorable for having been banned in Kenya for its focus on a romance between two young women. Samantha Mugotsia won a well-deserved award for Best Actress; she lights up the screen and brings cohesion to this film that strives to be young, musical, and widely appealing in order to spread the idea of a joyous and natural queerness that works against prejudices.

Abdoulaye Dao and Hervé Eric Lengani's *Duga* ("vulture" in bambara) (2019) is another film in which self-examination is successful. It was the only one of the three Burkinabian films in competition to navigate this effectively. It situates itself in the tradition of Pierre Yameogo's films, in which humor and social critique are intrinsically intertwined. The film features the hilarious Abdoulaye Komboudri, who must transport a coffin that no one wants. Dao is known for his television series—most notably *Vis-à-vis* (2004)—and in the film, he makes use of these same actors and tricks to move into the realm of cinema. The film oscillates between an abandoned baby and a dead person who no one wants to bury. Situated between life and death, a whole society is called into question. The narrative sets up situations in which the cynicism and hypocrisy of a few individuals endanger the entirety of the social fabric: money corrupts society, religious communities fold in upon themselves, government services lose all humanity. The open-mindedness and solidarity of a group of marginalized young people permits them to salvage their society in the face of the older generation's obsessions. They are vultures; they scavenge everything for reuse. Their land is filled with recycled objects. They are the future of their country.

We find this same sense of hope in the transgressive youth of *T-Junction* (2017, Tanzania), a film by Amil Shivji, whose documentary collaboration with Rebecca Corey, *Wahenga / Ancestors* (2018, Tanzania), was shown in an exclusive screening at FESPACO. It tells the story of a group of musicians who play zilipendwa, a nearly forgotten style of music that blends jazz and highlife. Apart from Nigeria, Tanzania is the largest producer of film in Africa, producing approximately five hundred films a year, which are filmed in Swahili. This film in particular is notable for its quality, and has thus made the rounds of film festivals. In *T-Junction*, Fatima's father has just passed away. She does not mourn him—he was already nearly gone. She meets Maria at the hospital where she goes to cure her fever, and Maria tells her her story. The film is constructed around the opposition between the emptiness of Fatima's life and the fulfillment that Maria has found—having joined a group of street vendors who gather around their kiosk, and with whom she has found a community. This group is chased and attacked by army commandos, whose job is to "clean up the streets," yet they have that which Fatima lacks—namely, community, solidarity, and freedom. As Maria tells her story to Fatima who, fascinated, comes back to hear more, the personalities of these marginal and forthright people who live such exciting lives come into focus. The film is interspersed with beautiful, poetic moments that ultimately culminate in the burgeoning romance between Maria and the shy Chine, a man who knows by heart the headlines of all the newspapers he sells in the street.

In these three films, those who transgress the norm are those who have understood life, offering the audience an emancipatory way of viewing the world.

The Cameroonian director Jean-Pierre Bekolo used an Aimé Césaire quote for his title *Miraculous Weapons* (2018), which fits into the same line of thinking as "that Africa which no longer asks but asserts." In this film set in the 1960s, three women are in love with a prisoner who awaits his execution, hoping to become immortal with the sensuality of poetry—that weapon of hope. This South African coproduction shifts between English and French and highlights the importance of words—those "windows on the world"— in the face of death. The prisoner, Djamal Okoroko (Emile Abossolo Mbo), receives a visit from each of the three women—his wife (who comes to the prison by bike), his lover (who comes in a red car), and a French teacher (who comes in a bright yellow car). As the three women are in love with him, they learn to overcome their mutual distrust in order to join together. The reason that Djamal wants to learn French is to use it against the colonizer, just as the Negritude poets did before him. But isn't it too late? Not if we believe that the sensuality of words and images allows death to be transcended. As he says, "I dream of a place where no one must die to save us. We must learn to save ourselves; we must learn to be immortal." To achieve this, one must look

deep within oneself, as suggested by Valérie Ekoumé's lyrics in the opening sequence of the film: "If each of the stars in your sky goes dark, if they disappear one by one, remember that by closing your eyes, you will find a glimmer of hope." The main character searches for this glimmer through his relationship with these three women. His wife Leseli (Xolile Tshabalala) is his reflection: must he seek her out within himself? At any rate, he needs both the knowledge that he discovers in his interactions with Laurence (Maryne Bertieaux) and that which he finds by exploring his fantasies and learning French with Stéphanie (Andrea Larsdotte) in order to understand the texts he is reading. This film against the death penalty, *Miraculous Weapons*, is also a metaphor for black expression—imprisoned, oppressed, and ultimately asking the question if culture can save it.

In her talk, Taubira underlined the idea that the mission of the seventh art is to "revitalize origin stories as they have been conceived, constructed, established, and transmitted throughout the African continent and throughout the rest of the world." And thus is the project taken on by *Barkomo / The Cave* (2019) by two young Malian filmmakers, Aboubacar B. Draba and Boucary Ombotimbe, who adapt a Dogon legend about a young woman who, having been thrown out for being infertile, is taken in by a king. Filmed in Mora, Ombotimbe's hometown, the film benefits from the stunning backdrop of the Bandiagara escarpment. It is inspired by a desire to pay homage to Dogon culture, without seeking to situate it in a contemporary context. Nevertheless, the story of the cast-out woman, discussions of left-handedness, and superstitions is relevant to the present moment. "It is better to sleep with snakes than with a sterile woman," the hunter says to Yamio, his wife, who has attempted all sorts of sacrifices to have a child. A second wife fulfills his desire for a child, yet he continues to despise the first wife, ultimately leading to her attempted suicide. "An exhausted woman will come. She holds the secret," the rainmaker and hunter of thieves says to the king of a far-off village, words that will become an established legend. Yamio is taken in by an old woman and, finally pregnant, gives birth to a left-handed, but gifted and adored, child. As an adult, he will defy the rules and leave in turn to establish another village.

The film was made for less than two million Fcfa—money that went toward transportation and materials for the film; the actors worked for free. Both directors are just starting out, have no backing for their work, and had to take on many of the production roles because of lack of funding. In keeping with the times, they had initially wanted to make a television series. When asked about their intentions behind the film, they note their desire to pay tribute to the cave in Barkomo, which historically served as both a storage space and as a refuge during tribal wars.

What are the stakes of such a film if not to assert that Africa is, in the words of Felwine Sarr in his 2016 book *Afrotopia*, "the spiritual lifeblood of the world"? Because it is indeed an "increase in humanity," as Achille Mbembe says, that these films propose through their plans to add to what Alioune Diop calls "the density and the maturity of human consciousness." It is about asserting an African perspective to consider a more humane alternative to progress, one that moves beyond mere exploitation and pursuit of profit.

Ambiguities

In this way, at this fiftieth anniversary these films follow in the footsteps of their acclaimed predecessors. However, although certain films in competition situate themselves within this same spirit, they do not escape ambiguity.

This is the case with Moroccan filmmaker Selma Bargach's 2018 movie *Indigo* (which won a prize awarded by the Federation of African Critique— an organization that sponsored an international workshop again this year and published four editions of an exciting critical bulletin, "Africiné," which can be found on africine.org). This film follows the story of a thirteen-year-old girl with unexplained supernatural powers. The film's intention is to promote respect for difference, starting with children's imaginations when faced with many forms of social conditioning. Yet, the film must resort to fantasy to achieve its ends.

Indigo is, first and foremost, from Nora's perspective, that of a thirteen-year-old girl who struggles to understand what is happening to her in a world that neither listens nor understands. She is surrounded by her mother, Leïla, who hopes to join her husband in far-off Australia; her half-aunt, Mina, who flits from man to man, hoping to find her soulmate; and her brother Mehdi, who mistreats her because he is jealous of her powers. The color indigo, from the title, refers to the aura that children gifted with clairvoyance and hypersensitivity possess. Yet Leïla does not believe in this, dragging Nora from psychologist to psychiatrist, all of who repeatedly diagnose autism when confronted with the young girl's intuitions. But the more these intuitions prove accurate, the more the film and this supernatural world fascinate the audience. In the film, special effects work to emphasize Nora's uniqueness. Nevertheless, this budding clairvoyant is frightened of her gift, and because those around her are so closed off to her internal world, she puts herself in danger when she uses it.

Although the film deals with the theme of imagination confronted with the norm, what interests Bargach is the suffering that this provokes. Neither Leïla, Mina, Mehdi, nor the medical system understand her. It is ultimately

Nora who resolves the problems with her relationships on her own. Set in Morocco, where rationality and ancestral beliefs still coexist, the film never questions the supernatural phenomena that it depicts, instead becoming proof of the strength of childlike imagination. It does so with grace, but the risk nonetheless affects the credibility of Nora's journey of self-discovery.

Winner of the third prize, the Bronze Stallion, (and the Golden Tanit at Carthage's Cinema Days three months earlier), Mahmoud ben Mahmoud's *Fatwa* (2018, Tunisia) is a well-constructed narrative in which a father discovers that his son has fallen into the trap of jihadism. In the film, Brahim returns from France to bury his son Marouane, who died in a motorcycle accident. His ex-wife is involved in the political movement against the Islamists, who are threatening her for having written a book called *Fatwa* on the subject. Little by little, Brahim learns that, before his death, his son had quit school, left the family home, and criticized his mother who—as a member of parliament—had published a book against the Islamists and attacked them in a speech given at the National Assembly. The film follows this grieving father in a search that will reveal, little by little, that his son had fallen into the trap of religious extremism, and that his death is suspicious. This well-constructed film, with remarkable acting, builds tension from the very beginning. The plot maintains moments with successive plot twists that lead up to the final scene. The fundamentalists prove to be unscrupulous, brutish obscurantists who are portrayed in opposition to the brave individuals who want to live in peace as before. It is this categorical binary that is troublesome in a film that is otherwise rich in subtleties, though it is nonetheless complicated by the story of a woman whose assault impelled her to become a defector.

The prize for Best Script went to Tunisian director Néjib Belkadhi's *Regarde-moi / Look at Me* (2018), who wrote the script himself. This film is very different from his previous films *VHS–Kahlucha* (2006) and *Bastardo* (2013). He tells the story of a father who must return to his country to take care of his nine-year-old autistic son after the death of the son's mother. As he is unable to establish a visual connection, Lotfi (Hidhal Saadi) keeps trying in order to bond with his son (hence the title), and struggles to accept him as he is. It is this contradiction that causes the character, as well as the film itself, to evolve; there are moments where his character is open to listening, but more often than not, he forces his son to make progress at any price. The film is, in fact, very ambiguous, though this is not necessarily a flaw, as it is invigorating and creates food for thought. Lotfi's wife is in France and is pregnant with his child. He is thus torn between two states of fatherhood, between two responsibilities, and is not—as is often the case for this film—in the process of reestablishing a paternal instinct. He employs exercises designed for autistic children in order to stimulate their attention—physical contact,

lights, colors, etc. Ultimately, the use of a video camera introduces an outside perspective which fractures their relationship; it severs the emotional bond that was forming based off of the main character's desperate attempts to break through the distance between them. This is no doubt a theoretically good idea in the film, though it detracts from the clarity of the subject at hand.

Lotfi navigates between two worlds—France and Tunisia, but also between "normalcy" and autism. Ultimately, his son leads him to abandon his sexism and disrupts his previous way of being. Throughout the story, the son gains, little by little, the status of personhood. From then on, the film leads the way in the fight for autistic people's rights, moving away from their status as victims.

However, the ending of the film discusses more than one social cause. When Lotfi left to live in Marseille, he abandoned his Tunisian family. Thus, Lotfi navigates ideas of guilt, forgiveness, and the capacity to change, through the many challenges he faces in this eventful narrative. In his own country, his son opens a new chapter of his life. The film's success in Tunisia is thus linked not only to its sincerity, but also to the assertion of an anchoring— speaking out against the exodus of young people leaving to find their fortune elsewhere.

Until now, FESPACO has seldom represented Nigeria, whose nearly two thousand feature-length films produced each year reach anglophone and francophone countries via DVD, often accompanied by slapdash translations. Since the birth of the Nollywood phenomenon in 1992, a full-fledged industry has developed, with its own stars and media, its own festivals and television chains, and streaming services that allow the diaspora to enjoy it as well. Nevertheless, its films are generally so far removed from cinematic creation that it is rare for a film to be circulated internationally. 2017's *Hakkunde* (meaning "in-between" in Hausa, but also similar to its main character's name, Akande) is autodidact Oluseyi Asurf Amuwa's first feature-length film. He took charge of camerawork and sound mixing, while also managing to avoid the usual issues of overacting and rushed production times meant to turn a profit. Rather, there is a sensitivity mixed with humor in the relationships between characters, especially when it comes to seduction. Financing for the film was originally a crowdfunding campaign launched by his friends on Facebook and Instagram. It funded just ten percent of the film, but allowed the rest of the funding to be found. The film provides a critical social look at Nigeria's thirty million unemployed people, and spreads a positive message about the possibility of attaining success with one's own capacity for resourcefulness. What's more, the film begins with a quote from Jack Canfield: "Everything you want is on the other side of fear."

Akande, an unemployed college graduate, doesn't know how he is going to make it. Hounded by his sister and left by his partner, his only choice is

to explore the possibility of subsidized cattle breeding. When he arrives in the village, he finds himself struggling to understand the Hausa language, but meets Aïsha, who was cast out for witchcraft because all of her husbands have died. Akande ultimately manages to start a business by investing in a local product—cow dung—which he packages and sells as fertilizer. With comedian Frank Donga in the leading role, emphasis remains on the comedic aspect of the film, an aspect that is kicked off in the beginning of the film by a delightful slow motion action sequence, in which Akande escapes his pursuers and knocks over a saleswoman's eggs. Thus, Akande becomes successful in business, from which stems the ambiguity of this well-constructed film. The end insists on the necessity of believing in one's dreams, which is to say, the individualistic solution to unemployment—becoming a businessperson.

The award for Best Music went to *Sew the Winter to my Skin* (2018) by South African filmmaker Jahmil XT Qubeka, whose black-and-white film about an obsessive student-teacher relationship, *Of Good Report*, was banned in 2013, even as it was meant to be the opening film at the Durban International Film Festival. Qubeka's most recent film (*Sew the Winter to My Skin*) is in the style of a Western—epic, lyrical, almost entirely without dialogue—and follows the hunt and capture of John Kepe, a Robin Hood figure from the 1950s who is still considered a hero today. The film reveals the contradictions in the myths that structure South African thinking. In order to do this, Qubeka chose an overly simplistic representation and aesthetic, which had the effect of moving the film farther away from its subject matter. Indeed, he replaces dialogue with camera effects and framing, strong music and a pervasive soundtrack, yelling, prayers, chanting, and on-screen text (a journalist wearing glasses types the story of Kepe's trial for having stolen cattle and provisions from white farmers to give to impoverished indigenous people.) Newspaper headlines, the news, and letters complete this written component of the film, which leads back to reality even as the content of the film is offbeat—the audience is asked to distinguish between the official discourse of the time and the facts seen from Kepe's perspective. This rewriting of history conserves the impressive memory of an extraordinary man who named himself Samson. He is a man who, with incredible determination, set himself the task of transporting a stolen sheep in difficult conditions while trying to escape his pursuers.

Which Africa?

As Aminata Dramane said, "What I see here as film decor—I do not see Africa. I see stories and images that say nothing. If they are going to serve the youth as a point of reference, we'll live to see the consequences! Opulent

armchairs, unbelievable curtains … I'm furious when I see these lost opportunities to create an environment that shows the youth an Africa that loves itself, whose production has a relationship with the craft industry." The Burkinabe people are moving in that direction, once again happily wearing clothing made with traditional cloths as during the Sankara era—the Koko Dunda's colored brushstrokes being the preferred pattern. Yet Ivory Coast filmmakers Boris Oue and Marcel Sangné's film *Resolution* (2019) takes place admittedly in an incredibly bourgeois community. This brutal story of sexual harassment and abuse within a couple—aggravated by an exorcist grandmother and a drug addict son—struggles to hide its ugliness beneath its supposed feminist intentions in a moment in which the entire world resonates with #MeToo revelations. We wait the entire film for some kind of resolution, in both senses of the term: a resolution for the beaten woman who does not report and thus condemn her husband's treatment of her, giving him second chances until she finds herself stuck—"when two trees fight, their roots intertwine"—and the resolution of a film which does not manage to find a necessary distance from its subject matter. Though of course, the resolution referenced in the title can be found elsewhere: in the determination to speak openly about these issues in the public sphere. The film ends by showing scenes of protest—"my body is not a drum." The problem is that the film speaks out on these issues rather than illustrating this resolution; the resolution takes place only after many scenes of torture.

When faced with a film of this sort, cinema itself is at issue. The way that the film treats its subject matter, as well as its content, reproduces the dominant narratives available on all the world's channels—emotion is replaced by either violence or sentimentalism, characters are stereotypes, and thought is impossible when complexity is absent.

Apolline Traoré is a great Idrissa Ouédraogo devotee and dedicated her film to him. Her film *Desrances* (2018, Burkina Faso) won the prize for Best Stage Design, an award that she perceived as a slight, considering that she had already imagined herself brandishing the Golden Stallion. This disappointing thriller is set during the first days of the war of 2012 in the Ivory Coast and tells the story of a father who finally recognizes his daughter's courage. Francis, a Haitian man, witnesses the massacre of his family by the military dictatorship's troops during the American intervention of 1994, which reinstated President Aristide after having been ousted during the coup d'état of 1991. The film depicts him in his ancestral home country, the Ivory Coast, where he has made a life for himself managing an electronics store. Already traumatized by his experiences in Haiti, he finds himself once again in the midst of a violent civil war, but this time his wife is pregnant with a son who he names Najak (the messenger).

When his wife and son are captured by thugs taking advantage of the problems linked to strict immigration policies, he disregards curfew and goes in search of them because he is obsessed with the transmission of his name. Francis calls himself Desrances, after Lamour Desrances, the Maroon slave who worked in opposition to Toussaint Louverture and Dessalines, and became an officer in Napoleon's army—hence, an exiled individual who chose the wrong camp. But politics are of little interest to Traoré. The focus of her film is on the consequences of the war for civilians, and on a young girl's struggle to be recognized as an equal to men. Haïla, must become a hero at only twelve years of age in order to earn her father's trust. Nevertheless, he ultimately loses his mind.

All this would work well if the film didn't stray into the implausible and the sentimental, not counting the caricatural thugs and a pervasive use of spectacle to hook the audience. The three films in competition from Burkina Faso benefitted from a remarkable grant of a billion CFA francs intended to help them get back on a prizewinning path and reclaim their status on the international film scene. *Desrances* benefited from three hundred twenty-five million, which came to the rescue of her budget of seven hundred million.

Winner of the Silver Stallion and prize for Best Sound Mixing, *Karma* (2018, Egypt) by Khaled Youssef (who is also member of the Egyptian parliament) was showered in accolades despite the lack of interest that it was met with in his own country, where many critics chose instead to see the most recent Ahmad Abdalla film *EXT. Night* (2018), which was selected for competition at the Louxor African Film Festival. Youssef plays with the norms of Hollywood action films to contrast two characters. These characters—a business tycoon and an unhappy, unemployed man—are mistaken for each other throughout the film and are played by the same actor (Amr Saad). Here is another film in which the real is tampered with in order to benefit the spectacle, complete with sped up sequences, explosions, references to other action films, and exaggerated sentimentalism. For two hours and fifteen minutes, a teeming constellation of characters discuss corruption, while also touching upon the redemption of humanity and the world. The film has a wide scope, moving between social and political issues, between religion and the economy, between psychology and philosophy. Karma does not refer to a reward or punishment in the next world, but rather to the equal distribution of wealth in this one. This is because, according to the director, excessive wealth leads to the same social problems as rampant poverty.

Five Fingers for Marseilles (2017), by white South African director Michael Matthews, is another thriller. Despite this, it sticks more closely to the norms of Westerns, drawing upon melodrama to address the cycle of violence and to attempt to build a South African mythology. Seven years of research went into the development of the film's framework and of its

rage-filled antihero. The reference to Marseille alludes to the train that under-lies the economic development of the Eastern Cape region near Lesotho and which linked urban colonial residences that had adopted the names of large European cities. This train facilitated transportation until a decline that placed the trains in the hands of organized gangs. In the film, five chil-dren band together like the five fingers of a glove in defense of their neigh-borhood, Railway. Yet when white police officers violently arrest Lerato, the girlfriend of their leader Tau (Vuyo Dabula), who is referred to as the Lion of Marseilles, he confronts and kills them. Twenty years later, when he is released from prison, Tau returns to Marseille, which is now controlled by a gang in league with the Five Fingers. Tau must play the hero and clean up the town, clearing out the villains by reuniting the Five Fingers and rekindling their original group ethic. The film guarantees its success by defending—in the Sesotho language—the point-of-view of those oppressed by colonialism, as well as by rallying White Honest John, who ultimately chooses the right camp, thus offering an allegory for current issues in South Africa. Yet the film relies heavily upon recycled tropes from Western classics and samurai films and is accompanied by a type of Africanized Western music. It strug-gles to establish the myth it is hoping to establish—that of the hero in search of redemption who, against his will, turns down the path of bloodshed. With a worldwide distribution, the film is easy to download or watch on Netflix. It is far from the subtle filmmaking of Oliver Hermanus and John Trengove, whose films would have been a more appropriate homage to the competition.

Let us conclude with Aminata Dramane Traoré: "It is essential to offer young people a future that comes from within our own culture—that is not a pale copy of that globalization in which we are the ones to lose the most."

A Gloomy Closing Ceremony

The president of Burkina Faso, Roch Marc Christian Kaboré, was accompa-nied by the president of Rwanda, Paul Kagamé, and the president of Mali, Ibrahima Boubacar Keïta, for the closing ceremonies. It lasted for five hours. The jury was not invited on stage and were unable to read their results as the master of ceremonies got muddled with his papers. The president of the jury for documentary, the Tunisian director, Nadia El Fani, wanted to point out that they had forgotten to announce a special mention that had been awarded by the jury, but was blocked by security. Later on social media, lamenting the bad working conditions endured by the jury, she announced that she would never again set foot at FESPACO.

This year's edition of the festival could have enjoyed the ambition of reestablishing the festival's future, had the gravity of the closing ceremony—in which politics detracted from the films themselves—not sent a gloomy

message; they were unable to make up for the ambiguity of the prizes awarded to feature-length films. Nevertheless, the fact remains that this twenty-sixth edition of the festival establishes the possibility for positive renewal that can be solidified and developed in the future in order to ensure the continuation of this important festival, for which cinema professionals have a real affection.

Olivier Barlet is author of *Contemporary African Cinema* (Michigan State University Press, 2016) and *African Cinemas: Decolonizing the Gaze* (ZED Books, 1996), among others.

Notes

Originally published as Olivier Barlet, "FESPACO 2019: Moving Toward Resurrection," *Black Camera* vol. 11, no. 1 (Fall 2019): 407-423.

1. In French, the MICA (Le Marché International du Cinéma et de l'Audiovisuel Africains).

2. Translator's note: films selected for Panorama are not included in the competition. (http://africultures.com/aminata-dramane-traore-christiane-taubira-colloque-fespaco-14630/).

Fifty Years of Memories for Shaping the Future!

Rémi Abéga

We are at the crossroads of a long, tumultuous walk that has punctuated the lives of so many filmmakers and image operators in Africa. Moments of confrontation of memories and glances on African peoples and their Diasporas. So many exciting movies gave birth to an indelible African identity, taken to the pantheon of exchanges among civilizations from all over the world.

This is the place where Africa and Africans have impregnated their various audiovisual and cinematographic approaches, where industries and image economies have developed and stated in a spirit of diversity, two great models, of which one is at the trailer of Nigeria, South Africa, and Ghana, and the other, in the maturation of a hybrid economic system, where so many countries and cinematographic approaches are still seeking ways and means for their survival since independence.

Given the magic of the African image underpinned by the relevance and recurrence of FESPACO, whose history provides sufficient information on the pathways of fifty-years-old Pan-African cinema, one would have had far fewer references from the past and dreams to forge a future, starting from this mirror that projects today in the face of the world, a fairly comforting reality of images from Africa.

In the exhortation of value scales and multicultural approaches that govern every corner of the African continent and its Diasporas, the thickness of our consciences and the vitality of our expectations are gradually shaping a system where genius and technologies serve as leftovers to the progressive construction of contributions and aftermaths of powers.

Hence the option of enlivening and glorifying this fiftieth meeting, FESPACO, in its essence and its extensions innocently born in naive hands and under the impulse of a generation seduced by the magnetism of the seventh art, and carried away by the tireless efforts of women and men of value who made the Pan-African Film and Television Festival of Ouagadougou (FESPACO), the world-class international event it has become.

Also, as a hymn and by reference to the poetry of one of the most illustrious champions of twentieth century Negritude, we must sing and dance to the glory of FESPACO, celebrate these mythical actions and the influence of this Pan-African institution among the most captivating events of the continent, that has generated so many feats, winners, and stars of African cinema and audiovisual.

Yes, let's sing and dance for this festival where are screened every two years for five decades, many films that convey through African and diaspora images, various forms of cultural expressions in the field of creative arts, whether literary, musical, decorative, or specific, etc., all of which are anchored in the bubbling of our habits and customs; so many memorable landmarks that symbolize the dynamism of many trajectories and generations.

We must sing and dance on the occasion of this fiftieth anniversary, as artists invigorated by the past and confident in a dazzling future, for these women and men of art, and for all African peoples often misunderstood or embittered, sometimes bruised and weakened, but always attractive and desirable. They create, develop, animate, convey, and proclaim in unison, the precepts of a common cinematographic heritage.

Let's sing and dance for our cinematographic productions, often victims of the indifference of elites who lack the emotion and/or willingness to imitate what is done elsewhere, and who turn African filmmakers into a caste of fearsome, scaring, and sometimes marginalized people without real privileges or recognition established by society, nevertheless special people who capture and tirelessly illuminate poor and precarious civilizations.

Together, we must sing and dance with frenzy and without shame to repulse instrumentalism and immobilism, in order to give our people and our environment, the social dynamics of the creators of Works of the Mind, in our countries with their specific realities, where it is not superfluous to note that others are moving backwards, or pulling down the icons and symbols of an African cinema carried by FESPACO, so that the maturation of socio-professional bodies and development opportunities rebound!

For the memory of the founders and forerunners of FESPACO, and for all those who work tirelessly to build this future, we must sing and dance with pride and vigor to welcome and celebrate with joy the accomplishment of this long dream that has reached its golden age, where experience and wisdom will consolidate the present and fertilize the hopes of a future for ourselves and for those who believe in African cinema and audiovision?

On this day of joy, landmarks and references strengthen our maturity and reflect our accomplishments over so many years. May the triumph of fifty years of FESPACO help us forget all dark nights and move away from constraints, for collective awareness and mobilization of all the vital forces

of African cinema and audiovisual, factor of affirmation, recognition, integration, and professional blooming.

Rémi Abéga is a Cameroonian filmmaker and cultural advisor with experience in the legal sector. In the 1990s he was a part of the French Embassy's Cultural and Cooperation Services in Cameroon. In 2000, he was crowned winner of the national matILA screenplay competition; and created the Douala Audiovisual Encounters (RADO) festival in 2009 with the support of the francophonie. In 2010 he launched the Central African Image Bank (BIMAC) project, with the support of UNESCO's FIDC, and in 2018 the Cameroonian Cultural Action Fund (FOCAC). He has written and produced numerous articles and artistic productions, and in 2019 he was appointed among the Arts Coordinators in charge of the Film and Audiovisual Division at the Ministry of Arts and Culture. His next book on cinema is called *Péripéties*.

IV. COMMENTARY

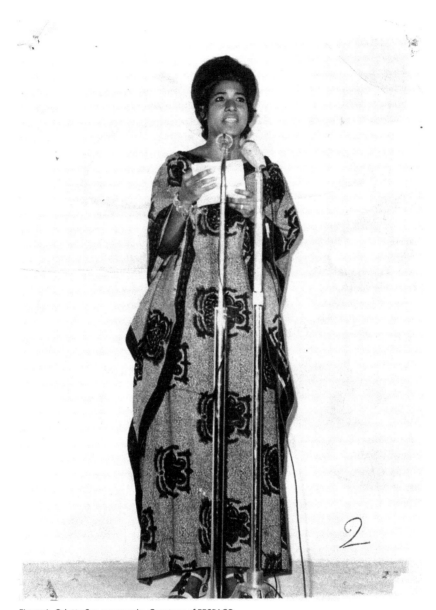

Figure L. Odette Sanogo speaks. Courtesy of FESPACO.

Commentary

Françoise Pfaff
Jean-Marie Téno
Danny Glover
Mariette Monpierre
Jean-Pierre Bekolo
Bassek ba Kobhio
Dani Kouyaté
Bridgett M. Davis
Jo Gaï Ramaka
Jane Bryce
Farah Clémentine Dramani-Issifou
Zézé Gamboa
Cheryl Fabio
Mansour Sora Wade
Fatoumata Coulibaly
Bérénice Balta
Cornelius Moore
Thierry Michel
Hicham Ayouch
Salif Traoré
Annette Mbaye d'Erneville
Makéna Diop
Catherine Ruelle
Melissa Thackway
Mahmoud Ben Mahmoud
Rachid Naim
Camille Varenne

Cameron Bailey
Emma Sandon
Claude Haffner
Jean Odoutan
Denis Mueller
Véronique Joo Aisenberg
Colin Dupré
Osvalde Lewat
Laurence Attali
Djamila Sahraoui
Malek Bensmail
Mata Gabin
Soaud Houssein
Maya Louhichi
Mohamed Challouf
Maïmouna N'Diaye
Berni Goldblat
Dora Bouchoucha
Sébastien Kamba
David-Pierre Fila
Abdelkrim Bahloul
Idriss Diabaté
Simon Bright
Sheikh Doukouré
Oumou Sy
Wasis Diop
Nadia El Fani

Françoise Pfaff

Pfaff is author of The Cinema of Ousmane Sembène, a Pioneer of African Film *and* Twenty-Five Black African Filmmakers *(both published by Greenwood Press). She is professor of French and Francophone Studies in the Department of Romance Languages at Howard University, Washington, DC.*

FESPACO Memories

It was in 1985 that I attended and participated in my first FESPACO as part of a delegation of U.S.-based film professionals, such as filmmakers Larry Clark, Haile and Shirikiana Gerima, and film exhibitor Cheryl Chisolm, as well as film scholars Pearl Bowser, Mbye Cham, Abiyi Ford, and Claire Watkins. It was a festival like none other: a display and celebration of African films that would be hard to match in any other place in the world, lively panel discussions assessing the cinematic output of the continent, and a budding film market. I remember that the whole host city of Ouagadougou was in a festive mood, with its residents rushing to film screenings and workshops. The presence and sponsorship of the Burkina Faso head of state, president Thomas Sankara, a firm believer in the role of African film as a tool for education and social change, gave the event additional historic significance.

That first year, I presented a research paper, "Present Realities of African Cinema in the United States." Since then, I have taken part in a number of FESPACOs. All of them greatly informed my career as a professor at Howard University, where I taught African and Diasporic cinemas for four decades. Meeting and interviewing filmmakers and film critics, viewing films, and gaining knowledge from the effervescent and inspiring Ouaga experience was reflected in many of my lectures and published articles, and in several of my books, including *Twenty-Five Black African Filmmakers* (Greenwood Press, 1988), *Focus on African Films* (Indiana University Press, 2004), and *À l'écoute du cinéma sénégalais* (L'Harmattan, 2010).

FESPACO will be affected by the new health challenges we are facing, as are many other international festivals, but I know it will soon recover, incorporate new digital technologies, and continue to assert its incomparable role in the promotion of African and Diasporic films as a part of the world's intercultural heritage.

☙❧

Jean-Marie Téno

Téno, Africa's preeminent documentary filmmaker, has been producing and directing films on the colonial and postcolonial history of Africa for over twenty years. Films by Téno have been honored at festivals worldwide: Berlin, Toronto, Yamagata, Cinéma du Réel, Visions du Réel, Amsterdam, Rotterdam, Liepzig, San Francisco, London. In the U.S., many of his films including Africa, je te plumerai / African, I Will Fleece You *(1992),* A Trip to the Country *(2000),* Clando *(1996),* Chief! *(1999),* Alex's Wedding *(2003), and* The Colonial Misunderstanding *(2004), have been broadcast and featured at festivals across the country. Teno has been a guest of the Flaherty Seminar, an artist in residence at the Pacific Film Archive of the University of California, Berkeley, and has lectured at numerous universities. Most recently, he was a visiting artist at Amherst College as a 2007–08 Copeland Fellow.*

Le FESPACO: Confiscated Voices

In February 1983 when I arrived in Ouaga for the first time to attend FESPACO, it was a huge emotional shock for me and a trip that marked my life forever. During the eight days of the festival, I witnessed the consolidation of the pioneering African filmmakers' dream: that of guaranteeing a durable space in which film would be king, a space in which we would watch African films of course, but also where voices could speak out to discuss film. These voices aimed to nourish the reflection that would contribute to transforming African societies in the interest of the many.

And indeed, the debates to define African cinema were passionate and captivating. I listened to everyone's interventions, I watched the films, I asked myself questions, I asked filmmakers questions, and I learned. People spoke out and their words were precious. Those of the filmmakers in particular were sought after and copiously debated. Audiences and the media wanted to know more about these crazy people who, against all odds, had chosen to create a cinema that resembled them and which justly and respectfully represented their people, who had chosen to make films conveying discourses that they articulated with joy before curious, demanding, and at times merciless audiences.

The filmmakers' discourses helped, where necessary, to illuminate the social and political questions of the time through their characters' identity quests, dreams of social success, and betrayals of the common ideals. Their discourses helped sublimate the real, inscribing this cinema in the realm of art, despite what certain European critics and film bodies thought, ever ready to pontificate on what African art should be.

In thirty-six years, I have seen the FESPACO transform, its center of gravity be displaced, the festival grow distant from Africa's cinema and filmmakers. From contributing to the reflection on the liberation of the continent, the FESPACO has—consciously or not—become an apologist of neoliberal discourse, encouraging a kind of imitation of European cinema in the name of professionalism, progressively marginalizing any reflection on the specific stakes of filmmaking on the continent in favour of an approach based purely on audience success, which has become *the* criteria of a film's quality.

Between my first FESPACO in 1983 and my last in 2019, the eclipsing of the filmmakers' public voice reflects the state of public debate in Africa. The mistrust of certain governments on the continent towards intellectuals and filmmakers in the early years of Independence became open hostility during the application of the 1980s and 1990s structural adjustment programs. Rather than heeding the artists and intellectuals of their countries, those in charge favoured ready-made solutions funded by usurious loans recommended by IMF and World Bank experts. To what end? Many thinkers were forced to go into exile or quite simply to stop speaking out to avoid the wrath of various regimes. The result: the perpetuation, more or less everywhere, of clientelism, corruption, poverty, and the progressive erasing of the general interest.

The place of cinema in African societies has changed too, abandoning a significant part of its role in educating and raising the awareness of Africa's populations in favour of entertainment, the market, and globalization. Once a space of prospective reflection, this cinema has often become a space of imitation.

In a context of ideological battles at the heart of which the cinema has found itself over the last fifty years, the FESPACO has lost its central place: that of offering a space and a market for films by Africans, a space in which the future orientations of our cinema can be freely defined, and in which people's voices, valued and protected, can truly continue to resonate. The contrary has happened, a failure tragically sealed during the Fiftieth FESPACO Awards ceremony in 2019 when the official juries were not permitted to state what motivated their choices; worse, where the awarded filmmakers were also reduced to silence as the presence of heads of state meant it was not possible to let just anybody speak.

In the space of thirty-six years, have filmmakers become nobodies whose words might trouble the digestion of the leaders and apparatchiks who have made cinema today anything but a tool at the service of their people's development? Just like the natural resources of most of the francophone African countries, grabbed and confiscated to the exclusive benefit of the kleptomaniac ruling class and their Western overseers, filmmakers' voices have been confiscated, watered-down, and rendered inaudible to people in Africa, for whom economic

and cultural impoverishment still often appears to be the only horizon. Yet, as Professor Kangue Ewane said in my film *The Colonial Misunderstanding*: "The economic and political renaissance of Africa lies in its cultural renaissance." Cinema, true cinema, is one of the pillars of that cultural renaissance.

Danny Glover

Glover is an award-winning actor, producer, and humanitarian with a performance career that spans more than thirty years. He has portrayed a myriad of popular roles and has distinguished himself as one of his generation's most consummate actors, such as his performances in such classic motion pictures as The Color Purple *(1985),* Witness *(1995),* Places in the Heart *(1984), and* To Sleep With Anger *(1990). Honored with awards from the NAACP, BET, and SAG, Glover has also received several Emmy nominations for his work.*

The Pan-African Festival of Cinema and Television is one of the most extraordinary platforms for African cinema and the African diaspora. Fifty years ago, as citizens began to shape ideas of nationhood, sovereignty, and citizenship specifically through cinema and art, FESPACO led the way and became an instrumental catalyst for change.

Mariette Monpierre

Monpierre has worked on feature films, documentaries, short films, music videos, and podcasts. Her first independent piece, Knowledge is Power, *was a documentary commissioned by the New York City Health Department in 1998 to raise HIV/AIDS awareness. In 2002, her documentary* Sweet Mickey for President? *won Best Documentary at the Reel Sisters Film Festival in New York. Monpierre's first theatrical work, the short film* Rendez-Vous, *was nominated for the Djibril Diop Mambéty Award in partnership with the Directors Fortnight in Cannes.* Rendez-Vous *experienced a successful run in several major international film festivals and took her around the world: Toronto, Marrakech, Montreal, FESPACO in Burkina Faso, Seoul, Milano, and the African Diaspora Film Festival in New York, to name a few. Her film* Elza *won FESPACO's Paul Robeson Award in 2003.*

When I heard Rigoberto Lopez say ". . . and the winner is *Elza* . . ." I ran to thank Mama Keïta, who fought so hard for the film to exist. Then I went onstage and kissed and held high the statue I received for having won the Paul Robeson Prize for the best film by a director of the African diaspora. I was so moved and proud to be recognized by my peers in a stadium packed with thousands of happy faces. The Caribbean woman that I am, born on the island of Guadeloupe, had finally come home to the land of my ancestors.

For me, FESPACO is a family affair. Everybody comes. Every two years I have a rendezvous in Ouaga with my people, my friends, and my audience that I wouldn't miss for anything in the world. I connect. I build relationships. I party. I do business. We make history. FESPACO empowers me and gives me the strength I need to continue to speak my unique voice because I know I have a venue to showcase my films. And that means a lot to me. I love you, FESPACO!

Jean-Pierre Bekolo

Bekolo is often considered one of Cameroon's most famous filmmakers. He has made Quartier Mozart *(1992),* Le Complot d'Aristotle (Aristotle's Plot) *(1996),* Les Saignantes (The Bleeding Women) *(2005),* Le Président (The President) *(2013),* Les Choses et les Mots de Mudimbe *(2015),* À la recherche d'Obama perdu *(2015),* Naked Reality *(2016), and* Afrique, la Pensée en Mouvement Part I et II *(2017). His film* Les Saignantes (The Bleeding Women) *won the Yennenga Silver Stallion in 2007.*

FESPACO Made Me An African

Arriving in this city—with the most African name: Ouagadougou, being able to see Ousmane Sembène, whom I studied at school, going on streets bearing names like Kwame Nkrumah, going to Thomas Sankara's grave, living the screening of my own film in a room full of people who look like me without being Cameroonian … this experience of being at FESPACO made me an African.

Bassek Ba Kobhio

Kobhio, born January 1, 1957 in Nindjé (Ndom), is a Cameroonian writer and director. Before approaching cinema, Bassek Ba Kobhio studied sociology and philosophy. He was in charge of the cinematography services in Yaoundé. He is the founder of the "Black Screens African Cinema" festival. He also created cinema classes with the help of the Cultural Cooperation services of the French Embassy and Unesco. He worked for several years on a project to create a Higher Institute for Training in Cinema and Audiovisual Trades of Central Africa (ISCAC), and has just obtained official approval to open such an institute whose entry into service is now imminent. His productions and his cinematographic and audiovisual achievements are very numerous and his personal filmography includes in particular four feature films: Sanfo Malo *(1991) (which received the audience award at the second African Film Festival in Milan in Italy 1992),* Le Grand Blanc de Lambarene *(1994),* Le Silence de la Forêt *(2003), and* Governors of the Rosée *(2018).*

My FESPACO!

FESPACO! I dreamed about it since the day I decided to make cinema, since that evening when, sitting in a seat of what was then the French Cultural Center of Yaoundé, I attended a speech by the filmmaker Jean-Pierre Dikongué Pipa, recounting Muna Moto's prodigious career around the world. He cited prices, places, and events, but I felt a particular tremolo in his voice when he spoke of Ouagadougou Cinema Week, which in the meantime became FESPACO after he received his prize there five or six years ago. And then came the moment when I was able to make my first film. I had obtained the important support of Gaston Kaboré who put me in contact with the Ministry of Culture of Burkina Faso in charge of cinema, which allowed me to benefit from the technical collaboration of the chief editor Marie-Jeanne Kanyala by way of South-South cooperation; as soon as this agreement was signed, I remember that I already thought I had a foothold in Burkina Faso. To experience the Ouagadougou festival for real was very different. Seen up close "this big village of Ouagadougou" was so so cheerful, so jovial, so friendly, and its magic unfolded and literally bewitched you. In reality the village was a welcoming city, warm, and warm in the first sense of the term, lively, animated, pleasant.

I spent several editions of FESPACO thinking that Ouagadougou was not growing and that its core consisted of Avenue de l'Indépendance, the United Nations Roundabout of the FESPACO headquarters and the enclosure of country of the Entente where Captain Thomas Sankara was killed, a mythical place that every African nationalist dreamed of visiting on his first visit to

Ouagadougou. It is a strange feeling to see that all of this is in the center of the Burkinabe capital, when there was a time when I believed that these places were in the suburbs. In fact, this tenacious impression arose from the fact that each of my stays at FESPACO, whatever the reason (film in competition, participation in a professional conference, meeting of the federal office of FEPACI of which I was a member), I was almost automatically accommodated at the Hôtel Indépendance, with its adjacent streets which united the whole city, the whole country, the whole of West Africa, like an enclave from which one hardly left.

My first trip to Burkina Faso, my first stay at FESPACO! I will never stop fondly remembering it. Of course, I knew that I would never live the visits of Thomas Sankara about which I had been told at Atria, in Paris, when I was editing the film *Sango Malo*, I would only live in my imagination these moments when Captain President Sankara, in what the ancients kept telling us about, landed in the middle of the evening at the edge of the legendary swimming pool of the Hôtel Indé, playing the guitar, we were told, discussing cinema and art until the middle of the night. But at my personal level, I had challenges to take up including that of being accepted under the Palaver tree where Ousmane Sembène reigned, whose name alone reminded me of where my dream of becoming a filmmaker had started, a book by Paulin Soumanou Vieyra on him received as the French prize in third class, and entitled "Sembène Ousmane Cinéaste."

I had already read the writings of the writer Ousmane Sembène explaining why he had embraced the art of cinematography, as a response to the illiteracy that was rampant in our regions. Son of a teacher and a teacher, I had nurtured since my childhood the ambition to become a writer, but now I said to myself, I would embrace the dual career of writer and filmmaker just like my illustrious elder Ousmane Sembène.

Not only did FESPACO receive me then, but it also gave me almost everything I dreamed of: a certain recognition, the paternal friendship of Ousmane Sembène and the other elders, the proximity of many if not all of the filmmakers who practiced at that time there, the co-optation by Gaston Kaboré of my person in the office of FEPACI, I received all this from FESPACO. And all of this in a city that I always believed to be unchanging. Filippe Sawadogo did me the honor of joining the group of those who were thinking about the future of the festival for the millennium which was about to begin as the curtain fell on the twentieth century, Baba Hama made me President of the grand jury, after my first feature film *Sango Malo*, I presented at FESPACO *Le Grand Blanc de Lambaréné*, then *Le silence de la forêt*, always with a new and youthful emotion, as if Ouagadougou was the place where everything was simple, where everything was sacred.

During this time the years passed and I did not really see it, or rather, surprising for someone who considered himself revolutionary, I did not want

this world to change, but of course whether we like it or not everything changes nevertheless. Avenue de l'Indépendance ceased to be the noisy, crowded, colorful street, the rue des artisans, the Hôtel Indépendance itself ceased to be the place where you absolutely had to be to see and be seen, and one day I had to go to Ouaga 2000 where a Libyan hotel had just opened its doors, and I then realized that the city had become or appeared to me extended, long, wide, populous.

Ouaga had changed. The festival too. It was no longer this festival took in a certain way under the armpit of the French cooperation which always tried to convey its views, and even if from my point of view the festival was still opening up more widely to the non-French speaking Africa, I must admit that it has always been since its creation and as far as I know of a Pan-African nationalism unlike any other. The first South African filmmaker I knew, Lionel Ngakané, it was in Ouaga that I met him and it was also in Ouaga that I saw the first films of East Africa.

But I need to talk about my indelible debt to Ouagadougou. The FESPACO, which is held once every two years, showed that it was possible to show our films to our audiences, that these audiences were interested in them, especially when they understood what was being said. FESPACO urged and warmly hoped that there were reproductions of this film festival which gave our films to our populations in at least one city in our sub-regions. There are certainly many reasons that led me to create the Ecrans Noirs festival, and all of the ones I have put forward are true. But FESPACO will always remain the basis of my reflection towards a festival in Central Africa. At the beginning, moreover, Baba Hama no doubt remembers, I wanted to achieve a decentralized FESPACO in Central Africa. But I was made to understand that in FESPACO there was the O of Ouagadougou, and that even Bobo-Dioulasso could not host a revival of FESPACO, since at the beginning we wanted to present the films awarded at FESPACO in our sub-region. From there comes the first and fundamental source of the creation of the Ecrans Noirs.

But I must say here, in this constant renewal, even in spite of itself, I must say what I would like to see reinforced at FESPACO:

1. The preeminence of filmmakers: during ceremonies, the most obvious filmmaker is relegated to the back of the audience, while unknown Western guests or guests of Burkinabe officials take the first places.
2. That non-French speaking cinema have its place in Ouagadougou, a suitable place for mixing African cultures and populations.
3. That without losing sight of the premium for excellence, attention be paid to the representativeness of the different African sub-regions.

These sub-regions, with bodies to be created, could be associated with the selection of films to be presented, some of which are unknown to Ouagadougou.

4. That the best cinema screenings on the continent be made in Ouagadougou, that is to say that the theaters and equipment are of the highest quality.

It will always remain that FESPACO has been at the base of the development of African cinema, it is to be hoped that it will participate in its best development in the days and years to come, and that thousands of other filmmakers can say, like me, "I would not have been quite what I have become, without FESPACO."

Dani Kouyaté

Kouyaté is an award-winning filmmaker and griot from Burkina Faso. In 1995, Kouyaté received the Oumarou Ganda Award for the Best First Work at FESPACO for his film Keïta! L'Héritage du griot. *He has also received the Special Jury Award in 2001 for his film* Sya, le rêve du Python / Sya, The Dream of the Python, *the Special UEMOA Award in 2003 for the documentary film,* Joseph Ki-Zerbo, *and the Baobab Seed Award in 2005 for* Ouaga Saga.

Although I was exposed to the world of cinema since I was very young thanks my father, the actor and storyteller Sotigui Kouyaté, I only really became aware of the importance of FESPACO when I enrolled at INAFEC (the Ouagadougou Film School) in the early 1980s.

My first FESPACO was in 1983, I think. I had never been a spectator at FESPACO before, even with my father. That year, I attended the festival as a film student, to see films and improve my knowledge. I remember that we were very proud! Proud to be part of the great movie family. We were very young and very happy to be at the heart of the event. Being there made us feel like we were already professionals.

FESPACO helped me be aware of the importance of my job as a filmmaker, of what it means in its essence.

When I made my very first feature film *Keïta*, I was very young, a "new comer," fragile and unsure of myself. I arrived at FESPACO and filmmakers came to see my film and when I saw all those people and the audience fighting to get into the movie theater to see my film, until the firemen came because

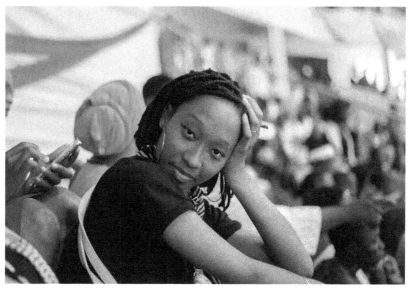

Figure 1. Film student Maylin Agbahan. Image courtesy FESPACO.

people were fainting, I was shaken up. All of a sudden, I had a real political awareness of what it means to make movies. Because, if people are fighting to see something, it has to make sense.

This excitement was symbolically strong for me. At the same time, *Rambo* was being seen in Burkina Faso and I broke the records for *Rambo* in Ouaga with *Keïta*. For me it was impressive to have a larger audience than *Rambo* in Ouaga thanks to FESPACO. I realized that cinema is something that touches viewers deeply and can be harmful or harmless. It's a weapon, in a way, and I became aware of what the elders used to say; like Ousmane Sembène, for whom cinema was like "evening school." All of a sudden, I understood that it was a tool for talking to people and an opportunity to say, to do.

As for the success of the film at the time in Burkina, I think it's a whole. It's true that the film was "at home," that Sotigui was the main actor, but it's also true that the theme of the film spoke to the audience, and not only to the Burkinabe, but to West Africa and to the Mandingo people as a whole, because it's a fundamental story.

Moreover, beyond West Africa, it spoke to African Americans: the film has become a classic in African Studies, in the universities there. Every year, I get reports on the exploitation of the film in the United States. It's been almost thirty years since it was released. So it's a movie that continues to "talk" to people.

Afterwards, it was difficult for me to find an emotion like the one I experienced at FESPACO with *Keïta*. With *Sya, The Dream of the Python*, I had

great success at FESPACO. In fact, *Sya* received twice as many awards as *Keïta*. But *Keïta* is still the film that continues to move me because it's a film that came out of my gut. What's more, I somehow wrote it for and with my father. We often "got into it" over the writing and the shooting, because I wanted to show that I was the director; at the time I still needed to prove that I also existed because it's not easy to be the son of such a strong and talented man, with such a strong personality! To tell the truth, I've always been at my father's school, I don't feel any shame about it, but it's still frustrating not to "exist" when you're an artist.

So I was fighting to exist and I wanted to show my father that, yes, I was his son, and yes, I was at his school, but that I was able to make a film with my own point of view. It was a rather difficult equilibrium task: at the same time, I was taking advantage of the talent of a great artist by exploiting it to the maximum, but I didn't want to be "eaten up" and I wanted to show that I was in control! My father was a great professional so he played the game totally. But it was a personal problem, a problem between me and myself.

My father was present at the public FESPACO screening. In fact, my father was very humble whenever he was in front of the public. He had an incredible respect for people, whoever they were. And he kept taking off his hat every time a stranger greeted him because he considered him part of his audience. And I remember that—as if by chance—I also got a leather hat, a bit like a cowboy, to feel like an artist and I was very proud of it. At the premiere of *Keïta* at *Ciné Neerwaya* or *Ciné Burkina*, I don't remember, we go on stage. My father goes up first, he takes off his hat, of course, bows to the audience and there I arrive with my leather hat on my head with a big smile and I stand next to him. I see that he gets close to tell me something, I try to understand, he whispers and says "take your hat off!" I say "sorry?" He says "take your hat off, respect your audience!" So, I take my hat off and it was funny because everyone saw that he was the one who told me to take my hat off. People applauded and for me it was a great lesson in humility.

There are a lot of memories on this film that I will never forget. During the writing of *Keïta*, I worked a lot with my father to adapt the script. He would invite me to his house at midnight to work because my home was always crowded. That night, I arrived at midnight to work, but I was exhausted. Around 2:00 a.m., I fell asleep. And he was so focused on every dialogue and every word that he didn't notice right away that I was sleeping. Then he turns around to see that I "was gone." He says "Vié," he calls me "Vié" (old man) because I am the namesake of his father, " are you sleeping?" I say "Yes, Dad, I'm sleeping, I can't take it anymore." He says, "Shall we continue tomorrow then?" I say, "Yeah, let's continue tomorrow, but I'd like to start a little earlier." But it wasn't possible to start earlier with him because the house was crowded until midnight. So we often worked from midnight to 3 o'clock

in the morning on the script *of Keïta*. I wanted the character I wrote for him to be a dying character who wanted to do one last mission; he didn't want that character. He didn't want the character to be a dying character. He said, "But why is your old man dying?" I explained the idea of the last mission, which is to give his story to his grandson before dying. The whole idea of the film was based on that. In the end, he seemed to accept; except that he played an old man who is not dying at all and I didn't even notice. And it was during the editing process that I realized that I had been fooled. Not only is he not dying, but he's giving lessons to the teacher. He's annoying the teacher, he's annoying everyone. He says nothing to do with you, I have a story to tell! That's how he played the character, and he was so astute that I—with no experience directing actors at the time—didn't notice anything. And then he played it the way he felt it and of course he was right! I was in the concept.

We got the First Work Award. I went on stage alone, because my father had left. And the prize was given to me by Ousmane Sembène, the President of the jury. A very beautiful memory.

Bridgett M. Davis

Davis is a filmmaker known for Naked Acts. *She is also author of the memoir* The World According To Fannie Davis: My Mother's Life in the Detroit Numbers, *a* New York Times *Editors' Choice, and named a Best Book of 2019 by* Kirkus Reviews *and* Real Simple *magazine. Davis's second novel,* Into The Go-Slow, *was selected as a best book of 2014 by* Salon, The San Francisco Chronicle, BookRiot, Bustle, *and* The Root, *among others.* Time Out New York *named Davis one of "10 New York Authors to Read Right Now." Davis' debut novel* Shifting Through Neutral, *published by Amistad/Harper Collins in 2004, was a finalist for the Zora Neale Hurston/Richard Wright Legacy Award; A* Quarterly Black Review *bestseller and an "Original Voices" selection by Border's Books. Davis was selected as 2005 New Author of the Year by Go on Girl! Book Club — the largest national reading group for African American women.*

Remembrance: FESPACO, Twenty-Three Years Ago

Upon learning that the feature film I had written and directed, *Naked Acts*, was an official selection in the 1997 Pan-African Film and Television Festival, I was thrilled. Throughout the previous year, my film had traveled along the festival circuit, screening at African film fests in Italy, the United States,

Brazil, and Zimbabwe, so what an honor to be invited to the most prestigious and largest African film festival in the world!

That week in Ouagadougou became and remains the gold standard of my festival experience. I'd always wished I'd been at FESTAC, the seminal arts festival that took place in Lagos back in 1977, and FESPACO felt like a 1990s version of that international Black cultural event. Being in dialogue with and seeing films by filmmakers from Africa, the Caribbean, Europe, and Canada broadened my understanding of African cinema and connected me to a diasporic community of fellow artists. Meeting Sharon Wilkinson, then U.S. ambassador to Burkina Faso, also impacted me, as she modeled what an African American woman could achieve on the world stage.

Another lasting impression was seeing Ouaga's locals attend various film screenings. I was moved by the sight of everyday people sitting on folding chairs, watching cinema projected onto outdoor screens throughout the city. Without free access to the festival's lineup of films, how many of Ouaga's residents would ever see images of people like themselves reflected back on the big screen? Inclusivity was clearly a mission of FESPACO, which further distinguished it. Of course, Burkina Faso was and remains a struggling African nation, and there's no escaping the frictions and challenges created by bringing a world-class festival to a poor country. Still, there's beauty in the effort.

Naked Acts screened during FESPACO at the Méliès Theater inside the French Cultural Center, a lovely proscenium-style open-air venue. Throughout the screening, as the packed audience watched my film, I kept glancing up, eyeing a plethora of tiny stars twinkling above in the night sky. Sitting there, I had an epiphany: *This* is why I worked so hard to make a good film—so that one day it could be shown beneath the stars in a proud West African country, seen by hundreds of beautiful Black people from all over the globe. "Remember this," I told myself. "Remember this moment."

And I'll never forget it.

Jo Gaï Ramaka

Ramaka is a film director, documentary filmmaker and producer from Senegal. His films include Karmen, It's my man!, *and* Plan Jaxaay. *After studying cinema at the Institut des Hautes Études Cinématographiques, Ramaka created the production company Les Ateliers de L'Arche and set up an associated branch in Dakar. Ramaka is currently based in New Orleans.*

It is good to remember that:

The creation of what would become FESPACO was the initiative of a few cinephiles, including Claude Prieux, director of the Franco-Voltaïque Cultural Center. FESPACO's origin was not uniquely African.

FESPACO attained its zenith thanks to the combined efforts of President Sankara and FEPACI. They shared a committed, Pan-African vision of FESPACO.

Blaise Compaoré's coup d'état against President Sankara and the Burkinabe people, against Africa, against the true mission of FESPACO transformed this important event into an enormous cover-up of the betrayal by the assassination of President Sankara and many Burkinabe patriots.

The resistance of African filmmakers and FEPACI to the hijacking of this event by Blaise Compaoré was weak and ambiguous.

Those who espoused resistance to this hijacking of the mission and the takeover of FESPACO by Compaoré were defeated.

Resistance to this coup d'état by the Burkinabe people came to fruition and resulted in the departure of Compaoré from Burkina, hounded from power.

It is important to reflect on and to interrogate the stance of FEPACI and African filmmakers during these dark years so as to brighten the future of a Pan-African committed FESPACO extoled by President Sankara.

Jane Bryce

Bryce is a Commonwealth Scholar, Obafemi Awolowo University, Nigeria, 1983–1988; a Leverhulme Research Fellow, Institute of Commonwealth Studies, 1990–1991; a Commonwealth Fellow, School of Oriental and African Studies, 1996–1997; a member, Frank Collymore Literary Endowment Committee of the Central Bank of Barbados, 1998-present; a judge for the Guyana Prize for creative writing, 1998; curator, Anglophone section of the Third Annual CineFest Nuestra America, 'Many Voices: Films of the Caribbean', at the University of Madison, Wisconsin, 8–11 November 2001; co-director, Barbados Festival of African and Caribbean Film, 2002–2004; co-editor of annual, Poui: Cave Hill Journal of Creative Writing, 1999-present; co-chair, Cave Hill Film Society: 1999–2004; co-ordinator, Literatures in English, 1999–2003; and Head, Department of Language, Linguistics and Literature, UWI Cave Hill, 2007-present.

A Diasporic Tribute to FESPACO

When I attended FESPACO in 2003 and 2005, it was as the director of the Barbados Festival of African and Caribbean Film, which ran from 2002–2005; and also as an academic at the University of the West Indies, Cave Hill, where I taught African literature and cinema. In those pre-streaming, pre-Netflix days, African cinema was inaccessible to Caribbean audiences outside of locally-based festivals or university film courses. I started the Festival of African and Caribbean Film in 2002 to create a context and an audience for African cinema in Barbados and the wider region, and to bring African and Caribbean filmmakers together.

As labels, "African" and "Caribbean" are not equivalent: the former falsely homogenizes and disguises the diversity of the continent's cultural expression, while the latter implicitly signifies a multiple Creole identity which is not exclusively African. However, I deliberately privileged "Africa" in the title because I wanted to claim a space for African cinema in the Caribbean, where so many people are still resistant to African modernity, wedded to a dream of origin and an unchanging, ahistorical Africa.

From the beginning, the festival was about relationships—between the different territories of the Caribbean, and between the Caribbean and Africa. This was uppermost in my mind when, after meeting the coordinator, Dr. Sade Turnipseed, at the Barbados festival, I became a participant in The Paul Robeson Award Initiative. This Initiative, designed to bring diaspora film into the mainstream at FESPACO, declared itself as having the slightly self-contradictory mission of "presenting the best of the best diasporic films" so as to "make FESPACO the 'Academy Awards' for all African films." This rubric was simultaneously inclusive—"all African films" and "the best of the best." And from a Caribbean perspective, what the invocation of the Academy Awards suggested was that both "best" and "African" meant American.

This pinpoints the problem for Caribbean filmmakers: despite the proliferation of regional festivals, the Caribbean film industry is necessarily fragmented by virtue of widely scattered territories, language differences, and political and economic configurations. It also faces peculiar problems posed by its proximity to the United States, and the sheer size and financial power of the U.S. media machine. Film culture in the Caribbean has to contend with an overall media imperialism which determines what we watch on television and cinema screens, both for entertainment and to find out what is happening in the rest of the world. The advent of cable has exacerbated this situation beyond the regular recycling or dumping of soaps and series from American TV, to a wholesale consumption of programs made by American producers for American audiences, with all the limitations that implies.

In this context, where Caribbean cinema is David to the American Goliath, Caribbean filmmakers–not all of whom identify as "African"—may creep under the net through another route: Pan-Africanism. According to Paul Zeleza's classification of trans-Atlantic Pan-Africanism: it "imagine(s) a Pan-African world linking continental Africa and its diaspora in the Americas" through "some idea of a shared, collective African identity in opposition to European identity."[1] The trouble here is that, though most Caribbean people can claim African heritage, they can also claim Indian, Chinese, and various European and Middle Eastern heritages. And though the Caribbean is often thought of in terms of islands, it includes continental countries like Belize, Guyana, Suriname, and Guyane Française and, through its Diaspora, extends to other parts of South America, as well as the United States, Britain, France, Canada, the Netherlands, etc. This cultural and racial diversity, which pulls against any single defining label, is best described by terms Caribbean thinkers themselves prefer, like *créolité* or *relationality*. In fact, in the first issue of the American journal, *Black Camera*, Gilberto Blasini proposes that, "Caribbean cinema needs to be understood in relation to the concept of *créolité* (which) not only documents the continual transformations of the Caribbean but also reinvents its geocultural scope."[2]

So it was that, finding myself at a discussion organized by the Paul Robeson Award Initiative at IMAGINE in Ouagadougou in 2005, I had to object to the narrow concept of 'diaspora' I saw reflected in that year's 'best of the best of diaspora films'. I don't remember what they were, only that they were all or predominantly U.S. productions, as was the winner. In fact, that year was something of an anomaly: since the Paul Robeson Award was established in 1989, it has been awarded twice to Brazilian films, once to a film from Curaçao/the Netherlands, twice to Martinquian films, twice to Guadeloupean films, once to a film from the United Kingdom, five times to films by (two) Haitians, and twice to filmmakers from the United States and Africa. Had I known this then, I might not have felt the need to mount my anti-imperialist challenge. Never mind, the important thing was that I was there, in Ouagadougou, as part of a community of cinema-lovers and engaging in a dialogue for which FESPACO had set the stage.

The fact that FESPACO started out with a "Prize for the most authentic African film" and by 1983 had discontinued it, speaks volumes as to how a narrow concept of 'Africa' has been transformed over the years into something larger, less specific, more incorporative. Yet this change was surely inevitable, when what African cinema does so effectively is demystify antiquated notions of an unchanging essence, enabling people to see Africa as fundamentally *not* separate, but a participant in the global project of modernity. It makes us look at what people in Africa do and make in the here and now. In this, FESPACO has been not only instrumental but a driving force, providing

a nexus for African and Diaspora filmmakers alike. In the Caribbean now, we can see African films on Netflix: the question is, what films? So far, not the winners of the Étalon d'Or. In the future, is there a greater role for FESPACO as distributor and promoter of African films to a global audience? With travel to Ouaga expensive from the Caribbean and air travel anyway currently embargoed, I certainly hope so.

Zézé Gamboa

*Gamboa is an Angolan director, screenwriter, and producer. He was born in Luanda (Angola) in 1955. He made his first documentary (*Mopiopio*) in 1991 and he made other documentaries until 1999 before tackling fiction cinema. A* Hero *(2004), his first fiction film, won the prize for first cinematographic work at the twentieth session of the Carthage Film Days in 2004 and the grand prize at the Sundance Festival in 2005 in the "World Dramatic Competition" category. His second feature film,* Le Grand Kilap *(2012), was selected by the Toronto International Film Festival (2013), the London Film Festival, and the Pan-African Film Festival of Ouagadougou (FESPACO 2013), to name but a few.*

When I first participated in the Pan-African Film Festival of Ouagadougou (FESPACO) in 1991, I presented *Mopiopio* and I was invited to go to the Ouaga film library, to see Pierre Yaméogo's new film, *Lafi*. It was a film which, for reasons that I later understood, was not selected in the official competition because it carried a political and social critique of his country Burkina Faso.

At the film library at the time, there weren't very good conditions for showing films… there was even sand… But it was interesting because we could see this film in which he, Pierre Yameogo, in as an artist-filmmaker had all the rights to tell things that could bother in his country. And that marked me… It's a film in which he criticizes the situation of privileged young people who come to study in France and evokes the situation of less well-off young people who do not have scholarships… We were very few at the screening: there was me, Mweze Ngangura, and one or two other filmmakers. The film library is not big either! About fifteen people saw this film. It gave me an understanding of how Burkina works.

The atmosphere has always been very good at FESPACO. Because in Ouaga, if there is one thing that is always great, it's the atmosphere and the festivalgoers; people meet with a lot of pleasure and talk about the things

of life, more besides than about future projects and it is a shame because FESPACO should really be a meeting place to scrutinize cinema deeply. We are all experiencing anxieties, funding problems, we all need to talk about it. But hey, people didn't even want to discuss it …

One year, however, there was a real discussion between Férid Boughedir the Tunisian and Idrissa Ouédraogo, through journalists at the Hôtel Indépendance. I remember it because I was with Férid and journalists came to ask him questions. And since Férid is a very good speaker, he said his ideas and all the things he thought about cinema. It was good. And on the other hand, the press also questioned Idrissa who was developing other ideas, also eloquently. It was great, I liked this friendly fight. I think there was some rivalry between them. But as filmmakers both liked each other.

Ouaga, anyway for me, it's more of a festival in Africa where there is an audience that loves cinema. The rooms are full, the spectators want to see films. There is the party and there it is.

In Ouaga from my point of view, there are two types of audiences. There is an audience that loves cinema a lot, no matter what kind of movies they see. What interests him is seeing movies. And there is another audience, a little more educated, more intellectual, who choose their films and come to you to discuss them with a certain curiosity and a desire to learn. We are all Africans, but across the continent everyone has their own culture, their own outlook and I experienced that in Ouaga, with locals.

In a way, most of the producers come with their films. So maybe they already have other productions in mind. In any case, I have never discussed a project with a producer from Ouaga or landed a production or a purchase with a television.

On the other hand we often live great moments; for example the meeting with Danny Glover, a real privilege for a large number of African filmmakers. Danny Glover had come to FESPACO as an actor in several films, and even a producer and co-financier. I remember taking part in a meeting with him at the Hôtel Indépendance with around twenty other African directors. Danny on this occasion wanted to know how African cinema worked and we talked about new strategies for our cinema.

As for the near absence of Portuguese speakers in FESPACO, we in Portuguese-speaking countries have enormous problems. We had the boom of the 1980s where the cinema could develop but nothing was done; in Angola and Mozambique there is a small budget for production, an embryo of cinematography. In the other countries, Guinea-Bissau, São Tomé, Cape Verde, it is difficult. I also think it's the responsibility of the states because I don't see private entrepreneurs, right now, giving money for movies.

Regarding the documentary, the genre in which I started, and moreover I was part of the documentary jury during one of the editions of FESPACO,

I believe that there could be a much larger place for this kind at FESPACO. Since there are more and more young people who want to make films and who do not yet have all the tools to do so, documentaries are a very good school, I believe. As a juror, I noticed that there was often a mix of formats in the documentary selection, reports mixed with real documentaries.

There is a real place to be taken for the documentary genre, but that implies a real selection.

With all the new technologies and new platforms, young people are able to make interesting documentaries and short films, but with very small means we cannot do great things either. Most of these young people did not even get a solid education; all the new technology, by its lightness, has democratized access to film production, but you still have to have good subjects to shoot films that matter and it is not that simple. The first prerequisite is knowing what you want to tell and the second prerequisite is figuring out how to tell it; without adequate financial means, sufficient time and minimal know-how, you can at most make a good report.

All these young people who are passionate about cinema and who finally have the possibility of filming must understand that cinema still continues to be the result of a whole cinematographic grammar structured around the writing of a screenplay, its production and then of its assembly. Even though there are other scriptures, the basis remains this one. New technologies are not enough by themselves, you have to know the fundamentals of cinematographic syntax.

For me, the real revolution in cinema took place after World War II, with the manufacture of lighter 35mm cameras, which allowed filmmakers to film in natural settings and resulted in the Neo-Realist Movement in Italy, that of the Nouvelle Vague in France as well as that of the Cinema Novo in Brazil. It remains to be hoped that today's new technologies will allow a real aesthetic and thematic revolution.

Farah Clémentine Dramani-Issifou

Dramani-Issifou is a film programmer for La Semaine de la Critique and the Marrakech International Film Festival, independent curator, and doctoral student. For ten years, she has initiated projects blending film programming, contemporary art, and research. From 2010 to 2017, she created and directed the Festival des Nouveaux Cinémas Documentaires *and BeninDocs (Paris, Porto Novo, Lomé, Phnom Penh). She is curator of the exhibition* Western Foura: Les cowboys sont noirs (Chapitre 1)! *and*

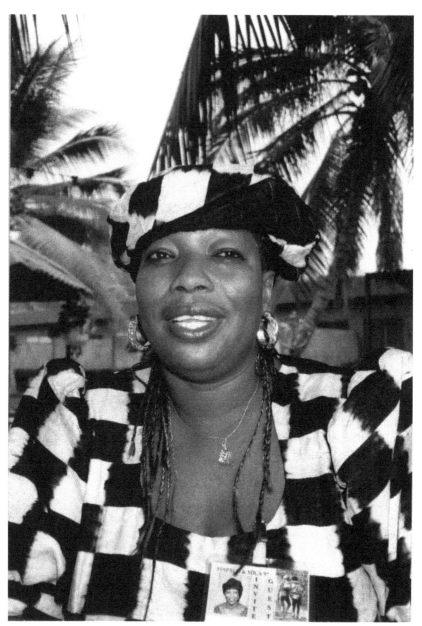

Figure 2. Martine Condé Ilboudo. Image courtesy FESPACO.

co-curator of Un air de famille *at the Paul Eluard Museum of Art and History in St. Denis, Headquarters of the Africa 2020 Season. Her research work focuses on the programming and broadcasting of Afro-Diasporic films in festivals. As such, she regularly participates in international colloquia and publishes texts in books (*L'énonciation curatoriale des festivals de cinéma en Afriques francophones*, L'Harmattan, 2020 and* Mille Soleils de Mati Diop, une esthétique de l'interstice, *L'Harmattan, 2019) and for the Frenchmania film review. She also works with the team of the Yennenga Center, a film hub created by filmmaker Alain Gomis in Dakar.*

Forging a Pan-African Future for Fespaco

Note to the reader: this text is an ongoing personal reflection, so it is neither fixed nor final.

The first film festivals in Africa were created after decolonization: the first Carthage Film Festival was held in 1966, ten years after Tunisia's independence, and it was not until 1969 that the First African Film Festival of Ouagadougou (1969), which became FESPACO in 1972, was organized. The objective of these festivals at their inception was clear: to promote African cinemas and reflect on their contribution to the construction of newly independent nations.

Indeed, cinema was another colonial propaganda tool until the 1960s, and its development was directly linked to the imperial business in the colonized territories.[3] It is thus impossible to understand the advent of film festivals without putting it into perspective with colonialism, white supremacy, and the relations and conflicts between European colonial metropolises.[4] These elements help capture the efforts that film festivals in Africa "must make to overcome their marginalization and participate as producers of their own cultural forms, in global culture."[5]

The Carthage Film Festival and the Pan-African Film and Television Festival of Ouagadougou—whose fiftieth anniversary we celebrated in 2019—have since established their legitimacy on the African and international scenes.

Considering cinema as a space for struggles over representations, it is also the means through which it is possible to utter "a new word that expresses our hopes as well as our illusions today."[6] In the postcolonial era, American-Palestinian intellectual Edward Said emphasizes the political importance of self-representations: they aim to "save or reconstitute the meaning and fact of community against the pressures of the colonial system."[7] From this perspective, film festivals in Africa become a political arena.

Moreover, since "African cinemas" are quite widely distributed outside the continent, they are dependent on external mechanisms such as Western

film festivals, which give them a meaning, outside their socio-cultural contexts of reference. These festivals thus make "African cinemas" a genre linked to the enunciation devices in which they are shown. In such a context, the increasing marginalization of FESPACO in the international channel of film festivals is all the more problematic. Successful "African films" go through circuits of visibility and validation giving primacy or exclusivity to Western festivals when they are neither considered nor selected by FESPACO itself. Yet the growing interest of Western film festivals as well as economic and cultural operators for African films may, on the one hand, strengthen an already great Western influence on African cinemas and, on the other hand, concomitantly maintain the hold of the West on this cinematographic heritage. By way of illustration, the Cinémathèque Afrique de l'Institut Français (French Institute Africa Film Library), created in 1961 by the French Ministry of Cooperation, is in charge of the conservation and dissemination of African film heritage, making the Institute the holder of one of the most important collections—one thousand seven hundred titles—of African films from the 1960s to the present day. This is not to repeat New York University Professor Manthia Diawara's argument that francophone African filmmakers would produce films intended to appeal to a Western audience, but rather to insist once again on the fact that the almost general lack of film support policies in African countries has made filmmakers dependent on support such as international festivals, without which many films could not have been created.

Forging the future of the Pan-African Film and Television Festival of Ouagadougou requires that we question what the symbolic content and concrete project assigned to cinema and Pan-Africanism on the continent is today.

Created in the Caribbean and the Americas in the eighteenth century as a liberation movement that became a political movement, Pan-Africanism—which the champions of negritude, Rastafarianism and independence claimed to belong to—is a doctrine of emancipation of peoples that led formerly colonized countries on the continent towards their liberation from the colonial yoke. At the same time, Pan-Africanism is the basis of the identity of FESPACO because, like the Carthage Film Festival, it has aimed since its inception, to promote African cinemas and reflect on their contribution to the construction of newly independent nations. "Since the beginning of the history of this festival, the event is very much linked to the domestic politics of Burkina Faso and its geopolitics: it has participated in the cultural movement of the 1960s-1980s marked by the anti-imperialism of filmmakers, and in the structuring of the African and Pan-African cultural fabric."[8]

While FESPACO's initial objective is to reflect on the role of cinema in the emancipation process of the African people, the festival seems today to

be at odds with what forged it: "les Cahiers du cinéma (...) even spoke of outright disregard for artists, the media, the public and the population."[9]

For the organizers of the festival—in a context marked by various difficulties—"FESPACO remains the main showcase for African filmmakers. It is no longer, however, the only springboard for directors, who now prefer to show their films at festivals in Durban, Cannes, Amiens, or Namur, etc."[10] How then can FESPACO reconcile political and cinematographic ambitions in the future? To what extent can the event become again the unmissable meeting place for the greatest contemporary filmmakers from Africa, the Diasporas, and the world and thus pursue its Pan-African vision revitalized in 2013 with the opening of the competition to films from the Diaspora?[11]

FESPACO therefore has a crucial role to play. The Pan-African festival must once again become a real springboard for filmmakers by presenting the current and future trends of Afro-Diaspora cinemas, in their plurality and their dialogue with the world. For this, the festival must be the crucible of an artistic, political, economic, and popular Pan-Africanism, driven by the values of solidarity and cooperation between Africa and people of African descent around the world.

Until now, the curatorial enunciation[12] of FESPACO seems to be mainly symbolic; that is to say, filmmakers find themselves at the festival as if on "pilgrimage." They meet there because it is one of the historical film events on the continent and no longer because the festival is for them a real showcase and a springboard on a continental and international scale. Yet, what needs to be reinvested is the sense created by the relationships between the works shown, the film professionals invited, the audiences, and the context in which the festival is enunciated, the continent, and the world. For it was at FESPACO that the African films that have left their mark on world cinema were revealed, that the discussions that gave birth to FEPACI (Pan-African Federation of Filmmakers) began, and which—despite difficulties—allows film professionals from all over the continent and beyond, to meet every two years.

Setting up an artistic directorate not controlled by the supervisory ministry could also ensure an editorial program that is consistent with the industrial stakes at the continental and international levels. Concretely, a Pan-African selection committee including programmers and critics from Africa and the Diasporas, with the general delegate of the event among its members, would program films based on a critical point of view and a thought on Africa and the world. The festival should also seek out the most outstanding films, as do larger and smaller festivals. The aim would be to showcase works that explore aesthetic forms and deal with pluralistic issues.

The festival would thus help promote the circulation of Pan-African films, ideas, people, and commitments for the benefit of filmmakers,

film professionals on the continent, and local audiences. Thinking on a Pan-African scale is to engage a collective, transatlantic responsibility and effective solidarity so that together we reveal what cinema can do in terms of creativity, renewed imagination and political, social, and cultural trans-formation on the continent. For cinema is not only on the screen, it is also and above all in the viewer; this is where its strength lies. It offers a mirror to society, a mirror which does not need to be fair, and it also draws from this a great utopian or sometimes even dystopian power. To paraphrase Franco-Senegalese filmmaker Alain Gomis, cinema is a "territory of encounters between oneself and others. [...] this common "I" that is not a place for answers but is the universe of the pleasure of recognizing oneself in the other and of sharing common doubts."[13] In societies in perpetual trans-formation, it brings into play the dreamed, imagined, detestable, or very real representations that societies have of themselves. It also aims at main-taining a dialogue between populations and the societies in which they live, between past, present, and future. FESPACO must remain this platform for meetings between filmmakers and professionals from Africa and the rest of the world. Moreover, it must once again make cinema an art for the populations, for their cultural, political, and economic emancipation. It is a question of making this ambition of cultural policy a concrete utopia, by tenuously linking cinema to the social world that surrounds it. Transatlantic collaborations, greater autonomy from the supervisory ministry, and audi-ences' better accessibility to films should be encouraged, so that FESPACO shows the world the African continent and its Diasporas' potential in terms of cinematographic creation. This challenge is all the more important as the continent is considered as the new growth relay for cultural and creative industries from the West. But if we want to make Africa the biggest cross-roads of cinemas on the continent, we must give ourselves the means to make it happen. Otherwise, as Burkinabe filmmaker, producer, and trainer Gaston Kaboré points out, "a society that is daily and almost exclusively confronted with images that do not reflect its collective memory gradually loses its ability to imagine and shape its own destiny."

So, what does it mean to forge the future of FESPACO—Pan-African Film and Television Festival of Ouagadougou, sixty years after the Independence of Burkina Faso?

Although one regrets the organization conditions of the festival and a programming not always up to the level of an international meeting, the function fulfilled by FESPACO remains essential for the future of Afro-Diaspora filmmaking. The festival remains essential to the African film landscape, first of all by its history. However, the latter is also written in the present and if it is to regain its place today, the festival must continue its Pan-Africanist political commitment that has made not only its history but

also its strength. To do so, it must encourage and support the emergence of filmmakers who invent new forms of cinema, contribute to the dissemination of films that are still barely seen on the continent and to the structuring of a professional environment in connection with a continental and global economy of cinema and audiovisual in order to become the Pan-African film platform from which the actors of continental film industries will set up structures facilitating the deployment of national film industries through (sub)continent-wide co-productions, training, distribution, and exhibition networks. This would give the festival the status of "a place to fill the gap between African cinemas as a project and the reality of the presence of cinema in Africa, of a cinematographic economy, and the socio-cultural practices associated with it."[14]

The festival therefore has a strong potential. It is a space where encounters take place and where a community of "double consciousness in the world" is built,[15] bringing together Africans from the continent and from the Diasporas, which after the struggles for Independence and for the memory of slavery, creates a transnational space, which is neither specifically African, American, Caribbean, or European, but all of these at the same time, a community within which our cinematographic heritages are "reserves of meaning for the audiences they meet and from which it becomes possible to fertilize new imaginations,"[16] new utopias, and to question the future of our African and Diasporic societies and the future of cinemas in Africa, and in the world.

Cheryl Fabio

Fabio has been working in documentary film since 1976. After receiving a BA in Sociology and Photography at Fisk University and MA in Documentary Film Production at Stanford, she started freelancing and eventually became a producer/director for KTOP TV and other community-based organizations. She was Program Director at Black Filmmaker's Hall of Fame in Oakland, CA, taught at City College of San Francisco, Managed EATV, and became Operations Manager at KTOP TV back in Oakland. In 2009, she graduated from John F. Kennedy School of Law. Fabio started a non-profit, Sarah Webster Fabio Center for Social Justice, named after her mother, the great revolutionary poet. She continues to work on documentary films. Thanks to a grant from the National Film Preservation Foundation, the Black Film Center/Archive at Indiana University preserved Cheryl Fabio's 1976 documentary film Rainbow Black: Poet Sarah W. Fabio, *a legacy of her mother and her work.*

I went twice. Each time quite unexpected. I believe in 1991 and again in 1993. In 1987 Thomas Sankara, the progressive president of Burkina Faso and founder of the festival, had been assassinated. The organizers' first impulse was to cancel in 1991, but Sankara's supporters felt that it was in his honor that FESPACO should continue. My traveling as the program director of the Black Filmmakers Hall of Fame Inc. (BFHFI), was completely improbable! BFHFI was an under-resourced and relatively small organization, and the investment in sending me to Africa was significant. BFHFI's operation depended on people's talent, goodwill, and a huge volunteer squad. We had a development director, an office manager, and my position was the only other full-time one. I knew many of the filmmakers who were attending FESPACO through the dynamic independent film movement, so I was really excited about going.

Gathering at FESPACO was magical. Boarding the plane to Burkina Faso, I knew my mission was to extend the outreach of BFHFI's independent film work to a wider African Diaspora audience. At the festival, I immersed myself in multiple days of nonstop Black films. I stayed up late with friends discussing all the issues that concerned us, while also laughing a lot. It was an exhilarating trip, truly the stuff of dreams. I sucked it all in, the stories, the colors, the comparisons, and common threads. I unraveled film techniques and marveled at the accomplishments of and international array of Black film artists. I thoroughly enjoyed screening works under the moonlight on warm nights in outside theaters. Each way my head turned I was greeted by a sea of Black faces jumping up and down, talking back to screens, laughing or anticipating characters' next actions. It's been heartwarming to confirm this as an African cultural practice, the active affinity for characters, and that it is engrained in Black film audiences all over the Diaspora. Talking back to screens remains both an icon of cultural retention and the source of a chuckle in my belly as I experience these differences when my own films show.

My second trip was different. It was now 1993, the mood in Burkina Faso was difficult. I was among academic scholars for whom status seemed important. The travel agent from my first trip had offered me the opportunity of taking on the administrative responsibilities of leading the African American contingent, settling them in their hotel, and presenting their documents to the hotel manager. What I didn't know was that the travel agent hadn't paid his prior bill, and this led to all sorts of complications. As I maneuvered through this experience with nearly no resources, I also attended the meetings of the Pan-African Federation of Filmmakers. I remember fumbling with the headsets to better understand the interpretations from French to English and back to French. Clyde Taylor sat next to me during one of those sessions. I felt the growing divisiveness at FESPACO between the colonial regions. The politics of francophone versus English-speaking filmmakers

seemed to dominate the meetings. Today, I understand they were vying for preference in a future, more monetized film presence. My son was having health difficulties at home, and the logistical challenges of navigating the festival overshadowed my FESPACO experience. I felt this trip required more of me than I had to give. I left the country marveling at the difference in my trips there in just a few short years. Regardless, being in Africa for a Black American will always be a learning curve.

While I was a student at Fisk University, in Nashville, Tennessee, I spent six weeks on a study trip to Ibadan, Nigeria. Recently, I was invited by the African Movie Academy Awards to attend their ceremony in Rwanda. My film *Evolutionary Blues . . . West Oakland's Music Legacy* had been nominated as the Best Diaspora Documentary. Not six months later, I was in Thika, Kenya, with Restorative Justice for Oakland Youth (RJOY) for a sixteen-day trip. My role then was to document RJOY's work with secondary school communities providing training in restorative practices. I find that no matter what the occasion, being in Africa always replaces pieces of my soul, creating in me a more complete vision of who I am and what it is that I bring to the world.

Mansour Sora Wade

Wade was born in Dakar, Senegal in 1952. After majoring in film studies at the University of Paris, he worked with various cultural agencies before beginning a career in 1976 directing television films. Among his films are Fary l'anesse *and* Aida Souka. *His celebrated film* Picc Mi *won the 1993 Prix Afrique en Creation and Prix de la Paix at FESPACO.* The Price of Forgiveness *won seven awards at film festivals around the world.*

My Vision of FESPACO

For us African filmmakers, FESPACO represents a showcase. I shall never forget my first participation in the early 1990s with my short film *Fary l'anesse* and it was that year that I made my first sale, which marked the beginning of my trips around the world.

FESPACO is par excellence the meeting place for broadcasters and international festivals. FESPACO participates in the valorization of African and diasporic cultures and is truly the meeting place between us and our audiences.

FESPACO has a promising future and deserves its place among international festivals. This is why, understanding the stakes, many young people have been engaging in the cinema and audiovisual professions.

Thanks to FESPACO and its worldwide resonance, many of our countries have understood the importance of cinema and have started creating their own financing mechanisms.

Today, FESPACO would, in my opinion, benefit from being independent from the State and should be more professional.

Fatoumata Coulibaly

Fatoumata Coulibaly is a Malian film actress and director, also a journalist and activist for women's rights, especially against excision. She played, among other things, an important role in Cheick Oumar Sissoko's Guimba *in 1995 and the main role in the film* Moolaadé *by Senegalese filmmaker Ousmane Sembène in 2004.*

The FESPACO is My Life

I played the role of Sadjo in the film *Guimba, the tyrant, an epoch* by Cheick Oumar Sissoko, a film entered in competition at FESPACO 1995. It was the first time I was able to attend FESPACO. We left Bamako by bus. At the time the rebellion had just started in Mali towards the North. So the rebels were on the road that led us to Burkina Faso. Our minibus broke down and we were stuck in the bush for over four hours. We were scared, very scared. The great costume designer, Kandjora Coulibaly, left with another decorator to fetch peanuts and water. They were absent for a long time. We were hiding in the bus, fearing that the rebels would find us. Then when the two men returned with water and peanuts, we ate, and the minibus could be repaired. And we left unharmed to FESPACO. It was the first time for the vast majority of Malian actors and technicians Cheick Oumar Sissoko wanted us to come with him.

We arrived in Ouagadougou and were very well received; our hotel was in the heart of the city and we immediately felt at home, watching the movies, meeting other film professionals and touring the city. To be honest, it was great until the last day.

Then came the day when the results were to be announced and that was a great memory. That day, in the morning we met the great Burkinabe director

Idrissa Ouédraogo (peace to his soul!) who told us that our film *Guimba* was impressive but that there were other films which were very good too, and he wished us good luck in announcing the results of the competition.

In the afternoon, at the closing ceremony of the festival, Papa Ousmane Sembène, president of the official feature film jury after having awarded the other prizes, challenged the audience by asking them: which film must have the Gold Étalon d'Yennenga. From the public voices were heard; some shouted *Guimba*, others said *Keïta*. But the majority chanted *Guimba, Guimba!* There you go, Papa Sembène proclaims: "The Gold Standard of Yennenga is awarded to the film *Guimba a tyrant, an era* by Cheick Oumar Sissoko."

Immediately, overcome with emotion, the young Malian actress who played the role of Tany in *Guimba* did not regain her senses until much later in her hotel room where she was brought back. Later at the start of the night, we took a triumphant stroll through the avenues of Ouagadougou before going to celebrate the prize with a good meal. This is my first and great memory at FESPACO.

My second great memory was in 1999 with my first film as a director, *N'Golo dit Papy who talks about street children...* and which received the French Cooperation award that year; I couldn't believe my ears when I heard the French Minister of Cooperation announced: "our prize is awarded to a lady, her name is Madame Somé Fatoumata Coulibaly." I almost fainted! These two memories there I will never forget them.

Going to FESPACO has become compulsory, it's like coming home; if I don't come home after work, it's because (laughs) nothing's there! I cannot stay in Bamako without going to FESPACO when it takes place even if I am not invited! The year Cheick Oumar Sissoko directed *La Genèse*, I was on his set as a director and actress; I took my return ticket on Air Burkina to go to FESPACO, because the whole team could not be invited, and there I had another great festival.

Since then, I have only missed one FESPACO, due to the fact that Papa Ousmane Sembène had done me the honor of asking me to accompany his film *Moolade* in which I had played the main role, in a screening tour in France which took place at the same time as the FESPACO of that year; I could not refuse that to Papa Ousmane Sembène, all the more so since beyond my role as an actress in the film, I was also a radio and television journalist and I had created an association to fight against excision.

FESPACO is cinema and my life is cinema. I was also a member of several juries at FESPACO and each time it was an enriching experience for me.

I've been to the Cannes Film Festival four times, but FESPACO is second to none. FESPACO gives us courage and the desire to make films, to encourage young people to make films; we make contacts, we have fun, we

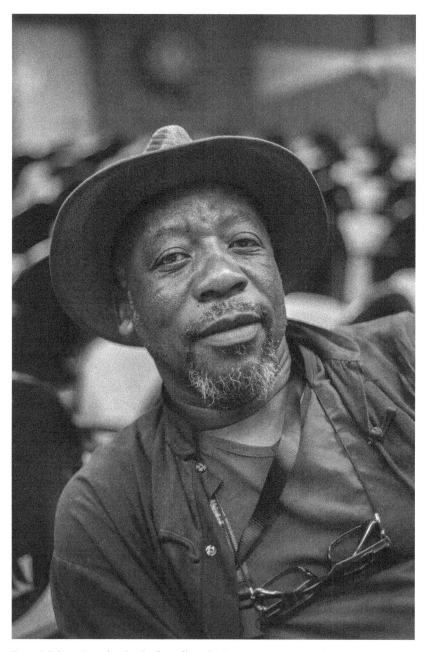

Figure 3. Suliman Ramadan, South African filmmaker, image courtesy FESPACO.

see a lot of films, we also hear a lot of strong words during conferences and other debates, we exchange ideas with others.

The FESPACO, it must continue, and we ask the organizers to fight so that the FESPACO can become again as before, that it finds its soul, because there are too many people now... The festival has grown too much too quickly? Now everyone knows the festival, but there are film schools, young people who want to come and who should be given priority.

The festival needs to be organized better, especially in terms of reception, badges, hotels, and transport between the different festival venues and especially between hotels and screening rooms. We need to give more attention and visibility space to young filmmakers and their works, without forgetting the deans. The pioneers and the elders have shown us the way and we must all continue to be worthy of it.

But I really care about the Festival and I want to thank the first organizers of FESPACO. I sit down with both hands behind my back to thank Madame Salambéré, this great lady. I thank her very much because she awakened us, she gave us lessons, quite simply by being active from the first session of FESPACO. Thank you very much and long life to the Festival.

Bérénice Balta

Balta is a journalist for Radio-France-International.

My first FESPACO...

1989 ... Twenty years after the initiative of a few lovers of the seventh art to set up a large-scale film festival in Ouagadougou, here I am, freshly landed in sub-Saharan Africa, in the then Burkinabe, and no longer Voltaic, capital city, since 1984. It has not been a year and a half since the man to whom we owe this change, Thomas Sankara, was murdered. Whereas I know well the Maghreb for having lived there, I don't know much about Black Africa; a few books, knowledge acquired from my parents, friends or colleagues, musical notes from balafons, coras or djembes that make me dance.

I am twenty-two years old and I am discovering a part of a continent that will—as I discovered much later—first divert and irritate me, and later delight and challenge me, to the point that, for various reasons, I decided to live there a few years ago.

In Paris, there is a wave of snow that turns pavements and landscapes grey. The plane is late … The arrival in Ouaga, in the middle of the night, is Kafkaesque. The heat, even at night, is stifling. The hotels are full, despite reservations in our names. A few of us will end the night on stoned sofas at the FESPACO headquarters, due to a lack of accommodation. The first three days are terrible. I don't have the operating codes of the country, of the inhabitants; I get annoyed about everything and, above all, I discover a frightening disorganization for the little toubab, "white lady" who came to do her first report on the festival.

Nothing will work as planned, from beginning to end … But, from meetings to discoveries, from interviews to screenings, from press conferences to memorable parties, I meet incredibly amazing people.

Day after day, I start, without realizing it, contracting the virus of the country, of the people. I marvel at the resourcefulness of the filmmakers and other artists, the inventiveness of the craftsmen, the conviviality experienced in the "maquis" with smiling strangers, the colors of the fabrics, the tea offered at the far end of a market where I got lost.…

This first FESPACO, the eleventh edition, is definitely unbelievable. Until the end, I switch from one surprise to another. I learn patience and humility; I discover strong works and I make unfailing friendships.

In the end, the end of my stay comes much quicker than I would have wished.

A little before the great award list celebration, I announce with some pride that the Grand Prix will be awarded to the Étalon de Yennenga. I trigger hilarity among a few people who kindly explain to me that the Étalon de Yennenga is not the title of the winning film but the name of the Golden Palme of Ouaga.

"Really, white girl, you make us laugh a lot."

I don't yet know that two years later, it would be with RFI and that "my Little Radio Mum," Catherine Ruelle, will still teach me a lot about African cinema, sorry, African cinemas.

I went back to FESPACO, almost every edition. And even in 2017, for the twenty-fifth anniversary, when I had already left the radio station. And yet, what remains, when I think about it, are not the bad memories, nor the memories of those who disappeared, Henri Duparc, Idrissa Ouédraogo, Claude Verlon, to name only those three people dear to my heart, but, on the contrary, the laughter, the meetings, the connivance with the directors, the actors, the teams with whom I worked.

I have to admit, each time, we say it's over, that we won't go back … Then, when February of the odd year approaches, the little "FESPACO" glow begins to shine, slowly at first, then stronger and stronger.

And then, a strange thing, not to say magical, we start, almost unconsciously, in automatic mode, to pack our bags, our bundles so as not to miss the plane, the plane to Ouagadougou, the capital of African cinemas…

Cornelius Moore

Moore is the Co-Director of California Newsreel, the non-profit film distributor and producer that focuses on race, African American life and history, Africa, and health and society. He has been with California Newsreel for thirty-two years, leads its African American Perspectives and Library of African Cinema projects and is extremely knowledgeable about African American and African Diaspora cinema, having curated film programs for the San Francisco International Film Festival, the African Studies Association, and the Museum of the African Diaspora. He serves on the Boards of Cal Humanities and the Priority Africa Network and is an advisor to the Afro-Latino film projects, Afro Uruguay: Forward Together and Cimarrón Spirit.

In the early 1970s, the first African film I saw was Ousmane Sembène's *Emitai* at the Philadelphia Black Film Festival curated by Oliver Franklin. I was blown away by the film's style, its anticolonial message, its unearthing of history, and the significance it gave to women. I wanted other viewers to appreciate the experience as much as I did.

In the late 1980s, I became the founder and director of California Newsreel's African film distribution project, the Library of African Cinema. It became imperative for me to attend FESPACO, the mecca for African film and the largest cultural event on the continent. In 1991, I finally got the opportunity to go—which was also my first trip to Africa—and distributed copies of our first African cinema catalogue to filmmakers and supporters of African film. As the apartheid system was finally on its deathbed, 1991 was also the first year that a sizeable delegation from South Africa participated—three years before the country's first democratic election in 1994. I continued to travel to FESPACO for eight subsequent editions, looking for films to distribute and to meet with international colleagues. FESPACO remains an important gathering place to experience enthusiastic local audiences (in unique outdoor screenings), for creatives and cultural organizers, especially for those from the continent and the African Diaspora (the Americas, the Caribbean, and Europe). There is nothing like it!

Along with funding, FESPACO faces the challenge of how to actively include documentaries as well as digital forms of media that are now being embraced by adventurous and emerging filmmakers.

Thierry Michel

Michel, born 13 October, 1952 in Charleroi, is a Belgian film director. He is primarily a filmmaker of political and social documentaries. He is one of the signatories of the Manifesto for Walloon Culture of 1983. "The keys are the same, here or there. The distances with the other are abolished. Man is the same everywhere, the impulses of life and death confront each other in an identical way. And I haven't finished looking." He is a filmmaker, member of the official Jury in 2003, and member of the 2019 documentary jury.

I have made about ten documentary films in Congo and they have all been shown at FESPACO since *Zaire, The Cycle of the Serpent*, but I was not present during the presentation of the first films. On the other hand, I was at FESPACO with my producer Christine Pireaux to present the film *Mobutu Roi du Zaïre*. We knew it was an important film that had a potential audience and that a career choice had to be made. So we thought of FESPACO as a launching pad, but it exceeded all of our expectations. It was unimaginable! We found ourselves faced with a very large and popular audience, a real audience. And this is the great strength of FESPACO, it is first of all this real Burkinabe audience, a very reactive African audience, who can challenge, laugh, applaud during the film, curse, get up, sit down, laugh! The movie premiered at the Neerwaya if I remember correctly and it was packed. Then we had the screenings at the Stadium on an inflatable screen and it started again with the same enthusiasm. Suddenly, we realized that this film touched the hearts of Africans and that it was not by chance. Afterwards it was released in theaters in many African countries; I have presented it in about fifteen countries, from South Africa, Cameroon, and North Africa. In Burkina Faso, a distributor had acquired the rights to the film and released it for a year. With one copy he had made eighty thousand entries. He told me "I do more with your movie than the Titanic"—which was coming out around the same time!

What is important is also the whole debate that films raise. FESPACO is obviously the privileged place for debate, not only for me, but for all African filmmakers; it is the very place where the assessment of what

African film is in all its economic dimension is made, on the one hand (because the producers and institutions which subsidize cinema are present) artistic on the other hand with the presence of authors and directors. It is a barometer of the situation of African cinema, a barometer of aesthetics and themes.

I have always presented my films out of competition since I am not African, and therefore my films cannot compete in competition, which I obviously understand perfectly… But at the same time, as my films had a certain importance for Africa, I must say that the festival has always programmed me in venues or at times when the public was present, so I have no complaints at all, on the contrary! It is true that there was not yet the documentary selection and there was certainly not the documentary competition which came very recently.

FESPACO is one of the places where I like to present my films. God knows how many tours I have done in Africa with an audience that is differentiated geopolitically; it's fascinating to see how the specific situation in a country can interact with the public's perception of the film. The films reflect a very different perception, depending on the history of each country, each audience. So some African filmmakers may have expressed reservations about my legitimacy to make films in Africa, in the Congo, but at the same time no one was doing it at the time. There is a long history of colonization between the Congo and Belgium as we know. I have no personal, family, or historical connection with colonization; so I filmed in Congo as I filmed in Brazil, Iran, Morocco, Somalia, or Guinea.

In fact, it was the historic moment that fascinated me. Initially, I wanted to make a film about the fall of President Mobutu, an end that was scheduled since he had accepted the principle of democracy and was coming to the end of his last term. For me, I was going to film the end of the match and in fact what I filmed was the terror and the political violence of a regime that wanted to continue, so the film on the fall of the Marshal, I could not do it; that happened seven years later. I wanted to follow this story and obviously I did not let go; I did *Zaire, Le Cycle du serpent* which shows this period of terror of the Mobutist explosion which suffocates and dominates society, then I continued with *Mobutu, King of Zaire*. Then I filmed Congo River, realizing the immensity of this country four times the size of France, to show its great cultural, traditional, linguistic, landscape, and historical diversity as well. I wanted to cross the whole country again, retrace the path of the river from the source to the mouth and it was a six-month shoot. And one thing leading to another, the films were made on different themes. When I arrived, I discovered how Katanga province had experienced an industrial revolution based on mineral wealth where a violent class struggle was taking place, at the level of artisanal miners, or at the level of workers in multinational companies.

In this economic war, opposing economic powers clashed. Between Asians, we will say mainly the Chinese but not only, the large western multinational companies, England, Australia, even South Africa, Algeria, etc. This is a film about industrialization, but it is also a film about the deep Congo. Then there was the emergence of a new leadership, that of Moïse Katumbi in Katanga businessman, media man, an African Berlusconi, and I painted his portrait. Then there was the assassination of Floribert Chebeya, founder of human rights organizations in Congo, who had lived in hiding under Mobutu. I felt there was a terrible stake looming there, and one had to testify through the trial and it became *The Chebeya Affair*. Finally, I wanted to tell the story of Doctor Mukwege, this defender of raped women, a gynecologist who had dared to denounce the impunity of criminals in Congo during the wars, especially the wars in East and South Kivu. So we, the doctor and I, really did advocacy work against impunity for rape used as a weapon of war in Congo and also for the accountability of multinationals that use blood minerals. There have been results and advances at the international level, at the legislative level, at the level of rules. And then the doctor obtained the Nobel Peace Prize and it was he who really insisted on making a film on impunity, on crimes, criminal history, let's say on the last twenty-five years of impunity that reigns in this country. So I picked up my pilgrim's staff, to return, to collect the words of the victims. Unfortunately the film will not be finished for the next FESPACO!

To come back to my presence at FESPACO, I was a member of the official competition jury with Idrissa Ouédraogo as president; it was not easy! He was great but the official selection is not easy. In 2003, we gave the grand prize to Abderrahmane Sissako's *Waiting for Happiness*. And then I was a member of the documentary jury in 2019. The festival management realized that documentary was a genre in itself with its letters of nobility and that it had to be given its place. Besides, we can say that women have taken over the documentary, there are a lot of them now, and that's very good.

When you are a member of the jury you are in a bubble, you are really cut off from the world with an extremely busy schedule. It was incredible the number of films in 2019! The screenings really went from morning to late at night, even into the night ... Normally we had to see the films in theaters, but there were some technical issues. It's true that we always prefer to see films in theaters, not necessarily with the audience, because watching with the audience always gives us a different perception of the film. All the same for African films, I like being in the audience, because what is fascinating in Ouaga is obviously to see and feel this audience so reactive and spontaneous, it is a pleasure that we have not always in Western rooms. But the festival is also a reflection of the evolution of the world; there were attacks in Burkina Faso before the 2019 festival so there were much more

drastic controls at the entrances; rooms like the French Cultural Center have become inaccessible.

On the other hand, when you are a juror, you obviously see all the films and debate them. It is intellectually intense since no one shares the same general, absolute vision of the selected documentary production. And there are always fruitful exchanges. But in any case this jury there in 2019, under the direction of Nadia El Fani, very dynamic and intelligent, really dealt with ethical, aesthetic, and of course also thematic questions.

When I look back, there was a time when the pioneers were there, the great filmmakers, who fought to make African cinema exist, a real auteur cinema with perhaps more technical imperfections but a commitment. Unbelievable; it was really the spirit of independence and postindependence that was present; it was obviously an exhilarating time; today are appearing films that come from more differentiated worlds and from African filmmakers who are more "in between." In fact, today there are African filmmakers in the diaspora and filmmakers making films in Africa. In the documentary there are, more and more, young Africans who have always lived in Africa, sometimes having only followed a seminar or an internship in Europe. While "poor," these African productions are doing works that's all new.

Hicham Ayouch

Ayouch is a director and writer, known for Fièvres *(2013),* Fissures *(2009) and* Tizaoul *(2006).*

What does FESPACO mean to me?

I had the honor of being awarded the Étalon de Yennenga in 2015 for my film *Fièvres,* a moment of extraordinary emotion and unusual communion with the audience and other filmmakers. As a result, FESPACO has and will always have a special place in my life. Beyond the personal aspect, FESPACO is a legend, it is part of the world cultural heritage. It has always embodied the vivacity and plurality of African cinema. It is a magnificent place where encounters, laughter, dark rooms and a passionate audience mingle. In short, I am in love with FESPACO!

What role can FESPACO play in the future of cinema in Africa and the Diaspora?

I don't tell the future, so I would find it difficult to answer this question, but I hope that the destinies of FESPACO and those of African and Diasporic cinema will remain linked forever to continue transmitting beauty and meaning.

Salif Traoré

Traoré was educated at the National Institute of Arts of Bamako (INA) in Bamako, then at the African Institute of Cinematographic Studies (INAFEC) in Burkina Faso. After several short films, he directed in 2007 his first long feature film, Faro, la Reine des Eaux; *later he directed other movies including,* Sigida, l'environnement *in 1994,* La danse du singe *in 1998, and* Le cri de la falaise *in 2000. In 2019, he has directed a documentary film entitled* Jamu Duman.

My FESPACO

After my studies in dramatic art, I was first fascinated by cinema; I wanted to be in front of the camera as an actor. But my internship, which was at the National Cinematography Center, fed another passion in me, the passion being behind the camera as a director. There, I was fascinated by reports and the making of all kinds of films.

Quickly in 1978, the Center got a scholarship for me to study at the University of Ouagadougou, at INAFEC, the African Institute of Cinematographic Studies of which Gaston Kaboré was part of the faculty. In 1979, I discovered for the first time, FESPACO, the Pan-African Film and Television Festival of Ouagadougou.

At the time, the students of the institute were part of the organizing committee and were in charge of welcoming guests. I was not only fascinated in movie theaters by directors and actors, but also by a cinema-going public from all over the world. A soothing atmosphere of conviviality was palpable between actors and those who came to admire them and discover their works. As students, most of us were among those who had our eyes turned towards the screens, confronted with the magic of the image and the technicality. I thus discovered African cinema, cinema from other African countries.

For the anecdote, the first African film that I saw was years before when I was in primary school; it was *La Noire de …* by the Senegalese director, Ousmane Sembène. What magics that day! I wasn't the only one who was fascinated in the schoolyard! After the screening, I looked for more information and learned later that an African could make films! I believe that this moment marked me forever.

When I discovered FESPACO, the emotion was great. I didn't believe that in such a short time one could see so many African films and discuss with film and audiovisual professionals about their creations. I was intensely marked and comforted by this unfailing expectation that the magic of the image could provide, through the screen, through debates, conferences, and the serene atmosphere between festivalgoers.

Beyond this emotion, I understood that each edition was like a school for me, a master class where my exchanges with other festivalgoers taught me a lot about my continent, the world, and the evolution of the sub-Sahara film industry.

Annette Mbaye d'Erneville

D'Erneville is a woman of letters, and Senegalese radio woman, pioneer of journalists in Senegal. She was the President of the OCIC Jury at FESPACO and Founder of the Dakar Film Days, the RECIDAK (Film Meetings of Dakar), which have just resumed after ten years of interruption.

FESPACO was a very important Pan-African organization because it allowed people to have fruitful exchanges around cinema. And it allowed people to see films made elsewhere, in movie theaters! Currently in Senegal, there are almost no more movie theaters. But I think it's very important to think back to that period concerning cinema in Africa: having movie theaters where films can be shown. But, to have theaters that operate too, there must be films. Do African countries trade with each other? Do they receive new works by filmmakers? Do they have the means to show them? Perhaps we could go back to older films and make a kind of retrospective.

But, I think, FESPACO is an organization that should be revived or reactivated because it would have not only a Pan-African focus on cinema but also an international focus. Whether Europeans, Africans, Asians, they were all interested in cinema, in what filmmakers do, in what African directors do in general. And it also allowed filmmakers to meet and share ideas. Because

Figure 4. Actress Xolile Tshabalala at FESPACO. Image courtesy FESPACO.

as long as you're focused on your own work, you don't make progress. By seeing others, by having contacts and exchanges, you can perhaps change your point of view and improve your own production.

So, my opinion is that FESPACO is an extremely important inter-African structure and that filmmakers should try to make it grow, especially by increasing the regularity of its meetings, by making it an annual meeting. And that would allow the exchange of ideas, processes, and techniques, meeting other people and giving new life to filmmaking, so that African cinema can always have a basis and a meeting place. Currently, to my view African cinema has weakened.

Makéna Diop

Diop is an actor known for his roles in Bàttu, Une Femme Pour Souleymane, The Hero, *and* Journey to Portugal.

My Best Memory of FESPACO

My best memory of FESPACO—if I can say so—maybe I should rather talk about a good memory that remained in my mind—was undoubtedly, that year when FESPACO, in a burst of happy intuition, initiated a forum, an open workshop, where actors, in front of directors, would talk about their practice and especially about their working relationships with directors.

It was very timely, because a film festival can always be used to broadcast and show films. It's legitimate to even have peacock parades, if you like, and interviews with stars, but also, and this was the case here, to promote meetings and exchanges to discuss problems that either hinder its smooth running, or open through joint reflection, prospects for its evolution.

And then is raised, by the actors of course, the taboo question of "directing an actor," which, it seems to me, is without question, one of the major obstacles that this cinema made in Africa by Africans is dragging. Hence also, and consequently, the poor representation of actors in this cinema and in festivals.

Yet, that year, actors, having taken the game, discussed the issue with enthusiasm and seriousness, and proposed avenues for reflection and concrete actions.

And then … Silence …

Because unfortunately, as the events that followed showed so well, neither FESPACO—at the origin of the initiative—nor the concerned directors, paid attention to it, and were not even present at these workshops.

And actors' work and proposals were simply forgotten.

Just like other imperatives that challenge such an endearing cinema.

And this inspired me to think about it: this cinema, which has shown its enormous potential through directors and major works, which has tremendous resources, given its cultural diversity and infinite language possibilities, is always spinning around, because it doesn't face up to itself and deal with its real problems.

And FESPACO—like all other meeting and exchange forums in the continent—should, more than ever, rethink its role as a strategic anchor point, and as the "propeller" of cinema towards its necessary maturity and real genius.

As for the acting Award I won for my role in *Battu* by Cheick Oumar Sissoko, I received it, with great pride, from the hands of Cheick himself, but several months after the festival and not at FESPACO!

Indeed, I had not been invited that year, which overshadowed my joy—sincere—and my happiness to have been recognized by my peers, under African skies!

Catherine Ruelle

Ruelle is an actress and writer, known for The Decline of the American Empire *(1986),* Safrana or Freedom of Speech *(1978) and* Carnet de Dubaï Hiver VI: Lumière et Reflets *(Carnet Filmé: 14 décembre 2011) (2012).*

The First African Film Festival of Ouagadougou

February 1–15, 1969

On February 3, 1969, Voltaic journalist Roger Nikiema,[17] recalls on international radio stations, the opening, two days earlier at the Maison du peuple of Ouagadougou, of the first film festival held in West Africa.

With no hope of being awarded an Oscar, a "Palme," or even an incentive prize, the works of some twenty African and foreign filmmakers from across the continent are taking part in the first African Film Festival in Ouagadougou. In a statement revealed by the Organizing Committee of

the festival, President Lamizana wrote: "Through this event of international cultural significance, my government and I wish to affirm the existence of an African cinema, made in Africa, by Africans, on African topics."

At the opening ceremony in the presence of the Head of State and Mrs. Sangoulé Lamizana, members of the government, the diplomatic community and other high-ranking personalities of the capital city, Mrs. Alimata Salambéré, Head of programs of the Burkinabe TV channel and Chair of the Festival Organizing Committee said: "From a very simple idea: to put the [Burkinabe] public in contact with the works of African filmmakers, was born our desire to create a festival. We could have made it a mini-festival, a festival for the poor, but our ambition went beyond that. We wanted a national and worldwide event. We wanted to fill a gap in Africa. Indeed, to the best of our knowledge, no state in West Africa has so far organized an African film festival, except for the screenings of the World Festival of Black Arts in Dakar.[18] I hope that this event will be such a success that the encouragement obtained will enable the Committee to plan the organization of the second African Film Festival of Ouagadougou in 1970."

This was the case since the first festival, which featured some thirty films from ten different countries,[19] recorded an exceptional participation of ten thousand spectators. We did it!

A look back at the birth of the Festival

Alimata Salambéré recounts that at that time in West Africa, including in Senegal, Niger, Burkina Faso, Mali and Congo, there were many very active Film Clubs around the French Cultural Centers, as well as some Camera Clubs through which aspiring filmmakers were getting introduced to cinema. Since 1961, as Véronique Joo Aisenberg, current Head of the Africa Cinematheque of the French Institute in Paris, reminds us—the French Ministry of Cooperation, under the leadership of Jean-René Debrix (and Jean Rouch, who was also very active on the ethnographic film committee), had created a cinema office and a film library; the cinema office provided technical and financial support to the first films made by filmmakers such as Paulin Vieyra, Moustapha Alassane, Oumarou Ganda, Urbain Dia Moukoury, Ababacar Samb, Timité Bassori, Henri Duparc, Ousmane Sembène, and many others. The cinémathèque (created in 1963) made it possible to preserve and disseminate in cultural centers, French films shot in Africa, especially those of Jean Rouch, but also those early African films.

The Organizing Committee that was preparing the Ouagadougou festival had been set up around the Franco-Burkinabe cultural center and its new director. This director of the Franco-Burkinabe cultural center and great film

lover, who came to the country in 1968, was Claude Prieux. He had a number of films from Africa provided by the Africa cinémathèque.

The festival was therefore prepared by a group of film lovers. The Organizing Committee was made up of seventeen members including François Bassolet, René Bernard Yonly,[20] Hamidou Ouédraogo Roger Nikiema, Claude Prieux, and Alimata Salambéré who was the first Chair in 1969 before becoming a few years later the General Secretary of the Festival. At the time, the country had six movie theaters supplied by foreign companies,[21] but the Burkinabe population did not have access to African productions from neighboring countries. The initiators therefore wished that, through this festival, people could eventually see films from their own continent.

"The idea of making a festival and not just film clubs came from Claude Prieux", says Alimata Salambéré. He was "a friend of Paulin Vieyra and Ousmane Sembène." He obviously knew Jean Rouch and was sensitive to "Auteur Cinema," as shown in the 1969 programming, with films by Joris Ivens or Marcel Camus (Orfeu Negro). The Organizing Committee, says Alimata Salambéré, felt a sense of injustice because the films made by Africans were not seen by Africans, while initially, all these filmmakers had made films with their people in mind. It was their cultural values that they wanted to convey and reappropriate through this medium; there was also a real spirit of creation and solidarity that triggered the impetus of this small group of filmmakers and friends; it was necessary to find other films than those that were at the cultural center. Claude Prieux asked the filmmakers if they could lend their films and all of them agreed. Although the initiative is in fact a private one at the beginning, the event is placed from the onset, under the high patronage of the Head of State, General Sangoulé Lamizana. The President even offered budgetary support from his own funds, and the city of Ouagadougou decided to exempt the festival from taxes usually levied on shows (ten percent of revenue). From the first festival, the Posts and Telecommunications were involved to work with existing means (telex, telegrams, telephone); also involved were the Information Directorate, the press, and especially radio stations.[22] Claude Prieux also brought in some French film critics. From the outset therefore, the event was thought as a festival open to the world and as a place for debate and meetings between the public and filmmakers.

The first of African Film Festival of Ouagadougou

The festival took place from February 1 to 15, 1969. Eight African countries were represented: Senegal, Côte d'Ivoire, Burkina Faso, Niger, Mali, Benin, Congo, and Cameroon, but also France and the Netherlands. Thirty films,

twenty-three of which are African, were screened. The films, documentaries and fictions, evoke very strong and still topical issues: emigration and decolonization in Sembène's *La Noire*; acculturation of intellectuals caught between two cultures in *Point de vue Numéro 1* and *La fleur dans le sang* by the Cameroonian Urban Dia Moukoury, as well as *Et la neige n'était plus* by the Senegalese Ababacar Samb; women's situation in *Kakayo* by the Congolese Sebastien Kamba, or *Diankha Bi* by the Senegalese Mahama J. Traoré; people's frustrations and the consequences of colonial wars in *Cabascabo* by the Nigerien Oumarou Ganda; the importance of deteriorating traditional culture in *La grande case Bamileke* by the Cameroonian Jean-Paul Ngassa, *Lamb* by Paulin Vieyra, *Ganvié mon village* by Pascal Abikanlou from Benin, *Mouna le rêve d'un artiste* by Ivorian-Guinean Henri Duparc or *Grand Magal à Touba* on the Mourides Muslim Brotherhood; let's mention the first African western and animated films by Mustapha Alassane, and the presence of a woman director, Thérèse Sita Bella, author of *Un tam-tam à Paris*, a film that unfortunately disappeared. As for Burkina Faso, it presented *Noce d'eau*, a film directed by Frenchman Serge Ricci with Sékou Ouédraogo.

Melissa Thackway

Thackway is an independent researcher and translator. She lectures in African cinema at Sciences Po and the Institut National des Langues et Civilisations Orientales in Paris.

FESPACO in the 1990s, a Space of Sharing

I first attended the FESPACO in 1995. As a PhD student working on West and Central African film, this research trip was an essential opportunity to discover a wide array of films that were difficult to access elsewhere at the time. Better still, it was the opportunity to view them with local audiences, more often than not in my case in Ouagadougou's cheapest, always packed open-air cinemas Oubri and Riale. Here, audiences' spontaneous, noisy interaction with films was a whole new viewing experience; it was one that gave me important insight into audience reception, developing my awareness of the specificities of context, and of the perception, place, and role of cinema locally.

This trip to the FESPACO was also an irreplaceable opportunity to meet filmmakers, who could always easily be found then in the grounds of the Hôtel Indépendance. Highly approachable and remarkably willing to give their time,

they patiently discussed their work with me, their cinematic intentions, their creative processes, sometimes for hours. Hearing their viewpoints was again fundamental to my learning and understanding, and the interviews I conducted at the FESPACO later appeared in my book *Africa Shoots Back*, so important was it to me to give space to the filmmakers' own voices and reflections. Fostering the critical conversations that undoubtedly help shape and enrichen cinema, these spaces of sharing and exchange were, in my mind, what gave the FESPACO of the 1990s its uniqueness, its magic, and above all its relevance.

Mahmoud Ben Mahmoud

Mahmoud is a Tunisian film writer and producer. He studied at the INSAS Belgian school of cinema where he completed his graduation in the field of filming. Later, he studied art history, archaeology and journalism at the Free University of Brussels (ULB). He made his first feature film Crossings / Traversées *in 1982. His second feature film, released in 1992,* Chichkhan, Diamond Dust / Chichkhan, poussière de diamant *was selected for Directors' Fortnight at the Cannes Film Festival. Mahmoud has also released a number of documentary films between 1992 and 2006, such as:* Italiani dell'altra riva *(1992),* Anastasia de Bizerte *(1996),* Albert Samama-Chikli *(1996),* Ennejma Ezzahra *(1998),* The Thousand and One Voices *(2001),* Fadhel Jaibi, a Theatre in Freedom *(2003) and* The Beys of Tunis, a colonial monarchy in turmoil / Les Beys de Tunis, une monarchie dans la tourmente *(2006). Meanwhile, he has still continued to make films that have marked his film career success, such as* Naps grenadines *(2003).*

My story with FESPACO is certainly not as rich as that of some other Tunisian or North African filmmakers. But it is undeniable that this festival has played a great role in my career development and the promotion of my films.

I attended FESPACO only once, at the end of the seventies, to receive an award from the Organisation de la Francophonie (then called Agence de Coopération Culturelle et Technique, ACCT) for the screenplay of my first feature film, *Traversées*. However, this trip to Ouaga allowed me to rediscover the links between my country, Tunisia, and its continent, a continent to which it gave its name, Ifriqia. Twenty years later, I shot *Les siestes grenadines* which celebrates this reunion with sub-Saharan Africa, an often repressed dimension of our identity. That film was shown at FESPACO in 2001 where it received the Best Soundtrack Award for its homage to "Stambali," the music of the Black community of Tunisia.

Previously, in 1983, *Traversées* was nominated at FESPACO and won the International Critics' Award. Unfortunately, I did not have the pleasure of being present to discuss it with the audience.

However, my greatest satisfaction comes from the success of my last film *Fatwa* at the 2019 edition, where it received two awards and a mention. Its screening in Ouaga made it known in sub-Sahara countries where it was featured in many festivals, from Durban to Cotonou, Yaoundé and Zanzibar, all new destinations for my films. *Fatwa* is indebted to FESPACO for having boosted its career in the entire African film circuit, including Europe and America, because it was in Ouaga that most festival directors discovered it.

The celebration of FESPACO's fiftieth anniversary is an opportunity to remind that this festival must and will remain (along with Carthage) the showcase of film productions from sub-Saharan countries and the unmissable meeting place for all African filmmakers who continue to resist the standardization of the world by taking an original and uncompromising look at the reality of their society.

Long live FESPACO!

Rachid Naim

Naim is a film critic, photographer, and university professor.

An unmissable event for African cinema, FESPACO is an unparalleled exchange forum. It is first and foremost a platform where cinema and audio-visual professionals meet, get together, and bring their common creative projects to fruition.

FESPACO is also our common African cinematic memory that I proudly claim all over the world. In fifty years, this prestigious event has indeed accumulated a glorious record of achievements in which masters of African cinema such as Souleymane Cissé, Souheil Ben Barka, Idrissa Ouédraogo, Mohammed Lakhdar-Hamina, Ousmane Sembène, Ahmed Rachedi, and many others have participated. This legacy must not only be consolidated, but also defended as a precious and fragile heritage.

FESPACO is also a space for rich discussions and exciting debates led by leading film critics who often serve as far sighted mediators between the works of African filmmakers from the continent and the Diaspora and their various audiences.

Thanks to its rich history, FESPACO is currently the main showcase for African filmmakers. A nomination in this illustrious event is a much sought after sesame for film producers. It should not be forgotten that thanks to this festival and its longevity, African audiences have been able to see films from their own continent throughout these fifty years. The presence at FESPACO, of the Marché International du Cinéma Africain (MICA, International African Film Market) in recent decades, has enabled more intense exchange between African filmmakers and international markets.

In recent years, FESPACO has even become a platform that reconciles African cinema with its Diaspora scattered throughout the world. This new contribution of African filmmakers from "outside" has been a breath of fresh air by bringing not only new visions of the world but also new ways of telling and filming stories. Looking to the future, filmmakers from the Diaspora will help FESPACO thrive in their host countries in the very short term.

The celebration of the fiftieth anniversary during this edition was an opportunity to not only take a retrospective look at FESPACO's past but also to study the future prospects of this festival. Indeed, the theme for the 2019 edition, "Memory and Future of African Cinemas," comes at the right time thanks to the screening of old African films restored by Martin Scorsese's World Cinema Foundation, young festivalgoers were able to discover the great works of the pioneers of African cinema. The less young were also able to rediscover the cinematic gems that had often embellished the various Award Lists of the twenty-six editions of the festival.

Besides, FESPACO's future prospects are closely linked to the capacity of African cinemas to become real cultural industries. Consequently, the festival will be able to better accompany African filmmakers from the continent and the Diaspora towards an inevitable internationalization. In this perspective, the Marché International du Cinéma Africain (MICA) must become more professional in order to expand and participate even better in the nascent African film industry.

Camille Varenne

Varenne is an artist-videographer. She works regularly in Burkina Faso, notably at the IMAGINE Institute and with the FESPACO in Ouagadougou. She graduated in Art Research (2018) from the Clermont Métropole Art School where she is now an associate researcher in the "Figures de transition" research group.

Westerns Made in Africa

I am an artist and filmmaker and I have been living in Burkina Faso and France since 2013. I received a PhD in Art about African western movies as a zone of transculturation. During this research, I had the chance to be trained in IMAGINE Institut of Ouagadougou, and assist Gaston J.M. Kaboré for the coordination of colloquium of FESPACO in 2017 and 2019. Working in the beating heart of FESPACO, I was able to meet the main protagonists of African cinema, vibrate with the ouagalais audience, educate my gaze, flourish my imagination, and find my place as researcher and filmmaker.

I met the riders of Burkina Faso, named the Warriors, when I directed with them my first documentary film *Wéfo* in 2015. Two years ago, they asked me to shoot a cowboy movie. I followed their wish and, together, we created *Blakata*, a forty-eight minute western documentary produced in 2019.

The Warriors usually live in the city centers of Ouagadougou or Bobo-Dioulasso. They are the guardians of equestrian traditions. They make a living by attending ceremonies such as baptisms or weddings, but they also are secluded from other people who are disturbed by their way of living, so closely tied up with horses. Urban centaurs, they inspire fascination and mistrust. With *Blakata,* I film them playing their own role. In front of the camera, the gaze of a son on his father is revealed. One day he will become a cowboy, like his father. John Wayne looks for meaning in his life, a foot in the day, the other in the night, lost in the dusk. Machérie rides with men and dream herself in Princess Yennenga. Ildevert Meda teaches these riders how to become a cowboy thanks to the "Magic If." During my films, the shoot is a moment of intimate sharing, of negotiations, and to build a common story. The camera, demystified, becomes a tool for bringing together. With my work, I invent other relational ethics with people I'm filming, by admitting misunderstandings and also the possibility to act together. It is therefore a place where I affirm the liberty and the joy to meet people and to ally myself with the people I admire to participate in the story of a plural world.

As I started to work with them, I discovered their passion for western movies. Some of them are nicknamed John Wayne, Sheriff, or Billy The Kid, and many of them wear leather hats, cowboy boots, and fringed jackets.

There are some similarities between the Warriors and crepuscular western movie heroes. For example, in John Miller's *Lonely Are the Brave* (1962), we follow the epic of a cowboy who tries to escape the police on the back of his faithful horse, Whisky, which he refuses to abandon. They have to climb up a mountain to get out of reach in the plains. They are being chased by helicopters. The modern world is after them.

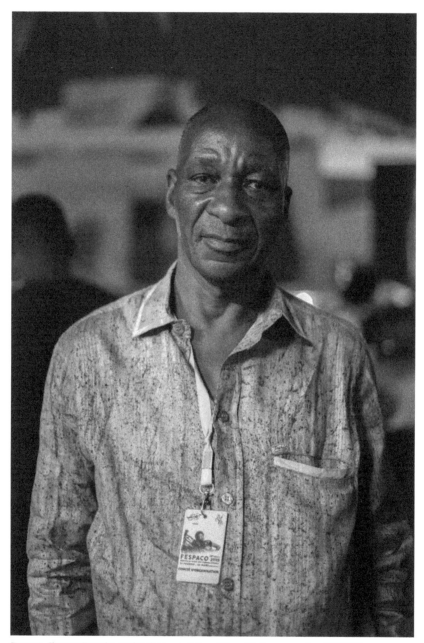
Figure 5. Clement Tapsoba, Burkinabe journalist and film critic, image courtesy FESPACO.

The Warriors of Burkina Faso also face these kinds of struggle: their attachment to traditional values and beliefs are shaken up by their relationship to the rest of the world. They pick the best out of each culture to reinvent themselves. *Blakata* tries to capture the possibility of creating one's own identity, to follow the construction of a developing being.

How can an African western movie become the illustration of a borderless world, where history can be rethought in its multiplicity and where a being can exist in its plural form?

Western movies are broadcasted in West Africa since the 1940s. Movie theaters were used by settlers as a place of entertainment, education, and propaganda of Western ideologies. After independence, theaters that belonged to European cinema networks were sold to national operators and most of them were jeopardized by the economic fragility of Western countries. In Burkina Faso, where revolutionary anti-imperialist President Thomas Sankara was elected from 1983 to 1987, filmmaking was enhanced as a vehicle of local culture and a window on the world. Zackaria Gnégné, owner of the theaters Ciné Burkina, Ciné Sagnon, and Ciné Wemtenga, explained to me that theaters were then equiped with Russian projection material to show, among others, American western movies.

Movie theaters are therefore a place where different cultures can meet, influence one another, and create a collective imaginary. African American western movies already existed in the 1960s in the USA. They were produced by directors such as Oscar Micheaux.

The cowboy as a cinematic character is the first American superhero. His whiteness, from one movie to another, becomes the common thread of a story being written and another in the process of being erased. However, a quarter of the cowboys tending to the cattle in the plains of the West were Black. The memory of these Black cowboys has been erased from the film industry. Some Black western movies were produced on the fringes, in the 1960s, by filmmakers like Oscar Micheaux. Today, we are seeing a resurgence of the western and the Black cowboy in American black pop culture. Lil Nas X's *Old Town Road* will have marked 2019 with the mixture of country music and hip-hop who gives birth to a new stream: the country trap. Throughout the music video Lil Nas X deploys cowboy imagery and revives Black cowboys history by reappropriating this forgotten heritage.

Already in 1969, Tom Gries realizes *100 Rifles,* a western movie that takes place in Mexico where the Yaqui indians are oppressed by the Spanish settlers. Joe Herrera robs a bank in the United States to buy guns and give them to the Indians. Black cowboy Lyedecker, played by famous boxer Jim Brown, is tasked with capturing him for his trial. Lyedecker, sickened by the colonial atrocities, gradually identifies himself with the Indians. He falls in love with the Indian princess Sarita, played by Raquel Welch. He ends up

joining the fight of the Indians. The sensual scene between Jim Brown and Raquel Welch shocks when the film is released. We see a carnal and romantic encounter, the union between a black man and a white woman rarely represented at the time. The film eloquently illustrates the necessary alliance of different people and genres for the fight against imperialism. By the way, the western movie can be a subsersive genre …

Dani Kouyaté's film *Ouaga Saga* was directed in 2006 in Burkina Faso. It takes place in the city center of Ouagadougou. A group of teenagers gather at night to watch *Rio Bravo* in their neighbourhood's open-air cinema. The place is crowded and children who could not pay for a ticket are lining up to watch the movie through a slightly opened door.

The sequence switches between shots of John Wayne galloping through the desert and shots of the public. The faces of the people in the audience are illuminated by the screen light. Their eyes are reflecting the image of the American hero. At the end of the sequence, the teenagers gather and Sheriff, played by Yacouba Dembélé, tells the story to those who could not watch the movie. He keeps getting interrupted by the restlessness of his audience. They all go back to their everyday life and to their quest for recognition. This sequence shows the passion of West African populations for western movies. Most people are not attracted to the story, they are attracted to the movement of these cowboys who fight for their honor. The cowboy is not seen as a colonizer who slaughters Native Americans, nor as a farmer who breeds cattle. They admire the Hollywood cowboy, a boorish and humble hero who struggles against rough landscapes and injustice.

In the movie *Lonely Are the Brave* (1962), Kirk Douglas plays John W. Burns. The movie starts with him cutting a barbed-wire fence. Burkinabe cowboys are inspired by this spirit of resistance and the questioning of the established order.

We find the same idea in *Return of an Adventurer,* the first West African western movie directed by Moustapha Alassane in 1966 in Niger. The movie tells the story of Jimmy, who returns to his village back from the Indochina War. He gives to all his friends a full set of clothing to dress up as a cowboy: leather jackets, jeans, and hats replace the usual Sahelian boubous. In the group, there also is a woman named Queen Christine, who rides horses and dreams like men. If someone forbids her to shoot with her gun, since a woman gives life and cannot give death, she takes revenge during fight scenes and crazy cavalcades.

The actress Zalika Souley had a long career afterwords and she is today the most senior person in Nigerian cinema. In 2003, Rahmatou Keïta made a documentary about her: *Al lèèssi, an African actress.* During interviews, Zalika Souley talks about the audacity of the character, Queen Christine, at a time when it was unimaginable to see a woman wearing pants and riding

a horse. Moustapha Alassane is twenty-four when he directs the movie. He wants to make a portrait of a changing youth, heir of both colonialism and independence, who needs to undertake its past and invent its destiny.

First, the movie characters get lost in banditry and robbery. They end up betraying and killing each other. They challenge the wisdom of the elders who try to reason with them and they laugh at the traditional hunter warriors who stand in their way. Their arrogance leads them to a dangerous perdition and they will find a solution in the return to the source. However, the mixing of cultures makes it possible to break the codes, as evidenced by the emancipation of Queen Christine.

In the middle of the film, a scene symbolizes well this energy, this spirit of renewal. Alassane is filming from the open sunroof of a 2CV. The cowboys are following him on the back of their galloping horses. The scene is shot in a long shot travelling to the rhythm of blues music. The cowboys are impetuously riding towards their destiny, with a proud expression on their faces. This is the image of an hybrid society in motion towards the future.

The idea of marginalized people (because of their culture, financial situation, gender…) taking revenge is often embodied by cowboys, even in classic movies such as *The Man Who Shot Liberty Valence* (1962), where John Wayne, who lives at the edge of the city, takes an important moral revenge. Is this action not doubled by African filmmakers taking their revenge by using the codes of the prevailing cinema?

In his western movie *Bamako* directed in 2006, Abderrahmane Sissako talks about corruption. The movie was shot in the director's family courtyard. It recounts the trial opposing the civil society to the World Bank and the IMF. Lawyers and witnesses follow one another and play themselves. They criticize the unfairness and the nonsense of the colonial debt, the imperialist policies and neocolonialism. The trial is interspersed by numerous digressions on the daily life of the people of the courtyard, where a thriller and a love story take place. *Bamako* is a plural movie, shaped by multiple genres, with which the filmmaker is having fun and which he uses to deconstruct his story. At night, the chairs of the witnesses are piled up in a corner of the courtyard and the people gather in front of the television. The anchorwoman announces the evening movie: the sound of a harmonica introduces the scene and the credits of a western movie begin. The leading role is performed by the famous African American actor Danny Glover, who also coproduces the film. Abderrahamane himself appears to play one of the cowboys. The movie *Death in Timbuktu* starts. A group of cowboys arrives in the city. A white man gives the order to kill one of the teachers on the grounds that there are too many of them. A Black man obeys and shoots at a random victim, while openly looking at the man who gave the order. Another cowboy kills a woman carrying her child while laughing "only one shot and two people

down!" Danny Glover, hidden on a roof, shoots at the criminals. As a fire-fight starts, the western stops and the trial is back on the screen. This small aside in the movie shows the level of complexity of the situation, the corruption of African governments who do not hesitate to sacrifice the people and be complicit in the extractivist policies.

In Boubacar Diallo's western movie, *L'Or des Younga,* directed in 2004 in Burkina Faso, conflicts between cowboys also symbolize actual international issues happening at the expense of local populations in order to exploit African countries' resources. Thomas, a young man who went to work in Ivory Coast, like many other Burkinabe immigrants, comes back to the lands of his childhood. His father Younga was murdered without any trial and the village is living under the fear of Pacco who commits atrocities to exploit the gold mines. This topical subject is very sensitive as it raises outrageous geo political situations. Through fiction, Boubacar Diallo manages to talk about this taboo topic. He is part of a new generation of filmmakers that emerges in the 1990s thanks to digital technologies. His films are meant for a local audience and the topics concern the Burkinabe population. He does not rely on western budgets and finances his movies thanks to product placements and awareness sequences. This explains why, at the beginning of the movie *l'Or des Younga*, a firefight is interrupted by a lesson on how to use a condom. These kinds of sequences are useful to get money from humanitarian NGOs and fulfill a need for education. When I asked Boubacar Diallo if he was not afraid to lose his originality by directing a western movie inspired by Hollywood films, he laughed and said, "I would be scared to get lost if I did not know who I am. But I know where I come from and I can rely on this knowledge to pick what I want out of other cultures. You have found inspiration in our tales to enrich your stories, why should we not do the same? We have the right to have our own cowboys!"

Cowboys from West Africa are good examples of what linguist Mary-Louise Pratt calls transculturation zones, regions where dominated people use the same expression codes as the dominant culture to assert themselves and claim their particularism. In her article *Arts of the Contact Zone*, she gives the example of the Inca Prince Felipe Guaman Poma de Ayala who writes a long letter to the King of Spain Philippe III in 1613: *The First New Chronicle, and Good Government*. Mixing the Spanish and Quechua languages, he tells the Inca history by weaving it into the biblical stories of Spanish history. He thus provides a global history where Incas are also key protagonists of the world history.

Too often, the West has considered its history as impervious to other cultures supposedly frozen out of time, in a primitive state. These examples of transculturation offer another interpretation of history, diverse and shared. An African western movie is also a tool to involve Africa in the representation of the world. Hybrid heroes and multiple references encourage us to open

our minds. It is the image of a multi cultural society with a sharp review of the world, capable of thinking and taking ownership of its own representation, with the aim of defining its own place. This lines up with the concept of Afropolitanism described by Achille Mbembe.

Films impact our imagination to build a collective imaginary. The western genre shapes a map of this collective imaginary integrating Africa. In 1972 in Egypt, Hassan Hafez does a remake of the American western *Viva Zapata*. The Western genre consequently meets with Bollywood codes which inspire Egyptian cinema, and *Viva Zalata* becomes a musical that criticizes the Western fantasy. African filmmakers struggle against a simplistic and stereotyped vision of Africa. This struggle does not lead them to look inwards, to turn to nationalism nor to protest for recognition. On the contrary it is an opening, an invitation from the far-off, from what is abroad.

Art forms become a place for translation, crossing and opening of possibilities. They are third places, accessible through the camera, providing a space where to invent the becoming being.

Like the third object in psychoanalysis, the camera becomes a tool of transfer and the movie theater becomes a place of projection. In *Bamako*, in *Return of an Adventurer,* and in *L'Or des Younga*, we face the trauma of colonialism and the violence of imperialism by giving a place for exposure and expression to struggles and revolts against dominant coercive systems.

The recent movie *Five Fingers for Marseilles*, directed in 2017 by South African filmmaker Mickael Matthews, describes the impossibility of overcoming a trauma. In post-apartheid South Africa, a group of cowboys who used to be friends are haunted by their childhood nightmares. The violence is gnawing their soul. Among those five wounded men is young Lerato, who has the strongest personality of all characters. He encourages the audience to think about the role of women in the process of rebuilding societies.

The director uses the genre codes: great landscapes, close-ups on faces chiseled by life … All components are there: duels, thirst for revenge, corrupt sheriff, lonely widows, and orphans. This time, however, confrontation with others is not at stake, there is no right and wrong. It is time to confront oneself.

Filmmaking sheds some light on dark zones where the world remains a unbalanced, lopsided, violent place. We refuse to face these dark zones, we ignore them, but directors make us look, with the strength of fiction.

This shift towards western movies, this step to the side allows us to voice the issues of the collective unconscious, our repressed zones. African western movies offer a rewriting of the world, a space of subversion to decolonize our imagination.

Cameron Bailey

Bailey is a Canadian film critic and festival programmer. He is the artistic director and co-head of the Toronto International Film Festival (TIFF). Educated at the University of Western Ontario, he worked as a film reviewer for Now, Canada AM, CBC Radio One, Take One and other publications before joining the Toronto International Film Festival as a programmer. He also cowrote the screenplay for the 1997 film The Planet of Junior Brown *with Clement Virgo, and wrote and directed the short film* Hotel Saudade.

FESPACO Memories

I first attended FESPACO in 1991. That one experience changed me, my work, and the work of the Toronto International Film Festival (TIFF).

It was my first trip to Africa. When I stepped down from the plane in Ouagadougou with TIFF's Piers Handling, I breathed in the hot, dusty air and was overtaken by the almost comical exhilaration of a Diasporic African. I summoned that deep feeling of going home that's expressed on "return" by so many Black people whose families were separated from the continent by the slave trade. Over the many editions I attended from 1991 through 2011, FESPACO became my strongest, most emblematic memory of Africa. I loved the gathering of sisters and brothers; I endured and embraced the logistical chaos; I came to understand more of the complexity of contemporary, urban Africa and the cinema it produces.

For many years, I attended FESPACO to see new films and to write about the event for *NOW,* the alternative weekly newspaper in Toronto. I also spoke about the festival from Ouagadougou to CBC Radio, Canada's national broadcaster. In those moments I felt most like a foreign correspondent, foreign to the place on the edge of the Sahel desert where I stood, but also to readers and listeners in far-off Canada, because FESPACO made me feel just a touch more African. Riding around town on a rented scooter, shopping in the Marche Central, watching films in open-air cinemas, navigating the city without a mobile phone, it was easy to feel free, easy to feel at one with Ouaga. I found my rudimentary French a far more effective way to communicate there than I ever did (or ever have) in Paris or even Montreal. There was a rhythm to Burkinabe French that matched the Caribbean English I learned in Barbados. And there was a bond, partly imagined no doubt, that went beyond language.

That first year, I selected my first African film for Toronto festival audiences. Over the next few years, I programmed more African films, eventually launching the Planet Africa section of the festival in 1995. The aim from the beginning was to bring continental and Diasporic African films closer

together, inviting our audience to both the connections and the divergences they saw in films from Bamako to Brooklyn, Kinshasa to Kingston. Through Planet Africa, we were fortunate enough to introduce North American audiences to new films by Djibril Diop Mambéty, Souleymane Cissé, John Akomfrah, Ngozi Onwurah, Frances Anne Solomon, and many more.

Beyond the contribution made to Diasporic thinking in Toronto by these filmmakers, the global community of film programmers, critics, scholars, and other supporters who met every two years in Ouaga also helped cement a network that still does valuable service to African cinema today. FESPACO gave me time with a whole army of intellects, including Mahen Bonetti, Manthia Diawara, Ayuko Babu, Keith Shiri, June Givanni, and Gaylene Gould, the last two of whom programmed Planet Africa in the years after I did. That time, those conversations, that sense of a shared mission built a foundation that kept me standing when indifference or even hostility to African cinema persisted in so much of the world. It's still amazing to me that people who consider themselves film experts and festival veterans have never attended even a single edition of FESPACO.

They missed out. They missed seeing African films with African audiences. They missed the ongoing debates about populist and art cinema, francophone, anglophone, lusophone, and African-language cinema. They missed the brochettes of capitaine fish, the Brakina beer, the bats swooping over the pool at the Hôtel Indépendance as dusk descended. They missed it all.

In my memories of FESPACO and how it shaped my sense of cinema, I'm grateful to former General Delegate Filippe Sawadogo, who traveled from Ouagadougou to Toronto in the 1990s to serve on a Canadian film jury at our festival, and to Gaston Kaboré, who not only shared with us his singular films, but also opened the doors to his critically important IMAGINE film school. Seeing students from all over Africa study the art and craft of cinema there was an enduring inspiration.

Most of all, I'm grateful to Professor Aboubakar Sanogo. I first met Aboubakar when he was a student, on what feels like my first day in Ouaga. His sheer enthusiasm for film, born and rooted in Burkina Faso, where he would have grown up with the African film world regularly descending on his city, built bridges between continents. Aboubakar went on to study in France and the United States before taking up a teaching position at Carleton University in Ottawa, just a few hours' drive from my home in Toronto. During those years we kept in touch, we talked cinema, and we worked to weave African voices into the global language of film. So many more have joined this work over the years. So many more must come.

<center>☙❦❧</center>

Emma Sandon

Sandon is a Senior Lecturer in Film and Television at Birkbeck, University of London. She is also a research associate at the University of Johannesburg to the Chair of the Centre for Social Change. Her research interests are in early British film and television history; film history in the British Empire; early South African non-fiction and documentary film; cinema in Africa; documentary and ethnographic film; law and visual culture; human rights film and video. Sandon is currently engaged in a number of film archive projects on British and South African colonial film history and women's film history.

The twenty-sixth edition of FESPACO that marked its fifty-year anniversary, which I was fortunate enough to attend, is testament to the festival's major and enduring importance and influence in the promotion of cinema and television made on the African continent. Wonderful and inspiring films were shown: features, documentaries, short films, and there were also film restorations, thanks to The African Film Heritage Project. Watching these films with audiences whose perspectives and points of view are African confirmed the importance of FESPACO's mission. Key to FESPACO's identity is its political commitment to Pan-African cinema, anti-colonial struggles, and its critique of racial, social, and economic inequalities across the globe. Some of the challenges FESPACO faces were raised at the festival symposium, "Confronting our Memory and Shaping the Future of Pan-African Cinema in its Essence, Economy and Diversity." One of these is the festival's digital presence and its use of social media, related particularly to how the festival can involve young people. The other issue is more long-standing—how can FESPACO involve women and promote women's contributions to cinema on the continent? For me personally, as a teacher of film and media, experiencing FESPACO's fiftieth anniversary and seeing its legacy firsthand, confirms the importance of cinema from Africa for our understanding of cinema history and for our experience of the contemporary world in which we live and the futures to which we aspire.

Claude Haffner

Haffner is a French-Congolese documentary filmmaker. She has produced and directed a number of critically acclaimed films including Ko Bongisa, Défilé Célianthe, *and* Noire ici, blanche là-bas.

MY FESPACO 2003

When I was a child, my father, Pierre Haffner, a film critic, used to travel to a country that seemed magical to me: Upper Volta. It was in the late 1970s-early 1980s. He came back to Alsace—where we lived and where he taught African cinema, which he had become a specialist of at the University of Strasbourg, with stories of films and extraordinary encounters from this young film festival called FESPACO. The names of Ousmane Sembène, Souleymane Cissé, Djibril Diop Mambéty, Férid Boughedir, Youssef Chahine, Sarah Maldoror, Safi Faye, Med Hondo, Ben Diogaye Beye, Idrissa Ouédraogo, and others fed my imagination.

Then, 1983 came and Sankara became president of Upper Volta. I was seven years old. Sankara emancipated the country by renaming it Burkina Faso: *the country of the upright people*. The stories of my father's trip to FESPACO became even more fantastic.

I was slowly getting into adolescence. I started imagining my future. I dreamt about this country. I dreamt about this festival. I dreamt of making films … against my father's advice, who knew how difficult this job was. That's why he forbade me to study cinema once I graduated from high school. I was obliged to do "serious" studies. So, I enrolled in the Faculty of History in Strasbourg. But, the dream of cinema did not leave me; I followed my father's cinema courses at the same time and ended up convincing him to let me go to Paris to become a scriptwriter: a "serious" cinema job in his eyes.

My father died in 2000. I was angry at his death, angry at him. I had to sublimate this anger, at the risk of falling seriously ill myself. That's how I decided to attend a training course in documentary filmmaking, during which I made my first documentary essay on an African hairdressing salon in Strasbourg-Saint-Denis: *Ko Bongisa Mutu*.

We are in 2003, my film is nominated at FESPACO, my dream has come true.

I will go to Ouagadougou to 'meet' these films and these extraordinary characters. The edition of FESPACO is dedicated to actors.

The film *La colère des dieux / The Wrath of the Gods (2003)*, by Idrissa Ouédraogo opens the festival. Rokietou Barry and Noufou Ouédraogo are the main actors. The same actors I discovered earlier in *Yaaba*. My friend filmmaker Mohamed Challouf (who knows the festival, the filmmakers, and Ouagadougou well), and myself, decide to film these two young actors. Rokietou invites us to film her at her home. We follow her in a cab—she on her motorcycle, camera in hand—when an army car orders us to stop. Armed soldiers in uniform grab the cab driver by the neck … and hit him. We sit in the back, stunned by the scene. In total incomprehension, the soldiers order the driver to follow them to the barracks. In front of the gate, they force us to get out of the car. We are under arrest, but we still do not know why.

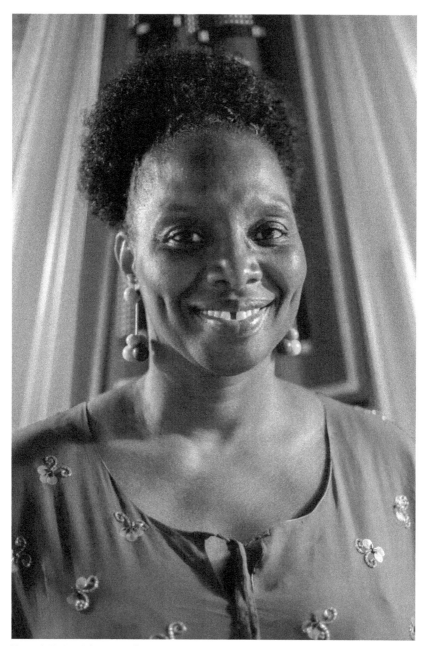

Figure 6. Mariam Kaba, actress from Guinea Conakry, image courtesy FESPACO.

Rokietou follows us from afar on her motorcycle. She is a witness to the scene. She immediately calls Idrissa Ouédraogo in the middle of the jury session of which he is the president. Idrissa rushes to the barracks. He is angry with the soldiers, explaining that they have made a serious mistake by arresting guests of the FESPACO. They let us go, telling us that it is forbidden to film in Ouagadougou without authorization.

I was pretty scared. I also felt very bad for the poor driver who didn't ask for anything … but who "should have known that it is not allowed to film without authorization in certain neighborhoods and he should have warned us" according to the soldiers!

We did not stop there: Challouf and I took another cab, followed again Roukietou to the planned destination. Her neighborhood is the place where Sankara's tomb is located. We gather there. We come to our senses. We leave, sufficiently recovered to take back the camera.

The images we shot will never be edited, but this story has given me one "hell of a cinema lesson." There is no documentary filmmaking without unforeseen events and risk-taking. Making films means putting yourself in danger.

At the next FESPACO, in 2005, I came back with a film about African cinema as seen through my father's criticism: *D'une fleur double et de quatre mille autres / Of a double flower and four thousand others.* And in 2013, I presented *Noire ici, Blanche là-bas / Black here, White there.* I now also bring back fantastic stories from the "country of the upright people."

Jean Odoutan

Odoutan (born in 1965) is a comedian, film director, composer, actor, screenwriter, and executive movie producer from the African country of Benin. He is also the creator of a film festival, the Quintessence International Film Festival of Ouidah. He has been involved in many films, either as actor, director, or producer. Among the movies he has participated in include Barbecue Pejo *(2000),* Djib *(2000), and* La Valse des Gros Derrieres *(2004).*

FESPACO, Festival of the Cinematic Echoes of the Continent

My first FESPACO is the most memorable! We all had to travel from Roissy-Charles De Gaulle airport in Paris to Ouaga by Air Afrique. All the directors were there. As I was a beginner, I didn't know many people. I just noticed

a bunch of well-dressed Black people, with an artistic tendency, swirling around me, right in front of the Air Afrique office.

It was an unbelievable commotion. The day before, we were supposed to travel, but we had come for nothing and we had been told to go home and be back the next day early in the morning.

That day, the new appointment was for 6:30 a.m. At dawn, 5:00 a.m., I was already there in the place. I wanted to be among the first ones to get on the plane and to discover this grandiose festival according to the sayings of many of my white friends.

And from ruckus to ruckus, drinking to getting tired, at thirteen hours, meaning eight hours after my arrival to the airport we were still there, stocked. Those who knew each other greet each other by kissing, forehead against forehead. Never seen before! At least for me. First ritual, first initiation: the greeting in the African way. And all these people call each other by name. I have heard names and have been able to put faces on them: Raoul Peck, Balufu, Mama Keïta, Rahmatou Keïta… And all these lads are virulent, adopting bellicose positions, ready to fight with …?

We won't be able to travel. It was Air Afrique's descent into the underworld. Bankruptcy was around. The company was delivering its last flights. And the priority of this African company, in delicacy with UTA, was to convoy Europeans in priority, in other words, the whites! The elders, not wanting to hear it this way, had to scratch and cut, and some, like Rosa Parks on December 1, 1955,[23] to sit in the place reserved for the "chalk faces," as one could affectionately hear it. Others, willing to attend by all means the opening of the festival, paid out of their pocket to travel on other planes; to pay fortunes, potentially reimbursable by FESPACO! I, little Jean Odoutan, penniless, did not find the elder brothers' gesture fair. For me, either all of us or nobody, had to get on that plane. The luminous action of these "famous" elders should have been to bring down the Europeans and give priority to us, professionals, we Africans, those for whom this festival—which could not exist without films—was primarily intended! No films, no FESPACO! So I went home.

Two days before the end of the FESPACO, I finally received my air ticket; I hesitated but I went anyway, since I wanted to establish contacts with my colleague filmmakers. For me, this first edition took place entirely in front of the swimming pool of Hôtel Indépendance. I was alone, I didn't meet anyone.

Back in Paris, enraged, I created Quintessence: Ouidah International Film Festival, with the motto: "Culture Without my Culture Acculturates me."

Denis Mueller

Mueller is a documentary filmmaker whose work includes, Howard Zinn: You Can't be Neutral on a Moving Train, The FBI's War on Black America, Soldiers of Peace, *and* Peace Has No Borders.

The Pan African Film Festival of Ouagadougou (FESPACO) is the most important film festival in Africa and one of the leading festivals across the entire African Diaspora. Since 1969 the festival has celebrated African film and culture by hosting one of the largest and most established film festivals on the continent. Every year thousands of filmmakers, industry insiders, and festivalgoers flock to watch the feature-length films and shorts being screened. That in itself would be quite an accomplishment, but the festival has championed African film and has helped put African cinema on the world stage as a cinema to be taken as a genre to stand alongside of other film genres. I recommend the festival as a filmmaker and as a lover of cinema. It is important that a festival like this exists. The festival has helped me, as a filmmaker, by making me aware of how vital African cinema is, and I endorse the festival completely. It is a treasure that is valued by all filmmakers across the world.

Véronique Joo Aisenberg

Aisenberg holds a Master of Arts and Culture from University of Nantes, in Mediating Culture. She lived and studied in Africa and the Indian Ocean for almost twenty years. In 1997, she became Head of Mission of the Association Française d'Action Artistique (AFAA). From 1999 to 2001 she worked as a cultural attaché in Moncton, Canada, her main task was to organize the French cultural presence during the VIII Francophone Summit. In 2001, she became the coordinator of the AFAA African-Caribbean Creative Support Program, Bamako African Photography Meetings (2001–2009). Since 2010, she is the head of the Institut Français Cinémathèque Afrique collection.

As the head of the Film Library for ten years (2010–2020), I was able to attend five FESPACO editions from 2011 to 2019. At the international level, FESPACO is the reference for African cinema. First of all, it is the festival that awards the greatest distinctions for African films on the African land. Its prizes are therefore the most legitimate. The Étalon de Yennenga and other prize-winning films are the most awaited and requested films by all

international festivals. FESPACO therefore plays a real role as a showcase for African cinema. This festival has no equivalent because of its importance, its Pan-African dimension, local involvement, and audience. Since its creation in 1969, its strength has been its popularity. It is the festival that has the largest local audience on the continent. It is also the most festive festival and the biggest meeting place for African professionals. This festival regularly challenges itself by organizing surveys among professionals and by developing. The last two editions were more professional (new categories, film and television market, digital screenings …). For me, this festival represents the most intense experience to live the African cinema in spite of its dysfunctions.

Colin Dupré

Dupré is a historian specializing in cinema. He graduated from a Research Master 2 in Contemporary History at the University of Toulouse le Mirail and a Professional Master 2 in "expertise and cultural mediation" obtained at the University of Lorraine. Traveling regularly to Burkina Faso, he specialized in the history of African cinemas. The safeguard and enhancement of African film heritage has been its credo for several years. Author of several articles for the journal Africultures, *but also* for Journal of Film Preservation, *the periodical of the FIAF (Fédération Internationale des Archives du Film) and for* Directory of World Cinema: Africa, *a collective work edited by Sheila Petty and Blandine Stefanson, Dupré offers the first historical work devoted to FESPACO, from its birth in 1969 to the present day.*

My FESPACO

It is not easy to find in my memory, *the* memory of FESPACO, the one that stands out. There are so many of them, so rich and so strong. And not only because it is this festival that allowed me to meet my wife!

If I had to recollect one memory, only one, it would be my first FESPACO. I am eighteen years old, I am in my final high school year and, with the cinema class of my high school, we are debating with the Film Club of the Nelson Mandela High School of Ouagadougou. The "Bagnérais" go to FESPACO for two weeks, and the "Ouagalese" come for two weeks to the Bagnères de Bigorre High School Video Meetings.

It is already extraordinary enough to create fabulous memories among high school students!

One evening, during our journey in Ouaga, we go to Ciné Burkina to watch a movie (I unfortunately forgot the title). I had been advised to see this film for many artistic and cinematographic reasons, but at the time it was not what caught my attention. What marks me at that precise moment is the atmosphere, the atmosphere that reigns in and around the movie theater. We had already watched a lot of films from all over the continent, with a fairly large audience (not always) but nothing memorable. That night, it's a crowd much too big for the number of seats that tries to get into the room at all costs. Some negotiate their way in through the fire escape (successfully!), others, including me, end up sitting on the floor or in the bays. The most important thing is to have a seat and see the film!

And in this overcrowded room, the audience is not quite the same as for other films since it is mostly made up of Burkinabe. And for a good reason! It is a Burkinabe film playing! During the screening, a good part of the audience participates in the film by tearing into the protagonists, loudly commenting each event, sometimes taking the other spectators to task. Debates arise right in the middle of the screening, etc. I had never seen that before. After the screening, I spend several hours debating the film with my friends and our correspondents from Ouaga—the tables around us are crowded with film lovers who are also in the midst of analysis. Sometimes, whole tables intervene in the discussions going on at the neighboring tables.

This is exciting!

And even though the fact that it's a Burkinabe film counts for a lot, it's quite revealing of the appetite for film that reigns in Ouaga this February. In the end, if I don't remember the title of this film, it's probably because what struck me deeply was all the passions that a film could generate. Beyond my astonishment at the time, I think it was precisely that moment that later guided me in my research on the history of the festival.

That night, from the top of my eighteens, I didn't "just" go to watch a film. I went to live *the* film, with all the other viewers. That's also what cinema is, a collective adventure. Since then, I've attended many screenings at FESPACO and elsewhere, but this one I remember as if it were yesterday.

If there's one thing that, I think, characterizes FESPACO, it's its popular aspect, in the noble sense of the word. This is the main reason for its creation in 1969, out of popular militancy, and it has been the guiding thread of the festival throughout its history. Showing African films to Africans is what gave birth to FESPACO.

That's also why the festival sometimes attracts so much public attention. Spare the rod and spoil the child, and in Ouaga we like FESPACO very much. Sometimes, the organization has probably not caught the importance of the festival in the hearts of the Ouagalese, Burkinabe, African people,

and even people beyond the continent, nor the almost vital importance of its popularity, neglecting the public a little (stopping screenings in more remote areas, raising prices, mismanagement). But, if FESPACO is so much a debating issue, it is because there is an attentive and cinema-loving public. Other festivals—reserved for professionals, or inaccessible—do not run the risk of being criticized by a non-existing public … However, at FESPACO, the very soul of the festival, its essence, is its audience.

Finally, with hindsight, this screening at Ciné Burkina could symbolize what FESPACO is all about. A popular festival, lively and endearing, the beating heart of cinema on the continent.

After more than fifty years of existence, my dearest wish is for FESPACO to last for decades. With the strands that have guided it since 1969: that the public and the popular aspect of the festival be at the heart of its concerns and orientations, that the programming be exemplary (quality, originality, innovation) and that the professionals meet there with as much envy and fervor as at the beginning. In this way, FESPACO will remain the beacon of African cinemas, in the hearts of all.

Osvalde Lewat

Lewat is a Cameroonian filmmaker and photographer best known for her sociopo-litical documentaries. Lewat was born in Garoua, Cameroon in 1977. She grew up in the city of Yaounde, where she fell in love with movies. She showed an early interest in photography, taking Polaroid photos of family members. Lewat studied in Paris at the Sciences Po. After graduating from the university, Lewat returned to Cameroon in 2000 to work for the daily newspaper the Cameroon Tribune. *She started making documentary films after several years working as a journalist. Lewat studied film in Canada where she began her documentary filmmaking career. Her first documentary,* The Calumet of Hope / Upsa Yimoowin, *was filmed in Toronto in 2000. It illustrates the marginalization of Native Americans in America, and won a human rights award at the Montreal Film Festival in 2003.*

Osvalde Lewat's Ouaga Appointment

First, there was the letter, the first of its kind, announcing that my film was nominated. The use of email was not yet widespread. As a film in competition at FESPACO, I was officially admitted to meet these filmmakers whose

work had made me want to add my voice to theirs. Then, there was the expectation, that of practical information related to my departure and my stay in Burkina Faso, in Ouagadougou, "Ouaga." This expectation, these often unanswered questions, these uncertainties so familiar to the artists who one day went to FESPACO.

Inside me has been growing for five months, a life; outside me, resounded the hope to have the result of three years of work seen, and why not, recognized by my peers.

Finally, a journey from Yaoundé with other filmmakers; Cotonou, and finally, Ouaga.

The memories of this first trip, of this first FESPACO are intertwined with those that followed over the years. New films added to the first one, the artistic recognition has somehow soothed my doubts, fortunately, without making them disappear. FESPACO offered me the chance to receive awards, to preside over a jury, and even to be transported, with my fellow female directors, by a horse-drawn carriage in the middle of a stadium.

How many times have I complained about the organizational shortcomings of the festival? How many times have I grumbled about the quality of the screenings betraying that of the films, of my films? How many times have I returned to Ouaga mocking the inconsistency of my resolution not to return "under these conditions?"

It's because FESPACO carries a great and long history of cinema in Sub-Saharan Africa, of films shot by the sons and daughters of the continent and its Diaspora, shown to the sons and daughters of the continent; it's because FESPACO is a beautiful and unique story, nourished by rough edges to which one becomes attached, which one cannot easily get rid of. FESPACO has in my life, fertilized strong artistic friendships, innovative creative ideas, and above all, this irrepressible desire not to miss the Ouaga gathering to continue to make my voice heard alongside that of my peers.

Laurence Attali

Attali is a French-Senegalese filmmaker. She is primarily a film editor but she has directed no less than thirteen movies including the one entitled Le temps d'un film *completed in 2007. From 2003 to 2017 she has worked as film editor and producer on all the films made by the Senegalese film director Ousmane William Mbaye, Xalima La Plume, Fer et Verre, Mere-bi la Mère, President Dia, and Kemtiyu Cheikh Anta.*

FESPACO Impressions

Hundreds of images and faces jostle in my head at the mere mention of the word "FESPACO."

Perhaps the first impression that comes to mind is the "arrival" "gathering day."

As soon I put down my suitcase, I ran to the terrace of Hôtel Indépendance to meet all the others, the friends from Ouaga and those from all over the continent, who also ran to shout for joy, laughter, hugs, in a contagious and cinematic euphoria that kept us awake for ten days.

When the Hôtel Indé burned down during the 2014 insurrection, we were a little lost to know where to meet from then on, and we did not recreate another rallying point, undoubtedly disappointed to understand that what had been our HQ for years, was considered by the insurgents as the symbol of a fallen regime.

Therefore, complicated for us, since we consider ourselves to be insurgent artists.

Another strong feeling: looking for a place in a crowded room at Ciné Nerwaya, Ciné Burkina, or Ciné Oubri under the stars, to discover a friend's latest film, and then meeting up at the restaurants L'Eau Vive or La Forêt to talk about it for hours, eating a poulet bicyclette, a guinea fowl, and local spinach.

Another image stands out again: that of Pierre Yaméogo who opened his house to everyone and organized the most beautiful parties one can imagine, with music and food all night long! His generosity was never equaled, and some have taken advantage of it a little too much.

Today, it is becoming increasingly difficult to imagine FESPACO populated by all the absentees who have lived and built this fiftieth anniversary of African cinema.

We miss them and we shall always miss them, every time we gather in Ouagadougou.

The first time I came to FESPACO was in 1995 to present my first Senegalese films, and since then, I haven't missed a single edition. From edition to edition, with growing fright each time, I've been there. I presented all my films and also all those I made with Ousmane William Mbaye. The awards we won there have kept a special flavor, mixed with emotion, happiness and pride, like never felt elsewhere.

I have never really liked or attended the stadiums, yet I must admit that the opening ceremony of FESPACO and the awarding of the Étalon de Yenenga continue to move me every time.

FESPACO … I also came as a member of the Short Film jury, then as assistant to the president of the Documentary jury. I could even come there

for no apparent reason, just to be there for the filmmakers of the continent and the festival of our cinema.

It was during a sleepless night on the terrace of Indé that, with a group of filmmakers, I made the firm decision to apply for Senegalese nationality, since it looks like I have planted my camera and my heart forever, in Dakar.

Long live the FESPACO, hoping that the 2021 edition can be held in due form!

Djamila Sahraoui

Sahraoui is a critically acclaimed documentary filmmaker from Algeria. Sahraoui is the first woman to win the Étalon d'Argent (Silver Stallion) in FESPACO's fifty-year history which she received in 2013 for her feature film Yema, *where she also acted in the main role.*

My FESPACOs

I remember with great emotion the very first time I came to the festival. It was in 1997, I was presenting my documentary film *La moitié du ciel d'Allah / Half of Allah's Sky,* which won the award for best documentary.

Something quite struck me that year; I had traveled at night to a faraway movie theater to see a film … my hotel was in the center of Ouaga. So, on my way back to the hotel at two o'clock in the morning, on foot, alone, in deserted streets, I was absolutely not afraid! And I thought, there aren't many countries where you can do that. And at that time at least, in Ouaga we could!

In Paris, I lived in the twentieth district and I wouldn't have dared go all that distance alone at night, at two o'clock in the morning … In Ouaga, I did it! I came back from the movie theater alone, all the way to the hotel without being afraid at all. And I was very happy.

And I said to myself: What a nice place we are in this country! Here, a woman feels good at two o'clock in the morning in the street!

I don't remember very well the movie or the reaction of the audience. I tell what really struck me. It was this: walking in the night all alone.

And afterwards, it was also the debates. Endless questions … I remember that. Especially at Hôtel Indépendance … And endless night events where everyone was talking about cinema, for hours and hours, days and days. And it was really wonderful. It really was!

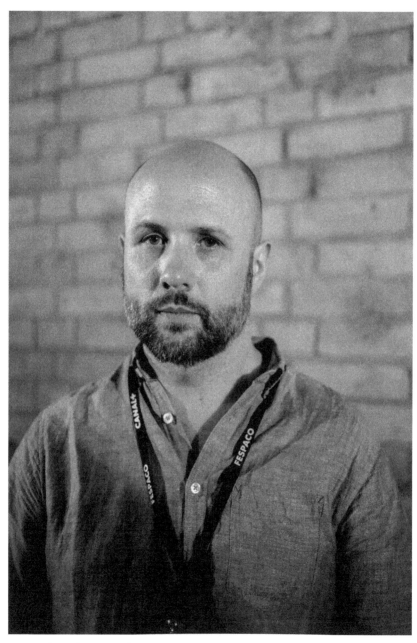

Figure 7. Idriss Gabel, Belgian filmmaker, image courtesy FESPACO.

In 2007, I presented in competition *Barakat*, a movie taking place during the black decade, in 1990s Algeria and featuring Amel, a young woman doctor, looking for her husband who had been kidnapped by an Islamist group. I received three Étalons for her film.

They were so heavy that I could not carry them! I received the award for Best Screenplay ... and for Best Music. And the Oumarou Ganda Award for the Best First Work.

It was really very, very nice ... something extraordinary!

There is one thing that is great about FESPACO ... the awards ceremony takes place within the big stadium.

It's the only country where you can see that! It's extraordinary! The opening ceremony takes place in the stadium, the closing ceremony too and it's really wonderful. We arrive in the afternoon when it's still hot! And then we are very happy to be there and time passes very, very quickly ... The evening arrives, the sun sets, the ceremony begins, and it is great! It is great ... because there is everybody. The people of Ouaga are there ... They fill the stadium ... And it's huge!

At the opening, we can see that people are ready to spend a crazy week of cinema and at the closing, it's the same thing, we've just spent an incredible week together! Watching movies, partying. That's what amazes me at FESPACO, these ceremonies and the outdoor screenings. It's great.

When I received the Étalon award, I was obviously very embarrassed, I didn't know what to say ... and then it was very heavy!

I was surprised to get the award! And then when I was called back a second time I was even more surprised.

The third time I couldn't believe it anymore and I said it's not possible! I wanted to say: "Stop it!" And I made a lot of filmmakers laugh, they said: it's the first time you see someone going for a prize and saying it's not possible... I received the Étalon with my hand on my mouth! I said I was very moved, that's all! I was really very moved!

When I presented *Barakat*, which is a hard film, and which was unfortunately very topical at the time, I was facing what any filmmaker feels when he presents his film: What will the audience think? Will people understand what I wanted to say, will they welcome the film? Will there be any communication with the viewers?

Because in general with this film it happens, yes! Yes! I think it happens. Maybe that's why it received all these awards!

Let's say I'm really lucky. It's true!

In 2013, I came back in competition with *Yéma*, which is also a very hard movie and in which I play the main character, the stakes were even more complex because I were both the actress and the director of the

film ... And it's a film about Algeria, about the history of the country during the years of terror.

And I were awarded the Étalon d'Argent (Silver Stallion). I was deeply moved; I did not expect the award at all. I didn't expect anything in fact! At least not in the award list. I even hesitated to go to the closing ceremony and then I thought, come on, I'm going! For the atmosphere of the stadium!

And they announce the Étalon d'argent… the Silver Stallion! I was so moved...how can I put it? Such an incredible emotion; and the award was so heavy! I remember the man who gave it to me was very tall...

He was 2 meters tall! And I was so small ... very small next to him, and I had this award that was so heavy ...

I couldn't carry it and I looked at it, nodding. There's a picture of me that is absolutely amazing at that moment. I was holding the award so firmly, as if it was going to be stolen; in reality I was holding it with both my hands because it was too heavy.

And I raised my head to look at the man!

And then I called someone to help me, a man; and I said listen, come and help me. So I came to my senses. I told him come and help Queen Yennenga!

I felt like Queen Yennenga there.

In fact, I was telling myself in that stadium that I was a somehow like Cinderella, I was on my coach... And I became Princess Yennenga! In fact, I was on Yennenga's stallion and after midnight, then, the carriage turns into a pumpkin! And I became Cinderella again. My carriage or stallion became a pumpkin again and I took the plane back to Paris. The ceremony ended at exactly midnight. There, they put us on the plane. And I had to come back to reality! We take the plane; we go back to Paris. We return in the grayness, in the cold; whereas a few hours before I was the Queen Yennenga with her silver stallion, very, very beautiful! By the way, this trophy is very beautiful.

The Cinderella side is because I toiled, and I toil all the time! And maybe I'm fed up with having hard times like that. I've toiled so much and... *Yéma* was the ultimate! It was very special anyway. I did everything in it.

Everything, everything, everything!

I did the production, I made the costumes. I drew them, I directed, I wrote the script, I played...well, it's incredible!

And by the way, about the fact that I played in the film, I was in another festival, the French-speaking film festival of Namur in Belgium...

And I am awarded the award for Female Interpretation. And there I was laughing out loud! When I went to receive the award, I said, but why did you give it to me? (laughing) I'm not an actress, why did you give me this award? I felt that I was a usurper, I was not the right person. I took the place of an actress.

In any case, before the ceremony, just after the screening of the film... a festival official came to talk to me about *Yéma*. He didn't know who I was, he told me what do you think of the film? He didn't recognize me. He told me, don't you think the actress is extraordinary? And I was looking at him; I saw that he didn't recognize me. In fact, the way I was dressed in the film... as an Algerian peasant girl... With a turban scarf and everything. Whereas in Namur, well... I was dressed with my jeans and nothing on my head!

And then, it's true that in the film I was physically devastated; it is believed that I was aged by the make-up. No, it was the worries of the film that ravaged me like that. So I looked very, very old.

Now, I looked a little younger, because I had had some rest...

And this guy didn't recognize me at all! And, well, he didn't even know that I was the director of the film, by the way!

He was talking to me about this actress and he asked me what I thought about her. "Oh what a great actress she is." I said, "Oh, really?"

And I looked at him, I really looked him in the face so he would understand. But no, he didn't. It was very weird.

But to come back to the Étalon de Yennenga, fortunately I got some recognition! People understood what I was doing! Absolutely, otherwise it was tearing everything else apart.

But you can't do that for every film. That's not true. You can't do it for every film. But I have a lot of energy, a crazy energy!

All my films have been great, but exhausting adventures. Exhausting! And for this one it was really the best.

What's terrible in this business, I think, is that you always start from square one.

In any case, for most of us, we are often back to square one. There hasn't been any experience, or fame for me. And there's no recognition either: "she's received awards at FESPACO, so she's now recognized." No, no, it doesn't work like that. In the next film, you have to prove yourself again.

For most of us anyway.

Especially when you're a filmmaker from Africa...you don't get much of a chance to shoot. You can't make a film every year.

I'm not complaining; truthfully, I think my films have had very, very good careers in festivals. Very good awards everywhere. You know, I've been really lucky on that side. A lot of awards in a lot of festivals around the world. But the commercial career is something else.

I don't even think my films have paid for themselves. But hey, they're not big productions with a lot of money either...

It's a difficult career. A beautiful but difficult career. When you're an African filmmaker who wants to make films, it's quite difficult. It's difficult

for everyone. Festivals and awards are a great pleasure. It's really great. I'm really happy about all that. But it's still difficult for all African filmmakers.

Malek Bensmail

Bensmail is a documentary filmmaker from Algeria. In 2005, Bensmail received the Special Jury Award for Fiction/Documentary for his film Aliénations *which focuses on psychiatric practices in Algeria.*

FESPACO and the Importance Of Documentary

It seems to me that the first time I discovered the city of Ouagadougou was in 1996, outside FESPACO, during an Input workshop where I presented my first film *Territoir(es)* at the same time as Abderrahmane Sissako and Mahamat Saleh Haroun. We then met for the first time and it was the beginning of a friendship that was to last for a long time. Each of us had a great career path afterwards!

Then I discovered FESPACO with *Aliénations,* and the film won an award: I kept the memory of an exceptional festival, full of energy and extraordinary debates, which continued in the city, the streets, restaurants, hotel lobbies, at night, and during the day. And discussions were constantly resumed.

I deeply felt my belonging to this continent, more than to the Arab world.

The importance of such a Pan-African festival is precisely that it brings together and anchors intellectuals and artists around a continent, and around different languages and cultures. Such a Pan-African festival also makes it possible to ask the essential questions of decolonisation and one's own future.

The only downside is that it avoids folklore, intentional or unconscious, which depoliticizes the words of filmmakers or artists.

I will not be able to cite the number of meetings I have had with other filmmakers, but what I can say is that the meetings are held without artifice and with sincerity. And this is not always the case at other festivals where representation takes precedence over human, sincere, cinematographic relationships.

As for the "Ouagalese" audience, it is just exceptional. Attentive, very cinephile! I remember very lively debates during the presentation of *Aliénations* or *La Chine est encore loin....* This audience truly hungers for cinema!

I was almost constantly and during each edition taken in by the audience. This hunger for cinema has somehow been lost in the West.

Documentary film has gradually found its place at FESPACO.

Documentary film, the real one, is the very "emergency" cinema for our continent. Fiction in Africa can only grow with the awakening of documentary: documentary films capture the real and builds a stronger imagination. Our populations need to see themselves. Not only in sitcoms.

We have a huge continent and rich countries. Algeria is one of them. It could largely finance our films and coproduce more films from the continent. I am thinking of South Africa, Nigeria, Côte d'Ivoire, Senegal, etc.

There should be South-South support, rather than the eternal North-South relationship; producers from the North often do not understand much about our cinema or its production challenges, and especially about how we see it.

I am convinced that the only way out for us is to strengthen coproduction agreements between all the countries of the African continent. Similarly, the involvement of TV channels and digital platforms, VOD, by really giving filmmakers the means, would make it possible to create quality.

And also, that the Maghreb (Mauritania, Morocco, Algeria, Tunisia, Libya) be definitely anchored in its continent rather than scattered in less welcoming cultures … in the end.

Mata Gabin

Gabin is a Martiniquean actress for both theater and film. She has worked with the likes of Raoul Peck, Jean Odoutan, and Lucien Jean-Baptiste. Gabin has also written a number of plays and performed in her own one-woman shows.

What does FESPACO remind me of? First of all, it is one of the oldest and best known of all African festivals, at least to my knowledge. I participated twice and each time it was for theater, to do readings, including a reading of a play by Tola Koukoui by the pool at Hôtel Indépendance. I was in good company, we were all invited, adorably accommodated.

I remember this definition of men of integrity, and I was able to verify it with my own eyes: one day I went to lunch in a restaurant with the team and

it was so good that I left without my stuff. And someone followed me down the street and said "madam, you forgot this and that." He brought everything back to me. It was really lovely and touching.

What do I still remember … Yes! An incredible rehearsal in a beautiful place. An open-air theater performance with great acoustics, I felt like I was playing in a theater in ancient Rome! It was really sublime. I also remember that there were some very pleasant evenings where I had good cinema meetings. I have many positive memories. Two of my short films were shown at the festival: *La métaphore du manioc* and *Le bleu-blanc-rouge de mes cheveux* and of course films by Raoul Peck or Jean Odoutan.

What else can we say about FESPACO, that it is a really important institution because it is the place where African cinema can shine. For me, it is really a kind of El Dorado of the African cinematic meetings. It is a place for intellectual and artistic meetings, a synergy of cinematographic enthusiasms. FESPACO is like a breeding ground for talent and at the same time like peer recognition. So, I wish FESPACO a very, very long life, and I hope that the COVID-19 pandemic will not affect the sustainability of this festival. I congratulate the organizers who ensure that cinema reaches audiences and that films produced are seen every two years.

I would very much like to go back there again, but as I have made very few films in recent years and especially very few African films unfortunately, I have less chance of being invited. Moreover, I think that African directors know little or nothing about me.

I fervently hope that I will return to the festival because talking about FESPACO is good, but participating in it is better!

Souad Houssein

Houssein, originally from Djibouti, is an executive of the International Organization of the Francophonie (OIF). She managed for five years (1999–2003) the Francophone Audiovisual Production Fund of the OIF, within the Department of the French Language and Cultural and Linguistic Diversity (DLC). As part of her duties, Houssein manages the production support mechanism: the French-speaking audiovisual production fund in the South, promotion and marketing operations as well as the training component. Since 2010, she has been developing a project to create a Pan-African film fund in partnership with the Pan-African Federation of Filmmakers (FEPACI).

My FESPACO

What makes this festival unique is that every two years it offers films from the continent to the public. What makes it unique is its Pan-African and (more recently) Diasporic dimension. It is this modesty, this humility that characterizes the people of Burkina Faso but also this fierce desire to carry every two years against all odds, this artistic form, this medium, so powerful that it can change the way the world looks at Africa, alone!

I admire the strategic vision of Burkina Faso who has decided to carry the image of the continent through cinema. Today, it seems obvious but at the time many richer countries had not thought about it and are lamenting. I understood that we had to have a humble attitude as officials of international organizations, because filmmakers all carry within them a political and strategic vision of their missions. We must treat them with respect and listen to them. Whatever our commitment, the solutions will come from the directors—men and women—who dream of an African cinema accessible to the international community.

Going to FESPACO and to the Carthage Film Festival (CFF), these two festivals, taught me much more about African cinema than all the books I read and all the contracts or meetings I have been able to organize. When I embarked on this career as a Film Program Specialist at OIF more than twenty years ago, I was able to measure the creative force, the legal, organizational, collective intelligence, human resource management, and the faith that filmmaking involved. And it is this respect that has irrigated my professional relations with this milieu, where, let's not forget, many were self-taught and multi-functional (author-director-producer). I could only respect and try to serve African cinema as well as possible, which was evolving especially at the time in these very difficult conditions.

I am among those who consider that, to understand the stakes of African cinema, it is essential that an observatory of African cinema be set up. It is only at this expense that decision makers will measure the importance—based on concrete data and analysis of the results of African cinema—of investing in African cinema. There is a lack of a reference tool that would make it possible to sensitize African decision-makers to the need to develop a cinema policy in all African countries.

For me, this great festival must become annual and be managed by a private structure jointly with an association or a producers' union for example. If in the past a biennial organization was sufficient, production having considerably increased, this is no longer possible today. FESPACO must increase its visibility and rely on Pan-African television channels for the broadcasting of the opening and especially the closing ceremonies and also, why not, for the broadcasting of several round tables.

The festival should undoubtedly gain in glamour and prestige by inviting personalities, important donors; isn't it said that what makes the strength of a festival beyond the organization, the award list, are the meetings and opportunities it offers?

The official awards are well endowed financially; it is a fact. But, it is absolutely necessary to increase their visibility during the event and afterwards. These awards must be recognized by the profession at the international level.

This great Pan-African festival should gain in prestige. It should also become the meeting place for African and world fashion stars, musicians, great sportsmen and women from Africa or from the Diaspora of course, and attract more journalists from all over the world.

At the same time, and without being contradictory, FESPACO would gain to be more demanding in terms of events that take place there. For me, FESPACO is not a fair or a showcase for partners, it is a mature event of international scope that allows African cinema to shine in Africa and in the world. Workshops, coproduction platforms, would benefit from being organized in synergy to gain in power for the benefit of professionals.

Finally, a Festival of Pan-African dimension must increase the involvement of Pan-African organizations and especially the African Union in order to ensure balance with international organizations, private international structures.

Beyond the organization, I have a wish that I will not stop defending: I wish that the African cinema of tomorrow allows our young people to learn to know themselves better, to know their culture, their history, in order to become complete adults and determined to defend their values while moving towards the future.

For my part, I made the decision to defend this dimension of cinema appropriation by the mainly concerned populations.

Finally, with regard to the Pan-African dimension of FESPACO, I think that an African cinema without a Pan-African dimension is a body that has lost part of its limbs—yes, FESPACO is vital!

Maya Louhichi

Louhichi is a Franco-Tunisian photographer and director living in Paris. After an audiovisual course and several experiences in the cinema, Maya decides to focus on photography and founded the webzine Freezmix.com *dedicated to urban dance. From 2009 to 2014, she covered numerous events as a photographer and specialist journalist. During this period,*

she produced several photographic series on the theme of bodily expression in the contemporary urban universe. In 2015, she directed two documentaries, Franco-Tunisian co-productions, which question the habits and living conditions of Tunisian society. In 2018, the death of her father, director Taïeb Louhichi, marks a turning point in her artistic research which is now oriented towards the representation of mourning, memory, and the intimate.

As far as I can remember, FESPACO has always been present at home. Without knowing exactly what this acronym meant, I remember the notebooks my father, Taïeb, brought back from the festival. Bags, pens bearing the effigy of the festival, but also and above all jewelry, pants, and various accessories from local crafts. This is how this institution has settled in my life, in small steps, like a landmark of African cinema. My father always had plenty of stories to tell when he came back from FESPACO. By listening to him, I built an imagination associated with this meeting.

For the fiftieth anniversary of the festival, I was lucky that Gaston Kaboré proposed to me to be the photographer of the festival because I am a professional photographer, and thus to cover all the stages of these days dedicated to African cinema. A tribute was also paid to my father at the festival, who died in 2018, with a special screening of his latest film.

When I arrived in Ouagadougou, despite losing my suitcase and a few surprises, I felt a strangely familiar feeling. Sensation that was confirmed during my stay. I had the chance to meet different professionals of African cinema, including friends of my father. These people I had heard so much about, with affection, and whom I was meeting for the first time. But also young Ivorian adults who came to train in cinematographic practices at the IMAGINE Institute. So many encounters around this festival. If there is one thing that I remember above all, it is the meetings that I have made. From strangers to media people. I felt like a family, and I know that my dear father, from where he is now, guided me to Burkina Faso for FESPACO.

I really enjoy observing the life around me. When I walked in the streets of Ouaga I spontaneously smiled, my heart warmed by looking at the handicrafts sold outside, because I finally understood where these objects came from which had settled in my childhood home in Tunis: trivets, wood, bronze, or pottery sculptures. My father, Taïeb Louhichi, Tunisian director, was a regular at the festival. Winner of several prizes at FESPACO, he claimed his Pan-Africanity from the start and passed it on to me quite naturally. I know he had a special affection for this festival where he was happy to see all his friends, his family from the cinema. I had the honor of presenting his latest film *La rumeur de l'eau* around Dido and Aeneas' opera at a tribute screening. The African cinema family was by my side to accompany me in this screening: Gaston Kaboré, Mama Keïta, Osange Silou Kieffer, Morabane Modise, and Ramadan Suleman to name a few …

Figure 8. Izza Genini, Moroccan film producer and distributor, image courtesy FESPACO.

Being where he was, in these places, these streets, this land, was an unforgettable experience. I am grateful to have had this opportunity to meet so many directors, journalists, the Burkinabe audience, and to have immortalized the fiftieth anniversary of this legendary festival.

Mohamed Challouf

Challouf was born in 1957 in Tunisia. Since 1986 he has lived and worked in Milan where, in collaboration with the Province of Milan, he organizes the cultural manifestation "The ultimate carovane." Since 1996 he has collaborated with the "Film Festival of Africa, Asia and Latin America in Milan." Director and producer, he has organized the Rencontres Cinématographiques de Hergla since 2005.

My First FESPACO

One of the most beautiful memories of my first FESPACO will remain forever this historic photo bringing together the Tunisian Tahar Cheriaa and the Senegalese Ousmane Sembène, the two founding brothers of Cinematographic Pan-Africanism.

At the time, I didn't have a camera yet and I only took black and white photos, and this was one of my first photos taken in Ouagadougou at the end of February 1985.

When I see this photo again today, I still remember the friendly and sympathetic atmosphere that already reigned on the special FESPACO flight "Le Point Afrique" Paris-Ouaga that I shared with the most important filmmakers of the African continent alive in Europe. She also reminds me of my arrival at the Hôtel Indépendance. At the reception, my compatriot and friend Taïeb Louhichi introduced me to his friends: Bachir Touré, the great Senegalese actor and comedian, Haile Gerima, the Ethiopian filmmaker, as well as the Burkinabe journalist Clément Tapsoba … (Taïeb was already a regular at the festival and knew a lot of people in Ouaga).

It was also my first trip to sub-Saharan Africa, which until then I had only known through films I had seen during the Carthage Film Days. And it was in Carthage that the SG of FESPACO at the time, Philippe Sawadogo, invited me to the Ouaga festival. I had met him at the JCC at the end of October 1984, and told him that I had been organizing a small film event in Italy for two

years "Les Journées du Cinéma Africain de Perugia." He promised me that if I bought my own plane ticket, I would be welcome at FESPACO.

In Ouaga I discovered an extraordinary cultural effervescence. All African cinema was present. The welcome of the guests was very warm and the state of Burkina Faso made sure that we all felt at home. I still remember the surprise made by the President of Faso, Thomas Sankara, at the reception of the Hôtel Indépendance; I still have the photos. In simple tracksuits and without body-guards, the head of state had come to personally ensure that we were well received.

For the opening ceremony, the people's house was packed: media from all over the world, film professionals from Africa and the Diaspora as well as many Burkinabe and foreign film buffs.

Several of my Tunisian compatriots were there. I also saw among the present two important Egyptian filmmakers and friends of Tahar Chériaa: Tewfik Salah and Atiyat Al Abnoudi.

Algerian cinema was in the spotlight at this ninth session of FESPACO which explained the large delegation of our Algerian neighbors. I recognized the filmmakers: Mohamed Bouamari, Brahim Tsaki, Ammar Laskri, the director of the Algiers Boudjemaa Karreche film library, René Vautier, and my friend the film critic Ezzeddine Mabrouki.

The 1985 FESPACO was also an opportunity for me to shake hands, for the first time, with filmmakers like Benoit Ramampy, pioneer of cinema in Madagascar, the Congolese Jean Michel Tchissokou, director of the film *La Chapelle*, the cameraman and filmmaker Joseph Akouissone from the Central African Republic, actress Zalika Souley from Niger, filmmakers Paul Zoumbara, Sanou Kollo, Emanuel Sanon, Idrissa Ouédraogo, all Burkinabes from different generations whom I met for the first time and with whom I spoke, later, a great friendship and deep brotherhood.

My first FESPACO was for me a unique opportunity for a total immersion in the cultures of my continent. It was a very intense week, not only in film screenings at the Burkina Faso cinema or in the open air at the Rialé cinema and the Oubri cinema, but also in dance and music shows that accompanied our trips to Ouaga to follow the activities of the Festival or for our buffet lunches and especially at random, very intense meetings with guests from Africa and other continents; all came to Ouaga for the love of African cinema.

This first meeting with Burkina Faso and the discovery of its young President Thomas Sankara was for me an extraordinary experience which deeply marked my life and had a great influence on my professional career. Above all, it allowed me to question a lot of prejudices and to start looking with more interest and brotherhood towards the South of the Sahara and all the rest of the continent.

❧

Maïmouna N'Diaye

N'Diaye, the French-Guinean actress and director, was the first African member of the Cannes Festival jury in 2019. Her role in Sékou Traoré's L'œil du cyclone *was awarded the prize for Best Interpretation at FESPACO 2015. In 2019, she was the Muse of FESPACO.*

I came to FESPACO for the first time in 1994. At the time I was a chorister and dancer in a band created by Burkinabe singer by the name of Nick Domby, based in Orleans and doing rock n' roll in Mooré, a local language. We performed at the FESPACO opening concert in 1994 and it was amazing. I felt like a super star, in front of the euphoria of the whole stadium standing up; it was great. When I think back on it today, I'm like … how was I able to do that? I was far from imagining that I was going to come back to FESPACO with films and documentaries and even win a prize.

I have attended every FESPACO since I have settled in Burkina Faso in 2005. The most outstanding one was in 2015, of course, with all the awards won by *L'œil du cyclone*.

I had already come to FESPACO with a documentary film, but presenting a fiction is something else. It was hallucinating, the room was packed to a bursting point and there was no seat anywhere! I just watched the beginning and went out. I would come back from time to time to see how people's reactions to specific scenes. And it was great! It's always strange to watch oneself; I usually don't like that, but I had to see the result. And the audience was delighted.

To be honest, we didn't expect to win any prizes at all. We were already very proud to be in the same competition as Abderrahmane Sissako! So much so that I didn't want to go to the closing party and I was far from imagining what was going to happen. My girlfriends did everything, they were three or four telling me that I absolutely had to go but I didn't want to. But they were so insistent that I finally resolved to attend the ceremony.

But when I say that I was far from imagining anything, I mean it. I was delighted to be seated next to "great people." I was not far from Abderrahmane, and I was already very happy to be there. And then the first time they called me, I didn't react, I hadn't actually heard. And the people shook me up and said, "but they called you." I say "What! Where did they call me? Where to go? They are calling you for the Interpretation Award!" I hadn't even heard my name. I stood up, walked on this sort of long carpet, received the award, and came back to my seat. As soon as I reached my place, the prize for Male Interpretation is awarded, and it is Fargass Assandé who got it. He wasn't there! Everybody is waving at me! So, I went back, like a zombie. Then I don't know what other prizes I got, but fortunately Sékou Traoré was there!

Then I traveled around the world with *L'œil du cyclone*. And I came back in the "eye" of the festivalgoers on the 2019 poster.

That year, I was on the film selection committee. FESPACO had set up a selection committee for visuals. And Mr. Philippe Sawadogo called me. He starts talking to me, as an "uncle" to his niece: "you, you've been around the "...the world;" he starts making a whole speech to say that in the end they decided to use the photo for the FESPACO visual. I say: "Sorry?" You might be joking now! And then a meeting is held with Soma who explains to me the why and the how; he said they had chosen me because of my various nationalities, my diversified origins, the fact that I am known internationally, and that no one was as representative of cinema and Africa as I was. I say if you want, but it's huge, it's heavy! I don't know if I'll really be able to make it and we did it. I was dressed by Martine Somé, and the photo was taken by Jean-Claude Frisque, a great photographer.

In 2016, I received the award for Best Actress in a French-language film, not just for the African continent, but for the whole French-speaking world. I was given the award by Michel Drucker. And then followed the FESPACO poster. And then there was Cannes and being the first African woman on the jury …

So, people saw me, knew I existed. I had proposals, but the time it takes to put a film in place is super long. And due to the COVID-19 pandemic, things slowed down, but I've done great stuff that are on standby and will come out in 2021, including two fiction films that may be at FESPACO.

There is a film made by a young director, Jean Eliot Ilboudo, a war film shot with Issaka Sawadogo. They had planned to release it in September 2020, but due to the situation, it was postponed to 2021. There's also a TV series, *Wara,* which was shot in Senegal, produced by TV5, also scheduled for release in September. Then a TV series shot in Côte d'Ivoire with Bogolan Production which is still in the drawers due to COVID-19. And then I've gone on stage and hosted a cultural program on TV.

And I am going into fiction, making my own films. I made a short fiction film as a director, my first, and I think I want to submit it to FESPACO.

And I am currently finishing writing a feature film which is an adaptation of the play I wrote and performed two years ago. A little bit of *L'œil du cyclone*, from theater to cinema, from cinema to theater and then there are always lots of things to develop and I'm very happy to be able to do it now. Even if for right now, being an actor on the continent is not yet given much consideration, particularly in terms of wages which are meaningless; many actors complain about directors and producers, but at the same time they accept the crumbs that are offered to them. At the end of the day, you have to know how to say no. You have to dare to say no.

An actor's work benefits the film and the production. The actor is the one the public identifies with, and this must come at a price on the continent, as in the rest of the world.

At least my word and what I defend go together.

Berni Goldblat

Goldblat is a director, producer, distributor, and film critic. He co-founded Cinomade in 2000 and, in 2006, Les Films du Djabadjah in Burkina Faso. He is known for his commitment to the reconstruction of Ciné Guimbi *in Bobo-Dioulasso, as well as for his documentaries, including the one about gold panners,* Ceux de la colline, *and a fiction film,* Wallay.

My first FESPACO was in 1999, the year in which *Pièces d'identité* won the Étalon d'Or. That year I was in Nouakchott, Mauritania. I lived there at that time! I had an itinerant movie theater that I used to make screenings all over Mauritania and I already knew Burkina but I had never experienced FESPACO! Because I was more and more attracted by cinema and films, I really had this dream: to go to FESPACO. I decided to leave Nouakchott by bush taxi to reach Ouagadougou. It took me five whole days of non-stop driving. It was epic … We took 4WDs crowded in the desert, we were sometimes on the roof, sometimes hung on to people…! I arrived in Ouaga just for the opening of the festival, and I was super happy to be there! So, I went to see a lot of films!

I already knew Ouaga and Burkina for I had already spent a lot of time there in 1993 and in 1995. A second home, but FESPACO as such, I didn't know at all.

I was a bit impressed; I was actually discovering. I thought everyone was great, I was like a child with my eyes wide open and then this Hôtel Indépendance! I was impressed, I was a bit afraid to go there… I had just arrived from Mauritania; you can imagine: pure austerity and I arrived in Ouaga with the crowded maquis, with people everywhere, for me it was a party!

For me, the first memory of FESPACO was the journey, five days on the road, and then arriving towards the light, towards the party, the African Cannes Festival! And the screenings at the municipal stadium with large screens, it was so beautiful! This film festival increased my desire to make films…

As a result, it strengthened my idea of itinerant cinema, of showing films in places where images are not seen, because they are less accessible. A desire to show films off the beaten tracks, out of the cities, and at the same time, I ask myself, "Am I not capable of making films?" So, I began to make small

films, short films that I tested in front of the public, live; it was really an itinerant, artisanal laboratory; we made films like craftsmen!

And it was a great school, the school of the field; I didn't have the chance to go to a film school.

And at FESPACO 2001, I presented a short documentary film that I had made in Guinea Bissau and which was selected to my great surprise!

So, I was at FESPACO, with a short film in competition, with the impression that I didn't deserve to be there and I was mega nervous! When my film was screened at 01:00 a.m. and in a "short film" venue, there were still spectators and I didn't know where to put myself.

As of 2001, it was really the meeting with the cinema family and I got integrated; I had the *Cinomade* project, I wanted to settle in Bobo; I met people during this FESPACO who came to join the *Cinomade* team, including Michel Zongo for example. I met him at FESPACO 2001 and he became a colleague, almost a brother, and one thing led to another and I stayed in Burkina Faso.

In 2017, I presented *Wallay*, but there was controversy because it had just had its world premiere in Berlin just before FESPACO, and instead of being in competition at FESPACO, to everyone's surprise, the film was shown in a panoramic format.

Like the Dani Kouyaté's. And it really caused a scandal. As a result, the screening of *Wallay*, out of competition, at Ciné Burkina, was packed! Everyone wanted to see which film was in Berlin and could not be at FESPACO, and even the Minister was there! There were people everywhere, some sitting on the stairs! For me it was important to show this film in Burkina Faso.

This is very important. I have an enormous sentimental attachment to FESPACO because I consider it to be our festival; that's why after its holding was threatened a few months after the revolution that brought down Blaise Compaoré, the 2015 edition was hyper-powerful, because they had managed to do it despite many doubts.

For me, FESPACO is a meeting place, a moment where we also work a lot because it's like Cannes, there are the films but there are also the "side events," meetings, discussions. This festival is unique and after having attended all these festivals throughout the world for all these years, I think no festival can be compared with FESPACO, although it has many flaws!

All of us, including me, will do everything we can to make FESPACO last and improve, because if it's not good, we're not good at all!

And as for me, FESPACO has always given me a place of choice for *Ciné Guimbi*, for example. FESPACO is a real partner; and FESPACO is not just Burkina Faso, it is a Pan-African, international festival; the very idea of FESPACO goes far beyond a territorial festival, it is truly eminently political, and it is the biggest cultural event in Africa.

It's not just a festival, it's an idea, people, faces, a struggle too, and that's why since 1999 I haven't missed one single edition. At FESPACO, we always meet extraordinary people, we establish links with films that have been imagined by us or by others! If it no longer existed, it would be like having a limb amputated.

We've made FESPACO our own, it belongs to all of us.

Dora Bouchoucha

Bouchoucha is a producer that founded Nomadis Images in 1995 and created the Project Workshop of the Carthage Film Festival (CFF) in 1992. She also set up the Ateliers Sud Ecriture of which she has been the director since 1997. She is a member of several juries and film commissions. She headed the CFF from 2008 to 2015. She is currently the director of the Manarat Festival.

In Tunis, I got to know Tahar Cheriaa, the creator of the Carthage Film Festival. His son and I went to the same school. We were friends and I used to have lunch at their house. Tahar was a wonderful and simple person; he was passionate about cinema. He was very easy to approach, pragmatic, while being a true intellectual. And I'm very happy to have been able to pay tribute to him at the Carthage Film Festival, just two months before his death.

This means that since my youth, I have been immersed in the atmosphere of Cinema!

The first time I went to FESPACO—a long time ago—it was "under the baobab tree," at "Indé"—Hôtel Indépendance; and I was amazed by this very pleasant hotel, absolutely not luxurious, but with a pleasant energy. It was a pleasure to spend the evening there as well; You could meet Djibril, Sembène, Mohamed Attia, and so many others. I listened to and swallowed their words. And they would speak, remaking the world, reinventing cinema.

I learned a lot from them, what their conception of African film was, what African cinema meant to them, the legislative frameworks they wanted to establish ... And what struck me were the stories. They wanted stories that would be told by children from the Continent, lively stories, with their own rhythms.

That's how I started, watching films, translating debates and meetings, and FESPACO was a revelation for me. I saw all these wonderful people, who thought African cinema, who thought African film and theorized about how to reappropriate their stories. At FESPACO, I discovered films that I would

have not been able to see anywhere else, even in Carthage, especially films from the Diaspora.

Today, Indé, the vital heart of the festival, has disappeared; and I'm afraid the same may happen in Tunis, for the Carthage Film Festival, now that we have the *City of Culture*, a little far from downtown. I wonder if there will still be the same energy? It's hard for a festival to grow up. The heart should stay in the city center, not elsewhere.

The experience of the CFF and FESPACO has been particularly useful for my job as a producer! I will always remember, for example, the difficulties faced by Syrian filmmaker Mohamed Malass in directing *The Night*. I saw the difficulties experienced by those young people who arrived at the festival with unfinished films; we are talking about a cinema that is not necessarily rich. So I know the challenges faced by directors and producers, from the inside. It's a hard job and having done the festival helped me to not only better understand this profession, but also to develop writing workshops, for example, to support young talents.

That's why in 2008, when I took over the CFF, I made sure that prizes be exclusively awarded to directors. I thought that after all, a director needs money more than a producer because, as "the writer," he must be paid because—unlike the producer—he can't do anything else at the same time. A producer can still do something else, make institutional films, commercials, etc … I'm not saying that all producers are rolling in gold, far from it. But I thought it was fairer that 100% of awards be given to directors, because it is really difficult to survive, to make money, during the making of a film, when you are an African director.

On the other hand, few of the films I produced, or Tunisian films, were nominated at FESPACO; I never really understood why! Mohamed Attia, for example, or other renowned Tunisian filmmakers have seldom been nominated or invited. This brings me to the issue of the selection of films at FESPACO. I don't know who chooses the films.

In fact, today the administration of FESPACO should be reviewed and rethought. There is a teaming issue for example. The administration should not be involved in artistic matters. There is a mix of genres at FESPACO. And the team is too large, which is not necessarily good, nor easy to manage.

I think the festival should be "smaller in scope" but take place every year. Nowhere will you see a biennial festival anymore. And how is it possible to be a global festival?

Before resigning from Carthage, I did everything I could to make it an annual festival. Organizing a festival every two years was relevant at the time when only few African films were produced. Today, many more films are produced. You can make a competition with only ten films, fewer people. FESPACO spends lots of money every two years and yet it is still

not considered as an A-Grade Festival on the world stage. The same applies to CFF. I think that Carthage has remained too big for an annual edition. I guess they don't need to invite 450–500 people. Honestly, we're spending a lot of money and yet we're not rich countries. Tunisia is a bloodless country today, so is Burkina Faso.

So we need to make it smaller, more centered, better adapted, and also, and above all, a festival for the public. We must try to change audiences' taste a little bit, by including commercial films, why not, but with a strong and well-made purpose. Festivals, especially on the continent, should be made for the public, not just for film professionals. A balance has to be found. For me, the audience is very important, especially in countries like ours. We have to build up an audience for the cinema of tomorrow. In any case, in Tunisia, many people have been going back to the movies. And it's thanks to the fact that Tunisian filmmakers have been modernizing their films.

The idea is to make more people come back, to diversify audiences and to change their tastes a little bit, so that they can enjoy films that are a little more difficult but still accessible. That's all we are asking. The true lifeblood of cinema is the audience.

Today, I'm fighting to have more movie halls everywhere, in remote areas, rather than costly festivals attended by few people, even though we still have a large audience at FESPACO and Carthage, which is rather great.

It's very important that festivals allow us to develop moments of exchange, because cinema is also emotion. But when you do a week-long festival, the disappointment and disenchantment are all the greater when the curtains fall, because afterwards there is nothing left. So we need multi-purpose theaters where one or two films are screened every week … and the Tunisian Minister of Culture is doing that.

Tunisia has a solid cinematographic background, though. Cinema has existed in Tunisia for over a century now, so we have a long history that has made it possible to build a real film industry, thanks to cinema clubs, thanks to the CFF and to amateur cinema. At the level of production, we have the whole chain today, including post-production.

I saw the beginning of FESPACO, the beginning of cinemas on the African continent, their evolution; there are interesting things happening. Currently, there is a real change that will soon make a difference, as it did some time ago in the Maghreb, Algerian cinema. I love Algerian cinema.

FESPACO is still the biggest event in West Africa. It is commercially huge, people come from everywhere. FESPACO must therefore continue to live while adapting to the evolution of filmmaking on the continent.

❧

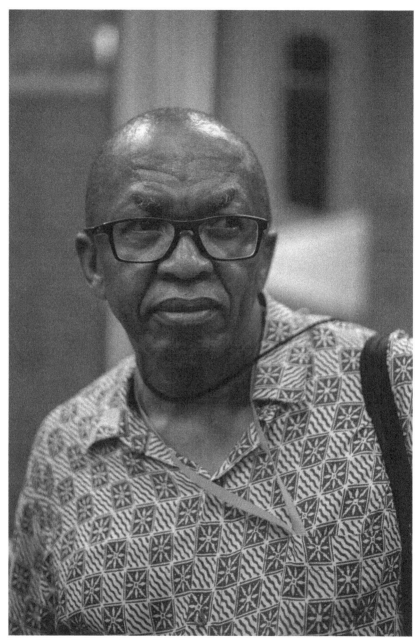

Figure 9. Kwate Nii Owoo, Ghanaian filmmaker, image courtesy FESPACO.

Sébastien Kamba

Kamba was born on 25 December 1941 in Congo. He studied at the French Radiophonic Cooperation Officiel (OCORA). He did a television internship in Paris and also worked as a teacher. In 1964, his political short film Le Peuple du Congo-Léo vaincra, *produced with television media, was the very first Congolese fiction film. Sebastien Kamba directed several other short films over the following years. In 1974, he directed* La Rançon d'une alliance, *the first feature film of Congolese cinema, an adaptation from the novel by Jean Malonga. In 1992, he published in France a work devoted to Congolese cinema.*

FESPACO. We dreamed of it; it has been in existence for more than fifty years.

This is what comes to mind when talking about FESPACO. The first memory is this question I ask myself: how did Burkinabe authorities—more than fifty years ago—come to understand the importance and the need to host in their country an event that, at the time, did not seem to have any chance of success?

The birth of FESPACO was like a wind of peace for the mind, a feeling of relief and profound determination.

Black Africa had just acquired an important media dimension. FESPACO then became an African mirror.

Today, FESPACO is more than fifty years old and it is worldwide none.

I am very happy, as one of the founding fathers of FESPACO, to see it become a big tree, a magnificent baobab.

FESPACO has lit a flame, it has breathed a good energy and a good dynamic into Pan-African cinema.

My gratefulness goes to the Burkinabe state and to the generous people of Burkina Faso.

David-Pierre Fila

Fila is a Franco-Congolese director and documentary filmmaker. Fila's 1991 documentary film Tala Tala *received the Air Afrique prize at FESPACO that year. He shoots his first short film in the Central African Republic: Letero (the Sorcerer's*

Mask); this work is presented at the Pan African Film Festival of Ouagadougou (FESPACO) in 1985. In 1986, he directed two short films of fifteen minutes, The Aluminum Founders *and the* Briefcases, *as well as a film for GTZ on lepers in Senegal. In 1987 he obtained a UNESCO scholarship to follow an internship as a cameraman at the Department of Film Studies at the Moscow Institute for Graduate Studies of Cinematography. In 1989, he directed* The Last of the Babingas, *addressing the issue of excessive exploitation and waste of forest resources in the equatorial regions of Congo, Cameroon, and Central Africa impacting negatively on the lives of the Pygmies. In 1993, he created Les Films Bantous Communications, in Congo Brazzaville. He directed* Sahara *(1995), the same year, he directed his first feature film* Matanga, *and then,* Dakar Blues *(1997), ZAO (2009) and he created the collective Bantous Productions in 2011.*

My First FESPACO

There are events in life that one must know how to grasp when one has the opportunity to experience them. This was the case for me during my first FESPACO. I had had the chance to participate for the first time in 1985; the theme was "cinema and the liberation of peoples;" Captain Thomas Sankara wanted to open up culture and cinema even more to the whole population.

In this revolutionary period, everyone was called to go out to watch films. Burkinabe music and dance, dishes from the different regions of the country were consumed every day by festivalgoers.

I went from Bangui to Lomé; then from Lomé, I traveled by road. At each entry and exit, whether town or village, I had to get out of my bush cab, show my passport like every other passenger, and have it stamped by the CDRs.[24] On arrival, no hotel, no badge, assistance, nothing.

At the time, Captain Thomas Sankara would always come to the festival to make sure that everything was going well. At that very moment, I suddenly found myself in front of him as I was coming out of Secretary General Filipe Sawadogo's office! I was carrying my little film entitled *Letero Le masque du sorcier* to represent my country, Central African Republic. Captain Thomas Sankara, as usual, was coming out of the Secretary General's office, walking on crutches, because he had just fallen off his bike a few days earlier. I had the nerve to go up to the Captain: "Comrade President, I come from People's Republic of the Congo, my film has not been scheduled, I have no support." All of a sudden, all my problems were solved very quickly …

One evening of that year, I met some colleagues from Central Africa: Arthur Sibita (*Les Coopérants*), Jean Claude Tchuilen (*Suicide*).

At the time, there were the CDR in a street. Suddenly, behind some sandbags: we heard shouting "Hands up!" Obviously, we obeyed and started shouting "FESPACO! FESPACO!," to signal that we were participants of the festival. But the guys did not calm down: "Hands up! Hands up!" We kept shouting "FESPACO, FESPACO," but in the long run it became "Don't be stupid! Don't be stupid!" And them: "Hands up, or else we'll send the elements." By the "elements," they meant "bullets!" It was only a matter of time before they shot us down!

I also remember that on the evening of the screening of my film, I had as godfathers: Victor Bachy, Pierre Haffner, Claude Prieux, Jean-Pierre Garcia, and Férid Boughedir. They had come to see my first film. It was the second Central African film to be screened at FESPACO, after *Zo kwe Zo* by Joseph Akouissonne.

There were also the discussions with the elders, where one's struggle became the others' struggles.

To conclude, my first FESPACO was a wonderful human adventure, women and youth forward and above all the most: the small black Renault 5 as the official car of the young revolutionary state, the black Renault 5 in which the armed guards also crowded together beside the Comrades Ministers! … Surprising and edifying image!

FESPACO had not only allowed me to discover various films from the continent, but also, and above all, raised my awareness that we must shoot, speak, and magnify our continent to show it to others!

Abdelkrim Bahloul

Bahloul studied at the National Conservatory of Dramatic Art in Algiers from 1968 to 1971, then at the National Conservatory of Dramatic Art in Paris in 1976–77. In 1973, he obtained a master's degree in modern letters at the Sorbonne-Nouvelle-Paris-III University. He studied cinema at IDHEC (1972–1975). He was camera operator at Antenne 2 and TF1 from 1976 to 1980, then assistant director at TF1 from 1980 to 1983.

My first FESPACO was in 2011, with the film *Voyage to Algiers*. I did well to go, because I was in dire straits and received lots of prizes! FESPACO gave me something like $25,000. I had a lot of prizes and parallel prizes.

It is very important festivals that give cash prizes because in African and Arab cinema the directors are not rich and in some countries there is no writing assistance. Filmmakers need money to keep working and moving forward. It's very important casually.

It allows people to come to their homes who want to showcase their films. The festival is famous, but if you don't donate the money, no one goes. On the other hand, Views of Africa in Quebec, whether it has prizes or not, you go. It is a French-speaking film festival. It's absolutely awesome. But FESPACO was just super fun.

The screening worked very well. Viewers were touched by the story of this mother, whose life unfolds against the backdrop of issues related to the country's independence; how one becomes independent, what upheavals that entails, the film told all that, but all the African countries knew this period in the 1960s when they became independent vis-à-vis France.

What touched me when I was at the festival was the way the Burkinabe welcomed us, anywhere in the country. Their kindness, friendliness, hospitality; for them, we were their guests. It touched me so much. We felt like the guests of a whole people. It's a wonderful feeling. The then president invited us into a large garden; I found it interesting to honor directors from another country. To shake their hands; it doesn't matter if I am told he was a dictator. He shook my hand and I was there to represent Algeria and France. And during the ceremony, I was blown away by the riders, who did incredible acrobatics, for example going under the bellies of the horses. It was wonderful. One of my best memories.

Burkina has become a bit of my country, I have maintained relationships with people who have written to me for many years. There is a small company that gave me 500 euros to buy the film rights. This is the first country where the film has been shown.

Unfortunately right now, I know there is terrorism out there and I am absolutely sad about it. Because they are such a magnificent people, who do not deserve this; they deserve to be left in peace.

Most important of all is that I became famous all over the world through social media. And that's because I got the prize at FESPACO. Thanks to the recognition of this festival I have been invited to several other festivals, in New York, Quebec, Africa. In Cameroon I won the Ecran d'or prize.

FESPACO, I realize, is much more important internationally than the Carthage Festival. Thanks to FESPACO, I even went to Madagascar to lead a screenplay workshop and I was able to meet the filmmaker Gaston Kaboré, an extraordinary man.

Idriss Diabaté

Diabaté holds a postgraduate degree in Communication for Rural Development and teaches Audiovisual at the National Institute of Arts and Cultural Action (INSAAC) in Abidjan. Associate researcher at the Center for Teaching, Research in Communication (CERCOM) of the University of Abidjan since 1986, he has been making documentaries on social facts in Africa. Kuma (2006), Bayeremashy (2005), and Parole sans paroles (2004), are among the works of this prolific documentary filmmaker.

FESPACO was for me one of the triggers that encouraged me to make films. I remember my first FESPACO very well. It was in 1983, I had just finished my studies in Paris. I returned to Côte d'Ivoire and worked at the National Institute of Arts in Abidjan. That year, we went to FESPACO with my wife, as spectators. The same evening we arrived we went to a big party which really impressed me. I was with Sanvi Panou and Catherine Ruelle arrived with Prime Minister Thomas Sankara; I even took pictures and showed Panou that he had his pistol on his belt! And the second thing is *Wend Kuuni*. Gaston Kaboré won the best first film award, among other awards, and I said to myself: I want to make films! *Wend Kuuni* touched me a lot… it was like a trigger.

And here it is at FESPACO that my vocation was really born! I had already acquired the love of cinema with Jean Rouch, whose lessons I had taken in Paris. With Jean Rouch, it was a bit theoretical. But figuring out how to use a camera and tell a story from someone who's like you really came from *Wend Kuuni*. So, I made a documentary in Abidjan called *Tam-tam*, created quite simply with the technique of Jean Rouch; I filmed peasants who left for the fields to cut trees, and who returned with the tree trunks to Abidjan to make drums; then I followed them in a baptism; a small film of 13mm, in 16mm. This film there I brought it to Ouaga. I think we saw the film on VHS but the audience liked it and I got a prize at the time; so from the start, FESPACO really got me started.

Then I presented this film in Paris at the Jean Rouch festival (Bilan du film ethnographique à Paris), I got the Bartok Prize and the film was bought by Canal plus and broadcast in clear.

I returned to FESPACO in 1997, with a film called *N'Gonifola the Visit of Hunters in Mandingo Country* coproduced with the Burkinabe culture ministry. I went to present the film in Ouaga, I was invited to the hotel as a director and there I began to feel like a filmmaker because I was in the same boat as all African filmmakers.

The Burkinabe filmmakers, I got to know them at that time and their welcome was very warm. I knew Pierre Yaméogo, Saint Pierre, who became

a great friend of mine, Idrissa Ouédraogo, their welcome was spontaneous, natural and at each FESPACO I go to, I hardly ever have lunch in the hotels where I am staying! I am always with Burkinabe filmmakers.

Afterwards, I came back in 2009, with *La femme porte d'Afrique*, which won the UEMOA award… The prizes are not just a question of money, they also help build self-confidence, because all in all, when by nature you do not have too much confidence in yourself, the attention that others give you becomes a motor for you, the gaze of your peers stimulates you.

And last year at FESPACO 2019, Gaston Kaboré when he saw me told me "Diabaté when I saw your name on the list with a film I was so happy!" It was a pleasure! This is to show what a real community of filmmakers there is. And when we screened the film Jean Rouch, an African filmmaker, he came to watch the film and, even if I did not have a prize, what is important is to be selected and to be at FESPACO.

All the more important since Jean Rouch is one of the founders of FESPACO and a friend of Sembène; Moussa Hamidou, Jean Rouch's sound engineer, came from Niamey; I paid for his trip, he came to Ouaga for the screening and he was very moved to see that Jean was a little better recognized.

Documentaries like this are important to show the early filmmakers; we are in the continuity of the work done; it's a testament to our heritage in fact. I think we have managed to show that this man has done a lot of things in Africa with the Africans.

Moreover, the documentary has taken more and more space at FESPACO. FESPACO gave a more important place to documentaries, but documentary filmmakers have also established themselves on the continent.

And that's thanks to Soma; in a way he brought something more to FESPACO and that we can only underline; it's good that there is now a real section with gold, silver, and bronze standards for documentaries that are cinema and not audio visual products.

Now, in the future FESPACO should no longer be simply funded by the host country, Burkina; it should be funded by Africans at the level of the OAU, the Organization of African Unity. This means that we could have a secretary general, who could operate at the level of the different countries and thus give a Pan-African dimension, endogenous funding and a different organization to FESPACO.

That would make it possible to promote the Prizes of course, but even the selection of films at FESPACO, on the continent first, and then in the world, as a label.

Simon Bright

Bright is from Zimbabwe and completed his first documentary film in 1987. The film,
Corridors of Freedom, *received a full invitation to go to Ouagadougou and present*
at FESPACO.

My First FESPACO

Can you imagine the impact that FESPACO had on me as a young (white)
man from the new state of Zimbabwe? Dancers in bordelane cloth walking
on stilts around the pool at the Hôtel Indépendance. Ousmane Sembène
smoking his pipe and chatting to Souleymane Cissé and men and women
dressed in amazing boubous. Such style and clothing I had never seen. And
then meeting Djibril Diop Mambéty again, as courteous as ever, welcoming
me as a newcomer to the festival.

But the euphoria of the arrival was cut short as I tried along with Anna
Mungai from Kenya and Moussa Touré to claim my room at the Hôtel
Indépendance. I thought at first that Moussa was being unreasonable as he
started shouting that he was going to claim his film and leave Burkina immedi-
ately back to Senegal unless he was given a room immediately. But by midnight
with no room to sleep in, I realised that the modest Anglo-Saxon way of
keeping cool was not going to work in West Africa, and I quickly developed a
style of high operatic drama. This seemed to work! I was finally given a bed to
sleep in and I managed to avoid the notorious junior officer's mess as a billet.

I loved the structure of the festival where films were shown the evening
before and then filmmakers and critics and lovers of cinema would meet
under the awnings at the Hôtel Indépendance. These *rencontres* where
African cinema was discussed, torn apart, reassembled and chewed over
was probably the best fast track introduction to what is African cinema that
anyone could have. The style was of course very different from what I was
used to. People spoke at length very passionately. Talk was loud with many
rhetorical flourishes. Still it was very fine to find African cinema had a home
and a place, given that for the next ten years first in Zimbabwe and then in the
new South Africa, we would be arguing whether Africans wanted to watch
African cinema at all. We were still fighting the cultural legacies of apartheid.

The screening of my film was also an adventure. It was a documen-
tary film in a festival where the fiction film is king. It was a film without
French subtitles about a part of the world that few people at FESPACO knew
anything about and I was a completely unknown director. I think there were

five people watching in the Ciné Burkina. All of them were jury. *En verité, mon premier film n'a pas eté un succès fou à Ouaga.*

But no problem. The best was yet to come and my company Zimmedia and I did win prizes with our later films *Flame* and *Mbira Music.*

My first FESPACO was a seminal introduction to the richness and possibilities of Pan-African cinema. I was able to freely talk with the leading figures and intellectuals of African cinema, Gaston Kaboré, Férid Boughedir, and I could meet my contemporaries, some of whom I later worked with. I should mention the women filmmakers of Africa in particular. Dora Bouchouha, Regina Fanta Nacro, or Nadia el Fani who I worked with on the series *Mama Africa.*

My first FESPACO created a vital link between Pan-African Cinema and Southern Africa. Working with other Zimbabweans including Steve Chigorimbo and Stephen Chifunyse, we then organised *The First Frontline Festival* which was attended by Souleymane Cissé, Gaston Kaboré, Haile Gerima, Med Hondo, Lionel NGakané, and many other great names of African filmmaking. Harare in the early 1990's became the venue where many activist South African filmmakers took refuge from apartheid and encountered African cinema for the first time. They had been cut off from the rest of Africa by apartheid. We went on to organize the Southern African film festivals and the first African Input workshop and this led to many African co-productions like *Kini and Adams, Flame, Africa Dreaming, Aristotle's Plot.* We brought Jean-Pierre Bekolo to teach at the UNESCO regional film project to inject some young West African cinema blood into Southern Africa.

Thanks to FESPACO for a vital hub for African cinema.

Sheikh Doukouré

Doukouré is a Guinean screenwriter, director, and film producer born in 1943 in Kankan, Guinea. He notably participated in the creation of a film which marked the Afro culture of Paris and France: Black Mic-Mac. *Doukouré left his native Guinea in 1964 for Paris. While pursuing a career as an actor in the theater and on television, he regularly made appearances in the cinema (*Les Ripoux, 1986; *An Indian in the City, 1994). At the end of the 1970s he began to write screenplays (*Bako, the Other Bank *1978;* Black Mic Mac, 1986) *and ended up directing in 1991 with* Blanc d'ébène *which took place in Guinea during the Second World War. In 1993, he founded his production company in Guinea: Bako Productions, thanks to which he was able to finance his second feature film* Le Ballon d'Or, *on a young African from the working class who became a football star. In 2001, he created Les Films de l'Alliance in France in association*

*with his screenwriter Danielle Ryan to produce Paris according to Moussa, which tackles
the subject of undocumented Africans.*

Happy Kisses From Ouaga!

I remember my first FESPACO well, it was in 1979 with *Bako!* It is a film
that I had cowrote and codirected with Jacques Champreux; I was also an
actor in this film alongside Sidiki Bakaba. There was a conflict around the
film. We did not know if the film was Senegalese, Guinean, or French; we
did not know what nationality to attribute to him or how to sign the realiza-
tion. In the end we thought anyway that it was an African film, and I asked
for it to be shown in competition at FESPACO. Subsequently, the film was
invited by FESPACO, and put in competition, but nobody told me about it.
FESPACO sent an invitation letter to Jacques Champreux with an invitation
for a second person. And Jacques Champreux said to invite Sidiki Bakaba,
who was playing the lead role in the film; I didn't know anything about it!
It was Sidiki who informed me. It was there that I wrote to the management
of FESPACO informing them that this film that I had cowrote and even
codirected *Bako*; I announced that I would be coming to Ouaga anyway
to talk about my film, so I bought my plane ticket. At the time, there was
only one flight from Paris to FESPACO. Obviously in the plane Jacques
Champreux saw me, he said to me "are you going too?" He was surprised
and it reminded me of one of the dialogue in the movie. In the film, with the
character played by Sidiki, we find ourselves in Mauritania and Sidiki says:
"but you also travel?" So I pat Jacques Champreux on the shoulder and said
to him: "From today we are making the trip to *Bako!*"

When I arrived in Ouagadougou, FESPACO, having received my letter
before, offered me full support, room for my stay.

But this is not the end of the story! Finally Jacques Champreux refused
to present the film as an African film. So he said the film was French. The
day after the screening, the debate on the film was to take place at the
Hôtel Indépendance next to the swimming pool and I had warned Jacques
Champreux: "Tomorrow if you want to grab the film, it won't work, and I
will show you that this African audience is mine…" On the evening of the
screening, Jacques Champreux returned to France by medical evacuation.

Jacques Champreux had asked Pierre Haffner, professor and film critic
in Strasbourg, to replace him during the debate and when Pierre Haffner
started to speak, I interrupted him by saying this: "Wait, do you know this
film?" He replied that he knew Jacques Champreux and that he was a friend;
so I repeat the question before throwing him, how can you debate the film
without knowing anything about it? I let him know that I am the author and

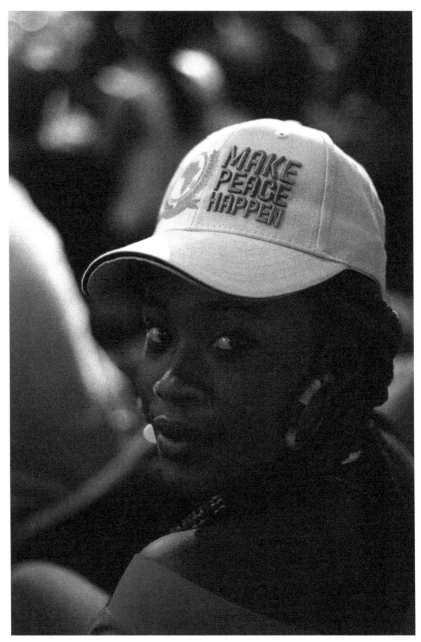

Figure 10. Portrait of an audience member at the FESPACO ceremony. Image courtesy FESPACO.

that this is an autobiographical film that I wrote and in which I played my own part. In short, I forbade him to talk about the film, and the audience was enthusiastic! Finally the film was put out of competition, as a French film; but it's a strong memory. There are many journalists who still remind me that "the *Bako* debate had been something, eh!"

A few years later, *Le Ballon d'Or* was invited too, but at that time I couldn't go to FESPACO because I was shooting a series for TV5 Monde. And then, at FESPACO in 2003, I got the interpretation prize for the film *Paris, according to Moussa*, of which I am the director.

I think that at the start of the festival the directors were considered much more than the actors, but in recent editions FESPACO has made more room for actors; there was even an edition dedicated to comedians, and from there the comedians became more visible, especially as Georgette Paré, a Burkinabe film actress, was tasked with organizing tribute ceremonies for the comedians. However, I believe that the directors are still a little privileged! After all, they are the authors of the films and they are also the ones who created this festival!

FESPACO had a family character and we African filmmakers felt at home; it was not the flashy thing of Cannes … But the festival has grown, the cinema has evolved, with all that that entails as changes.

Oumou Sy

Sy is a Senegalese costume designer and stylist, also a decorator and jewelry designer— one of the biggest names in contemporary African fashion. Of Fulani origin, she was born in 1952 in Diatar near Podor, in the Fouta-Toro region, near the Senegal River. Under the Bagatelle-Couture brand, she opened at the age of twenty her first ready-to-wear store in Dakar. Its vocation is no longer in doubt. In 1996, she opened an innovative convivial space, the Metissacan cybercafé, then launched an online store in 2000, which enabled her to distribute some of her creations.

The first time I went to FESPACO was in 1991; I went there with Djibril Mambéty Diop as a movie costume designer. The shooting of *Hyenas*, Djibril Mambéty Diop's latest feature, was not yet fully completed.

I took movie costumes to do a fashion show, which took place at the Hotel Silmandé and at the Palace of Culture, I believe, in the presence of President Blaise Compaoré.

His wife, Chantal Compaoré had noticed me at the 1990 Cannes Film Festival, thanks to Idrissa Ouédraogo's film *Tilaï*, for which I had made the

costumes; a film in official competition at Cannes where it won the Grand Prix.

I had just finished the big bicentennial parades in 1989. France even wanted to give me a French passport that I did not want to take elsewhere.

At this FESPACO, many African stylists were invited including Alphadi from Niger and myself.

As among them, I was the only movie costume designer, we talked a bit about the movies between us. At that time I was also working on *Guelwaar* a film by Ousmane Sembène and I was also collaborating on the film *Mossane* by Safi Faye. All three films I mentioned were still in production or postproduction.

It was Ousmane Sembène who was the first to make me go on a film set in 1989 and it was on a French film *La nuit africaine* directed by Gérard Guillaume and on which Gaston Kaboré, from Burkina Faso, was co-adapter of the book from which the screenplay was taken. The profession of film costume designer was not used much in African films at the time.

During the 1990s and 2000s, we had a lot of work because there were a lot of films being shot. I went from film to film and apart from Senegalese films (*Guelwaar, Hyènes, Mossane, Le Prix du Pardon* and others), I was also a costume designer on two films by Idrissa Ouédraogo (*Samba Traoré* and *Tilaï*). From those years, I was very regularly invited to successive editions of FESPACO; I went several times as a guest of honor, notably in 2001. That year, following an unfortunate error in the addressing of the packages, my costumes which were to parade in Ouagadougou went to Germany and I had to remake them all with textiles, leather, and accessories bought locally in Ouagadougou. Ultimately this incident turned into an extraordinary creative adventure full of quality, pleasure, and satisfaction.

There you have it, creativity, talent, success, all of these are gifts from God!!!

I have stored up a lot of memories about the African films I have worked on; I have often seen myself transformed into a friend, confidante, and even a mother to help filmmakers get out of the problems they were faced with with respect to sets, costumes, and certain props. I remember in particular the film *Po di Sangui* by Flora Gomes with its main character, a spider man whose costume had to unravel and cover the whole village like a spider's web. Flora Gomez was very keen to make this streak a success and I was very happy to find a simple and inexpensive solution for her.

For the record, it was on the set of *Po di Sangui* that I met Michel Mavros, the man who would become my husband and who was the production manager on the film.

I love my job as a fashion designer and movie costume designer, I love working and collaborating to create universes, I love cinema and its magic.

Wasis Diop

*Diop is a Senegalese musician and composer born in the middle of the twentieth century in Dakar. In 1974 in Paris, he joined the West African group Cosmos formed by Umban U'Kset from Guinea Bissau and which many consider to be the first African rock group. He has composed several film soundtracks (all or part), including two for productions by his brother, the filmmaker Djibril Mambéty Diop (*Hyènes, *1992 and* La Petite Vendeuse de soleil, *1999).*

I got to know FESPACO through Djibril, my brother; because he is the FESPACO! I "listened" to FESPACO while thinking of him, because I know that he was there and that he was in the center of the crowd, as he liked him, and that he was surrounded by friends, as he loved her too. But at the same time, FESPACO is an important place for our imagination because cinema is important. And it is a festival that has come to conquer its place in the history of world cinema. Nonchalantly!

If FESPACO were to disappear today, for one reason or another, that would leave a great void, not only in cinema but in the development of Africa, in terms of exchanges between countries and of friendship as well. Because it's a festival where people go for cinema, films, but also to meet.

FESPACO is Africa, a "portrait" of Africa in its rough, messy, lively side that we like. Me, for example, I had never seen in my life a fight to get into movie theaters and team up to see a movie! This is extraordinary, and it does not exist anywhere else.

I had won the award for best film score several times and it was even starting to bother me a bit because I wondered how I was not the only composer! Until the day I went to FESPACO for the first time in 2011 and had to climb the stairs to get my award. I was given an award for all of my works, because that year, in 2011, there were five films in competition, at least, that I had made the music for. And so suddenly, for this work, I was given a price, indisputable, because I had broken the record for composition of film scores that year!

And really I have felt all these feverish gestures that you do when you have to go get something. It was extraordinary. You had to walk, wait for the two friends who were on the stage to finish their presentation, and that

at some point, it was obviously my turn to receive the prize. And the fact of leaving the stands, of clearing your way to go there … receiving the prize, coming back to sit down, it's a round trip that we cannot forget, it is truly exceptional!

And the public is there in the stadium. This is what is great about FESPACO. We manage to motivate an entire city, almost an entire continent for that matter, because there are spectators coming from everywhere and suddenly it is a very important cultural and political event.

In this regard, I remember something that stood out to me. In 1989, I could have gone to the festival, because my brother bought me a ticket. This was the edition that followed Sankara's disappearance. I will always remember it; I did not understand, moreover, that that year, the filmmakers decided to do the Ouagadougou festival anyway. It shocked me, and I did everything not to go despite the fact that Djibril had spent a lot of money to buy me a ticket. I didn't want to go and I remember that Djibril gave my ticket to a journalist. This is the sole fault of the entire "cinema people;" I say this because I know that Sankara was a real supporter of cinema and culture. We couldn't discuss his engagement. At one point he was at the center of FESPACO with his guitar, his energy, his enthusiasm … This is the only regret I can have, not for myself, but for the festival. This edition should not have happened. In any case, all the filmmakers should have boycotted this edition.

Going back to my relationship with Djibril, my brother and I were not rivals, but we were competitors. In reality, when we were at the age of the first shudder, when we had to project ourselves into the world with all the emotion of our hearts which were beating unreasonably, Djibril hesitated for a long time before embarking on the path to the cinema. He wanted to make music. He even had a singer's name—which I forgot! And I really liked the actual photo; it's extraordinary! Then things suddenly turned around, and so he passed on to me how much he liked music. And there you go! He was the one who became a filmmaker and I make music!

But in reality when Djibril was filming, I was still with him in the cinema. The music I did for myself, to accompany me in my solitude, in my little life, in my room … I did not project myself beyond my little room. On the other hand, I was very active on the sets of Djibril, I even acted in his films; I lent him my energy on his sets, which is quite normal. It gave him all the leeway to take time off when he felt the need to, go into meditation and come back because that's how he worked, to be really sure what he wanted to do. When he wrote, Djibril liked very much to tell his sequences in bars. And telling them took him much further, because he had performed so much with his friends in bars that, on set, he changed completely. It was also his way of renewing himself. He kept writing, all the time, in fact.

As for me, I really became a musician in Paris, with the West African Cosmos, the group put together by Umban Ukset. I don't know if it's because of our talent or if it was just a good fortune story but this album was recorded for CBS, and we had incredible momentum, energy, enthusiasm … and we were free because we had left our territories of origin to find ourselves in Paris.

Because, all the same, in Africa, we belong to caste societies where only griots were allowed to make music. And so being on neutral ground away from our parents made us really let go. And as a guitarist, I even wonder if I'll be able to do that again today. To say how determined we were and how loaded with things we wanted to give.

We started to compose for the cinema, for the film of the scenario writer William Klein on the fight of the century, that of Mohamed Ali in Zaire. Mohamed Ali the greatest, in 1974. We recorded a soundtrack which is the song of the end credits of this film in black and white. It was the first time I had come across the idea of making a film score. Then I left the West African Cosmos which was kind of my school, my band … and that's where I really started to compose songs, to discipline myself, to work. I think *Hyenas* was the first film that opened the way to cinema for me in 1992; and then the soundtrack was bought by Universal Music, another big blow!

There was something decisive: I was marked by cinema. That's why you find a lot of my songs in movies—so much so that I can't even count them anymore—because I really have a cinematic view of music. When I make music, I tell a story, I see images. Everything I do in music is cinematographic. I worked a lot with my brother; we spent hours trying to make plans, thinking about the composition of a shot. And that's something that has haunted me to this day. I remember a singer who brought me to America to work with her. She had listened to my record and she said to me: I made you come because I like your scenes, I like your atmospheres. So she was really talking about pictures. It's something I owe to the movies. Even when I write a song, I'm still in the movies.

Nadia El Fani

El Fani is a Franco-Tunisian director, screenwriter, secular activist, and producer. She began working in the cinema as an intern in 1982, on the film Besoin d'amour *by Jerry Schatzberg, shot in Tunisia. She then became assistant director and worked in particular with Roman Polanski, Nouri Bouzid, Romain Goupil, and Franco*

Zeffirelli. She moved to Paris in 2002, during the postproduction of her first feature film, Bedwin Hacker. *Close to groups of Tunisian activists, she embarked on documentaries in 1993 with* Femmes Leader du Maghreb *and* Tanitez-moi. *She directed several documentaries including* Ouled Lenin *in 2008,* Laïcité, Inch'Allah! *in 2011 and* Même pas mal *in 2012. In 2013, she codirected with Caroline Fourest* Nos seins, nos armes!, *a documentary on the Femen movement for France 2. She has just completed a feature film (an auto-fiction) shot during confinement in Paris in 2020 entitled* Capitale Parenthèse. *She is currently preparing a fictional film* Frankaoui *which takes place in Paris, and a documentary* Le Plus Bel Age *on the ten years of the Tunisian revolution.*

Overall, I remember the joy I had each time going to FESPACO. At each FESPACO session, we go back and forget the one before! But this is a festival that I have always had in my heart, because I was much more "recognized" as an African filmmaker than in Tunisia, my own country. I have always been selected for FESPACO; all my short films, all my feature films were shown there. Each time it has been adventures, but above all happiness, the pleasure of meeting all the filmmaker friends of the continent! This is the opportunity to see each other's films and discuss them. Each time it was a delight and then there were the fights at the general assemblies of FEPACI; we miss it. It was super constructive this mixture of generations with the big names of the cinema of the time, like Ousmane Sembène, Djibril Dip Mambéty, the great era of Souleymane Cissé, Gaston Kaboré … and each time it was an artistic, intellectual emulation, super interesting policy. And each time I went to FESPACO with renewed pleasure.

Women filmmakers have long had their place at FESPACO since there was already a woman at the first festival and North African filmmakers too. It means that I, who am one of those who defend the Africanity of the Maghreb, was like a fish in water at FESPACO. We were on an equal footing, which is not necessarily the case in other festivals for African filmmakers.

It was a real treat. Obviously, the greatest happiness was the day I received an award for my film *Even not bad*, in 2013. There, I was able to understand the emotion that one feels when one goes up on this platform and that we see all these people in the stadium in front of us. At the time it was unfortunately still dictatorship in Burkina Faso and I remember saying "I hope that one day all of Africa will finally be democratic, free, and secular." And I felt on top of the world! It was something extraordinary! Tunisia had just had its revolution in 2011; I was being chased by the Islamists in Tunisia and I never imagined that this could happen in Burkina. I just saw that this revolution was going to spread oil in Africa. And suddenly even greater was my disappointment at the last FESPACO.

In 2019, I was president of the documentary jury. It was the first time that there were specific standards for the documentary. Being president of the jury, I thought it was a nice sign, since everyone knows my reputation as a nonconformist and a brawler. So I thought that it was finally the recognition of diversity in all its forms whether it is at the level of men and women or at the level of cinemas; in addition we had some nuggets that we won unanimously, among many films, some of which had no place in the competition.

My documentary film jury awarded our prizes to women because they happened to be the best films and above all we were very happy that the first gold standard awarded for the documentary went to a Burkinabe filmmaker who had made a courageous, beautiful, poetic film, a work! This is *Balolé's Golden Wolf* directed by Aïcha Boro. In addition, it was a first work on a political subject. And we thought it had been very courageous to select her even though she had a hard time getting a correct projection during the festival! But really the award went to her unanimously, there was no discussion.

On the morning of the prize list all the juries were gathered at the FESPACO headquarters for the ceremony to be recorded. Me and the presidents of the feature film and short fiction jury, we said that we wanted to go on stage to say why we were giving the prizes, the expected, as in all festivals. They didn't want the entire juries to take the stage; we ripped off the idea that we, as presidents, could go on stage anyway. Why be a president if not to be the spokesperson for the jury. So they end up conceding it to us.

And besides I remember that this is what was done before. It's important to listen to what a filmmaker says about their film, but unfortunately our winners were not properly communicated on the day of the awards.

However, my jury and I were very happy with this prize list, which for the first time included a gold standard from Yennenga which was awarded to a female director and who, moreover, is Burkinabe.

We also honored four other female directors that year and made sure to argue our prizes so that no one would assume that they were convenience prizes.

FESPACO 2019 Documentary Jury Awards

Documentary Feature Competition:

Étalon d'Or de Yennega (Unanimously): *Le Loup D'or De Balolé / Balole Golden Wolf*, **Aïcha Boro-Leterrier** (Burkina Faso)

A compassionate film with high cinematic qualities that portrays its protagonists not as victims but who are able to organise for their rights even when they are the poorest part of society.

Étalon d'Argent de Yennenga (A L'unanimité): *Au Temps Ou Les Arabes Dansaient / When Arabs Danced*, Jawad Rhalib (Morocco)

This film combines art and politics and cinema, telling a contemporary and crucial story about the rise of conservatism through religious decree, and which stands as a warning for the whole world.

Étalon de Bronze de Yennenga: *Whispering Truth To Power*, Shameela Seedat (South Africa)

A portrait of a powerful woman in South Africa who stands strong against the forces of corruption, and is a role model for the fight for justice and a free society.

Special Mention: *Ntarabana*, François Woukache (Cameroon)

Documentary Short Films Competition:

Yennenga Poulain d'Or (unanimously): *Contre Toute Attente / Against All Odds*, Chartity Resian Nampaso and Andrea Ianetta (Kenya / Italy)

This film shows how young women can effect change and take back control of their bodies against the harmful practise of female genital mutilation by traditional society.

Yennenga Poulain d'Argent (Unanimously): *Ainsi Parlait Félix / Thus Spoke Felix*, Nantenaina Lova (Madagascar)

A film that gives voice to those who fought against colonialism while warning the youth of similar dangers today.

Yennenga Poulain de Bronze (unanimously): *Tata Milouda*, Nadja Harek (Algeria)

A powerful woman who is a migrant in France and who gives support to others while dealing with her own troubles.

Diaspora Competition / Paul Robeson Prize: *My Friend Fela* By Joel Zito Araujo

An uncompromising and intimate portrait of one of the most popular African musicians who used his music as resistance to dictatorial powers

and embodied the affirmation of African culture in all its radicalism but also artistic expression.

Cinema on the continent, if it is not political, it is nothing! I say it loud and clear and I mean it.

Notes

1. Paul TiyambeZeleza. "Imagining and inventing the postcolonial state in Africa." www.press.uillinois.edu/journals/contours/1.1/zeleza.html 18 May, 2006.

2. Gilberto M. Blasini, 'Caribbean cinematic créolité,' *Black Camera*, Vol 1 No 1 (Winter 2009), 70–90.

3. Marijke De Valck, *Film Festivals: From European Geopolitics to Global Cinephilia* (Amsterdam: Amsterdam University Press, 2007); Cindy Hing-Yuk Wong, *Film Festivals: Culture, People, and Power on the Global Screen* (New Brunswick, NJ: Rutgers University Press, 2011).

4. Lindiwe Dovey, *Curating Africa in the Age of Film Festivals* (NewYork: Palgrave MacMillan, 2015).

5. Carmela Garritano, *African Video Movies and Global Desires: A Ghanaian History* (Center for International Studies Ohio University, 2013).

6. V.Y Mudimbe, *The Idea of Africa* (Bloomington: Indiana University Press, 1994).

7. Edward Said, *Culture and Imperialism* (New York: Vintage, 1994): 252–253.

8. https://FESPACO.bf/historique

9. Ibid.

10. Ibid.

11. As such, French-Senegalese filmmaker Alain Gomis is the second director in the history of the festival, after Souleymane Cissé, to win the *Étalon d'or du Yennenga*. The first time was in 2013 with *Tey* and the second in 2017 with *Félicité* which also received a few weeks before the FESPACO, the Silver Bear at the Berlinale.

12. Farah Clémentine Dramani-Issifou, "L'énonciation curatoriale des festivals de cinéma en Afrique francophone," in *Festivals de cinema en Afriques francophones,* ed. Claude Forest (Paris: L'Harmattan, 2020).

13. Farah Clémentine Dramani-Issifou, "Entretien avec Alain Gomis: Something we Africans got," (May 2018), 40.

14. Samuel Lelièvre, "Les festivals, acteurs incontournables de la diffusion du cinéma africain,"*Afriquecontemporaine* no. 238 (2011) : 126–128.

15. Paul Gilroy, *The Black Atlantic: Modernity and Double-Consciousness* (Cambridge: Harvard University Press, 1993).

16. Remarks made by Bado Ndoye during the inaugural conference of the *Doctoral School of Thought Workshops* organized by Felwine Sarr and Achille Mbembe at the Museum of Black Civilizations in Dakar, January 2019.

17. Who later became one of the active members of FESPACO, (Pan African Film Festival of Ouagadougou).

18. FESMAN, 1966. Festival Mondial des Arts Nègres (World Festival of Black Arts)

19. Senegal, Niger, Upper Volta, Cameroon, Benin, Ivory Coast, Mali, Congo, France, Netherlands.

20. Director of the first Voltaic feature film *Sur les chemins de la réconciliation.*

21. La COMACICO (Compagnie africaine cinématographique et commerciale) et la SECMA (Société d'exploitation cinématographique africaine)

22. Roger Nikiema was the Head of Information department of the national radio station and Alimata Salambéré producer and host at the national TV channel.

23. On December 1, 1955, Rosa Parks, a 42-year-old black woman, was arrested for refusing to give her seat to a white man on a bus in the city of Montgomcry, Alabama (United States). This sanction provoked a boycott of Montgomery buses led by Martin Luther King. This was the beginning of the campaign for civil rights and demands for racial equality. Rosa Parks, "The woman who stood while sitting."

24. Comité de défense de la Révolution—Committee for the Defence of Revolution.

V. DOCUMENTS

Figure M. Opening ceremony of the 18th edition of FESPACO (2003). Courtesy of FESPACO.

Resolution on the Pan-African Film Festival of Ougadougou (FESPACO)

Resolution adopted by the Nineteenth Ordinary Session of the OUA Council of Ministers held in Rabat, Morocco, from June 5th to 12th, 1972

C/M Res 288 (XIX)

The Council of Ministers of the Organization of African Unity meeting in its Nineteenth Ordinary Session in Rabat, Morocco, from 5th to 12th June 1972.

Having considered document CM/472 on OAU assistance to the Pan-African Film Festival of Ougadougou (FESPACO).

Notes with satisfaction the constant efforts made by the Republic of Upper Volta to organize an all-African film festival with a view to promoting the production of typically African films, in view of the importance of this event for the development of African culture.

RECOMMENDS that Member States of the Organization of African Unity give their full support to the Pan-African Film Festival of Ougadougou.

Regulations of the Carthage Film Festival

This set of regulations was in use following the establishment of the festival throughout the 1970s.

Article 1:

The Carthage Film Festival (CFF) is a biennial international cultural event based on the public screening of films and the organization of meetings between their authors, directors, screenwriters, technicians, actors, etc.
They aim to:

- Contribute to the development of a national culture in each African and Arab country;
- Encourage the promotion of African and Arab cinemas, both in terms of production and distribution:
 - By fostering creative emulation;
 - By supporting films that are representative of their cultural heritage and social reality;
 - By promoting the emergence of an original and specific style, likely to contribute to the development of a new cinematographic model;
- Enable fruitful meetings and debates between cinema professionals for better mutual recognition, for a wide confrontation of experiences and ideas, and particularly for the promotion and development of viable film structures in African and Arab countries;
- Contribute to the international-scale distribution of African and Arab films;
- Facilitate contacts and dialogue between the various African and Arab cultures and those from other countries.

Article 2:

The CFF is placed under the aegis of the Ministry of Cultural Affairs. A Management Committee is in charge of its organization.

Article 3:

Any film taking part in the CFF may be shown within the country subject to the prior agreement of the party that included it in the program.

Article 4:

The official CFF agenda includes the following events:

- An Official Competition, open to African and Arab short and feature films, as defined in Article 6 below and selected for this purpose by the CFF Management Committee;
- An Information Section, open to short and feature films of all origins, selected by the CFF Management Committee for their thematic relationship to African and Arab realities or for any other interest they may arouse;
- A Children's Film section, open to short and feature films of any origin, selected by the CFF Management Committee;
- A Retrospective section: tribute to a national cinema, to a film director, to a film genre, etc.;
- An International Film Fair, open to feature films and short films of all origins;
- Symposia, seminars, and conferences on the film art and industry in African and Arab countries.

Article 5:

Film selection for the Official Competition, the Information section and the Children's Film section, is the exclusive prerogative of the CFF Management Committee, which has the sole authority to determine the number of short and feature films that may participate in one of the above-mentioned programs.

To be eligible, films must:

- Be solicited by the CFF Board of Directors from their directors or producers or their assigns who have accepted their registration in one of the above-mentioned sections;

- Be proposed to the CFF Management Committee by their directors or producers or their assigns for inclusion in one of the above-mentioned sections.

Article 6:

To be entered in the Official Competition any film must:

- Have been directed by a director of African or Arab nationality;
- Have been made within two years preceding the relevant edition of the CFF;
- Have not been awarded at previous international film festivals organized in Africa or the Arab world;
- Have not been commercially exploited in Tunisia, except for Tunisian films which are not subject to this obligation.

Article 7:

Films participating in the CFF represent only their directors and/or producers, for whom the awards and bonuses or other benefits are explicitly intended.

These films are presented to the public by the CFF Management Committee under its exclusive responsibility in accordance with these General Regulations. In no case can they be considered as binding or officially representing the governments or states of which the directors and/or producers are nationals at the CFF.

Article 8:

The Official Competition is consecrated by an official award list established and proclaimed by an International Jury appointed by the Minister of Cultural Affairs upon proposal of the CFF Management Committee, and comprising a Chair and a maximum of ten members.

The International Jury meets, deliberates, and takes its decisions in accordance with these Regulations.

Anyone who has taken part in the technical and artistic production, or the distribution of a film selected for the Official Competition of the ongoing edition of the CFF, may not be part of that International Jury.

Article 9:

The Official Competition of the CFF is comprised of the following awards:

I. The Tanit
- Golden Tanit (First Prizes):
 - ➢ Golden Tanit for the best feature film
 - ➢ Golden Tanit for the best short film
- Silver Tanit (Second Prizes):
 - ➢ Silver Tanit for a feature film
 - ➢ Silver Tanit for a short film
- Bronze Tanit (Third Prizes):
 - ➢ Bronze Tanit for a feature film
 - ➢ Bronze Tanit for a short film

II. Other Awards
- A Special Jury Prize awarded to a feature film and/or a short film participating in the Official Competition but not included in the above-mentioned prize winners.
- A First Work Prize awarded to the director of a first feature and/or short film in the Official Competition but not included in the above-mentioned prize winners.
- An Acting Award for the best actress and the best actor of the films participating in the Official Competition.
- Other prizes (optional) may be awarded to the Image, Editing, Music, etc. of the films participating in the Official Competition.
- The award of all these prizes is the exclusive prerogative of the Jury.

Article 10:

The Tanit awards confer the following benefits;

Golden Tanit:
- Feature films: specific medal and a bonus of one thousand five hundred Tunisian dinars (1,500 DT).
- Short films: A specific medal and a bonus of five hundred Tunisian dinars (500 DT) to the director of the film.

Silver Tanit:
- Feature films: A specific medal and a bonus of one thousand Tunisian dinars (1000 DT) to the director of the film.
- Short films: A specific medal and a bonus of three hundred Tunisian dinars (300 DT) to the director of the film.

Bronze Tanit:
- Feature films: A specific medal and a bonus of five hundred Tunisian dinars (500 DT) to the director of the film.
- Short films: A specific medal and a bonus of two hundred Tunisian dinars (200 DT) for the benefit of the director of the film.

All of the amounts mentioned above are paid in Tunisian Dinars or in a transferable currency.

Article 11:

To appear in the programs of the CFF, copies of the films must be in 16 or 35mm with their optics.

Article 12:

The CFF's working languages arc Arabic, French, and English.

Article 13:

Films selected for the Official Competition and not originally shot in one of the working languages of the Festival must be subtitled in one of these languages.

In addition, the submission of copies of such films must be preceded by the submission of their written dialogues in one of the working languages of the Festival.

Any film presented at the CFF but not in the framework of the Official Competition and which was not originally shot in either Arabic or French must be subtitled in one of these two languages.

Article 14:

The General Regulations of the CFF and its annexed documents can be obtained from the headquarters of the CFF Management Committee or from Tunisia's diplomatic representations abroad.

Article 15:

The deadline for registering films is forty-five days before each CFF edition.

Article 16:

Copies of films must reach the headquarters of the CFF Management Committee no later than one month before the edition for which they are being submitted.

The films and their related documents and correspondence must be sent to:

COMITE DIRECTEUR
DES JOURNEES CINEMATOGRAPHIQUE DE CARTHAGE
BP 1029 1045-TUNIS
R.P. (TUNISIE)
Adresse Télégraphique
AFCULT-TUNIS
Télex : 12032 TN.

Article 17:

Insurance and transport costs incurred by the shipment of films to Tunis are the responsibility of the shippers.

The CFF Management Committee assumes material responsibility of film copies between the date it receives them and the date it returns them. If the film arrived through a direct intermediary in Tunis, such as a diplomatic representation, the latter must take care of its reshipment at their own expense.

Article 18:

The request for participation in any event of the CFF implies the unreserved adherence of the relevant film directors and producers to these General Regulations.

Article 19:

The CFF Management Committee alone is empowered to make any decision concerning either points not provided for in these General Regulations or their interpretation.

Regulations of the Pan-African Film Festival of Ouagadougou (FESPACO)

Ouagadougou, Burkina Faso, August 1980

Preamble

The Pan-African Film Festival of Ouagadougou, (FESPACO) created by Decree No. 80/276/PRES/-INFO of August 27, 1980 and recognized by the Pan-African Federation of Filmmakers, has for essential goals:

- to promote the dissemination of all works of African Cinema and hence to encourage all African filmmakers through contacts and confrontations of works and ideas;
- to make known the various cultures and currents of African civilization through their expression through animated images;
- to contribute to the development of African Cinema as a means of expression and a phenomenon of culture and education.

Participation

Article 1: The Pan-African Film Festival of Ouagadougou is an exhibition of African Cinematographic Works. It is open to all African Filmmakers and to all their films.

Article 2: In addition to the officially scheduled African films, it is planned, for information, the screening of non-African films accepted by the Festival.

Article 3: The FESPACO Committee alone remains empowered to register or refuse any film proposed to the Festival. Consequently, any film selected will be screened under the sole responsibility of FESPACO.

Article 4: Any participation in the film implies, on the part of the Director, the Producer or any other official representative of the film, the scrupulous respect of the following:

- send no later than January 1st of the year in which the Festival is held (early February), the duly completed registration forms, films, film synopses, posters, and if possible any other medium advertising.

Article 5: Films, registration forms, and advertising material must be sent to the following address:

MINISTRY OF INFORMATION
B.P. 2505
TELEX 5255 BF
 5231 BF
OUAGADOUGOU,
BURKINA FASO

Article 6: The Festival is not responsible for errors in the routing of films on arrival, nor for damage resulting from poor packaging or transport. The Festival can in no way be held responsible for deterioration resulting from the poor initial condition of the copies.

Article 7: Any film participating in the Festival can only be withdrawn by the director or the producer (before or after its screening) with the agreement of the General Secretariat of FESPACO and after signature of a release and verification of the Customs services of the Burkina Faso.

Article 8: In the event that a film is held in Ouagadougou with the agreement of the owner, the Festival will send it back in accordance with the instructions given to it to do so.

Of the Competition

Article 9: The official competition of FESPACO is reserved only for African films fulfilling the following conditions:

(a) The zero copy of the film must be dated within three years.

(b) The film must not have been screened in public on Burkinabe territory. Burkinabe films are not subject to this last condition (b).

Article 10: The official competition is open to two films per country, presented by the competent authorities of that country and failing that selected by the Organizing Committee and produced by different Authors.

Article 11: The films are offered for official competition either by the official services of the participating countries, or by the Director, or by the Producer.

Of the Jury

Article 12: The Official Jury of FESPACO is an international jury composed of a president and ten members at most including two Burkinabe.

Awards

Article 13: The members of the Jury are appointed by the Festival; their designation is subject to the approval of the competent authorities of Burkina Faso.

Article 14: The members of the Jury are supported by the Festival; compensation may be awarded to them.

Article 15: The official FESPACO Awards are as follows:

- Grand Prize: Étalon de Yennenga awarded to the feature film judged by the jury as the film which best reflects African cultural identity or the social realities of Africa today. This film must also be remarkable for the rigor of its construction, its technical qualities, the mastery of its staging. In addition to the trophy, this prize is endowed with the sum of 1,000,000 CFA francs.
- Best Short Film Prize: awarded by the jury to the short film in accordance with the criteria defined above by the grand prize. This prize is endowed with 500,000 CFA francs.
- Seventh Art Prize: will be awarded to the director who demonstrates through his work, a perfect mastery of cinematographic language. This prize is endowed with 300,000 CFA francs.
- Award For Best Feminine Interpretation: awarded to the feature film actress who has best embodied her character. This prize is endowed with 250,000 CFA francs.
- Prize For The Best Male Interpretation: awarded to the feature film actor who has best portrayed his character. This prize is endowed with 250,000 CFA francs.
- Best Image Prize: awarded to the cinematographer who has taken the best photograph. This prize is endowed with 250,000 CFA francs.
- Gold Camera Prize: awarded to the operator who achieved the best framing. This prize is endowed with 250,000 CFA francs.

- Best Golden Perch Award: awarded to the sound recording operator who produced the best sound. This prize is endowed with 250,000 CFA francs.
- Golden Manivelle Prize: awarded to the technician who produced the best cut. This prize is endowed with 250,000 CFA francs.
- Best Scenario Award: awarded to the author who wrote the best story. This prize is endowed with 250,000 CFA francs.
- Oumarou Ganda Prize: awarded to the first work of a director whose creative efforts are particularly remarkable and worthy of encouragement. This prize is endowed with 300,000 CFA francs.
- General Public Award: awarded to the film that has proven to be the best in an audience poll. This prize is endowed with 300,000 CFA francs.

Article 16: There can be no tie in the awarding of prizes.

Article 17: A participation diploma is awarded to any film that has actually been screened during the Festival.

Article 18: The Pan-African Film Festival of Ouagadougou may accept other prizes, mentions, or material endowments.

General Provisions

Article 19: The official participants of the Festival are delegates from African States and any other person whose presence is deemed useful in various capacities by the Festival.

Article 20: The subsistence expenses of official participants (accommodation, meals inside Burkina Faso) within the framework of the official program are provided by the festival within the limits of its possibilities.

Article 21: No reimbursement of travel expenses will be made by the Festival.

Article 22: The Organizing Committee alone is empowered to rule on cases not provided for in these regulations.

Article 23: Participation in the Festival implies acceptance of these regulations.

Regulations for the Official Juries of the 26th Edition of FESPACO[1]

Ouagadougou, Burkina Faso, February 23–March 2, 2019

Article 1: The purpose of the present regulation is to determine and to set the rules for the establishment, organization, and workings of the official juries.

Article 2: Within the framework of the 26th edition of FESPACO, four international juries are established,

The official jury for long fictional films.
It is composed of one president and six members;

The official jury for both long and short documentary films.
It is composed of one president and six members;

The official jury for short fiction films and films from African cinema schools.
It is composed of one president and four members;

The official jury for animated films and television series.
It is composed of one president and four members.

Article 3: The members of the official juries are appointed by the General Delegation of FESPACO.

Article 4: No member of the jury must have taken part in the making, production, or distribution of a film in competition.

Article 5: The role of these juries is to view the films in the competition and to award the prizes designated on the official prize list.

Article 6: Each jury is sovereign in its area of competence,

The decisions of each jury are made by a two-thirds majority and can be opposed by all members.

The members of the juries are required to see in the screening room all the films they are called upon to evaluate.

Article 7: The General Delegate of FESPACO attends the deliberations of the juries as an observer. He may however be represented.

Article 8: The working languages of the juries are: English and French.

Article 9: The criteria for admission of films to the official list are those adopted by the members of the juries at the beginning of their session.

> However; the basic criteria are the technical, artistic, and aesthetic qualities of the work, the originality of the treatment, and the relevance of the subject.

Article 10: Each official jury must communicate the official report of its deliberations to the General Delegation the day before the proclamation, no later than 12:00pm.

Article 11: The prizes designated in the official prize list must be awarded.

Article 12: The General Delegate of FESPACO is competent to hear any dispute relating to the interpretation of the clauses of these regulations. Only the French version of these rules is valid.

Notes

1. Translated by Eileen Julien, August 20, 2020, Bloomington, IN, USA.

Figure N. The Gold Étalon de Yennenga FESPACO award. Courtesy of FESPACO.

FESPACO Award Winners
(1972–2019)

Including:

Gold Stallion – Grand Prize (Étalon d'Or de Yennenga – Grand prix)
Silver Stallion (Étalon d'Argent de Yennenga)
Bronze Stallion (Étalon de Bronze de Yennenga)
Stallion of Honor (Étalon d'Honneur de Yennenga)

1972 / 3^e	Grand Prize: *Le Wazzou polygame*, Oumarou Ganda (Niger)

1972 / 3^e Grand Prize: *Le Wazzou polygame*, Oumarou Ganda (Niger)

1973 / 4^e Grand Prize: *Les Mille et Une Mains*, Souheil Ben-Barka (Morocco)

1976 / 5^e Grand Prize: *Muna Moto*, Jean-Pierre Dikongué Pipa (Cameroon)

1979 / 6^e Grand Prize: *Baara*, Souleymane Cissé (Mali)

1981 / 7^e Grand Prize: *Djeli*, Fadika Kramo-Lanciné (Côte d'Ivoire)

1983 / 8^e Grand Prize: *Finyè*, Souleymane Cissé (Mali)

1985 / 9^e Grand Prize: *Histoire d'une rencontre*, Brahim Tsaki (Algeria)

1987 / 10^e Grand Prize: *Sarraounia*, Med Hondo (Mauritania)

1989 / 11^e Grand Prize: *Heritage Africa*, Kwaw Ansah (Ghana)

1991 / 12^e Grand Prize: *Tilaï*, Idrissa Ouédraogo (Burkina Faso)

1993 / 13^e Grand Prize: *Au nom du Christ*, Gnoan Roger M'Bala (Côte d'Ivoire)

1995 / 14^e Grand Prize: *Guimba*, Cheick Oumar Sissoko (Mali)

1997 / 15^e Grand Prize: *Buud Yam*, Gaston Kaboré (Burkina Faso)

1999 / 16ᵉ	Grand Prize: *Pièces d'identités*, Mwezé Ngangura (Democratic Republic of Congo)
2001 / 17ᵉ	Grand Prize: *Ali Zaoua*, Nabil Ayouch (Morocco)
2003 / 18ᵉ	Grand Prize: *En attendant le bonheur (Heremakono)*, Abderrahmane Sissako (Mauritania)
2005 / 19ᵉ	Gold Stallion: *Drum*, Zola Maseko (South Africa) Silver Stallion: *La Chambre noire*, Hassan Benjelloun (Morocco) Bronze Stallion: *Tasuma*, Kollo Daniel Sanou (Burkina Faso)
2007 / 20ᵉ	Gold Stallion: *Ezra*, Newton Aduaka (Nigeria) Silver Stallion: *Les Saignantes*, Jean-Pierre Bekolo (Cameroon) Bronze Stallion: *Daratt*, Mahamat-Saleh Haroun (Chad)
2009 / 21ᵉ	Gold Stallion: *Teza*, Haile Gerima (Ethiopia) Silver Stallion: *Nothing But the Truth*, John Kani (South Africa) Bronze Stallion: *Mascarades*, Lyes Salem (Algeria)
2011 / 22ᵉ	Gold Stallion: *Pégase*, Mohamed Mouftakir (Morocco) Silver Stallion: *Un homme qui crie*, Mahamat-Saleh Haroun (Chad) Bronze Stallion: *Le Mec idéal*, Owell Brown (Côte d'Ivoire) Stallion of Honor: An award given to actor Sotigui Kouyaté for his entire cinematographic work and received by his family.
2013 / 23ᵉ	Gold Stallion: *Tey (Aujourd'hui)*, Alain Gomis (Senegal) Silver Stallion: *Yema*, Djamila Sahraoui (Algeria) Bronze Stallion: *La Pirogue*, Moussa Touré (Senegal)
2015 / 24ᵉ	Gold Stallion: *Fièvres*, Hicham Ayouch (France, Morocco) Silver Stallion: *Fadhma N'Soumer*, Belkacem Hadjadj (Algeria) Bronze Stallion: *L'Œil du cyclone*, Sékou Traoré (Burkina Faso)
2017 / 25ᵉ	Gold Stallion: *Félicité*, Alain Gomis (France, Senegal) Silver Stallion: *L'Orage africain : Un continent sous influence*, Sylvestre Amoussou (Benin) Bronze Stallion: *A mile in my shoes*, Saïd Khallaf (Morocco)

2019 / 26ᵉ Gold Stallion (Feature): *The mercy of the jungle,* Joël
 Karekezi (Rwanda)
 Silver Stallion (Feature): *Karma,* Khaled Youssef (Egypt)
 Bronze Stallion (Feature): *Fatwa,* Ben Mohmound
 (Tunisia)
 Gold Stallion (Documentary): *Le loup d'or de Balolé,* Aicha
 Boro Leterrier (Burkina Faso)
 Silver Stallion (Documentary): *Au temps où les arabes
 dansaient,* Jawad Rhalib (Morocco)
 Bronze Stallion (Documentary): *Whispering truth to power,*
 Shameela Seedat, (South Africa)

FESPACO 50th Anniversary Symposium

By the Coordinating Committee of the 50th Anniversary Conference of
FESPACO
February 25–26, 2019, auditorium of CBC (in front of FESPACO)

"Confronting our memory and shaping the future of a
Pan-African cinema in its essence, economy, and diversity"

FESPACO was founded in 1969 in Ouagadougou, capital city of Upper
Volta, which became Burkina Faso in 1984. Formerly the capital of the Mossi
Empire, Ouagadougou has been transformed over centuries into a cosmo-
politan megalopolis, whose current dynamism and creativity make its charm
and notoriety. Ouagadougou is the ultimate repository of the Memory of
African Cinema. As such, it is the only city in the world with a Filmmakers'
Square where each edition of the festival is punctuated by a ceremony held
in memory of filmmakers who passed away. The ceremony brings together
film professionals and festivalgoers from all over the world. At this square is
the Filmmakers' Avenue, starting with statue of famous Senegalese Director,
Ousmane Sembène.

The film festival held in this city has embodied and continues to
embody a dream: that of passionate women and men driven by the lack of
images and stories which Africans from the Continent and the Diaspora
can identify with, while forging self-awareness. Passion, cultural, polit-
ical, and historical claim, Pan-African character, commitment and faith,
desire and aspiration, determination, all contributed to building, shaping,
nurturing, and developing FESPACO. It was carried by a whole people
endowed with an innate sense of hospitality and which succeeded in giving
rise to an audience will to travel and discover stories and narratives; a
people whose availability, enthusiasm, and fidelity helped FESPACO take
root and grow. It is this belief in the ability of Cinema to explore the world
and the society, to participate in the building of humanity in its diversity
that helped FESPACO stand up against all odds. How can we keep up with
this vision and aspiration, and give this festival a new lifespan, beyond the
next fifty years?

FESPACO's ambition has always been and remains to provide a space for the confrontation of imaginations and talents, a space for sharing and building not only a memory, but also a present and a future. The key feature of the festival is that it has succeeded in establishing a fusion relationship between the Ouagadougou, Pan-African, and global cinema audiences and the film and audiovisual professional community. That audience has always been able to release fervour, breath, friendliness, goodness, respectful familiarity, and unalterable expectation that anyone attending FESPACO for the first time could but notice and be marked by. Beyond the emotional intensity it creates, many expect FESPACO to cure all the ills that undermine African cinemas and hinder their development. The diverse symposiums, conferences, round tables, and professional workshops organized by FESPACO since its inception have undoubtedly contributed to advancing theoretical reflection and to updating strategic solutions for the development of cinemas from Africa and the Diaspora. It is the fiftieth anniversary of this festival—which is much more than a festival—that we mean to celebrate today in the most memorable way. The symposium is one of the cornerstones of this celebration. It should aim at providing a framework to look back over fifty years of progress and formulate visions, desires, and objectives for the near and distant future: indeed, FESPACO has been the screen on which has been projected for fifty years Africa's history, marked not only by the ups and downs of colonialism, the failure of the new post-independence ruling classes, neocolonialism, economic and political imperialism, the assassination of resistance fighters; but also by struggles for independence, Pan-Africanist experiments, liberation movements and independence acquired with weapons. The festival also served as a screen for Afropessimism, the resignation of intellectuals, disillusionment and disenchantment, disasters induced by measures dictated by the Bretton Woods institutions; the unacceptable deterioration in the terms of trade, the looting of African mining resources, wars waged by external actors, the tragedy of migration to the West, and land grabbing, violent extremism, religious radicalism, but also the birth of the African Union, nonviolent practices, the anti-imperialist struggle, the fall of apartheid, the Non-Aligned Movement, the revolt of peoples and the wind of democracy, the fight against corruption, the release of Nelson Mandela, Afrofuturism, the desire and fight for Africa's renaissance.

This 50th Anniversary Symposium is therefore an invitation to reflect on all these issues, to contribute to the shaping and transformation of the Continent's greatest cultural event. To this end, reflections will focus on four axes in a retrospective-prospective continuum:

- Once upon a time was FESPACO
- Confronting our memory
- Shaping the future and sustaining FESPACO
- New economic bases

Main Themes of FESPACO Symposium: Once upon a time was FESPACO...

What is this flame that FESPACO was able to ignite, this spirit that it has imprinted, this energy and this momentum that it has infused into Pan-African cinema? How did it feed aesthetic research and image production? How was it able to trigger and maintain interest and critical look upon African and Diaspora cinemas? If the Festival had not existed, what would have changed in Africa's cinematographic destiny? What are the foundations laid by FESPACO that have enabled the emergence and consolidation of a collective consciousness and the capitalization of an African and Diaspora cinematographic memory that is open to the world, and that draw their strength from the imaginary cultural and societal singularities of Africa and its Diasporas?

Workshop 1: Confronting our Memory

Would it be true to say that FESPACO has been the witness of an evolution of African cinemas that started with the values of duty, commitment, responsibility, combat, and Collective credo; cinemas of the affirmation of individual freedom of creation, intimacy, and self-reflection; the pleasure of telling, the claim of an entertainment cinema? Or, beyond appearances and divergences, have their rather been continuities, extensions, hybridizations, commuting, crossings, crossbreeding? How to capitalize on a collective film experience and build a living, vibrant and accessible culture for the greatest number of people? Archives, film library, preservation of the heritage, and its circulation.

Workshop 2: Shaping the Future and Sustaining FESPACO

How can new economic bases be created for the film and audiovisual industries from Africa and its Diasporas? What role can FESPACO play in the advent of a new dynamic trend, in the creation of plural images and narratives for the development of an African and Afro-descendant that is rich

with their history and oriented towards their own reinvention? How will FESPACO succeed in reflecting intensely the new cinematographic languages that are being invented before our eyes? How can the festival be the place where young filmmakers from the continent and the Diaspora find an expression, exhibition, and experimentation?

Workshop 3: New Economic Bases

How can the financial autonomy of the festival be seriously envisioned? How to strengthen the Pan-African status of the festival by involving new State, institutional, and private actors in its organization, policy, and funding, so as to consolidate a continental instrument for the exhibition and defense of African and Diaspora film and audiovisual expressions? Who are the new players in the environment of production, exhibition, and distribution of audiovisual pieces? How to get young African businessmen—bright, cosmopolitan, and proud of their Africanness—interested in the film industry?

The pioneers of African Cinema and of the Pan-African Film Festival of Ouagadougou, and the new inheriting generations, are strongly involved and needed for this Symposium. All film professionals, artists, and creators coming to FESPACO are of course invited to take an active part in this gathering. Intellectuals, faculties, researchers, critics, journalists, mediators, and cultural activists are also actors of this Symposium, through their respective disciplines ranging from history, art history, philosophy, sociology, anthropology to semiotics, linguistics, musicology, economics, or political science, because cinema must be fed itself beyond its own borders. The Symposium is of course open to all festivalgoers to make it a unique framework for sharing, exchanging, mutual listening, reflecting, and building a common future.

FESPACO Fifty-Year Anniversary Symposium Program

Monday, February 25th
Auditorium of CBC (in front of FESPACO)
8:30 a.m.: Arrival of Participants

9:00 a.m.
Symposium Opening Ceremonies
Address of:
Ardiouma Soma, General Delegate of FESPACO
Cheick Oumar Sissoko, Secretary General of FEPACI
Youma Fall, Director of Cultural Diversity & Development, Organisation
Internationale de la Francophonie (01F)
Abdoul Karim Sango, Minister of Culture, Arts and Tourism of
Burkina Faso

10:00a.m. **Start of Symposium work**
Introduction
Gaston Kaboré, Symposium Coordinator

1st Line of symposium: Once upon a time was FESPACO...
10:15a.m.–1:00 p.m.
1st Plenary Session
What is this flame that FESPACO was able to ignite, this spirit that
it has imprinted, this energy and this momentum that it has infused
into African cinematography and this of her Diasporas?

10:15a.m.–12:00p.m.
The Floor given to the First Witnesses
(Time limit is ten minutes per speaker)

12:00p.m.–1:00p.m.
Discussion with the audience

1:00p.m.–2:30p.m.: Lunch Break

2:30p.m.–4:00p.m.
2nd Plenary Session
How has FESPACO contributed to meeting the need for representation
of the peoples of Africa and the Diasporas while helping shape the citizen
filmmaker's image in their eyes?

Two Generations of Inheritors Speak
(Time limit is five minutes per speaker)

4:00p.m.–6:30p.m.
3rd Plenary Session
What are the foundations laid by FESPACO that have enabled the
emergence and consolidation of a collective consciousness and the
capitalization of an African and Diaspora cinematographic memory that
is open to the world, and that draw their strength from the imaginary
cultural and societal singularities of Africa and its Diasporas?

Three Intellectual Activists Question History
(Time limit is thirty minutes per speaker)

Tuesday, February 26th
Auditorium of CBC (in front of FESPACO)

*8:30 a.m.: Arrival and installation of participants at the different workshops
venues*

9:00a.m.–1:00p.m.
Three workshops to be held simultaneously:
Workshop 1: Confronting Our Memory
Workshop 2: Shaping the Future and Sustaining FESPACO
Workshop 3: New Economic Bases

1:00p.m.–2:30p.m.: Lunch Break

2:30p.m.–4:30p.m.
Workshops Report

4:30p.m.–6:30p.m.
Plenary Session
What role can FESPACO play in the advent of a new dynamic trend in the
creation of plural images and narratives for the development of an African
and Afro-descendant that is rich with their history and oriented towards
their own reinvention?

Two thinkers suggest metaphors for the future
(Time limit is thirty minutes per speaker)

Manifesto of Ouagadougou

25th Edition FESPACO Ouagadougou, Burkina Faso
February 28—March 1, 2017

***Preface*:**
"Training for Cinema & Audiovisual Trades:" For What Purpose?
Michael T. Martin

Good Afternoon.

I am very pleased and honored to moderate this workshop devoted to the role of media professionals as mediators in what is an ever more complex and daunting imperative in sub-Saharan Africa.

But first, our thanks to the General Directorate of FESPACO for supporting this colloquium. And to Gaston Kaboré, filmmaker extraordinaire and Director of the Institut IMAGINE, and to the good work of the co-organizers of this workshop, June Givanni and Raymond Weber with the indispensable assistance of Camille Varenne.

The theme of this two-day colloquium has been discussed since 2005 among African cinéastes: "Training for cinema and audiovisual trades."

Why revisit this subject? Why does it continue to command our attention? What could possibly come of another intervention on this topic?

The answer, I fear, is that the conditions that continue to make training in media trades a matter of urgency have not changed—indeed, conditions have seemingly worsened.

For whom does training matter? Current and future generations of media professionals? Current and future generations of media consumers? A people's identity? A nation's representation in the world? A continent's destiny—if it is to create one—of its own making?

Consider the big picture—the world-making scale of things and the micro-implications at the level of everyday life in African societies.

In the larger frame of things, what role exists for media professionals as cultural mediators in a continent struggling to develop its human and natural resources, a continent exploited and subject to the homogenizing forces of globalization? A continent struggling against the wrongs and failures of globalization and failures of western modernity—and by this I mean, not the technologies that save lives, ease and facilitate our daily labors, but

rather the unintended and collateral consequences of processes and technologies that alienate us from ourselves, each other, and the communities we belong to and with which we identify.

Consider corporate capitalism's out sized reach to every corner of the planet, every square meter of land that can yield a financial profit. Instead of satisfying essential material needs or harvesting energy to fuel a nation's productive capacity and well-being, natural resources are used to manufacture unnecessary products. Such consumption and the processes that enable it alienate us from ourselves, our communities, and society, only to sustain the unrelenting drive of accumulation.

How can this be?

How might we, as media professionals, refute, denounce, and disavow our complicity?

How might we contribute to a counter-history of the social world—a project that is, above all, committed to revealing what informs and shapes our views, attitudes, behaviors, and notions of progress, community, and the common good?

- A project that foregrounds cultural differences that affirm our humanity.
- A project of recovery and invention that animates our collective will and resolve to cultivate an African modernity that enables the continent's development—moral, social, as well as material.
- How can media professionals, against the odds, against the interests of the market and the political class that supports or defers to it, work on behalf of the citizenry, national, continental, and global?

One such intervention in this counter-historical process of renewal and invention will be that of cultural workers in the true pedagogical and progressive sense of the term, however constrained they may be by resources, by the limitations of their specialized crafts and artistic endeavors, or by the enormous challenges such endeavors impose.

In other words, can we imagine and pursue an artistic practice for our times that unmasks the "truth" of these times, that renders new ways of thinking and seeing through media literacy from grade school forward and, if only with this in mind, to educate audiences to become critical consumers of media?

To our good fortune, we have five presenters among us who are eminently qualified to address these questions from the vantage of their own distinct orientations.

And we have students in the audience who will share with us aspects of their training, their ideas, and expectations to remind us how we may

improve our work and, yes, even convince some of us to abandon current practices and pursue new and different modes suitable for our time and capabilities, a project that privileges Africans and Africa above former imperial and now neo colonial and corporate interests.

With that said, please welcome June Givanni, Director of the June Givanni Pan African Cinema Archive (UK); Aboubakar Sanogo, Professor of Cinema, Carleton University, Ottawa, Canada; Yoporeka Somet, philosopher, Egyptologist, Burkina Faso; Aissa Maiga, actor, France, Senegal, Mali; Ildeveit Meda, Director and Professor, ISIS-SE, Burkina Faso; and Clement Taposoba, Film Critic, Burkina Faso.

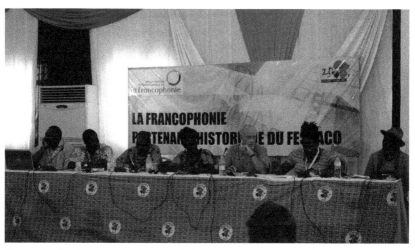

Figure 1. Panel at the 2017 FESPACO. Image courtesy FESPACO.

Manifesto of Ouagadougou

We, the participants of the Colloquium, "Training for Cinema and Audiovisual Professions," held from February 28 to March 1, 2017, during and in the framework of the 25th edition of FESPACO in Ouagadougou, Burkina Faso declare:

Recognizing

That the destiny of peoples is challenged and determined by their ability to tell their own stories, represent themselves, and have access to such images they create;

That Africa must appropriate and reconstitute a proper and accurate view of itself, its history, collective memory, self-constructed imaginary, understanding of others and the world, as well as foreground and celebrate its cultural, artistic, and philosophical achievements and contribution to world civilization;

And in recognition of this fundamental responsibility and project of self-determination, affirm and practice the legitimate right of Africans to critically question and analyze our own historical trajectory over time.

Convinced

That we must resolve to move beyond ensconced intellectual assumptions and stereotypes in order to enable Africa's renewal and encounter with other peoples in a rapidly changing world.

Knowing

That the urgent and immediate challenge today is to create new and enhance existing venues for training the next generation of media professionals;

And to innovate with technologies and varied platforms and develop new practices that will align cinema and audiovisual sectors with Africans' artistic, political, and economic needs and ambitions;

And that training in *all* cinematic and audiovisual sectors of production, distribution, and exhibition begin with the conception of an idea through the encounter with and consumption by the public.

We declare

That training in cinema and the audiovisual arts must necessarily include the development of critical thinking that is enabled and enhanced by such related disciplines within the humanities and social sciences.

We call for

The provision that all current and future training entities in cinema, audiovisual, and interactive media throughout Africa adopt and implement the goal that will enable young professionals to acquire the knowledge and tools to create original works reflecting the vision of Africa confident and

in command of its own destiny and poised to participate no less as an equal partner within the community of world nations.

We proclaim

That the realization of democratic citizenship depends upon educating the creators and consumers of images.

We affirm

That a necessary imperative to enable the implementation of effective strategies for strengthening the film and audiovisual sectors is a coherent plan of action and collaboration between *all* actors and institutions.

We therefore

In order to create and improve film and audiovisual conditions and training in Africa, endorse the implementation of the "Action Plans" and "Recommendations" adopted by media professionals, the Pan-African Federation of Filmmakers, the African Union and regional economic, political, and cultural cooperation organizations in order to create and improve film and audiovisual training in Africa.

To achieve the above objectives and goal, we are ready to fully assume our responsibilities and call upon *all* political, institutional, and professional leaders in Africa and globally to coordinate their efforts and act with urgency and in the spirit of solidarity.

This document was deliberated and completed in Ouagadougou on March 1st 2017.

FESPACO Poster Gallery: 1969–2019

premier festival
de
CINEMA AFRICAIN
de
OUAGADOUGOU

du 1er au 15 Février 1969

sous le
Haut Patronage
de son
Excellence
Monsieur le Président
de la République

Figure 1. FESPACO, First edition (1969)

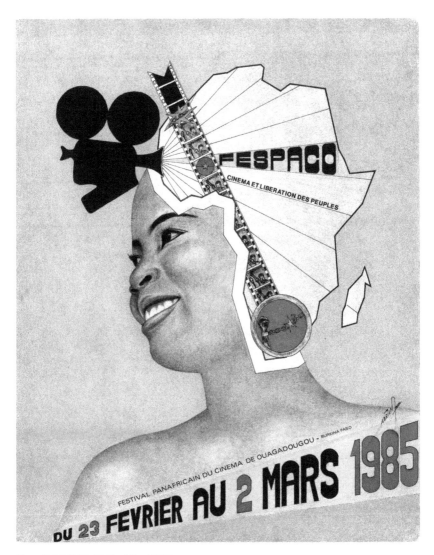

Figure 2. FESPACO, Ninth edition (1985)

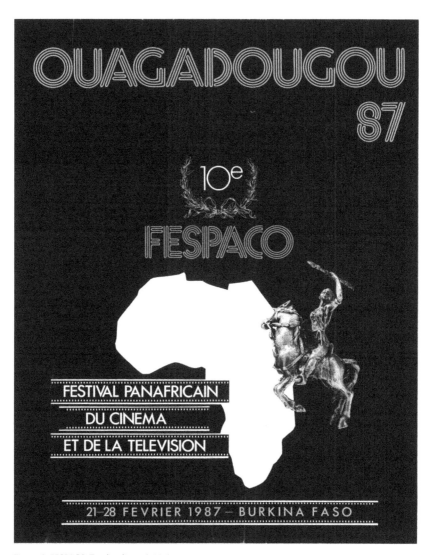

Figure 3. FESPACO, Tenth edition (1987)

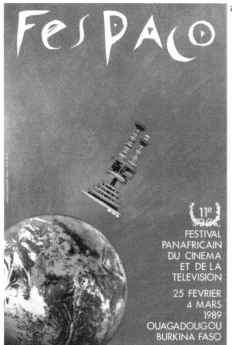

Figure 4. FESPACO, Eleventh edition (1989)

Figure 5. FESPACO, Twelfth edition (1991)

Figure 6. FESPACO, Thirteenth edition (1993)

Figure 7. FESPACO, Twenty-fifth Anniversary Poster (1994)

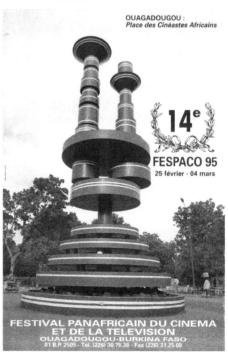

Figure 8. FESPACO, Fourteenth edition (1995)

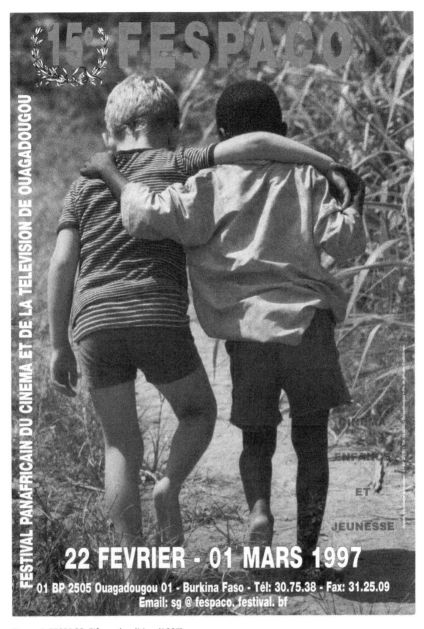

Figure 9. FESPACO, Fifteenth edition (1997)

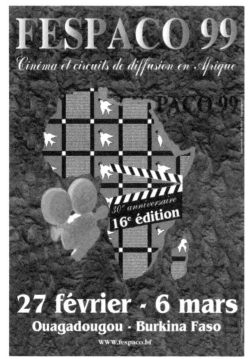

Figure 10. FESPACO, Thirtieth Anniversary and Sixteenth edition (1999)

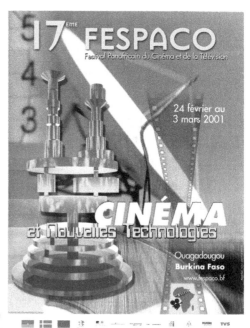

Figure 11. FESPACO, Seventeenth edition (2001)

Figure 12. FESPACO, Eighteenth edition (2003)

Figure 13. FESPACO, Nineteenth edition (2005)

Figure 14. FESPACO, Twentieth edition (2007)

Figure 15. FESPACO, Twenty-first edition (2009)

Figure 16. FESPACO, Twenty-second edition (2011)

Figure 17. FESPACO, Twenty-third edition (2013)

Figure 18. FESPACO, Twenty-fourth edition (2015)

Figure 19. FESPACO, Twenty-fifth edition (2017)

Figure 20. FESPACO, Fiftieth Anniversary and Twenty-sixth edition (2019)

Organizing Themes of the FESPACO Festival: 1973–2019

Themes of the Various Events

The FESPACO Festival is a space of encounter that promotes the development of African cinematography. Since 1973, each edition has been assigned a theme of discussion. The general theme for the sessions is chosen by taking into account African concerns and the role African cinema has to play in raising consciousness among African peoples. In this light, the theme should be understood as a reflection of the issues of our time and not as a criterion for the competition.

Important questions have been raised and debated. Some of them have already been resolved. Throughout the years, these meetings have led to commitments and results and have contributed to affirming the identity of our festival.

The Different Themes:

1973 / 4[e] The role of cinema in raising a consciousness of Black civilization

1976 / 5[e] The African filmmaker of the future: educational involvement

1979 / 6[e] The role of the African film critic

1981 / 7[e] Production and distribution

1983 / 8[e] The African filmmaker in front of their audience

1985 / 9[e] Cinema and liberation of the peoples
Colloquium: African Literature and Cinema

1987 / 10[e] Cinema and cultural identity
Colloquium: Oral tradition and new media

1989 / 11[e] Cinema and economic development
Colloquium: Cinema, women, and poverty

1991 / 12[e] Cinema and the environment
Colloquium: Partnership and African cinema

1993 / 13e	Cinema and freedoms Colloquium: Cinema and children's rights
1995 / 14e	Cinema and the history of Africa
1997 / 15e	Cinema, childhood, and youth
1999 / 16e	Cinema and networks of diffusion in Africa
2001 / 17e	Cinema and new technology
2003 / 18e	Actors' role in the creation and promotion of African film
2005 / 19e	Professional training and the stakes of professionalization
2007 / 20e	African cinema and cultural diversity Colloquium: African cinema and cultural diversity Panel: Auteur cinema and popular cinema in Africa
2009 / 21e	African Cinema: Tourism and cultural heritage
2011 / 22e	African cinema and markets
2013 / 23e	African cinema and public politics in Africa
2015 / 24e	African cinema: Production and diffusion in the digital age
2017 / 25e	Professional training in the film and media industry
2019 / 26e	Confronting our memory and shaping the future of a Pan-African cinema in its identity, economy, and diversity

The twenty-sixth edition will celebrate the fiftieth anniversary of the festival. It will be the opportunity for professionals in cinema to confront their memory and to shape the future of a Pan-African cinema in its identity, economy, and diversity.

Major Events of FESPACO: 1969–2019

1969 First Festival of African Cinema in Ouagadougou from February 1–15

1970 Nationalization of film distribution and exploitation in Burkina Faso

1972 Institutionalization of FESPACO and creation of a permanent secretary office
First Permanent Secretary: Louis Thombiano
First Étalon de Yennenga awarded to *Le Wazou polygame*, Oumarou Ganda (Niger)

1979 FESPACO becomes a biennial event to take place during uneven years, the last Saturday of February

1982 Second Permanent Secretary: Alimata Salembere

1983 First International Market of African Cinema and Television (MICA)

1984 Third Permanent Secretary: Filippe Sawadogo

1985 Creation of the vendors street fair
Rebirth of the Pan African Federation of Filmmakers (FEPACI)
Gaston Kaboré is elected General Secretary

1987 Creation of the Diaspora section in the official selection

1988 FEPACI's call for the constitution of the first film archives of the African Film Library of Ouagadougou

1989 FEPACI Convention

1993 FEPACI Convention
Creation of a TV/VIDEO section in the official selection
Organization of opening and closing ceremonies as entertainment shows at the stadium

1995 Official inauguration of the African Film Library of Ouagadougou
Installation of the FESPACO Foundation

1996 Fourth Permanent Secretary: Baba Hama

1997 FEPACI Convention (dissolution for a re-formation)
 Launch of FESPACO's Internet website

1999 Creation of a film selection committee
 FESPACO becomes a public administrative institution

2001 Creation of the FESPACO movie club

2003 FEPACI Convention, Jacques Behanzin is elected General Secretary

2005 Inauguration of the new FESPACO headquarters
 Extension of the prize list with the creation of Gold, Silver, and
 Bronze categories for Stallions (full-length) and Foals (short film)

2007 Promotion of documentary films with the creation of the docu-
 mentary section in the official selection

2008 Fifth General Delegate: Michel Ouédraogo

2009 Celebration of the fortieth annivesary of FESPACO
 Promotion of the documentary film section in the official selection
 with the creation of two new prizes
 Creation of a jury for documentaries for the official documentary
 competition
 Creation of the second and third prizes in the documentary section
 Creation of the prize for the best movie poster
 Inauguration of the Avenue Ousmane Sembène (February 28)
 Inauguration of the first statue for the Stallions Column (March 1st)
 Creation of the "Pass" in addition to the usual media accreditations
 to the various showings
 Creation of the professional opening ceremony
 Professionalization of the Film Market (MICA), change of location
 from MICA to SIAO

2012 Second Edition of the African Women Image Makers Cinema Days
 (JFCA)

2013 Introduction of the Night of Television Series

2014 Third Edition of the African Women Image Makers Cinema Days
 (JFCA)
 Sixth General Delegate: Mr. Ardiouma Soma

2015 Introduction of the digital in the competition

The amount of money attributed to the three Stallions prizes is doubled

The official competition welcomes long features from the Diaspora

2016 Fourth Edition of the African Women Image Makers Cinema Days (JFCA)

All these initiatives have reinforced the trademark of the FESPACO and increased the visibility of its concrete interventions in the field.

Figure O. Film storage depository at FESPACO, eighteenth edition. Courtesy of FESPACO.

The African Film Library of Ouagadougou

Presentation

The African Film Library of Ouagadougou was created in 1989 on the occasion of the commemoration of the twentieth anniversary of FESPACO. Created at the initiative of African filmmakers who have been thinking about it since 1973 through conferences and professional meetings, this African film library aims to safeguard Africa's film heritage. It meets the expectations of filmmakers and men of culture, concerned with the safeguarding of Africa's cultural heritage.

The African Film Library of Ouagadougou is a public institution of the State, under the supervision of the FESPACO and affiliated to the International Film Federation (FIAF) since 1994.

Objectives

- The collection of African films and any work relating to Africa.
- The treatment, preservation, and enhancement of films collected through various consultations by researchers, and film and audio-visual professionals.
- The inventory and cataloging of Africa's film heritage.
- The development of filmographies of African countries.

Film Collections

Forty copies of films were the first archives of the film library. Today, it has a modern center for the conservation of works (a functional center since 1995), where more than a thousand works are processed and stored: documentaries, fiction, news, feature films, and short films representative of the cinematography of all the regions of Africa.

News Films:

The film archives of the national television of Burkina were recovered, identified, cleaned, and stored in the cells of conservation. Four hundred 16mm coils, almost abandoned, were saved in 1998.

They represent the socioeconomic and political history of Burkina Faso from the 1960s to the 1970s.

The Films of the Colonial Period:

The films of this period are important, as they are the only images of Africa in the first half of the twentieth century. The African Film Library has twenty or so, with production periods ranging from the 1920s to the 1950s.

Didactic Films:

The collection of the film library also includes educational films. Most of these works date back to the 1960s. They were produced by governments and dealt with different themes such as: agriculture, health, citizenship, for the largely illiterate populations.

African Author Films:

The films of authors collected are fairly representative of African cinematography, from the Maghreb to West Africa, Eastern Africa, and Southern Africa. A significant number of copies of works were collected in 1988.

The African Film Library also has almost all the films of some famous authors such as Ousmane Sembène and some countries like Burkina Faso and Gabon.

Other Films:

The rest of the collection consists of about twenty Cuban films and some classics of French and European cinema.

Other Materials

Important non-film material related to African cinema has been collected. A very diverse documentation center is available to the public for consultation. This center has a background of more than six thousand photos, more than five hundred movie posters, several thousand news articles, trade journals, press reviews, film press kits, books, scripts, and more.

Facilities

The African Film Library does not have a laboratory, but the necessary equipment for small restoration works on the copies of used films: physical analysis of the copies, repair of the perforations, dry cleaning of the reels of film. Services in this area are regularly granted to professionals, film clubs, etc.

Copies of films are kept in specially designed rooms where the temperature and humidity are strictly controlled. An air-conditioning production system keeps the temperature inside the cells between fifteen and twenty degrees celsius with relative humidity between thirty percent and forty percent.

Access to Collections

The African Film Library has already opened its collections to many students, teachers, researchers, and film professionals. Students came from Africa, Europe, and America to see films, do research, and meet resource people, as part of their dissertations or graduation theses. Access to the collections is conditioned by a reasoned request.

The African Film Library also has several mobile film and video units, as well as qualified staff for organizing film screenings in Burkina towns and villages. These non-profit screenings are done in partnership with NGOs, associations, schools, and other public and private institutions.

Construction Project of the African Film Library of Ouagadougou

Apart from these projections, FESPACO works for the promotion of African cinema in international festivals. The institution also organizes various film events: film week, major film premieres, etc.

International Cooperation

The African Library of Ouagadougou has been a member of the International Federation of Film Archives (FIAF) since 1994. It has been twinned with the CNC / France film archives since 1995. Like other members of the FIAF, the African Library contributes to the promotion of film archives through common activities such as:

- FIAF training courses in London in 1992 and 1996;
- The programming of films in Amsterdam in 1996 and Paris in 2000;
- The FIAF congress in Jerusalem in 1996.

The Projects of the Cinematheque

The African Film Library plans to strengthen the collection of films to have a filmography by country and locate the negatives of African films mostly scattered in European laboratories.

She also plans:

- The construction of a screening room of the African Film Library with an exhibition space that can host a film and television market, a film museum, etc.
- The development of the documentation center, with the creation of a database on African cinema on the institution's website.

The Importance of the African Film Library of Ouagadougou

The African Film Library of Ouagadougou undoubtedly ensures the cinema of the continent a permanent visibility and stimulates reflection and endogenous research on African cinema.

In addition, it contributes to a better knowledge of the contemporary history of Africa, through the scientific consultations of the old films and is a source of inspiration for the professionals of the cinema and the audio-visual one.

Finally, the African Film Library of Ouagadougou participates in the film education of the public through regular retrospective programs and the organization of various exhibitions.

Dossier 1: Paul Robeson Award Initiative

This section includes documents on the Paul Robeson Award Initiative (PRAI), an award given to honor films of the African diaspora at FESPACO.

1. PRAI Inaugural Program (2005)
2. PRAI Objectives, letter from C. Sade Turnipseed
3. PRAI List of Award Winners, 1989–2019
4. Information from the PRAI website, 2004

Figure 1. Paul Robeson, internationally-known actor, singer, and internationalist. Photo courtesy of FESPACO.

Paul Robeson Award Initiative – Inaugural Program (2005)

KHAFRE PRODUCTIONS & IVORY COAST PICTURES
In conjunction with the
PAUL ROBESON AWARD INITIATIVE
Present

The Best of the Best
FESPACO 2005
The Documentary

With Africa as a backdrop, this film offers an introspective glance into the dynamics of Africa, its Diaspora and the international filmmaking community. Through the use of interviews and historical memory, the film seeks to bring to light the rifts between people so alike and yet so different... as well as provide a means for discussion and consolidation. By following the path of filmmakers in competition and in attendance for the Pan African Film and Television Festival, Ouagadougou (FESPACO) this film challenges its viewers to wonder... who are the real winners?

C.Sade Turnipseed, Executive Producer
Kevin Arkadie, Executive Producer, Director
David Massey, Producer
Gaston Kabore, Co-Producer — Africa
Danny Glover, Narrator
Daniel Ferguson, Director of Photography
Cedric Pounds, Camera Operator
Dayo Beverly, Production Coordinator— USA
Dominique Phelps, Production Coordinator — Africa

For more information, please contact KHAFRE Productions

662.285.9798 — KHAFREBA@aol.com

www.RobesonAward.com

Figure 2. Poster for *The Best of the Best: FESPACO 2005* documentary, photo courtesy of FESPACO.

Message from Baba Hama, Director General, FESPACO

Dear All,

Congratulations for the job well done. Thank you for all the hard work and coordination that went into pulling together a virtual organization of over 150 people to bring nearly fifty filmmakers and thirty films at FESPACO 2005.

Welcome to Ouagadougou and enjoy the festival.

Thank you again and keep up the good work!

—Baba Hama

Message from C. Sade Turnipseed, Messaging Director, FESPACO

What an amazing work this has been …

I would like to begin, by extending a deep and heartfelt THANK YOU … to all 150 people on the FESPACO-PRA listserv (online committee), who made the mere virtual existence of the Paul Robeson Award Initiative (PRAI) actually come to life. Ours was a humble beginning emanating from a "need to serve;" a need to step-up to the challenge and do a much needed job, for our people, by our people and with our people … in the true spirit of Pan-Africanism. A need that members of PRAI not only embraced, but picked up and earned forward … on their backs, they coiled from ocean shore to shore, with new definitions, old restrictions and future challenges of working in such a constricting environment, as chat of the internet.

With all things being said and done, PRAI delivered, over thirty films, for screening and/or competition: over fifty filmmakers and film enthusiasts to FESPACO 2005! Plus, a documentary production well in the works! We did this and we had no allocated budget … I repeat … No money to do any of this … only the loving spirit and embrace of a few angels sent to us directly from God. The angels I would like to give recognition to are: Iman Drammeh, Kevin Arkadie, Cedric Pounds, Todd L. Lester, Prema Quadir, David Massey, the attorneys: Avalyn Pitts, Heidi Riviere, Theodora Brown, and Judge Jim Hull. It is no exaggeration to say, we could not have done this tremendous task without their love and their contributions.

PRAI not only thrived, in spite of continuous obstacles that still, just keep coming … we conquered that "crab-in-the-barrel" mentality and achieved

our goal. We, the Paul Robeson Award Initiative, not only accomplished our will and stated mission ... we, the PRAI are a phenomenal success! Yes, I am proud ... and, I bow deeply ... as I thank each and every single person that made this triumph a reality ... with all my soul and oh-so-much love for you ... Thank you God!

One Aim ... forever!

Sade

PS. Look for us in the whirlwind ... FESPACO 2007!

Committee Chairs

Festival Director
Baba Hama
FESPACO Director General, Burkina Faso
hamab@fespaco.bf

Managing Director
C. Sade Turnipseed
UME Public Relations, Mgmt., USA
prai.director@robesonaward.com

Trustees
The Honorary Board of Trustees lend their name, ears, resources and talents to facilitate a true Pan-African film and television festival, on the African continent. We are honored, this year, to have Dr. Maya Angelou and Mr. William Greaves, as co-chairs for the Paul Robeson Award Initiative 2005.
trustees@robesonaward.com

Advisory Board
The Board of Advisors shall have intellectual and procedural oversight of all activities. If there is a problem, or error of any nature (glaring or subtle), the Board's function is to bring clarification and solutions to the Managing Director and Chairperson(s) of the specific committee(s).
Avalyn Pitts, Esq., USA
chair.advisory@robesonaward.com

Development
The Development Committee is charged with the responsibility to secure underwriting and endorsements, for all functions. The areas in need of underwriting are: Awards, Sponsorship, General Operations, Publicity, Promotions, and Travel.
Iman Drammeh
Drammeh Institute, USA
chair.development@robesonaward.com

Library
The Library shall devise a system to catalog, document, and store all submissions.
George Oluwaboro, USA
chair.library@robesonaward.com

Catalog
The Catalog Committee oversees publishing of the official Catalog of candidates and subsequent winners.
Wangari Nyanjui | USA
chair.catalogue@robesonaward.com

Program
The Program Committee shall coordinate all events in Ouagadougou before, during, and after.
TBD
prai.director@robesonaward.com

Public Relations
The Public Relations Committee shall coordinate and manage all promotional and media campaigns, throughout specified target areas, in an effort to promote FESPACO 2005; thereby, soliciting submissions for the Paul Robeson Award. The PRAI Public Relations Committee shall also locate and network with all relevant film entities, to choose productions that will be forwarded to the PRAI Screening Committee.
Jacquie Taliaferro
LAHitz, USA
chair.pr@robesonaward.com

Youth Watch
The Youth Watch Committee is charged with locating and networking all youth-centered organizations and individuals twenty-five years old and under, who have a passion for making films. During FESPACO 2005, PRAI will present its inaugural award to a first-time filmmaker, for outstanding technical and creative works in film or video. This year's award is sponsored by The Judge Jim Hull Foundation.

Todd L. Lester
Rwanda Film Festival, USA
chair.youthwatch@robesonaward.com

Screening
The Screening Committee shall preview all videotape submissions and then vote to select the official slate of films and television for presentation at FESPACO.
David Massey
Festival Tours, USA
chair.screening@robesonaward.com

Technology
The Technology Committee shall provide technical expertise to all aspects of the committees. This involves communicating, on a regular basis, with our Board of Advisors, Committee Chairs and the Managing Director to obtain relevant information on all undertakings. The Technology Committee's responsibility is to ensure that all functions and events are as timely and techno savvy, as possible.
Vernard R. Gray
RiverEast NewMedia, USA
chair.technology@robesonaward.com

Translations
The Translations Committee shall translate major promotional material, correspondence and critical dialogue to and/or from French to English, for the benefit of Committee members and the administration in Burkina Faso.
Samba Gadjigo
chair.translations@robesonaward.com

Travel
The Travel Committee shall coordinate and administrate all "official" travel and hotel accommodations to/from domestic and international film/television festivals.
Nanaesi Betty Ray
Access Africa, Inc., USA
chair.travel@robesonaward.com

2005 Paul Robeson Best of the Best: Films from the African Diaspora

Mission Statement
The Paul Robeson Award Initiative researches, networks, archives, and presents the "Best of the Best" Films/Videos from the African Diaspora.

Goal
It is our intent to assist in firmly establishing FESPACO, as the awards are the preeminent festival and marketplace of African films.

Objectives

- To organize our talents and resources in an effective manner, which secures the permanent offering of three Paul Robeson Awards: Feature, Documentary, and Short Film categories.
- To solicit and professionally assess films/videos by collaborating with existing Diasporic film/television festivals and independent filmmakers.
- To efficiently deliver such films/videos to FESPACO officials in Burkina Faso, for final determination of FESPACO: Paul Robeson Awards.

Three Awards

1. **Paul Robeson Award**, for full-length feature drama/documentary. Provided by FESPACO (there are six films in this category). The winner receives the trophy and a cash prize.
2. **Paul Robeson Initiative, Special Prize**, for "Special Interest," "Documentary (Short)" and/or "Drama (Short)." Provided by Drammeh Institute (there are twelve films in this category). The winner receives the trophy.
3. **Paul Robeson Initiative, Special Prize**, for "Youth Watch." Provided by Judge Jim D. Hull Foundation. The winner receives the trophy.

Six Films Competing for the Paul Robeson Award

Sweet Honey in The Rock: Raise Your Voices
Stanley Nelson (Director)
Raise Your Voice is a documentary about Sweet Honey in the Rock, the Grammy Award-winning African American female a cappella vocal ensemble. Founded by activist/singer Bernice Johnson Reagon in 1973, probably no other ensemble has so successfully distilled the essence of the musical legacy of Africans in America. *Feature documentary | 84 min*

Chisholm '72–Unsought Unbossed
Shola Lynch (Director, USA)
Chisholm '72 chronicles Congresswoman Shirley Chisholm's campaign for the presidential nomination in 1972. Fabulous, fierce and fundamentally "right on"—Chisholm's bold act reminds all Americans of their power and inspires many to join the "The Good Fight." *Feature documentary | 78 min*

Beah: A Black Woman Speaks
LisaGay Hamilton (Director, USA)
This documentary reveals the remarkable life of the African American actress, poet, teacher, dancer, and political activist Beah Richards. From Vicksburg Mississippi to Broadway and Hollywood, Beah remained committed to two cultures she loved deeply, the arts and the African American community. This is a story of a revolutionary's tireless struggle for freedom through her artistry. *Feature documentary | 90 min*

One Love
Trevor Rhone (Writer, Jamaica, WI)
Jamaica's very own "Romeo and Juliet," *One Love* is set against the backdrop of the country's rich musical heritage. Ky-Mani (son of Bob Marley) plays Kassa, a reggae musician striving to remain "conscious" amidst the corrupt commercialism of the music business. His world is turned around by the luminescent Serena (Cherine Anderson), a church girl with an angelic vocal range who is forbidden to sing reggae or date a Rastafarian; besides, she is engaged to the stuffy, jealous Aaron—so when Kassa proposes they join creative forces and she feels her ardor rising, she is plunged into confusion and chaos. *Feature | 96 min*

Woman Thou Art Loosed
Michael Schultz (Director, USA)
An adaptation of Bishop TD Jakes' self-help novel, chronicling a woman's struggle to come to terms with her legacy of abuse, addiction, and poverty. *Feature drama | 97 min*

Scent of Oak
Rigoberto Lopez Pego (Director, Havana City, Cuba)
Scent of Oak is a story of love, ambition, dreams, and disillusions, in an environment where "miracles still happen": the lands in the Caribbean in the early 19th century. The meeting of two persons in Havana triggers the relationship of two different forms of seeing the world that complement each other through an intense passion full of sensuality and desire to live and, at the same time, capable of creating a dream: establishing a coffee plantation, the largest in the Island, which is at the same time the wish to create Utopia and fulfill a destiny. *Scent of Oak* is also the history of an obsession and a hope: to live in a better world. *Feature | 127 min*

Figure 3. Ky-Mani and Cherine Anderson in the Jamaican film, *One Love,* directed by Trevor Rhone, photo courtesy of FESPACO.

Films Competing for the PRAI Special Prize

Brother-to-Brother
Rodney Evans (Director, USA)

A drama that looks back on the Harlem Renaissance from the perspective of an elderly black writer, Bruce Nugent, who meet a black, gay teenager in contemporary New York. *Feature | 91 min*

Love, Sex & Eating the Bones
Sudz Sutherland (Director, Canada)

Love, Sex & Eating the Bones is a sexy romantic comedy about an aspiring photographer who moonlights as a security guard. Frustrated with a life he can't control, Michael finds himself with a porn habit that has a hilarious life of it own. *Love, Sex & Eating the Bones* is a film not afraid to push the boundaries and deliver laughs at the same time. *Feature | 101 min*

All Our Sons Fallen Heros of 9/11
Lillian E. Benson (Director, USA)

Framed by the events of September 11th, *All Our Sons-Fallen Heroes of 9/11* tells the story of the twelve Black firefighters who gave their lives along with 332 other emergency personnel in the World Trade Center tragedy. *Feature documentary | 28 min*

Where Are They Now
A. Rico Speight (Director, USA)

An in your face portrayal of African American and Black South African youth focusing on the similarities and contrast in their lives shot on location

Figure 4. *Love, Sex & Eating the Bones*, directed by Sudz Sutherland, photo courtesy of FESPACO.

in New York City and Soweto. This hard-hitting documentary gives visceral expression to the aspirations, frustrations, and insights of these young people as they negotiate their places in two societies in transition. *Feature documentary | 80 min*

I'd Rather Be Dancing
Yvonne Farrow (Director, USA)
A paralyzed dancer, now wife and mother is confronted by her ex-lover/ dance partner showing her that the spirit of a dancer doesn't die with the use of her legs. *Narrative short | 34 min*

Figure 5. *I'd Rather Be Dancing*, directed by Yvonne Farrow, photo courtesy of FESPACO.

Figure 6a. *My Nappy Roots*, directed by Regina Kimball, photo courtesy of FESPACO.

Figure 6b. *My Nappy Roots,* directed by Regina Kimball, photo courtesy of FESPACO.

Silence
Mateen Kemet (Director, USA)
A gritty yet surreal drama exploring the cycles of abuse in one Bronx family, seen through the prism of sixteen-year-old Marquita, who harbors a horrendous secret. *Narrative short | 22 min*

My Nappy Roots
Regina Kimbell (Director, USA)
My Nappy Roots explores the history and culture by examining hairstyles of Africans and African Americans. We start in Africa, the Middle Passage, slavery, modern day business leaders, and back. *Narrative short | 22 min*

Long Story Short
Simbi Hall (Director, USA)
Long Story Short follows Temple Ross, as she tries (aided by her two best friends) to get her hair done. The mission seems easy enough to accomplish; but, just like the world of Black hair, things are rarely as they appear. In the end she realizes her life long quest for "perfect hair" was really a journey for self-acceptance. *Narrative short | 20 min*

Healing Passage
S. Pearl Sharp (Director, USA)
For more than 300 years the Trans-Atlantic slave trade carried Africans from their homeland across the Atlantic Ocean into chattel slavery in the Americas and the Caribbean. The psychological impact of "the other Holocaust," still reverberates in the African Diaspora today. *The Healing Passage* features artists whose work helps us tackle the repercussions of the Middle Passage. Featuring Haile Gerima, Oscar Brown Jr., Ysaye M. Barnwell, Tom Feelings, Chester Higgins Jr., Katrina Browne, Riua Akinshegun, Gil Noble, and others. *Feature documentary | 90 min*

Land of the Free
Edford Banuel (Director, USA)
A fictionalized depiction of what can happen when a victim of racism is pushed to defend his integrity and manhood. *Narrative short | 25 min*

Bringin In Da Spirit
Rhonda Haynes (Director, USA)
Inspired by her friendship with a dynamic, contemporary midwife who lives and works in the Harlem community, which they both share, director Rhonda Haynes has crafted a film which not only details the history and heralds the accomplishments of African American midwives in the United States, but also chronicles their efforts to preserve not merely a profession, but a traditional way of life. Through the use of first person narratives and rare archival images, *Bringin In Da Spirit* provides a moving glimpse of the women who have skillfully brought scores of children across the threshold of existence. This evocative and passionate film celebrates women who have committed themselves to holistic answers amidst powerful misconceptions about the practice of midwifery and virulent opposition from practitioners of Western Medicine. *Documentary | 60 min*

Youth Watch: PRAI Special Prize

Venue: American Embassy
Date: Tuesday, March 1, 2005
Time: 6:00–9:00 p.m.

Black Visions/Silver Screen:
Howard University Students Film Showcase
S. Torriano Berry (Director, USA)

This series of programs originally screened student produced film and video productions including comments and dialogue with the student filmmakers. These are the "best of the best" of the Howard University 2nd Annual Black Vision/Silver Screen Student Film Showcase. *Narrative shorts | 50 min*

Rubber Soles
Christine Turner (Director, USA)
An eleven-year-old whose got moves on the dance floor, but not on the court, gives up his prized soul records collection when he falls for a neighborhood basketball player. *Narrative short | 10 min*

Global Action Project
(Director, USA)
Documentary | 47 min

I Promised Africa
Jerry Henry (Director, USA)
Documentary | 2 mins

Ragu & I
(Director, India)
A Film on Children's Rights.
Animation | 47 min

Best of the Best: Screening Schedule

Monday

Film Title	Director	TRT	Genre	Time
Reflections Unseen	Aarin Burch	26:00	Doc	12:00
A Spoonful of Love	Andrea Williams	19:00	Drama	12:30
I'd Rather Be Dancing	Yvonne Farrow	30:00	Drama	1:00
L-O-V-E	Tamiko Joye Ball	28:00	Drama	1:30
Silence	Mateen O. Kemet	22:41	Drama	2:00
Where Are They Now	Rico Speight	60:00	Doc	3:00
Gift For The Living	Tamika Miller	17:23	Drama	4:00
Standing On My Sister's Shoulders	Laura Lipson	60:00	Doc	4:20

Healing Passage	S. Pearl Sharp	90:00	Doc	5:25
A Panther in Africa	Aaron Matthews	60:00	Doc	7:00

Tuesday

Film Title	Director	TRT	Genre	Time
Etu & Nago	Morenike Olabunmi	23:00	Doc	12:00
Mboutoukou	Victor Viyuoh	28:00	Drama	12:25
Shooter	JJ Goldberger	14:00	Drama	1:00
Stone Mountain	JJ Goldberger	23:00	Drama	1:15
My Nappy Roots	Regina Kimbell	22:00	Doc	2:00
Long Story Short	Simbiat Hall	15:32	Comedy	2:25
Bringin' in da Spirit	Rhonda L. Haynes	60:00	Doc	3:00
Not So Private	Sandye Wilson	33:00	Doc	4:00
Afro Punk	James Spooner	66:00	Doc	4:30

Wednesday

Film Title	Director	TRT	Genre	Time
Red Eye	Kevin Gordon	15:00	Drama	12:00
YOU	Charles Kenneth Maye	30:00	Drama	12:15
Allergic To Nuts	Rosalyn Coleman	26:18	Comedy	12:45
Boroom Keur de Goree: Joseph N'diaye	Dr. Debra Boyd	15:00	Doc	1:15
Single Rose	Hanelle Culpepper	20:00	Drama	1:30
All Our Sons Fallen Heroes 9/11	Lillian E. Benson	28:00	Doc	2:00
Durban 400	Al Santana	53:00	Doc	2:30
Land of the Free	Edford Banuel	30:00	Drama	4:00
Walking on Eggshells	Faith Pennick	13:00	Drama	4:30
Chattel House	Gladstone Yearwood		Doc	4:45
Love, Sex & Eating the Bones	Sudz Sutherland	100:00	Comedy (R)	6:15

❧❧

Thank You!

A very special thanks to our festival affiliates, corporate and fiscal sponsors:

PRAI Members

Advisory Board
Avalyn Pitts, Esq., Intellectual Asset Dev., IAD*,
Kojo Ade, Kojo and Associates
Mariet Bakker, Filmfestival Africa in the Picture
Ako Abunaw, Akobat Global Endeavour, Cameroon
Mahen Bonetti, New York African Film Festival
St. Clair Bourne, Chamba Mediaworks, Inc.
Theodora Brown, Esq.
Dr. Jane Bryce, Barbados Festival of Afro Carib. Film
Iman Drammeh, The Drammeh Institute, Inc.
Shari Frilot, Sundance Film Festival
Samba Gadjigo, Mt. Holyoke College
Tunde Giwa, The Julliard School
Vernard R. Gray, RiverEast NewMedia
Jacquie Taliaferro
Preston "Dakarai" Holas, Producer
Tanya Kersey, Hollywood Black Film Festival
Heidi Lobato, Filmfestival Africa, Amsterdam
George Oluwaboro, BYSAT Television
David Massey
Ave Montague, S.F. Black Film Festival
Cornelius Moore, California Newsreel
Donna Mungen, Reel Black Women
Mweze D.Ngangura, Filmmaker
Sandra Rattley, Writer/P.R. Specialist
Nanaesi Betty Ray, Access Africa, Inc.

Terra Renee, African American Women In Cinema
Heidi M. Riviere , Esq
Tom Spencer-Walters, Ph.D., CSUN
Professor Walter Turner

Development Committee
Iman Drammeh, The Drammeh Institute, Inc.,*
Farika Berhane
Akosua Arbitton
George Oluwaboro, BYSAT Television
Lekan Salaam, African Bridge

Library Committee
George Oluwaboro, BYSAT Television*
Carol Afua Yates, Trinidad/Tobago, West Indies

Catalogue Committee
Wangari Nyanjui*

Program Committee
Ako Abunaw
Dominique Phelps
Dayo Beverly
Dr. Debra Boyd
Dr. Jane Bryce
Madea Willis

Public Relations Committee
Jacquie Taliaferro, Lahitz/Agora Series, Cannes*
C. Sade Turnipseed, UME Public Relations, Mgmt
Farika Berhane
Vernard R. Gray, RiverEast NewMedia
Carletta S. Hurt, Blu Topaz, lnc./ lKAM Productions

Malik Heru-Seneferu, Malik's Art
Bobby Jones, Ph.D.
Moza Mjasiri Cooper, PAFF-LA
Cedric Pounds, Videographer
DeBorah Pryor
Deardra Shuler, Black Star News

Youth Watch Committee
Todd L. Lester*
Carletta Hurt

Screening Committee
David Massey*
Jule C. Anderson
donnie I. betts, No Credits
Productions
Mel Donalson, Filmmaker &
Author
Ray Forchion, Actor & Producer
Carol Afua Yates, Trinidad &
Tobago, West Indies

Technology Committee
vernard r gray, RiverEast New
Media*
Wangari Nyanjui
Monique Shaifer

Translations Committee
Samba Gadjigo*
Ako Abunaw
P. Julie Papaioannou, Ph.D.

Travel Committee
Nanaesi Betty Ray, Access Africa,
Inc.,
Carol Afua Yates, Trinidad/Tobago,
West Indies

*Committee Chair

Paul Robeson Award Initiative Objectives

I. To assess films and television productions by collaborating with existing Diasporic Pan-African and international film & television festivals, independent filmmakers and African film enthusiasts to acquire submissions to the "Best of the Best" archive.

II. To score by judging each submission not only on the technical and artistic qualities, but on the content of the message. The chosen films must adhere to the standards set by Paul Robeson, in being the best of the best. Therefore, we score each submission based on whether, or not, it indeed upholds the proper image of Africans and the Diaspora, by presenting clear images of respect, love, tolerance; as well as, examples of how to uphold and build a better society through the demonstration of enlightened people doing what they do best shine their "little light" on relevant issues and events, for the world to appreciate and enjoy!

III. To deliver such films for final judging determination to FESPACO officials, in consideration of the Diaspora Prize, i.e., the Paul Robeson Award.

Looking forward to your comments …

C. Sade Turnipseed,
Managing Director FESPACO/PRAI

Paul Robeson Diaspora Award Winners

1989 / 11ᵉ *Ori*, Raquel Gerber (Brazil)

1991 / 12ᵉ *Almacita Di Desolato*, Felix de Rooy (Netherlands)

1993 / 13ᵉ *Lumumba: la mort du prophète* (*Lumumba: The death of the prophet*), Raoul Peck (Haiti)

1995 / 14ᵉ *L'Exil de Behanzin,* Guy Deslauriers (Martinique)

1997 / 15ᵉ *The Last Angel of History*, John Akomfrah (United Kingdom/Ghana)

1999 / 16ᵉ *Sucre amer* (*Bitter Sugar*)*,* Christian Lara (Guadeloupe, France)

2001 / 17ᵉ *Lumumba*, Raoul Peck (Haiti)

2005 / 19ᵉ *Beah: A Black Woman Speaks*, LisaGay Hamilton (United States)

2007 / 20ᵉ *Le président a-t-il le Sida*, Arnold Antonin (Haiti)

2009 / 21ᵉ *Jacques Roumain, la passion d'un pays* (*Jacques Roumain, the passion of a country*), Antonin Arnold (Haiti)

2011 / 22ᵉ *Les Amours d'un zombi*, Arnold Antonin (Haiti)

2013 / 23ᵉ *Le Bonheur d'Elza*, Mariette Monpierre (Guadeloupe)

2015 / 24ᵉ *Morbayassa, le serment de Koumba*, Cheik Fantamady Camara (France/Guinea-Conakry)

2017 / 25ᵉ *Frontière*, Apolline Traore (Burkina Faso)

2019 / 26ᵉ *Mon ami Fela*, Joel Zito Araujo (Brazil)

<center>∝୨୧</center>

FESPACO Paul Robeson Award

Initiative Information and Committee Membership preceding FESPACO 2005

Paul Robeson Award Initiative:
"The Best of the Best in the African Diaspora"

About Us:

FESPACO Paul Robeson Award

The coveted FESPACO Paul Robeson Award was created in 1987. The first prize, awarded in 1989 was presented with the expressed honor to pay tribute to the legacy of Paul Robeson, our International Legend of African descent. This prize goes to "The Best of the Best in the African Diaspora" FESPACO festival section, for its remarkable technical and artistic qualities.

Statement of Purpose

The FESPACO Paul Robeson Award Initiative (PRAI) presents "The Best of the Best in the African Diaspora" film and television productions to the Pan African Film & Television Festival of Ouagadougou, Burkina Faso, more commonly known as FESPACO.

Our sole purpose is to enable the timely processing of submissions for inclusion and consideration of the FESPACO Paul Robeson Award. It is our intent to assist efforts in Burkina Faso to make FESPACO the "Academy Awards" for all African films.

Objectives

I. To assess films and television productions by collaborating with existing diasporic Pan African film and television festivals, and independent

filmmakers for submissions to the Ouagadougou, Burkina Faso-based, FESPACO.

II. To deliver such films for final determination to FESPACO judging officials, in consideration of the 2005 FESPACO Paul Robeson Award.

Criteria for Submission

The criteria for submitting projects to the FESPACO Paul Robeson Award Initiative (PRAI), for consideration in the FESPACO Paul Robeson Award category are:

I. Direct submission, from film festivals in support of FESPACO Paul Robeson Award Initiative (PRAI) presenting "The Best of the Best in the African Diaspora" films and videos, from festivals throughout the Americas, Caribbean and West Indies.
II. By invitation: to producers, directors and writers for the remarkable technical and artistic qualities presented in their recent work.

There are three film and video categories for submissions:

1. Feature Length (long)
2. Documentary
3. Short Film

If your submission has either won an award at a recent film or video festival, between 2003 and 2005, and you are the writer, producer and/or director on your film/video project, you are invited to complete the FESPACO Paul Robeson Award Application Form.

For all other inquiries and more information on how to get your film screened at FESPACO 2005, please contact the Paul Robeson Award Initiative Screening Committee.

Paul Robeson Award Initative Committees

Honorary Board of Trustees

The Honorary Board of Trustees lend their name, ears, resources, and talents to facilitate a true Pan African film and television festival, on the African continent.

We are honored, this year, to have Dr. Maya Angelou chair the FESPACO 2005 Paul Robeson Award Initiative Honorary Board of Trustees.

Dr. Maya Angelou is a remarkable Renaissance woman who is hailed as one of the great voices of contemporary literature. As a poet, educator, historian, best-selling author, actress, playwright, civil-rights activist, producer, and director, she continues to travel the world, spreading her legendary wisdom.

Within the rhythm of her poetry and elegance of her prose lies Angelou's unique power to help readers of every orientation span the lines of race and Angelou captivates audiences through the vigor and sheer beauty of her words and lyrics.

Members (in alphabetical order)
1. Dr. Maya Angelou, USA, Chair
2. Professor Spara Stanislas Adotevi, Retired UNESCO
3. Kevin Arkadie, Ivory Coast Pictures
4. Youl Bahisimine, FESPACO
5. Professor Mbye Cham, Howard University
6. Sheila Crump Johnson (pending confirmation)
7. Djibril Diallo, United Nations Development Programme
8. Danny Glover, Carrie Productions
9. Julianne Malveaux, Ph.D., Last Word Productions
10. Cheick Ouedraogo, Pmr. Pres. de la Cour de Cassation
11. Professor Clyde Taylor, New York University
12. Mel Theodore, Min. African Affairs, Cote d'Ivoire
13. Oprah Winfrey (pending confirmation)

Advisory Board

The Board of Advisors shall have intellectual and procedural oversight of all FESPACO Paul Robeson Award activities.

If there is a problem, or error of any nature (glaring or subtle), the Board's function is to bring clarification and solutions to the Managing Director and Chairperson(s) of the specific committee(s).

It is also the function of the Paul Robeson Award Initiative Advisory Board to be instructive, inquisitive, and overall helpful in all aspects of the FESPACO Paul Robeson Award efforts. It is productive and extremely useful to all if a situation is noticed, to then make suggestions of possible changes. To be a positive motivating force is the goal.

Members
1. Avalyn Pitts, Esq., Intellectual Asset Development, IAD, Chair, PRAI Advisory Board

2. Kojo Ade, Kojo and Associates
3. Mariet Bakker, Filmfestival Africa in the Picture
4. Adilah Barnes, Actor
5. Mahen Bonetti, New York African Film Festival
6. Dr. Jane Bryce, Barbados Festival of African and Caribbean Film
7. Iman Drammeh, The Drammeh Institute, Inc. (Chair, PRAI Development Committee)
8. Shari Frilot, Sundance Film Festival
9. Samba Gadjigo, Mt. Holyoke College, (Chair, PRAI Translations Committee)
10. Tunde Giwa, The Julliard School
11. Vernard R. Gray, rivereastmedia.net, (Chair, PRAI Technology Committee)
12. Preston "Dakarai" Holas, Grenada Spice Jazz Festivals, (Chair, PRAI Program Committee)
13. Tanya Kersey, Hollywood Black Film Festival
14. Heidi Lobato, Filmfestival Africa, Amsterdam
15. David Massey, Chair, PRAI Screening Committee
16. Ave Montague, S.F. Black Film Festival
17. Cornelius Moore, California Newsreel, www.newsreel.org
18. Donna Mungen, Reel Black Women
19. Mweze D.Ngangura, Filmmaker
20. Prema Qadir, BSCE, PRAI Web Architect, Videographer
21. Sandra Rattley, First Voice Int'l Foundation
22. Terra Renee, African American Women In Cinema
23. Tom Spencer-Walters, Ph.D., CSUN
24. Professor Walter Turner

Program Committee

The Program Committee shall coordinate all Paul Robeson Award Initiative events in Ouagadougou before, during, and after FESPACO 2005.

Members
1. Preston "Dakarai" Halas, Chair
2. Ako Abunaw, Prod/Dir Akobat Global Endeavour, Cameroon
3. Adilah Barnes, Actor
4. Jacquil Constant, Constant Productions
5. Avalyn Pitts, Esq., Intellectual Asset Development, IAD
6. C. Sade Turnipseed, UME Public Relations Mgmt.
7. Ron I. L. Wheeler
8. Florene Wiley, Wiley Entertainment
9. Gladstone L. Yearwood

Library & Catalog Committee

The Library & Catalog Committee shall devise a system to catalogue, document, and store all Paul Robeson Award submissions. This committee will also oversee publishing of the official Paul Robeson Award Catalog of candidates and subsequent winners.

Members

1. George Oluwaboro, Bysatv.com, Chair
2. Avalyn Pitts, Esq., Intellectual Asset Development, !AD
3. C. Sade Turnipseed, UME Public Relations Mgmt.
4. Carol Afua Yates, Trinidad/Tobago, West Indies

Research Committee

The Research Committee's function is to locate and network with all relevant festival organizers, universities, and independent producers/directors, to choose those films/television productions that will be forwarded to the Screening Committee.

Members of this committee may be asked to travel to the various festivals, for said purpose, as well as to oversee festival and filmmaker compliance of necessary documentation and transport.

Members

1. Florene Wiley, Wiley Entertainment, Chair
2. Shenae Armour, aka Sascha Smith
3. Avalyn Pitts, Esq., Intellectual Asset Development, IAD
4. Helen Rijkaard
5. C. Sade Turnipseed, UME Public Relations Mgmt.

Technology Committee

The Technology Committee shall provide technical expertise to all aspects of the Paul Robeson Award committees. This involves communicating, on a regular basis, with our Board of Advisors, Committee Chairs and the Managing Director to obtain relevant information on all FESPACO Paul Robeson Award Initiative undertakings.

The Technology Committee's responsibility is to ensure that all FESPACO Paul Robeson Award Initiative functions and events are as timely and techno savvy, as possible.

Members

1. Vernard R. Gray, rivereastmedia.net, Chair
2. Tunde Giwa
3. Wangari Nyanjui
4. Avalyn Pitts, Esq., Intellectual Asset Development, IAD
5. Prema Qadir, BSCE, Web Architect, Videographer
6. C. Sade Turnipseed, UME Public Relations Mgmt.

Translations Committee

The FESPACO Paul Robeson Award Initiative (PRAI) Translations Committee shall translate major promotional material, correspondence, and critical dialogue to and/or from French to English, for the benefit of Paul Robeson Award Initiative Committee members and the FESPACO administration in Burkina Faso.

Members

1. Samba Gadjigo, Chair
2. Ako Abunaw
3. P. Julie Papaioannou, Ph.D.
4. Avalyn Pitts, Esq., Intellectual Asset Development, IAD
5. C. Sade Turnipseed, UME Public Relations Mgmt.

Letter of Support for Paul Robeson Award Initiative (2005)

Support Us!

From: FESPACO Paul Robeson Award Initiative (PRAI)

To: Festival Organizers

Greetings from the Paul Robeson Award Initiative (PRAI) as official representatives of the Pan African Film & Television.

Festival of Ouagadougou, Burkina Faso (FESPACO), we formally request your assistance in facilitating the submission of international films and videos (from your Festival/Organization) to be considered for the FESPACO 2005 Paul Robeson Award.

As you know, the late Paul Robeson is one of the most influential and admired African American artists. His accomplishments as an actor, linguist, cultural scholar, international activist, author, and sports legend brought him worldwide acclaim. Many consider his immense talents to be "The Best of the Best." In Mr. Robeson's honor, we are establishing "The Best of the Best in the African Diaspora" films for submission to FESPACO 2005 (February 26 thru March 5, 2005). The Paul Robeson Award will be awarded in three major categories:

- Long (Feature Length)
- Short
- Documentary

All festival organizers with an African (or any derivative thereof) category are encouraged to submit films for consideration to the FESPACO Paul Robeson Award Initiative. The FESPACO guidelines state all winners of FESPACO prizes must be of African descent. Therefore, all submissions are required to adhere to this criterion.

We seek your support in these ways:

- Providing a clearance form signed by the winning producer/director that gives the Paul Robeson Award Initiative the rights to review their film for screening and automatic (free) submission to the Paul Robeson Award competition in Burkina Faso (NTSC videotape preferred; PAL accepted).
- Collaborating with the Paul Robeson Award Initiative to facilitate transportation of the materials to Paul Robeson Award Initiative headquarters in Louisville, Mississippi, USA, or arranging for pickup by our staff (if in the vicinity of a Committee member), or by parcel post delivery.
- Providing sponsorship(s) for Paul Robeson Award Initiative representatives to attend your festival, in order to manage the above-stated tasks. We would need to receive a formal invitation to attend your festival that includes travel and hotel accommodations.

I will contact you, by phone and/or email, within the next week to talk more about this with you. In the meantime, please feel free to contact me directly with any questions you have.

On behalf of the entire FESPACO and FESPACO Paul Robeson Award Initiative family, we thank you in advance for your support and encouragement.

Sincerely,

C. Sade Turnipseed, Managing Director
FESPACO 2005 Paul Robeson Award Initiative
March 1, 2004
e-mail: prai.director@robesonaward.com

Dossier 2: Higher Institute of Image and Sound / Studio School

This section includes important documents concerning the Higher Institute of Image and Sound / Studio School (ISIS-SE), located in Burkina Faso.

1. ISIS-SE Charter (selections, 2017)
2. Mission and Strategy of ISIS-SE
3. Curriculum of ISIS-SE (2016–2017 School Year)
4. International Creative and Research Partnerships of ISIS-SE
5. ISIS-SE Photo Gallery

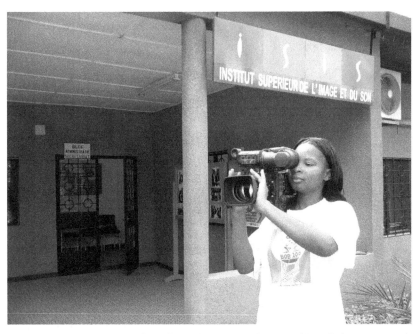

Figure 1. Blanche Sanou, student filmmaker, Higher Institute of Image and Sound, photo courtesy of FESPACO.

Charter of the Higher Institute of Image and Sound / Studio School (ISIS-SE) (*selections*)

Unity—Progress—Justice

DECREE No. 2017-_0270_ / PRES / PM / MCAT / MINEFID approving the specific statutes of the Institute Higher Image and Sound / Studio School (ISIS-SE).

President of Burkina Faso, President of the Council of Ministers

CONSIDERING the Constitution;

CONSIDERING Decree No. 2016–001 / PRES of 06 January 2016 appointing the Prime Minister;

CONSIDERING Decree No. 2017–0075 / PRES / PM of 20 February 2017 on the reshuffling of the Government;

CONSIDERING Decree 2017–0148 / PRES / PM / SGG-CM of 23 March 2017 on the attributions of the members of the Government;

CONSIDERING Decree 2016–436 / PRES / PM / MCAT on the organization of the Ministry of Culture, Arts, and Tourism;

CONSIDERING Law No. 047–2004 / AN of 25 November 2004 on the Orientation Law for Cinema and Audiovisual Media;

CONSIDERING Law No. 010–2013 / NA of 30 April 2013 on the rules for creating categories of public establishments;

CONSIDERING Decree No. 2006–032 / PRES / PM / MFB / MCAT of 8 February 2006 establishing a public institution of the State of a Scientific, Cultural, and Technical nature called the Regional Institute of Image and Sound;

CONSIDERING Decree No. 2006–496 // PRES / PM / MFB of 30 October 2006 on the change of name of the Regional Institute of Image and Sound;

CONSIDERING Decree No. 2014–612 / PRES / PM / MEF of 24 July 2014 on the General Statute of State Public Establishments of a Scientific, Cultural, and Technical Nature (EPSCT);

On report of the Minister of Culture, Arts, and Tourism;

The Council of Ministers heard at its meeting of 1 February 2017;

Decreed

Article 1: The special statutes of the Higher Institute of Image and Sound / Studio School (ISIS-SE), the text of which is attached to this decree, are approved.

Article 2: This decree repeals Decree No. 2007–395 / PRES / PM / MCAT / MESSRS / MFB of 23 June 2007 approving the statutes of the Higher Institute of Image and Sound (ISIS-SE).

Article 3: The Minister of Culture, Arts, and Tourism and the Minister of Economy, Finance, and Development are responsible, each as far as he is concerned, for the execution of this decree which will be published in the Official Journal from Burkina Faso.

Ouagadougou, May 08, 2017
Roch Marc Christian Kaboré

The Prime Minister
Paul Kaba Thieba

The Minister of Economy, Finance, and Development
Alizatou Rosine Coulibaly-Sory

The Minister of Culture, Arts, and Tourism
Tahirou Barry

Title I: General Provisions

Article 1: The Higher Institute of Image and Sound / School Studio, abbreviated ISIS-SE, is a State Public Establishment Scientific, Cultural, and Technical (EPSCT). He enjoys moral personality and pedagogical, scientific, administrative, and financial autonomy.

The missions, the organization, and the functioning of the Higher Institute of Image and Sound / Studio School are governed by the texts in force and the provisions of these special statutes.

Article 2: The headquarters of the Higher Institute of Image and Sound / Studio School is set in Ouagadougou.

Article 3: The Higher Institute of Image and Sound / Studio School has the following missions:

- to welcome and train in the fields of cinema and audiovisual the State agents recruited by the Burkinabe civil service or by other countries;
- provide initial and continuing training in the fields of film and audiovisual and issue diplomas or certificates;
- promote and disseminate cinematographic and audiovisual culture as well as theoretical, artistic, and technical research in the fields of image and sound;
- design, produce, produce, edit, and distribute any artistic, technical, or scientific document relevant to the image and sound professions;
- cooperate with national, regional, or international institutions and institutions with similar aims;
- to contribute to improving the technical and artistic quality of film and audiovisual production;
- provide technical services in the film and audiovisual fields;
- provide professional entertainment in the form of exchange meetings through cinematographic and audiovisual activities;
- to participate, within the scientific and cultural community, in the debates, the progress of research, and the meeting of cultures.

Article 4: The Higher Institute of Image and Sound / Studio School can receive in its programs of initial and continuous training, development, and research, auditors of other nationalities as well as individual candidates or presented by private and public institutions.

Article 5: The Higher Institute of Image and Sound / Studio School creates and confers degrees and diplomas that it delivers in accordance with national regulations and international conventions in force.

Title II: Tutorship

Article 6: The Higher Institute of Image and Sound / Studio School is placed under the technical supervision of the ministry in charge of the cinema.

The Ministry of Technical Supervision ensures:

- the coherence of the Institute's activities with the national policy of training, teaching, and scientific research and film and audiovisual production;
- the inclusion of ISIS-SE in the national, regional, and international education system.

Article 7: The Higher Institute of Image and Sound / Studio School is placed under the financial supervision of the Ministry of Finance.

The Ministry of Financial Supervision ensures that the activity of ISIS-SE is part of the Government's financial policy and that its management is as healthy and as efficient as possible.

Article 8: Within the framework of the exercise of the guardianship, the President of the Board of Directors of the ISIS-SE is obliged to address to the ministers of tutorship:

1. in the three months following the beginning of the financial year, the estimated income and expenditure accounts, the investment financing program, the conditions for the issue of the loans;
2. within three months following the end of the financial year, the revenue and expenditure account, the administrative account, the activity report and the annual report on the difficulties encountered in the operation of ISIS-SE.

Article 9: In addition to the documents referred to in Article 8, the Chairman of the Board of Directors shall, after each session of the Board of Directors, transmit to each minister responsible for observations, the minutes, and the deliberations adopted, within a maximum of twenty-one days.

The transmission of the minutes does not preclude the production of a detailed minutes which will be adopted by the Board of Directors at the next session and archived within ISIS-SE for all purposes.

Article 10: The deliberations of the Board of Directors of ISIS-SE become enforceable either by a notice of non-opposition of the Ministers of guardianship, or by the expiry of a period of thirty days from the date the deposit of the said deliberations to the Ministers' Offices.

In case of opposition, the execution of the deliberation in question is suspended.

However, deliberations relating to the issue of loans and the placement of cash can only become effective after express approval by the Minister of Finance.

Title III: Organization and Functioning of ISIS-SE

Article 11: The administrative and management bodies of ISIS-SE are:

- board of directors;
- the general direction;
- the Scientific, Technical, and Cultural Council.

Article 12: ISIS-SE has two advisory bodies, namely:

- an advisory body;
- the Disciplinary Council.

Chapter I: The Board of Directors

Article 13: The Board of Directors of ISIS-SE is composed of managing members and observer members.

Article 14: There are twelve director members as follows:

- two representatives of the Ministry in charge of the cinema;
- one representative of the Ministry of Higher Education;
- one representative of the Ministry in charge of the digital economy;
- one representative of the Ministry of Finance;
- one representative of the Ministry responsible for the civil service;
- one representative of the Ministry of Vocational Training;
- one representative of the Ministry in charge of communication;
- one representative of film and audiovisual professionals appointed by the representative organizations of the profession;
- one staff representative of ISIS-SE;
- one faculty representative;
- one student representative.

Article 15: Directors representing the State shall be appointed on the proposal of the Minister responsible for cinema.

The other directors are appointed according to the rules specific to their structure. This designation is confirmed by decree in the Council of Ministers.

Article 16: The Board of Directors is officially installed by the Secretary General of the Ministry of Cinema. When a new director takes office, it is copied by the directors already in office.

Article 17: The term of office of director is three years renewable one times. In the event of the termination of office of a director for any reason whatsoever, he shall be replaced on the same terms and for the remainder of his term of office.

Article 18: No director of ISIS-SE can be a member of more than two Boards of State Public Establishments.

Article 19: Can not be administrators of the ISIS-SE under the State, the presidents of institution, the members of the government, the directors of cabinet, the heads of cabinet, the members of the control bodies of the State.

Article 20: The administrators can not delegate their mandate. However, they may, by means of a delegation, be entitled to be represented at a session of the Board by another regularly appointed director. The delegation of authority is valid only for the session for which it was given. No administrator can represent more than one administrator at a time.

Article 21: The President of the Board of Directors is appointed by decree taken in the Council of Ministers among the administrators. He is appointed for a term of three years renewable one times.

Article 22: In accordance with articles 20 and 21 of the decree no. 2014–612 / PRES / PM / MEF of the 24th of July 2014 on the general status of the State Public Establishments of a Scientific, Cultural, and Technical Nature (EPSCT), are observer members of the Board of Directors of ISIS-SE with consultative voice:

- a representative of the General Directorate of the Treasury and Public Accounting (DGTCP);
- the Director of Controlling Public Contracts and Financial Commitments (D-CMEF);
- the Director General;

- the Director of Administration and Finance (DAF);
- the Accountant;
- the Person in charge of the Markets.

However, at the discretion of the Chairman of the Board of Directors, the members of the Board may deliberate, on specific items of the agenda, in closed session, without the presence of observer members.

Mission and Strategy

From the Certification Application for (ISIS-SE)

In 2005, the government of Burkina Faso decided to open a new film school with a regional ambition, training the students from Burkina Faso and other African countries. Created in February 2006, ISIS-SE since 2017 has the status of a State public institution of a scientific, cultural, and technical nature (EPSCT) and is under the supervision of the Ministry in charge of culture. Our structure is the result of a long process in order to create an institute in which will be trained African youth in cinema.

Since its inception, ISIS-SE has trained more than two hundred students of twenty nationalities from the various horizons of the world (Europe, Asia, and Africa), has produced more than one hundred educational films (fiction or documentary), and has accompanied several film professionals.

Objectives of ISIS-SE are:

- to promote and inculcate the culture of cinema, of filmmaking, of television (audiovisual) and make theoretical, artistic, and technical research in image and sound;
- to design, make, produce, publish, and broadcast/distribute audiovisual works and documents;
- to improve the technical and artistic quality of the cinematographic production;
- to bring technical help to professionals;
- to encourage students' audiovisual projects;
- to cooperate with national, regional, or international institutions and establishments pursuing similar goals.

ISIS-SE aims to be a school of excellence for training in the film and audio-visual professions in Africa.

Curriculum: 2016–2017 School Year

Field of Study
ISIS-SE is a higher institute for artistic, technical, and support training in cinema and audiovisual professions with a subregional vocation, with the status of a public institution of a scientific, cultural, and technical nature. ISIS-SE offers students initial training and film and audiovisual professionals receive continuing education.

Status and Educational Program of ISIS-SE
The hourly volume of classes per week is thirty-five hours of theory and practice. French is the language used to teach classes.

Ongoing training is aimed at upgrading, retraining, and retraining professionals by organizing workshops in all areas of the film and audio-visual professions. These training programs are run by national, African, and Northern professionals whose skills are recognized.

Initial and continuing training is the responsibility of the Initial and Continuing Training Department (DFIC).

Teachers
There are around sixty teachers, who can be divided into two main groups: film professionals and university professors. For this year, four teachers are also members of the administrative staff.

Admission Criteria
Access to the initial ISIS-SE training is open to candidates who are required to have a bachelor›s degree or an equivalent diploma and who possess prerequisites in computer science. Final admission is pronounced after:

- A preselection on file;
- A written test and/or motivational interview.

For the Master, admission is on file selection followed by an interview.

The students take continuous examinations during the year, a final examination at the end of the year, and a catch-up session for the adjournments of the first session.

Language of Study
The language of study is French.

Outline of ISIS-SE Curriculum

Year	Section / diploma courses	Section / diploma courses
1st year	Common Core	-
2nd year	Directing	-
	Production	-
	Image	-
	Sound	-
	Editing	-
3rd year	Directing	License
	Producing	License
	Image	License
	Sound	License
	Editing	License
4th year	Common Core Directing	Master I
5th year	Fiction Directing	Master II
	Documentary Directing	Master II

First Year Curriculum

Number of subjects: 17
Total credits: 40
Number of hours per year: 900 hours

	Subjects Taught	Credits	Lecture Hours	Tutorials/ Practical Work Hours	Total Hours
	Basic Subjects	**27**	**270**	**360**	**630**
1	Initiation to the writing of the documentary scenario	3	30	40	70
2	Initiation to the writing of the fictional scenario	3	30	40	70
3	Techniques and equipment of shooting	3	30	40	70
4	Sound recording techniques and equipment	3	30	40	70
5	Editing techniques and equipment	3	30	40	70
6	Cinematographic language and film analysis	3	30	40	70
7	Production	3	30	40	70
8	Documentary film making	3	30	40	70
9	Fiction film making	3	30	40	70
	Support Subjects	**10**	**160**	**40**	**200**
10	Technology & maintenance of audiovisual equipment	2	30	10	40
11	Industrial sectors of cinema and audio-visual	2	30	10	40
12	History of cinema	2	40	-	40
13	Computer science applied to audiovisual	2	20	20	40
14	Cinema and audiovisual law	2	40	-	40

	Environmental Subjects	3	70	-	70
15	The history of art	1	25	-	25
16	Written and oral expression technicals	1	25	-	25
17	Audiovisual English	1	20	-	20
Total :		**40**	**500**	**400**	**900**

Second Year Curriculm

Number of subjects / credits / hours by track :
Directing : 17 / 26 cr. / 835 hr.
Production : 15 / 21 cr. / 740 hr.
Image : 13 / 21 cr. / 785 hr.
Sound : 13 / 21 cr. / 730 hr.
Editing : 14 / 24 cr. / 820 hr.
Includes a mandatory 1-month internship in a company.

Subjects Taught			Tracks (Hours Spent in Tutorials and Practical Work)				
Code	Course Title	Credits	Directing	Production	Image	Sound	Editing
Support Subjects		**18**	**200**	**280**	**240**	**200**	**200**
TC2.1	Team and staff management	2	40	40	40	40	40
TC2.2	Applied computing (DVD design & posters)	2	40	-	-	-	-
TC2.3	Applied computing (management software)	2	-	40	-	-	-
TC2.4	Movie analysis	2	-	40	40	40	40
TC2.5	Sociology of cinema	2	40	40	40	40	40
TC2.6	Psychology of the character and the actor	2	40	40	40	40	40
TC2.7	Creation and management of a film or audiovisual production structure	2	-	40	-	-	-

TC2.8	Introduction to music	2	40	40	40	40	40
TC2.9	Aesthetics and semiology of the image	2	-	-	40	-	-
Environmental Subjects		**2**	**50**	**50**	**50**	**50**	**50**
TC2.13	Audiovisual English	1	25	25	25	25	25
TC2.14	Cinema and audiovisual law	1	25	25	25	25	25
Total : *(including track-specific courses)*		**21–26**	**835**	**740**	**785**	**730**	**820**

Directing Track					
Code	**Course Title**	**Credits**	**Tutorial Hours**	**Practical Work Hours**	**Total Hours**
R2.1	Fiction script writing	3	25	50	75
R2.2	Writing of documentary scenario	3	25	50	75
R2.3	Fiction filmmaking	4	30	60	90
R2.4	Documentary filmmaking	4	30	60	90
R2.5	Staging and Direction of actors	3	25	50	75
R2.6	Initiation to the film-making multi camera	3	20	40	60
R2.7	Aesthetics and Semiology of the Image	3	20	40	60
R2.8	Movie analysis	3	25	35	60
Total:		**26**	**200**	**385**	**585**
Production Track					
Code	**Course Title**	**Credits**	**Tutorial Hours**	**Practical Work Hours**	**Total Hours**
P2.1	Study and scenario analysis	4	25	65	90
P2.2	Assembly of production files	4	25	65	90
P2.3	Production contracts	4	25	65	90

P2.4	Production process of a cinematographic or audiovisual work	5	25	65	90
P2.5	Cinema and Audiovisual Marketing	4	25	65	90
Total:		*21*	*125*	*325*	*450*

Image Track

Code	Course Title	Credits	Tutorial Hours	Practical Hours	Total Hours
I2.1	Applied optics	3	25	50	75
I2.2	Theory and practice of cinematographic and audiovisual lighting	4	30	60	90
I2.3	Video shooting and digital photography	4	30	60	90
I2.4	Initiation to cinematography and audiovisual direction	4	30	60	90
I2.5	Tests and camera assistantship	3	25	50	75
I2.6	Technology and maintenance of shooting equipment	3	25	50	75
Total:		*21*	*165*	*330*	*495*

Sound Track

Code	Course Title	Credits	Tutorial Hours	Practical Work Hours	Total Hours
S2.1	Architectural acoustics	3	25	50	75
S2.2	Electroacoustic string	4	45	45	90
S2.3	Digital audio techniques	3	30	30	60

S2.4	Stereophonic sound pickup & synchronous pickup	4	30	60	90
S2.5	Postproduction sound	4	30	60	90
S2.6	Technology & maintenance of sound equipment	3	25	50	75
Total:		**21**	**185**	**295**	**480**

Editing Track					
Code	**Course Title**	**Credits**	**Tutorial Hours**	**Practical Work Hours**	**Total Hours**
M2.1	Theories of image and sound editing	2	60	-	60
M2.2	Practical editing Image	4	-	90	90
M2.3	Editing clips, spots & TV Shows	4	20	70	90
M2.4	Practical editing sound	3	-	75	75
M2.5	Workflow post-production channel	4	20	70	90
M2.6	Infographics	4	20	70	90
M2.7	Technology and maintenance of assembly equipment	3	25	50	75
Total:		**24**	**145**	**425**	**570**

Third Year Curriculm (Professional License granted)

Number of subjects / credits / hours by track:
Directing : 15 / 26 cr. / 835 hr.
Production : 11 / 21 cr. / 740 hr.
Image : 11 / 21 cr. / 785 hr.
Sound : 11 / 21 cr. / 730 hr.
Editing : 11 / 24 cr. / 820 hr.

Includes a mandatory two month internship in a company.

Defense and evaluation of final film must be completed to obtain Professional License.

Subjects Taught			Tracks (Hours Spent in Tutorials and Practical Work)				
Code	Course Title	Credits	Directing	Production	Image	Sound	Editing
Support Subjects			**260**	**80**	**220**	**160**	**160**
TC3.1	Movie decor	2	40	40	40	40	40
TC3.2	Scriptwriting from sitcom and TV series	2	50				
TC3.3	Adaptation of a literary work to the cinema	2	50				

Code	Course Title	Credits					
TC3.4	Management of film and audiovisual archives	2	40	40	40	40	40
TC3.5	Film music and musical effects	2	40			40	40
TC3.6	Calibration	2			50		
TC3.7	Digital electronics	2			40	40	40
TC3.8	Computer maintenance	2					40
TC3.9	Visual special effects	2	40				
TC3.1	Technical cuts	2			50		
Environmental Subjects			55	55	55	55	55
TC2.11	Research methodology	1	25	25	25	25	25
TC2.12	Participation in the making of a collective film	1	30	30	30	30	30
Total:			**715**	**710**	**725**	**705**	**705**

Directing Track

Code	Course Title	Credits	Tutorial Hours	Practical Work Hours	Total Hours
R3.1	Fiction film making	4	20	80	100
R3.2	Documentary film making	4	20	80	100
R3.3	Multi camera film making	4	20	80	100

Code	Course Title	Credits	Tutorial Hours	Practical Work Hours	Total Hours
R3.4	Staging and direction of actors	4	20	80	100
Total :		**16**	**80**	**320**	**400**
	Production Track				
Code	**Course Title**	**Credits**	**Tutorial Hours**	**Practical Work Hours**	**Total Hours**
P3.1	Economics of cinema and audiovisual	4	75	25	100
P3.2	Development and management of film and audiovisual projects	4	75	25	100
P3.3	Practice of production	4	75	25	100
P3.4	Distribution, exploitation and diffusion	4	70	30	100
P3.5	Marketing of cinematographic and audiovisual products	4	70	30	100
P3.6	TV and Sitcom series production	3	40	35	75
Total :		**23**	**400**	**175**	**575**

Image Track

Code	Course Title	Credits	Tutorial Hours	Practical Work Hours	Total Hours
I3.1	Machinery	4	20	80	100
I3.2	Lighting	3	25	50	75
I3.3	Cinema Photo Direction	4	20	80	100
I3.4	TV direction	3	25	50	75
I3.5	Multi-camera shooting	4	25	75	100
Total:		18	115	335	450

Sound Track

Code	Course Title	Credits	Tutorial Hours	Practical Work Hours	Total Hours
S3.1	Stereophonic sound	4	25	75	100
S3.2	Dramatic sound film making	4	25	75	100
S3.3	Dubbing and postsynchronization	4	25	75	100
S3.4	Power sound system	4	30	60	90
S2.5	Editing and mixing	4	25	75	100
Total:		20	130	360	490

Editing Track

Code	Course Title	Credits	Tutorial Hours	Practical Work Hours	Total Hours
M3.1	Practical editing Image	4	15	85	100
M3.2	Practical editing sound	4	25	75	100
M3.3	Works-flow post-production chain	4	30	60	90
M3.4	Calibration	4	25	65	90
M3.5	Rigging and special effects	4	25	75	100
Total :		20	120	480	600

Fourth Year Curriculm (Master Pro Directing)

Number of subjects: 14
Total credits: 40
Number of hours per year: 840 hours

Includes a mandatory one month internship in a company.

Course Title	Credits	Lecture Hours	Tutorials/ Practical Work Hours	Total Hours
Basic Subjects	**23**	**230**	**365**	**585**
Cinematic adaptation of literary works	3	25	50	75
Art of the scenario	4	75	25	100
Staging & direction of actors	3	25	50	75
Technical cutting & storyboarding workshop	4	20	80	100
Documentary genres	3	25	50	75
Investigation for the documentary filmmaking	3	40	20	60
Design documentary workshop	3	20	80	100
Support Subjects	**6**	**120**	**30**	**150**

Audiovisual anthropology	2	50	00	50
Cinema and traditional artistic expressions	2	50	00	50
History of cinema	2	20	30	50
Environmental Subjects	**4**	**70**	**35**	**105**
Poetic of the filmic narrative	1	15	10	25
Right to the image	1	25		25
Practice of English	1		25	25
Research methodology	1	30		30
Total:	**40**	**420**	**430**	**840**

Fifth Year Curriculm (Professional Master Directing) Fiction or Documentary

Number of subjects: 17
Total credits: 40
Number of hours per year: 900 hours
Includes a mandatory two month internship in a company.
The final work for the Master's degree is the submission and defense of a thesis film (twenty-six minute short film, fiction, or documentary) before a jury.

Course Title	Credits	Fiction Option Hours	Documentary Option Hours
Presentation and validation workshop of the scenario projects		70	70
Doctoring script / scenario analysis	2	60	60
Fiction script writing / Documentary scenario writing	4	100	100
Scenario pitching techniques	2	70	70
Shooting of a 26-minute film	8	200	200
Elaboration of a thesis	8	200	200
Total:		700	700

Higher Institute of Image and Sound / Studio School
Participation in International Research / Creative Collaboration

Partnership Program with Wallonia Brussels International (WBI) / INSAS Belgium

2008–2017

Partners

- WBI and INSAS Brussels

Aims

- Organization of training workshops of two to four weeks for the professionals of cinema and audiovisual
- Organization of project "cross-views" allowing ISIS-SE students to make films in Brussels inspired by their realities and vice versa with students from INSAS and IAD.

Results

- More than one hundred trained professionals
- More than a dozen films made

Ciné Nomad School

2017–2019 (which will continue next year because the convention is annual)

Partners

- Ciné Fabrique de Lyon with other partners (ISMA / Benin, Lodz Film School / Poland, New York / USA College Purchase, AFRIFF / Nigeria, Blue Nile / Ethiopia, ESAV / Morocco, Forever-Living Product / Burma)

Aims

- To question their artistic practices by confronting another reality, other ways of writing, working, or thinking the world;
- To work without being supervised by educational workers in order to acquire a professional autonomy;
- To confront the difficulties inherent in international coproductions: understand, learn, and share ways of working that can encourage collaborations between future professionals;
- To work and shoot in a foreign language

Results

- Coproduction and realization of twelve film projects being finalized (postproduction) in 2019
- Coproduction and production of twelve films in 2018
- Coproduction and production of thirteen films in 2017

Multi-year Program Agreement between Africalia and ISIS-SE

2006–2018

Aims

- Organization of educational workshops and master-classes
- Support for the payment of tuition fees by awarding scholarships
- Production of end of cycle study films

Results

- Production of more than forty films of 13mm
- More than nine hundred participants during the master class during FESPACO
- More than one hundred participants in the workshops for a better preparation of the film production

UNICEF-ISIS Partnership Agreement

2018–2020

- Accompaniment by a donation of technical materials for the studio-school to forty-five million CFA francs for three years

- Home of ISIS-SE trainees on UNICEF projects
- Accompaniment to staff training or during UNICEF activities

Partnership with TV5 Monde

Since 2011

- Accreditation of students during FESPACO
- Contribution for the Idrissa OUEDRAOGO Prize of the Schools of Cinema which will be awarded for the first time at FESPACO 2021
- Supported infrastructure maintenance
- Shopping school movies

Partnership being formalized with INA

2019–2023

- Home and student exchange for Master's programs
- Creation of a media library at ISIS-SE to improve the management and access of its audiovisual and digital cinematographic archives

Partnership with the US Embassy in Burkina Faso

Since 2017 (annual)

- Organization of two master classes during FESPACO 2017 and 2019 with Mr. DJ Johnson of LA / USA which resulted in the production of ten short films with thirteen participating African schools.

ISIS-SE Photo Gallery

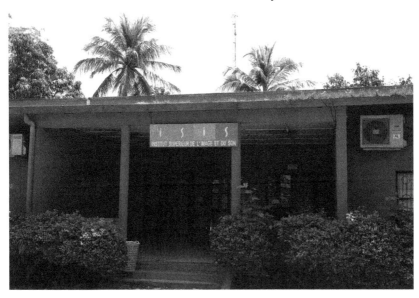

Figure 2. Main entrance of the pedagogical bloc of Institute of Image and Sound, photo courtesy of FESPACO.

Figure 3. Abiba Ouedraogo, second-year film student practicing a crane shot, photo courtesy of FESPACO.

Figure 4. Students enrolled in Ciné Nomad, an International Partnership with Ciné Fabrique de Lyon, photo courtesy of FESPACO.

Figure 5. Practicing a crane shot at Higher Institute of Image and Sound, photo courtesy of FESPACO.

Figure 6. Student filmmakers at Higher Institute of Image and Sound setting up a shot, photo courtesy of FESPACO.

Figure 7. Members of CILECT visiting the African Film Archives, photo courtesy of FESPACO.

Dossier 3: IMAGINE Institute

This section includes important documents concerning the IMAGINE Institute, a center for film training located in Burkina Faso.

1. IMAGINE Press Kit (2013)
2. IMAGINE Institute Association Action Plan (2019–2022)
3. "Power to the Imagination," by Rod Stoneman (2020)
4. "Founding Myths and Storytelling: The African Modern," by Michael T. Martin (2011)
5. IMAGINE Photo Gallery

Figure 1. Students in front of IMAGINE Institute. Image courtesy FESPACO.

1. IMAGINE Institute Press Kit, 2013

Ouagadougou, Wyalusing District, Burkina Faso

As part of the IMAGINE Institute 10th Anniversary, and within the framework of the Pan-African Film Festival of Ouagadougou (FESPACO), the IMAGINE Institute is pleased to invite you to its different activities.

What is the IMAGINE Institute?

Founded in 2003 in Ouagadougou, the capital city of Burkina Faso, by Burkinabe filmmaker Gaston JM Kaboré, the IMAGINE Institute is an international institute offering initial improvement and mentor training opportunities regarding every trade linked to cinema, TV, and multimedia.

As the driving force behind the imaginative capacity of a majority of Africans is increasingly affected by opinions foreign to the continent, IMAGINE has undertaken to offset that trend by promoting a new approach and adequate training for those who bet on the audiovisual sector for insuring a brighter future for Africa.

Since 2003, IMAGINE trained more than seven hundred professionals from twenty-six African countries.

A Privileged Place for Transmitting Knowledge and Know-How

As a privileged place for transmitting knowledge and know-how, the IMAGINE Institute is a 2,900 sq. meter complex where professionals from all over Africa perfect themselves through bilingual (French/English) training sessions in:

Conception / Writing / Creation / Filmmaking Field (from six to eight weeks);
Shooting / Sound recording / Editing / Mixing Techniques (from four to six weeks);
Economics / Management / Film Production Field (from two to four weeks);
Artistic trades related to Cinema and the audiovisual industry (actors, set designers, costume designers, music composers; from two to four weeks).

An Archives Department to Build An Audiovisual Memory

In 2008, an Audiovisual Archives Department inspired by Cambodian filmmaker Rithy Panh's Bophana Center, was created within the IMAGINE Institute to build an audiovisual memory of the history and culture of Burkina Faso. It is available for researchers, students, professors, youth, and resource centers of the country, and the rest of Africa. The Audiovisual Archives Department gathers Burkinabe archives covering the period from 1944 to today, along with other relevant information.

Since 2011, the Audiovisual Archives Department hosts visitors on a regular basis, and organizes "Memory Camps" to sensitize a wider public to the importance of preserving and to add value to its audiovisual heritage.

Initiation Trainings for Youth

In 2012, based on the successful operation of the Memory Camps and at the request from participants, the IMAGINE Institute developed the "120H Chrono," an initiation training to short digital filmmaking techniques from scriptwriting to the movie completion and its public screening. This "120H Chrono" concept is aimed at members of cinema clubs from high schools, colleges, schools of higher education, and universities in Burkina Faso.

CHRONOLOGY

2003: Launching of the IMAGINE Institute
2008: Creation of the Audiovisual Archives Pole
2010: Creation of the IMAGINE Association
2013: The IMAGINE Institute celebrates its 10th Anniversary

The Founder, Gaston Kaboré

Born in 1951 in Bobo-Dioulasso, Burkina Faso's second largest city, Gaston JM Kaboré grew up in Ouagadougou then returned in his hometown where he received a literature baccalaureate in 1970. While studying in France at the University La Sorbonne Paris IV and Paris I, he graduated with a Bachelor's degree in History (1973), a Master's degree in African History (1974), and a DEA in History (1975). He then undertook PhD studies, but gave up to concentrate on filmmaking. Becoming aware of the importance of cinema as a manner to reappropriate oneself, Kaboré integrates the Higher School of Cinematographic Studies (ESEC) in Paris, France, and received a Higher Diploma in Cinema, Filmmaking Option in 1976.

A Life Devoted to the Seventh Art

Back to Burkina Faso, Kaboré worked from 1977 to 1981 in the Ministry of Information and Culture as a technical advisor in charge of the cinema. Simultaneously, he took an active part in the development in the seventh art in his country as Manager of the Burkina Faso National Cinematographic Center (from 1977 to 1988); teacher at the Film Studies African Institute, INAFEC (from 1977 to 1986); Member of the Expert Committee for the setup of the Inter-African Cinematographic Distribution Consortium (CIDC) and the Inter-African Film Production Center (CIPROFILMS) (from 1977 to 1986); Committee Member of the Pan-African Cinema and Television Film Festival in Ouagadougou (FESPACO) since 1978.

In addition to reports and documentaries shooting since 1977, in the 1980s and the 1990s Kaboré's name became world renowned thanks to his features *Wend Kuuni* (French Cesar for Best Francophone Film in 1985), *Zan Boko* (Silver Tanit, Carthage Film Festival 1988), *Rabi* (Special Jury Prize, Carthage Film Festival 1992) and *Buud Yarn* (Étalon de Yennenga, FESPACO 1997).

From 1985 to 1997, Kaboré received three successive elective mandates as a General Secretary of the Pan-African Filmmakers' Federation (FEPACI). From 1989 to 2002, he was also the General Manager of the independent production company for cinema and television, Cinecom Production.

To Tell Stories, To Train, To Transmit

Kaboré was a member in the Artistic Council of the Africa Creation Foundation (from 1991 to 1993), as well as the Administration Council of the Screens of the South Foundation and Committee President of the "Training and Technical Assistance" of the same foundation in Paris, France (from 1992

to 1993). He became cofounder, head of publication, and editorialist of the quarterly and bilingual (French and English) African magazine on cinema, TV, and video, *Ecrans d'Afrique/African Screen* from 1992 to 1998.

Kaboré's book, *Africa and the Centenary of Cinema* was published by FEPACI/Présence Africaine editions in 1995. Additionally, he never ceased organizing professional training sessions in Africa, from Senegal to South Africa. He was also a jury member of many international film festival juries in Locarno, Venise, Cannes, Rotterdam, Berlin, and Ouagadougou.

Thanks to his numerous experiences and his desire to continue his work, Gaston Kaboré founded the IMAGINE Institute in 2003 and continues to manage the Institute.

Exhibition: Africa's Gift to the World
February 22nd to March 9th, 2013

As a follow up to the success met by the exhibition *What We Owe to Africa* from October 2010 through January 2012 in the Grenoble City Musée Dauphinois (France), and as part of its 10th Anniversary, the IMAGINE Institute is pleased to present the exhibition *Africa's Gift to the World*.

This exhibition, which aims to be mobile, will present a panorama of African History, from the birth of Humanity to contemporary themes including the different African Empires, slavery, and the colonial ordeal through paintings, photography, African art objects, and archeological pieces.

Exhibition Scenography

Birth And Prehistory
- In the RIFT Valley (the Origins of Humanity)
- Lucy
- Archaeological Pieces Legends
- Prehistoric Africa
- Egypt
- Ancient City Wall: Zimbabwe
- Nomad Pastor in the Omo Valley

Empire City Charters
- Kingdom, Empires, or City-States?
- Text of the Mande Charter
- Charter's illustration

Contemporary Spaces
- Corruption, Traffic, Fiscal Escape
- On Meeting Difficulties
- On Masks' Life and Death
- On African People's Culture
- On African Cultures and Their Contribution to Humanity
- On the Myth of Origins
- On the Contemporary Young Artists Creativity On the Scientific and Technical African Inputs

Slavery, Colonial Human Ordeal, Colonies as Reservoirs
- Sought-After Wealth
- Slavery—Boat—Code Noir
- Slavery Abolition and Racism
- Slavery Abolition
- Colonial Expansion
- 150 Dahomeans
- Africa's Sharing
- Colonial Propaganda
- King Kongo's Baptism
- Colonial Exhibitions
- Independences
- On What Africa Supplies

Symposium: Africa's Gift to the World
February 22–25, 2013

Africa, cradle of humanity, has seen Lucy's birth, invented the metalworking industry, hieroglyphs, and the solar calendar originally of the calendar we use nowadays. Egypt and its pyramids generated passion among generations of researchers, archaeologists, historians, and travelers. Yet this civilization was not the only one and other glorious societies succeeded from the fifteenth century BCE through the fifteenth century CE, from Hafside (Libia) to

the Great Lakes (DRC), through the Abdelwadide, Yoruba, and Salomonide kingdoms, the Malian Empire or the Haousa Cities. Those societies, respected for their social and political balance, were totally modified through twelve centuries of slavery and one century of colonization.

As part of the IMAGINE Institute's 10th Anniversary, eminent intellectuals are invited to debate with the audience on the African supplies to the world.

Guest List (Non-Exhaustive):

- **Cheikh M'Baké Diop,** PhD in Science, is the author of *Cheikh Arad Diop, l'homme et l'aeuvre.* With the Egyptologist, linguist, and historian Théophile Obenga, he is the editor of *ANKH, Revue d'Egyptologie* and *des Civilisations africaines.*
- **Yoporeka Somet**, PhD in Philosophy, is also an Egyptologist, specializing in hieroglyph writing. His publications include *L'Afrique dans la philosophie and Introduction à la philosophic africaine pharaonique.* Somet also contributes to the *ANKH Journal.*
- **Jean Guibal**, PhD in Ethnology, is the Manager of the Musée Dauphinois of Grenoble City (France). As a Head Curator for the Conseil General de l'Isère, Guibal managed almost forty permanent and temporary exhibitions. He also directs the collection *Les Patrimoines* and the journal *L'Alpe.*
- **Mahamade Savadogo**, PhD in Philosophy, is a Philosophy Professor at the Ouagadougou University (Burkina Faso), the Bouaké University (Ivory Coast), the Cotonou University (Benin), the Dakar University (Senegal), and the Lille University (France). Head of Publication of the journal *Cahier Philosophique d'Afrique,* he published various essays including *Pour une éthique de l'engagement* 2007).
- **Olivier Cogne**, is the Manager of the Musée de la Resistance et de la Déportation (France). Cogne, who has a historian and archivist background, was the Commissioner of the exhibition *What We Owed to Africa,* presented at the Musée Dauphinois from 2010 to 2012.
- **Lassina Simpore**, PhD in Archaeology is a Deputy Master in African Archaeology and Administrator of the Patrimonial Cultural Property in the Ouagadougou University Archaeology Laboratory (Burkina Faso). He is also Curator of the Loropéni Archaeological site in Southern Burkina Faso.

With the support of the KHEPERA association, the ANKH magazine, Culture et Développement, the Museé Dauphinois from Grenoble City, and the Ouagadougou University.

Panel: IMAGINE the Future for Teaching Cinema
Tuesday, February 26, 2103 from 9:00a.m. to 5:30p.m.

On the occasion of the last anniversary of the IMAGINE Institute, trainees, mentors, and film schools will gather to explore the future for teaching cinema.

Tomorrow, when technologies will push back the frontiers for large scale film production and broadcast, how will African film schools be able to stand up to these new challenges? Will they be able to answer the film professionals next generation's needs? Will the trained professionals be able to take up the challenge of images and tales production in which Africa recounts to itself and to the rest of the world?

Guest List (Non-exhaustive):

- **Centro Sperimentale di Cinematografia (Italy):** Founded in Rome in 1935, the Centro Sperimentale di Cinematografia is the oldest cinema school in Europe. Spread across Centro Sperimentale di Cinematografia in various location, this school trained Animation, Fiction and Documentary film professionals. As a partner of the IMAGINE Institute, the Centro Sperimentale di Cinematagrafia received a Burkinabe animation director and sent an Italian professor in Burkina Faso in 2011.
- **Huston School of Film & Digital Media (Ireland):** Created in Galway in 2003 with the support of the American actor John Huston's family, the Huston School of Film & Digital Media trains Huston graduates (MA, PhD) through digital technology and creative practice. Since 2009, the Huston School of Film & Digital Media is actively involved in the production of the *IMAGINE FESPACO Newsreel* directed during the 2009, 2011, and 2013 edition of the Pan-African Film Festival of Ouagadougou (FESPACO).

- **Higher Institute for Sound and Image - ISIS-SE (Burkina Faso):** Created in 2006 in Ouagadougou, the Higher Institute for Sound and Image (ISIS) is a higher institute dedicated to artistic, technical training, and support in the audiovisual domain. This would-be subregional school was given the mandate of an establishment with scientific, cultural, and technical status. Since its creation, the IMAGINE Institute regularly receives the ISIS-SE students as part of its trainings.
- **Higher Institute for Cinema, Audiovisual, and Music - ISCAM (Burkina Faso):** Created in 2012, the Higher Institute for Cinema, Audiovisual, and Music (ISCAM) will provide, through a BA, MA, and PhD course, higher trainings in cinema, audiovisual, and music. Its activity will be embedded in the IMAGINE Institute from 2013.
- **Lingnan University (Hong Kong):** Created in 1888 in the Guangzhou Canton (Republic of China), then reestablished in Hong Kong in 1967, Lingnan University was fully recognized as a public liberal arts university in 1999. Amongst its seven arts departments, the Visual Arts Department is affiliated with the Center for Cinema Studies specializing in research on film. Since 2011, it is actively involved in the production of the *IMAGINE FESPACO Newsreel* directed during the 2011 and 2013 edition of the Pan-African Film Festival of Ouagadougou (FESPACO).

Panel: Documentaries That Matter
Thursday, February 28, 2013 from 10:00a.m. to 4:00p.m.

How can urgent social issues be incorporated into film?

How can film enhance human rights awareness?

How do you use films for influencing social change?

Hosted by the Huston School of Film & Digital Media, film professionals will debate with the audience on the use of film and video advocacy as an instrument for enhancing awareness of critical, social, political, and environmental issues, and to influence change.

Guests:

Jean-Marie Téno (Cameroon): "Political documentary making"
For over twenty years, Téno has been producing and directing films on Africa which gave him international recognition. From *Africa I will Fleece You* (1991), to *Chiefl* (1999), *A Trip to the Country* (1999), *Alex's Wedding* (2002), and *The Colonial Misunderstanding* (2004), his films recount the colonial and postcolonial history of Africa.

Mette Hjort (Hong Kong): "Documentary Filmmaking Greater China Today"
Hjort is Director of the Centre for Cinema Studies and Chair Professor of Visual Studies at Lingnan University (Hong Kong). She is also an Affiliate Professor of Scandinavian Studies at the University of Washington (USA) and Honorary Professor at the Centre for Modern European Studies, University of Copenhagen (Denmark). Much of her recent research has focused on creativity under constraint and artistic projects as alternatives or complements to cultural policy.

Nick Danziger (United Kingdom): "Photography and Documentary"
Danziger is a photographer, filmmaker and travel writer. Travelling the world, he shot various countries such as Turkey, China, Bosnia, and Afghanistan. Most of his work is based on the world's most dispossessed and disadvantaged people living in extreme poverty. Internationally renowned, his portrait of Tony Blair and George W. Bush won the World Press Photo First Prize in 2004.

Moderator:

Rod Stoneman (Ireland):
Director of the Huston School of Film & Digital Media, Stoneman was previously Deputy Commissioning Editor in the Independent Film and Video Department at Channel 4 Television and Chief Executive of the Irish Film Board.

FESPACO Newsreel
From February 15th–March 2nd, 2013

In 2013, the IMAGINE Institute will produce *IMAGINE FESPACO Newsreel*'s third season thanks to seventy professionals from Burkina Faso, Benin, Nigeria, France, Ireland, England, Hong Kong, and Rwanda.

IMAGINE FESPACO Newsreel is a professional and informative magazine which offers a fast, colorful, and dynamic cover of the Pan-African Film Festival of Ouagadougou (FESPACO) program. It gives the floor to filmmakers, auxillary artists, professionals, film critics, the audience, and Ouagadougou citizens with all the social, cultural, professional, political, economical, and intellectual scopes of this event.

IMAGINE FESPACO Newsreel is a concept which includes training, production, postproduction, editing, and broadcasting. From February 15–22, 2013, participants will define the editorial content and the subjects' choices and the handling of equipment. This year, three fifteen-minute episodes will focus on the FESPACO twenty-third edition and one episode will cover the IMAGINE Institute's 10th Anniversary activities.

IMAGINE FESPACO Newsreel will be broadcast throughout the festival, simultaneously in FESPACO partner movie theaters, on the Burkina National TV Channel (RIB), but also on the Cinema Numérique Ambulant (Mobile Digital Cinema) screens and on Internet platforms such as YouTube, Dailymotion, and Burkina 2m WebTV.

With the support of the Pan-African Film Festival of Ouagadougou (FESPACO), the Burkina National TV Channel (RTB), the Burkinabe National Voluntary Programme (PNVB), the Swiss Agency for Development and Cooperation (BUCO), Don Faso, the Huston School of Film & Digital Media, the Lingnon University, Den Donske Filmskole, Higher Institute for Sound and Image (ISIS), the Burkina Faso Ministry for Culture and Tourism, the French Ministry of Foreign and European Affairs (MAEE), the Cooperation and Cultural Action Service of the French Embassy in Burkina Faso (SCAC), the Goteborg Film Festival Fund, PUM Netherlands Senior Experts, Loco images, Transpalux/Transpocom, the Cinema Numérique Ambulan (CNA), and Burkina24.

Thank You

A

Afrikamera (Germany)
Agence canadienne de développement international (ACDI, Canada)
Amabassade de Frace au Burkina Faso
Ambassade Royale des Pays Bas au Burkina Faso
Ambassade Royale do Danemark au Burkina Faso
Association burkinabè du cinéma d'animation (ABCA)
Association des amis d'IMAGINE (Netherlands)
Association gestion du Fonds Succès Cinéma. Burkina Faso Association Khepera (France)

B

Binger Institute (Netherlands) British Film Institute (United Kingdom)
Bureau de coopération Suisse au développement (BUCO, Switzerland)
Burkina 24 (Burkina Faso, Canada)

C

Canal France International
Carlton University (Canada)
Carrefour international de théâtre de Ouagadougou (CITO)
Centre international de formation à l'audiovisuel et à la production (CIFAP, France)
Centro Sperimentale di Cinematografia (Italy)
Cinéma Numérique Ambulant (CNA, Afrique)
Club d'Histoire et d'Archéologie
Cheik Anta Diop (Burkina Faso)
Conseil international des Radios Télévisions d'Expression francaise (CIRTEF, France)
Concordia University (Canada)
Conseil Général de l'Isère (France)
Culture et développement (France)

D

Dan Faso (Denmark)
Danske Filmskole (Denmark)
Deutsche Welle Academy (Germany)

E

Espace Gambidi (Burkina Faso)

F

Fédération burkinabè des cineclubs (FBCC)
Federation des clubs RFI (Burkina Faso)
Fédération du Cartel (Burkina Faso)
Festival panafricain du cinéma et de la télévision de Ouagadougou (FESPACO,
Burkina Faso)
Festival Récréâtrâles (Burkina Faso)

G

Génération Joseph Ki-Zerbo (Burkina Faso)
Global Film initiative (USA)
Goethe Institute (Germany)
Goteborg Film Festival Fund (Sweden)

H

Hivos (Netherlands)
Hubert Bals Fund (Netherlands)
Huston School of Film & Digital Media (Ireland)

I

Independent Television Producer Association of Nigeria
Indiana University (USA)
Institut national de l'audiovisuel (INA, France)
Institut supérieur de l'image et du son (ISIS, Burkina Faso)
Institut Francais de Ouagadougou (Burkina Faso)

L

Lingnan University (Hong Kong)
Loca images (France)
LVIA association de solidarité et de coopération (Italy)

M

Ministère de la de la Culture et du Tourisme (Burkina Faso)
Ministère des affaires étrangères et européennes (MAEE, France)
Musée Dauphinois (France)

N

National Film Institute (Nigeria)
New Democratic Institution (NDI, USA)
Newton Film School (USA)

O

Organisation internationale de la Francophonie (OIF; France)

P

Prince Claus Fund (Netherlands)
Programme national de volontariat burkinabè (PNVB, Burkina Faso)
PUM, experts seniors néerlandais (Netherlands))

R

Radio Télévision du Burkina (RTB)
Revue ANKH (France)

S

School of Sound (United Kingdom)
Service de coopération et d'action
Studio Malemba Mae (DRC)
Sundance Training Workshop (USA)

T

Transpalux / Transpacam (France)

U

Union nationale des cinéastes du Burkina (UNCB)
Union de la presse Francophone (UPF)

V

Village Opéra (Burkina Faso)

*"You may say I'm a dreamer. But I'm not the only one;
I hope someday you'll join us."*
John Lennon

Contact IMAGINE

IMAGINE Institute
01 BP 2713
Ouagadougou 01
BURKINA FASO
Phone: 00226 50 36 46 16 / Fax: 00226 50 31 36 24
Email: imagine@fasonet.bf.

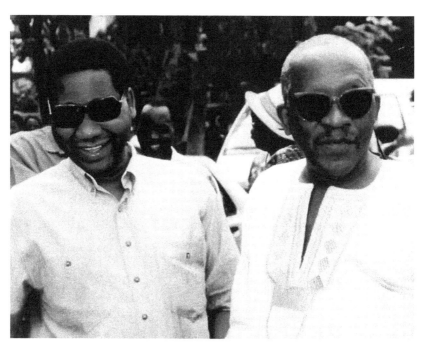

Figure 2. Gaston Kaboré and Ousmane Sembène. Image courtesy FESPACO.

IMAGINE Institute Association: 2019–2022 Action Plan
(selections)

The 2019-2022 Action Plan of IMAGINE Institute Association is based on an overall objective, which is "To promote the contribution of cinema, audiovisual and new technologies to the educational, social, cultural, and economic development of all citizens, particularly young men and women." Its specific objectives are as follows:

Objective 1: to organize continuing and advanced training sessions in the film, television, and multimedia sectors for the purpose of consolidating the professional practice of creators and technicians involved in the field, while raising their awareness on the fundamental importance of images in the rebirth of Africa and the development of all social strata of the Burkinabe population;

Objective 2: to educate the broadest and youngest segments of the population in the image and historical/cultural memory in order to provide them with the necessary tools for the understanding and critical review of images broadcast on television and on the net;

Objective 3: to strengthen the institutional and governance capacities of IMAGINE Institute.

Over the next four years, IMAGINE Institute Association aims to achieve the following results:

- Strengthen the capacities of 640 young professionals (Level One and Level Two), of whom 160 women (twenty-five percent) in their technical and artistic practices through sixteen workshops lasting fourteenth days each, at the end of which they will have produced 160 short films that can be broadcast on Internet platforms.
- Consolidate the technical and artistic skills of 144 experienced professionals, including thirty-six women, through twelve Level Three workshops.
- Educate, in the image and historical and cultural memory, 13,536 secondary and university students, urban youth from the working classes, young people from outlying urban districts, youth from rural municipalities, including 4,116 girls (30.40%) in twenty-five localities of the forty-five provinces of Burkina Faso.
- Strengthen the institutional and governance capacities of IMAGINE Institute staff.

The budget for the implementation of the Action Plan amounts to 1,325,796,972 CFA francs.

I. Background

A. Remote Historical Background

For obvious historical reasons, Africans—like all peoples who have been submitted to long-term exogenous domination, occupation, and administration to external systems of thinking and explanation of the world and to foreign imaginaries—have gradually lost the "boot codes" of the engines of their own imaginaries.

It is imperative that Africans emerge from this involuntary hibernation and undertake on their own account the exploration of the inner and outer worlds as well as the visible and invisible worlds; in such a vital endeavor, consciousness and the subconscious, cognition and experience, intuition and imagination, memory and emotion are all equally involved.

It is at this price alone that they will once again broaden the horizons of all possibilities and collectively pursue the inexhaustible invention of their humanity. To me, imagination seems to be the only vehicle capable of taking them beyond the narrow boundaries of the real and reality that tragically imprison them and restrict their capacities for plural rebirth to themselves. There is an urgent appeal to fertility and production of meaning, a need to a dive into the inner universe that is far more immense than the entire cosmos.

This call must resonate at the level of mind, reason and soul, visions and emotions, and must echo our quest for the infinite. The ultimate question that Africans must ask themselves is: "Who are we?"

The fragments of answers to this question are scattered in the stories, histories, tales, myths, and legends that have been shaped over the 35 million years of history of the continent and of the African man which today's Africans must rediscover and claim as they become producers of new stories, founders of their near and distant future.

B. Current Background

In Burkina Faso, as in most African countries, the emergence of cinematographic and audiovisual expressions faces objective obstacles related to issues of organization, legislation, regulation, financing, production, broadcasting, dissemination, and building of an image memory and culture, as well as to the lack of training opportunities.

The issue of training affects professionals, audiences, the media, critics, public decision-makers, and politicians. The absence of a coherent training

policy in the sector's professions, the absence of production support, and the weakness of infrastructures hinder the satisfaction of the expectations of audiences who are very fond of stories from their regions, whether in documentary cinema, fiction in real life shooting, or cartoons (for screening in cinema rooms or for television and web broadcasting). It is clear that only intelligent consultations at the regional and continental level will make it possible to identify and implement effective strategies to revive the sector.

The very relevant recommendations of the 2009 Brussels International Symposium on "Culture and Creation, Factors of Development" are in line with such vision, as they concluded that we must resolutely support: "... professional training so that it be able to provide the human resources capable of working on the structuring of the sector, the production and marketing of works, both at the local and international levels."

The overall objective of film and audiovisual education should be to equip young professionals with the necessary knowledge and skills to create original works from their local roots and also to adapt to the needs and requirements of the image production industry.

We must bear in mind that a large portion of African youth are totally uprooted and stripped of their connection with their own culture due to almost exclusive consumption of audiovisual programs that are at odds with the realities in which they live, and in total ignorance of their cosmogonic, mythological, imaginary, and memory heritage.

Yet, a large part of the destinies of peoples is determined by their ability to represent themselves and to tell their stories. In fact, in today's world, anyone who does not see himself and who is not seen, does not exist; thus, the lack of representation from which African peoples in particular suffer strongly handicaps their ability to take the initiative of defining their being. Young Africans are in need of heroines, heroes, and role models that resemble them and stimulate their quest for identity and development. This youth is seriously in danger.

Young African film and audiovisual professionals must be equipped to meet this challenge.

It is in this gigantic reconstruction task that IMAGINE Institute, opened in February 2003, aims to take part with humility, stamina, inventiveness, and determination that are essential.

C. Film and Audiovisual Challenges/Issues

The "Country of Honest People," like other small countries with very limited resources, has been exploring ways and means, deploying enormous resources to get out of this situation and offer its populations a decent life based on culture as a factor of development.

Indeed, since the 1970s, the country has been engaged in a proactive national cultural policy, which has been driven both by the State and by a very active network of cultural associations, making Burkina Faso a crossroads of major cultural encounters of continental and global scope, around cinema, theatre, music, dance, masks, puppetry, crafts, books, oral history, etc.

Africans deeply need their own image. The moment of this encounter with oneself through image can no longer be postponed, if not African youth will lose all reference points and fall into a vertiginous spiral that will undermine their existence. This must be avoided at all costs, even if the task seems very daunting, we bet that it is possible and it is such conviction that constitutes the driving force behind our action, especially since cultural diversity must be promoted, supported and rooted more than ever, especially in the heads, minds, looks, hearts, and souls of African youth. The support of technical and financial partners to a training entity such as IMAGINE Institute is more than vital because the advent of Digital Terrestrial Television (DTT) seriously jeopardizes African youth who, if they are not firmly anchored to their own myths, memories, and fundamental quests for their future, will crush and break on the reefs of a globalization that sees them just as a herd of consumers. IMAGINE Institute wants to be one of the lighthouses that will help prevent that risk of shipwreck.

Beyond traditional cinema and audiovisual media, new technologies offer opportunities for massive and appropriate responses. That's why the peoples of Africa tremendously need their own images. Cinema and audiovisual media must also contribute to the consolidation of the rule of law and respect for the human person, and to the political and social anchoring of freedom and justice. Thanks to new technologies that reduce production costs and foster greater diversification of forms of expression through images while offering greater space for broadcasting (cinema broadcasting, digital terrestrial television, web TV, Internet sharing platform, etc.), Africa can begin its rebirth.

II. Presentation of IMAGINE Institute

A. Historical Background

IMAGINE Institute was created in February 2003 to offer on-the-spot continuing and advanced training opportunities, as well as "training of trainers" in all professions related to cinema, television, and multimedia. IMAGINE is a place where knowledge and know-how are transmitted, where the passion for the invention of stories and the art of storytelling are transmitted, a place where talents flourish and are stimulated.

It is therefore mainly a place of learning and transmission thanks to teaching devices in the form of two to six-week professional workshops (script writing, production, directing, shooting, sound recording, editing, mixing, training of actors, and directing of actors, etc.), three-day, six-day and ten-day master classes, a laboratory for shooting three to six-minute short films, introductory film production sessions for young (high school) students (120 hours), "Memory Camps" to raise awareness among children, young people, and adults to the issue of preserving, safeguarding, accessing, and circulating memory; technical support and coaching of film projects conducted by young African professionals, stimulating historical, cultural, social, strategic, professional, artistic, and aesthetic reflection through the organization of symposia, seminars, conferences, and round tables with participants from the film and audiovisual fields, history and philosophy, anthropology and sociology, literature and theatre, music and dance, painting, sculpture and all other forms of art and expression. Since its creation, IMAGINE Institute has always provided its training sessions free of charge and more than 2,060 people from twenty-six African and Indian Ocean countries have benefited from it; besides, more than 4000 participants from eighty-five countries around the world have participated in other events organized by the Institute (conferences, symposia, seminars, round tables, film screenings).

In the light of the 2015-2018 Action Plan, we believe that it is important to initiate a deep reflection in order to better match our training offers to new emerging needs that that can be summarized as follows:

- Need for more expertise in animation film,
- Need for authors, directors, and producers,
- Need for camera operators, gifted with a documentary eye,
- Need for a true professional editor mastering the language of cinema and having a proven artistic and stylistic perception.

Besides, the arrival of a new wave of filmmakers who have trained on the job or who have just completed their film studies makes it necessary to implement twenty-one to twenty-eight-day Level One training sessions the aim of which is to provide them with a solid foundation of theoretical and practical knowledge that will serve as a springboard towards the start of a professional career in the creative artistic and technical fields of film and television. The challenge is about training a strong professional next generation in quality and quantity, especially for the purpose of fulfilling the enormous production needs generated by the advent of (DTT). It is likely that those we train today will be busy working tomorrow if they know how to cultivate the love and passion for their profession that go hand in hand with high standards, discipline, and professionalism.

B. Objectives of IMAGINE Institute

Overall Objective

The overall objective of IMAGINE Institute is to help the film sector contribute to the education of populations in the broadest sense by stimulating their needs for coming into terms with their imaginations and their own views of reality, and for establishing a genuine film industry that benefits our country and the African continent in social, cultural, political, and economic terms.

Concrete Objectives

The concrete objectives of IMAGINE Institute are as follows:

Objective 1: To plan and implement continuing and advanced training sessions in the film, television, and multimedia sectors, with a particular focus on young men and women;

Objective 2: To contribute to the development of an expression and film industry in Burkina Faso by stimulating reflection and definition of effective strategies that promote genuine complementarity between the public and private sectors and synergy between all actors involved in the field;

Objective 3: To contribute to the improvement of the quality of fiction films produced in Burkina Faso by strengthening the skills of all trades involved in the film manufacturing process.

IV. Intervention Rationale

Overall Objective

To foster the contribution of cinema, audiovisual, and new technologies to the educational, social, cultural, and economic development of all citizens, particularly young men and women.

This ambitious objective aims to enable actors of the sector and audiences to acquire the theoretical and practical knowledge and know-how required to find jobs and develop entrepreneurial skills, express themselves in their diversity and create and produce content and works that can be valued in terms of education (secondary schools, universities, associations, and all other spaces) and income generation through access to the various local and international broadcasting markets (cinemas, DVDs, television, Internet platforms and social networks, DVD publishing).

Specifically, the Action Plan has the following objectives:

Objective 1: To organize continuing and advanced training in the film, television, and multimedia professions in order to provide the sector with competent and experienced professionals capable of responding to all the challenges of standard-quality film and audiovisual production that complies with the expectations of local and international audiences, particularly young audiences;

Objective 2: To educate the broadest and youngest segments of the population in the image and historical/cultural memory in order to provide them with the necessary tools to understanding and critically reviewing images broadcast on television and on the net, and teach them the basics of film writing;

Objective 3: Strengthen the institutional and governance capacities of IMAGINE Institute.

V. Target Audiences And Beneficiaries

A. Targets of Training Actions

Burkina Film Professionals, the National Union of Burkina Filmmakers (UNBC) and film and audiovisual professions, film and video production companies, public and private television companies, former students of ISIS-SE (Higher Institute of Image and Sound), former IMAGINE Institute trainees, students of the National School of Administration and Magistracy (ENAM), university students, film lovers trained on the job, young people, pupils, college students, high school students, working class urban youth.

B. The Targets of Image Education and Historical/Cultural Memory Actions

Burkina Film Professionals, secondary and university students, working classes urban youth.

C. Final Beneficiaries

- At least 784 Burkina Film professionals, including 584 young people and 196 women of whom 896 amateurs including 180 women;
- At least fifty film and audiovisual production companies;
- At least five public and private TV companies;
- At least 12,640 young people, secondary school and university students, working class urban youth.

The State of Burkina Faso, the Ministry of Culture, Arts, and Tourism (MCAT), the General Directorate of Cinema and Audiovisual (DGCA), the Fund for Cultural and Tourist Development (FDCT), the National Union of Burkina Filmmakers (UNCB), the film and audiovisual professions' international and Burkina private production companies, Burkinabe and international cultural operators, technical and financial partners, the Burkinabe and international public.

VII. Implementation Modalities

A. Human Resources

The current salaried staff consists of eleven members:
- An accountant;
- A cashier;
- A switchboard secretary;
- A courier driver responsible for delivering mails and collecting packages and registered mail received from third parties;
- A driver in charge of controlling and maintaining the backup generator;
- Three cleaners;
- Two day watchmen;
- One night watchman.

IMAGINE Institute's 2019-2022 Action Plan includes a wide range of activities whose core is the training of professionals ready to serve in the field. Such an ambition requires a sufficient number of qualified and competent staff to carry out all administrative and management tasks, theoretical and practical teaching tasks, logistical tasks, and infrastructure maintenance.

The permanent salaried staff listed above is insufficient to ensure dynamic operation and consistent management of equipment, logistics, and infrastructure. Until then, IMAGINE Institute had voluntarily limited the volume of staff especially with regard to the pedagogical component mainly using short-term contractual trainers hired either locally or from abroad. Only one non-salaried volunteer trainer that is the founder himself provided the educational coordination and the General Management of IMAGINE Institute.

Nowadays, it has become essential to have a more extensive and diversified workforce capable of meeting the new challenges linked to the evolution of the film and audiovisual sector at the conceptual, creative, technical as well as managerial levels. This is why IMAGINE Institute wishes to have permanent salaried staff for the implementation of this new Action Plan, as follows:

- A General Manager;
- An Administration and Finance Manager;
- A cashier;
- A switchboard Secretary;
- A staff responsible for project formulation and fundraising as well as internal and external communication;
- A person in charge of the pedagogical program and training follow-up;
- A permanent trainer specialized in multimedia creation, production and distribution;
- An image technical manager;
- A sound technical manager;
- A postproduction technical manager;
- A courier driver responsible for delivering mails and collecting packages and registered mail received from third parties;
- A driver in charge of controlling and maintaining the backup generator;
- Five cleaners;
- Three day watchmen;
- Three night watchmen.

This quantitative and substantial staffing will certainly bear some cost, but that is what will enable IMAGINE Institute to fully achieve its qualitative and quantitative objectives in terms of number of people trained and effective improvement of the works created, disseminated and viewed by the public with the psychological, social, cultural, imaginary, political, and economic impact sought.

B. *Infrastructure Resources*

In terms of infrastructure, IMAGINE Institute can consider that it has everything required to fully implement the activities included in the Action Plan for the next four years. Indeed, IMAGINE Institute has three blocks of buildings with three level two and two level one and several annexes, the largest of which serves as complementary teaching units while the others are warehouses for storing various materials sporadically used.

The buildings are spread over a fenced area of 3000 square meters and total 2,512 square meters of premises divided into:

- Eight classrooms;
- Five editing rooms;
- One animation studio;
- Seven offices;

- One projection room (eighty seats);
- Twenty permanent bedrooms;
- One restaurant;
- Four warehouses;
- One guard house.

These highly functional premises can accommodate four to six workshops simultaneously dedicated to various disciplines (actor training, scriptwriting workshop, shooting training workshop, sound recording training workshop, editing training workshop, production training workshop, Memory Camp sessions, etc.)

This infrastructure is an important factor in the representativeness, visibility, and professional and educational legitimacy of IMAGINE Institute.

Technical equipment and logistics resources: The IMAGINE Institute's equipment resources have evolved in quality and quantity over its fifteen years of existence. IMAGINE Institute has always been concerned with the acquisition of equipment adapted to the training provided and enabling trainees to be familiar with the most widely used professional technical equipment and thus to be operational to work in local and international teams. During the last five years, a special effort has been made to raise the level of equipment to international standard. It has regularly happened that trainers from the North visiting IMAGINE are surprised to find the latest generation material enabling them to raise the theoretical and practical pedagogical content of the workshop they have come to supervise.

- Six shooting and sound recording complete units;
- Eight editing units with the most used professional software;
- One full range of lighting projectors;
- One postproduction sound unit;
- A 16 and 35mm scanner for the digital transfer of celluloid-supported films;
- A unit for data and sound digital files storage, photographic and film documents (analog images on celluloid and video media);
- A digital server for database consultation;
- Four on-site consultation stations;
- Four desktop computers;
- Eight video projectors;
- Six pairs of mobile speakers;
- One sound mixing console;
- One multi-camera production unit;
- One self-supporting and soundproof generator.

Although IMAGINE Institute Association does not own its own rolling stock, it has a fleet of seven vehicles made available by the Founder, which makes it possible to carry out educational activities with ease of transport for people and equipment, particularly as part of practical shooting exercises on natural outdoor settings.

C. Youth and Gender Considerations

Youth Consideration

Youth is the main target of all the trainings, Image Education and citizen awareness activities provided by IMAGINE Institute. 397 young people, or 95.43% of the beneficiaries of IMAGINE Institute's activities, will be impacted by our Action Plan. And when one knows how the flows (of information and communication of ideas, thoughts, practices, habits, modes) circulate between young people, we cannot reasonably doubt that a multiplier effect will occur from young people who have had direct access to our training sessions.

The ambition of decentralizing our training sessions to significantly cover the entire country is fully justified in this vision and necessity to offer equitable access to the new alphabet that is the image and with which the desires, aspirations, demands, identities and destinies of young people will now be written. During the training sessions, the stories they will write, the films they will make, the web stories they will produce and which will be posted on the platforms will act as so many ferments and yeast that will stimulate their creativity and sharpen their perception of reality, giving them new capacities for proposals and assuming responsibility.

Gender Considerations

It is well known that there is a very high inequality of access for women in the process of making and creating cinematographic and audiovisual works. This is linked to the general problem of the gendered division of labor in the various professions of the sector. The ambition of IMAGINE Institute is to contribute to correcting this inequality by ensuring as much as possible an optimal percentage of place for women in the recruitment of trainees at all levels, both for beginners and professionals who are in need of skill consolidation.

The gender-specific program that had been codeveloped by IMAGINE Institute and Succès Cinèma Burkina Faso could not take, off, but it did sow seeds that IMAGINE Institute intends to help water in order to obtain a plant whose growth and flowering are more than expected. All the trainers working for IMAGINE Institute will be instructed on the particular attention they should pay to women, not by treating them as "handicapped" but by creating

an atmosphere conducive to the development of their creativity. In this way, women's self-confidence will grow and they will change the way others look at them as well the way they look at themselves. Everything will also be done to increase the number of female trainers. The number of 124 women, 29.8% of the total number of trainees, is the first sign of the place that IMAGINE Institute would like them to occupy. In addition to the training sessions and all other programmed pedagogical and cultural elements, it will be ensured that women benefit from at least forty percent of the coaching, creative and technical support that IMAGINE Institute will offer.

For further information: www.institutimagine.com

Power to the Imagination

Rod Stoneman

> "So that the place of utopia, which by definition has no place, has a place..."[1]
>
> FERNANDO BIRRI

Moving images are part of a pervasive image system which crosses the globe, reiterating authorized narratives that disclose events deceptively. Training young people to enter that system in Africa as elsewhere involves the development of critical practitioners who have created their own emancipatory intelligence. Shaped by its own context and history IMAGINE Institute was created and developed by Gaston Kaboré in a close and symbiotic relationship with FESPACO and FEPACI.

An active Burkinabe filmmaker, Kaboré's feature films include *Wend Kuuni* (1982) and its extraordinary 'sequel' made with the same community and actors fifteen years later, *Buud Yam* (1997), and also several varied shorter films. Bringing a filmmaker's perspective of creating images and sounds to shape a vision, to follow an individual quest through the realization of films to the setting up of a farsighted alternative film school is rare enough. There was a determination to take an open and responsive route, he talked at its inception of embracing "a process through which the Institute

will seek continuously to reinvent itself," creating a place where knowledge and expertise could be distributed in a new way.

From its commencement in 2003, the approach of the IMAGINE Instutite was based on the idea that the future of film training must be embedded in the dynamic of the changing technological and institutional circumstances of its time and place. The IMAGINE Institute was set up to provide a full range of training in all activities related to the cinema, television, and multimedia activities within Burkina Faso and reaching out to students elsewhere in the continent. The song John Lennon and Yoko Ono composed in 1971 is an inspiring starting point:

> Imagine there's no countries
> It isn't hard to do
> Nothing to kill or die for
> And no religion too.

The starting point for this mission commences with a fresh and rigorous examination of the wider culture industry, analyzing its determinations and effects, its mechanisms and methods at home and abroad. The cinemas of Africa are seen in relation to a dominant American cinema, commercial and confident, which contributes to the contemporary world's image of itself and is embedded in a resilient ideology which interacts with the economic order. Different perspectives from outside, diverse forms of cinema from other cultures are already situated as marginal and subordinate as they challenge and relativize the domination of the US model. For clear historical and political reasons it is not surprising that some of the most dynamic new filmmaking comes from the cultures of the South—where the very act of making cinema is both more difficult and more urgent.

How are audiences drawn into a global and centripetal reduction of cultural diversity? The lack of textured direct speech in circulation from other parts of the world allows Western representations to misconstrue the experience and perspectives of most of the planet. Europe and the US tend to construct Africa as a place of disrepair and disorder in order to grant themselves interpretive mastery over it. The IMAGINE Institute and its students and collaborators set themselves the task to use creative tools for resistance and refutation.

The Institute is unique in so many ways—financed from diverse sources as a smaller, more independent film school it is able to take more mobile and independent initiatives than larger state structures and institutions over the years.[2] It has been able to maneuver flexibly with various formats for short courses and workshops, refreshed with changes of tutors and has developed and thrived with over 120 workshops and courses (short filmmaking, editing, cinematography, sound, scripting, acting, animation) addressing a

wide mix of students and professionals, focused on Burkinabe but also with a Pan-African reach. Over the years a committed range of trainers have run courses which have involved over two thousand students coming from twenty-six different countries.

IMAGINE aims to be a place for sharing knowledge and expertise as part of communicating the art of storytelling and filmmaking. There has also been a focus on developing socially-committed producers, who can access sources of funding and distribution for an independent sector which is financially precarious and does not imitate the more commercial orientation of large sections of the anglophone film industries such as Nollywood and South Africa. It is a place where practitioners teach their art to hand-picked students (no fees are charged) amongst whom a few will become 'knowledge mentors' in order to carry this work to new creative communities. Levels of experience move from starting out from basic education to experienced filmmakers extending their work and capability, including a course specifically aimed at women joining the industry; a conference on "Women's Access to Equal Representation in Creative, Artistic, and Cultural Professions" was organized in June 2017. There were a series of "Memory Camps" in regional centers such as Koudougou, Kongoussi, and Dédougou in 2018 aiming to familiarize young people with issues of memory, identity, and the use of audiovisual archives.

Part of the project has involved training the trainers—focusing on knowledge communicators and course facilitators who pass on their approach to film. The site of extraordinary solidarity and friendship, IMAGINE aims to be complementary to other courses and colleges providing training in Burkina Faso and beyond, operating with a cooperative and non-territorial approach. It has maintained an autonomous funding structure with financial support coming from diverse sources.

A workshop for "Filmmaking for Advocacy and Activism" held in August 2014 was attentive to the calibration of images and sounds and how political ideas could be communicated to an audience even under an authoritarian regime. One of the short films depicted concerted civil resistance— a premonition of the events leading to the fall of Blaise Compaoré months later. A practical workshop in February 2018 focused on creative possibilities from the use of sound and music to explore the expressive potential of the soundtrack in filmmaking looking to go beyond the usual teaching of sound design and composition to combine the technical and professional demands of soundtrack production with an enhanced degree of creative decision-making and experimentation.

Alongside courses, public seminars, and symposia have involved leading practitioners, essay writers, philosophers, technicians, and theoreticians in the area of art and creation; artists and critics, sociologists and anthropologists

provide an informed and clear-sighted view of movements and issues in the areas of art and communication, writing and storytelling, individuals and society, history and imagination. This close and versatile relation of courses to events and conferences has worked particularly well, often facilitated by the wide range of African and international participants in Ouagadougou during FESPACO. The 2011 conference on "Myth and Storytelling" brought scholars from around the world to explore oral narrative, film, and "The phosphorescent layer of myth which is at the foundation of all our existences," in Kenneth Anger's phrase. When Des Bell's creative documentary *The Last Storyteller?* (2002) was shown parallels between the West African griot and the Irish seanachaí were evident and correspondences between the folk tales circulated in rural communities in both places emerged.

An exhibition entitled *Le Don de l'Afrique au Monde / Africa's Gift to the World* explored aspects of African history and heritage, and suggested that Africa as a continent that built the past can also shape the future. It was first launched during FESPACO in February 2013 and has remained open since then. As Kaboré explained, "we have to do this kind of research because Africans need to know who they are, who they were. If you want to know where to go, you need to know where you are coming from."

Activities during three editions of FESPACO in 2009, 2011, and 2013 included a series of three fifteen-minute newsreels which were made during the festival each year by teams of young filmmakers. New generations have made a point of taking unexpected variations of political filmmaking as a starting point for their work with moving images. For example, following the production of these three series of newsreels made for FESPACO, the 2014 workshop "Telling Microstories" became an intense ten-day workshop supporting young filmmakers having "something to say in an innovative form." Participants undertook a series of sound and image exercises and experiments leading to the production of short films posted on the internet.

The space to play, even to make mistakes, is fundamental—as Irish writer James Joyce quipped "Error is the portal of discovery." Teaching young people technical skills is not enough, it is crucial to strengthen their capacity to develop new desires, new reflections, new aesthetics, and new ways of self-representation. Imagine stands in contrast to the narrower approaches in many current filmmaking courses and colleges worldwide which often place their entire emphasis on technical training for the industry and exclude political or critical thinking. Instrumental, craft-based approaches do not create space for the necessary imaginative engagement and understanding of the broader social importance of film and television. The argument that modern pedagogy should propose that critical analysis and production will be continuously connected and interactive is elaborated more fully in Duncan Petrie and Rod Stoneman's *Educating Film-Makers: Past, Present and Future.*[3]

The ethics that need to be embedded in training lead to questions such as: What role can filmmaking have in the repair of the condition of humanity? What behavior helps or harms sentient creatures? How should filmmakers conceive of ethics and their responsibility for the Other? Do we need to remind ourselves that there is a point to making the moving image? Radical approaches to the reformation of filmmaking and systems of communication are crucial if we are to avoid the dangers inherent in neglecting a moral human compass with respect to our engagement with each other, the natural world and potential technological "progress."[4]

As Paulo Freire indicated in his seminal book, the *Pedagogy of the Oppressed* (1968), a continued shared investigation between teachers and students can lead to new awareness of selfhood, forms of criticism and radical consciousness that set in motion engagement in the effort to objectively transform concrete aspects of the social formation.[5] The openness to the art of the past in Africa and the free movement of speculation should release curiosity, challenge supposition, develop dissent.

The advance of digital technologies provides fast-changing possibilities for film students to progress their own work—both in the way it is made, and also in how it is distributed. New forms of rapid access to information and other audiovisual material open stimulating new perspectives and an abundance of alternative forms. This may have especial emancipatory potential in places where expensive capital equipment is limited.

Integral to IMAGINE is its wide-ranging and diverse interaction with the country and culture in which it exists. Recent engagements have contributed directly to social and political urgencies in Burkina Faso: as part of the support program for the electoral process in the approach to the country's first full election on November 27, 2015 IMAGINE initiated thirty-eight half-minute films to create awareness of the procedures for voting and encourage full political participation. Most recently, the Institute produced a series of five short awareness-raising films with Artistes BF and the actors of Compagnie le Ruminant; available online they contributed public information to the attempt to stop the spread of the COVID-19 virus in Burkina Faso.

Cultivating filmmakers, as the agricultural term suggests, involves nourishing and enlightening new generations, taking them towards a refreshed social and aesthetic function for the moving image in Africa and beyond. IMAGINE approach enables them to think flexibly and strategically outside of the acquisition of technical skills—technique is a tool and not a goal. There can be a displacement of attention which makes a fetish of new equipment; but it is always important to remember that a much better film can be made with intelligent and imaginative ideas on basic equipment than many a specious short shot on expensive cameras and edited with sophisticated software. The unique singularity of IMAGINE is as a place to train

young filmmakers to be strong, audacious, independent, and profound in their desires and visions—no one except themself will tell their stories... The catalytic function of art for curiosity, intelligence, and emotion moves it towards the possibilities of discovery, dissent, and social intervention. As Kaboré explained at the outset, "The ultimate objective of the Institute is to promote innovation and the invention of new forms of aesthetics as well as a new creative economy." Imagining new ways of teaching film is part of the attempt to find new ways of thinking and new ways of living.

The dynamic of Lennon and Ono's song recurs in the utopian lyrics of "Silence, on rêve" by Tatouages, a group of five women originally from Kasai province in DR Congo: "Identities of people, countries, and cultures have become a product of marketing . . . We are the spokespeople of the planet with riches that are forgotten by globalization, sold down the river by politicians. But we have the power to transform the world immediately."[6]

L'imagination au pouvoir![7]

Rod Stoneman is an Emeritus Professor at the National University of Ireland, Galway and a Visiting Professor at the Universities of Exeter and the West of England. He was the Director of the Huston School of Film & Digital Media, Chief Executive of Bord Scannán na hÉireann / the Irish Film Board, and previously a Deputy Commissioning Editor in the Independent Film and Video Department at Channel 4 Television in the United Kingdom. In this role he commissioned and bought and provided production finance for over fifty African feature films. His 1993 article "African Cinema: Addressee Unknown," has been published in six journals and three books. He has made a number of documentaries, including *Ireland: The Silent Voices, Italy: the Image Business, 12,000 Years of Blindness* and *The Spindle.* He is the author of *Chávez: The Revolution Will Not Be Televised, A Case Study of Politics and the Media; Seeing is Believing: The Politics of the Visual,* and *Educating Film-Makers: Past, Present and Future* with Duncan Petrie.

Notes

1. This graceful formulation by Argentinian filmmaker Fernando Birri (1925 – 2017) is inscribed on a plaque in the entrance to the Cuban Film School in San Antonio de Los Baños.

2. IMAGINE received some subsidies from Burkina Faso, South Africa, the Netherlands, France, Ireland, UK, Sweden, Switzerland, USA, Taiwan, Germany,

Denmark, International organisation of la Francophonie and notably, since the beginning, substantial support from Edith Ouédraogo, Gaston Kaboré's wife.

3. Bristol: Intellect, 2014.

4. This is developed from a talk originally given as part of the symposium '*Imagine quel future pour l'enseignement du cinema?*' at the Imagine Institute on 26 February 2013.

5. Paulo Friere, *Pedagogy of the Oppressed*, Trans. Myra Bergman Ramos (London: Penguin, 1996).

6. Lyrics from *Africa Remix / AH FREAK IYA*, Sai Sai Productions, Éditions Milan Music 2005; part of *Africa Remix: Contemporary Art of a Continent*, a large-scale exhibition staged in Paris and London in 2005.

7. *L'Imagination au Pouvoir*, a slogan from the *évènements* of May '68 in Paris, was the title of a book of photos by Walter Lewino (Paris: Losfeld,1968).

❧❧

Figure 3. Salle Melies artwork. Image courtesy FESPACO.

Founding Myths and Storytelling:
The African Modern

Michael T. Martin

IMAGINE Institute
February 28, 2011
Ouagadougou, Burkina Faso

Good evening!

I am very pleased to participate in this timely colloquium on "Founding Myths and Storytelling."

And I am especially grateful to Gaston Kaboré and the film training institute IMAGINE for this important initiative. And to the President of this séance Raymond Weber.

Among the remarkable aspects of this colloquium is the foresight of its organizers. They have assembled a distinguished group of individuals whose views, collective experience, and practice offer diverse but related readings of myth and storytelling.

Together, and in conversation with our audience, we are revisiting the subject of myth; a subject that demands continuous study as societies evolve, fade, transform, and—in the long sweep of history—migrate reproducing themselves in a variety of iterations in diasporas—Black/African diasporas most evident in the Caribbean and South America.

I want to situate myself in this conversation by noting that I am not trained as an anthropologist or ethnographer. The subject of "myth," however, interests me as an organizing concept or principle because from myths we can discern a peoples' conception of their collective past, indeed, the founding assumptions of their nation's formation.

I have no original ideas to share with you about African mythologies. Others before me and during the course of the colloquium have eloquently addressed such mythologies, how they are constituted and manifest in the play of culture and politics, and with respect to this gathering, how they are deployed by the storyteller.

My purpose then is to invite you to consider the importance of myths in the project of world-making because in myth we find the soul and promise of a people. And we find there, too, perhaps traces of a people's future—what Gaston Kaboré calls their "destiny." These traces were evident yesterday in

the documentary, *The Last Storyteller* [dir. Desmond Bell, 2002, Ireland], that Rod Stoneman generously shared with us.

Having said this, I want to return to several assertions made during the colloquium.

- The first and most important assertion in my view is that Africa is the purveyor of a rich, varied, distinct, and ancient storytelling tradition. A tradition as complex and sophisticated as that of any other civilization in the world.
- The second assertion is that most, if not all, storytelling traditions deploy allegory, legends, fables, and so forth as modes of signification. Whatever their modes, stories are recounted orally, in writing, or visually—all of which constitute and record the narrative of humankind.
- The third assertion is that the raw material—*la materia prima*—of storytelling is not imagination, although imagination elaborates, refashions, edits, and interprets lived experience.

In this creative intervention in the material world, the storyteller conjures an alternative and fictive reality where the protagonist—real or other worldly— reveals ideal and universal aspects of the human condition.

- The fourth assertion is that each generation reimagines its founding and organizing myths, reworking them to conform to their reality, to their values, exigencies, and social and spiritual needs in real-time.

Which leads us to consider another factor along this historical trajectory: myths are neither static nor immutable. The forms they take arise and permutate in time and space, they are evoked by their contexts. I expect during the discussion to follow that others will cite examples of African myths that operate along these lines.

- The last assertion to examine, evidenced in *The Last Storyteller*, the film I referenced earlier, is that myth, regardless its framing in the storyteller's narrative, can instruct its public on how to comport itself in a world fraught with deceit, greed, and violence. In this sense, myth works in our imaginary to engage problems in the social world. Similarly, we can argue that myth serves to regulate acceptable forms of behavior in communities. So myth, its deployment in storytelling, can carry multiple intentions and significations.

I began this conversation, not to recover and reclaim the past, however fundamental and necessary this imperative might be, but to consider myth deployed by the storyteller in the project of world making. How, then, can we discern traces of a people's future in their labors to imagine another world?

Why do I think this project merits our consideration? What relevance can it have for Africa's future? How can myth reveal the absurdities and contradictions in our lives? How can it help us understand our circumstance—our reality—in order to change it?

We are—that is the world is and African descended people are—increasingly subject to two historical processes working in tandem, or rather one is derived from the other: the imperatives of *capital* (corporate capitalism) and *globalization.*

While capital denies or appropriates the past on behalf of a consumer universe, the underside of globalization levels cultures to a common denominator on behalf of consumption and a distinctly western conception of modernity.

The assumptions and iconography of popular culture under these relational processes in the contemporary period is the matter that African storytellers must challenge, as they have the colonial project and imperial rule. Can African storytellers imagine new myths appropriate for these times and under these historical conditions?

I conclude with questions to invite discussion, questions for which I do not have answers.

- Should African storytellers reappropriate popular images, particularly ones that engage with every day urban and rural life, and challenge commercial interests which would refashion such images for financial or regressive political gain?
- Will African storytellers invent myths that correspond to the realities of the social world and promote myths that validate African experiences—traditional and modern—while affirming universal and "home truths"?
- By imagining myths and legends for contemporary audiences, will African storytellers affirm that a different world is possible and that the material and spiritual needs of Africans can co-exist on equal terms?
- Evoking new myths, corresponding to the realities and experience of the day, can African storytellers stand in counterpoint to the interests of capital and the reductive processes of globalization?
- What might the themes and subtexts of such myths and the expressive forms be in the commerce of ideas and transformation of societies?

Africa has its living and deceased, known and unknown legends from the epic hero to the humble farmer, civil servant, and mid-wife who labor on behalf of their families, communities, nation, and humanity.

It has its local heroes who defend women's rights and the environment upon which *all* life depends.

Their stories are the raw material for African storytellers and the stuff of legends.

Every epoch births its own myths, derived from historical activity, and corresponding to the cultures and peoples who invent and portray them.

What are the myths of the African modern that the storyteller—poet, artist, dramatist, or filmmaker—has yet to imagine?

I believe IMAGINE is one such site to realize this historical project of recovery, renewal, and invention.

Thank you.

IMAGINE Photo Gallery

Figure 4. Students, IMAGINE personnel and Gaston Kaboré. Image courtesy FESPACO.

Figure 5. Students posing for a photo outside IMAGINE Institute. Image courtesy FESPACO.

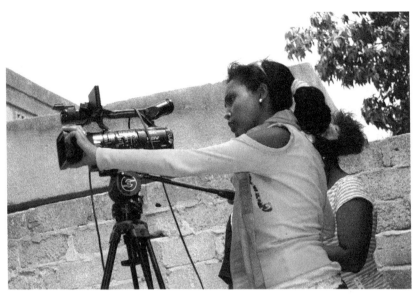

Figure 6. Betelhem Abate operating the camera. Image courtesy FESPACO.

Figure 7. Esley Philander (left) and Yidnekachew Shumete (right) reviewing a script. Image courtesy FESPACO.

TOP: Figure 8. Aster Bedane helping with a light reflector. Image courtesy FESPACO.

LEFT: Figure 9. Kagho H. Akpor (left) and Feleke Abebe (right) setting up a shot. Image courtesy FESPACO.

MIDDLE: Figure 10. Students preparing for a take. Image courtesy FESPACO.

BOTTOM: Figure 11. Yidnekachew Shumete directing an actor. Image courtesy FESPACO.

Figure 12. IMAGINE students take their footage to post-production. Image courtesy FESPACO.

Figure 13. Sound trainer Bertrand Lenclos mixes audio. Image courtesy FESPACO.

Figure 14. Student films receive their final cut. Image courtesy FESPACO.

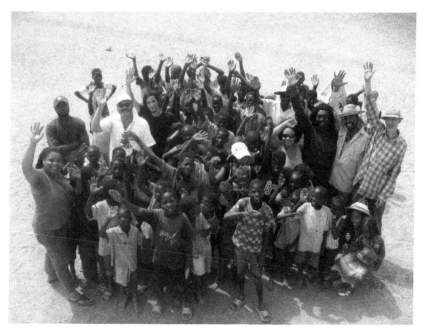

Figure 15. Students, trainers, actors, and primary schoolboys of a village used as a filming location. Image courtesy FESPACO.

Index

Page numbers in italics refer to illustrations.

Printed in the USA
CPSIA information can be obtained
at www.ICGtesting.com
LVHW051742021123
762716LV00004B/4